Modern Landscape Painting

Modern Landscape Painting

Pier Carlo Santini

Phaidon

Translated by P. S. Falla

Phaidon Press Limited, 5 Cromwell Place, London sw7

Published in the United States of America by Phaidon Publishers, Inc.
and distributed by Praeger Publishers, Inc.
111 Fourth Avenue, New York, N.Y. 10003

First published 1972
Originally published as *Il paesaggio nella pittura contemporanea*
© 1971 by Electa Editrice® - Industrie Grafiche Editoriali S.p.a., Venice
Translation © 1972 by Phaidon Press Limited

ISBN 0 7148 1504 7
Library of Congress Catalog Card Number: 79-165863
All rights reserved

Printed in Italy

CONTENTS

LANDSCAPE IN TWENTIETH-CENTURY CIVILIZATION AND PAINTING

At the beginning of the present century the population of the world was about 1,500 million; it is now double that number, and in the year 2000, less than three decades from now, it will have doubled again to 6,000 million. This is sufficiently alarming, not to say catastrophic, without pushing the prophecy any further. It is not surprising that more and more energy and resources are being devoted to the large-scale study of ways of coping with a problem that will be acute when today's young people are still alive.

The growth of population has already vastly increased the speed of the process by which, ever since prehistoric times, the features of our planet have been altered and added to by the hand of man. The period in question has indeed been one of a few millenniums only. In the long ages that preceded it, the face of the earth gradually evolved to a shape that appeared immutable, and in fact was so for a considerable time. Then came the day when man set about moulding nature to a new image, designed to present a stable and recognizable appearance for a longish period—in short, when he created landscape. Emilio Sereni has described the increasing tempo of change in Europe as ploughing replaced hoeing during the Bronze Age and early Iron Age; but although this made a greater difference to the appearance of cultivated areas than more primitive agriculture had done, 'the area affected . . . was relatively small. Moreover, the predominant agricultural system was of the "field and grass" type or, in forest areas, the equivalent process of "denshiring": in other words, cultivation was carried on precariously in virgin lands which, when their natural fertility was exhausted by one or two productive cycles, were once more left to vegetate in a haphazard manner.'

In historic times, then, the 'natural' landscape produced by mere chance, i.e. by geographical, climatic and biological factors independent of human agency, disappeared gradually as man took possession of his earthly kingdom. There were great variations from continent to continent and region to region, but few areas indeed were exempt from the progressive transformation. Today, the more civilized a country is and the fewer its 'natural' sites, the more concerned its people are to establish and protect 'national parks' in which portions of nature are safeguarded like precious relics, in the same way as historic cities and ancient monuments. Nature is thus preserved not by being left alone but by human intervention and the conscious application of science. Moreover, the purpose is not to preserve nature pure and simple (since nature to some extent contains a self-destroying principle) but to preserve it in a particular form: the aim is to achieve conservation by establishing and maintaining a fixed balance between the various forms of animal and vegetable life. In addition to preserving all this, some attempt at least must be made to ensure that the natural resources in question are put to use, without which the park would lose much of its *raison d'être*—just as would cities and other historic sites if they were no longer considered as objects of use but merely as the custodians of a mysterious message addressed to some problematic society of the future. The reference to human purposes and destiny, both practical and scientific, is fundamental to the policy of conserving unspoilt areas in accordance with rational criteria which may not coincide with, and are often opposed to, the laws and reactions of true nature in its blindness of creativity and destruction. On the one hand,

man wishes to repair the many injuries that he has done to nature, and on the other he desires to feel and enjoy, even though only in miniature, the fascination of a spectacle that seems to refuse all contact or compromise with human history, past and present. This applies equally to national parks in Europe and America and to African reservations which meet the more sophisticated demands of international 'jet society'.

Nature, in so far as it is not controlled by man, is that which is against man, which rejects, assaults and destroys him. This is true of deserts, mountains and other areas which it is impossible or pointless to turn into long-term settlements; or again of the seas and oceans in their changeless testimony to the mighty power of Earth. Of course, mankind today has devised means of overcoming every obstacle and every difficulty: no doubt ever wider areas will fall under our power and be radically transformed, while others have already been abandoned and are, in consequence, taking on a completely new appearance.

Apart from the exceptions we have mentioned—striking in themselves, yet only marginal by comparison with the multitude of humanity—the world in its visible substance is at any given time the result of an encounter, and sometimes a clash, between natural forms and structures on the one hand and, on the other, the needs, desires, industry and intellect of mankind. This interchange has given birth to what I propose to call 'historic landscape', not in the sense in which this term is applied to ancient cities and so forth, but to emphasize that landscape in general is a part of human history, and that it behoves mankind to preserve and study it as a record of that history and as the work of human hands. There is in fact an essential unity in all forms of human activity which have the purpose or result of changing a given state of things. The rigorous harmony of the Castilian plain, the rocky, shut-in countryside of the Umbro-Latian area, the modern villages nestling in the woods around Copenhagen, the Los Angeles conurbation—all these are very different phenomena, but they are alike historical documents and, as such, belong to a common field of study.

Geographers, town-planners and historians have all concerned themselves with landscape, and scholars of each group have naturally considered it from the standpoint of their own interests and discipline. An actual landscape of any size and complexity is bound to provide material of interest to geology, orography, botany, town-planning and architecture, agriculture etc. The physiognomy of a landscape, in both its individual and its generic features, is the resultant of all these concomitant factors and their mutual relationships.

In 1958 the Istituto Nazionale d'Urbanistica devoted its sixth congress to the 'defence and improvement of the urban and rural landscape'. The debate was a memorable one: the most eminent Italian architects were present, and contributions of the utmost value were made from the point of view of theory and methodology, of history, law and engineering. The proceedings and conclusions were drawn up in a document of some fifty pages; but, some twelve years later, a study of the recent work on the subject both in Italy and abroad, both general and specialized, shows that the results of the congress have for the most part been ignored, although the problems are still the same and have become a good deal more acute. As Adriano Olivetti put it at the time, they involve 'consideration of the highest duties that confront modern man, beset by dangers yet more clearly aware of his vocation than ever before'. Then as now, what is needed is a moral and political effort which must be based on widespread critical awareness and concern for civilized values. To defend landscape in the proper way—which means defending ourselves against chaos, discord and confusion—we must study it from an up-to-date point of view, asking ourselves in the first place what landscape is and how it can be defined.

In another paper read at the congress, Domenico Andriello put the question why the problem of landscape was of the utmost topical interest, and replied that it was due to the exacerbation 'of a state of affairs which has been pointed out and lamented since the beginning of the century—the decay of our cities and other places of habitation owing to unplanned expansion, shortage of housing at the centre and the congestion of traffic due to an inadequate road system'. As a result of these and other frustrations, men were confronted with 'a threat to the very existence of what they had built up, in toil and pride, over the centuries: the fruit of a long labour devoted firstly to satisfying their material need of a home and secondly, by the harmony and continuity of its execution, to linking them with the past and assuaging their spiritual need to exist in time as well as space'. The anomalies of the situation and the emptiness of the modern age, which had destroyed the past but had nothing worth while to offer in its place, brought into the forefront a whole range of problems connected with man's control over his environment, both urban and rural. It was not a question of vainly attempting to stem an irresistible development, but rather of finding some means to grapple actively with a complex and confused situation. As modern civilization seemed less and less able to provide a solution, so the desire for it grew more intense.

Rivers of ink were poured forth in newspapers, books and periodicals. It was generally realized that the problem was only to a small extent one of defending this or that ancient monument, duly identified and known throughout the world. Rather it was a matter of preventing the disintegration of a whole historic environment as it had accumulated through the ages, in all its artistic and documentary value. Attention was first of all concentrated on cities and towns; but it was soon perceived that they could only be preserved and developed in the wider setting of the countryside, and equal thought began to be devoted to the latter. This led to the appreciation, in the planning context, of landscape and the need to study and understand it if its character and purpose were not to be spoilt by human intervention. Man's requirements must be satisfied in such a way as to take account of the environment, avoiding the crude utilitarianism that had done so much harm. These matters are described in the past tense by way of recalling the origin and duration of a debate which is still in full swing throughout the world, though in Italy the struggle has perhaps been more dramatic and desperate than elsewhere. The defeats and setbacks of the few men of good will who have denounced abuses or tried to devise rational and progressive solutions have gradually been offset, in part at least, by victories and successes. Above all, the problems of town and country planning have been studied in depth, clarified and brought to the notice of sections of public opinion that have in the past been averse to such questions or, worse still, completely unconscious of them.

It seems desirable to consider first of all the aspects of interest to geographers, even though it may appear that their discipline is less affected by contemporary events than any other. We owe to them in fact, as Andriello pointed out, the basic distinction between 'the original, natural landscape, shaped by internal natural forces and modified by external ones, and a secondary, geographical or human landscape due to the hand of man, though he too works under the influence and control of natural forces'. The geographer is interested in studying the landscape at a given moment, as it results from the protracted operation of forces which have given it a particular form. He is aware that the object of his study is of a transitory nature, but he records and describes forms and elements as if they were static, ignoring the incessant changes to which they are subject. Doubt is sometimes cast on the practical utility and accuracy of the geographer's classifications, the validity of his interpretation being called in question on account of the incompleteness of his outlook. As Ferrara argues, a geographical description is even less adequate to a human landscape than to a natural one, 'partly

because the former is more changeable, but mainly because in a human landscape the causes are not plainly visible from the facts themselves'. As the historians from Marc Bloch to Emilio Sereni have taught us, historical research may throw light on the causes of formations that go back to ancient times, for example the traces in our landscape of the Roman system of measurements and boundaries known as *limitatio*: what might seem an ephemeral tracery of lines has endured through the centuries owing to what Sereni calls the 'law of inertia' in rural landscape, i.e. the survival of forms after the social, technical and economic conditions which produced them have disappeared.

However, the geographer is not always wholly indifferent to history, and in any case his work has its own value and relevance to the study of a particular territory. Take for example Sestini's description of the Pliocene hills of Tuscany: 'The features are mostly small, though from the hilltops we can see extensive vistas of undulating ridges, rising one behind the other to an approximately equal height . . . The fact of human habitation leaps to the eye everywhere: these hills are a classic home of sharecropping, yet the peasant population is sparse—a family to each cottage, and each cottage on the farm to which it belongs . . . Most of the townships and farms are situated on sunny ridges and slopes, as were the medieval walled castles, the appearance of which is preserved by many a small town perched on a summit, its houses crowded closely together.' These lines, and the whole passage of Sestini's work from which they are taken, are an excellent example of what the geographer can tell us: they are succinct, precise and clear, giving the main facts in a nutshell. If we read his descriptions carefully we are well placed to understand the spirit and character of a given territory and what form of human intervention is best suited to it.

We have mentioned the way in which different geographers define the concept of landscape. Some of their definitions have been collected by Ferrara: they draw attention on the one hand to the coexistence of forms in a single visual orbit, and on the other to the permanence or repetition of constant elements in different physical formations. The contributing factor of time is not ignored, and is expressly emphasized by Toschi and Ranieri. Geographers in general tend to use classification as a part of definition, and to combine conceptual elements into formulas which are as broad and omnivalent as possible.

Sestini begins by saying that 'landscape in its elementary phase consists in a panoramic view, that is to say a portion of the earth's surface as perceived by the human eye from a certain viewpoint.' But, he continues, 'there is a second phase in which the concept of landscape is detached from that of an actual view and becomes a synthesis of views, either real or potential.' Two types of elements are distinguished here: on the one hand 'volumes, lines and colours co-ordinated in space by a particular pattern of distribution and proportions'; on the other, 'the actual features which make up the view, such as the contours of the ground, vegetation whether natural or cultivated, dwellings isolated or in groups, etc., these too forming a pattern by virtue of their respective mass and position'. The two categories go to form a single whole, but according as one or the other predominates we have either 'a formal, aesthetic landscape or an objective, substantial one'. Sestini uses the term 'geographical landscape' for a combination of visible or perceptible objects in their 'specific character and real function in relation to the other elements of the earth's surface'; but the pattern which constitutes a 'perceived geographical landscape' (in which we must also take into account sounds and smells, atmospheric conditions etc.) does not exhaust the range of phenomena and incidents that go to make up landscape as a whole. This latter is determined or modified by hidden or 'unperceivable' factors, and the term 'rational geographical landscape' is therefore used to cover the 'complex of objects and phenomena, linked in an organic whole by their mutual functional relationships other than those of position'. Naturally the landscape has been profoundly affected by the

hand of man, both individuals and societies: great cities have virtually obliterated large parts of the countryside, while a multitude of human activities, more or less petty and casual, have altered it in some degree. Thus the 'humanized landscape' of Italy, and Europe in general, is 'an historical creation which has developed gradually by a multiple process of change'. I have tried to summarize Sestini's views as accurately as possible: he is both clear and authoritative and seems to me to represent aptly the point of view of geographers in general, at least in its broad lines. Moreover, there are points in the foregoing which seem to require further consideration before we can proceed in our analysis of the concept of landscape.

Let us first consider the various forms that human intevention may take. When man builds a city, as I observed just now, he may completely alter the structure of the ground, so that the natural substratum is no longer visible. The city is a palimpsest, the summing up of countless superimposed efforts and purposes: from age to age the desires, needs and interests of its citizens have been blended with aspirations and achievements that determine the culture and taste of an epoch, even its poetry. The city is in fact the supreme example of man imposing himself on nature, to the point where nature drops out of the equation, the dialogue instead being between man and society or between the present and the past. If nature does return to the stage it is in the form of some abnormal catastrophe, like a flood or an earthquake.

Cities are remote from 'natural landscape' to the extent to which they form a self-contained structure bearing and embodying the marks of history—civic and administrative, political and social. The countryside, however, is also the result of a long accumulation of changes due to human agency, even when this appears most tenuous and impalpable. On this point Sereni quotes Leopardi's admirable words in the *Elogio degli uccelli*: 'Much of what we call nature is really artificial: ploughed fields, trees and plants aligned and taught to grow in a certain way, rivers confined in their banks and courses —all these and many other such things are not in the state and semblance of nature. Any piece of territory in which civilized men have lived for a few generations, let alone towns and other places of resort, has been much altered from its natural state.'

It should be noted that human intervention may take different forms. Men may introduce expressive elements into the landscape for aesthetic reasons; their games, pleasures or necessities may lead them to create new scenes or modify existing ones; or finally, a landscape may bear the marks not of deliberate change but of neglect, carelessness and desertion. Besides the 'good husbandry' that Lorenzetti celebrated, there is the opposite kind with more or less permanently deleterious effects due to faulty methods of cultivation, misuse or chronic neglect of the soil. Some minor piece of damage may bring about a sequence of unforeseeable and disastrous consequences, the penalty of man's forgetting that nature is the preordained setting of his activity, which must be harmonized with it. Tunnard and Pushkarev, in their remarkable work on *Man-made America*, observe that 'Man's imprints on the landscape are often detrimental to the future After the collapse of Roman civilization in Tripolitania, overgrazing and the neglect of soil control measures led to erosion of the wadis and the deterioration of a large part of the northern Sahara. The nineteenth-century American pioneer made a practice of burning down the forest, cropping the soil until it was exhausted, then moving on to virgin land; and when "suitcase" farmers expanded their holdings to grow wheat and overgraze thin-cover grasslands in Oklahoma and Texas during an eight-year drought in the 1930s, the ensuing race against their creditors produced the disaster of millions of acres of dust, ready to blow in every breeze.

'Against these examples one can place the careful methods of Dutch and Japanese farmers, whose

elaborate methods of irrigation, intercropping and fertilization of the soil have kept it in production through many centuries; in this country, one can point to the enrichment of their farmland by the Pennsylvania Dutch and the proper maintenance of farming in parts of Iowa, where agricultural land is so valuable that it is only rented to farmers who guarantee to maintain soil fertility. And it is largely due to the example of the national government and the efforts of private farmers using good cultivation practices that the American "dust-bowl" has been reclaimed. But eroded land, marginal land, scrub-forests and the scars of surface mining all over the world are testimony to the fact that we have not yet come to consider the total landscape as a productive unit in the scheme of human progress.'

Sartre has also written eloquently on the same subject, e.g. where he describes the efforts of Chinese peasants through the centuries to acquire land for cultivation on their country's borders, wresting it from the grasp of Nature and nomadic tribes and, in the process, de-foresting the whole area. The total effect is both good and bad: land is gained for cultivation, but the mountain loess, no longer stopped in its course by trees, silts up the rivers and causes them to rise dangerously or even to burst their banks.

In Italy we are all too familiar with perilous situations of this kind, many of which are irreversible and involve huge responsibility at all levels. The disasters and attendant scandals at Longarone, Agrigento and Naples, or the floods of 1966 which caused such damage and suffering throughout the country, were so many instances of frivolity, irresponsibility and lack of foresight. In the case of more gradual 'historical' phenomena such as indiscriminate deforestation, we all know what harm resulted over and above the aesthetic damage to the landscape. Today we can watch with our own eyes the large-scale, even though gradual, transformation of the hill and mountain areas of the Apennines as the land is left uncultivated: this too will one day be an 'historic' process, but meanwhile it is causing a number of harmful though secondary effects. The untilled lands lose the capacity to absorb water, and in the event of heavy rain they form an inclined plane down which floods sweep into the valleys with disastrous consequences. But the main catastrophe is that the landscape becomes degraded, impoverished and dehumanized, without any individual being to blame unless responsibility is laid at the door of politicians. For many years past the peasants have been forsaking their lands and even the villages where they have lived for a thousand years or more. The chestnut trees are dead, the slopes covered with wild undergrowth; the terraces that conformed so closely to the contour of the hillside are becoming blurred and shapeless; cottages, huts, hay-lofts and oast-houses are falling into decay; roads and paths are disappearing. The spreading briars cover what were once features imparting rich variety to the rural scene: from year to year, from generation to generation, every season presented a complex of familiar sights, forms and symbols, transitory though each might be in itself. Today this whole area, once so carefully guarded and cultivated, is a no man's land, which will show traces of human agency for a little longer until it returns to a 'natural' state. Man is transferring his vital activities elsewhere: his desires, needs and demands have changed, and the land, still bearing the marks of habitation and cultivation, will gradually revert to what it was in the beginning. After a certain time, not far distant, this process will be unpreventable, unless new social or economic reasons should come into play and the land be reclaimed as a result. But this would mean the creation of a new landscape, starting from a new zero point in time.

But there is another of Sestini's points which we should consider before passing on to other disciplines: namely his distinction between landscape as the complex of features which go to make up a particular view, and landscape as the sum of independent elements, co-ordinated in various ways,

which are regarded as composing a kind of ideal image of a given territory or region. By abstracting from the particular in this way, we may arrive at a 'typology' which is fairly fixed in itself and embodies both natural and non-natural elements: from geology to altimetric observations, from the type and quality of crops to their seasonal alternation and rotation, from the type of buildings to whether or not they are grouped community-fashion. In addition the account would cover such adventitious or cyclical factors as human customs, animal and bird life, weather and climatic features, the play of light on the landscape etc. Both painting and literature have described landscapes in such terms as these and also in the 'particular' manner as defined by Sestini: one can think of countless examples, from Montaigne to Kokoschka, both of the ultra-sensitive reflection of an actual scene and, on the other hand, the attempt to distil from it types and symbols of a more permanent, underlying reality.

It appears to me that both the former, more direct mode of perception and the latter, more analytic and far-sighted approach are necessary to those who, in our day, are responsible for the conservation or, more properly, the control and planning of landscape. If it is true, as seems to be generally accepted, that only total and organic planning can safeguard the harmony of human existence and preserve the terrestrial environment from chaos, it is clear that we shall need more and more accurate and effective means of setting about the job. As far as landscape is concerned the approach should be twofold as described above, proceeding from analysis to synthesis and thus painting a coherent picture of the tendencies, characteristics and values involved. This remains true whether we are mainly concerned with the teaching and function of history or with promptings and criteria of a different order such as the well-known ones put forward by Kevin Lynch. If we are to foresee changes and steer them in the right direction, our action must ultimately be based on attentive visual observation.

As we can all remember from a not very distant past, the outcry against skyscrapers in Italy was based on the charge that they were a 'discordant note' or an 'offence' to the landscape. This point of view derived, in part at least, from the conviction that the historical landscape, whether urban or rural, was something fixed and unchangeable: the 'face of nature' was the paramount consideration and everything else must conform to it, especially architecture which was man's most permanent contribution. This meant that around 1950, when much of the Italian scene was being rapidly and radically altered—when widespread demolition was changing the face of town and country alike, and the landscape became the scene of all kinds of violence and enormity—at this very time people rose up in arms against a type of structure which may be aesthetically dangerous but which for that very reason is easier to control, and which is the hallmark of the only valid landscapes of the modern age. If it had been adopted it would have spared the country a great deal of petty hideousness and would have saved space for better and more appropriate ends. Instead of a rigid concept of 'nature' with paramount and immutable demands, the proper approach is to study as accurately as possible the character of each particular landscape, but also to adapt it to the changes of human life and, so to speak, re-invent it to suit the needs of tomorrow.

Again, I would draw attention to what Sestini says about the 'mutability of aspect'. This, he writes, 'may be accidental and fleeting, or periodical and seasonal; in any case its importance will vary according to how the landscape is conceived. From the aesthetic point of view, a slight change of lighting may make all the difference to the way in which a given prospect strikes the eye, whereas such variations are of little or no importance from the viewpoint of geographical landscape, especially of the "rational" type. There may be immense seasonal changes, e.g. between an Alpine valley in summer with its different shades of green and the same valley when covered with snow, or again in the flatlands of the Po valley between autumn and early summer: the former a vast expanse of misty

grey, with bare poplars and willows, the latter dazzling and luxuriant with yellow crops and greenery. According to the integral conception of geographical landscape, these rhythmical variations are themselves a characteristic of the scene in question.'

In this passage we again notice the geographer's habit of classifying and defining with care the appropriate subjects of investigation by himself and others, specifying cases, exceptions and hypotheses. The coefficients of variability in a landscape, numerous and interconnected as they are, may produce macroscopic changes which profoundly alter our perception of matter even if they do not affect its material structure. This is particularly the case in landscapes with a preponderance of 'greenery', i.e. trees and herbaceous crops. The appearance of a medieval walled city is little affected by the seasons, since it consists almost entirely of fixed and durable architectural features; whereas in an Alpine valley the whole range of seasonal phenomena and the infinite variability of weather conditions make up a spectrum of the utmost richness. It is true that an urban or rural landscape can only be viewed in the light that nature affords, independently of human volition, and that this is a constitutive element in the scene as perceived. But urban and architectural forms and structures have a life of their own transcending the variability of perception, while with landscape in the wider sense our vision depends basically on light and other natural or biological factors, permanent or cyclic. Any good photographer knows that the poetic atmosphere of a particular outdoor scene can only be captured at the right time and season and in the right lighting conditions. In this way the appearance of many landscapes is 'fixed' by convention, popular enjoyment of them being linked to a specific point of time or to particular conditions. The mist in the Po valley becomes just as 'necessary' a part of the scene as other features that might seem more permanent and distinctive; though in fact there are not two separate categories here, but a blending whose effect is not confined to the visual sphere. The great modern interpreters of the 'mutability of aspect'—the fluid succession of moments, the all-important incidence of light—are of course the Impressionists, as when Monet resolves the mighty structure of Reims Cathedral into tones that are quiet and delicate or kindle into strength as the fugitive element dictates.

To conclude this point, I would observe that mutability is not merely a question of 'how the landscape is conceived', but rather of its essence: for I would include under this head the whole complex of biological and natural factors, both cyclical and momentary, and would emphasize its importance in comparison with the 'fixed' elements in the landscape. Visually, all these elements—the fixed, cyclical and momentary—blend into a single image, as is shown by the fact that, when we want to cure a landscape of over-familiarity or extract a new image from it, we make use of the aggressive and stimulating possibilities of impermanent features which may be wholly exceptional. We may note, finally, that even in architecture—the 'eternal' *genre* above all others—the use of glass on a large scale, with its varying degrees of transparency, opaqueness and reflective properties, and the role played by natural and artificial light (the latter lending itself especially to the multiplication of effects), have greatly increased the importance of what is fleeting and unpredictable.

Leaving geography for the moment, we may now consider how town-planners approach the question of landscape, and what special criteria serve them as a basis for assessment and action. Throughout the Italian academic world town-planners base their operations on historical data, though they do not neglect the information and conclusions furnished by other disciplines. Since the purpose of planning is to adapt the environment to tomorrow's needs—i.e. to make an organic and comprehensive plan for the co-ordination of human activity, its purposes, methods and location—and since present-day conditions make this an increasingly formidable and vital task, the need for an inter-

disciplinary approach is all the more evident. However, since virtually the whole Italian landscape is steeped in history, it is not surprising that our planners should pay special attention to historical values and to various aspects of the problem which are rooted in past ages. The recent volume dealing with the smaller walled towns of Tuscany—a detailed study, basic to the understanding of one of the most 'historicized' landscapes in the world—is a striking illustration of our planners' historical approach and general background. Edoardo Detti, who directed the investigation and wrote the introduction to the essays and conclusions of G. Franco Di Pietro and Giovanni Fanelli, observes that 'this line of research is virtually dictated to us by the fact that we are assembling what may well be the last available evidence of a system of economic and social relationships and community organization which is disappearing beyond hope of recall.' A study of this kind, even when not strictly historical in intention, must be based on the 'warp and weft of history', though it may require further interpretation from an historico-analytical point of view.

This awareness of history—a history so often transfigured by human themes of the greatest significance and beauty—has enriched the science of town planning in Italy from the point of view of theory and method, although some think it has had a constricting and even paralysing effect on imagination, and this in regard to the present as well as the future. According to this view, the historical complex is responsible for bringing about critical situations which call for intervention in depth and drastic surgery. A whole group of today's young Italian architects are committed to iconoclasm, though they differ considerably on specific measures. There is a certain amount to be said for their point of view, and for that of less aggressive critics who urge us not to treat the past as a fetish. Nevertheless, the view which dominates among us as far as urban problems are concerned is that set out by Piero Maria Lugli in his *Storia e cultura della città italiana*: 'There can be no valid modern approach in practice that is not based on the firm recognition of an actual historical situation. By understanding the shape of the historical curve on which we are situated, we can exercise our will to determine its future course. . . . To adopt the right starting-point, we must first of all restate in exact terms the problem of the historical past, its interpretation and our consequent judgement of the situation in which action is necessary.'

'Today,' Fanelli continues, 'our task is not to invent new forms and institutions, or to discover new truths, but rather to devise a mode of operation which is appropriate to the times, both in its scale and in the relationships with which it deals.' The crucial point is this. Given that our contribution to historical conservation can and must be compatible with our right and duty to assert ourselves as men and women of the present day, and in so doing to impose profound changes on our environment; given that, as Cesare Brandi puts it, 'the only true way in which our age can become aware of itself is to define where it stands in regard to the past; only thus can it hope to possess the future'; having thus rejected the laissez-faire principle with its attendant risk of hasty, last-minute intervention, and having recognized the inadequacy of mere passive conservation or unadventurous mimicry of the past—having established all this, the question we must ask ourselves is: what are the criteria and methods that will enable us to achieve continuity with the past, while acting on the urban or rural environment in ways that are bound, in large measure, to rob it of its identity? This brings us back to the problem of acquaintance with the historical landscape and with landscape as history.

As far back as 1958, Eduardo Vittoria wrote: 'The term "landscape", as traditionally used, has become meaningless, or rather it is merely a cue for the discussion of unending problems of preserving and restoring antiquity. The problem of the future is thus turned into a problem of the past, which is one way, as good as any other, of stamping with our approval the present-day squalor of Italian towns, big and small.' Vittoria goes on to say that 'to formulate the problem of landscape in

modern terms means taking account not only of a medieval, Renaissance or baroque "atmosphere" but of the sum total of the works which men have created or are creating in order to meet their requirements of every kind.' In other words, we must get into our heads that the existing landscape cannot be 'divided into two parts, good and evil, according to a sweeping judgement of historical periods'. As Renato Bonelli puts it, we need 'a new conception of landscape as a single whole comprising urban and rural areas, town and country, nature and architecture—the three-dimensional scene in which our lives are lived and which man devises or modifies according to his own needs and interests, from the viewpoint of a given historical moment.' This formulation, which seems to us to go to the root of the matter, was endorsed by Ernesto N. Rogers and Leonardo Benevolo: the latter discerned, in both urban and rural landscape, the fundamental characteristics of 'continuity' and 'articulation'.

Bonelli, with his usual precision and clarity, developed the conception of landscape as 'human environment, the precondition, instrument and fruit of human endeavour'. As he observed, if our historical centres are a documentation of the science and art of architecture, 'rural landscape too, in so far as it is touched by the hand of man, must be regarded as a documentation. . . . Whereas in architecture every form is created *ex novo*, in the rural scene natural elements are adapted and combined into a single whole, after the fashion of a coral reef: yet the articulation and continuity are the same in the country as in town. . . . We must restore to such human artefacts the value of a creative act expressed in a form which relates it both to specific practical motives and to the historical conditions which constitute the mind of an era: so that they speak to us in their own figurative language and at the same time reflect the ideas and spiritual values of their time. . . . This new conception of landscape as a living and dynamic, continuous and articulated form of the human environment is directly opposed to the notion of an historical city enclosed in itself and contrasting with the countryside, or of gardens and fields as the work of Nature considered as man's rival and his superior.'

Against this background of historical integralism Bonelli took a pessimistic view of the modern age, condemning it as 'lacking in ideals and therefore one-sided, maimed and shapeless'. Events have gone a long way to bear out his misgivings; but we are more concerned here with what he says about the indissociability of history from landscape as it is seen and felt today. Conversely, the present form of the landscape must be studied by anyone who wishes to comprehend its history, whether in town or in the countryside. All its individual features, their inter-relation and time-sequence, must be examined if we are to understand the conditions that gave them birth. The relationship between history and landscape is not so much one of cause and effect as of a close, inalienable connection and mutual clarification, so that often the discovery of particular features, however fragmentary and mutilated, has thrown light on periods of history that were almost or quite unknown. In short, though the position varies greatly from one case to another, the study of present-day conditions and forms enables us both to understand the landscape itself more deeply, including its potentialities for the future, and also to acquire a deeper knowledge of cultural, economic, social and political history. We may, for instance, trace the history of agriculture through the ages from the standpoint of technical progress, social institutions etc., seeking confirmation and elucidation in well-known documentary and pictorial sources and also in the evidence of the present day; or we may study the agricultural landscape from the point of view of its formation, transformations and present-day structure and appearance, in the light of predetermining political and socio-economic conditions.

In this way the history of landscape may partake of the nature of archaeology, since many of the features with which it deals have been eroded or destroyed by various factors operating over the

centuries. Sometimes minute traces are all that remain of buildings, institutions and activities that were once important and widespread: yet these traces, although barely visible, are of great evidential value. Apart from their historico-archaeological value they help us to understand better the actual face of the countryside: they explain apparent anomalies, bearing witness to functions and purposes different from those of today, and may in this way suggest useful possibilities of future action. It may be recalled that as a result of studying the countryside in the neighbourhood of two early Romanesque churches, which has completely altered in character since the churches were built, Eugenio Luporini was able to explain certain peculiarities of their structure and ornamentation which showed that the architects had been very much alive to topographical conditions.

There is, however, one classic example of the inter-relation between a socio-economic system and a resultant form of landscape which, over the centuries, acquires a symbolic character. I refer to the system of sharecropping, which still prevailed as late as the Second World War but which present-day conditions have made hopelessly out of date, so that it has largely disappeared from the scene. As long as it continued, it gave the countryside a more or less permanent form independent of changes in the method of cultivation. The cottages linked to their respective farms and forming a modest, regular pattern on every hill and plain were the most, though not the only, distinctive feature of this typical landscape. Man lived on the land, close to it and attached to it: it was the centre of his thoughts and of his life. The result was a noble harmony, a gradual evolution of works and customs forming a single rich tradition. Every peasant was in some measure also a craftsman, inheriting and transmitting the mysteries of his art. His methods and customs, rites and gestures did not relate solely to agriculture but to the creation of objects and implements the forms of which remained unchanged through the ages, as we note with surprise when we come across pictures of them in some ancient document. Great ramparts of oak-trees protect the cottage from the wind; cypresses line the paths and mark off boundaries; ploughed fields extend up to a barrier of stones, or to a wooded slope; haystacks, wells, fences, huts, lone-standing trees, wash-houses, manure-pits, sheaves and log-piles—all these fitted into a pattern of astonishing neatness, uniformity and harmony. It is difficult today to recall, anywhere in Italy, the lost image of that admirable landscape born of man's fertile intercourse with the land—man with his toil and industry, his creative ingenuity and sense of design. If the historian wishes to call it back to life he must take account of a whole series of causes, effects and traditions, some of them reaching deep into the past. At the present time many old farmsteads are being restored; but the new owners do not have the background of upbringing or memory which they would need in order to revive the grandeur of the old system, and in any case the *raison d'être* of that system has gone. Perhaps we must accept Guido Piovene's view that 'the world will lose in beauty as well as in diversity: it will have less power to stimulate, or to arouse admiration.'

None the less, historical continuity is as real as the breakdown or disappearance of tradition. In his introduction to the Italian edition of Smailes's *Geography of Towns*, Ceccarelli quotes as follows from Marcel Poëte's work of 1924 entitled *Une vie de cité: Paris de sa naissance à nos jours*: 'Continuity is an essential feature in the life of towns. The Paris of former times and the Paris of today are not successive entities but a single reality in constant evolution. What we call *vieux Paris* is a Paris younger than the one we know. If we study the city's past we are not examining a skeleton, but a living being at an earlier stage than the present. Like an individual, the collectivity that we call a city undergoes the different effects of time at each period of its life. The notion of a life-cycle must be introduced into our study of urban centres. . . . An entity which is still alive must be studied through its past so that we can determine its state of evolution. The individual lives in society, on the earth and by

means of it, so that in addition to historical data we require those of sociology, geography and economics. The sum total of these will explain the city that we now behold and will enable us to shape its future.'

Some fifty years after Poëte's work, with all the advances we have made in knowledge and the improvement of our methods, his words remain very much to the point. As Ceccarelli also remarks, 'an economist's city is different from that of a sociologist, a geographer or an architect,' and this fragmentation of outlook and methodology is not conducive to an all-round view of a city or region. By 'continuity', in fact, we do not mean simply the permanence or repetition or the continuous development of events in time, but also the interconnection of all the agencies, reactions and phenomena of which the city is composed. As usual, the existence of more and more concrete problems demanding a solution forces on our attention the need for a clearer methodology and more exhaustive study; and in consequence our historical knowledge of cities has grown since the irresistible pressure of current problems has impelled us to embark, not without trepidation, on the perilous seas of *urbanismo*. Both in Italy and abroad, much progress has been made in recent years. In Detti's words, the cultural debate centring on the historical environment 'should find expression in defining methods of study as precisely as possible, in conducting experiments and arriving at assessments which can be checked and verified in the same way as economic and social forces.' The problem of criteria and interests subsisting in watertight compartments is still with us. But recent historical studies have brought to the forefront a new detailed technique which makes it possible to draw a coherent and irrefutable picture of reality. An example is the recent volume by Maurice Cerasi and Piergiorgio Marabelli, *Analisi e progettazione dell'ambiente - Uno studio per la valle del Ticino*, which, while uncompromising in its politics, comprises a mine of interesting data and original observation.

Town-planners, then, are also at pains to study our environment from the historical point of view, generally with particular regard to the lessons which can be drawn for the future. It is appropriate here to make some remarks about the orientation of research as it is understood and practised by many Italian and foreign planners, especially those of the younger generation.

We are not concerned here with political angles, but we may note a shift of emphasis away from the city considered as a complex of independent forms, and towards the role of society, past and present, as the creator of cities or towns in which to live its life. (Although, here and elsewhere, reference is made only to cities and not to the countryside, it has already been made clear that there is no difference between the two as far as methods of study and research are concerned.) Attention is devoted not so much to the external form of the city or territory as such, but rather to the relationship between it and the human interests which it serves, reflects or symbolizes. As Gian Franco Di Pietro puts it in his excellent study already quoted, 'a town is the result in space of a particular system of production and the political regime on which it is based: it is, in fact, primarily the *locus* of various functions and forms of revenue and consumption, within a social framework varying, in medieval terms, from absolute homogeneity to a pronounced degree of stratification. . . . It will be argued here', he continues, 'that a classification based on the most comprehensive structural principle, i.e. the socio-economic one, makes it possible to take account of criteria and subdivisions related to sectoral aspects, whether geographical, orographical, morphological or functional; whereas the latter are often too imprecise to illustrate the urban phenomenon in its economic and territorial aspects.'

Certainly, as this line of thought suggests, it is possible to make a rigorous and apt classification of 'urban phenomena in accordance with the social and productive system in force', and to establish 'the intrinsic correlation between the socio-economic structure and the laws of morphological de-

velopment of urban organisms'. One can reconstruct the laws, institutions and ideologies by which a political and social system is characterized and regulated; one can trace the birth and development of urban prototypes as the instrument and basis of a particular mode of organization, and see how these prototypes evolve or are replaced as a result of changing conditions of life and work. What one cannot do by such means, however, or at all events not by them alone, is to comprehend the urban phenomenon in its actual three-dimensional identity; and it is illegitimate to write this off as irrelevant or secondary to the themes which constitute, so to speak, its human content. This identity results from the combination in space and time of an infinity of forms which may be manifested from time to time in stylistically recognizable features, but which in general correspond to a common language of varying scope and extent. What the Di Pietro method leaves out are the motives and contributions associated with what may appear (as far as day-to-day building is concerned) fugitive or transient manifestations of popular taste, craftsmanship, artistry, choice of materials and so forth. But a city which is born and develops in response to human needs derives its appearance, and in fact its essence, from such visible elements as well as others. The effect of our criticism therefore is to argue that an historical landscape, urban or rural (but especially the former, since the hand of man is more present there), should once again be looked at as an intended complex of visible forms. It is our business at present to consider these forms in themselves, irrespective of their origin in terms of historical events.

It is relevant here, and indeed essential, to recall Croce's theoretical contribution to the problem of nature and aesthetic contemplation, in various works ranging from the *Aesthetica in nuce* to his *Last Essays*. Nature as such is chaos and shapeless disorder: it is man's creative imagination which extracts from this disorder the elements of his own 'creation', just as the artist does when he transforms his vision into an aesthetic object. Beauty in nature is thus a creation of human fantasy. But Croce does not tell us how we should regard nature when its physical appearance has been altered by the hand of man—when it is no longer shapeless but regulated and endowed with recognizable differentiated images such as we meet with in the extreme case of human intervention, viz. the creation of cities.

Rosario Assunto, in his *Introduzione alla critica del paesaggio*, provides us with a further guiding-line which is of particular interest as it is linked with Croce's thought. He distinguishes between 'landscapes whose material existence and aesthetic essence are alike the result of human activity,' and 'landscapes whose aesthetic essence is not so much the outcome of a productive process as of the "bestowal of meaning" on their material existence—a "discovery", as the phrase is, by which purely natural objects are turned into aesthetic ones.' Having made this distinction, Assunto continues, 'we must further distinguish on the one hand landscapes which, in so far as they result from human agency, owe their aesthetic essence and material existence to a predetermining artistic intention, and, on the other hand, those whose artistic quality springs from a formative process whose main intention was other than aesthetic.' The effect of this view is to relate nature to man, whether he transforms it with an avowed aesthetic purpose or in the pursuit of other ends which may incidentally endow it with aesthetic qualities. Clearly the aesthetic attributes thus conferred on the landscape may differ greatly in degree and permanence. As V. Ghio Calzolari has remarked, 'the interior image that may take shape in an individual or a community at a particular time or over a given period, and that leads them to discern aesthetic value in a certain piece of the earth's surface, is impermanent not only because it does not involve the physical reproduction of an idea, but also because it is apt to decline or die away as soon as the observer's circumstances alter—his physical, psychological or

intellectual condition, his tastes and sensibility, changes of fashion and changes of interest.' On the other hand, as Ferrara says, 'landscape considered as a work of mankind and of history is a form of diffused architecture, working in materials that are highly subject to change and decay, yet capable of adapting space to man's measure and demands in a way very similar to the building of cities.' (So similar, we would add, that there is no distinction of principle between the two.) An illuminating observation was made some years ago by Carlo L. Ragghianti when he wrote that 'the term "architecture" properly belongs to formal town-planning,' and proceeded to distinguish, in terms that have become well known, between planning in general, urbanism and architecture—these being separate in their nature and purposes though connected in various ways. From this point of view he argues for a set of criteria whereby each of the different aspects of the birth and life of cities can be judged in its own context and with the appropriate methodology.

Outdoor landscape may be related to life in a variety of ways, the most basic of which is perhaps a kind of 'mystic or sublimated contemplation' (Caruso): a persistent desire, expressing itself in diverse ways, to assuage what are really physico-psychological needs. The senses are duly stimulated and gratified; feelings and emotions are aroused by an infinity of objects of all kinds, and their intensity and duration is the measure of the delight which we take in landscape—the soft rustling of leaves, the scent of flowering meadows, animal and bird life, the clear sky and the vast horizon, the play of light, the silence broken only by pleasant sounds, and the endless variety of change that every moment brings. Certainly our appreciation takes account of historical themes and motifs that have left visible traces in the landscape, but these are of lesser consequence or even of none at all. Just because we seek in outdoor nature a relief or counterpoint to our daily lives, we like it to be as far as possible divorced from human activity and the signs of human presence. The attitude of most people towards landscape can be judged from the way it has been treated, with a desire to respect and even increase its beauty, except where utilitarian motives may have led to an attitude of contempt or indifference.

Thus human beings constantly turn towards outdoor nature, and this is not only true of the bourgeois—as Eugenio Turri claims in his somewhat aggressive essay on 'natural beauty'—but of all those who are 'impelled to seek beauty in the landscape in accordance with approved formulas, be they literary or scientifico-naturalistic.' The attraction of nature takes a vast number of forms, from week-ends and summer holidays to cruises, safaris and many other modes of escape from everyday life. As Turri rightly says, these tend to conform to a pattern. 'People flock to newly discovered "unspoilt" places, which become covered with villas and soon lose their beauty and amenity. It should be realized that on this planet with its myriads in search of space, its changing demographic and social conditions, beauty has to be re-defined and striven for intelligently. As it is, the latest beauty-spot soon palls, and it is ruined from the moment when people start saying "I won't go there any more, it's too crowded."'

There is in fact only one way to solve the problem. As Turri goes on to say, 'man should be able to discover beauty in the place where he lives, reflecting as it does the old and new causes that have gone to form it through a succession of ages, cultures and generations. The problem of how to create a new idea of the beauty of landscape is essentially an urbanistic one. The joy of physical perception can be awakened by a skilful construction of human landscape.' But until this end can be achieved—and the present work is intended in some degree to contribute to it—all we can do is to improve and sharpen the technique of 'reading' and depicting the landscape in terms with which the lay public is, generally speaking, not much concerned. In the first place, the public in Italy and elsewhere tends to be detached in its attitude towards modern culture. At best, its sensitivity towards

landscape is defined in terms appropriate to Romanticism or *fin de siècle* academic art, as we see from the use and abuse of such categories as 'picturesqueness'; and it is unfamiliar with the artistic and literary products of our time which, as I shall try to show, have played or can play a part in forming taste and awareness of visual form in particular. This is not a question of generalized, indirect influence but of specific education in the art of 'seeing', which thus becomes basic to the individual's consciousness. The acquisition in this way of a fresh range of images makes it easier to apprehend forms and to escape from the constraint of particular types regarded as exclusive standards of perfection. A seascape by Dufy, a *faubourg* by Sironi, a sky by Nolde, a townscape by Kokoschka are so many different ways of avoiding a sterile fixity of taste which is death to imagination. The blind acceptance of conventional standards means that whatever is outside them never becomes part of our experience, and we are thus precluded from even comparing one set of phenomena or stimuli with another. The effect of this blinkered approach is seen in design of all kinds, including landscapes or elements therein which are calculated to please popular taste. As any photographer knows, the hardest thing of all is to avoid a facile reading of a given landscape, whether urban or rural—that is to say, a banal or insignificant way of looking at it which has become a convention for some such reason as a convenient choice of viewpoint, the inclusion of as many features as possible, or the prominence of specific ones.

Leaving aside these basic aspects of perception and contact with the forms of landscape, we may now consider what methods and instruments will best enable us to read it in accordance with its distinctive visual features.

The first objective is to minimize the discordant effect of non-visual aspects that have little or nothing to do with the landscape as such but may impair our assessment of it. Such aspects, as we have seen, may be fugitive and imponderable, or recurrent and of more significance. They may come into play at a later stage, when the landscape has been assessed visually and the problem is one of planning and exploitation, when of course many non-visual factors are involved. It would, for instance, be absurd to set about creating a seaside resort on some cold, windswept northern coast, beautiful though it might be; or to build a village in an Alpine valley, however suitable otherwise, that was subject to frequent avalanches. On the other hand, townscapes like those of Sienna or Toledo are not to be judged in terms of climate, traffic problems or the like, since they have a radiance of their own which triumphs over all disadvantages. Naturally our image and appreciation of Venice is different according as we see it in the summer sun, the mists of autumn or the warmth of a spring evening. But the city that confronts and surrounds us has its own life and physiognomy, irrespective of the phases which make it so captivating in its diversity.

There is a passage in Ragghianti's *Impressions of Munich* which, in my view, admirably expresses the balance that should be struck between urban features on the one hand and social and cultural aspects on the other. It runs: 'Outside the city, like some boundless microcosm of the Rococo, lies Nymphenburg, the remnant as it were of a lost world or planet which has no relation to life elsewhere. The sleepy autumn air, the silent pools, the sloping lawns and dead leaves—all these give the impression that even ghosts have ceased to visit the deserted royal dwelling-place. . . . Nymphenburg was foreign to Munich, it was felt as alien ever since Ludwig I refashioned the city in the course of two or three decades. This oasis set down amid the Bavarian countryside, this imitation Versailles, self-sufficient in its economy and mode of life, had nothing in common with the new Munich created by the romantic *Sehnsucht*, energy and dilettantism of its extraordinary monarch.' This passage gives a good idea of the remainder of Ragghianti's portrait of the city.

Let us turn to another definition of historical or, as some would call it, anthropo-geographical landscape. According to Sestini's view as summarized by Emilio Battisti and Sergio Crotti, it consists in 'the application, in time and space, of techniques designed to organize and exploit the territory in question in all possible ways; and it remains in being by virtue of a balance between the creation and maintenance of human constructions and the constant response to human action by the totality of natural forces.' The purpose of these two authors is to emphasize the importance of geography but at the same time to make clear its limitations in regard to the 'interpretation of concepts concerning the value of landscape'. In their essay on the 'reading' of anthropo-geographical landscape they illustrate the criteria put forward by the Finnish scholar J.G. Granö, who, assisted by a team of workers, 'demonstrated over a period of years the immense variety of visual detail revealed by a close analysis of the apparently uniform Finnish environment'. Basing himself on the principle that 'forms are the most important aspects of a landscape', Granö compiled an exhaustive analysis comprising observations divided into categories and types of phenomena which he denoted by numbers and letters. In this way he elaborated a 'formula of landscape' summarizing the factors of homogeneity in the region, and a form of synthetic cartography producing highly consistent results; he applied a kind of 'geographical physiology, taking account of the different behaviour of morphological types as a function of the spatial dynamic of landscape', and made much use of statistical techniques in view of the 'high frequency of recurrence of identical forms in the area under study'.

This form of systematic 'reading' is not, of course, the only technique that has been adopted in this field. Apart from the work of Lynch, to which we shall refer later, an interesting contribution has been made by Christian Norberg-Schulz in the special number (87-88) of *Edilizia Moderna* devoted to 'the shape of landscape' (*La forma del territorio*). The Norwegian author applies the theory of *Gestaltpsychologie* to the reading of landscape in order to show 'how landscape and the work of man can together visually express their functional unity'. The chief task, he argues, is to 'find a common denominator for landscape and architecture', and he begins by using such concepts as 'space', 'mass' and 'surface' in both connections. The form is composed of elements standing in a mutual relation which he terms 'order'. On this basis he proceeds to a highly detailed classification of topological relations and geometrical structures, after which he indicates some of the factors (rarity of strictly geometrical forms, function of horizontal and vertical elements, of colours, space and structure) 'which determine the shape of the landscape, and hence our perception of the environment'. The 'contribution of the landscape to the whole' is to constitute a background, while human constructions should be 'distributed and composed in such a manner as not to disturb or destroy its character'. It is man's part to interpret the landscape by means of his works and activities, and architecture thus becomes an 'active element' of primary significance. From the writer's elaborate analysis of the relationship between landscape and architecture we may glean such observations as that 'every building has an architectonic task to fulfil and must therefore have a definite and differentiated form' (an evident link with Giedion's thought), or that 'adaptation to landscape means not only adaptation to the terrain but also to local materials, colours and climate'; or again where Norberg-Schulz refers to places of ancient habitation as islands amid the countryside, with which they enjoy a stable relationship. He also throws light on the subject when he observes that: 'If the landscape were to lose its character as a background, and if architecture lost its figurative character, the result would be chaos. The shape of landscape is never completely articulated, but landscape and the works of man together can be continuously so. Diffuse or "open" landscape acquires meaning as one element of a whole, the opposite element of which is articulated architecture. Architecture gives value to landscape, which is of no significance except as it relates to human intentions.' Thus there are three

characteristic forms of the relationship between landscape and architecture: one which presents the latter as a closed, isolated form, another which presents it as subordinate and a third which assigns independent value to both elements. Our own age, in Norberg-Schulz's view, has not yet made its choice among these, and has lost control of its own works. The city is no longer the *civitas*, and we are still faced with the problem of creating a new urban structure, 'a new order providing for significant interaction with nature'.

An important British contribution towards a comprehensive definition of the visual characteristics of the urban scene lies in the concept of 'townscape' which found authoritative backing in the *Architectural Review*. The method of the British group concerned, which was to some extent anticipated in Germany, did not claim to embrace or supersede all other theories, but it spread rapidly in the 1950s to other cultural milieux, especially in America where it served to revive forgotten values, stimulate fresh ideas and help to meet new demands. It was referred to, as noted below, by Lionello De Luigi at the congress of the Istituto Nazionale d'Urbanistica at Lecce. The word 'townscape' is of course a neologism modelled on 'landscape'; it presupposes English traditions and an English approach to methodological problems, and its implications are naturally not wholly valid for countries which differ from Britain in their history, ideology, tastes and visual attitudes. The Englishman's attitude to the town in which he lives, identifying himself with it and integrating himself into its life, is very different from that of the Italian, who tends to confine himself to aesthetic contemplation—a result, in part, of the stronger influence of the past and the persistence of an impalpable historical atmosphere. Interest in the theory of 'townscape' was in fact awakened in Britain by the concrete problems of the 'new towns', though it was soon applied to old urban centres as well. The result was to open up a whole range of new problems, interests and solutions which in some cases had a profound effect on urban culture.

When we consider a town from the aesthetic standpoint—its component elements, the complexity of spaces and volumes, the appearance of its buildings and the strata belonging to different ages— we are concerned with an entity and a set of values extraneous to the notion of townscape. Apart from the town as an aesthetic object, a formal abstraction transcending even history and the socio-historical conditions by which it has been formed, there is also the town considered as a series of streets, squares and districts as these are immediately perceived by the human eye: as De Luigi puts it, 'the visible reality of the phenomenon in its entirety, in the dimension of our daily life'. The notion may be clearer if we consider the nature of the restorative or illustrative measures that are generally used to exemplify and document theses and solutions in the *Architectural Review*. These measures would hardly be considered very precise if they related to the constructive and spatial aspects of the urban problem in general, but they are well suited to concentrate attention on the visual circumstances that are prevalent or dominant at a particular moment. To take a single example: suppose that in front of a building of importance, with a distinctive appearance and function of its own, an advertiser decides to place a huge neon sign, the building will certainly suffer and may lose its significance for the area in which it stands. If a succession of other incongruous elements are added, the whole district may assume a totally different character. It may be possible for a student of architecture or a keen-eyed observer to perceive the original nature of the district despite the accretions, but the view formed by the ordinary townsman or the hasty passer-by will be dominated by them. The environment has not been materially destroyed, but its relation to the townsman has been profoundly altered.

If a student of townscape wishes to represent an adverse situation of this kind, he will use every possible photographic, graphic and chromatic resource to concentrate attention on the offending

accretions: the architectural and environmental reality, which of course continues to exist, will be left in second place. By thus artificially stressing certain elements he underlines and pinpoints the visual importance they have acquired. The imagined case is, of course, an extreme one. Experts in townscape are concerned to formulate a methodology whereby human works of all kinds can be made to harmonize with the expressive nature of the environment—bearing in mind also that in the case of environments which are of no special interest from the architectural or urbanistic point of view, the works in question may be so designed as to contribute elements of functionalism, purpose and amenity. We may recall De Luigi's observation that 'from one point of view, public works may be regarded as the application of "design" on an urban scale. . . . From another, however, they seem to me to reflect studies devoted first and foremost to determining the nature of the environment as a whole. These studies are concerned primarily with discursive and narrative elements, with the counterpoint of mutual relationships rather than the specific value of each single object, building or feature.'

In one way, therefore, advocates of townscape fail to perceive, and in a sense neglect, the complex spatial reality of an urban centre; but in another they enrich the image of the city with a wide variety of factors and heterogeneous aspects that have been too much neglected in our own cities, as any observer may verify.

The Image of the City is in fact the title of a well-known book by Kevin Lynch which, as various debates and practical applications have shown, is still of much topical importance. It appeared in America in 1960, i.e. a few years after the 'townscape' debate: Lynch's work has only a few points of contact with the latter, but it is related to the same cultural background. In this book he not only sets out a method but also indicates its practical possibilities and the techniques involved. One of these is a concise and effective system of graphic symbols, developed and elaborated in a later work by Appleyard, Myer and Lynch entitled *The View from the Road* (1964).

The problem to which Lynch addresses himself in the former book is the concrete one of establishing a new methodology of city design. He rejects the historical approach and, while not ignoring the aesthetic aspect, insists on the constant link between the city and the daily life and interests of its citizens. 'Nearly every sense', he writes, 'is in operation, and the image is the composite of them all.' The task is to examine the visual character of the city (the American one in this case) and to analyse 'the mental image of that city which is held by its citizens'. This depends on what he calls the 'clarity or "legibility" of the city scape' in all its aspects of 'size, time and complexity', that is to say the 'ease with which its parts can be recognized and can be organized into a coherent pattern'. (Gyorgy Kepes uses in a similar way the notions of differentiation, variety, and the interplay of 'unstructured randomness' and 'patterned orderliness'.) The image here in question is not an individual but a collective one: the 'common mental picture carried by large numbers of a city's inhabitants'. Lynch analyses the conception of the image in terms of 'identity, structure and meaning', and defines 'imageability' as 'that shape, colour or arrangement which facilitates the making of vividly identified, powerfully structured, highly useful mental images of the environment', while concrete experiment determines the 'role of environmental images in our lives'.

Lynch's pupil and translator Gian Carlo Guarda has observed that: 'The inspiration of Gestalt psychology, which certainly furnished Lynch with valuable experimental ideas, combined with the more indirect influence of the Bauhaus (on a visual and phenomenological plane; perhaps Kepes's contribution is especially to be seen in this light) to form his opinion that awareness of the urban environment is to be interpreted in biological rather than conceptual terms.' If the original impulse

to become acquainted with a city is due to the desire to find one's way about, it becomes a vital need for the citizen to acquire a sense of direction and to recognize the identity and shape of its various features. This involves the elaborate memorization of details and sequences, and attention is thus focused on their schematic perception: the urban scene is presented to the observer as a *Gestaltung* or pattern of perceptions. This process, in Lynch's view, is of essential importance in regard to the form of a city. If it is the planner's task to mould that form to a conscious design, it is of fundamental importance that the design should be based on an understanding of the nature and mechanism of the perceptive process.

In the last decade or so the Kepes-Lynch line of thought and its application by Gulick and others has encountered much agreement, some disagreement and occasional doubts. Looking back, we can see that it has enriched our 'image of the city', though it should not divert us from the consideration of more stable and objective values. Thanks to Lynch, a number of factors and relationships to which we formerly paid no attention are now in the forefront of our minds, waiting to be investigated and assessed. Apart from the specific function of his method in the urbanistic context, it reminds us of the need to take account of *all* the visual elements that make up the city scene and, within it, derive significance from their mutual relationships of juxtaposition, alternation and sequence.

In the above paragraphs we have reviewed some of the major contributions to the problem of reading and interpreting landscape, understood as the result of the encounter between man and nature. Obviously a great many more would have to be mentioned if we were to give a complete account. But the foregoing will, I hope, give some idea of the development of research and analysis in recent years and the wide range of thought on this subject throughout the civilized world.

As we have noted more than once, the great debate concerning urban, rural and historical landscape has been stimulated and kept in the forefront of attention by the huge weight of practical problems and responsibilities which have arisen during the past century or so as a result of technical development, social change and the growth of population. It seemed for a time, and in some ways it still does, that the whole problem is beyond human control and is bound to culminate in extreme forms of degradation, disintegration and chaos. A multitude of good and bad reasons, lawful and unlawful pressures may have crucial and irreversible consequences. The situation varies greatly from one country to another: the problems of America are not those of the Soviet Union, those of Spain are not those of Germany. In some countries, such as Britain, Denmark and Sweden, the degree of civic spirit and political maturity are such that the more alarming phenomena can to some extent be controlled. But, apart from criticisms of detail (such as have been levelled in full measure against the British 'new towns'), it is only too clear that we do not possess adequate means of ensuring the mastery of situations that always arise unexpectedly, so that control measures are tardy and ineffectual. There is something paradoxical about the frustrations that have beset the history of towns and town-planning over the last hundred years. On the one hand, theorists and planners have carried out studies and evolved increasingly apt measures to prevent the situation from getting worse: in the last quarter-century in particular, as we have seen, the debate has been pursued without ceasing and with the help of experts of many disciplines. But, on the other hand, the proposals, plans and suggestions put forward as a result have found little or no support from public opinion, economists and administrators. In this respect the experience of the Communist and non-Communist worlds has been similar: in the USSR, around 1930, a major experimental plan was buried by the state bureaucracy. There is in fact a split between civilization and society, which has always existed but has become deeper and more dangerous by reason of the increased association of the public with political

power. Together with much lively discussion of Utopias and forecasts of tomorrow there has been an appeal to 'planning from below', i.e. solutions not dictated by rulers but expressing the collective will and participation of consumers. The difficulty of the problem is shown not only by the frequency with which theses and conclusions are tried and found wanting, but also by the fact that solutions which purport to reflect the needs of our civilization do not attract a firm and substantial following: instead of homogeneous groups aligned in a common front, there is a persistent dispersal of effort and crumbling of what should be allied forces. Yet it is clear that the problem of cities, or rather of human geography altogether, is today absolutely paramount. It is not our purpose here to study the mass of hypotheses and proposals, the studies of urban and rural typology that have been put forward. Urbanistic studies today are in the forefront of critical attention, and syntheses have been attempted in the quite recent past.

For our own part, however, we would repeat that the so-called problem of cities is really a problem of the earth's surface as a whole, or, if one prefers to put it so, a problem of the city and its surrounding territory as well. There is here a change in the scale and nature of the original problem, to which planners must pay attention if we are to avoid the spontaneous, anarchic, haphazard proliferation of settlements, whether independent or subsidiary, and in fact the indiscriminate occupation of the earth's surface. This process is taking place before our eyes. The role of the architect as a 'creator of form' (in Giorgio Piccinato's phrase) is subject to challenge: 'the material in which he formerly worked has lost its power to signify (Kepes), and the formal structures which took their place around the architectural object are reduced to the role of supports for eclectic images.' Our task is to find on the new scale 'those possibilities of semantic designation which have been lost on the old'. Each and every element becomes 'potentially significant', and a building as such loses much of its importance as one among many components of a complex landscape corresponding to the 'enlargement of daily life in space and its contraction in time'.

Whatever the planner's basic ideas and orientation, his political, social and professional ideology, it is clear that he must henceforth think and work in terms of 'territory', though the scope of this term may vary widely in particular cases. This is plain enough from Lynch's examination of the various possible schemata for the city of tomorrow. But this means taking into account a heterogeneous mass of factors involving all human activity without exception: it is in fact a task of re-inventing landscape, 'weighting' it in different ways in accordance with a multitude of relationships and reactions. Clearly this is a task of the utmost difficulty requiring the co-ordination of many independent types of skill and experience; yet there is a greater difficulty still. As Richard Neutra wrote nearly twenty years ago: 'Naïve parochial outlook needs supplementation by global forethought, experience and contemporary know-how. With all sincere respect for regionalism, there does exist now a cosmopolitan "joint responsibility" for reconstruction anywhere. Human planning cannot really remain compartmental or sectional in an age of mutually braced security.' Although the consequences of this may be more clearly seen in other fields than that of the environment, where changes are necessarily gradual, it is none the less true that territorial planning and operations are carried out today on a scale involving the interests of more than one country, and are therefore essentially supranational. These plans are not, as yet, 'global' ones in the sense of involving every aspect of the territory in question, but they none the less concern important interests and far-reaching international issues. Examples are main roads and railways, the siting of key industries, tourist facilities etc. When our authorities consider the future of a city like Genoa, and the possibility of developing industry there, they take account not only of Italian factors and implications but of foreign ones also.

There is certainly nothing 'futuristic' in what Lynch and Rodwin wrote in 1962 in *The Future*

Metropolis, in the chapter entitled 'A world of cities': 'The city has swollen to a vast organism whose scale far transcends individual control. . . . It appears that these metropolitan complexes will become the dominant environment, at least in the most highly developed regions of the world, for they contain the bulk of the population, and they produce and consume most of the goods. The living space will become a set of such areas, at times separated by areas of low population that provide raw materials. The metropolitan regions may be very large, even grouped in chains several hundred miles long; but they will be more or less continuously urbanized, however low their suburban densities may be.' This prediction, which is already to some extent a reality, presents the world as a chain or series of territories, varying in their use and population but closely interconnected. If territorial planning ever becomes possible on a world scale there will no doubt be sharp opposition between those who wish to see cities concentrated, thus reviving the 'ancient conflict' with the countryside, and those who see the two as coexisting and interacting, the difference being one of proportion rather than of kind. However, both schools of thought will have the same objectives, the chief one being, as Neutra puts it, 'to preserve life on this shrunken planet and to survive with grace.'

In any case there is little doubt that the 'countryside' will be transformed out of recognition. As Gregotti writes, 'It takes five years to construct a polder or to colonize the desert; a hydro-electric plant can change the shape of a valley in two or three years; an isthmus can be cut through in a few months; power can be transferred to any desired spot; and there may in future be ways of controlling the climate and so bringing about even faster changes.' The scope of such changes, even today, can be seen by looking at any series of aerial photographs of affected regions. These show clearly enough 'the process by which man brings nature under cultivation in order to enjoy its products'. As we pointed out earlier, the process is taking place on an ever more rapid scale, the improvement of machinery and technique leading to a kind of geometrical progression. As Gregotti also says, the invasion of the countryside by technology reduces the importance of any particular locality: the forces at work are not interested in the 'character' of a place, and tend to obliterate it.

Another question arises when, comparing the present with the past, we acknowledge the urgent necessity of measures to obviate the disintegration of man's relationship with his environment. Why is it that instead of freely enjoying our surroundings as heretofore, we have to accept a principle of control and management, including positive direction as well as conservation (whether such control is in fact possible is irrelevant to the present question)? Why has twentieth-century man not been able to preserve the tremendous inheritance of the past and to remain, as he has been for centuries, the master of nature?—especially at a time when he has become aware of environmental problems from the historical point of view. Why must his freedom and initiative be cramped, as is bound to happen whenever individual responsibility is replaced by scientific planning and direction?

There are, of course, several answers to this question—or rather there is a single one, but it is so general as to be tautologous. The problem of 'modern times' is that of a whole host of factors which distinguish the present from the past, and questions of environment are not the whole story. But some more specific answers may be given.

In the past, there was nothing like the same pressure on land as there is today. There was more space per head of population, and the occupation of the soil was never feverish in its intensity or imposed by inexorable need. The agrarian system and the organization of crafts ensured that the land was kept in cultivation or reclaimed if it had fallen into disuse. Husbandry consisted in a multitude of detailed operations—pruning olives, building walls, paving roads, making tools—which have left their traces in physical forms of great harmony and beauty. Crises and upheavals, violent as they

might be, did not disturb the regularity of functions, traditions and tastes which had come into being throughout the ages. The decade after 1945 witnessed the sudden and brutal disappearance of types of objects that had survived in use, unaltered, for centuries and even millenniums. Another point is this. Today, life is on a world scale—that is to say, ideas, tastes, aspirations, purposes and ideologies are common to all the earth's inhabitants; transport and the communication of ideas have been vastly accelerated, and an event can be experienced simultaneously in all parts of the globe. In the past, separate centres of life and culture were well defined and circumscribed. They did make contact to some extent, but only on an élite level, and the rate of interdiffusion was slow. What we may call 'localism', whether the territory concerned was large or small, led to the stabilization of more or less homogeneous types and forms, protected from change by the norm of a common nomenclature. The apparatus of life was thus codified by daily practice as well as memory and tradition; the changes it underwent were small and gradual and did not, as a rule, obscure its distinctive character. In this way each city with its surrounding area, each province or region (the size of the unit would be different in different cases) could be defined or identified in terms of the traditional, 'anonymous' features that constituted its mode of life. In the countryside and in small localities the circle was even more restricted, and many of these were shut off in self-sufficient isolation. In such historical conditions it is not hard to see the reasons which would have ensured the continuity of a discourse free from *a priori* denials and artificial forms of respect that were not dictated by the conditions of life, work and production.

But, in Bonelli's view, there are deeper and more general reasons for the opposition between present-day mankind and the city or landscape (Bonelli, in fact, refers chiefly to architecture, which he regards as an index of exact significance). We have to do with 'a purely economic motive, choking the natural aspiration towards other forms of life. The link between our civilization and present-day building is supplied by this economic impulse, a utilitarian one which permeates the age in all its aspects, so that the resulting picture is a mere reflection of contemporary culture. The world we live in is one which has thought it necessary and possible to dispense with the satisfaction of the prime needs of our being: it has done away with ethical principles, logical unity and the play of the imagination.' On this we may comment that if things are really so and our world is, in Bonelli's words, 'lacking in ideals and therefore one-sided, maimed and shapeless', then any attempt to plan our salvation is not only doomed to failure but is not even conceivable in terms of the sharing of aspirations by appreciable bodies of opinion and by those in authority.

It is the case, nevertheless, that studies, proposals and plans have been put forward in large numbers, especially of late years, as men became aware of the growing threat to their historical environment and the impoverishment and degeneration of their own lives. Conscience, culture and a sense of responsibility are less effective in stirring to action than the frequent instances of paralysis, disfunction, degradation and disorder which have resulted from the utilitarianism deplored by Bonelli and have brought home to mankind the impossibility of letting things continue in this way.

What, then, are we doing about it, or what can and should we do? 'Up to the present time,' writes Cesare Pellegrini, 'or rather up to the beginning of the industrial era, at all events in Europe, the minor changes brought about by successive ages were superimposed on one another without giving rise to any problem of historical identification. The slowness of the process and its limited material effects were a sufficient guarantee of its place in history.' (We may note that it was the problem of restoration which first introduced the ideas of 'conservation' and 'historical environment'.) 'The problem of our own age, however, is that of an "archival" landscape of disparate features in a residual setting.'

As regards the relationship between conservation of the past and affirmation of the present with an eye to the future, and in order to clarify the problem of the historical landscape amid the transformations of the present day, I would quote a passage by Luigi Piccinato which seems to me lucid and convincing.

'A landscape or a hallowed piece of scenery can be preserved within the framework of a regional or general plan which also covers such features as offices, factories, houses, hotels, roads etc. A second condition of its preservation is that the planners should have the necessary desire and sense of purpose to imbue the scene with everyday life, as in the regeneration of old quarters of cities. What must not be allowed is that the region or quarter should remain still, dead, embalmed, cut off from the new age. On the contrary, it can only be saved by being rationally and organically incorporated into the framework of human lives.

'It cannot, however, be said that in so doing we have "preserved" the quarter, landscape or ancient monument in an absolute sense. What we have done is to preserve it in our own way, the only way open to us as men of the present time, with a viewpoint that is today's and not yesterday's or tomorrow's. Similarly, old pictures or statues cannot be absolutely preserved by means of varnishing or cleaning or restoration, however accurate. We cannot see them as they once were: the colours have faded, the varnish is oxydized, the surface is cracked, the panel worm-eaten; the marble is covered with patina, the quality of the atmosphere has changed, we view the object by electricity instead of an oil lamp; but every time we do so, we perform a work of reconstruction or rather re-creation, an analysis and a synthesis which the picture or statue calls on us to perform, and in which it is our duty to seek the aid of restoration and critical study.'

Piccinato wrote these words in 1958. Twelve years later, the terms of the question have changed a great deal, though from the point of view of method his remarks are unchallengeable. Many illusions have been dispelled and many problems overcome, but also many initiatives have failed. We do not refer only to the Italian scene, which has been protected in some measure: the towns have escaped the worst damage, whereas the countryside is everywhere crumbling under the assault of a mindless, indiscriminate wave of building. We refer to the world situation at the present time, and the fact that remedies of ten years ago seem antediluvian because, among other things, the scale of activity has grown out of recognition. Realistic forecasts of the near future, involve macroscopic quantities. The whole conception of life and habitation has undergone drastic modification, and may do so again. Our plans and expectations must take into account the young generation which is not so much opposed to history as outside it, ignorant or oblivious of a continuity which has made its own representatives what they are. In a situation so fluid and evolving so fast as to preclude any thought of stabilization, with new structures becoming out of date as soon as they are created, under the pressure of economic advance and new modes of production, the task of preserving the environment by integrating 'our own life' into it may well seem a hopeless one, though there is little we can do but attempt to carry it out. Left to itself, the external world might founder in an abyss which would end history as we know it. It is easy enough to imagine a kind of automatic evolution, lit by the sinister glare of an impending apocalypse; what is difficult is to find ways of controlling the physical world in accordance with today's needs without prejudicing those of tomorrow. Yet there is no other course than to do so: we must indeed 'plan in order to survive'.

What are in fact the most important changes that modern society has imposed on the historical landscape; to what demands and functions do they correspond, and by what means have they been carried out?

Without prejudging degrees of importance and priority, we may mention: industrialization with all its changes and the sapping of old ways, including the agricultural system; secondly, the creation of a road network corresponding to man's increased mobility and opening up areas which would otherwise have been abandoned as impossibly remote; thirdly, the expansion of cities and the proliferation of building, not only in relation to dwelling problems but also to meet the demands of increased leisure, recreation and sport, involving in modern times all sections of the community. These three primary causes of the transformation of the countryside are of course closely interconnected, and have produced between them long chains of consequences.

Let us take a typical example from the Italian scene: the village of X in the Tuscan Apennines. In 1955 there was no paved road connecting it with anywhere. The inhabitants of the village tilled its land, looked after the sheep, cut firewood and burnt charcoal. There was a local iron-working tradition: nails, tools, locks etc. were made by hand. The whole of life was divorced from real historical time. It took an hour to reach the carriageway that ran along the valley: ten years earlier, people would have thought nothing of this, but today it is an evident anachronism. So, one fine day, a road is built as far as the village, reducing the distance to ten minutes. The once forgotten spot is within easy reach of the local township and the seaside, a coast which happens to be popular with tourists and holiday-makers. The village is still a picturesque sight, compact yet extensive, stretching in a slight curve just below the summit of its protecting hill. No single feature, however small, conflicts with the amazing uniformity of atmosphere: not a form or a colour breaks the continuum of the earth, rocks and houses, the tender grisaille framed in the green of woods and chestnut trees. . . . Now that the road is built, the villagers find jobs in the valley where some form of industry has sprung up, or in a town not far off. The countryside is soon abandoned: wild vegetation overgrows the terraces that once gave bread to man and fodder to beasts. But besides the exodus from the village, there is an inflow from the lands beneath. Attracted by its solitary and unspoilt charm, people make trips to it and look for a shop selling bread and cheese, sausages and wine, or a tavern where they can sit quietly and taste the local delicacies. The village, which has only just emerged from abject poverty, does not in fact possess a butcher's or baker's shop, and certainly has no culinary tradition of its own; but in summer, when the coast resorts are full to bursting and the flood of restless visitors increases, the locals begin to think that it might be a good idea to start one. . . . It is not hard to guess the sequel. The popularity of the 'little place' grows from month to month, from year to year. More and more money flows in, more accommodation is needed, old houses are enlarged and new ones are built, in frenzied haste, wherever there is room for them. Space has to be found for parking, and it is provided by pulling down wayside cottages. Every now and then a visitor falls in love with the place's cool, dry atmosphere and decides to buy a plot of land which can be had for a song and build himself a country cottage near the village street which is bound to be paved some day. . . . The village suffers one blow after another, losing its shape and coherence: it was a microcosm, impeccable in structure but also fragile, and the pressure is too much for it.

I have purposely chosen a small, insignificant but actual example of the transformation of a Tuscan mountain site, not remarkable in any special way for its charm or scenery, in order to illustrate the precariousness of a situation left to develop freely, and also the sequence of primary and secondary causes which may bring about radical change in a community and its surroundings. In this example, an anachronistic system of production leads to the impoverishment and decay of an out-of-the-way community; to remedy this, a road is built which links the village to a system of contacts and exchanges on a province-wide scale. This road brings people from outside, and their presence leads to the creation of structures and infrastructures which have a profound effect on the appearance and

atmosphere of the countryside. Very well, one may say: is this necessarily a bad thing? Of course it is not: the process is not a pathological one, it brings new enjoyment and pleasure to many people, and may give them new faith in life and in the future. The villagers, for their part, are enchanted: at last some of the local 'drunks' can be made to do an honest turn of work. The benefit to the community is undoubted, but unfortunately it takes a form which offends the most elementary aesthetic sense. Yet present-day reality, especially in our country, is made up of thousands of such cases, some of them so close together geographically as to form a continuous zone of change, reflecting an ephemeral and transient face of civilization. We spoke of industrialization, roads, the growth of cities and the proliferation of building as the main factors operating, directly or indirectly, to alter the landscape. Alongside them there are others of varying scope and gravity, but common expressions like 'an industrial landscape' or 'a roadside landscape' speak for themselves. We may consider a little further what these imply; as to the third factor, it is specifically associated with cities and therefore goes beyond the scope of our present examination.

Anyone who travels on roads and motorways has many opportunities of observing the catalytic effect of industry on the environment. The radius of influence of a given industry may be only a few hundred yards or it may be many miles, determining conditions throughout a region. Apart from this question of scale there is that of the rapidity of development involving changes of size and structure, the apparatus of publicity, the increase of heavy traffic and the installation of auxiliary services. Here too we have a sequence of causes and effects which is arrested only when some degree of equilibrium is achieved among all the contributing factors. Whether the norms and directives of a plan are good or bad will have much effect on the future condition of the territory and the quality of its landscape.

In modern times, views have evolved considerably on the relationship between industry and towns, industry and the country, industry and housing—in short, the physical place occupied by industry among other human activities. The popular opinion is that industry and the countryside are antithetical: industry is synonymous with unhealthy conditions, degradation of life, contamination of the environment and so forth. On this view, no fruitful interchange is possible between industry and the features of the landscape which it disturbs or disfigures. But such an opinion will not really hold water. Certainly there are many adverse instances, but they do not cancel out the others any more than truth is destroyed by the prevalence of error. The popular image of industry which equates it with a forest of factory chimneys, a grey, desolate area of sheds, roofs and enclosures, smoke and mire, is so out of date as to belong almost to the Romantic era. Today industry has changed its face thanks to new working methods and types of machinery, new sources of power, health, safety and welfare arrangements and the whole progress of technology. Factories have become objects of prestige and publicity value as well as efficiency: each has its own recognizable 'style' and appearance. The difference between the design of an industrial building and that of a civic one is that the former does not aspire to be 'architecture'—in the wrong sense—and is thus unblemished by the grotesque and pretentious elements with which we are all too familiar. A factory, big or small, may either be a shapeless hangar, a container and nothing more, or it may be genuinely architectural. In view of its functional character it tends to transform itself into a stable type of organism, whether simple or complicated. The absence of inappropriate stylistic ambitions is precisely what gives it style. The spread of pre-fabrication involves the creation of series of homogeneous elements, disposed in volumes and spaces and arrangements of great power and visual quality; dimensions grow larger, the tension of structures more expressive. The whole effect is that of a synthetic type of architecture which may

revitalize and re-create the landscape, as the cathedrals did once, by introducing symbols of the present age. One thing is certain: the image of our own times is better and more nobly expressed in the factories of Ivrea, Sparanise or Pordenone than in the clutter of buildings with which we have decorated our coasts, hills and mountains in the hope of making them more attractive and pleasant as places of escape and recreation.

In order to grasp this we must get away from the thought of landscape as 'pure nature': in Pietro Derossi's words, landscape is not 'primeval matter against which it is man's destiny to wrestle, but rather the expression of man's mind and the evolution of nature, in a reciprocal and indissoluble connection. Abandoning the attempt to define nature and landscape in terms of eternal properties, we see them as the result of human research, experiment and construction.' From this standpoint Derossi proclaims the 'deep significance' of industry 'as the reflection of human activity upon nature and the landscape'. Among its effects he notes 'the desertion of rural homes and farms, the replacement of traditional modes of cultivation by labour-saving ones etc. . . . To avoid a slow death, agriculture is compelled to adapt itself to the productive rhythm of new economic activities. The effort to raise farm wages to the level of factory ones involves changes in farming methods and the size of plots, mechanization etc.'

As regards the relationship of industry to the landscape, Derossi observes that 'the basic problem is to work out methods of study and proposals which will ensure the maximum comprehension and control of the relevant factors and a sufficiently prompt response to their evolution.' Much hard work of an interdisciplinary kind will be needed in order to grasp the interrelation of problems and find overall solutions. 'Industry, no longer activated merely by the production-consumption nexus, would be integrated into its social setting; while landscape, no longer subjected to the sterile rules of preservation, would be the resultant of a superior rational order dictated by society's real demands and consciously accepted responsibilities.'

In the case of roads there is perhaps less ground for anxiety, though here too we have an element which (while in itself traditional, unlike industry) is capable of profoundly affecting the appearance and use of a given territory. The ways in which this can happen are sufficiently well known, but for the present I wish to consider roads not in their practical aspect but as a landscape feature.

The mechanization of labour, the advance of building techniques, in fact the whole scientific progress of the last century and a half has revolutionized the making of roads and multiplied their purposes. Excavators, modern methods of transport an dother equipment have made it easy to build roads in a short time in areas where it would once have seemed almost impossible. The increase of mileage is enormous, though it varies a great deal from country to country. There are, of course, many other well-known factors which have meant a change from the past, especially that of speed. The heavy increase of motorized traffic poses grave and urgent problems. The communications system as a whole is so absurdly inadequate to present needs that it may soon have to be radically overhauled; but for the moment attention is concentrated on the road network, its difficulties and dangers. Efforts are constantly made to improve roads and increase their number so as to provide rapid and safe means of transport for people and goods. The technique of planning and construction is advancing by leaps and bounds, although the planners themselves have their doubts and disagreements about the transport problem in general and specific innovations in particular. Speed and safety are not always easy to reconcile; but the art of road-building in fact affords one of the best possibilities of doing so.

The road system is therefore thought of as a problem for technicians, who are admired for their indifference to obstacles and the boldness of their handiwork. In most parts of the world roads are

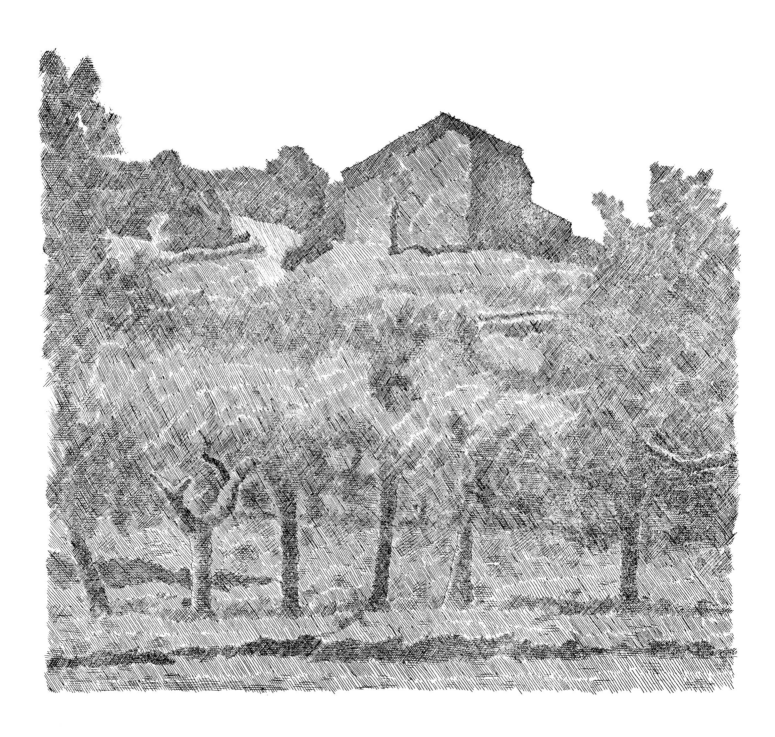

37

still the principal means of communication, but at least two other aspects are involved besides that of technique. There is road policy, depending on the overall plan for the territory of which roads are the infrastructure; and there is, as we have at last come to see in Italy, an aesthetic problem of the road as an element of expression and an instance of 'architecture'. This last term is fully justified, and, like other architectural elements, the road stands in a complex and necessary relationship towards its environment.

The roads of former times—either those on flat ground, forming a close network and winding about as they 'sought' the way to towns and villages, or those which ascended hills and mountains, clinging closely to the latter's contours—soon became themselves, as it were, a part of nature. Long-lasting as they were, they became one with the earth's surface, following its shape and observing its laws in the same way as other, less durable features: plants, fences and so forth. When the terrain lent itself to panoramic views, the road was often of great optical importance as a guide to heights and distances.

The roads of today, especially main arteries, present a different picture as a result of the way they are planned and their manifold uses. By their width and straightness, the apparatus of road-signs, auxiliary constructions and services, they constitute major features of the landscape with a configuration that is entirely their own. In some cases the effect may be monumental and highly expressive: especially when, as in the Mediterranean landscape, the natural features tend to be small, diverse and variable, a great highway can make a radical change in the view. This being so, it is clearly impossible to divorce aesthetics from planning. A modern road cannot be camouflaged, nor can it blend with nature and take second place to it. It is a great single theme on its own, inseparable from the landscape, and must be treated as such. As a factor of renewal it will be acceptable in so far as it combines functionality with respect for the spirit and identity of the landscape, be it natural or historical. Thus, while it was once possible for the road, like many other things, to be the spontaneous, anonymous outcome of an empiricism based on tradition, today it must be the result of a conscious planning operation taking into account the new relationship between it and the countryside.

The story of modern road-building and the concomitant aesthetic problems is a complex one; it has led to the publication of studies which give some idea of the degree of progress attained. Our own country has not been entirely backward of recent years: we may recall the national congress on road landscaping organized by *Italia Nostra* at Florence in April 1968, though its proceedings have unfortunately not been published. It was an illuminating meeting, not least because many different specialities were represented. Among the problems discussed were those of restrictions on building in particular zones, the standardization of planning criteria, the choice of routes in relation to locality and terrain, the landscape as seen by the driver, the relationship between speed and visibility; further, the interference with agriculture, the problem of hoardings, feeder roads, separate motorways, the idea of a 'cultural register' as a guide to landscape planning, and many other such topics.

The common factor in all these questions is that they involve the dual aspect of a road in a landscape. The same type of problem is, of course, met with whenever a feature is added to a landscape and at the same time opens up new views of it: a large building, for instance, a panoramic terrace or the like. But in the case of the road, the validity of the two aspects is always equally balanced: its planners must take account not only of what it enables us or forces us to see, but also of the road itself as an object of vision from this or that point in the landscape, whether near or far. To correlate these two points of view is by no means easy, the less so as a road runs both ways and the visual effect from both directions has to be considered. The conditions of the problem are numerous,

complicated and changeable; they can scarcely be classified as a whole, though some principles may be laid down. Apart from the limiting cases which provide, like an elementary grammar, a catalogue of mistakes to be avoided, there is a wide range of instances which require the exercise of the planner's sensibility, taste and cultural awareness. These attributes are the more necessary as modern engineering makes it possible for the road to be more and more of an independent element, detached from the terrain and creating visual effects additional to those afforded by nature. The future of some landscapes seems in fact to be closely dependent on the presence and layout of the road, which is their most durable human element. While minor aesthetic injuries will no doubt be smoothed over by the passage of time, any grave violation of natural beauty will remain an eyesore, the more difficult to remedy because of the secondary consequences which the planner's decision entails for the territory as a whole.

Up to now we have spoken of landscape as the object of conscious planning by modern man, who has provided himself with the necessary logical and critical apparatus in order to understand its nature, structure and history. As we have seen, there is some agreement and some disagreement on issues which everyone is agreed in regarding as crucial. Plans and proposals have been put forward, methods of action and supervision have been devised. There has been abundant discussion, not all of it constructive or to the point, but there have also been results. In so far as our main theme is how to meet the future, we have made only occasional reference to plans for preserving the landscape, or rather producing a new harmony of form and function in the environment as a whole. Within the various disciplines concerned, one may note a division between the advocates of conservation and innovation. The former reject the values of modern culture, which they believe has damaged the world by its spiritual poverty and sterility, and proclaim the duty of defending the tried values of history. The latter group, whether or not they take such a pessimistic view of the present, point out that scientific and technical progress, the growth of population and the march of history are real factors which cannot be ignored or reversed, though in the long term they may be deflected or mitigated. Instead of a barren intransigence which is bound to be overrun by the facts, they are resolved to do what they can to create a world in which the human race can express itself. There are no fixed and unchanging images in real life: history is a continuous chain of destruction and reconstruction. We have the right to act as we see fit, but we have not the right to let slip our responsibility and allow the world to fall into anarchy, destroying and powerless to rebuild. As regards the landscape, our works and activities must imprint themselves upon it even if this means effacing images that are dear to our hearts. Experience in this domain has shown that what is best in our age is not the result of countless petty occasions and isolated actions but of the orderly deployment of large-scale plans, evolved in full awareness of the values and relationships at issue and the effect on neighbouring fields of activity.

Landscape, as we have seen so far, is a part of man's life, of which it is also the scene, and is profoundly interwoven with his many problems, activities and aspirations. In the latter part of this essay we shall consider how, from the visual point of view, our perceptions have been refined and our understanding sharpened by those select beings whom we call artists. They have done this in two ways: not only by reflecting in a unique fashion the innumerable data of the visual world, but by devising, each on his own account, a vocabulary and use of language which provides a valuable stimulus, intellectual as well as physical, to our understanding of their works and those of nature. This, however, is not all. The British architect and town-planner G. A. Jellicoe, in his *Studies in*

Landscape Design, Vol. II, refers to the geometrical square as the 'symbol of reason' which 'has fascinated architects of all kinds' and 'is first and foremost a shape significant to landscape architecture'; he recalls that 'for some six years Malevich was preoccupied with the square and its relation to other objects,' and that finally he produced the famous *White on White*, now in the Museum of Modern Art, New York. Jellicoe says of this work that 'the significance is twofold: it shows the ultimate and timeless attraction of the square for the human mind; and it shows that the square is no longer a shape sovereign in its own right. It is to be seen only in its effect upon other shapes and, in reverse, in their effect upon itself. That is to say that no work of architecture is complete in itself, but is dependent upon its relation to environment. This is surely the greatest of all rebellions against our immediate history, and one that places a weight upon the landscape architect or his colleague, the architect-planner, hitherto unknown.' This passage in Jellicoe's book concludes a rapid survey of the ancient civilizations, from Egypt to Persia and from Greece to China, in which he traces the appearance of this figure in the works of man: for 'Nature, who can make circles and ellipses and countless wonderful forms from crystals to seashells, cannot easily make a square.' The square is found in later civilizations too, and its power can be seen in many important modern works, such as Churchill College, Cambridge, the West German pavilion at the Brussels Exhibition of 1958, or the 'myriads of interdependent squares sweeping through space' in Zoltan Kemeny's *Banlieue des Anges*. 'All these designs convey emotion and pleasure and boundless horizons. Perhaps it is that in history our square has been under compression, and today for the first time is in tension. It is released for destinations unknown.'

According to Jellicoe, 'the freedom of the square is symbolic of the explorations into imaginative space that have been taking place since the beginning of the century.' The examples are obvious enough. 'Mondrian resolutely excluded organic forms from his studies in space design and is wholly geometric. The constructivists led by Gabo and Schöffer created abstract drawings inspired by constructions in vast urban spaces. Kandinsky was inspired by the movements of the heavens and the spaces of the sky; Mirò in his younger days was delighted by strange and wild shapes in relation to geometry, and clearly loved the serpent. The English painter, Graham Sutherland, has penetrated deeply into organic form. One of the greatest landscape painters, Mordecai Ardon, gives vision to the scene in Israel and should indeed inspire the landscape architects of [his] country to lift technical accomplishment into the sublime.' Apropos of Ardon's work, Jellicoe concludes that the 'universal objective [of] all artists [is] to explore and exploit the abstract world without losing touch with the material world. This is a basic objective, too, of all landscape architects.'

I have quoted at length from Jellicoe's study—which contains stimulating chapters on a number of themes relating to landscape and the way it has been composed, felt and studied by various past ages and artists—because it forms a good introduction to the debate on non-figurative art that has developed to and fro during the present century. In so far as artists choose to ignore external reality and natural forms, it would seem that landscape too would be outside their field of interest. But, as recent experiments and tendencies have shown (and as might easily have been foreseen), there has in fact been a reciprocity of experience, transcending the fragile boundary between 'figurative' and 'abstract' with results beneficial to both sides. Ragghianti has shown how a single artist, Mondrian, observes similar principles of composition and execution before and after the radical transformation of figurative points of reference. Despite the varying degree of recall, suggestion or contact with external reality, Mondrian's workmanship is characterized by a sense of measure and balance and by 'rules' which bear witness, among other things, to certain early influences and cultural loyalties.

Nevertheless, the many experiments of non-figurative or, to speak more simply, abstract art have

a lesson to teach us which goes well beyond the technical confines of painting in general. In the first place, they have affected popular thinking to the point where a distinction is made between the 'antique', synonymous with beauty, grace and elegance, and the 'modern', representing all that is bare, rough, ugly and meanly practical. Secondly, abstract art has taught us a new, non-naturalistic method of apprehending the physical scene, which of course includes landscape. This is a general, many-sided and pervasive process which has affected the whole of sentient mankind and the whole art of seeing: instead of regarding nature as the ultimately comprehensible yardstick, everything is related to form as the sum total of absolute, autonomous values. An example may make this clearer. Anyone who walks along the Via San Leonardo in Florence—of all the city's hill-ways, perhaps the richest in plastic unity and the harmonious development of ages—cannot avoid remembering the masterpieces of Ottone Rosai, who fixed the scene in clear, basic architectural terms while not forgetting the tenderness of light and colour which gives it such diversity from one hour to another. Rosai returned to it almost obsessively, painting different views at different times but concerned above all with its inescapable unity. . . . No one, indeed, prevents us from savouring the silence, or the spring breeze with the gentle perfume of wistaria from the roadside wall. In the evening, one might hear the delicate notes of a piano in some villa behind its iron railings; or there were the dusty olive-trees, the occasional shaft of light through some gap in the wall enclosing the magic street, with its inexhaustible power to revive memories that were alike yet always different. In short, the whole range of motifs and myths, allurement and delight that generations of visitors had found fascinating and irresistible.

But there is, no less certainly, another way of experiencing the Via San Leonardo: in its human measure, the rhythmic breath of space that dilates and expands, the gradual change in the visual field that slows up the wanderer's steps; the transitions that are never abrupt; the clarity and restraint of the buildings, with nothing superfluous or blurred; the warm, uniform basic tone splashed with livelier colour; the firm, shapely cypresses rising above the leafy olives; the wonderful, shifting texture of the pavement, the delicate grain of the plaster. We remember Rosai, and we see through his eyes; but not through them alone. We discover in the depths of our own consciousness a new faculty of sight in which the physical is reduced to a minimum and in which we perceive similarities, relations and harmonies of aesthetic significance. The artists of our day, by deliberately altering or ignoring natural appearances, have forced us to realize the existence of formal values independent of physical reality.

It seems appropriate here to consider the point of view expressed by Kenneth Clark in the Epilogue to his *Landscape into Art*, which may serve as a starting-point for the last section of this essay. Clark begins by saying that 'in Western art landscape painting has had a short and fitful history. . . . Only in the nineteenth century does it become the dominant art,' when 'faith in nature became a form of religion.' This faith, he continues, has waned considerably in modern times, although the average man, 'if asked what he meant by "beauty", would begin to describe a landscape—perhaps a lake and mountain, perhaps a cottage garden, perhaps a wood with bluebells and silver birches, perhaps a little harbour with red sails and whitewashed cottages.' Such, however, is not the attitude of the 'informed minority' which traditionally reflects the 'living art of a period. . . . By 1900 the more adventurous and original artists had lost interest in painting facts. By a common and powerful impulse they were driven to abandon the imitation of natural appearances.' Photography played an important part in this, for it 'enabled artists to enlarge the range of their aesthetic experience far beyond the range of their direct experience of nature'. It thus helped to create 'museum art', the

danger of which was foreseen by Constable when he wrote to Fisher in 1822: 'Should there be a National Gallery (which is talked of), there will be an end of the art in poor old England. The reason is plain: the manufacturers of pictures are then made the criterions of perfection instead of Nature.' The first artist, Clark observes, to state that he was aiming directly at 'pure' aesthetic responses was Gauguin, who wrote prophetically in the 1880s: 'I obtain by arrangements of lines and colours, using as pretext some subject borrowed from human life or nature, symphonies, harmonies that represent nothing real in the vulgar sense of the word; they express no idea directly, but they should make you think as music does, without the aid of ideas or images, simply by the mysterious relationships existing between our brains and such arrangements of colours and lines.'

It is ironic, Clark goes on to say, that Cézanne, 'the most earnest and scrupulous follower of nature', should be regarded as the spiritual father of Cubism. However, 'although it is quite clear that Cézanne never envisaged Cubism, or any other form of so-called abstract art, we cannot deny that his late work goes a long way towards abstraction.' But—and here we come to the nub of Clark's argument— 'although Mondrian, the painter who achieved the purest of all abstractions, tells us that he drew some of his original inspiration from waves and beaches, we cannot seriously consider the more austere forms of abstract art as a possible basis for landscape painting.' So, he continues, landscape painting has in fact been in decline both for special or technical reasons and because of the activity and methods of science which have prevailed for the past hundred years. Among other things, 'the microscope and telescope have so greatly enlarged the range of our vision that the snug, sensible nature which we can see with our own eyes has ceased to satisfy our imaginations. . . . Nature has not only seemed too large and too small for imagination: it has also seemed lacking in unity.' Finally, we have lost the medieval feeling 'that nature was friendly and harmonious. Science has taught us that nature is the reverse; and we shall not recover our confidence in her until we have learnt or forgotten infinitely more than we know at present.'

We would not deny that there is some truth in Kenneth Clark's thought-provoking argument, and he makes specific points with acuteness and originality. But, in his concern to maintain a thesis, he has over-identified art with civilization. The ideas and tendencies, symptoms and anxieties to which he draws attention are no doubt widely present in society, but it does not follow that they are shared by all or even most artists. One may agree with him that 'we should no more expect landscape from [Picasso or Braque] than we do from Ingres and David;' but it must be pointed out that he has over-looked or ignored a multitude of painters—from Kokoschka to Morandi, from De Chirico to Ben Shahn, from Derain to De Staël, from Ben Nicholson to Mafai—whose work gives us every reason to speak of landscape as an inspiration to twentieth-century artists. The examples in this book alone suffice to illustrate the wealth and variety of its forms. Certainly there is no single landscape convention that has been broadly accepted by every school or group. There are several reasons for this: the interruption of development by successive avant-garde schools, the stimulus of scientific and technical progress, the rapid evolution of tastes and the breaking-down of fixed cultural forms due to the worldwide diffusion of new tendencies and ideologies. If there is no such thing as 'twentieth-century landscape' in general, with an identifiable visual approach, it is none the less true that despite Kenneth Clark's theories the artists of our time have created a landscape of their own in which they have often shown great independence of natural forms. I would go further and say that they have often reflected, if not anticipated, some of the most important discoveries and themes of modern times, such as speed, for instance, or views from high altitudes.

If we examine a Fauvist landscape by Vlaminck or Matisse alongside a Cubist one by Picasso or Braque—to mention only artists of the same generation and environment—we must recognize that

they proclaimed unmistakably enough what were to be the century's chief characteristics, especially the violence of contrasts and the confrontation of opposite views, beliefs and purposes. The situation soon became even more confused, and it is no easy task to unravel the details of its feverish conflict and dispersal of effort. We may study the multiformity of vision and understanding through the development of landscape painting during the century and in so doing avoid the temptation to reduce art history to a kind of regulated succession, the chronicle of a privileged dynasty to which every true artist must by definition belong. And we may acknowledge that our awareness of landscape has become more flexible and many-sided thanks to the wealth and variety of forms and images created by contemporary artists, to a higher degree perhaps than those of any previous age.

The extraordinary tale begins with the first decade of the century. In itself the year 1900 is no more than a date in the calendar, a link rather than a dividing line between adjacent facts and ideas. But in the ensuing ten years the artistic scene began to develop at a furious rate; and we may therefore take 1900 as our starting-point for what is intended not as an historical survey but as a study of how certain artists envisaged landscape in accordance with their individual style of painting.

Raoul Dufy, in response to a spectator baffled by the 'unnatural' purity of his colours, declared significantly: 'Nature is a mere hypothesis.' This was to set the tone for many painters in the coming decades, and there were artists and critics who saw the point at once. Crespelle recalls Maurice Denis's comment on the work of Matisse and his companions: 'This is painting purged of contingency, the pure act of painting in itself. Representation and sensibility are alike excluded: it is a quest for the absolute.' Many years later Friesz explained that it was a problem of 'representing sunlight by a technique of orchestrated colour'; while in 1929 Matisse himself spoke retrospectively of 'a construction . . . in which the expression is conveyed by a coloured surface which the spectator apprehends as a single whole'.

It was colour, then, on which the Fauves relied as the embodiment of their daring and exalted vision. Critics have sought and discovered an affinity between their art on the one hand and, on the other, their social origins, musical preferences, anarchism or taste in clothes. No doubt such circumstances may have had their weight, but the human, historical and cultural roots of Fauvism are deeper. As has often been observed, the movement derives firmly enough from Gauguin, Van Gogh and the Neo-Impressionists; but its brief heyday was a further sign of the absolute freedom which all artists regarded as their birthright after the great conquests of the latter part of the nineteenth century.

Fauvist colour is intense and vibrant, sharply juxtaposed and impatient of chiaroscuro; generally of very light timbre, it covers larger or smaller areas of the picture surface, which reinforce one another; it is applied with rapid, impetuous strokes of the brush. No purpose is served by trying to break down the scene into a formal design. Space and perspective, volume and mass are all completely unexpected; it is our own instinctive reference to objective reality that enables us to read into the composition actual shapes, relationships and distances. A tree, in Fauvist art, is a ragged outline between two bands of colour: a green, red and pink one for the earth and a blue and light green one for the sky. The top of the tree and the lower part of the trunk are therefore red, while the centre is black. Half the canvas or more is covered by twisting branches and foliage, and these are bright red. This is a description of Vlaminck's picture of the Seine at Carrières, but it might equally well be Derain's *Charing Cross Bridge*, or Friesz's and Braque's views of *La Ciotat*, or Manguin's *Saint-Tropez*. Certainly all these artists differ in style, and still more in poetic intention, but their work is pervaded by a kind of family likeness.

The Fauvist paroxysm died down rapidly, but not before producing some masterpieces: the refined work of Matisse, who believed that the artist should 'go against instinct', as we prune a tree to make it grow better; the fiery whorls of Vlaminck, who painted 'with his heart and loins, oblivious of style . . . since instinct is the base of all art'; or the restless hatching that breaks into the mosaic texture of a Braque seascape. Sea-pieces are indeed characteristic of all the Fauves, as are water and sky in general. Very often the features of the landscape are few: water and sky, without the addition of concrete shapes, tell us all that needs to be said, and furthermore they have no shadows. In a letter to Vlaminck, Derain speaks of 'a new conception of light, consisting in the absence of shade. The lights here are very strong, the shadows very clear. The shade is a luminous clarity opposed to the light of the sun: what are called reflections. . . .' Sometimes (as with Friesz, and also Vlaminck and Braque) the Fauves turn their eyes to the summer countryside with its yellow cornfields, the jagged shapes of hills and mountains or the mottled trunks of unreal trees, sprawling over the landscape and blending with it. But the rush of inspiration refuses objective definition, and too close analysis seems to blunt the directness of the image. Friesz's brush-strokes, like so many sweeping gestures, outline the elements of his picture in baffling shapes: hills that look like trees, and vice versa. The great thing is to achieve an immediate, icastic quality of unmistakable impact. This was accomplished in the first encounter with the public at the Salon d'Automne of 1905, when the young innovators scored their *succès de scandale* and unintentionally acquired a label, in accordance with the precedent of Leroy and the Impressionists.

This time the critic was Louis Vauxcelles, who exclaimed: '*Donatello parmi les fauves!*' It was he, three years later, who, together with Matisse, spoke of Braque's 'cubes' and thus created the second famous 'ism' of the century. Whether the label 'Cubism' be good or bad, it was quite appropriate to describe a certain type of morphology, seen in Braque's *Houses at L'Estaque* (1908, H. Rupf collection), painted in the same year as Picasso's *Landscape* in the same collection. Thus the two founders of the movement joined forces and inaugurated a long debate which soon attracted other champions and their supporters from far and near. Although we cannot fully agree with Rosenblum and others that Cubism 'was to alter the entire course of Western painting, sculpture and even architecture,' either in the novelty of its method or in its practical influence, it was certainly an experiment of crucial importance and produced some of the finest works of our time.

Braque's *Houses at L'Estaque*, already mentioned, shows clearly enough what was to become of landscape in Cubist hands. The various elements blend into a single whole, while remaining distinguishable thanks to the extreme simplicity of arrangement. The formula is a pregnant one and marks the beginning of a process whereby many artists came almost to lose interest in objective reality, thus eliciting such judgements as those we have quoted from Kenneth Clark. Here is Rosenblum writing of Braque: 'His Provençal houses, boldly defined by the most rudimentary planes, have so thoroughly lost contact with the realities of surface texture or even fenestration that at places—as in the background and the lower right foreground—they are subtly confounded with the green areas of vegetation. And, just as the description of surfaces becomes remote from reality, so, too, do the colours take leave of perceived nature and tend towards an even more severe monochrome. . . . In the same way, the light follows the dictates of pictorial rather than natural laws. . . . Braque's houses, despite their ostensible bulk and suggestions of perspective diminution, are so tightly compressed in a shallow space that they appear to ascend the picture plane rather than to recede into depth.' The painter's anti-naturalistic intention produces a kind of *horror vacui*: surfaces are represented by solids piled on top of one another and similar in effect to some villages clinging to the rocky

hillsides of Tuscany, Umbria or Latium. The viewpoint may be closer or more distant, comprising a single house or tree or an organic complex; but there is a consistent denial of material reality and a growing tendency to base the composition on vague, indistinguishable forms or elements. Both Braque and Picasso, who at this time were so close that their development was almost identical, present us with a 'confounding of architecture and landscape in a shimmering fabric of dismembered planes'.

Their landscapes, however, are no more than the overture to a series of seemingly irresistible consequences. Between 1910 and 1912 the advance was made towards highly geometrical forms with a complete ambiguity of reference. There are indeed some landscapes like Braque's *Roofs at Céret* (1911); but, except for the occasional overt symbol, it would be hard to decypher amid the kaleidoscope of faceted planes an allusion to reality that could not equally be found in his still-lifes. Nor is there even a spatial scale of reference that might serve to explain or justify the artist's deliberate retreat from the external world. There are, however, signs of a desire to keep open, with an eye to the future, a debate on the aspirations, crises and ideologies that characterize modern civilization.

From 1910 onwards, with Juan Gris and Fernand Léger, the Cubist experiment broadened out into fresh forms and variations. Only Léger, however, took an interest in landscape, especially around 1920, when he approached the domain of Ozenfant and Le Corbusier. Urban scenery provided him with a variety of themes; but while in his first period he shows distant traces of Impressionism, such as the high viewpoint and oblique foreshortening, in later years he idealized the Paris scene, combining figures and symbols in a way significantly related to contemporary ideas of urbanism. As Rosenblum well puts it: 'Using the flat, fragmentary planes of Synthetic Cubism, Léger evokes the rapidly shifting visual environment of the contemporary world, with its continuum of abrupt and vivid sensations only fractionally observed. Here is the smoothly churning labyrinth of the modern city, infinitely extendible; and here are its human inhabitants, who become only impersonal elements in the functioning of the vast urban machine. Yet Léger's interpretation of this phenomenon is optimistic, for he has emphasized the modern city's potentialities of order and beauty rather than its confusion and ugliness. With his purified shapes, flat poster colours, and impersonal perfection of brushwork, Léger has found a rich harmony in the very aspects of mass production and anonymity that are the targets of many critics of the contemporary industrial society.' His encounter with Le Corbusier and Ozenfant encouraged a development which was already concerned with problems very similar to theirs and which remained lively and creative into the 1930s, with elements that may be called 'Metaphysical': e.g. the 'animated landscapes' in which the outlines show a geometrical clarity in balance with the simplified organic mobility of vegetable and animal elements. The clear colouring, whether uniform or shaded, sharp in tone or subdued as in a pastel, and the introduction of stylized decorative motifs like a mechanical trellis-work, go to make an atmosphere of complete artificiality, a scenic abstraction of magical unreality.

The great city, and one of its principal monuments, also inspired Robert Delaunay, who was in close contact with the two founders of Cubism in 1909-10. The Eiffel Tower, the symbol *par excellence* of modern technology, was the outstanding feature of the Parisian scene. Delaunay reverted many times to this congenial theme, which he placed amid steep cadences of slanting planes: the Tower, by contrast, becomes slender and almost disintegrates as it stretches upward through the cascade. These studies are the most brilliant works by Delaunay, who also attempted a panoramic synthesis of the Paris landscape. The vast scene with its insistent pattern of strips and tesserae gives a certain sense of fatigue, of mechanical craftsmanship and discontinuity; nevertheless it is a striking recapitulation of Cubist themes and methods.

Order and clarity of arrangement, based on a judicious balance of geometrical 'reductions', are seen in the work of Roger de la Fresnaye, who approached Cubism by way of methods and conventions that go back to Cézanne. By 1913, when he painted his great work on the conquest of the air, he had attained a remarkable sureness of style and a rich and faultless colouring in juxtapositions and light gradations of tone.

Jean Metzinger and Albert Gleizes also did their most original work between 1910 and 1915; in 1912 they jointly published *Du Cubisme*, which appeared in English the following year. Less of a formal Cubist than Metzinger, Gleizes painted landscapes in a disciplined manner until he encountered the Americans and, inspired by their violence, executed his remarkable *Brooklyn Bridge*, in which he 'puts his lucid structural grids to vigorous use, for they offer analogies to the real structural tensions of cables and sweeping arches in the great suspension bridge' (Rosenblum).

One should not lose sight of secondary artists either. The Cubist doctrine was cultivated outside French soil, in Italy, Germany, Britain and America. Several artists of these and other countries, singly or in groups, were more or less consciously inspired by Cubism, but not necessarily by Braque or Picasso. The story of their relations with the movement is a complex one involving a variety of traditions and tendencies, some harmonious and others conflicting. It is moreover to a considerable extent identical with the history of art in our century, even though many artists of high quality who lived at the right time to be influenced by Cubism were in fact unaffected by it. The Cubists gave a spectacular and decisive push towards a new conception of relations between man and nature: from then on the problem came to be expressed in diverse changing forms, however much or little account might be taken of Cubist theory and ideology. The movement is in fact the triumphant expression of a revolt which began in the latter half of the nineteenth century, against the view typified by Courbet's dictum: 'Painting is essentially a concrete art, and can only consist in the reproduction of real objects. An abstract, non-existent object does not belong to its domain.' By contrast, the Cubists accepted the Symbolist doctrine that may be formulated thus: 'We must no longer seek to represent nature and life by means of fortuitous objects or the illusions of the eye: our business, and our proper attitude to art, is to represent our emotions and dreams by the harmonious use of colour.'

It was perhaps in Germany that the European tide of anti-naturalism met with most resistance. As Haftmann puts it, Expressionism was the German response to conditions which, in France, gave birth to Fauvism. Germany, like Italy, was a country of many cultural centres, but significant links began to form between them. At Dresden the small group composed of Kirchner, Heckel and Schmidt-Rottluff formed a self-taught community, reading Nietzsche and convinced of their onerous mission to convert society. Their viewpoint was anarchistic, anti-bourgeois and anti-traditional. Interrogating the past and seeking new and exotic ways in the present, they formed the conception of 'an art strongly expressive in its simplification of line, large uniform areas of composition, clear bright colours and lapidary emblems with a primitive strength such as we find in Gothic woodcuts and in the art of Negro and Oceanic tribes' (Haftmann). Simultaneously with the Dresden trio, other individuals and more or less coherent groups—Emil Nolde, Paula Modersohn-Becker and Christian Rohlfs in North Germany, Kokoschka in Vienna, and in Munich Kandinsky, Jawlensky, Gabriele Münter and afterwards Kubin, Marc and others—developed in their various ways what became known as Expressionism. Like the other 'isms', but still more so, this term is wholly inadequate to describe, even outwardly, an extremely intricate artistic and cultural situation. There was a profusion and a constant renewal of contacts, initiatives, meetings and groupings, and a corresponding medley of styles and reactions. At Munich the artists composing the *Neue Künstlervereinigung* maintained—in the words of

one of their number, Otto Fischer, that: 'Colour is a means of expression which appeals directly to the soul. Colour is a means of composition. The essence of things is captured, not by a correct drawing, but by the powerful and dynamic, compelling and fully mastered outline. Things are more than things when they are the expression of the soul.' Fischer also declares that 'A picture does not express the soul directly, but rather the soul as reflected in the object. A picture without an object is meaningless.' But at the same time as these principles were being formulated, Kandinsky had embarked on the fateful adventure which contradicted them in letter and in spirit. Together with the most intelligent and open-minded of the Munich painters—Jawlensky and Gabriele Münter, Marc, Macke and Klee—Kandinsky formed, in 1911-12, the Blue Rider group of 'friends sharing similar ideas': their work was intermittently affected by Cubism and, especially as regards the function of colour, by Delaunay's Orphism, as well as the Italian Futurists.

Almost all the German artists, including those who were German by adoption—such as Kandinsky, who was 34 years old in 1900; Rohlfs was then 51 and Macke a child of eleven, so from this point of view too the group is a curious one—almost all painted landscapes, though for many of them the human figure remained the centre of interest, as a symbol of spiritual and moral commitment. While the landscapes are strongly individual, they have enough in common to indicate their relationship to what was a many-sided and ever-changing movement. In particular they all show a kind of deliberate distortion, intended to emphasize tension, expressiveness and the inviolable claims of feeling. This applies both to the forms of objects and to the composition: balance and symmetry are disregarded, perspectives are warped, wide areas unrelated to the main theme produce improbable and discordant spatial effects. With few exceptions the works show a contempt for the orthodox beauty of flowing, attractive forms, precision and simple harmony. All is discord, elision and refraction. Houses, forests, waters and the sky are engulfed in a dramatic violence that scorns restraint and compromise. This was true of Kokoschka and, in 1909-10, of Kandinsky; it was also especially true of the *Brücke* group and of Emil Nolde. The latter is one of the great artists of the century, not only in Germany. Rather than merely 'depicting' nature, he plucks it like a fruit from a tree, with aggressive and barbaric passion, while the earth seethes with flame and cataclysm. Kokoschka's route was a longer and more intricate one: a tireless traveller, he produced views of Germany and Italy, Spain and Egypt with the inspiration of a visionary discovering fresh life in the most hackneyed landscape. In his restless, eccentric way he transgressed the boundaries of Expressionism which he had helped to establish by revealing 'the method of covering the canvas with a swarm of hallucinatory images, of displaying supernatural appearances in an objective scene, of describing oneself by means of the painter's art' (Haftmann). As the years went by, Kokoschka forgot the problems and anxieties of his youth and concentrated on landscapes which are among his finest works, though they do not closely reflect local character and atmosphere: Hamburg or Lyons, Venice or Madrid, Prague, Jerusalem or an Alpine valley are alike subdued to the painter's graphic idiom, rich and even sumptuous as it is. Through his eye we behold cities in a kind of sprawling grandeur, as through a wide-angle lens distorting spaces and contours. The term 'dramatic Impressionism' has been used to describe this style adopted by Kokoschka fifty years ago, with reference to his manner of painting and also the imperious instinct which informs his work.

The career of Franz Marc was shorter, and that of August Macke shorter still: both were killed in the First World War. A brief but fruitful contact with Cubism enabled Marc to effect 'a union of animal form and background by dissolving the various parts into each other through the transparency and mobility which the method permitted, at the same time preserving his colour symbolism' (Myers). He displays emotion and sometimes violence, especially in pictures painted before 1913, but in that

year he begins to use colour in patterns that show accuracy and discrimination, though they remain free and mobile. In 1908 he had written: 'I try to heighten my feeling for the organic rhythm of all things, try to feel myself pantheistically into the trembling and coursing of the blood in nature, in trees, in animals, in the air.' He remained faithful to this resolve, whether creating with a few symbols the image of 'poor Tyrol' or depicting horses and deer in the heart of a forest, vibrant with colour and lit by slanting sunbeams.

Macke's evolution was not unlike that of Marc, though he seems to have undergone more influences during his frequent journeys; first Impressionism, later the Fauves and suggestions of Cubism and Futurism, also a particularly close relationship with Delaunay. In two years of intensive work, 1913 and 1914, he painted several versions of the *Woman looking at hats in a shop window* and also *Two girls*, in which the combination of stylistic elements is clearly visible. His watercolours of Tunis show that 'in the old buildings under the African sun' he came to realize 'his own type of figurative form . . . the "coloured planes", beyond objective forms and colours, which are the constituent elements of a picture' (Busch).

Macke was accompanied to Tunis by Paul Klee, who has left a short diary of the journey. While it was the last episode of importance in Macke's life, for Klee it was no more than a brief intermezzo, although the 'fanciful architecture and sun-drenched colour' of Kairouan 'remain a permanent part of his art' (Myers). He was active throughout the inter-war period and was connected with the Bauhaus, where he taught until 1930. His personality has been fully studied and he appears one of the most sensitive and complex characters of our time. Eschewing literal transcription and every trace of naturalism, he sees landscape as a microcosm composed by all organic forms, living and inanimate. 'It is a great difficulty and a great necessity to have to start with the smallest,' he wrote in 1902 after his return from Italy. 'I want to be as though new-born, knowing nothing, absolutely nothing, about Europe; ignoring poets and fashions, to be almost primitive. Then I want to do something very modest; to work out by myself a tiny, formal motive, one that my pencil will be able to hold without technique. One favourable moment is enough. The little thing is easily and concisely set down. It's already done.' A deep gulf soon appears between the artist and his European background. Links of style and method may remain, but the tone is so individual that very few can be regarded as his successors. Klee's mode of seeing, based on profound observation, enables him at an early stage to 'perceive behind the single forms of figurative nature a common relationship, a system of roots and patterns from which the varied images of nature derive their origin according to a "natural" order' (Haftmann). It is above all an active mode of seeing: birds and water-plants, roads and hills, ponds and cities are all reduced to forms vibrating with a mysterious inner life. Geometry, or the foundation of the complex musicality inseparable from his works, is at no time accepted in its untroubled coldness. In his *Diary* for 1917 we read: 'By evening I had finished five watercolorus, including three excellent and moving ones. The last, painted at nightfall, echoed the miracle all about me; it is abstract, and also an "ilex landscape".' Carola Giedion-Welcker, who quotes these words, comments that 'we feel here the poetic urge to grasp and convey the essential, invisible, secret splendour that hovers about natural objects. The reality that prompts a confession like this itself fades into oblivion.' Will Grohmann compares Klee's painting with the poetry of Verlaine, and writes: 'In both works we find a deliberate poverty of artistic instrumentation, used to obtain the maximum expressivity and "atmosphere".' When we spoke of the way in which great artists can contribute to a modern 'reading' of landscape, we had in mind among others the exceptional power of Klee, who 'is at home everywhere, in all dimensions of the cosmos, where the dimensions of forms reproduce themselves in their own image' (Schmalenbach).

Nolde, Kokoschka, Marc, Macke, Kandinsky and Klee, together with Kirchner, Schmidt-Rottluff and Heckel, are only some of the artists of the first rank who were active in the German cultural area in the first half of this century. The landscapes of Ludwig Meidner, with their insistent distortions and unequal rhythms, are clearly Expressionistic in tone; they are full of dramatic emotion and a sense of impending doom. While Meidner is closer to Kokoschka, Christian Rohlfs has more in common with Nolde, whose evolution he followed especially in 1905-10: in the latter year he was already sixty. But a landscape like his *Belfry of Saints Peter and Paul at Soest* (1919) is very different from Nolde and suggests a free personal interpretation of Futuristic themes. Karl Hofer shows a certain degree of affinity with Expressionism properly so called: he was first influenced by Cézanne (though with overtones peculiar to himself) and later, especially in the 1920s, reverted to a serene, harmonious vision of the countryside, churches and villages, which he depicted in a dry, clear, linear style.

Among the immediate members of the *Brücke* were Max Pechstein and Otto Müller, who, however, were for different reasons out of sympathy with the chromatic paroxysms and tortured forms of Kirchner and his friends. Pechstein showed affinity with Van Gogh, e.g. in his *Landscape* of 1909 with its 'heaving, twisted ground forms and the brazen sun, gleaming low in the sky out of heavy, spatulated colours' (Myers). Later, after his visit to the Palau Islands, he preferred colour effects which, while intense, were free from stress and violence. Müller is still more serenely absorbed in lyrical isolation, not smugly sensual but primitive and anti-hedonistic: his slim bathers are innocent denizens of a kindly, relaxed world of greenery enclosing narrow sheets of water and patches of sky.

Two artists of great interest to our theme, of almost opposite temperament and training but both connected with Munich and the Blue Rider group, are Heinrich Campendonk and Lyonel Feininger. It is true, as Myers says, that in Campendonk we find traces of Marc's 'animal mysticism', Kandinsky's 'colour symbolism' and Macke's 'Cubist-influenced forms and poetic feeling'. But his pleasing, delicate style reflects his primary allegiance to popular primitivism, and it was Rousseau who taught him to interweave forest scenes with men and animals forming an intense and opulent colour pattern. The influence of Gauguin is also visible in the juxtapositions that ignore perspective, the prominence of symbols and the physiognomy of his models.

Feininger, who came to Europe from the United States in 1887 at the age of 16, set out to be a musician and did not adopt painting as a career until 1907. While he never broke entirely free from his background and the impressions of his youth, it was the Cubists and Delaunay who influenced him decisively. Dynamic and mobile at the outset, firmer and more balanced in later years, he remained faithful to an unmistakable style based on clear though complex geometrical relationships. His boats, harbours and city scenes are elaborate compositions of planes meeting, intersecting and merging into one another. The inclination towards description which he showed about 1911 disappeared after he had clarified his field of interest, defined his style and de-materialized his forms.

Despite Nazi repression, the German school of art which flourished in the first two decades of the century continued to develop fruitfully in many directions. If we look for its first beginnings, we may find them in the great Norwegian artist Edvard Munch, whose longevity entitles him to be considered as belonging to either the nineteenth century or the twentieth. In his youth he visited several parts of Europe, including Germany and Paris at the most propitious times from an artistic point of view. In France he came into contact with Van Gogh and the Post-Impressionists, in Germany with the Berlin group and Van de Velde, while the whole range of these influences served as a counterpoint to his solitary, introspective nature. The sufferings of his life are reflected in his paintings,

which have provoked a variety of psychological interpretations. His intention was to lay bare the depths of the human soul, which he did sometimes crudely and in a highly dramatic fashion for his day. In the process he was prepared to overthrow conventions and deny principles of every sort, above all those concerning the technique of painting. His landscapes are characterized by sharp, poignant colouring, especially violent yellows, with juxtapositions of unbearable emotive force. They show indifference or contempt for outward grace and harmony and an extraordinary power of simplification and synthesis, by concentrating attention on a few salient features or, more often, on the dark, obsessive and heartless void in which those features have their being. He is unrivalled in his vision of the Northern night, which is free from any concession to sentiment. In Haftmann's words, he 'transformed into painting the panic and psychic element which he discerned, as in a vision, beyond visible reality'.

The other great, unquiet, solitary figure spanning the two centuries is that of James Ensor, who was three years older than Munch but, unlike him, accomplished his most vital work before 1900. His disturbing hallucinations took the form of vast crowded compositions and spectral, enigmatic characters; however, he also painted many landscapes which reveal him as a great artist—and there were also his favourite seascapes. As Paul Haesaerts wrote, 'Ensor painted, with enjoyment and with stress of soul, everything that the great sea contains or washes up on shore, everything it attracts and every thought it gives rise to. He loves it in all its aspects and at every moment of the day: misty and silvery as Artan saw it, sparkling as in the works of Spilliaert, heavy and oily as in those of Permeke. He welcomes everything that lives on its shores and on its broad back—boats, fishermen, fish-vendors, bathers—and all the fruits of its union with the sky, the sands and the fiery sun; mermaids clad in seaweed, ballerinas in tutus made of foam, Christs rebuking the storm and demons unchaining it.' But this is only one aspect of the younger Ensor. There are his famous etchings—grandiose sheets such as *The Cathedral*, the *Kermesse with the Windmill*, the *Conquest of a strange City*; or again the *Devil in the Belfry*, and above all the amazing *Carnival at Brussels*: monumental works in which the dominant feature is space, differentiated and resonant, defined by curtains of masonry and by vistas drawn with the accuracy and detailed care of a design engineer, and emphasizing by their virtuosity the cultivated nature of Ensor's art.

The first years of the century were marked by the early fame of Georges Rouault, a contemporary of the Fauves whose discoveries and revelations led to the production of some masterpieces in 1905. Whether painting clowns and prostitutes or Scriptural episodes, Rouault's chief concern is with men and women, their griefs and tribulations, which he depicts with genuine compassion. 'When he portrays our imperfections and the whole human inferno—a drunkard, a whore or the most repellent criminal—there is always at the heart of his characters a spark of appeal to our charity and tolerance, a longing to rejoin the Communion of Saints' (Courthion). His landscapes, apart from one or two youthful experiments, are the scene of actions for which they form the appropriate and inevitable setting: it is in fact hard to find anywhere outside Rouault's work a closer link between characters and their environment. The dark tones, heavy outlines and dense impasto, the emphatic reds and blues of the figures are all precisely reflected in the fields, waters and skies brooded over by a falling star. Nature in Rouault is a sanctuary for the rites of a humanity which is not merely that of yesterday or today, which cannot be assigned to a particular stage of history because the themes it embodies are spiritual and everlasting. 'His sacred landscapes' (these are unpublished words by Georges Chabot, quoted by Courthion) 'are so many Biblical or Oriental pastorals. The stars blaze in a sky of midnight blue. Small figures wander here and there, by a riverside or on a faintly defined road, amid

buildings that have no age or style. They have no haloes, but we do not doubt their sanctity. Night has just fallen and they bend towards one another, uttering words of consequence.'

Piet Mondrian, Rouault's junior by a year, is by no means to be neglected in a study of twentieth-century landscape. Thanks to Ragghianti and his critical method we understand better many problems relating to Mondrian's pre-Cubist and pre-abstract work between about 1900 and 1912, including 'factors which are of decisive importance for the development of his vision, so that his first experiences take on a new and additional meaning'. We notice first a fairly direct link with Dutch landscape painting, 'either continuity of tradition or a deliberate recall born of nostalgia for the great seventeenth-century school'; at the same time, Mondrian shows predilections and qualities 'which, we are bound to recognize, surpass the artistic setting he has chosen by their loftiness of form and above all their internal clarity of stylistic determination'. Ragghianti discusses the painter's relation to Hodler, his interest in British watercolours, the Dutch Pre-Raphaelites, *art nouveau* and finally Munch. He traces 'a persistent Abstractism' up to 1911, the unmistakable 'identity of guiding-lines' up to 1911-12, and the 'repetition of figurative compositions in the form of abstract ones' (to quote only two or three headings from Ragghianti's wealth of examples, dates and argument). In their remarkable 'mobility or instability of arrangement' Mondrian's landscapes display 'recurrent compositional structures' and 'a series of constants in the rhythmic guiding-lines' despite variations of theme, morphology and execution during the ensuing years. For reasons such as these, a study of Mondrian's landscape in its apparent naturalism and varying degree of concern with the clarity and importance of visual structures not only enriches our general picture of the genre but provides valuable criteria for the reading of landscape in general.

If Mondrian's work involves ideological attitudes and mental processes of a fairly elaborate kind, Utrillo's suggests no intellectual background over and above that of the average man. Utrillo, however, is a poet: the lonely, isolated poet of a reality that is sometimes trivial in the extreme, sometimes majestic and sumptuous. He stands towards Paris as Rosai does towards Florence, and the two are more than superficially related. The city is presented to us in thousands of views expressing an irrepressible lyric participation. Utrillo has no need of any special figurative setting: walls, grilles, hoardings, trees, lamp-posts, cobblestones, rows of houses, cathedral towers, pavements, fences, factory chimneys and great dark windows all take their place in his work with their own peculiar expressiveness. These and many other objects are imbued with feeling, sometimes with drama: they suggest the passage of time, the waning of life, the desperate melancholy of certain times and seasons. It is hard to forget the evocative power of his pictures when we come upon the reality that moved and enthralled him, whether it be the Impasse Cottin or the vistas of old Montmartre.

Chagall came from St Petersburg to Paris in the summer of 1910, and met the Fauves prior to his more significant encounter with Cubism and Delaunay. Soon afterwards he painted his first masterpieces, replete with the symbols which remined characteristic of his work. Despite the mixture of influences we perceive the naïve simplicity of an artist living on fantasy and memories, confounding myths and reality and firmly resisting too much rigidity of theory. Reflecting and transforming the present and the past, his adventures in the world of dreams are rich in incident, character and invention. He did not paint landscapes in the strict sense, but rather an intricate and mysterious web of juxtaposition and interference. His town and country scenes—the tiny villages between the green earth and the red sky, the wretched huts around Vitebsk—are often depicted from an eccentric aerial viewpoint as if the artist were identified with his own delicate, fantastic or allegorical figures.

Thus, as Meyer puts it, he dissolves the rational links between objects, presents us with elemental nature in all its wealth of contradiction and opposition, and resolves its contrasts in a new unity of everything that lives.

Let us, however, turn briefly to the Italian scene and consider its contribution to modern landscape. As regards the Futurists, some remarks apply which we have already made concerning the Cubists. But in Boccioni, Carrà and Severini, and later in Sironi, Soffici and Rosai, the urban scene affords a figurative basis from time to time. Leaving aside Boccioni's earliest works, in 1909-11 he painted well-known suburban scenes with a 'bold, insistent manipulation of perspective . . . the same breathless, instantly readable message that we find in the rapid obliquities of the *Police Raid* and the *Galleria Brawl*' (Ragghianti); then, later, the *Brawl* itself, the *Simultaneous Visions*, the *Street invading a house*, *States of mind* and other works in which urban fragments appear in some fashion or other: rows of buildings, roofs, streets, scaffolding, wire netting, arcades, forming a subjective and aggressive picture, an image of tomorrow's city rather than today's or yesterday's. In 1916, the year of his death, Boccioni foreshadowed new pictorial ideas and gave evidence of having paid close attention (perhaps not for the first time) to Cézanne: in both respects he was a forerunner of subsequent Italian artists.

Immediately after the First World War the Futurists went their several ways, not to mention Carrà's Metaphysical diversion. This period marked the fullest activity of the generation which gave its character to Italian painting in the first half of the century. The oldest member of it was Arturo Tosi, born in 1871; the youngest, Scipione, was born in 1904. Between them, in order of age, we may list Semeghini, Soffici, Carrà, Viani, Rossi, Sironi, Casorati, De Chirico, Morandi, Guidi, Licini, Campigli, Rosai, De Pisis, Soldati and Mafai. From this chronological sequence one may deduce in some cases the different influences undergone by the artists in question, whose backgrounds were very different and who were only partially sharers in a common culture. Nearly all of them were long-lived (De Chirico, Guidi and Campigli are still active), and they belong to an era full of events, crises and revolutions. Each of them was affected by these as regards his poetic approach and idiom, but each remained faithful to himself as a man and an artist: this led to well-known disputes and polemics that are still lively today. The Florence exhibition of 1967 presented a rich harvest, but doubts and downright opposition are still met with.

In 1919 Carrà made the significant statement: 'Now that the war is over, life is once more a dialogue between man and his soul.' This remark shows mistrust, even rejection of experiment and theory in all their forms, including those which prescribed the abandonment of figurative art. In the words of Haftmann, one of the few foreign critics to have studied this phase of Italian painting: 'In the profoundly altered state of modern sensibility, Italian art seeks to return to the Italian idea of the original solidity of objects. The simple and substantial, the concrete and physical, solemnity and precision are upheld in opposition to Impressionism and Futurism with their quest for the fleeting moment. In these values artists seek the true dignity of the real world, its second reality.' Futurism, despite its wide claims, had in fact not attracted many followers for any length of time. Many deserted it, some ignored it and others were hostile from the beginning. One such was Arturo Tosi, who in 1911 was forty years old and had a varied artistic career behind him. In that year, however, he embarked on a course which 'enabled him to achieve greater simplicity of form and a straightforward development of his interior vision . . . the only right course for him, combining truth to nature with the irreducible claims of feeling' (Valsecchi). His perception became more and more refined and free from all that was adventitious; his landscapes became lighter, with a spaciousness and balance that appeared to be second nature.

Another artist who ignored Futurism was Semeghini—a remarkable painter who has only been properly studied in recent years, his fresh, light and skilful execution serving to conceal a modest, reserved personality. His chief affinities are 'with the last heirs of the Impressionists, such as Cézanne, Ensor, Gauguin, Bonnard, Vuillard and others of the *Revue Blanche*' (Magagnato): his talent is a vigorous one despite the impression it sometimes gives of languor and fragility. His world is enwrapped in a veiled, diffuse light, in which a few bold lines create images of great sureness and accuracy. At one stage he appeared as an opponent to the *Novecento* movement to which, at all events in name, most Italian artists belonged.

Ardengo Soffici was another who, partly because of his literary background, defended in practice and theory the return to figurative painting after the many avant-garde experiments of the first two decades of the century, and in so doing became the interpreter of many half-formed aspirations. As early as 1904-11 his work shows a striving towards limpid, balanced composition. As Raimondi observes, 'He sees landscapes and natural scenes devoid of human presence, actions or sentiments: nothing is there except the painter contemplating nature. . . . It is possible that he learnt something from Pissarro, who took so long to imbue the image with his own sense of truth: namely, a rule of selection when it came to landscape, preferring to find in nature a complex, articulated scene.' After the precocious works we have mentioned, Soffici went on painting for another fifty years and more, moving from seascapes to the countryside and depicting the Tuscan scene in a more or less constant fashion. He was influential at Florence, less on account of his work than of the support and encouragement he gave to Achille Lega, whose best period was between 1919 and 1924, and Ottone Rosai, with whom he was intimate for some years.

Rosai, from his earliest years as an artist, accepted no limitation as far as subject was concerned. Perpetually captivated by life and in love with it, he was equally close to man and nature and to all the phenomena of his native soil, to which he was irrevocably attached. His love went to Florence with its tangible atmosphere of history, and to the Tuscan countryside which, more than any other, seems to be the work of human hands. In a long procession of works he celebrated the city, from its monumental churches and palaces to its narrow alleys and piazzas full of everyday life. While Utrillo's Paris is a vibrant perception of the shifting scene in all its ephemeral complexity, in Rosai's Florence we find well-constructed volumes and spaces and an eternal stability in the streets, the dark green cypresses and the firm, pellucid blue of the sky.

For a time at least after 1920 Carlo Carrà worked in a similar vein to Rosai, though he had been through a Futurist phase and, as a native of Ferrara, had been close to De Chirico, the author of some of the finest works painted in Italy, or even Europe. In the 1920s De Chirico painted the *Pine-tree by the sea* (1921), the *Marble quarry*, *Morning by the sea* (1928) and other works in which 'he has become fully possessed of his style: compositional structures, imposing by their volume and mass, are unified by a colour-scheme of infinite sensibility, the interior vision is more and more intense and poetical, the weight of contemplation more complex and lasting' (Ragghianti).

Not all the artists we have mentioned chose landscape as their sole or main theme. Casorati, a great painter of indoor scenes, produced a few landscapes in his mature period only. Campigli painted landscapes for a while in his youth. Giorgio Morandi, however, alternated his still-lifes with a fair number of remarkable landscapes: one dated 1911 is taken to mark the beginning of this important series, much other evidence having been lost. Morandi's story is poor in externals but rich within. After youthful contacts and experiments (Cézanne, a 'vague curiosity' about Futurism, a short but intense interest in the Metaphysicals), he found himself and produced one of the most poetic series of works in our century. Arcangeli writes of one of his landscapes: 'It reminds us of Corot,

but the proportions are more spacious; of Cézanne, but without his urge to refashion the world. Morally rather than stylistically, there are solemn echoes of Giotto, Masaccio and Piero. The painter's style, so plain as to recall Secessionism . . . is imbued with the late-summer smell of scorched grasses, fields of stubble, dust and whitewashed walls—an intoxicating odour in which we feel the whole strength of a sense of nature that was Morandi's alone.'

Of the others we have mentioned, Lorenzo Guidi—'a nationalist and an anarchist, a man of letters and a vulgarian, methodical and intemperate, cultured and primitive, a subversive and a Fascist, a Carduccian and a D'Annunzian, artful and naïve, provincial and European' (Cardellini)—poured forth in landscapes, as he had previously in human figures, his intensity of passion and 'sincere, tormented feeling for his fellow-man, finding atonement in shared suffering and in rebellion'. His Apennine scenes are rigorously geometrical, while in his youthful and later seascapes the subdued colouring produces an elegiac atmosphere comparable to the leaden solitude of the courtyards of the Ruche. A similar feeling and a more dramatic effect is conveyed by Sironi's suburbs in their naked emptiness, with long walls and tall houses stricken by a livid, glaring light, as well as by his bleak mountain ridges with forms reminiscent of the Italian old masters. De Pisis—a great heir of the *Settecento* Venetians, a profound and original interpreter of Manet's limpid clarities—may seem whimsical beside Viani and Sironi, but his mood is in fact one of unceasing delight in the world's variety: he is alive to all experience, whether it be the curves of a baroque Venetian church, the Quais of Paris or a lonely beach lit by a huge, luminous sky. Sometimes, especially in his later years, he showed a streak of intense melancholy, but it is that of a man who has first beheld the great pageant of the world and its creatures.

In Guidi, adherence to a pure and almost monumental classicism took the form of human figures which might or might not be framed by an external scene. But even at twenty he gave promise of being a great landscapist, painting the houses and monuments of Rome in vast panoramas followed by those of Venice and its lagoons, while in his last works he seems to have forced the sea and sky to reveal to him the secret of their diffuse, impalpable light. From the beginning of his career he painted the earth with an austere solemnity, bathed in crystalline brightness which might be sharp and implacable but could take many other forms, resembling the warm dewy light of Mafai's huge Roman landscapes or the flash and glare that illuminates 'Scipione's Roman and Catholic world, with its fury and mystery even in urban scenes' (Visentini). The profusion of works by Gino Rossi, De Chirico, Licini, Soldati and many others would show how landscape continued to inspire artists who at one time or another belonged to the avant-garde, although among these four it was only Licini before 1930 who displayed an interest in nature as such, without the ideal or abstract qualities imparted by an intellectual idiom.

The generation that was active in Italy and abroad immediately before and after the Second World War took an uncompromising stand against what it regarded as old-fashioned academicism and provincial narrowness of view. This gave a further twist to the problem of relations with external reality, which involved all forms of expression without exception. Rejection of figurative art became an automatic corollary of the long-standing principle of independence of the world of objects. It was an age of 'critical' awareness of a state of things which artists of all periods and civilizations had perceived and expressed more or less clearly, but which now, being the focus of world debate, made itself felt on a much greater scale. The process had in fact been going on for several decades before the 1950s. It may be said to begin with Gauguin, and in 1908 Matisse wrote: 'As far as I am concerned, expression is not to be found in the passion that a face or a violent movement may suggest, but

57

in the arrangement of the picture: the position of bodies, the spaces around them, the proportions and so forth.' This is a precise, categorical statement of the rights and autonomy of form: it has a prophetic quality, and it is not accidental that it dates from the same time as early Cubism. Certainly the development of art since then has been anything but simple and rectilinear; but there is no doubt that from the first abstract experiments to the present day, a great deal of painting and of the other arts has been non-figurative. However, whereas up to 1940 artists were split into two opposed camps according to whether they were 'representational' or not, in the twenty years or so since the war practically all younger artists have regarded the various types of non-figurative experiment as a theme or starting-point inescapably imposed by present-day circumstances. It is perhaps a fair enough generalization to say that even the most naturalistic of these artists, such as the 'Peintres de tradition française' or the 'Fronte Nuovo delle Arti', while they may treat the external world as a source of inspiration and not merely an arsenal of pretexts, do not feel in any way obliged to conform to its morphology. As Lionello Venturi explained in 1952, they wish to be neither abstract painters nor realists: the former carries with it the danger of mannerism, the latter involves political directives that may stifle creative freedom and spontaneity.

This viewpoint is clearly expressed by Jean Bazaine, who writes (in a passage quoted by Ponente): 'When we look at a figurative painting . . . what it reminds us of or suggests is not brute reality, a world independent of ourselves, but something of our own creation, born as we contemplate the painter's work. This is why a painting can affect different viewers so differently. We do not judge it by its degree of resemblance to some crude myth of unchanging reality, but in terms of our own inventive powers.' As Ponente comments, 'the whole art of painting was directed towards a new realism—not a pictorial inventory of appearances, but an attempt to cultivate "inventive powers" through all the shades and variations of the outside world.'

There is no need to insist at length on a point we have already referred to, namely the help which modern painting affords us in apprehending nature and reading a landscape. The artists of the last thirty years have done ample justice to the new modes of perception that have themselves changed the face of the visible world. What the men of past ages looked on as familiar objects more or less anchored in memory are to us mere aspects, and often fugitive ones, of a multiple, heterogeneous, ever-changing vision. Speed has had its effect, and so has aerial photography with its revelation of patterns that were hardly perceptible in former times. In such ways science has moulded the experience of modern artists and helped them to escape from a microcosm of sentiment. There is in fact a perfect correspondence between the possibilities and forms of current experience on the one hand and the products of figurative art on the other. What some artists have felt and expressed in the autonomous language of images is confirmed and encouraged by new methods of studying near and distant objects. Distortions of perspective, transformations of space, form and colour, the introduction of ephemeral features and eccentric light effects—in short, the whole gamut of means by which physical reality is made to appear other than it does in literal fact: such has been the inspiration of art in the last few decades. We need only think of Pignon, Vieira da Silva, Birolli, Dubuffet, De Staël, Ben Nicholson, Ben Shahn or Morlotti—to take some names almost at random—to be convinced of the way in which pictorial form has matched the differentiation of experience. As the problems of man and society increase and multiply, as the failure to co-ordinate facts, ideas and purposes leads to revolt and a flight towards the irrational, as the pace of existence becomes ever more murderous, there is a danger that the very concept of landscape will become corrupted and obsolete, at least as a part of nature and a factor of spirituality. In other words, we may come to think of it not as an his-

torical and aesthetic legacy but merely as an occasional refuge from life. Many younger painters, with the prescience that artistic intuition confers, have pointed out the incongruity between the idea of landscape and the more urgent claims of conscience and fantasy, when the latter is not thwarted in its rights and freedom. As a result of such thinking, large sectors of international culture deny the very possibility of art as a permanently valid form of expression. It is hard indeed to see how the artists of today, with their peculiar interests and problems, can make a substantial contribution to the interpretation and 'invention' of landscape as the theatre and manifestation of human life.

We cannot predict the future, but we may reasonably think that among the old values to be restored or the new ones to be established, there must be room for a deep and serious re-thinking of our terrestrial environment. The possibility of such a move seems to exist among some élite groups that are more than marginal to the current debate. When it becomes a reality, we may be sure that artists will make their indispensable contribution to it in their own modern and personal idiom.

BIBLIOGRAPHY

This bibliography lists the sources of quotations in the text and can be considered as a basic bibliography of the subjects discussed. The sources are given in the order in which the quotations appear.

Emilio Sereni, *Storia del paesaggio agrario italiano*, Laterza, Bari, 1962.

Various authors, *Difesa e valorizzazione del paesaggio urbano e rurale*, Atti del VI Convegno dell'I.N.U., 1958.

Guido Ferrara, *L'architettura nel paesaggio italiano*, Marsilio Editori, Padua, 1968.

Aldo Sestini, *Il Paesaggio*, Touring Club Italiano, Milan, 1962.

Tunnard, C., and Pushkarev, B., *Man-made America*, Yale University Press, New Haven, 1963.

Kevin Lynch, *The Image of the City*, M.I.T. Press, Cambridge, Massachusetts, 1960.

Edoardo Detti, F. Franco Di Pietro, Giovanni Fanelli, *Città murate e sviluppo contemporaneo*, CISCU, 1969.

Piero Maria Lugli, *Storia e cultura della città italiana*, Laterza, Bari, 1967.

Arthur E. Smailes, *Geography of Towns*, Hutchinson, London, 1966; Aldine, Chicago, 1968.

Maurice Cerasi and Piergiorgio Marabelli, *Analisi e progettazione dell'ambiente - Uno studio per la valle del Ticino*, Marsilio Editori, Padua, 1970.

Rosario Assunto, 'Introduzione alla critica del paesaggio', in *De homine*, No. 5-6, 1963.

Carlo L. Ragghianti, *Il pungolo dell'arte*, Neri Pozza Editore, Vicenza, 1956.

Various authors, 'La forma del territorio', in *Edilizia Moderna*, No. 87-88.

Donald Appleyard et al., *The View from the Road*, M.I.T. Press, Cambridge, Massachusetts, 1964.

Gyorgy Kepes et al, *La metropoli del futuro*, Marsilio Editori, Padua, 1964.

Richard Neutra, *Survival through Design*, Oxford University Press, London, 1954.

Lloyd Rodwin, *Future Metropolis*, Braziller, New York, 1968.

Pietro Derossi, *Il paesaggio industriale*, Turin, 1967.

G. A. Jellicoe, *Studies in Landscape Design*, Oxford University Press, London, 1966.

Kenneth Clark, *Landscape into Art*, John Murray, London, 1949; Beacon Press, Boston, 1961.

Jean-Paul Crespelle, *Fauves*, New York Graphic Society, Greenwich, Connecticut, 1962.

Robert Rosenblum, *Cubism and Twentieth-Century Art*, Thames & Hudson, London, 1968; Abrams, New York, 1966.

Werner Haftmann, *Enciclopedia della pittura moderna*, Il Saggiatore, Milan, 1960.

Bernard S. Myers, *Expressionism - A generation in revolt*, Thames & Hudson, London, 1958.

Gunter Busch, *Viaggio a Tunisi*, Il Saggiatore, Milan, 1959.

Will Grohmann, *Paul Klee*, Abrams, New York, 1955.

Paul Haesaerts, *James Ensor*, Boston Books, Boston.

Pierre Courthion, *Georges Rouault*, Thames & Hudson, London, 1962.

Carlo L. Ragghianti, *Piet Mondrian e l'arte del XX secolo*, Edizioni di Comunità, Milan, 1961.

Franz Meyer, *Marc Chagall*, Thames & Hudson, London, 1964.

Giuseppe Raimondi, *Soffici*, Nuovedizioni Enrico Vallecchi, Florence, 1967.

Francesco Arcangeli, *Morandi*, Edizioni del Milione, Milan, 1964.

Nello Ponente, *Tendances contemporaines*, Skira, Geneva, 1960.

THE AGE OF REVOLUTION
1900-1915

Vieszaya Road is lined with two rows of one-storey hovels tightly squeezed together, with crumbling walls and irregular windows and roofs—damaged by the inclemency of the weather—roughly patched up with bark and covered with mould. Above them here and there protrude long poles carrying cages for the starlings; the dusty foliage of elders and rugged willows spreads over the miserable dwellings of the poorest inhabitants of the town.

The window-panes, green with age, gaze upon one another like old and lazy beggars. Between the pavements a stream winds its way among deep holes eroded by the rain. Here and there lie heaps of rubble, covered in weeds—remnants of some repair-work abandoned in the hopeless battle with violent streams of rain-water rushing down from the town. Above, on the hill, elegant houses peep from the luxuriant foliage of the gardens, and the church steeples rise proudly into the blue sky, their golden crosses gleaming in the sun.

On rainy days all the mud from the town slides down to Vieszaya Road, but in dry weather the whole place is covered with dust and all its wretched hovels look as if they have been hurled down from above, like useless ruins.

Delapidated cottages cover the hillside and owing to the effects of sun, dust and rain they have taken on a uniform grey, similar to the colour of wood that has begun to decay.

At the end of the road, at the foot of the hill, stands a derelict, two-storey house belonging to the merchant Petunnikov. Just behind it the fields slope away down to the river.

The old house is among the gloomiest of the neighbourhood. It is in a state of complete ruin; not one window retains its original shape, and the pieces of glass in the broken frames are the dull-green colour of stagnant water. The cracks and the dark patches where the plaster has fallen off the walls form between the windows strange designs and mysterious hieroglyphics, in which time has written the story of the house. The roof, leaning over the road, is also badly damaged. It seems as if the house, bending towards the ground, is waiting, resigned, for the *coup de grâce* that will reduce it to dust.

The People of the Past (Byvsie liudi), 1905 MAXIM GORKY

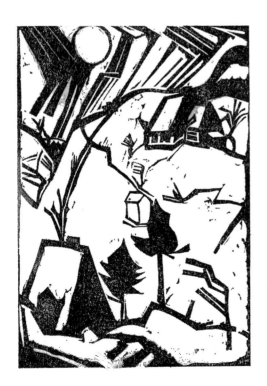

Standing in a garden which is neither very large nor very fine, and which has nothing special to distinguish it from a number of other Normandy gardens, the Bucolins' house, a white two-storied building, resembles a great many country houses of the century before last. A score of large windows look east on to the front of the garden; as many more on to the back; there are none at the sides. The windows have small panes; some of them, which have been recently replaced, seem too light in colour among the old ones, which look green and dull beside them. Certain others have flaws in the glass which our parents used to call 'bubbles'; a tree seen through them becomes distorted; when the postman passes he suddenly develops a hump.

The garden is rectangular and is enclosed by a wall. The part which lies in front of the house consists of a fairly large, shady lawn with a gravel path all round it. On this side the wall is lower and allows a view of the farmyard and buildings which lie round the garden; the farm is bordered, according to the custom of the country, by an avenue of beeches.

Behind the house on the west side the garden spreads more spaciously. A walk, gay with flowers, runs along the south espalier wall and is protected from the sea winds by a thick screen of Portugal laurel and a few trees. Another walk running along the north wall disappears under a mass of branches. My cousins used to call it the 'dark walk' and would not venture along it after twilight. These two paths led to the kitchen-garden, which continues the flower-garden on a lower level, and which you reach by a small flight of

steps. Then, at the bottom of the kitchen-garden, a little gate with a secret fastening leads, on the other side of the wall, to a coppice in which the beech avenue terminates right and left. As one stands on the door-step of the west front one can look over the top of this clump of trees to the plateau beyond with its admirable clothing of crops. On the horizon, at no great distance, can be seen the church of a little village and, when the air is still, the smoke rising from half a dozen houses.

Every fine summer evening after dinner we used to go down to the 'lower garden'. We went out by the little secret gate and walked as far as a bench in the avenue from which there was a view over the country; there, near the thatched roof of a deserted marl-pit, my uncle, my mother, and Miss Ashburton would sit down; before us the little valley filled with mist, and over the distant woods we watched the sky turn golden.

Strait is the Gate, 1909 ANDRÉ GIDE

From a long way off one could distinguish and identify the steeple of Saint-Hilaire inscribing its unforgettable form upon a horizon beneath which Combray had not yet appeared; when from the train which brought us down from Paris at Easter-time my father caught sight of it, as it slipped into every fold of the sky in turn, its little iron cock veering continually in all directions, he would say: 'Come, get your wraps together, we are there.' And on one of the longest walks we ever took from Combray there was a spot where the narrow road emerged suddenly on to an immense plain, closed at the horizon by strips of forest over which rose and stood alone the fine point of Saint-Hilaire's steeple, but so sharpened and so pink that it seemed to be no more than sketched on the sky by the finger-nail of a painter anxious to give to such a landscape, to so pure a piece of 'nature', this little sign of art, this single indication of human existence. As one drew near it and could make out the remains of the square tower, half in ruins, which still stood by its side, though without rivalling it in height, one was struck, first of all, by the tone, reddish and sombre, of its stones; and on a misty morning in autumn one would have called it, to see it rising above the violent thunder-cloud of the vineyards, a ruin of purple, almost the colour of the wild vine.

Often in the Square, as we came home, my grandmother would make me stop to look up at it. From the tower windows, placed two and two, one pair above another, with that right and original proportion in their spacing to which not only human faces owe their beauty and dignity, it released, it let fall at regular intervals flights of jackdaws which for a little while would wheel and caw, as though the ancient stones which allowed them to sport thus and never seemed to see them, becoming of a sudden uninhabitable and discharging some infinitely disturbing element, had struck them and driven them forth. Then after patterning everywhere the violet velvet of the evening air, abruptly soothed, they would return and be absorbed in the tower, deadly no longer but benignant, some perching here and there (not seeming to move, but snapping, perhaps, and swallowing some passing insect) on the points of turrets, as a seagull perches, with an angler's immobility, on the crest of a wave. Without quite knowing why, my grandmother found in the steeple of Saint-Hilaire that absence of vulgarity, pretension, and meanness which made her love— and deem rich in beneficent influences—nature itself, when the hand of man had not, as did my great-aunt's gardener, trimmed it, and the works of genius. And certainly every part one saw of the church served to distinguish the whole from any other building by a kind of general feeling which pervaded it, but it was in the steeple that the church seemed to display a consciousness of itself, to affirm its individual and responsible existence. It was the steeple which spoke for the church. I think, too, that in a confused way my grand-

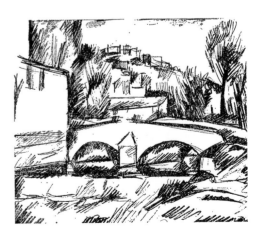

mother found in the steeple of Combray what she prized above anything else in the world, namely, a natural air and an air of distinction. Ignorant of architecture, she would say:

'My dears, laugh at me if you like; it is not conventionally beautiful, but there is something in its quaint old face which pleases me. If it could play the piano, I am sure it would really *play*.' And when she gazed on it, when her eyes followed the gentle tension, the fervent inclination of its stony slopes which drew together as they rose, like hands joined in prayer, she would absorb herself so utterly in the outpouring of the spire that her gaze seemed to leap upwards with it; her lips at the same time curving in a friendly smile for the worn old stones of which the setting sun now illumined no more than the topmost pinnacles, which, at the point where they entered that zone of sunlight and were softened and sweetened by it, seemed to have mounted suddenly far higher, to have become truly remote, like a song whose singer breaks into falsetto, an octave above the accompanying air.

Swann's Way, 1913 MARCEL PROUST

I

The winter evening settles down
With smell of steaks in passageways.
Six o'clock.
The burnt-out ends of smoky days.
And now a gusty shower wraps
The grimy scraps
Of withered leaves about your feet
And newspapers from vacant lots;
The showers beat
On broken blinds and chimney-pots,
And at the corner of the street
A lonely cab-horse steams and stamps.

And then the lighting of the lamps.

II

The morning comes to consciousness
Of faint stale smells of beer
From the sawdust-trampled street
With all its muddy feet that press
To early coffee-stands.

With the other masquerades
That time resumes,
One thinks of all the hands
That are raising dingy shades
In a thousand furnished rooms.

'Preludes', from *Collected Poems* 1909-1962 T. S. ELIOT

There they were, together in the night, lost in the long, wide, empty, dreary avenue that led to the sea, amid the sleeping villas and houses of that city, so remote from their first and true affection, yet so near to the dwelling-places that cruel fate had assigned to them. The intense pity each felt for the other did not draw them together but impelled them to remain wretchedly apart, wrapped in private, inconsolable misery.

Without saying a word they walked to the sandy beach and approached the sea. The night was quiet, and a delicious cool breeze blew towards them.

The boundless, invisible waters could be felt, palpitating like a living being, in the calm, dark, infinite, abyss of night. Far away to one side, a cloudy, blood-red shape quivered on the misty horizon: apparently the moon in its last quarter was sinking into the black void.

The great foamless waves broke on the beach and spread like silent tongues. Here and there they washed up a shell on to the smooth, bright, watery sand; then, as the wave ebbed, it disappeared again.

Overhead, the enchanted silence was pierced by the sharp, incessant sparkling of numberless stars, so lively that it seemed as if they had something to tell the earth, amid the dark mysterious night.

The two wanderers, still silent, walked for a long time along the damp, yielding sand. Their footsteps were visible for a moment only: each disappeared almost before the next was imprinted. The only sound was the rustle of their clothes. . . .

They fell silent again. Gazing into the night, they felt as though their unhappiness was evaporating—as though it no longer belonged to them but to the whole world of beings and things: the dark, unsleeping sea, the glittering stars, and every living creature that is born, loves and dies without knowing why.

The cool calm darkness over the sea, pricked by the multitude of stars, seemed to envelop their grief so that it welled out into the night, vibrated with the stars themselves and broke with the waves in a slow, gentle, monotonous cadence on the silent beach. The question 'Why?' came from the stars with their sharp points of light in the abyss of space; it came from the sea with its weary waves, and the little shells scattered about the beach.

Gradually the darkness began to thin, and the first chilly pallor of dawn appeared over the sea. Then, as the two wanderers leant against the side of the boat upturned on the beach, their affliction lost its vaporous, secret, almost velvety softness and became sharp, hard and clear, like their features in the wan, wavering light of dawn.

Night, 1912 LUIGI PIRANDELLO

He saw it once more, that landing-place that takes the breath away, that amazing group of incredible structures the Republic set up to meet the awe-struck eye of the approaching seafarer: the airy splendour of the palace and Bridge of Sighs, the columns of lion and saint on the shore, the glory of the projecting flank of the fairy temple, the vista of gateway and clock. Looking, he thought that to come to Venice by the station is like entering a palace by the back door. No one should approach, save by the high seas as he was doing now, this most improbable of cities.

The engines stopped. Gondolas pressed alongside, the landing-stairs were let down, customs officials came on board and did their office, people began to go ashore. Aschen-

bach ordered a gondola. He meant to take up his abode by the sea and needed to be conveyed with his luggage to the landing-stage of the little steamers that ply between the city and the Lido. They called down his order to the surface of the water where the gondoliers were quarrelling in dialect. . . .

Is there anyone but must repress a secret thrill, on arriving in Venice for the first time—or returning thither after long absence—and stepping into a Venetian gondola? That singular conveyance, come down unchanged from ballad times, black as nothing else on earth except a coffin—what pictures it calls up of lawless, silent adventures in the plashing night; or even more, what visions of death itself, the bier and solemn rites and last soundless voyage! And has anyone remarked that the seat in such a bark, the arm-chair lacquered in coffin-black, and dully black-upholstered, is the softest, most luxurious, most relaxing seat in the world? Aschenbach realized it when he had let himself down at the gondolier's feet, opposite his luggage, which lay neatly composed on the vessel's beak. The rowers still gestured fiercely; he heard their harsh, incoherent tones. But the strange stillness of the water-city seemed to take up their voices gently, to disembody and scatter them over the sea. It was warm here in the harbour. The lukewarm air of the sirocco breathed upon him, he leaned back among his cushions and gave himself to the yielding element, closing his eyes for very pleasure in an indolence as unaccustomed as sweet. 'The trip will be short,' he thought, and wished it might last forever. They gently swayed away from the boat with its bustle and clamour of voices.

It grew still and stiller all about. No sound but the splash of the oars, the hollow slap of the wave against the steep, black, halbert-shaped beak of the vessel, and one sound more—a muttering by fits and starts, expressed as it were by the motion of his arms, from the lips of the gondolier. He was talking to himself, between his teeth. Aschenbach glanced up and saw with surprise that the lagoon was widening, his vessel was headed for the open sea. Evidently it would not do to give himself up to sweet *far niente*; he must see his wishes carried out. . . .

Leaning back among soft, black cushions he swayed gently in the wake of the other black-snouted bark, to which the strength of his passion chained him. Sometimes it passed from his view, and then he was assailed by an anguish of unrest. But his guide appeared to have long practice in affairs like these; always, by dint of short cuts or deft manoeuvres, he contrived to overtake the coveted sight.

The air was heavy and foul, the sun burnt down through a slate-coloured haze. Water slapped gurgling against wood and stone. The gondolier's cry, half warning, half salute, was answered with singular accord from far within the silence of the labyrinth. They passed little gardens high up the crumbling wall, hung with clustering white and purple flowers that sent down an odour of almonds. Moorish lattices showed shadowy in the gloom. The marble steps of a church descended into the canal, and on them a beggar squatted, displaying his misery to view, showing the whites of his eyes, holding out his hat for alms. Farther on a dealer in antiquities cringed before his lair, inviting the passer-by to enter and be duped. Yes, this was Venice, this the fair frailty that fawned and that betrayed, half fairy-tale, half snare; the city in whose stagnating air the art of painting once put forth so lusty a growth, and where musicians were moved to accords so weirdly lulling and lascivious. Our adventurer felt his senses wooed by this voluptuousness of sight and sound, tasted his secret knowledge that the city sickened and hid its sickness for love of gain, and bent an ever more unbridled leer on the gondola that glided on before him.

Death in Venice, 1912 THOMAS MANN

Taking a cross-path I soon came to the edge of the wood. For the first time in my life I was alone in unfamiliar country, like some patrol with whom the corporal has lost touch.

And now I imagine myself on the brink of that mysterious felicity Meaulnes had one day caught a glimpse of. I have the whole morning to explore the boundary of the wood—the coolest and most secret spot for miles around—and at the same moment my big brother is making an exploration of his own. I follow what must once have been the bed of a brook, under low branches of trees whose name I don't know—they may be alders. A few moments ago I got over a stile at the end of the pathway, to find this stream of green grass flowing beneath the foliage. Now and then I brush against nettles or trample the tall stalks of valerian.

Now and then my foot encounters a patch of fine sand. And in the silence I hear a bird—I imagine it to be a nightingale, but how can it be if they only sing at night?—a bird which repeats the same phrase over and over: the voice of the morning, a greeting that comes down through the leaves, a charming invitation to roam through the alders. Invisible, persistent, it accompanies me on my promenade under a roof of foliage.

For the first time I too am on the path of adventure. For once it is not for shells left stranded by the tide that I am prospecting, with Monsieur Seurel close at hand, nor for specimens of orchis unknown to the schoolmaster; nor even, as so often in old Martin's field, for that deep but dried-up spring protected by a grating and so overgrown with weeds that on each visit it took longer to find . . . I am looking for something still more mysterious: for the path you read about in books, the old lane choked with undergrowth whose entrance the weary prince could not discover. You'll only come upon it at some lost moment of the morning when you've long since forgotten that it will soon be eleven, or twelve . . . Then, as you are awkwardly brushing aside a tangle of branches, your arms at the same time trying to protect your face, you suddenly catch a glimpse of a dark tunnel of green at the far end of which there is a tiny aperture of light.

The Lost Domain (Le Grand Meaulnes), 1913 ALAIN-FOURNIER

Jonathan Houghton

There is the caw of a crow,
And the hesitant song of a thrush.
There is the tinkle of a cowbell far away,
And the voice of a plowman on Shipley's hill.
The forest beyond the orchard is still
With midsummer stillness;
And along the road a wagon chuckles,
Loaded with corn, going to Atterbury.
And an old man sits under a tree asleep,
And an old woman crosses the road,
Coming from the orchard with a bucket of blackberries.
And a boy lies in the grass
Near the feet of the old man,
And looks up at the sailing clouds,
And longs, and longs, and longs

For what, he knows not:
For manhood, for life, for the unknown world!
Then thirty years passed,
And the boy returned worn out by life
And found the orchard vanished,
And the forest gone,
And the house made over,
And the roadway filled with dust from automobiles—
And himself desiring The Hill!

Charles Webster

The pine woods on the hill,
And the farmhouse miles away,
Showed clear as though behind a lens
Under a sky of peacock blue!
But a blanket of cloud by afternoon
Muffled the earth. And you walked the road
And the clover field, where the only sound
Was the cricket's liquid tremolo.
Then the sun went down between great drifts
Of distant storms. For a rising wind
Swept clean the sky and blew the flames
Of the unprotected stars;
And swayed the russet moon,
Hanging between the rim of the hill
And the twinkling boughs of the apple orchard.
You walked the shore in thought
Where the throats of the waves were like whippoorwills
Singing beneath the water and crying
To the wash of the wind in the cedar trees,
Till you stood, too full for tears, by the cot,
And looking up saw Jupiter,
Tipping the spire of the giant pine,
And looking down saw my vacant chair,
Rocked by the wind on the lonely porch—
Be brave, Beloved!

Spoon River Anthology, 1915 EDGAR LEE MASTERS

In long lassoes from the Cock lake the water flowed full, covering greengoldenly lagoons
of sand, rising, flowing. My ashplant will float away. I shall wait. No, they will pass on,

passing chafing against the low rocks, swirling, passing. Better get this job over quick. Listen: a fourworded wavespeech: seesoo, hrss, rsseeiss, ooos. Vehement breath of waters amid seasnakes, rearing horses, rocks. In cups of rocks it slops: flop, slop, slap: bounded in barrels. And, spent, its speech ceases. It flows purling, widely flowing, floating foampool, flower unfurling.

Under the upswelling tide he saw the writhing weeds lift languidly and sway reluctant arms, hising up their petticoats, in whispering water swaying and upturning coy silver fronds. Day by day: night by night: lifted, flooded and let fall. Lord, they are weary: and, whispered to, they sigh. Saint Ambrose heard it, sigh of leaves and waves, waiting, awaiting the fullness of their times, *diebus ac noctibus iniurias patiens ingemiscit*. To no end gathered: vainly then released, forth flowing, wending back: loom of the moon. Weary too in sight of lovers, lascivious men, a naked woman shining in her courts, she draws a toil of waters.

Five fathoms out there. Full fathom five thy father lies. At one he said. Found drowned. High water at Dublin bar. Driving before it a loose drift of rubble, fanshoals of fishes, silly shells. A corpse rising saltwhite from the undertow, bobbing landward, a pace a pace a porpoise. There he is. Hook it quick. Sunk though he be beneath the watery floor. We have him. Easy now.

Bag of corpsegas sopping in foul brine. A quiver of minnows, fat of a spongy titbit, flash through the slits of his buttoned trouserfly. God becomes man becomes fish becomes barnacle goose becomes featherbed mountain. Dead breaths I living breathe, tread dead dust, devour a urinous offal from all dead. Hauled stark over the gunwale he breathes upward the stench of his green grave, his leprous nosehole snoring to the sun.

A seachange this, brown eyes saltblue. Seadeath, mildest of all deaths known to man. Old Father Ocean. *Prix de Paris*: beware of imitations. Just you give it a fair trial. We enjoyed ourselves immensely.

Come. I thirst. Clouding over. No black clouds anywhere, are there? Thunderstorm. Allbright he falls, proud lightning of the intellect, *Lucifer, dico, qui nescit occasum*. No. My cockle hat and staff and his my sandal shoon. Where? To evening lands. Evening will find itself.

Ulysses, 1914 JAMES JOYCE

Here the crow starves, here the patient stag
Breeds for the rifle. Between the soft moor
And the soft sky, scarcely room
To leap or soar. Substance crumbles, in the thin air
Moon cold or moon hot. The road winds in
Listlessness of ancient war,
Languor of broken steel,
Clamour of confused wrong, apt
In silence. Memory is strong
Beyond the bone. Pride snapped,
Shadow of pride is long, in the long pass
No concurrence of bone.

'Rannoch, by Glencoe' from *Collected Poems* 1909-1962 T. S. ELIOT

1. PIERRE BONNARD: *The Garden*, about 1935. Oil on canvas, 127 × 100 cm. Paris, Musée du Petit Palais.

Bonnard sees the garden as a tangle of multicoloured vegetation, concealing the horizon and almost enveloping the spectator as it invites him to advance along the vaguely indicated path.

2. PIERRE BONNARD: *The Esterel range*, 1917. Oil on canvas, 56 × 73 cm. Amsterdam, Municipal Museum.

It has been said that Bonnard's composition is noted for its 'witty and whimsical lack of symmetry'. The present landscape is an example of this and, with its startling colour-scheme, shows how thoroughly the artist assimilated the lessons of Impressionism.

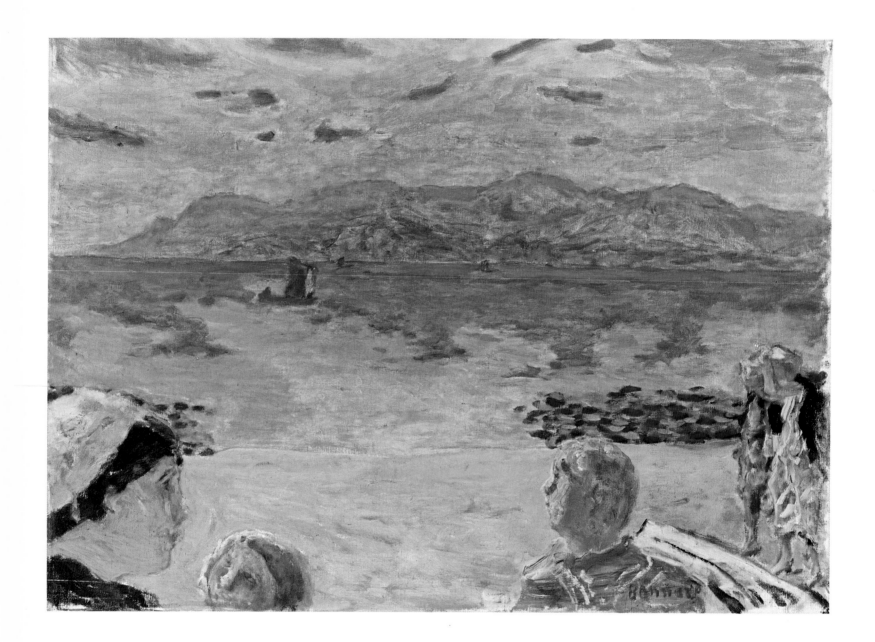

3. EDOUARD VUILLARD: *The game of draughts*, 1906. Oil on canvas, 66 × 109 cm. Berne, Hahnloser Collection.

A quiet Sunday scene, depicted with Vuillard's characteristic attention to detail. However, the numerous anecdotic observations are absorbed by the vivid unifying texture of the ground, to which the bird's-eye view lends especial importance.

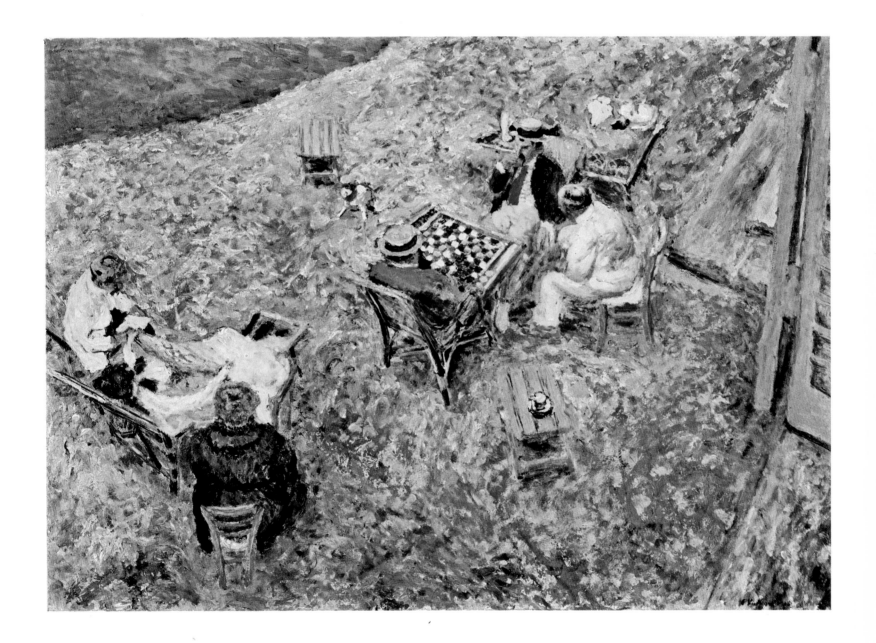

4. EDOUARD VUILLARD: *Blue hills*, 1900. Oil on canvas, 42 × 68 cm. Zürich, Kunsthaus.

One of the few outdoor scenes painted by this artist, who preferred interiors at a time when their furnishings offered unusual pictorial opportunities. The serene and orderly countryside extends in successive planes to the distant horizon.

5. EDVARD MUNCH: *White night*, 1901. Oil on canvas, 115.5 × 110 cm. Oslo, National Gallery.

One of the three well-known Nordic 'nocturnes' of this great Norwegian artist. The trees in the foreground are like strange disquieting characters in a mysterious, dramatic episode.

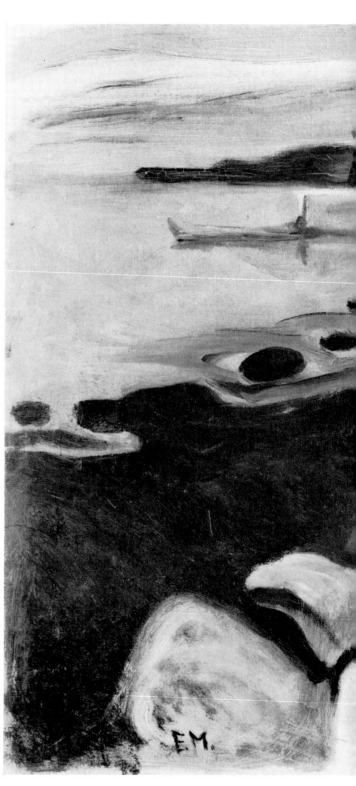

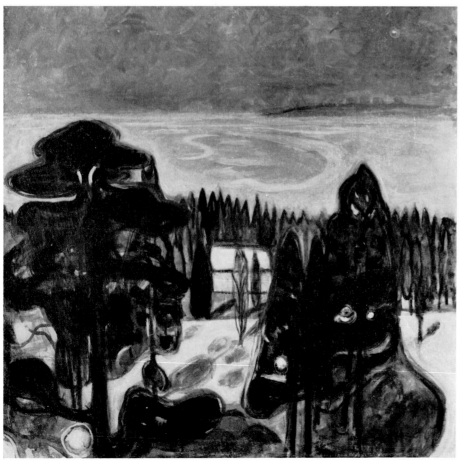

6. EDVARD MUNCH: *Melancholy*, 1895. Oil on canvas, 65 ×96 cm. Oslo, Private Collection.

One of Munch's most grandiose and disturbing visions, even apart from the tragic and impenetrable figure in the foreground. Each element in the landscape—the trees, the beach, the massive rocks and the sea—is depicted with the utmost conciseness and a kind of primeval crudity.

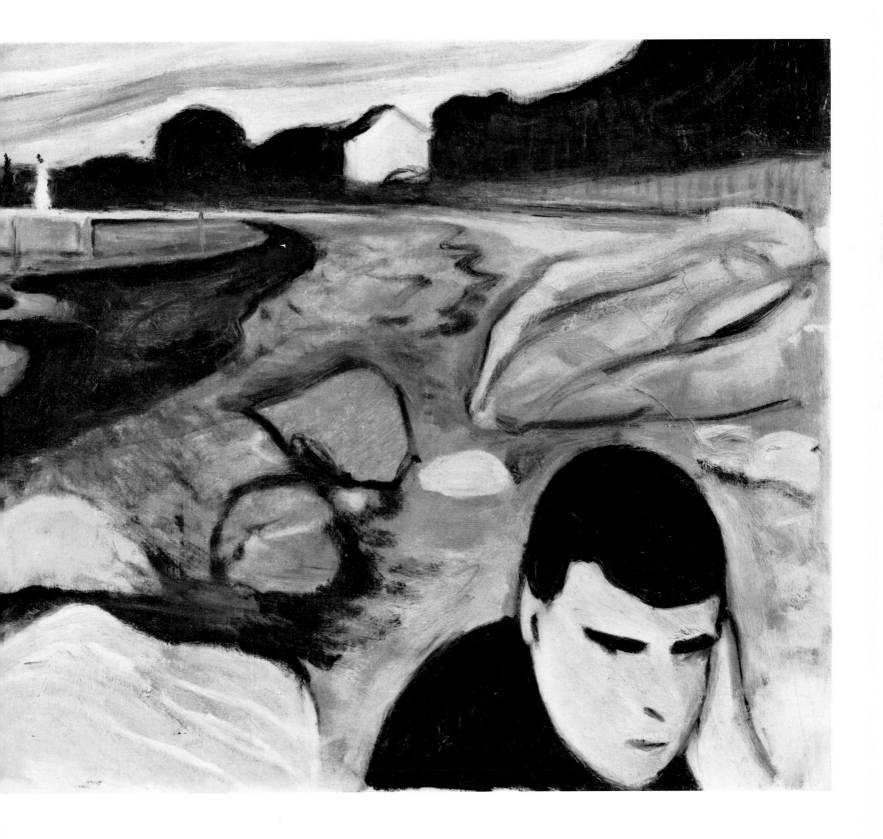

7. EDVARD MUNCH: *Four girls on a bridge*, 1905. Oil on canvas, 126 × 126 cm. Cologne, Wallraf-Richartz Museum.

If this picture suggests ideas and rhythms that are characteristic of the *Jugendstil*, it is certainly not because we are able to date or identify the girls' clothing. In this theme, of which there are several variations, the painter again presents us with a close correlation between human beings and nature, linked together by a grim, mysterious chain of circumstance.

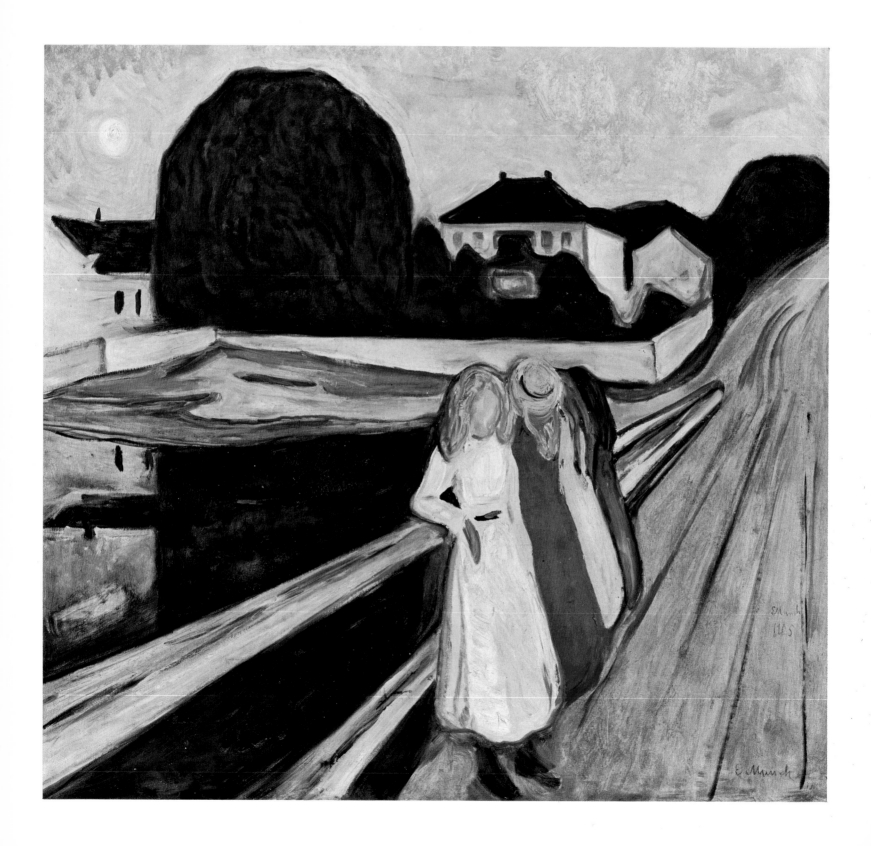

8. Harold Sohlberg: *Flowering field in the North*, 1905. Oil on canvas, 96 × 111 cm. Oslo, National Gallery.
An extraordinary 'vision': the scene is fragmentary but undeniably lyrical in quality. The eye hesitates between the soft carpet of marguerites and the tender green of the countryside, with the pallid sun standing over the distant hill.

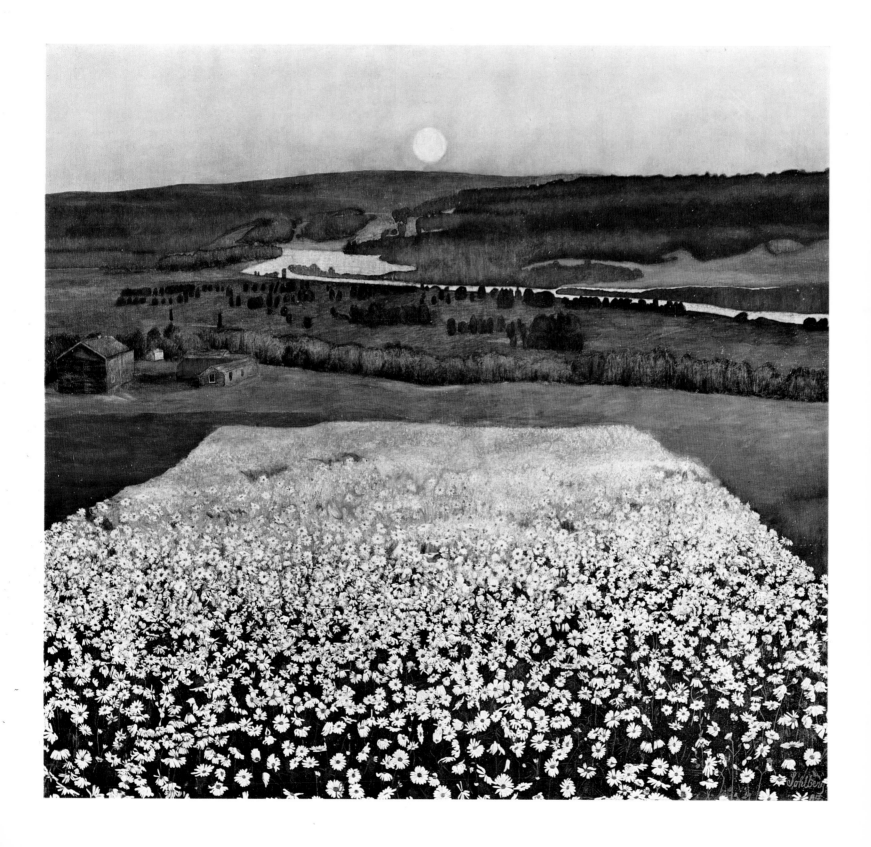

9. FERDINAND HODLER: *Lake Geneva*, 1905. Oil on canvas, 82.5 × 104. cm. Basle, Kunstmuseum.

A panoramic view with a careful balance of land, water and sky. It aims at an effect of rarified sublimity, but does not escape a certain coldness.

10. FERDINAND HODLER: *The Niesen*, 1910. Oil on canvas, 83 × 105.5 cm. Basle, Kunstmuseum.

Another example of Hodler's love of symmetry. The clouds form a variegated pattern around the craggy mountain-top, but the picture is fundamentally centralized.

11. JAMES ENSOR: *View of Mariakerke*, 1901. Oil on canvas, 50 × 64 cm. Ostend, Fine Arts Museum.

Although painted at what is usually thought of as the beginning of his decadent period, this is a good example of Ensor's work as a landscapist. It contains scarcely a hint of the wild atmosphere of those scenes of his which most clearly foreshadow the sensibility of our own time.

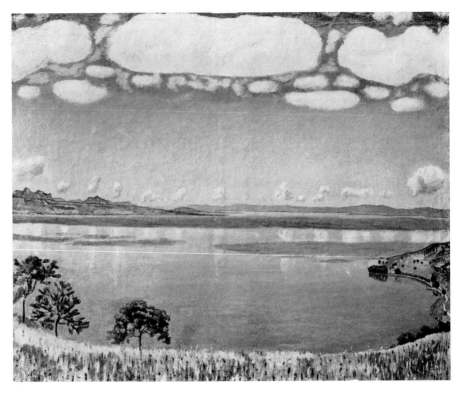

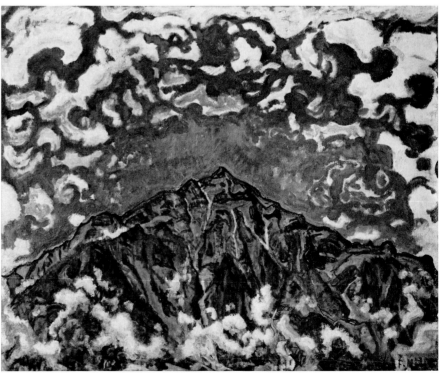

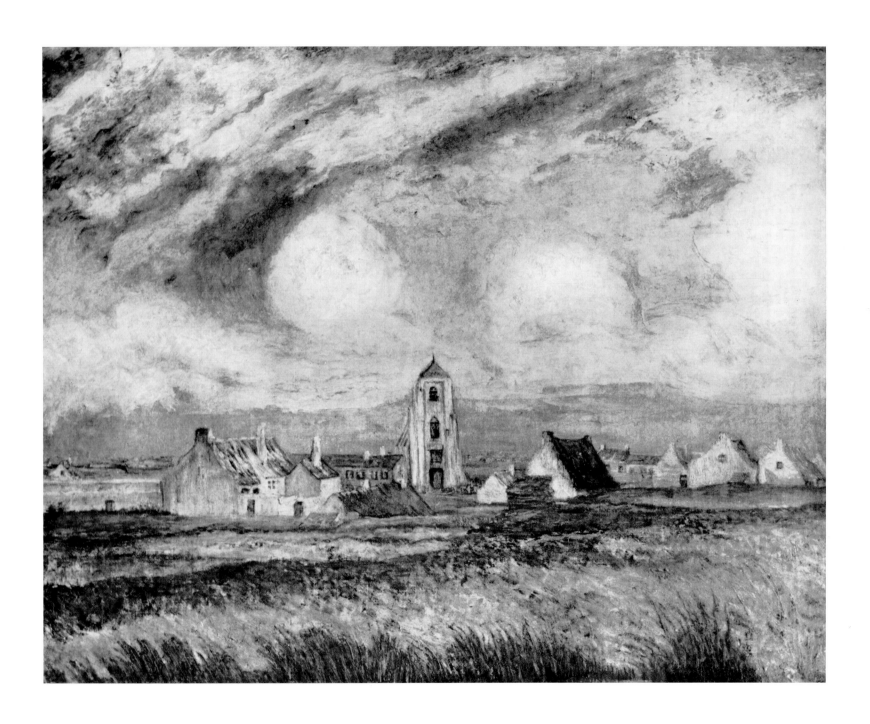

12. GUSTAV KLIMT: *Schloss Kammer on the Attersee*, III, 1910. Oil on canvas, 110 × 110 cm. Vienna, Austrian Gallery.

Despite its incisive drawing the picture has a touch of impressionism which is rather unusual with Klimt. The building is hardly more substantial-looking than its reflection in the quiet waters of the lake.

13. JENS FERDINAND WILLUMSEN: *Mountain in sunlight*, 1902. Oil on canvas, 209 × 208 cm. Stockholm, Thiel Gallery.

In this fantastic landscape Willumsen, a companion of Gauguin and Bernard, shows himself at his most openly Symbolistic. There is something reminiscent of Hodler in the cosmic emphasis given to this remote, inaccessible spot.

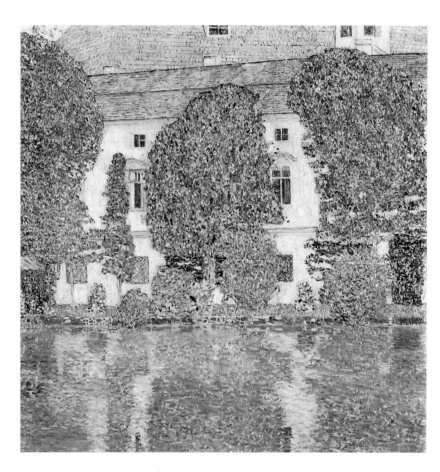

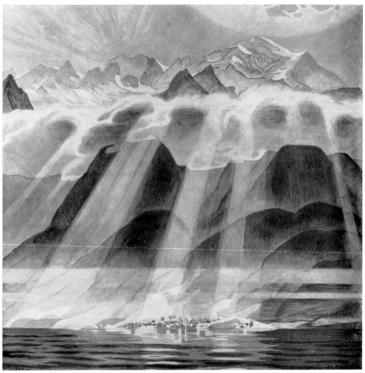

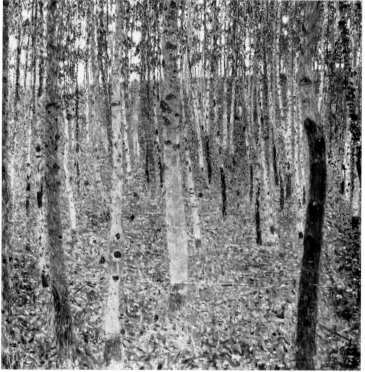

14. GUSTAV KLIMT: *Forest*. Oil on canvas, 100 × 100 cm. Dresden, Art Gallery.

In this fairy-tale forest, painted with minute accuracy, the light-coloured trunks of innumerable trees stand out against the ground, itself swarming with life, which rises towards a high horizon.

15. GUSTAV KLIMT: *Schloss Kammer on the Attersee* (detail of Plate 12), 1910. Oil on canvas. Vienna, Austrian Gallery.

This shows clearly the liveliness of the strokes which go to make up a homogeneous yet infinitely varied pattern. The subtle vibration of the purples offsetting the tender green and dull yellow shows a precise and sensitive feeling for colour which goes back, above all, to Claude Monet.

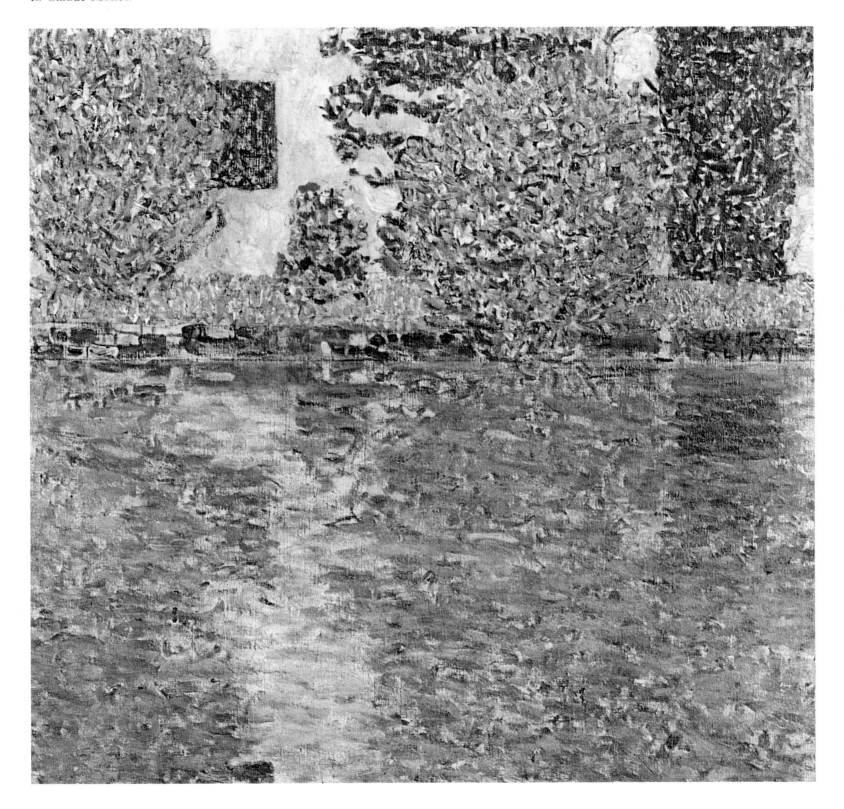

16. HENRI MATISSE: *A glimpse of Notre-Dame in the late afternoon*, 1902. Oil on canvas, 72 × 54 cm. Buffalo, Albright-Knox Art Gallery (gift of Seymour M. Knox).

Matisse returned to this theme some years later, altering the proportions considerably but with little change as regards the viewpoint. However, the present version is much more compact and self-contained by reason of its clearly defined vertical shapes and perspectives.

17. HENRI MATISSE: *Saint-Tropez*, 1901. Oil on canvas, 35 × 48 cm. Bagnols-sur-Cèze, Museum.

The village with its golden tones, contrasting vividly with the intense blue of the sea, is seen beyond a brief expanse of countryside and walled gardens. The painter is still using a pointilliste technique, but with an admixture of continuous brush-strokes.

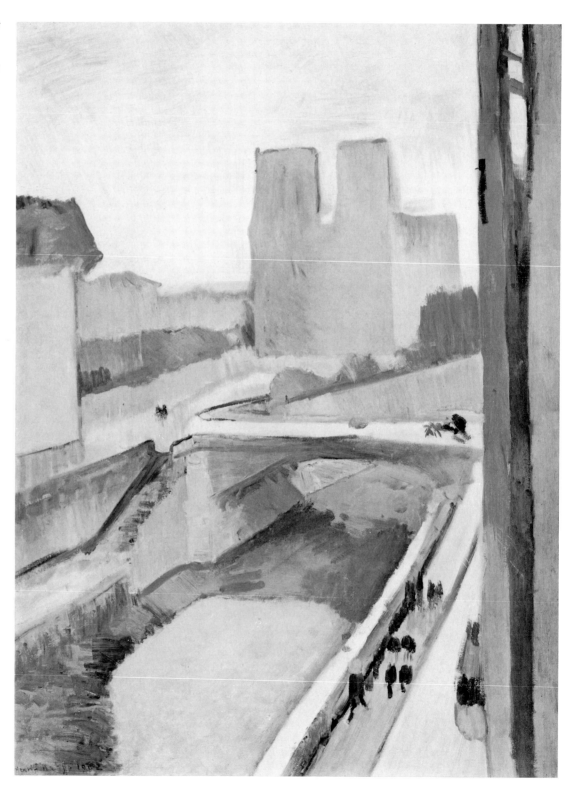

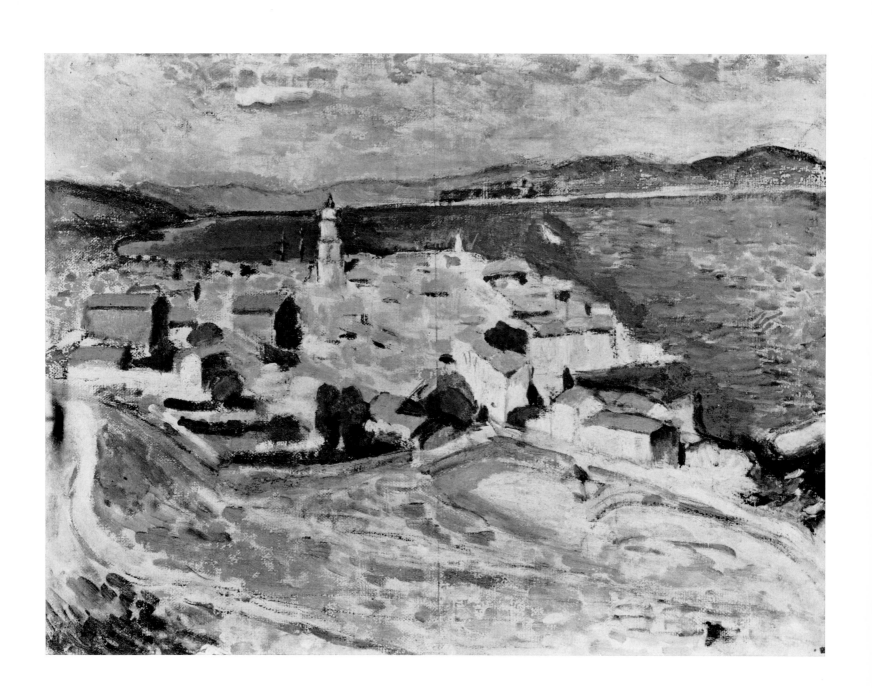

18. HENRI MATISSE: *Trees at Collioure*, 1905. Oil on canvas, 46.5 × 55 cm. New York, Robert Lehman Collection.
The two trees fill the entire upper half of the picture with their branches, through which we see a mysterious background of vivid colour.

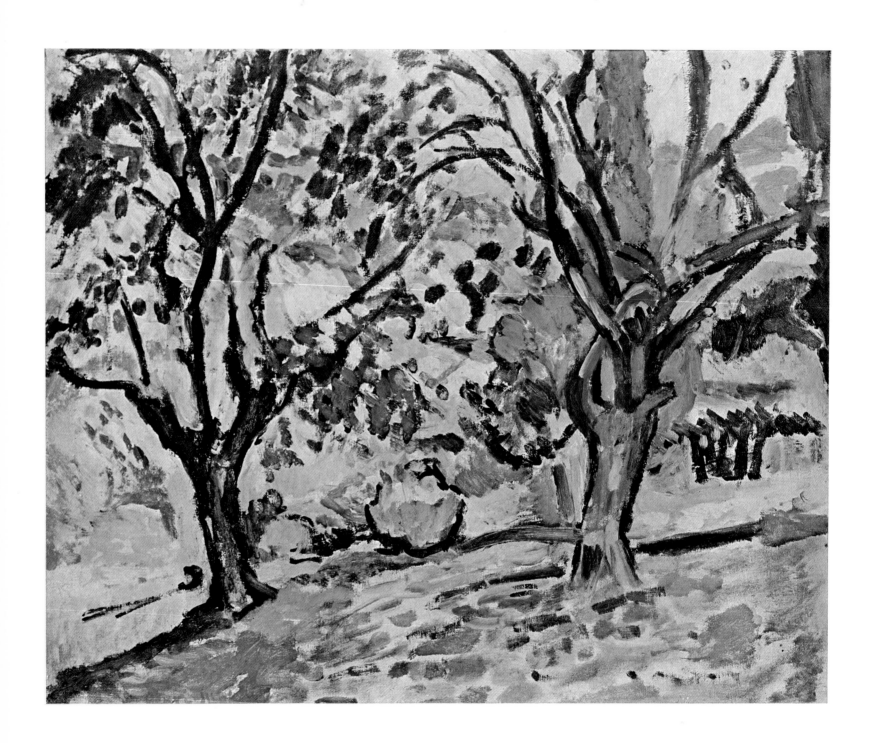

19. ANDRÉ DERAIN: *Riverside scene at Chatou*, 1905. Oil on canvas, 81 × 130 cm. New York, W.S. Paley Collection.

The scene here chosen, in which the more violent colour effects of Fauvism have no place, was a favourite one with Derain, who reverted to it in later works. The setting and the numerous figurative elements afford many opportunities of varying the range of greens by some sudden contrast.

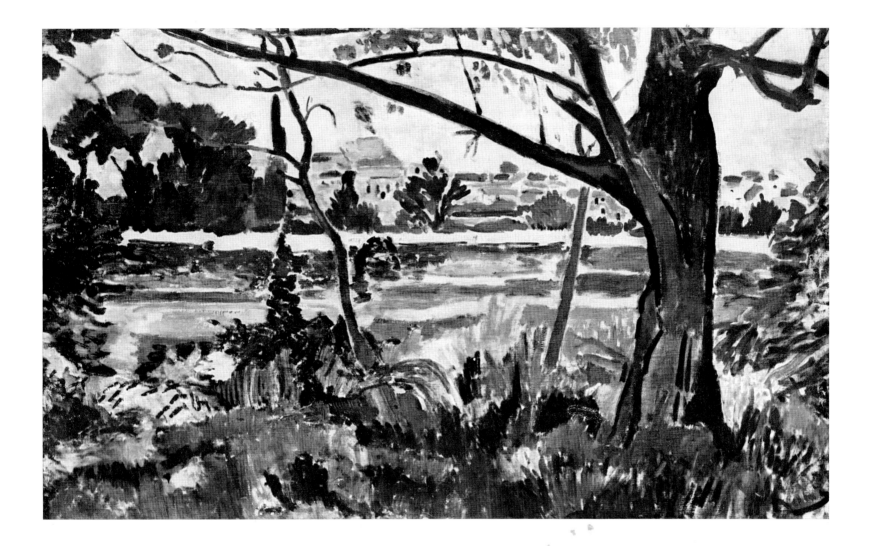

20. GEORGES BRAQUE: *L'Estaque*, 1906. Oil on canvas, 60 × 73 cm. Paris, Maeght Gallery.

A complex view from above, bearing witness to the convictions of Braque's Fauvist period; and, at the same time, a hint of the immediate future when he reproduced spatial elements with iron consistency.

21. GEORGES BRAQUE: *The port at La Ciotat*, 1907. Oil on canvas, 65 × 81 cm. New York, John Hay Whitney Collection.

Here again we find a clearly articulated spatial sequence. The parallel lines of the background (the huts, ships and hills) contrast with the foreground, where the boats scattered about on land and water produce a multiple and complex set of inter-relations. The colour-scheme, imaginative and extremely rich, exemplifies the types of overlapping and juxtaposition dear to the Fauves.

22. GEORGES BRAQUE: *The port at La Ciotat*, 1906. Oil on canvas, 48 × 60 cm. Paris, Maeght Gallery.

Another view of the port, showing a much more marked use of hatching, especially in the sky and the reflections in the water. The colour-scheme is vivid, but there is a clear striving after balanced construction based on the oblique line in the lower part of the picture.

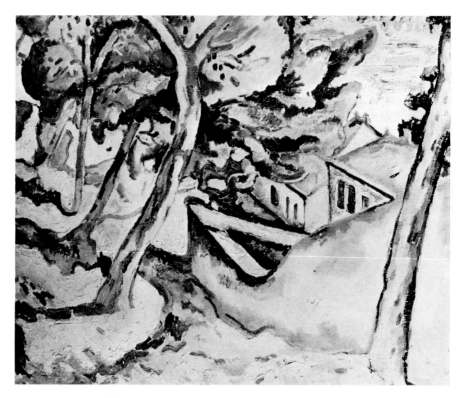

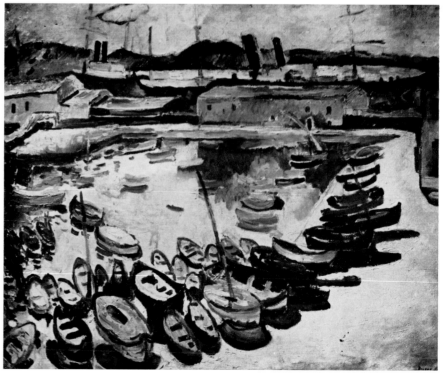

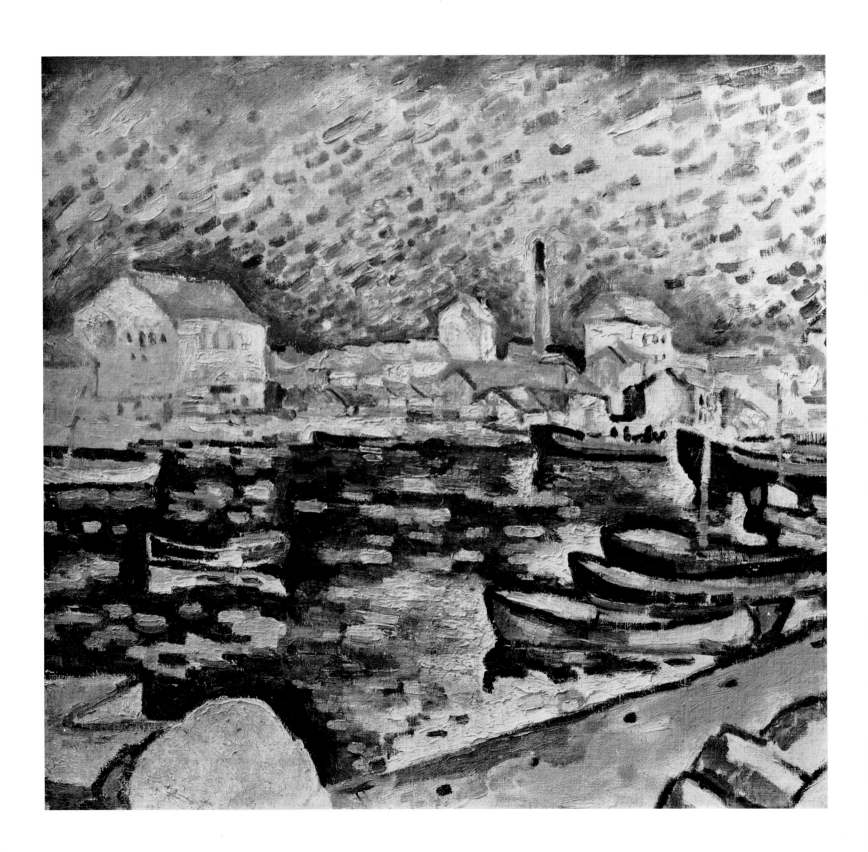

23. ANDRÉ DERAIN: *The Houses of Parliament, London*, 1906. Oil on canvas, 79 × 99 cm. New York, Robert Lehman Collection.
The building with its monumental towers forms a backdrop of dark tonality beyond the bright water, on which a tug and some barges stand out. In the background, to the right, we see the blurred outline of the city in a dim, diffuse light.

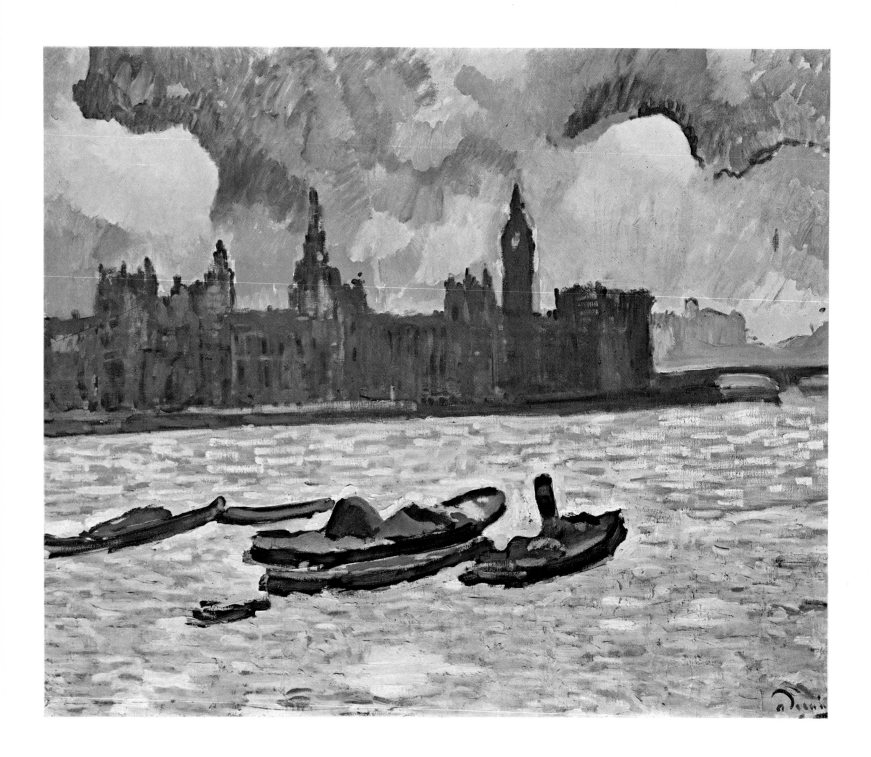

24. ALBERT MARQUET: *The Pont-Neuf*, 1906. Oil on canvas, 50 × 61 cm. Washington, D.C., National Gallery of Art (Chester Dale Collection).

In this picture, one of Marquet's chief works, we again find the Fauvist colour-scheme replaced by a sharp contrast between light and dark—the latter predominating except for the bright diagonal of the bridge, which other famous artists had taken as their subject a few decades earlier and which, picked out with rapid strokes, constitutes the visual axis of the painting.

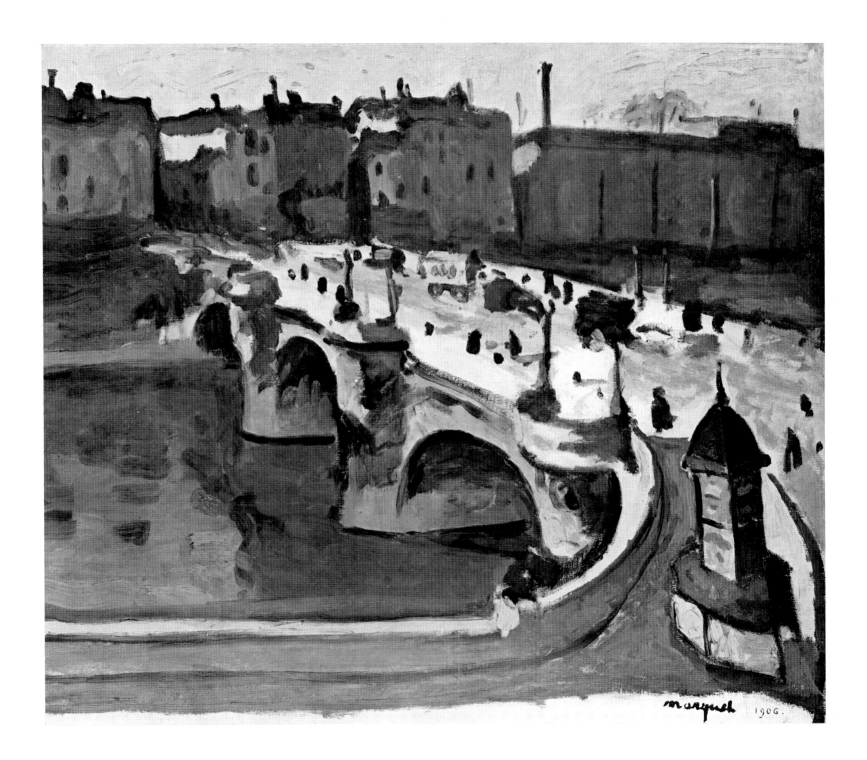

25. LOUIS VALTAT: *Rocks*, 1902. Oil on canvas, 81 × 100 cm. Geneva, Petit Palais (Oscar Ghez Collection).

The Impressionist heritage and, in this case, the influence of Monet remain visible despite a radical change of artistic intention and thus of pictorial technique. This applies with equal clarity to the very diverse range of colour.

26. ALBERT MARQUET: *The beach at Fécamp*, 1906. Oil on canvas, 51 × 61 cm. Paris, National Museum of Modern Art.

The rapidity of the brushwork does much to define the character of this well-known work. As often with the Fauves, the scene is depicted from above and foreshortened. Here again, the vivid contrasts are mainly formed by light and dark patches.

27. FÉLIX VALLOTTON: *The estuary at Honfleur*, 1911. Oil on canvas, 88 × 83 cm. Lausanne, Paul Vallotton Gallery.

The high viewpoint and the clear-cut foliage of the large tree in the foreground diminish greatly the extent of sky surmounting the expanse of water beyond the township and the almost geometrical curves of the river. The scene appears faithful to nature but, as has been observed, there is no 'atmospheric corrosion': it is as if the landscape were covered by a glass case (Barilli).

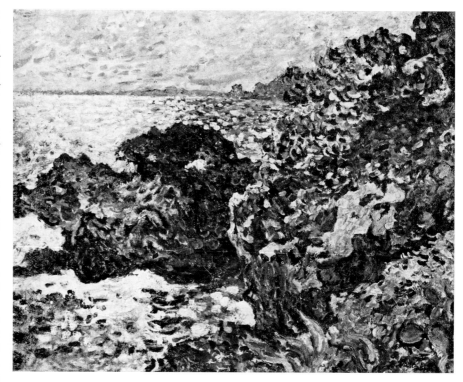

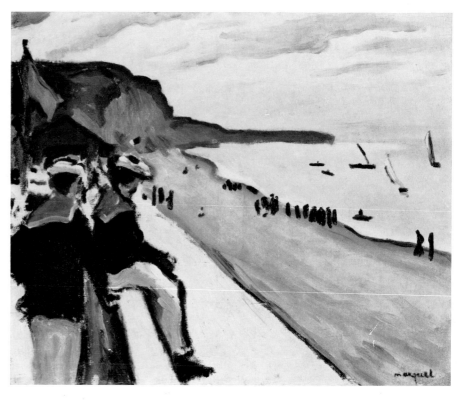

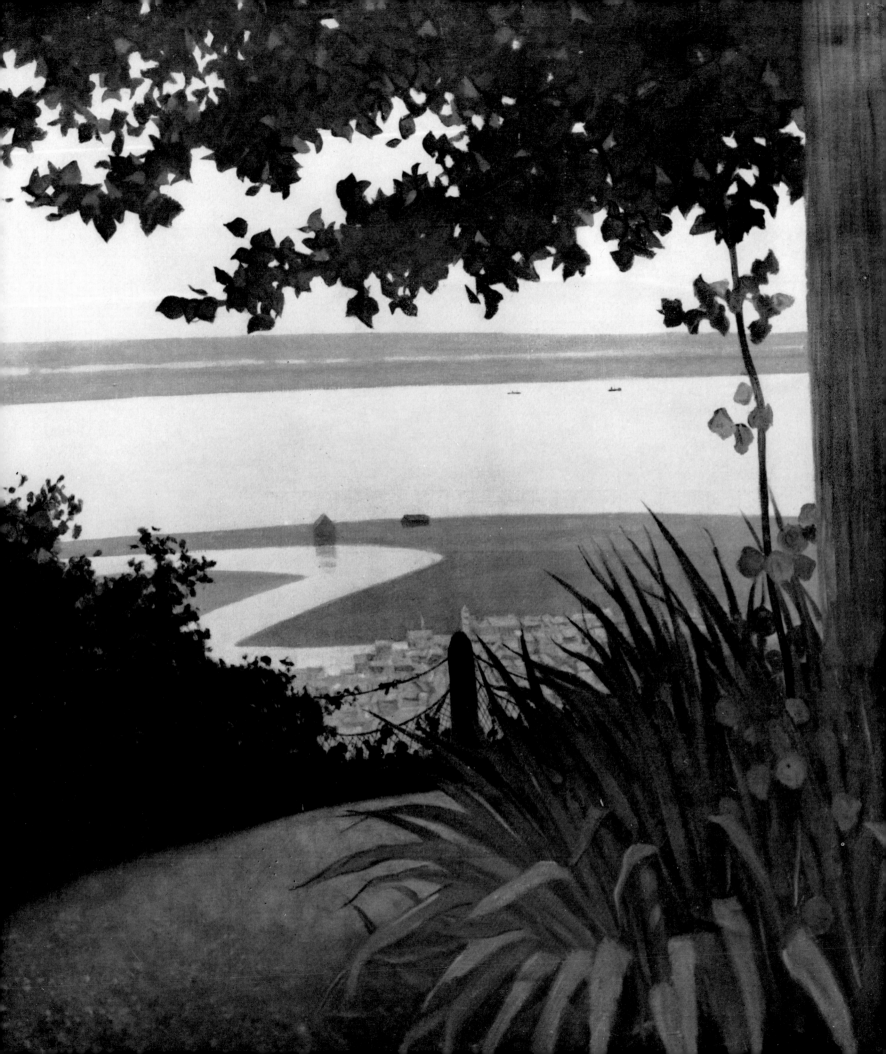

28. MAURICE DE VLAMINCK: *Landscape with red trees*, 1906. Oil on canvas, 65 × 81 cm. Paris, National Museum of Modern Art. One of the most 'classic' and significant examples of Fauvist painting. All the shapes appear to be outlined with the object of marking off the colours and so making them more effective: the reds, greens, yellows and blues jostle one another, filling up the space and, as it were, saturating it from end to end of the canvas.

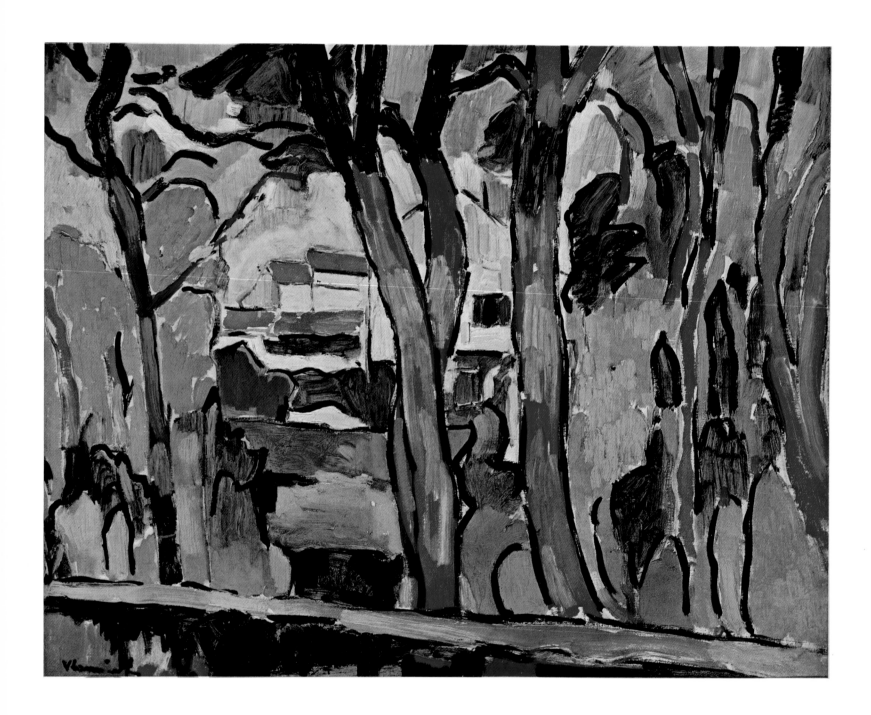

29. MAURICE DE VLAMINCK: *Sailing-boat on the Seine*, 1906. Oil on canvas, 54.5 ×73.5 cm. New York, Robert Lehman Collection.
A light and evocative scene, much less heavy and 'constructed' than the painting reproduced opposite, yet using the same range of colours. Here too, the foreground is close to the spectator; but the background does not appear distant either, so that the river becomes a narrow strip of many-coloured reflections.

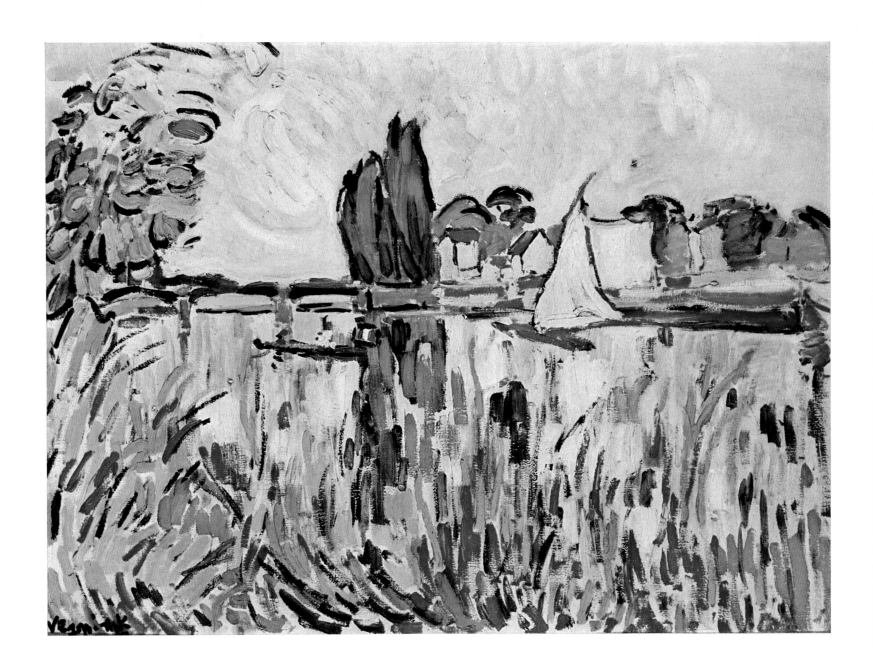

30. CHARLES CAMOIN: *The harbour at Marseilles*, 1904. Oil on canvas, 60 × 81 cm. Le Havre, Fine Arts Museum.

A view of the harbour at Marseilles by the most moderate of the Fauves. The masts and spars rhythmically divide up the wide expanse of sky above the peaceful city on the slopes of the hill. The contrasts in the foreground are more sharply defined.

31. ALBERT GLEIZES: *The market at Courbevoie*, 1905. Oil on canvas, 54 × 65 cm. Lyons, Fine Arts Museum.

The extensive urban scene resolves itself into a series of obscure minor episodes, centring on the single street which gently curves into the left background. The animation of the human figures and objects is strongly reminiscent of certain scenes by Pissarro.

32. HENRI MANGUIN: *The fourteenth of July at Saint-Tropez*, 1905. Oil on canvas, 61 × 50 cm. Paris, Lucille Manguin Collection.

One of several versions of this theme, in which orange and red tints play an important part. The partially furled sails mark off the space in height and in depth. The Fauves, in their own manner, showed much intuition in reproducing the harmony of themes and objects which, in their day more than in ours, characterized the coastal landscape of southern France.

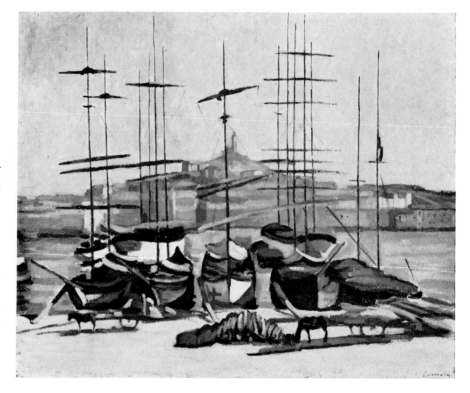

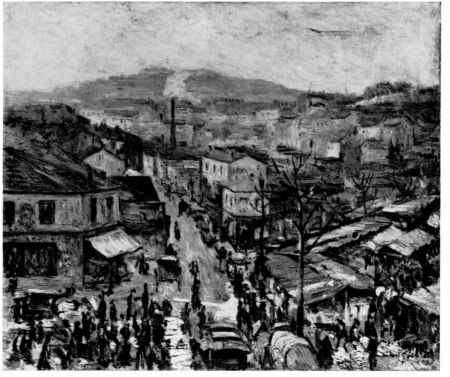

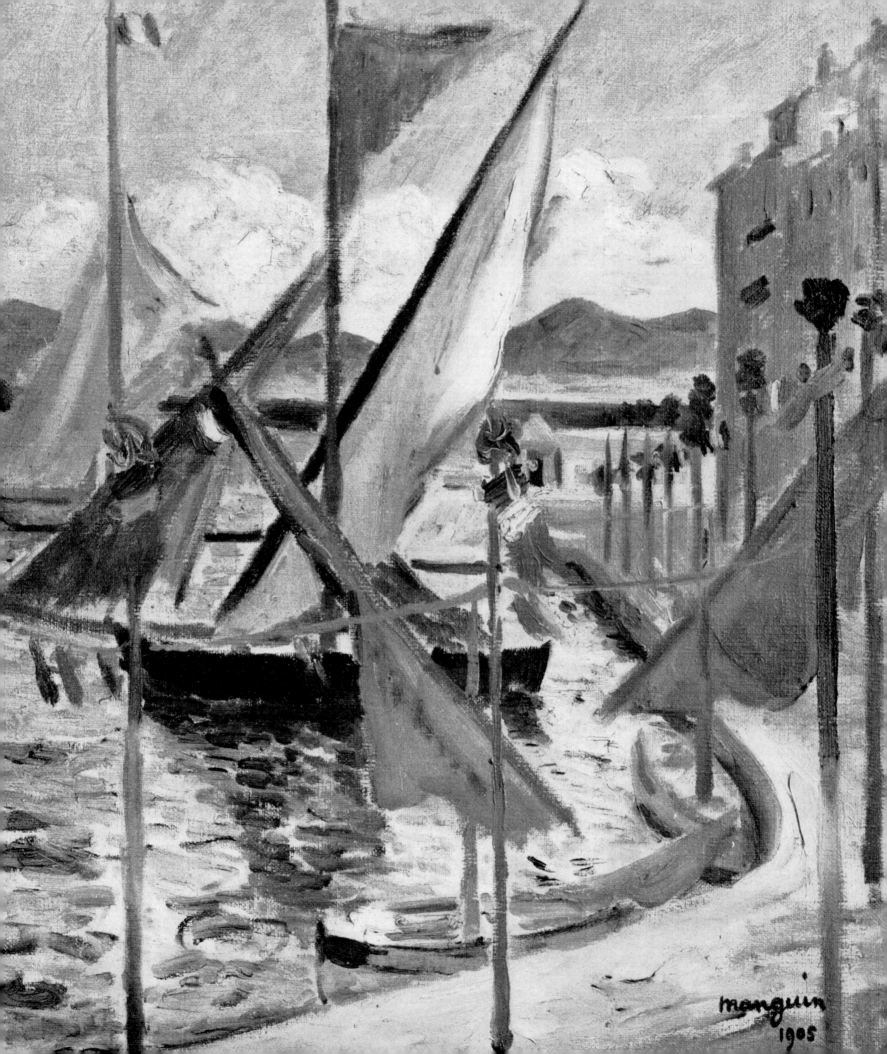

33. OTHON FRIESZ: *La Ciotat*, 1905. Oil on canvas, 33 × 41 cm. Paris, National Museum of Modern Art.

One of several views of La Ciotat painted by this artist around 1905–6. For the surface of the water especially, much use is made of parallel strokes of varying chromatic intensity, like the pieces of a mosaic. Elsewhere Friesz uses a more summary technique, full of lively variation.

34. RAOUL DUFY: *Posters at Trouville*, 1906. Oil on canvas, 65 × 81 cm. Paris, National Museum of Modern Art.

The variegated colours and patterns of the posters lining a busy street at Trouville compose the central part of this work, which has some affinity with Marquet. Everything in it is sketched rapidly, especially the immediate foreground.

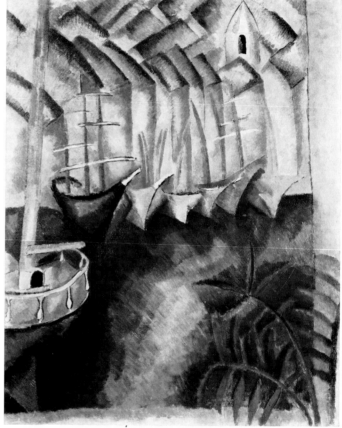

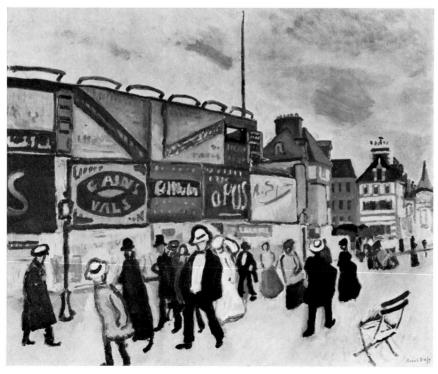

35, 36. RAOUL DUFY: *Boats in Marseilles harbour*, 1908. Oil on canvas, 73 × 60 cm. Paris, National Museum of Modern Art.
An interesting and unusual landscape by Dufy, who went through a brief Cubist period in 1908–10. The boats form a serried row, as do the buildings which block off the picture. Some of the shapes recall by their elegance Dufy's later work on very different themes.

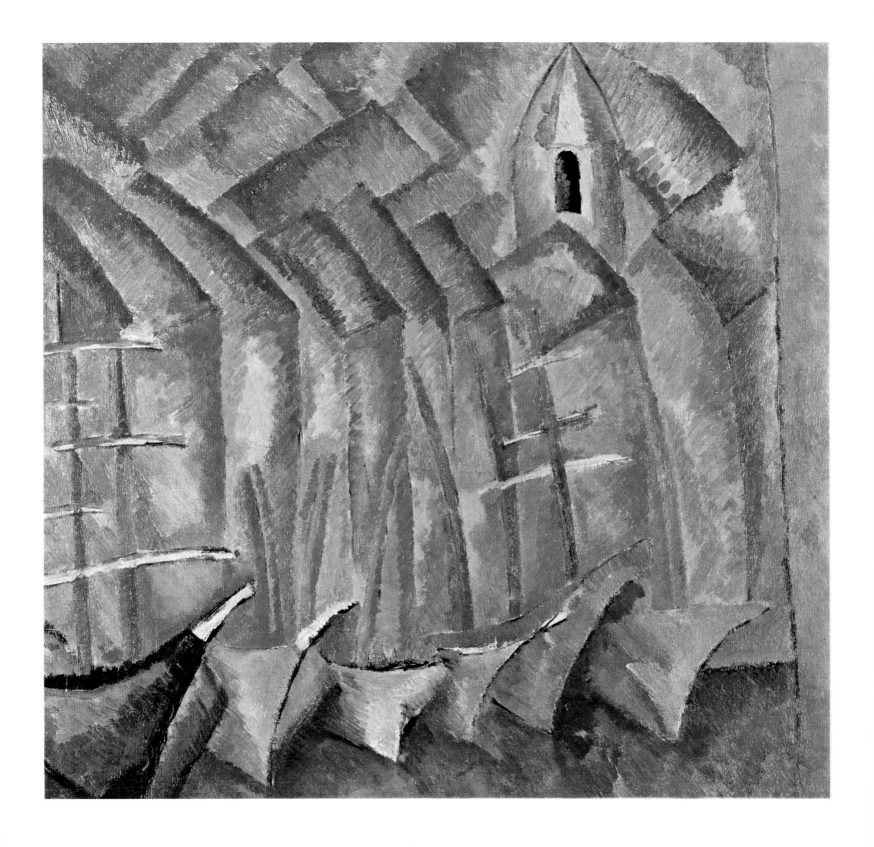

37. GEORGES ROUAULT: *Winter landscape*, 1912. Oil on canvas, 31 × 20 cm. Berne, Hahnloser Collection.
Rouault seldom devoted himself to landscape except as a background and commentary on his dramatic scenes and melancholy figures. In this work the human element is lacking, but pathos is implicit in the wintry bareness of the impoverished village.

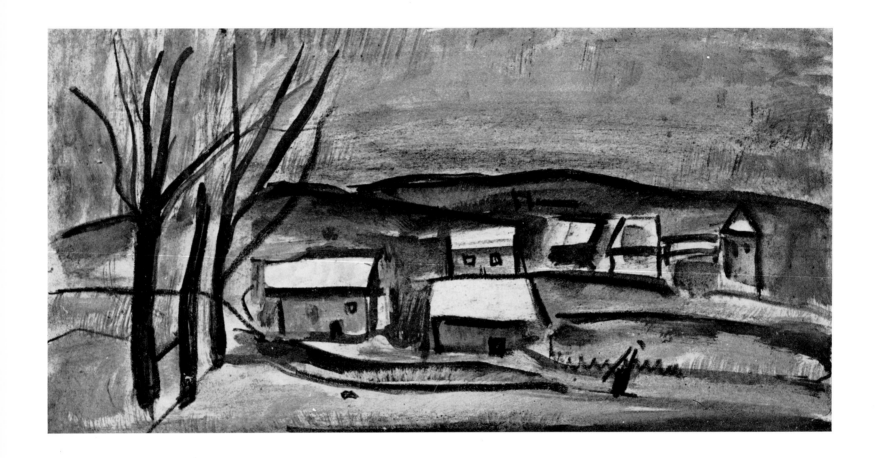

38. PABLO PICASSO: *Landscape with bridge*, 1909. Oil on canvas, 81 × 100 cm. Prague, National Gallery.

The simplified construction is dominated by the transverse theme of the bridge, with hills rising beyond. In the foreground beside the tree-trunk—a motif also frequently met with in Braque's paintings at this period—are the oblique planes and closely packed masses of the houses and church tower. Despite these fairly explicit references, the painter has already abolished naturalistic space.

39. PABLO PICASSO: *The reservoir at Horta del Ebro*, 1909. Oil on canvas, 60 × 50 cm. Paris, Louise Leiris Collection.

Picasso spent the summer of 1909 at Horta del Ebro, while Braque was working at La Roche-Guyon. This work throws valuable light on the development of the painter's experience. Despite the increasing number of broken-up forms, the landscape is seen as a distinct succession of planes, irregularly reflected in the waters of the reservoir in the foreground.

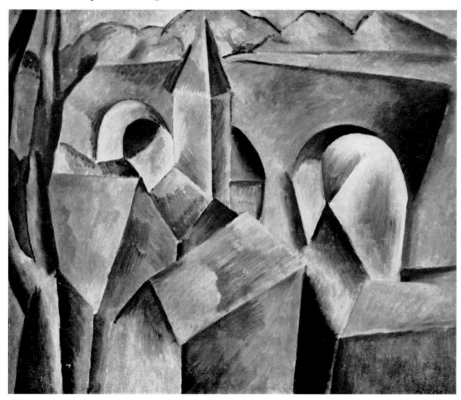 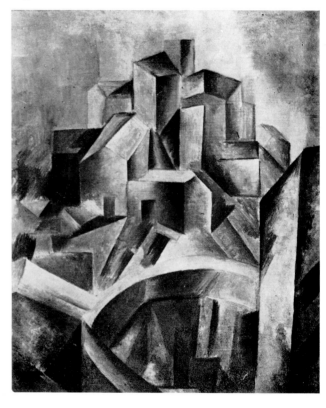

40. PABLO PICASSO: *Landscape*, 1908. Watercolour and gouache, 64 × 49.5 cm. Berne, Fine Arts Museum (Hermann and Margrit Rupf Foundation).

One of the 'prototypes' which bear witness to Picasso's early interest in landscape. As Rosenblum writes, 'The trees, land and clouds are purged of their idiosyncrasies of form and forcefully combined into a basic pictorial architecture which, like a still-life, is at once monumental and Lilliputian.' The work shows 'a deliberate economy of pictorial resources, based on an intellectualism whose principles are clearly discernible.'

41. GEORGES BRAQUE: *Road near L'Estaque*, 1908. Oil on canvas, 60 × 50 cm. New York, Museum of Modern Art.

A magnificent landscape, still closely linked in style with certain works of the painter's Fauvist period. The scene is dominated by the rising diagonal of the wall and road, with the massive overhanging trees shutting out the horizon. Straight lines and curves join and alternate in a rhythm similar to that of Picasso's paintings. The clarity of vision is intensified by the relative uniformity of the subdued colour-scheme.

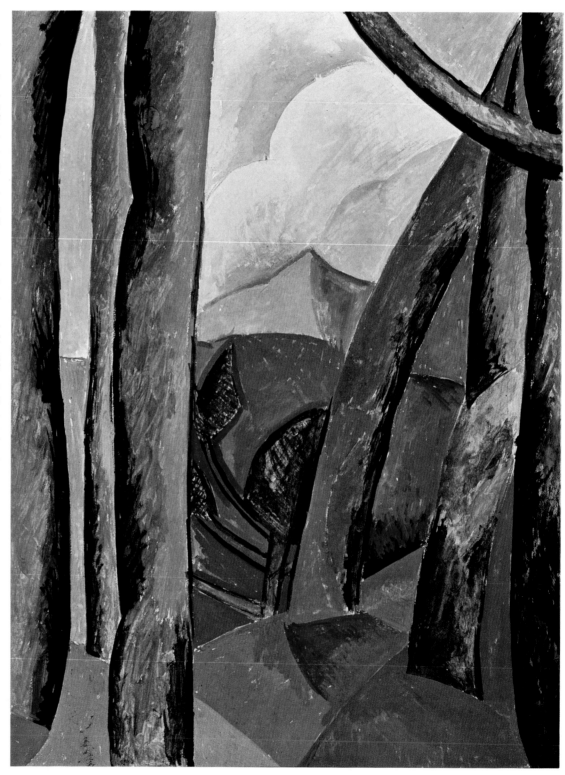

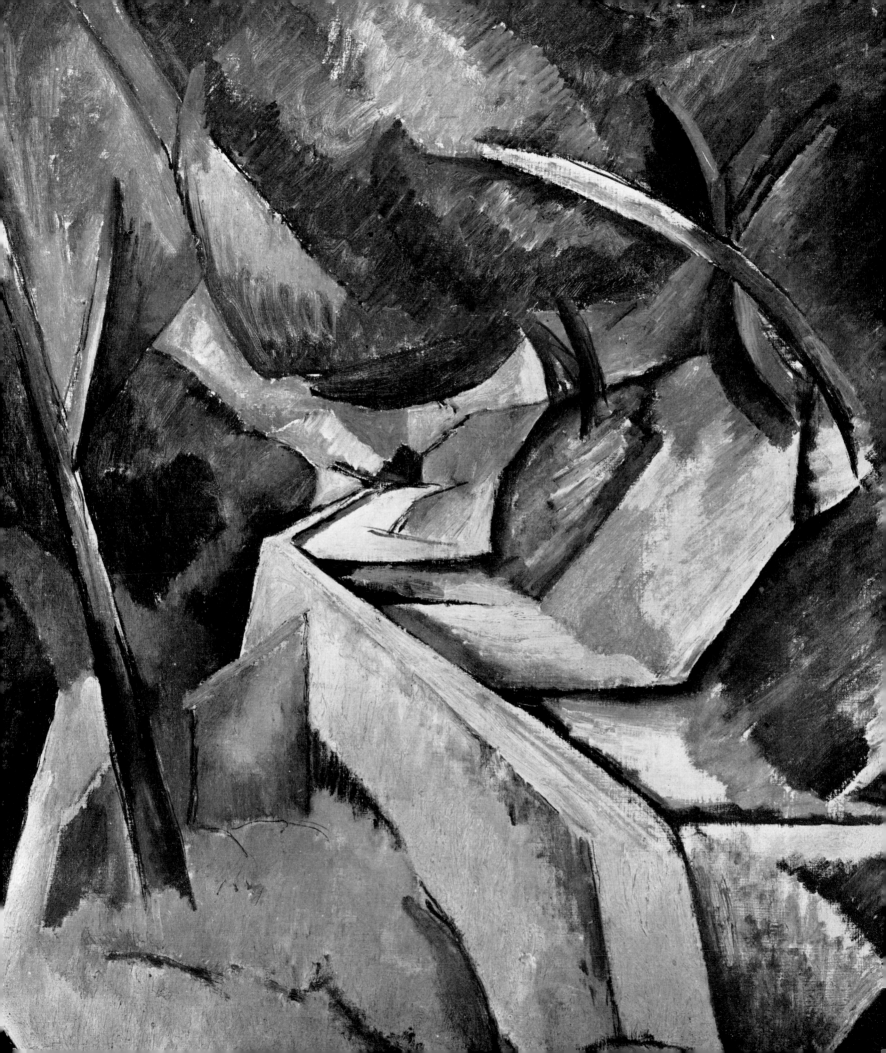

42. ANDRÉ LHOTE: *Trees*, 1914. Oil on canvas, 61 × 38 cm. Le Havre, Fine Arts Museum.

André Lhote has been described as the 'academician' of the Cubist movement, of which for the most part he assimilated the external elements only. This landscape, however, while there is something mechanical in its arrangement, also shows a wealth and freedom of design, especially in its upper part, where the composition is less artificial than in his later phase.

43. GEORGES BRAQUE: *Roofs at Céret*, 1911. Oil on canvas, 82 × 59 cm. New York, Ralph F. Colin Collection.

Picasso and Braque spent the summer of 1911 at Céret in the Pyrenees, working together and developing their experiences of the previous few years. The narrow, piled-up houses of the mountain village offered a large choice of subjects: their general structure is well seen in this picture, although the technique of breaking up and transposing planes has reached an advanced stage.

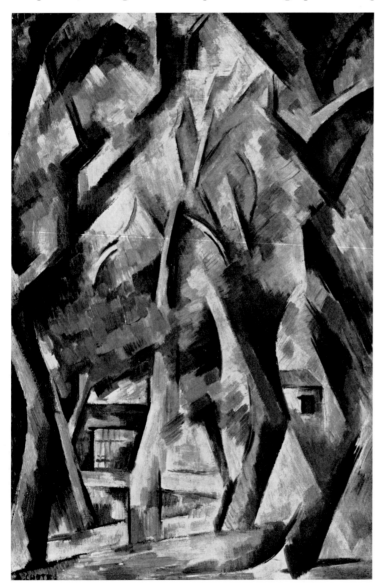
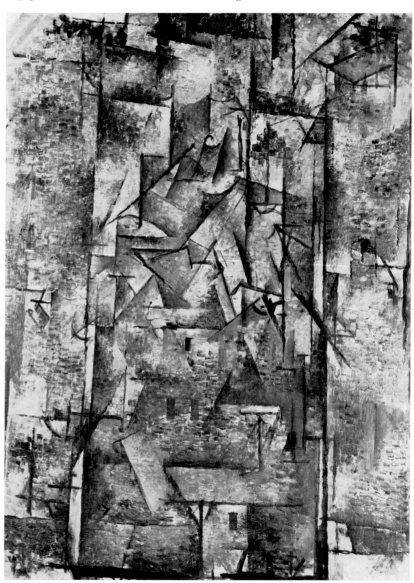

44. FERNAND LÉGER: *Landscape*, 1911. Oil on canvas, 91 × 81 cm. Vienna, Kunsthistorisches Museum (New Gallery). ▷

An example of Léger's early Cubist phase, which resulted from his encounter with the work of Braque and Picasso at the Kahnweiler Gallery in 1910. We see here some of the painter's main predilections of future years, such as the contours of trees and a fondness for rounded forms in general: these foreshadow the puristical solutions he was to adopt after his encounter with Ozenfant and Le Corbusier. The picture is full of movement and is intricately articulated from the point of view of composition and space.

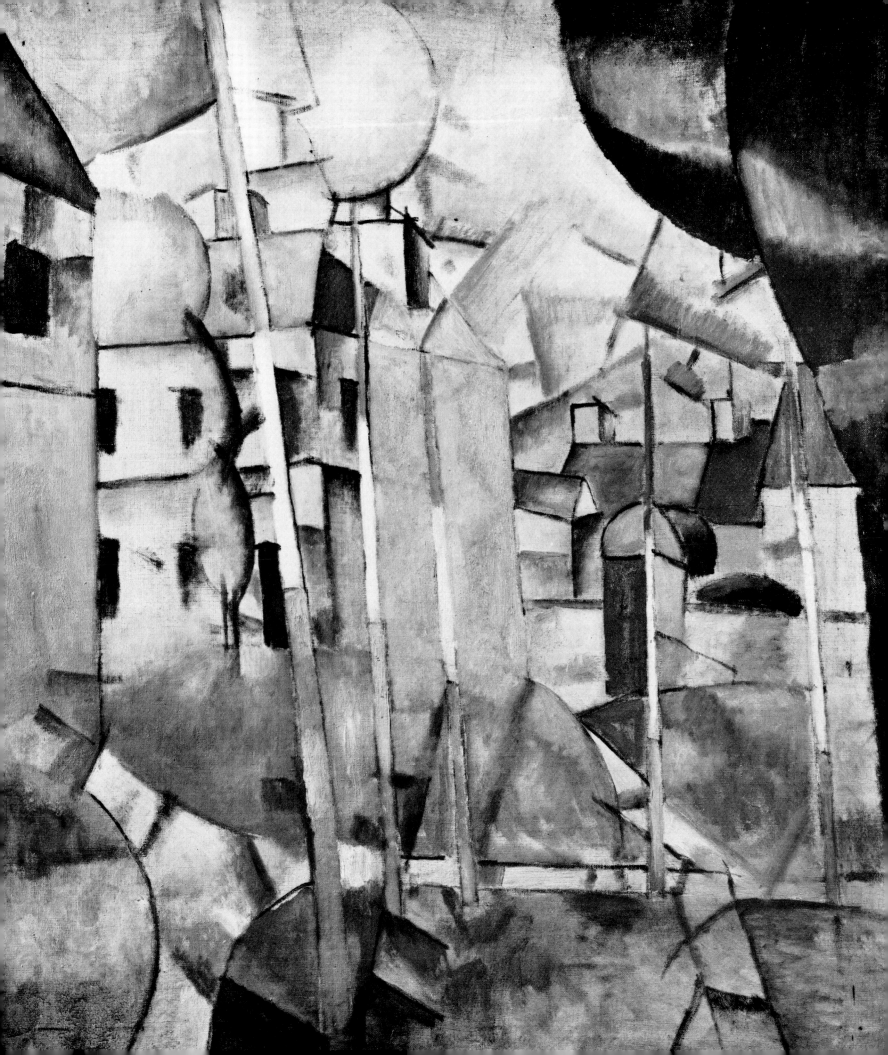

45. JUAN GRIS: *Still-life in front of an open window: Place Ravignan*, 1915. Oil on canvas, 116.5 ×99 cm. Philadelphia, Museum of Art (Louise and Walter Arensberg Collection).

Juan Gris was exclusively a painter of still-life pieces. This is one of his very few works in which a glimpse of landscape is seen beyond the prismatic composition in the foreground.

46. ALBERT GLEIZES: *Brooklyn Bridge*, 1915. Oil on canvas, 100 ×100 cm. New York, The Solomon R. Guggenheim Museum.

One of Gleizes' best known works, reflecting the strong impression made on him by his visit to America in 1915. The painting consists of an abrupt and syncopated connection of lines and planes, reproducing the structural tensions of the bridge in a highly abstract fashion. It also represents an aspiration towards the modernity of certain 'technological' landscapes—a tendency found in other Cubist painters.

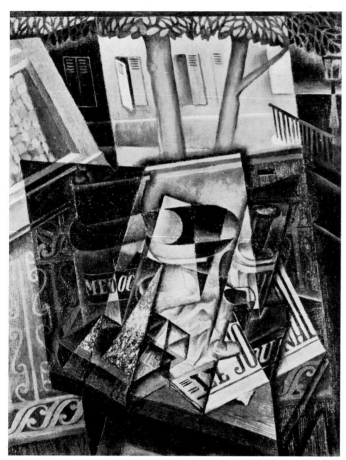
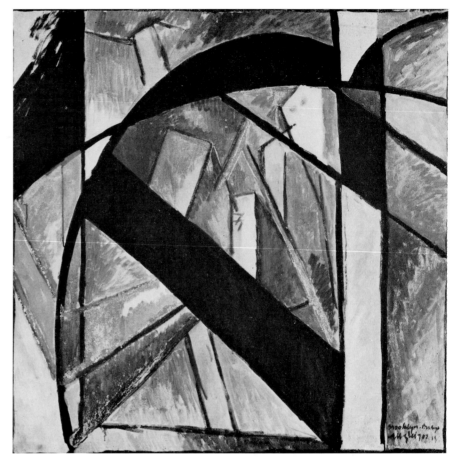

47. ALBERT GLEIZES: *Chartres Cathedral*, 1912. Oil on canvas, 67.5 ×57 cm. Hanover, State Gallery of Lower Saxony.

The majestic, composite forms of Chartres cathedral are here expressed in a complex representation, almost too openly based on Cubist principles and theory. The techniques of analysis and permeation are combined in a figurative system in which spaces too are embodied in planes, setting up a lively dialogue with the architecture. The rhythm is uneven, and the outlines do not in all cases correspond with those of the actual building.

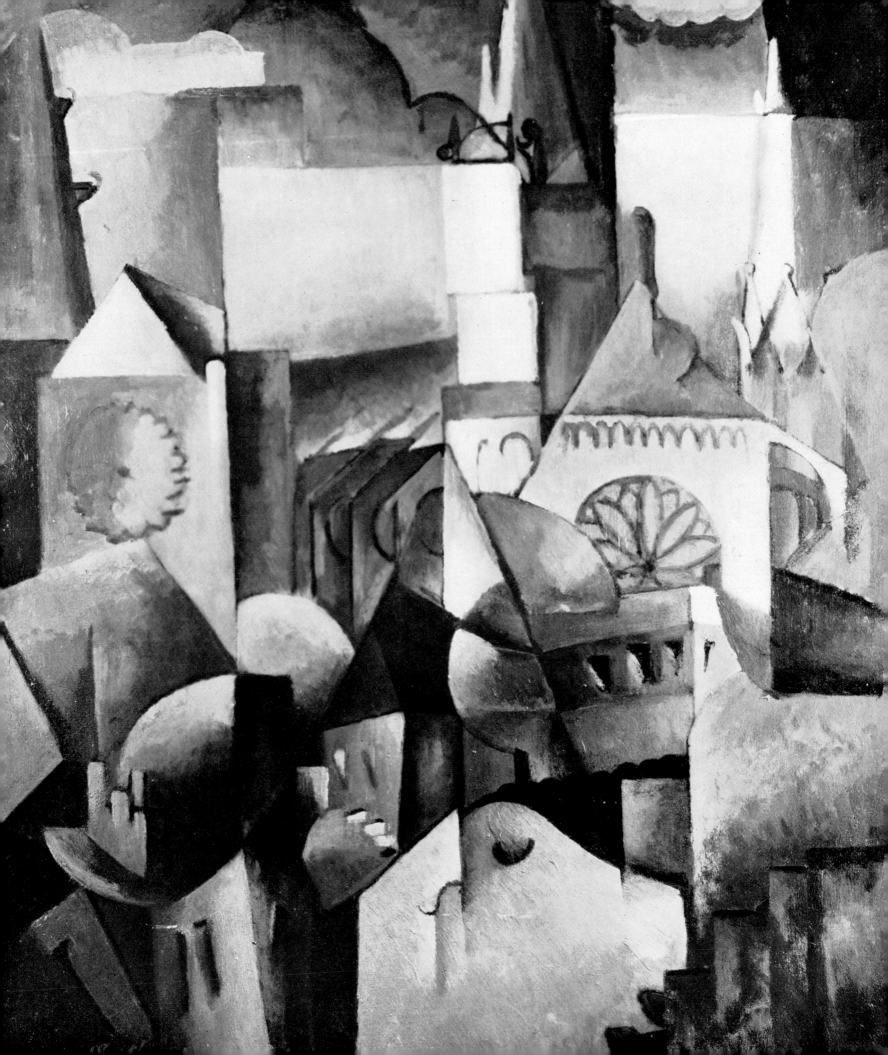

48. LOUIS MARCOUSSIS: *The Bar du Port*, 1913. Oil on canvas, 81 × 63 cm. Paris, Holicka-Marcoussis Collection.

The sign from which the painting takes its name is seen below in the centre. As is his custom, the artist has created a network of straight lines as a framework for his composition and a support for shapes which still bear a fragmentary resemblance to 'real life'. The reminiscence of Picasso or Braque is very clear, but does not disguise the artist's keen sensibility.

49. LYONEL FEININGER: *The bridge, I*, 1913. Oil on canvas, 78.5 × 98.5 cm. St. Louis, Missouri, Washington University.

One of Feininger's best known and most important paintings, showing his initial leaning towards Cubism and Futurism but also, in its three-dimensional quality, reminiscent of Expressionism: the latter movement, which the artist encountered when he was over thirty years old, played a part in the evolution of his personality. The meeting of influences is clearly seen in this picture, where the dynamism of forms is stabilized in a construction marked by insistence on the relation between large and small compositional features. Despite this element of calculation, the landscape has a character and verve of its own, typical of Expressionism not only in the field of painting but also in that of cinematography.

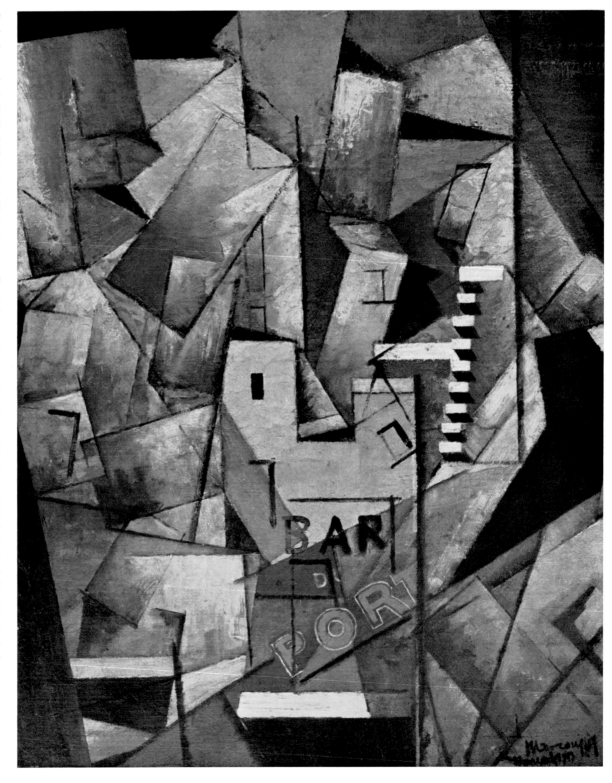

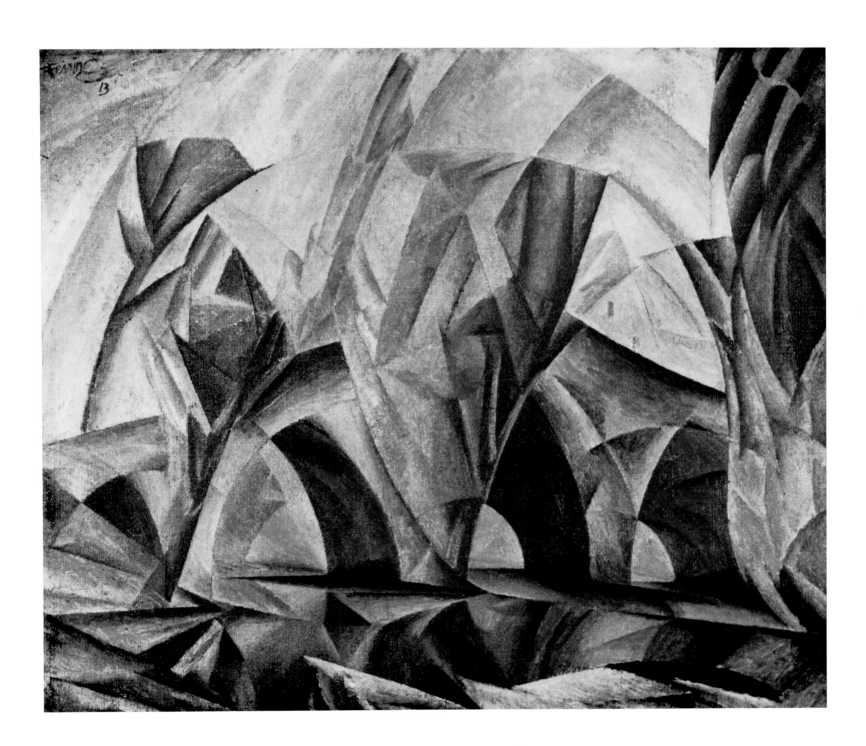

50. ROGER DE LA FRESNAYE: *Factory at La Ferté-sous-Jouarre*, 1911. Oil on canvas, 50 × 71 cm. Paris, Decorative Arts Museum.

Mindful of Cézanne's teaching, the artist's first contacts with Cubism were of a cautious nature. We see in this landscape the meeting-point of the two influences and also the foreshadowing of certain forms that were characteristic of de la Fresnaye's painting from 1912 onwards.

51. AUGUSTE HERBIN: *Banks of the Oise*, 1912. Oil on canvas, 60 × 73 cm. Otterlo, Kröller-Müller Museum.

Auguste Herbin is perhaps one of the most important of the minor Cubists. The negation of the figurative element and the reduction of the landscape to geometrical forms are a foretaste of the abstractionism to which Herbin was to remain faithful.

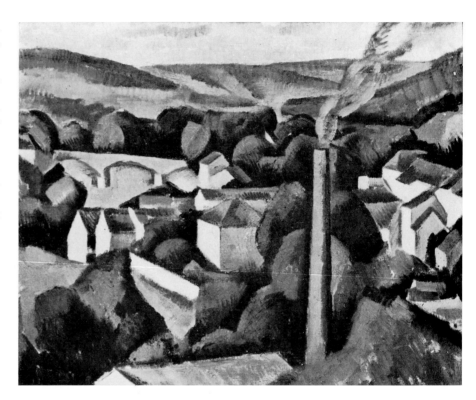

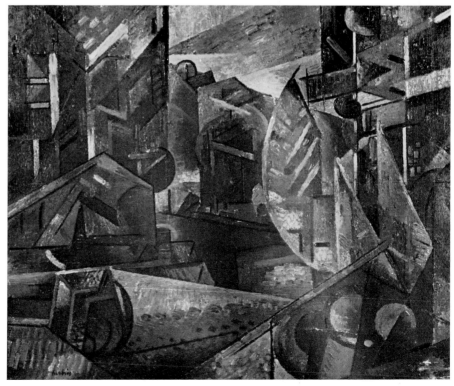

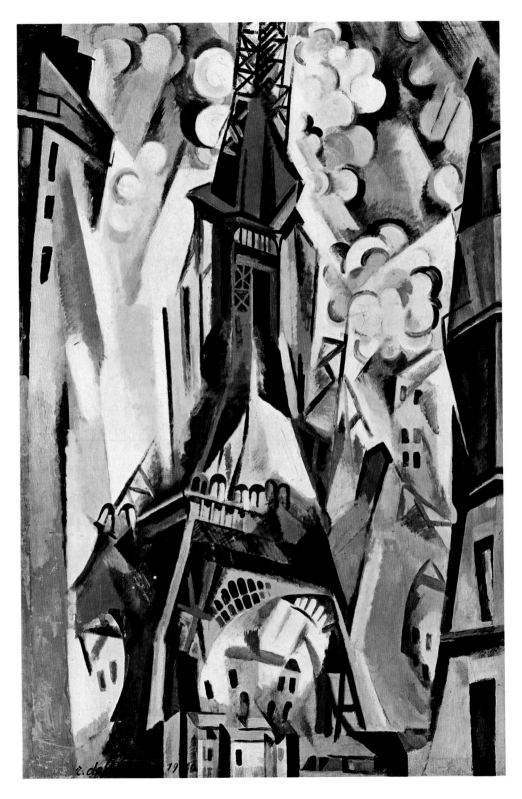

52. ROBERT DELAUNAY: *The Eiffel Tower*, 1910. Oil on canvas, 199.5 × 129 cm. Basle, Kunstmuseum.

One of several paintings of the Eiffel Tower executed by this artist around 1910. As this date indicates, he intervened at a propitious time in the debate which Braque and Picasso had set going not long before. However, Delaunay's work displays a permanent lyrical and emotive strain which is not found in his two predecessors. The profile of the tower, segmented and vibrating upwards, is balanced and echoed by the surrounding urban landscape and the clouds that envelop its summit.

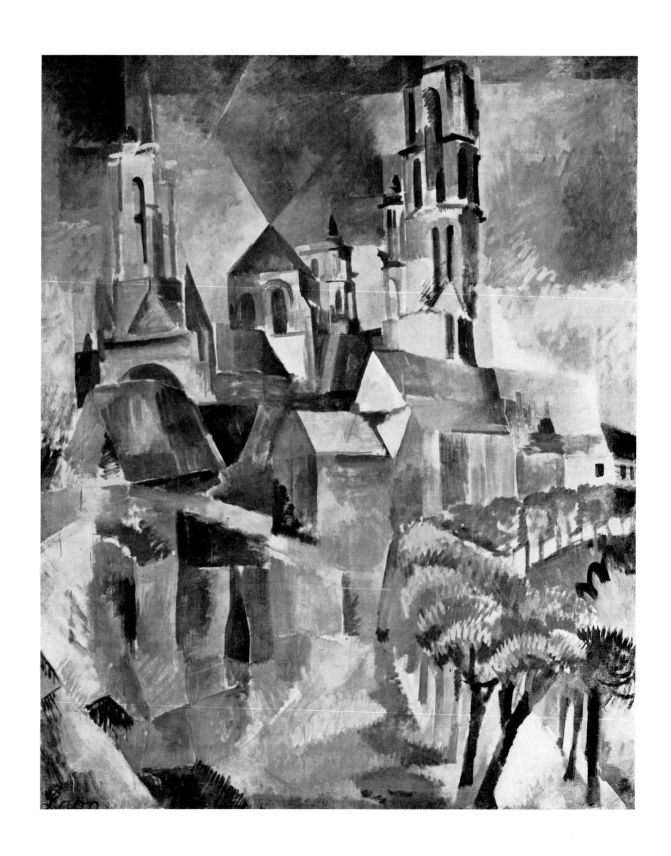

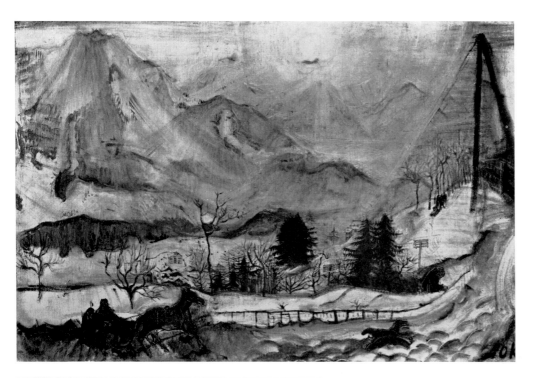

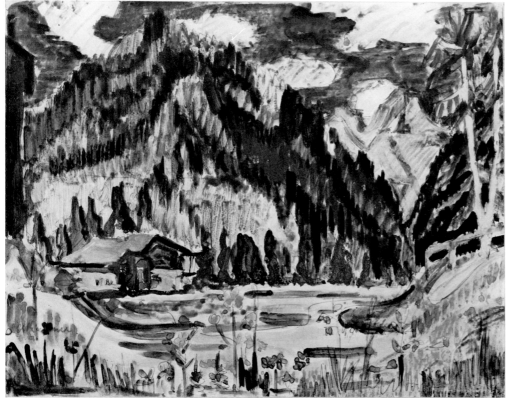

53. ROBERT DELAUNAY: *The towers of Laon*, 1911. Oil on canvas, 162 × 130 cm. Paris, National Museum of Modern Art.

Despite some elements of naturalism we find in this picture the regular network of Cubist planes which forms the basis of the artist's monumental *City of Paris*, exhibited at the Salon des Indépendants in 1912 and described by Rosenblum as a 'sort of museum of Cubism'. The upsurge of the *Eiffel Tower* is here somewhat diminished. Soon afterwards, however, Delaunay painted the *Premier Disque*, which only remotely recalls Cubist themes.

54. OSKAR KOKOSCHKA: *Les Dents du Midi*, 1909–10. Oil on canvas, 80 × 116 cm. Zürich, Marianne Feilchenfeldt Collection.

An astonishing landscape by the young Kokoschka, recalling the incisive delicacy of his early portraits. The extensiveness of the visual field is similar to that which we find in other panoramic studies by this artist, up to quite recent years. Towards the foreground of the spacious and airy scene, various features are depicted in careful detail, but they too are separated from us by the effect of perspective.

55. ERNST LUDWIG KIRCHNER: *Mountain landscape*, 1923. Watercolour, 35.5 × 46 cm. Frankfurt, Städel Art Institute.

Kirchner shows much sensitivity to landscape, especially during the middle period of his activity. He does not copy its features closely, but uses extreme simplification and the repetition of certain themes to express its spirit, as in this view of a mountain seen across a short patch of flat ground, and rising to the top of the canvas.

56. ERNST LUDWIG KIRCHNER: *The Red Tower at Halle*, 1915. Oil on canvas, 120 × 92.5 cm. Essen, Folkwang Museum.

An excellent example of Kirchner's angular style and fondness for distortion. All the lines of perspective are falsified and the planes tilted as if seen through a distorting lens. In the lower part of the canvas there is a curious empty space, within the angle formed by the two streets, in front of the Tower, whose pinnacle stands out against the bright clouds.

57. KARL SCHMIDT-ROTTLUFF: *Sandbanks at low tide*, 1912. Oil on canvas, 76 × 84 cm. Düsseldorf, Kurt Forberg Collection.

This 'seascape' is a good example of Schmidt-Rottluff's sensitivity to landscape: a dark, obsessive chromatic tension is imposed on a clearly Fauvist theme. The sea and sky are red and the sands dark blue: the whole picture consists of a synthesis of these tones, charged with the fullest possible significance.

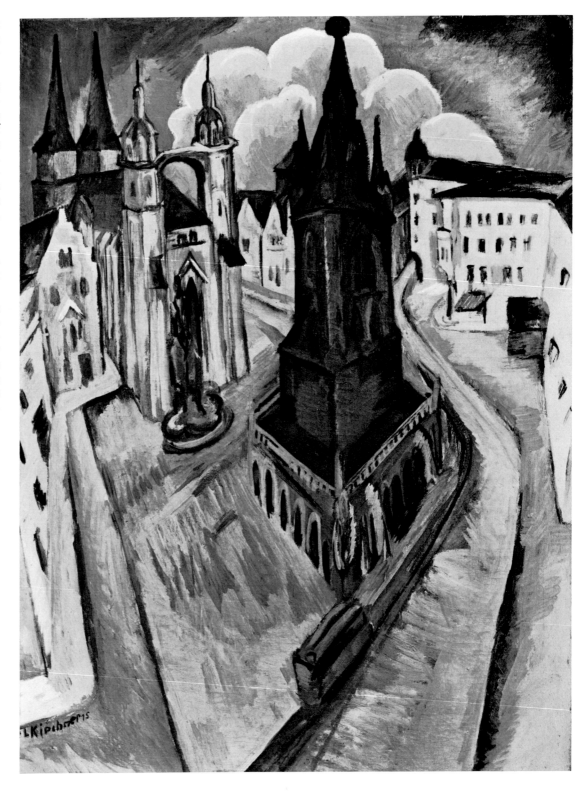

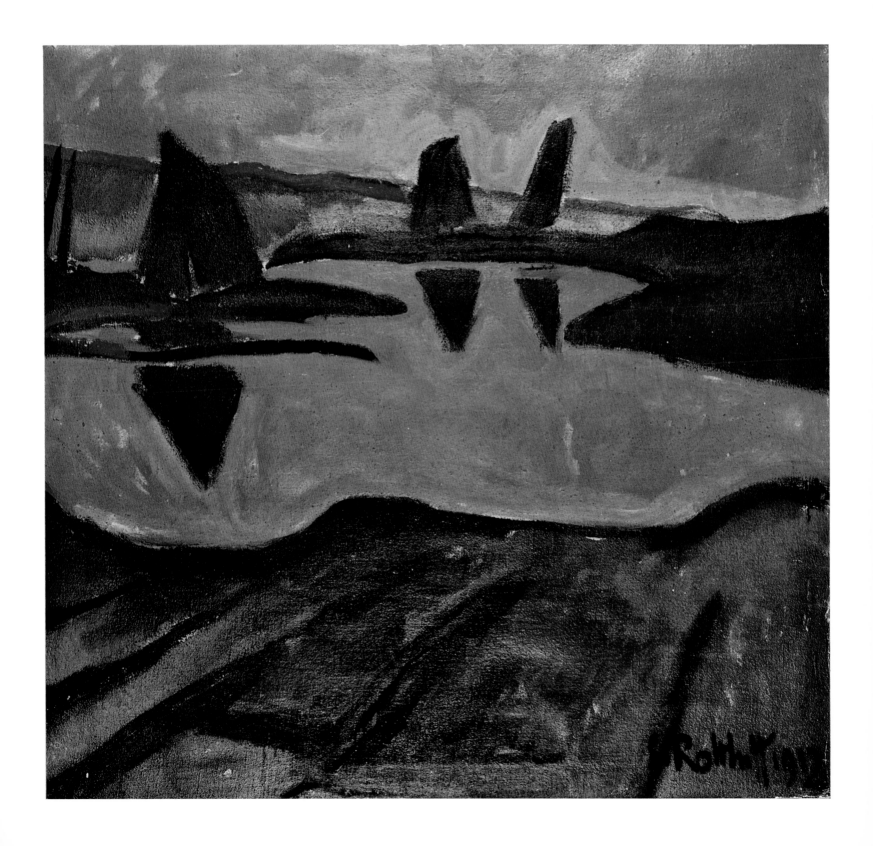

58. KARL SCHMIDT-ROTTLUFF: *Moonrise*, 1919. Oil on canvas, 87 × 95 cm. Berlin, National Gallery.

Another landscape by Schmidt-Rottluff showing his disdain for careful finish and for all that is accessory or merely picturesque. Lack of precision in execution, loose ends and irregularities, hardness and lack of symmetry—all this remains visible as a testimony to the expressiveness of the painter's intentions.

59. ERICH HECKEL: *Village in Saxony*, 1910. Oil on canvas, 70 × 82 cm. Wuppertal, Municipal Museum.

Another explosion of colour—the road is bright red, contrasting with the more or less strong green of the fields; patches of red and deep yellow stand out at various points. This landscape was painted by Heckel shortly before his Berlin period of romantic symbolism with primitive overtones. The brushwork is rapid and free from afterthoughts.

60. KARL SCHMIDT-ROTTLUFF: *Forest*, 1921. Oil on canvas, 112 × 97 cm. Hamburg, Kunsthalle.

From 1920 onwards Schmidt-Rottluff begins, though sparingly, to admit some decorative elements, such as are seen in this picture, though here too the keynote is simplicity of delineation. The road in the centre extends for a short distance towards the background; on either side of it the scene is closed by the tall, slightly inclined trees and thick clumps of lesser vegetation.

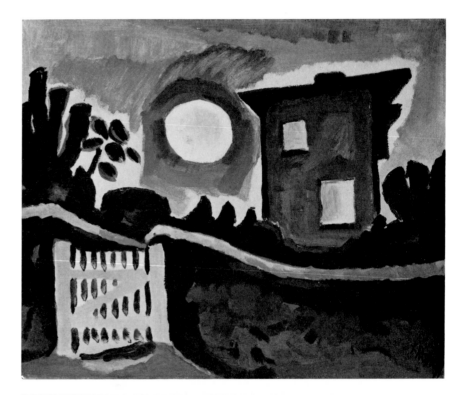

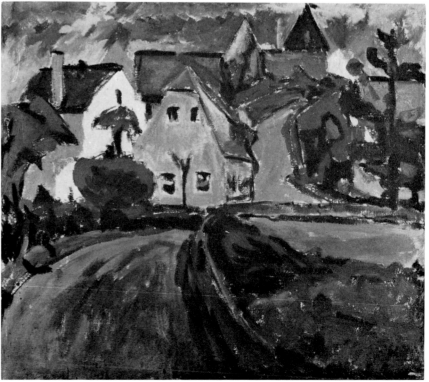

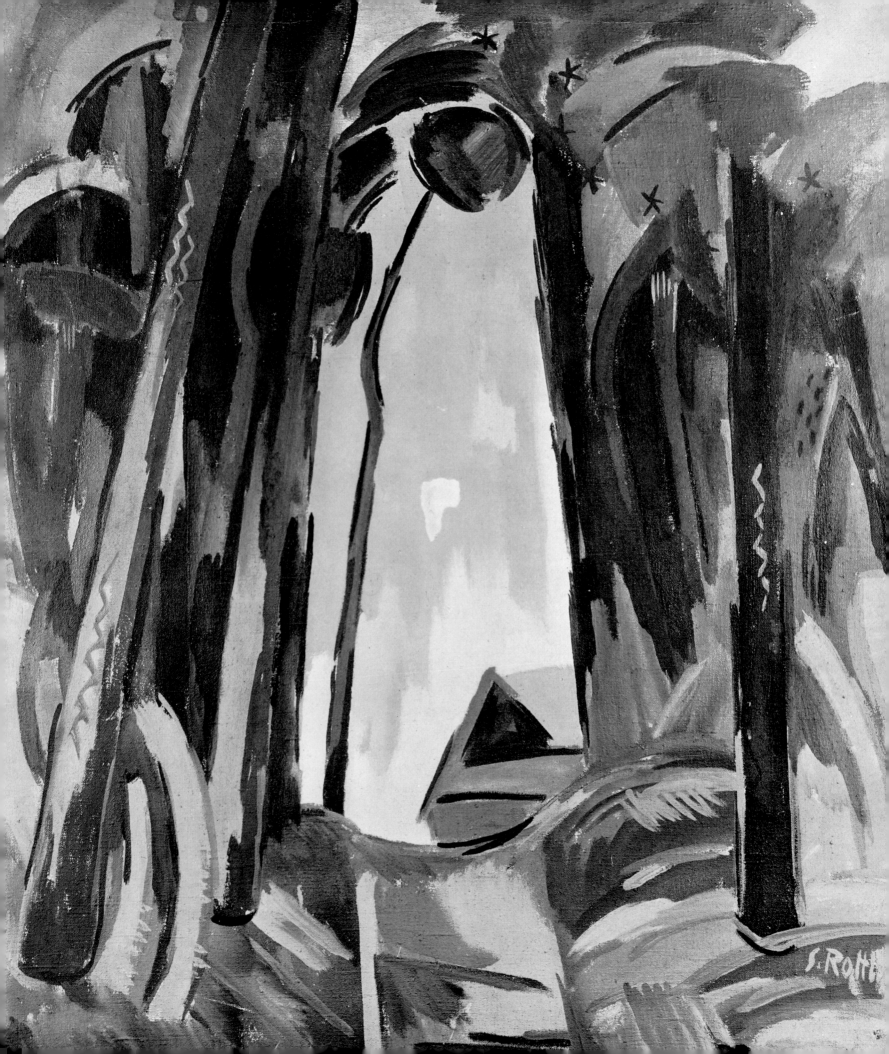

61. ERICH HECKEL: *Pyrenean landscape*, 1939. Oil on canvas, 98 × 111 cm. Munich, Bavarian State Art Collections.

A picture belonging to the artist's late period, marked by closer observation and sympathy for nature. The deep ravine, bordered by precipitous crags, winds towards the mountain pass imagined in the background. The tiny figures of two riders are seen on the path half-way up the face of the cliff.

62. ERICH HECKEL: *House at Dangast*, 1908. Oil on canvas, 72 × 81 cm. Lugano, Thyssen Gallery.

An early work, closely reminiscent of Plate 59. However, the composition is even more simple and uniform, and the road with the two confining walls occupies nearly the whole lower half of the canvas. The long continuous brush-strokes show acquaintance with the work of Van Gogh.

63. OTTO MÜLLER: *A sunny day*, 1921. Oil on canvas, 80 × 98 cm. Berlin, National Gallery.

It was one of Müller's most constant objectives to achieve a closer correlation, almost a permeation, between figures and their surroundings, as manifestations of a common principle of innocent, virginal life. While remaining close to his fellow-artists of the *Brücke*, Müller preserves his own delicate, introspective talent in scenes like the present one, which is perhaps the most happily lyrical of its kind.

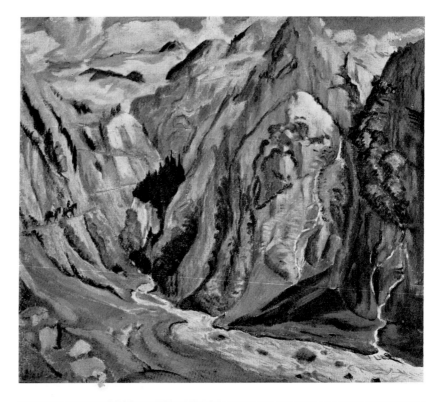

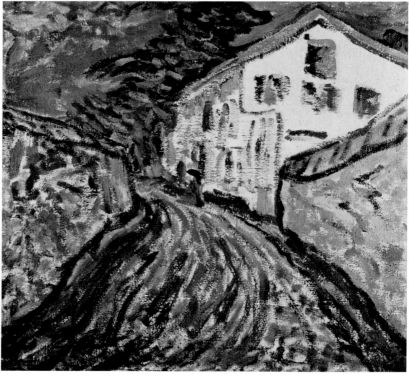

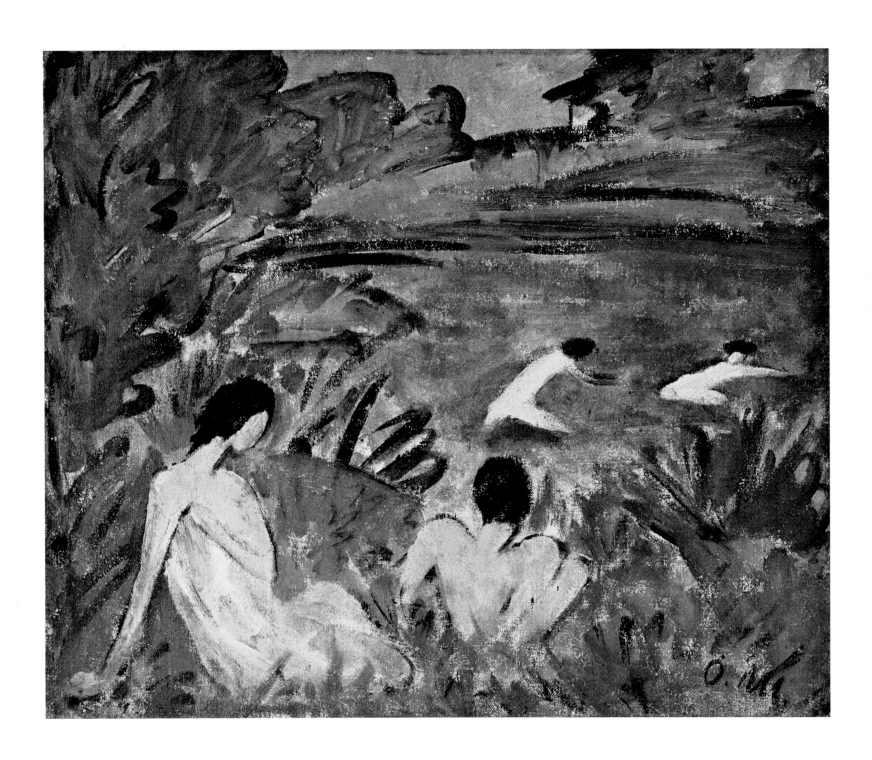

64. MAX BECKMANN: *Landscape with a balloon*, 1917. Oil on canvas, 75.5 × 100.5 cm. Cologne, Wallraf-Richartz Museum.

An unusual painting by this artist, whom some regard as one of the chief representatives of twentieth-century German art. It recalls the sense of loneliness that we find in Rousseau and there is a suggestion of Munch in the way in which the road stretches towards the spectator and in the tiny figure with the parasol, as well as the accentuated curves. From this period onwards, Munch's work was indeed of fundamental importance to Beckmann.

65. MAX PECHSTEIN: *The port*, 1922. Oil on canvas, 80 × 100 cm. Amsterdam, Municipal Museum.

Because of the lack of open and violent expressions of feeling in Pechstein's work he is usually thought of as one of the less Expressionistic members of the *Brücke* group, though he had a share in popularizing their ideas. The present work shows a fine clarity of composition and a range of colour worthy of the Fauves. The episodic features are grouped on diagonals to one side of the canvas, while combination and contrast are afforded by the empty central space.

66. EMIL NOLDE: *Marshy landscape*, 1916. Oil on canvas, 73.5 × 100.5 cm. Basle, Kunstmuseum.

One of Nolde's masterpieces, displaying with the greatest clarity his exalted fantasy and tragic conception of nature. The artist has no need to 'construct' a landscape from a variety of elements and episodes: he merely shows us a large sky lowering over a watery surface, with menacing clouds reddened by the setting sun. As he said of his youthful period, 'I saw the sky and the great clouds, and they were my friends.' In this marshland scene there is perhaps more than a vague reminiscence of the native village whose name he took for his own.

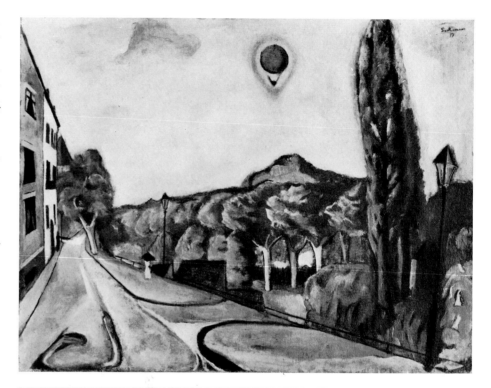

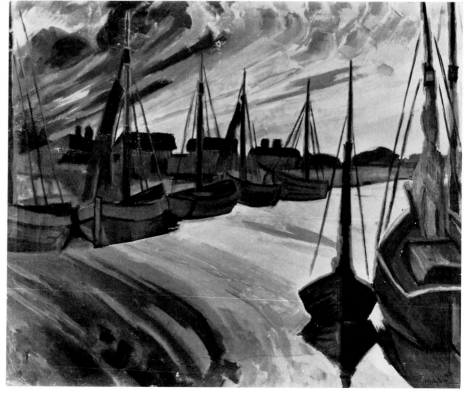

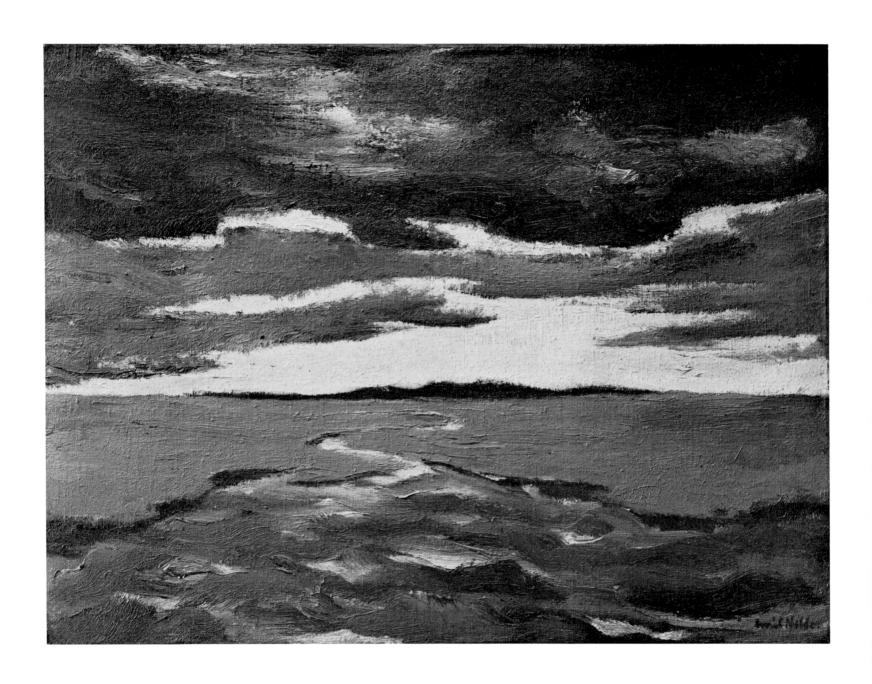

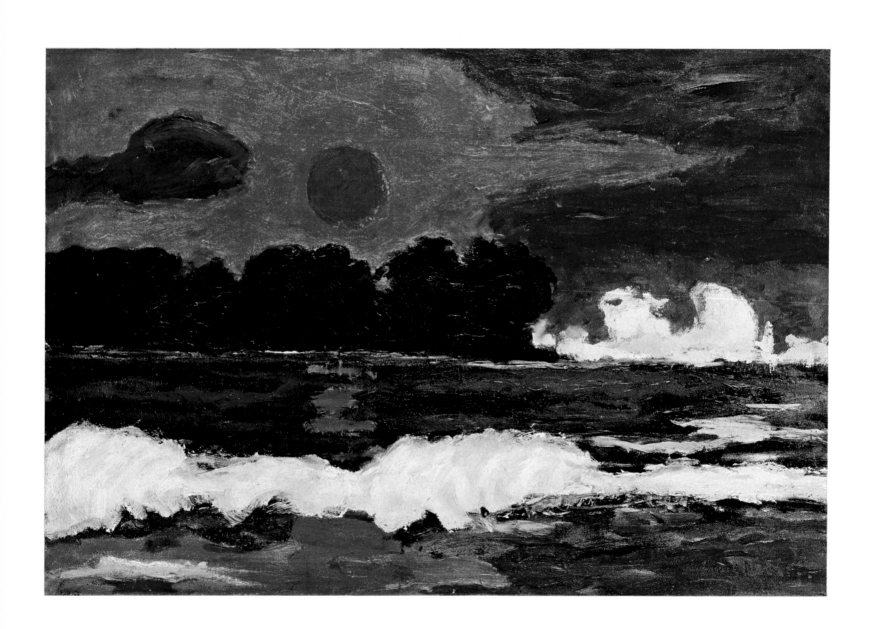

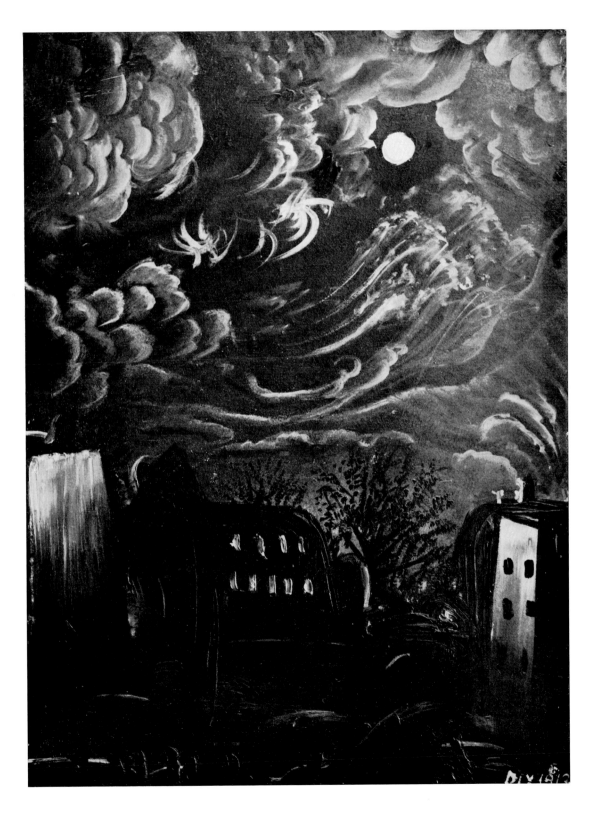

67. EMIL NOLDE: *Tropical sun*, 1914. Oil on canvas, 70 × 106 cm. Seebüll, Ada and Emil Nolde Foundation.

In 1913–14 Nolde travelled to New Guinea, and this 'seascape' gives a good idea of what he sought and found there. The world of passion and barbarism stands revealed in all its primeval force, and we can see why Klee called Nolde a 'demon of the infernal regions'. Works such as this display his simple and intense humanity without restraint, unless it be the limit imposed by his own violent and aggressive nature. Here as always, his art strikes home and disturbs us.

68. OTTO DIX: *Landscape*, 1913. Oil on canvas, 65 × 50 cm. Rome, Iginio Sambucci Collection.

More alarming than dangerous, a huge sky animated by clouds in the form of strange creatures overhangs the earth plunged in shadow. The picture is a foretaste of developments that came to fruition after the First World War, in a great variety of directions and purposes.

69. WASSILY KANDINSKY: *Street in Murnau with a woman*, 1908. Oil on cardboard, 33 × 45 cm. Paris, Nina Kandinsky Collection.

Kandinsky spent many weeks at Murnau in and after 1908. This painting is one of those in which he seems to have finally achieved the peace of mind that he sought so anxiously. This and other works of the same period show a great wealth and effervescence of colour, a sonorous alternation composed of multiple touches and heightened contrasts.

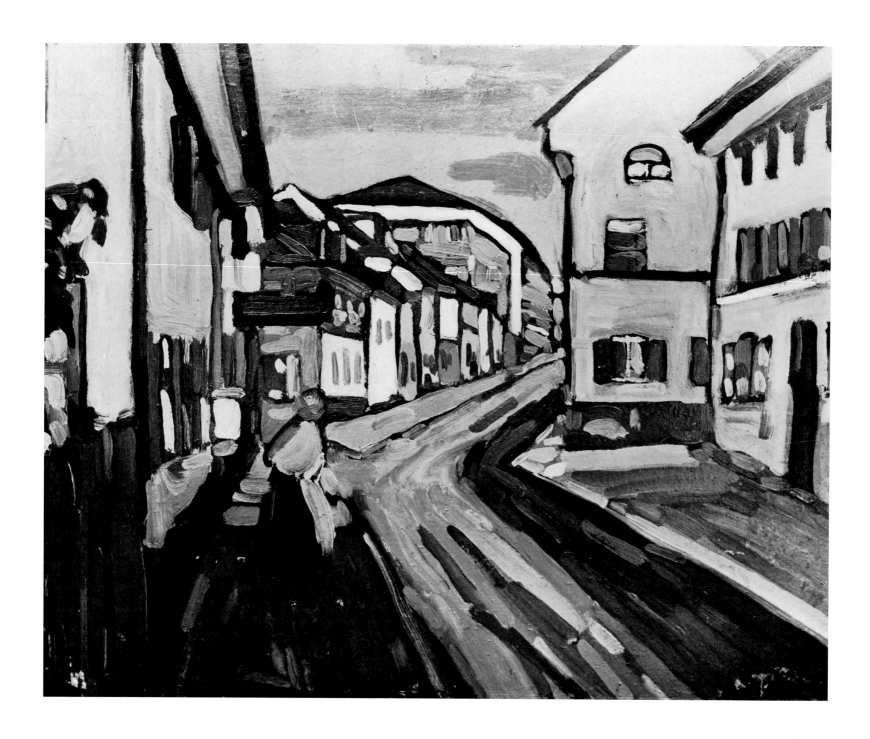

70. FRANZ MARC: *Tyrol*, 1913–14. Oil on canvas, 136 × 148 cm. Munich, Bavarian State Art Collections.

At the end of 1913 and the beginning of 1914 Franz Marc, who was killed in the war two years later, began to introduce strong abstract elements into his work, of which this large landscape is one of the chief examples. As he expressed it, 'Our passion is no longer to spend itself in sentiment, but to impose a formal discipline on objects by means of thought-out, significant images revealing to our astonished eyes the newly apprehended laws of the physical world.'

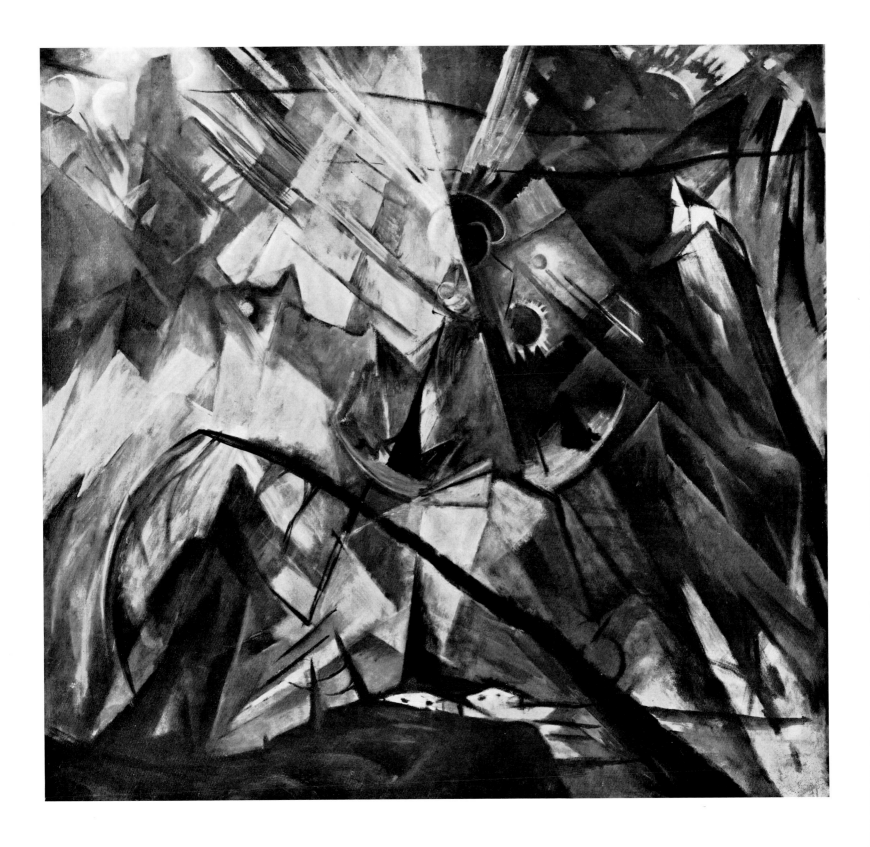

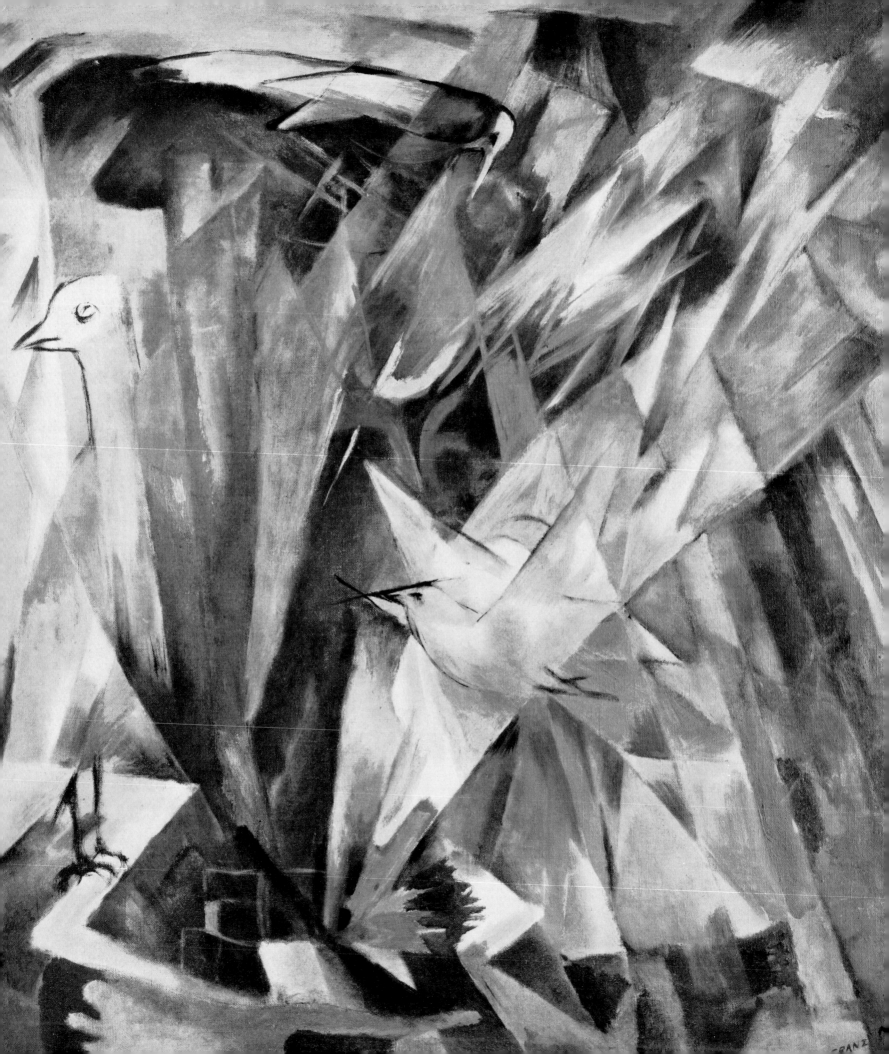

71. FRANZ MARC: *Birds*, 1913–14. Oil on canvas, 110 × 110 cm. Goteborg, Victor Hasselblad Collection.

The imaginary birds that compose the painting are absorbed into an unbroken succession of beams of light and colours which separate and recombine, suggesting for all their magic and mystery a perfect natural order. In this artist's work animals and things of every kind form an indissoluble unity composed of colour and light.

72. WASSILY KANDINSKY: *Landscape with church*, II, 1913. Oil on canvas, 114 × 135 cm. Venice, Peggy Guggenheim Collection.

There are two almost identical versions of this picture, both painted in 1913—a year of importance for Kandinsky as for other pre-war artists. They are among his last figurative works: a year later he gave up depicting objects altogether, a development for which he had been preparing the way for a considerable time. Even in the present painting, despite the exactitude of its title, the analogy between real and pictorial forms appears faint and inconsistent.

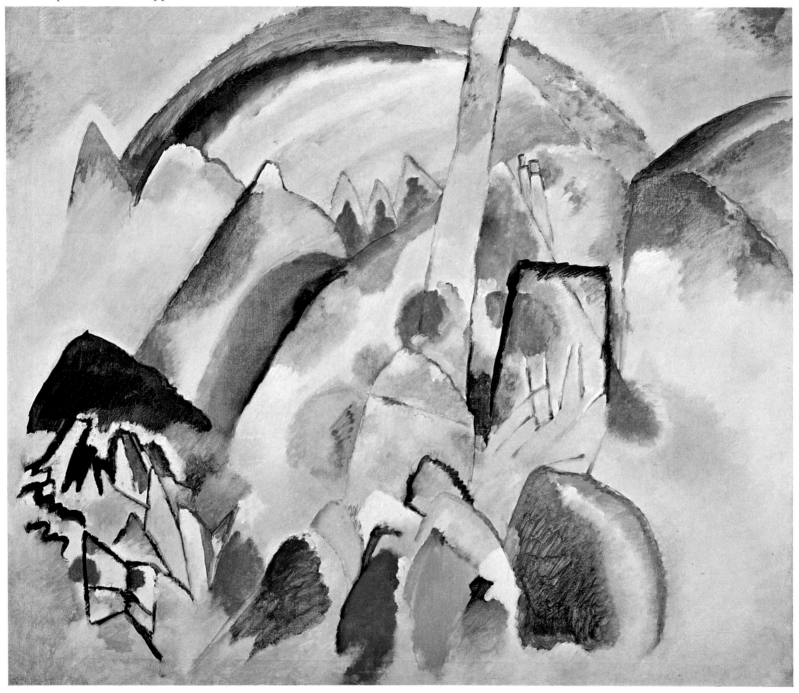

73. OSKAR SCHLEMMER: *Houses in brown tones*, 1913–14. Oil on canvas, 58.5 ×45 cm. Stuttgart, Tut Schlemmer Collection.

In the precise relationship and harmony of its parts, this work is a good example of Schlemmer's early adherence to the principle, to which he remained faithful, of reducing to a single spiritual order the world of living, organic reality and the world of geometry. There is only a slight anticipation of the 'purism' of his later years.

74. AUGUST MACKE: *Woman looking at hats in a shop window*, 1914. Oil on canvas, 60.5 ×50.5 cm. Essen, Folkwang Museum.

A pleasant picture with a bright, limpid, festive colour-scheme. Macke was fond of creating a psychological link between a human figure and the object of its interest—in this case the many-coloured window full of hats and faintly reminiscent of the influence of Delaunay. He returned more than once to this subject, offering as it did such opportunities in the field of colour.

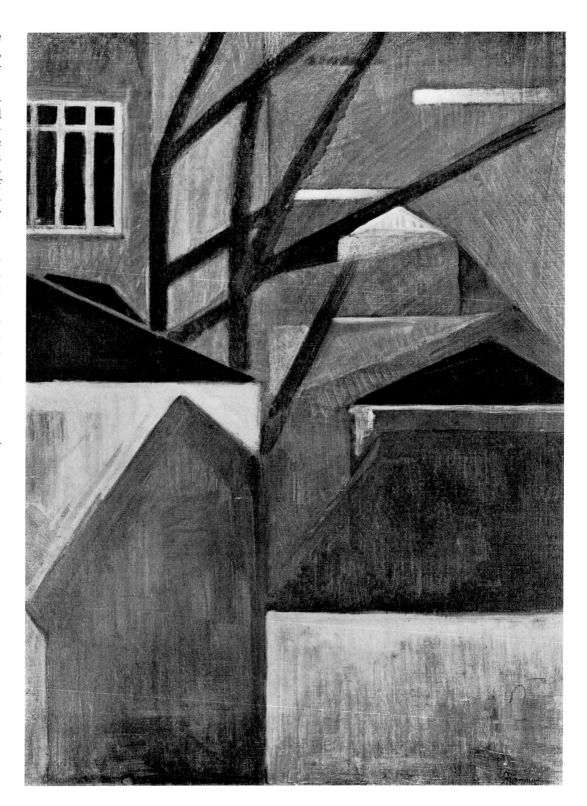

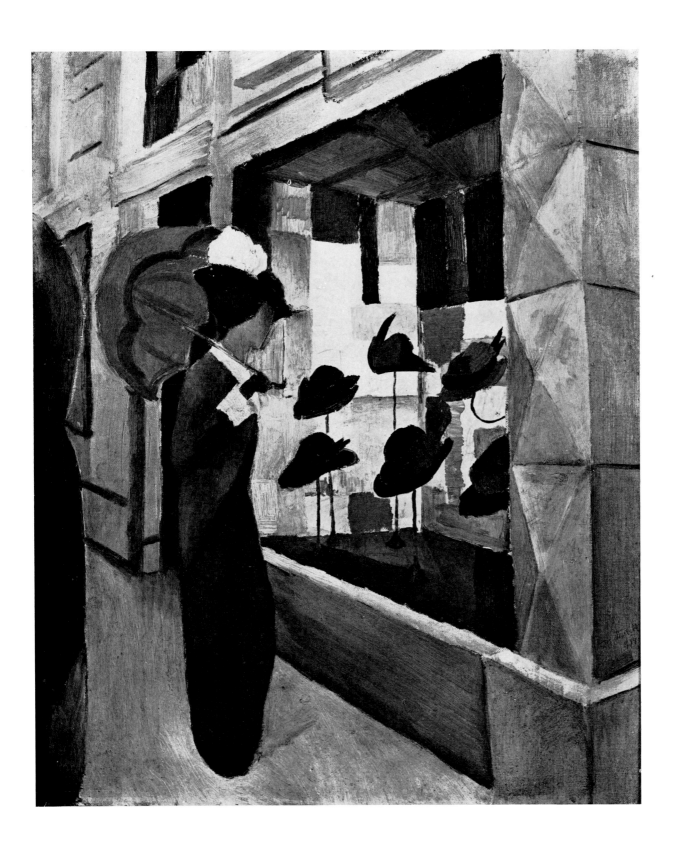

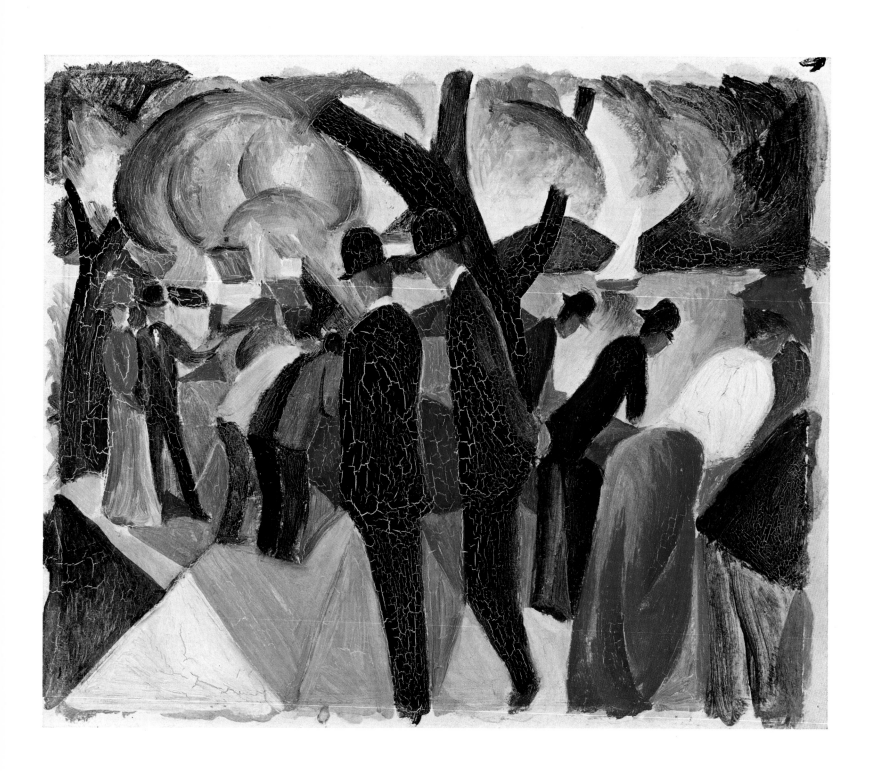

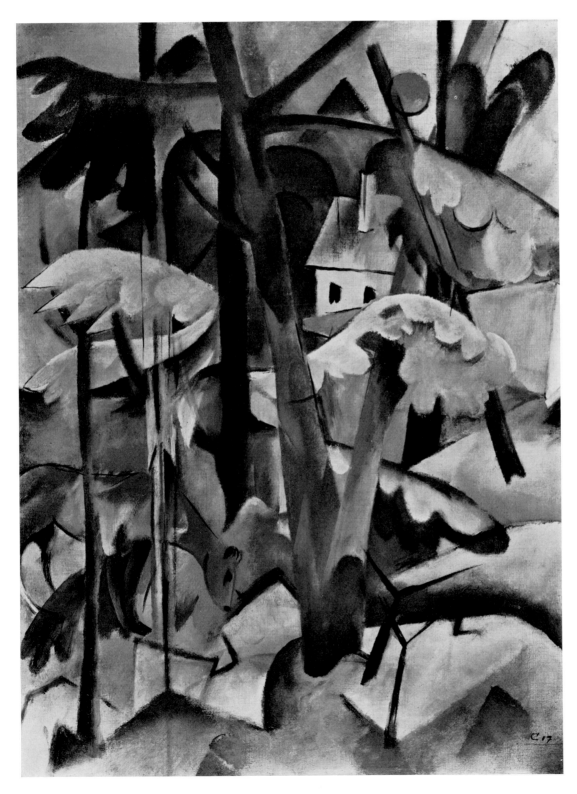

75. AUGUST MACKE: *Promenade on a bridge*, 1913. Oil on cardboard, 51 × 57 cm. Munich, Municipal Gallery.

The picture shows elegant figures strolling under the trees of a park or leaning over the parapet of a bridge. It gives the impression of an attempt on the artist's part to create a synthesis between the precepts of Cubism and the Fauves' free use of colour. Macke's relationship to Marc is also clear, though the atmosphere of this scene is very different from the obscurity and secrecy of the other's work.

76. HEINRICH CAMPENDONK: *Roebuck in a forest*, 1913. Oil on canvas, 67.5 × 50 cm. New York, Private Collection.

The influence of Marc on this scene goes beyond the analogies of subject and form that may be discerned in it. At the same time it is marked by an ingenuous, fairy-tale simplicity reminiscent of Rousseau, so that Campendonk may be thought of as the latter's German counterpart.

77. EGON SCHIELE: *Four trees*, 1917. Oil on canvas, 100 × 140.5 cm. Vienna, Austrian Gallery.

This landscape, drawn with an almost harsh incisiveness, is based on a precise correspondence and symmetry between its parts. The delicacy of the drawing is suggestive of the young Kokoschka, but we are also reminded of Hodler's regular rhythms.

78. EGON SCHIELE: *Town's end*, 1918. Oil on canvas, 109.5 × 140 cm. Graz, Joanneum Provincial Museum.

The bird's-eye view enables the artist to dwell lovingly on the fragmented roofs and gables, walls and windows of what seems less like a 'suburb' than an integral part of some isolated township.

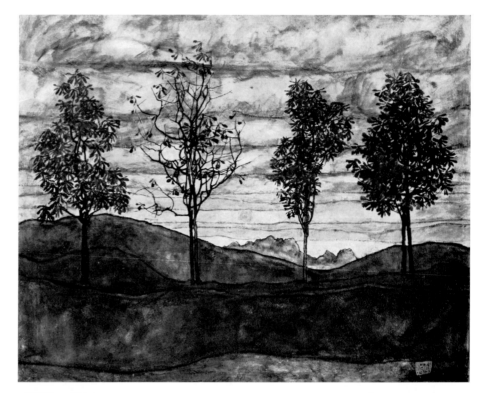

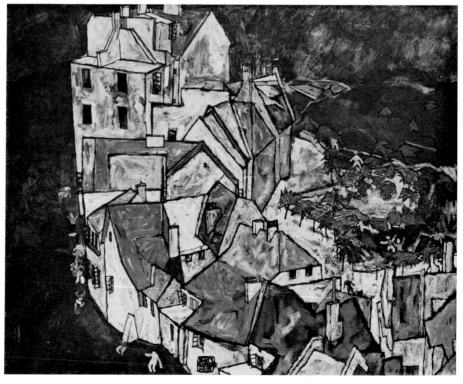

79. UMBERTO BOCCIONI: *Suburban scene*, 1908. Oil on canvas, 75 × 145 cm. Milan, Italian Commercial Bank.

One of Boccioni's most interesting works as a Divisionist and forerunner of Futurism and closely related to the following illustration. The spacious scene viewed from above, and the light which glides over the planes throwing long shadows, give the artist an opportunity to cover the canvas with light, innumerable specks of colour.

80. UMBERTO BOCCIONI: *Morning*, 1909. Oil on canvas, 60 × 55 cm. Milan, A. Mazzotta Collection.

Despite the Divisionistic uniformity of the colour-pattern, there is a deep sense of naturalism in this wide landscape, cut in two by a strong diagonal as was the artist's custom. The artist's use of perspective is bold and insistent, with the same rapid, legible quality that we find in the slanting lines of some of his other pictures.

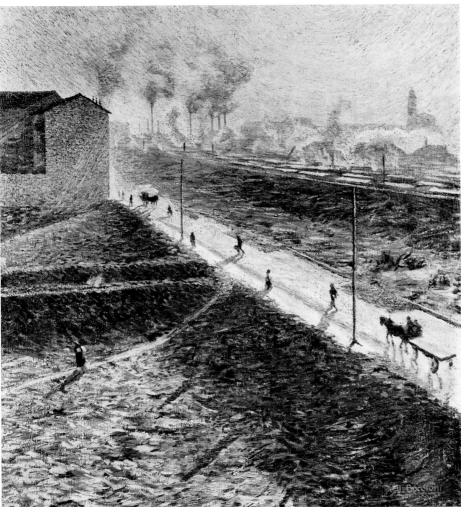

81. UMBERTO BOCCIONI: *Simultaneous visions*, 1911. Oil on canvas, 100 × 100 cm. Hanover, State Gallery of Lower Saxony.

An over-elaborate composition but an effective confrontation of diverse, almost antithetical styles. There is an unmistakable force in this urban landscape with the factory yard and a large figure in the centre, with smaller ones to the left and right of it.

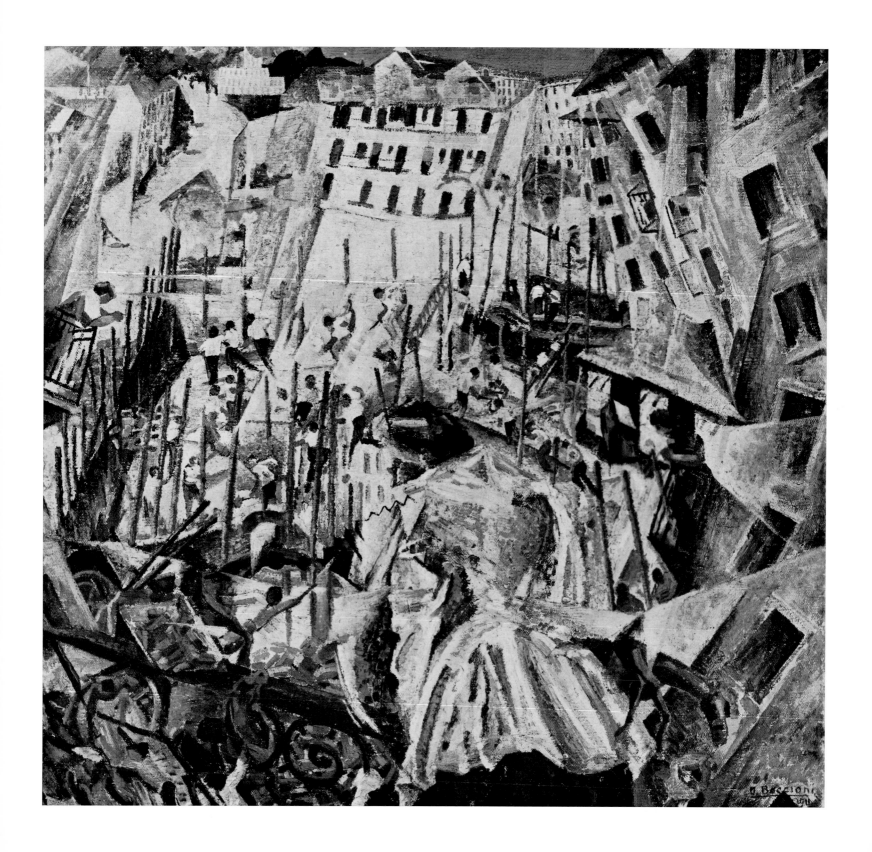

82. UMBERTO BOCCIONI: *Landscape*, 1916. Oil on canvas, 33 × 55 cm. Milan, Mattioli Collection.

In 1916 Boccioni was in Milan, on leave from the army. His energetic life was to come to an end a few months later. This landscape represents an integral re-thinking of the artist's task: it is clear that he has paid attention to Cézanne, while there are only sporadic indications of Futuristic forms. The picture is fresh, lively and unburdened by intellectual schematization.

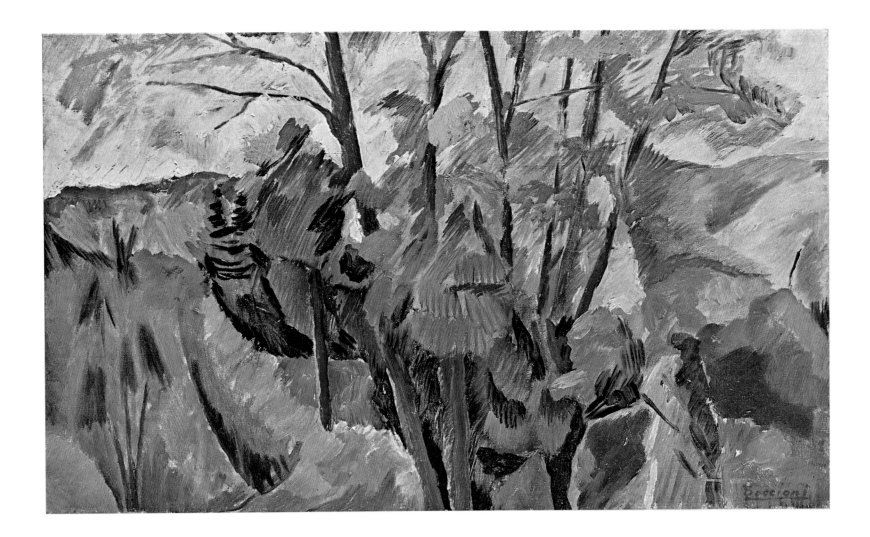

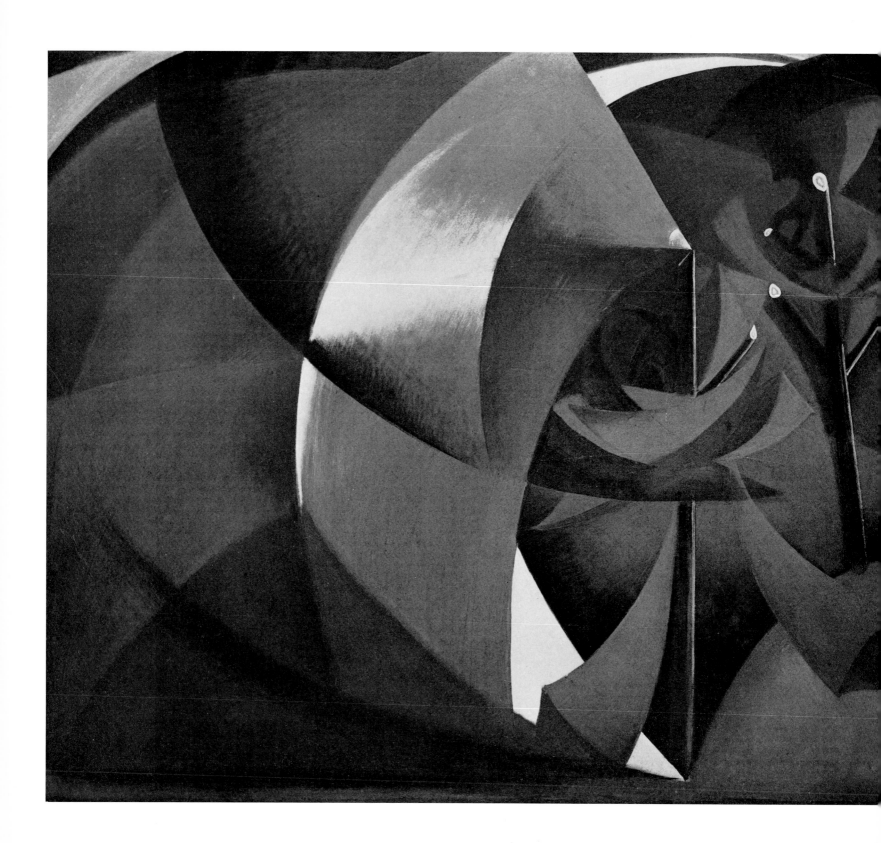

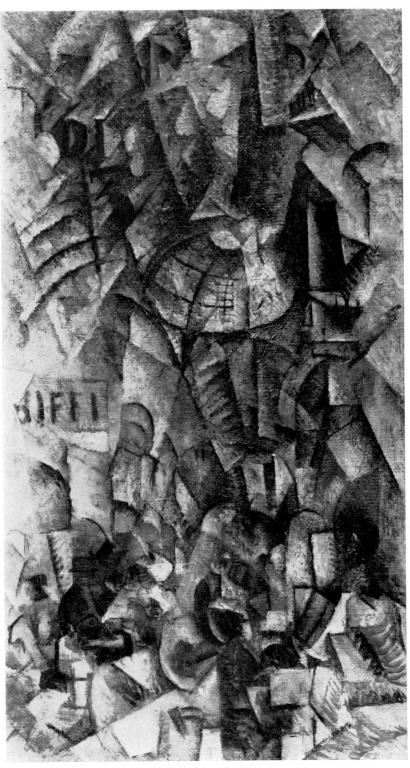

83. GIACOMO BALLA: *Mutilated trees*, 1918. Oil on canvas, 175 × 113 cm. Rome, Campilli Collection.

The recognizable shape of tree-trunks entitles us to consider as a landscape this composition of Balla's, which both recalls and anticipates certain round or curved motifs that are typical features of his style. The deep, warm shades of green give a sense of direct contact with reality.

84. CARLO CARRÀ: *The Milan Gallery*, 1912. Oil on canvas, 51.5 × 91 cm. Milan, Mattioli Collection.

A well-known painting and a fine specimen of Carrà's Futurism, essentially 'dynamic' in the impression of movement conveyed by the innumerable faceted objects of which it is composed. The dome of the Gallery in the centre of the canvas is scarcely discernible amid the tangle of uncoordinated lines and planes in precarious equilibrium.

85. GINO SEVERINI: *The Nord-Sud Métro line*, 1912. Oil on canvas, 49 × 64 cm. Milan, Emilio Jesi Collection.

In 1912 Severini painted a series of compositions (for example, *The motor-bus*) designed, as he explained, 'to convey by means of lines and planes the rhythmic sensation of speed, spasmodic motion and deafening noise.' The irregular arrangement is broken up still further by the station-signs, which afford repeated pretexts and stimuli from the compositional point of view.

86. GINO SEVERINI: *The boulevard*, 1910. Oil on canvas, 65 × 92 cm. London, Tate Gallery.

A rich, bright, kaleidoscopic feast of colour uniting figures, buildings and trees in a single happening, like 'a Bruegel fantasy in twentieth-century terms'. This forward-looking work with its very personal message is characterized by refinement, balance and order transcending the apparent brittleness of the composition.

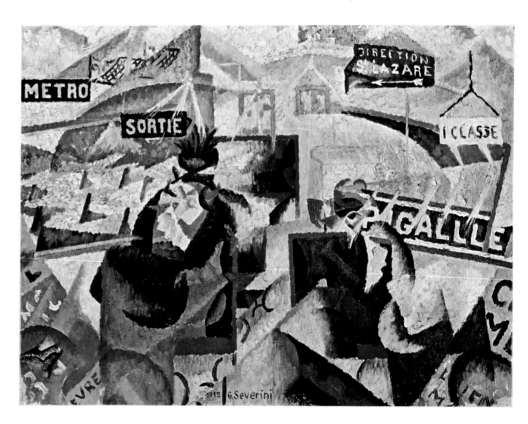

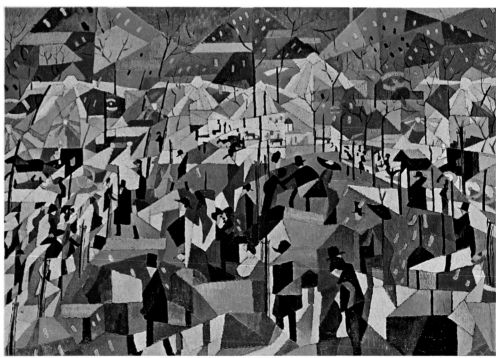

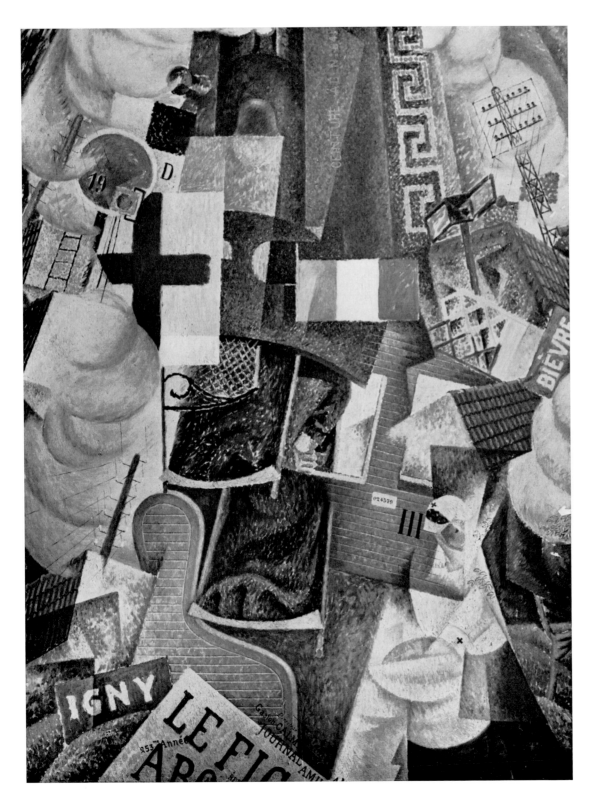

87. GINO SEVERINI: *Hospital train*, 1915. Oil on canvas, 117 × 90 cm. Amsterdam, Municipal Museum.

Apart from studies and preparatory drawings, Severini executed another war painting in 1915, entitled *The armoured train*. This concentrated attention on the 'section' of the train as seen from above, while in the present picture the landscape, signboards, symbols and objects are fragments of a composition co-ordinated from top to bottom of the canvas by means of diagonal lines, converging or diverging as the case may be.

88. C.R.W. NEVINSON: *The Arrival*, about 1914. Oil on canvas, 76 × 63.5 cm. London, Tate Gallery.

After painting some Cubist pictures, Nevinson became a Futurist in Paris, where he had come into contact with Picasso. The present work is a combination of forms and elements that are easily recognized: it is not a question of analysis but rather of fragmentation and juxtaposition. Keels, funnels, cranes, rigging, gratings, railings, waves and billowing smoke—all these are merged and interlocked in a somewhat mechanical system.

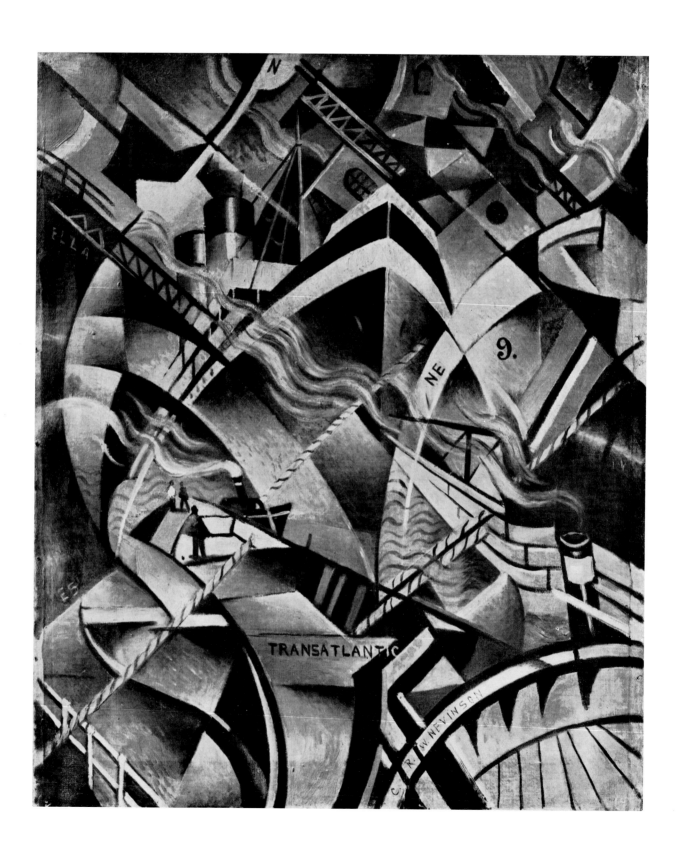

89. FRANK KUPKA: *Water (woman bathing)*, 1905–9. Oil on canvas, 63 × 80 cm. Paris, National Museum of Modern Art.

A work of Kupka's early maturity; the artist was to become, through Orphism, one of the most convinced and austere proponents of abstract art. The painting is a fine example of his gifts as a colourist and his very personal sensibility. The ripples generated by the bather's movement afford many chromatic opportunities.

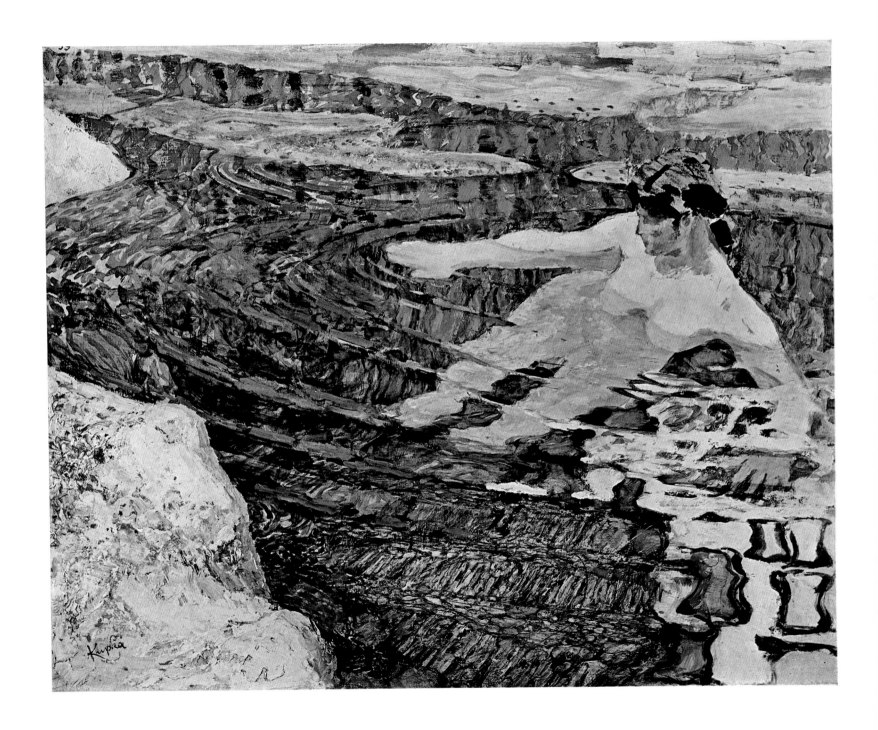

90. MIKHAIL LARIONOV: *Sunset after rain*, 1908. Oil on canvas, 68 ×85 cm. Moscow, Tretyakov Gallery.
Before becoming a Futurist, Larionov was strongly influenced by the Fauves. This landscape is relevant to that experience, while it also bears witness to an artless decorative faculty and anecdotal leanings.

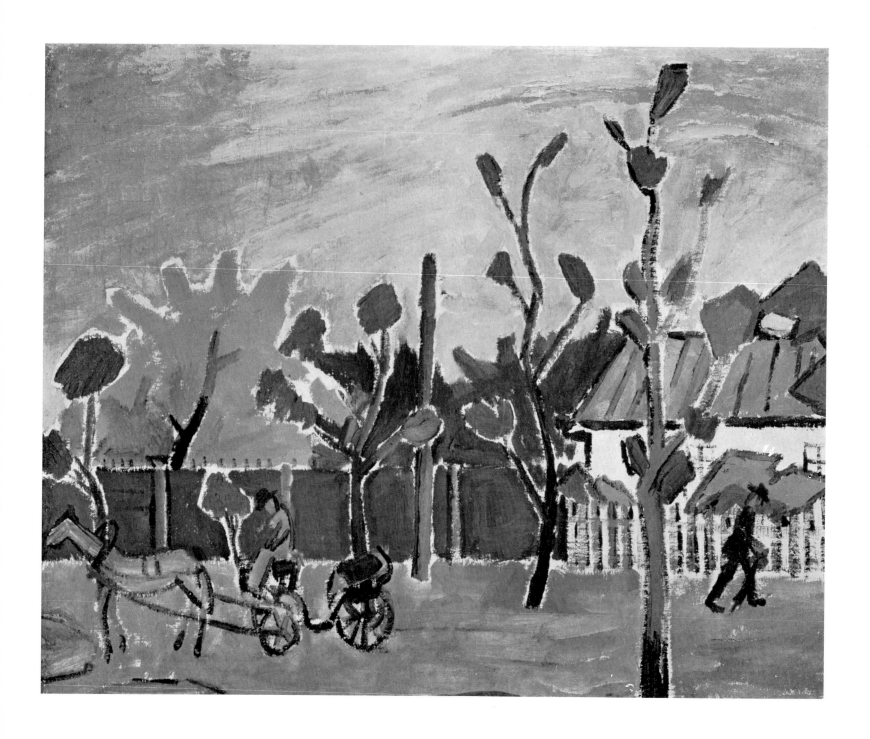

91. KASIMIR MALEVICH: *Morning in the country after rain*, 1912–13. Oil on canvas, 80 × 80.5 cm. New York, The Solomon R. Guggenheim Museum.

Before reducing the art of painting to 'zero', i.e. eliminating all objects, Malevich produced several pictures of a Cubist type, comparable to the work of Léger. As this example shows, the technique was a simple one: the outside world furnished basic elements, from which geometrical themes and motifs were extracted, and these were then situated and combined in various ways.

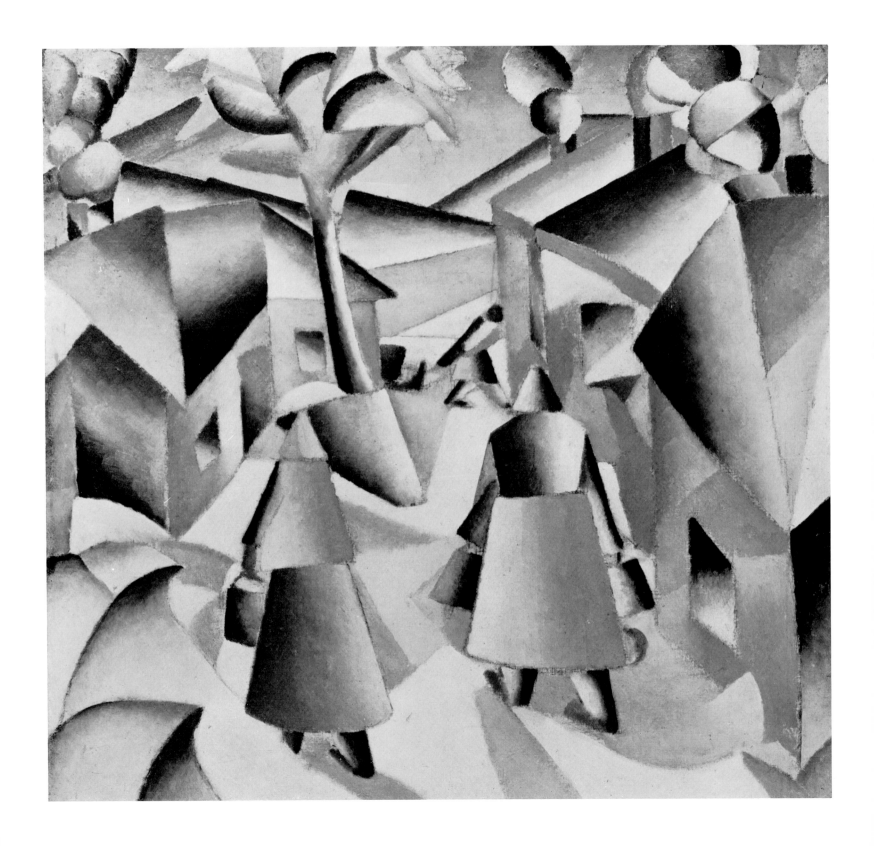

92. ALEXEJ VON JAWLENSKY: *Mountains (landscape near Murnau)*, 1912. Oil on cardboard, 49.8 × 53.9 cm. Hofheim, Bekker von Rath Collection.

A landscape showing how much Jawlensky owed to Kandinsky at this period, following his other basic encounter with Matisse. The similarity is noticeable for instance in the figurative treatment of the bulging shapes in the foreground and the profile of the mountains.

93, 94. MARC CHAGALL: *Paris seen from the artist's window*, 1913. Oil on canvas, 132.7 × 139.2. New York, The Solomon R. Guggenheim Museum.

A typical Chagall landscape in which reality, dream and recollection are blended. The window is wide open, and the painter himself—a head with two faces, opposite a chair with flowers and a cat with a human face—is seen in a corner near the lower edge of the picture. Like the painter's two faces, the indoor and outdoor scenes permeate each other—at one and the same time we are amid the lights and bustle of Paris and the mysterious images that surge up from the depths of the painter's mind.

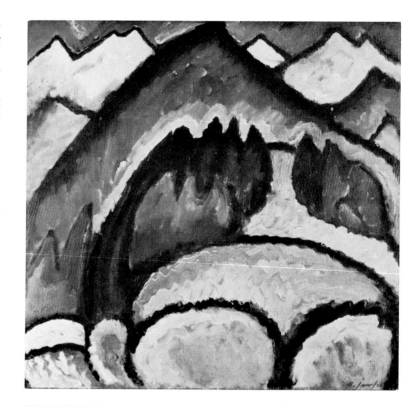

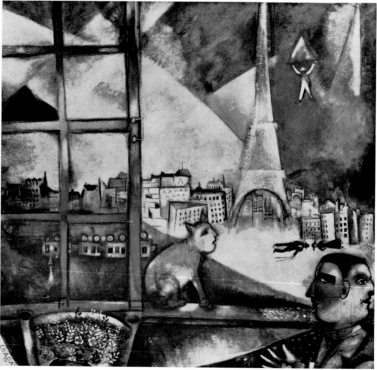

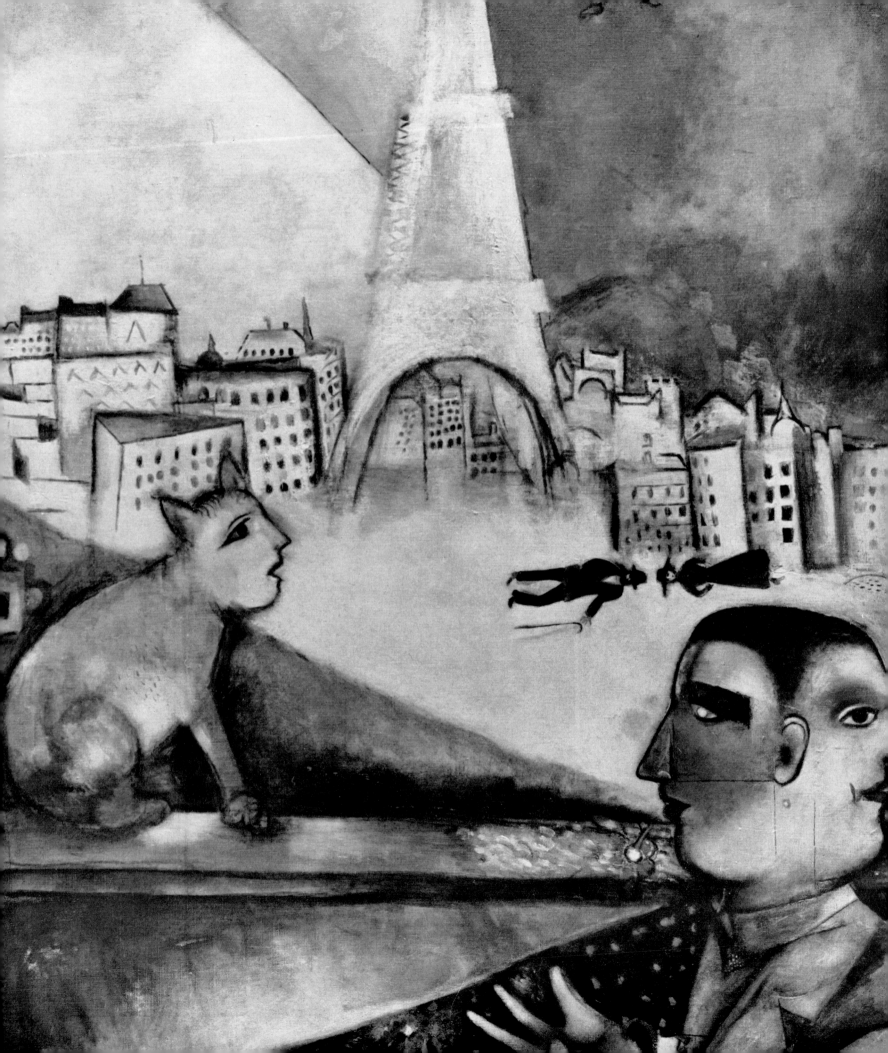

95. LEO GESTEL: *Tree in autumn*, 1911. Oil on canvas, 113 × 87.5 cm. The Hague, Municipal Museum.

This large tree, painted partly with continuous brush-strokes and partly with blobs of colour, shows the meeting-point (as in Mondrian's case) between Fauvism and Divisionism, before Gestel's Cubist period, which began in the following year.

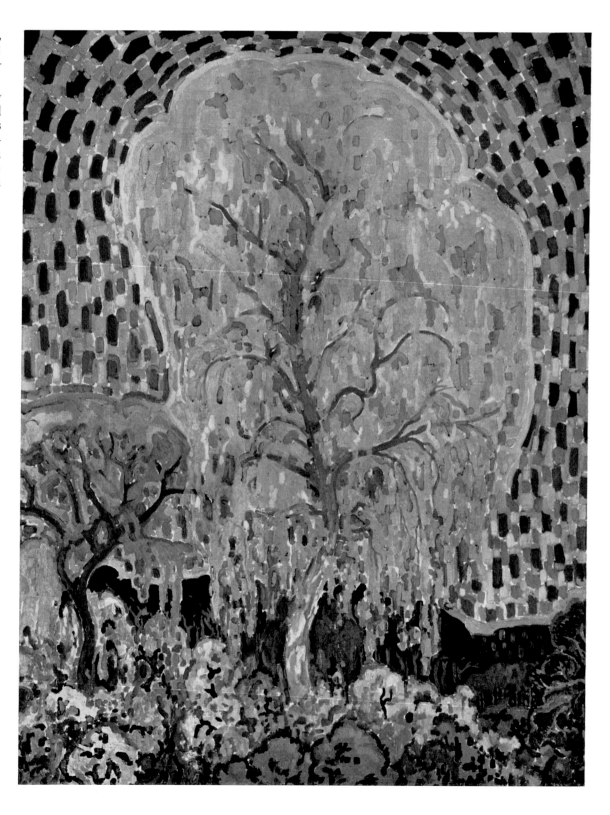

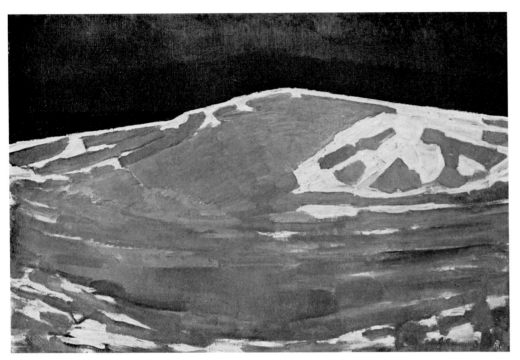

96. PIET MONDRIAN: *Dune V*, 1909–10. Oil on canvas, 65.5 × 96 cm. The Hague, Municipal Museum.

The extreme sobriety of this work painted by Mondrian before his Cubist period is also found in his other paintings of similar themes. His palette is subdued, especially by comparison with the *Windmill in the sun*, painted scarcely a year later.

97. PIET MONDRIAN: *Farm at Duivendrecht*, 1907–8. Oil on canvas, 85.5 × 108.5 cm. The Hague, Municipal Museum.

One of several paintings of the same subject in which Mondrian came closest to the explicitly decorative style of the Secessionists. Mondrian pursued this line with great tenacity, until he became convinced of the limitations inherent in this kind of 'sensuous stylization'.

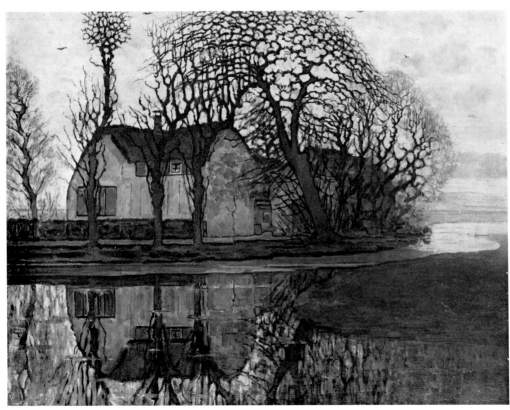

98. Piet Mondrian: *Windmill in the sun*, 1911. Oil on canvas, 114 ×87 cm. The Hague, Municipal Museum.

Mondrian wrote of one of his pictures: 'I have sometimes enjoyed painting a red windmill against the blue sky.' In the present work the relationship of the terms is different, but the principle is the same. The great red structure stands out majestically against an unreal sky consisting of grey patches on a yellow background; the latter extends to the land, where it surrounds the reflecting surface of the pond.

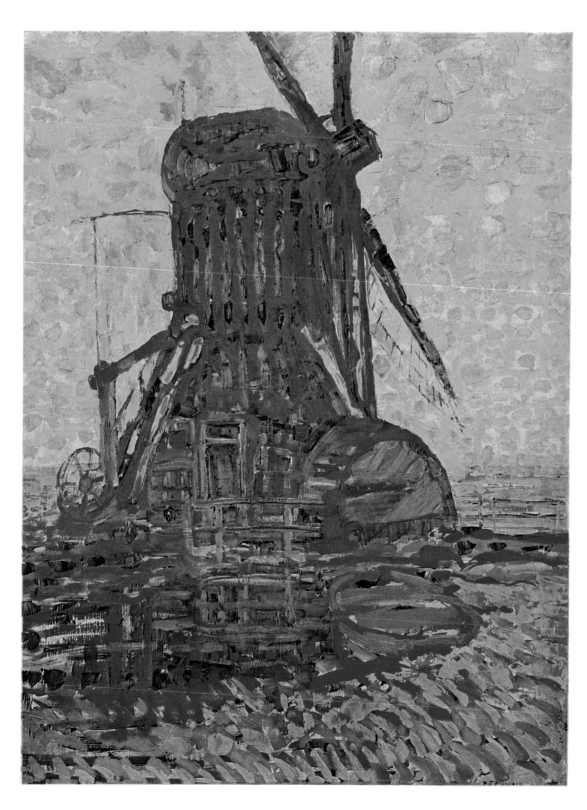

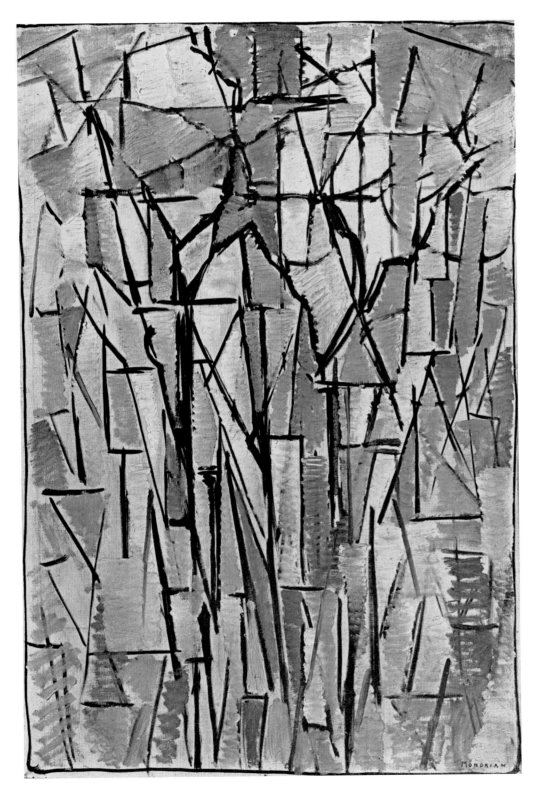

99. PIET MONDRIAN: *Landscape with trees*, 1912. Oil on canvas, 98 × 65.5 cm. The Hague, Municipal Museum.

Similar paintings by Mondrian are entitled simply 'Composition'. The natural landscape, at this period, is in fact a mere substratum bearing no direct relationship to the pictorial form, which we see as an intricate network pattern too irregular to be called a grille, yet which might serve as the support for a further construction. This phase of Mondrian's work was a brief one, prior to his discovery of a new method.

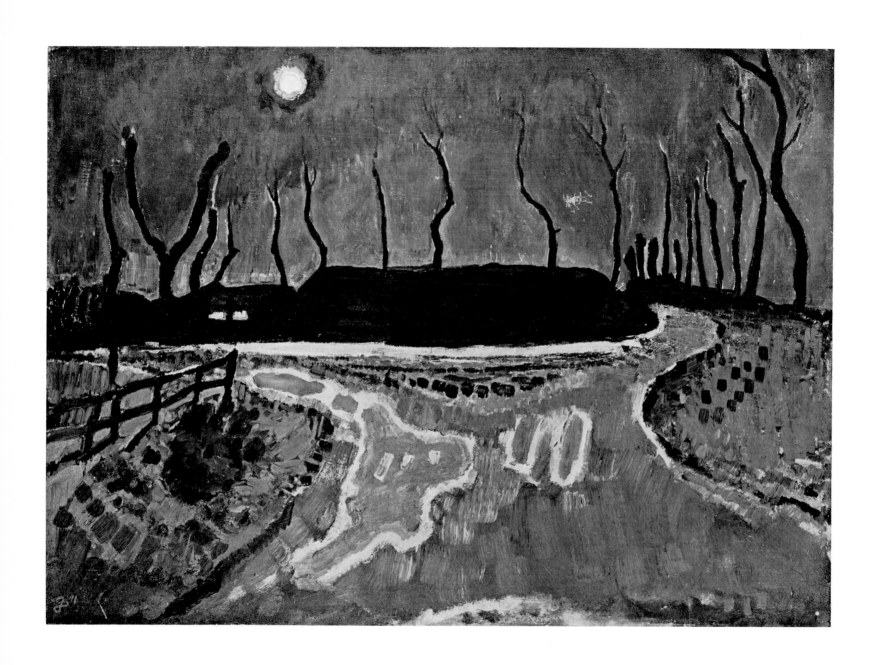

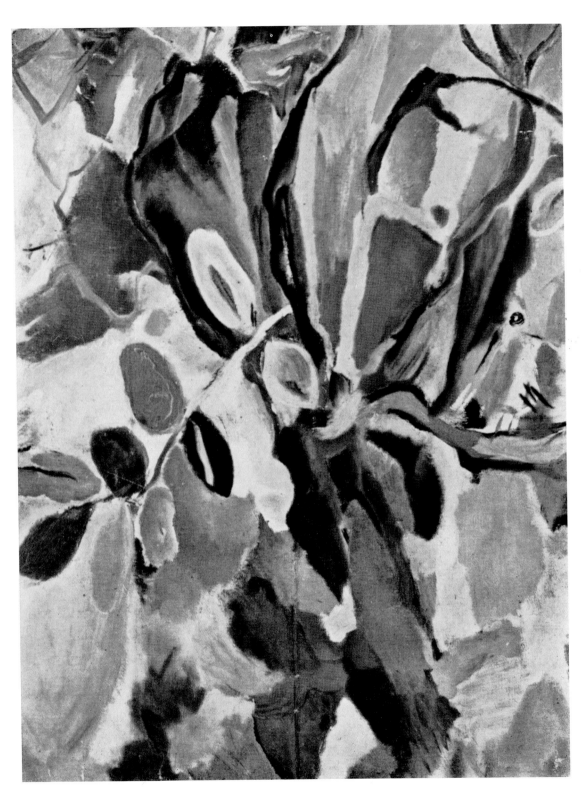

100. JAN SLUYTERS: *Moonlit night*, 1911. Oil on canvas, 50.5 × 71.5 cm. The Hague, Municipal Museum.

By its technique, arrangement and atmosphere this austere landscape calls to mind Mondrian's work of the same period. As with Mondrian, we are aware that Munch has exerted more than a passing influence, discernible here in the bleak emptiness of the vast Northern night.

101. HANS RICHTER: *Autumn*, 1917. Oil on canvas, 79 × 63 cm. Locarno, Richter Collection.

An exceptional specimen of the work of this painter, who became increasingly experimental after drawing nearer to the avant-garde school (his first abstracts were also painted in 1917). The present work is related to his experience as it developed in a German framework in the first fifteen years of the century, and foreshadows fairly clearly the evolution mentioned above.

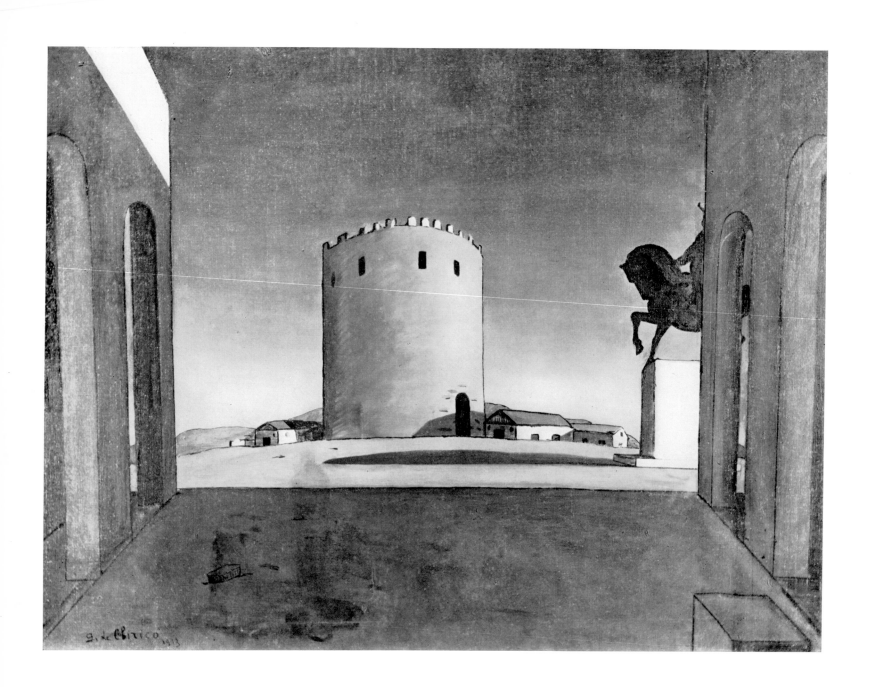

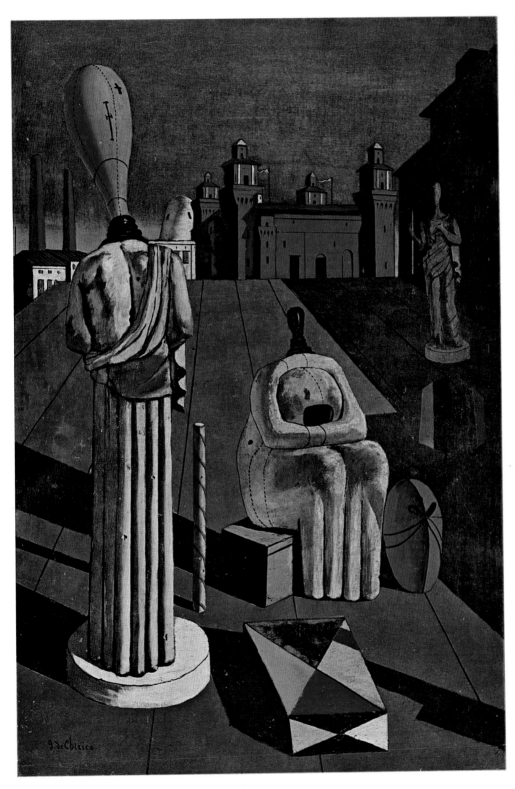

102. GIORGIO DE CHIRICO: *The pink tower*, 1913. Oil on canvas, 100 × 73 cm. Venice, Peggy Guggenheim Collection.

Framed by two colonnades like the wings of a stage décor is a vast unreal town, limitless because we can neither see nor imagine its boundaries. The mysterious tower and the low buildings around it belong to no period and perform no function in an unpeopled world: they are mere volumes, bathed in a magic light and divorced from the effects of time.

103. GIORGIO DE CHIRICO: *The disquieting muses*, 1916. Oil on canvas, 97 × 66 cm. Milan, Mattioli Collection.

Perhaps De Chirico's most famous work. The broad open space is composed of perfectly straight boards, running towards the background in rapid foreshortening; the scene is closed by a large turreted castle and factory chimneys. All the objects, figures and buildings cast shadows of immense length. The construction, at once flawless and absurd, creates juxtapositions that are truly 'disquieting', like the muses that inhabit the deserted, mythical city.

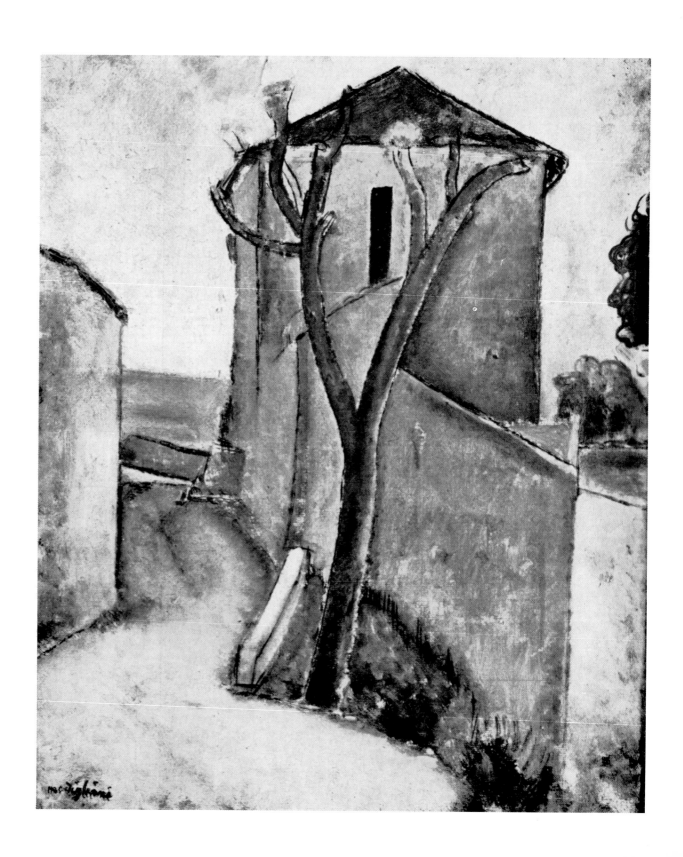

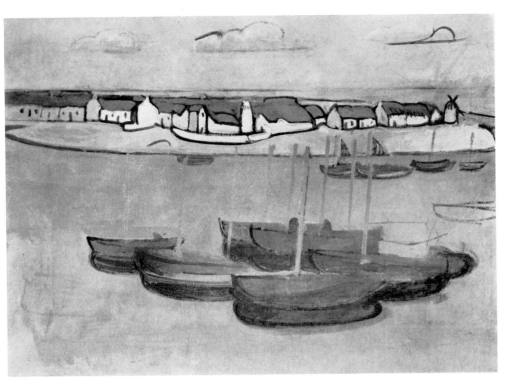

104. AMEDEO MODIGLIANI: *Landscape in southern France*, 1917–18. Oil on cardboard, 55 × 46 cm. Paris, Private Collection.

Modigliani's fluent cadences can be recognized in this well-known painting, a very unusual one since he almost always confined himself to human figures and portraiture. A light, delicate palette is used to establish subtle tonal relationships among the serene, purified forms of the composition.

105. GINO ROSSI: *Douarnez*, 1910. Oil on canvas, 46 × 64 cm. Venice, Gallery of Modern Art.

A quiet seascape illustrating the Venetian artist's extreme simplicity of means, both in landscape and in figure painting. The influence of French Post-Impressionism is evident, although in this as in other works the painter displays resources and interests of his own.

106. GINO ROSSI: *Haystacks*, about 1912. Oil on cardboard, 27 × 37 cm. Milan, Gian Ferrari Gallery.

Here too we accept without question Rossi's technique of outlining contours and depicting the rest of the object as simply as possible. In and between the elements of the picture, the colour gushes forth like a pure song in tones that are sometimes radiant, sometimes deeper and more intense.

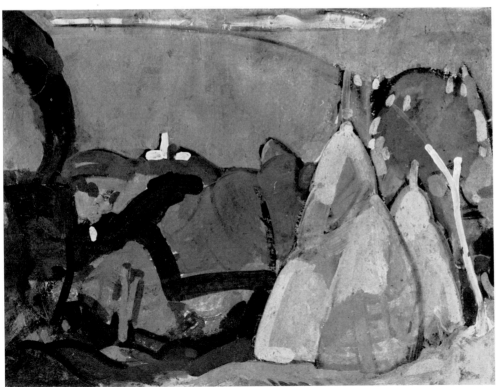

107. HENRI ROUSSEAU: *Suburban scene on the banks of the Marne*, 1903. Oil on canvas, 48 × 65 cm. Basle, Collection of Dr. Hänggi.

A continuous fence, painted with great care and exactitude, marks off the bank with its tiny fishermen; sheds, factories and houses are seen beyond. The river is glassy, the light chilly and of moderate brightness, as on a winter's morning; the clouds are faintly coloured in a sky of the tenderest blue. The complex scene gives an effect of extraordinary serenity.

108. HENRI ROUSSEAU: *The toll-house*, about 1900. Oil on canvas, 37.5 × 32.5 cm. London, Courtauld Institute Galleries.

Another of the Douanier's tenderest and most thoughtful works. The arrangement is complex, with the main axes running diagonally. There is the usual accuracy of analysis, and at the same time an exceptional feeling for the spirit of the landscape, stretching gently away past the row of cypresses to a dim horizon.

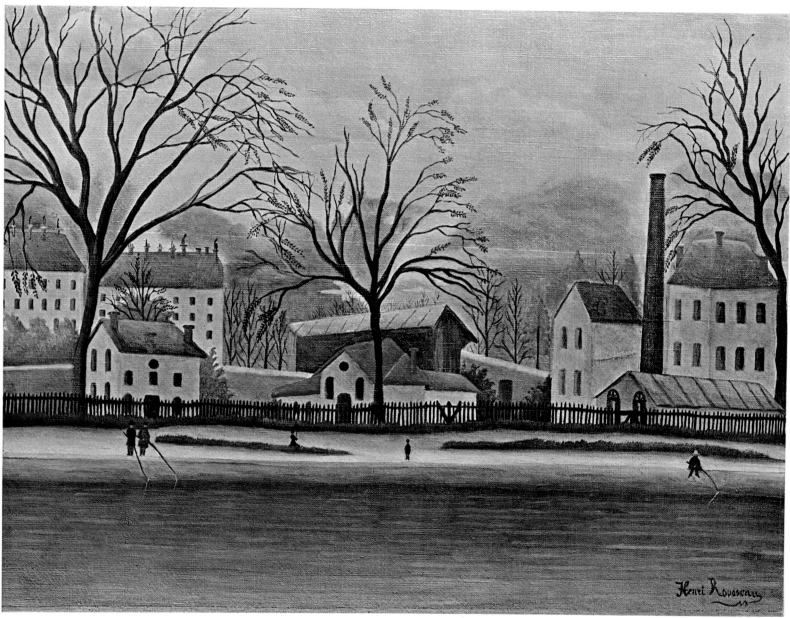

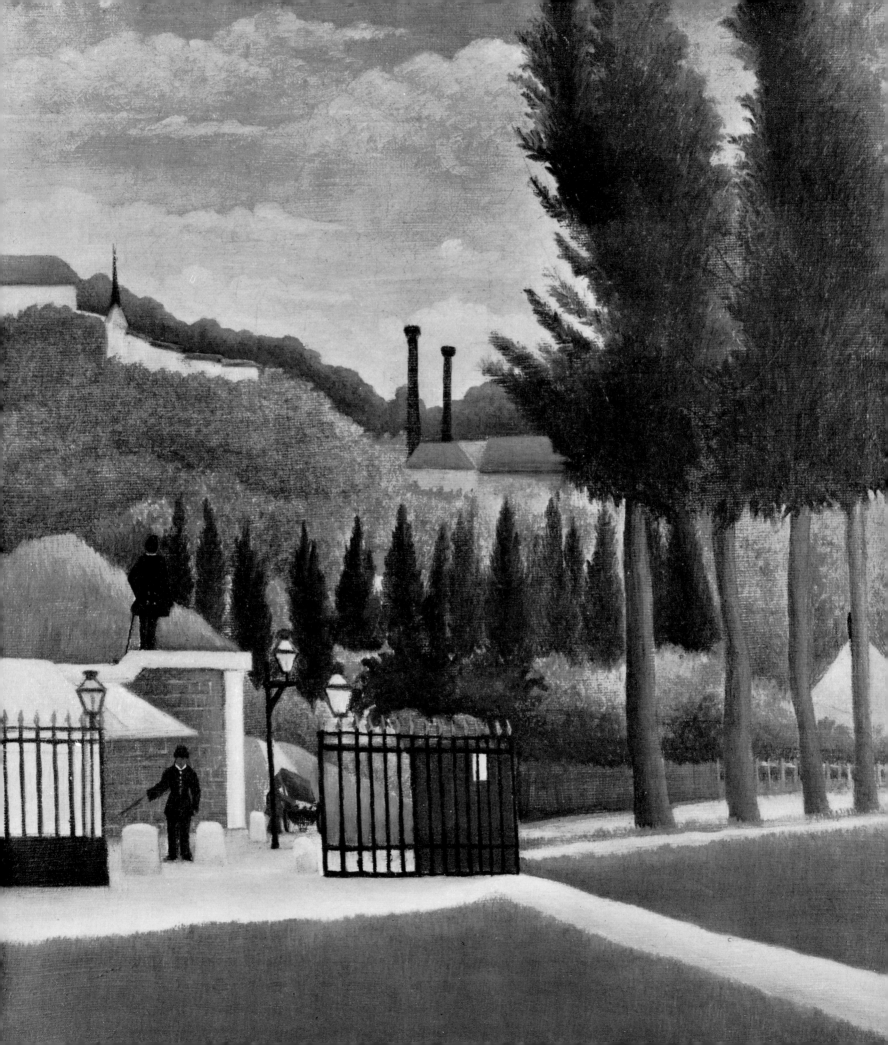

109. MAURICE UTRILLO: *The church of Saint-Séverin*, about 1913. Oil on canvas, 73 × 54 cm. Washington, D.C., National Gallery of Art (Chester Dale Collection).

This street in its simple perspective offers a good example of what was certainly the artist's most fruitful period. Conventional though the scene is in itself, we feel in it a love of reality which can sublimate the most trivial and fleeting aspects of urban life. It is clear how much the painter's 'lyrical realism' owes to the teaching of Sisley.

110. JOSEPH PICKETT: *Coryell's Ferry*, 1914–18. Oil on canvas, 95 × 124 cm. New York, Whitney Museum of American Art.

Like many other American amateurs, Pickett took up painting late in life. This work is full of fantasy and a childlike ingenuousness, shown in the combination of motifs with a characteristic disregard of perspective. There is a remarkable freshness of observation, for instance in the reflection of the banks in the water.

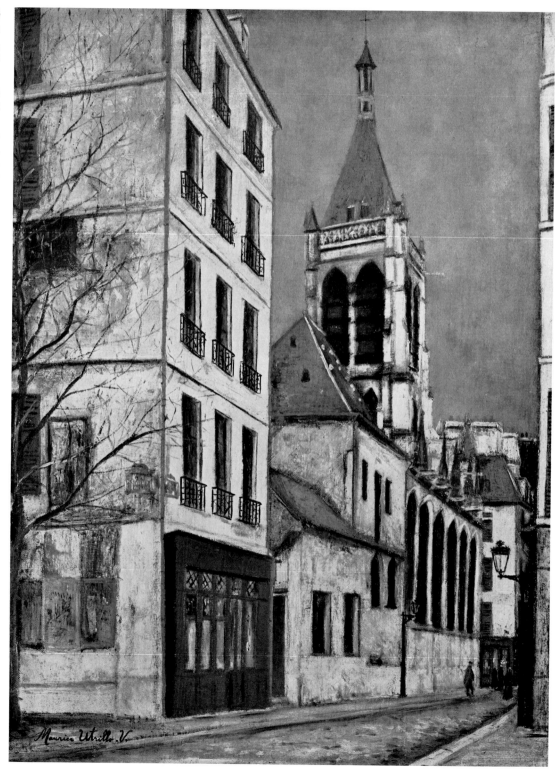

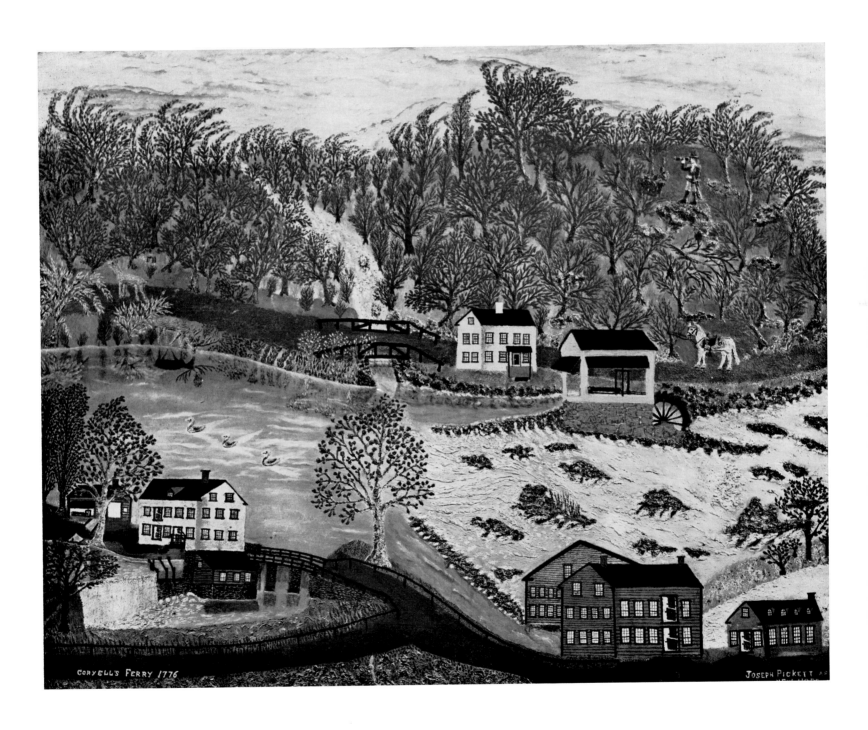

CORYELL'S FERRY 1776 JOSEPH PICKETT

111. JOSEPH PICKETT: *Manchester Valley*, 1914–18(?). Oil and sand on canvas, 114.5 × 152.5 cm. New York, Museum of Modern Art (gift of Abby Aldrich Rockefeller).

This is Pickett's best-known picture, partly on account of the classical American themes that go to form its subject-matter. It shows a keen delight in material things and in the exact portrayal of reality. The ritual multiplication of elements in the landscape, and the prominence given to visual incidents of all kinds, is typical of the 'naïf' school of painting.

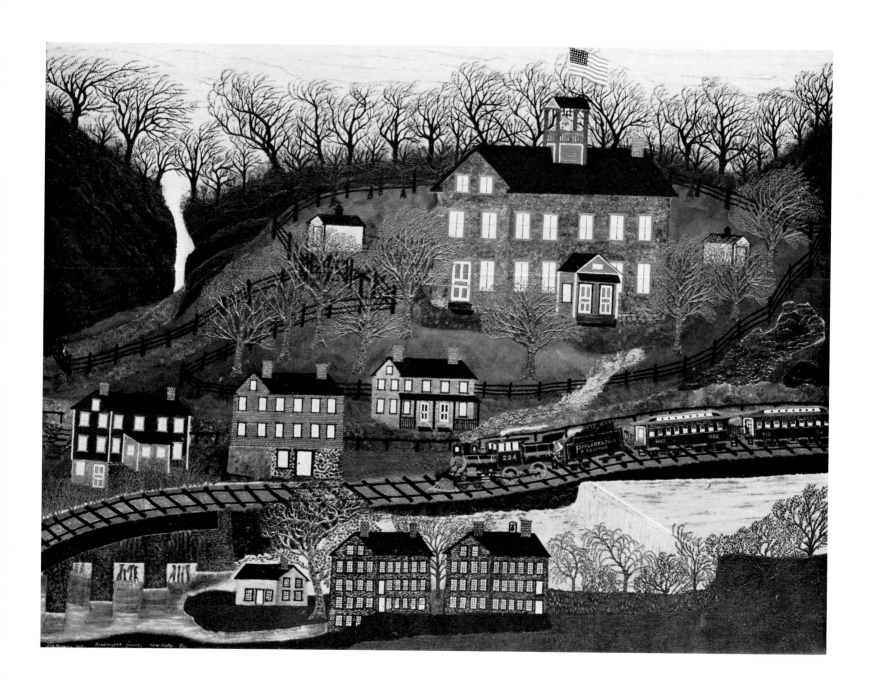

A RETURN TO TRADITION
1920-1940

Morning
Wreathed in fresh thoughts, it shines in the flowery waters.

Noon
The hills are mere wisps of smoke; the encroaching desert swarms impatiently; sleep is murky, the statues become blurred.

Evening
Taking fire, she becomes aware of her nakedness. The sea turns bottle-green, and the bright glow of flesh fades to mother-of-pearl.

 Justifying human melancholy, creation's moment of shame reveals the endless wasting-away of all things.

Night
All is dispersed, confused, attenuated. Trains whistle as they depart. There are no more witnesses: here is my true face of toil and disappointment.

Landscape, 1920 GIUSEPPE UNGARETTI

As he landed on the piazzetta a cup of beauty was lifted to his lips, and he drank with a sense of disloyalty. The buildings of Venice, like the mountains of Crete and the fields of Egypt, stood in the right place, whereas in poor India everything was placed wrong. He had forgotten the beauty of form among idol temples and lumpy hills; indeed, without form, how can there be beauty? Form stammered here and there in a mosque, became rigid through nervousness even, but oh these Italian churches! San Giorgio standing on the island which could scarcely have risen from the waves without it, the Salute holding the entrance of a canal which, but for it, would not be the Grand Canal! In the old undergraduate days he had wrapped himself up in the many-coloured blanket of St. Mark's, but something more precious than mosaics and marbles was offered to him now: the harmony between the works of man and the earth that upholds them, the civilization that has escaped muddle, the spirit in a reasonable form, with flesh and blood subsisting. Writing picture post-cards to his Indian friends, he felt that all of them would miss the joys he experienced now, the joys of form, and that this constituted a serious barrier. They would see the sumptuousness of Venice, not its shape, and though Venice was not Europe, it was part of the Mediterranean harmony. The Mediterranean is the human norm. When men leave that exquisite lake, whether through the Bosphorus or the Pillars of Hercules, they approach the monstrous and extraordinary; and the southern exit leads to the strangest experience of all. Turning his back on it yet again, he took the train northward, and tender romantic fancies that he thought were dead for ever flowered when he saw the buttercups and daisies of June.

A Passage to India, 1924 E. M. FORSTER

To laze the noon
To laze the noon pale and thoughtful
near to some blazing garden-wall,
to listen in the thorn-hedge and the brake
to clattering of blackbird, rustle of snake.

In cracks of the soil, where the vetch is
to catch the red ants in their single tracks
now breaking formation, now intersecting
upon the top of their minute stacks.

To watch through green branches the throbbing
of sea-scales far in the offing
while the wavering creak goes up
of cicadas from the bald mountain-tops.

And as you go on in the dazzling sun
to feel with sad bewilderment
how all of life and its suffering
is in this steady following
a wall with jagged bottle for its rim.

'To Laze the Noon', 1916, from *Ossi di Seppia*, 1921-26 EUGENIO MONTALE

'It suddenly gets cold. The sun seems to give less heat,' she said, looking about her, for it was bright enough, the grass still a soft deep green, the house starred in its greenery with purple passion flowers, and rooks dropping cool cries from the high blue. But something moved, flashed, turned a silver wing in the air. It was September after all, the middle of September, and past six in the evening. So off they strolled down the garden in the usual direction, past the tennis lawn, past the pampas grass, to that break in the thick hedge, guarded by red-hot pokers like braziers of clear burning coal, between which the blue waters of the bay looked bluer than ever.

They came there regularly every evening drawn by some need. It was as if the water floated off and set sailing thoughts which had grown stagnant on dry land, and gave to their bodies even some sort of physical relief. First, the pulse of colour flooded the bay with blue, and the heart expanded with it and the body swam, only the next instant to be checked and chilled by the prickly blackness on the ruffled waves. Then, up behind the great black rock, almost every evening spurted irregularly, so that one had to watch for it and it was a delight when it came, a fountain of white water; and then, while one waited for that, one watched, on the pale semi-circular beach, wave after wave shedding again and again smoothly a film of mother-of-pearl.

They both smiled, standing there. They both felt a common hilarity, excited by the moving waves; and then by the swift cutting race of a sailing boat, which, having sliced a curve in the bay, stopped; shivered; let its sail drop down; and then, with a natural instinct to complete the picture, after this swift movement, both of them looked at the dunes far away, and instead of merriment felt come over them some sadness. . .

To the Lighthouse, 1927 VIRGINIA WOOLF

The four of them galloped off uphill and, following obscure tracks or none at all, crossed one after another of the massive ridges, produced by landslips in the clayey soil, that are known in the Bologna region as *calanchi*. Passing through Val di Ravone and skirting the peaks of Paderno and Sabbiuno with the broad barren ridge between them, they came out on the plateau that extends at a moderate height between Savena and Reno, shortly before the Apennine foothills die away near Bologna. The plateau forms a beautiful, secret enclosure: on two sides it is bounded by hills with twin rivers at the foot, on another by

Paderno and Sabbiuno forming the last vestige of the Apennines, while the view behind is closed off by the majestic silvery range itself. The air is pure.

Valleys, hills and rivers thus surround and protect a sunburnt area of neat, infertile fields, of yellow, grey and blue soil and pruned trees. A gentle, quiet place, its inhabitants have perhaps learnt a tradition of peaceful elegance from the cypresses: what a lot of these there are, and how wisely they are planted! Upright and unassuming, they watch over the rural paths; in groups of three, four or five they protect springs, wells and threshing-floors; single ones surmount the hill-tops. The wayside ones are aligned in ranks; those in groups appear to converse together; those on the hill-tops make answer one to another without so much as a rustle, for the cypress is of all trees the most silent.

But the biggest group of cypresses, the one to which all the others seem to lead us, is that surrounding the green churchyard of the Pieve del Pino. Popular language has a way of falling into poetic error: the trees here are not pines, they are cypresses.

Il diavolo al Pontelungo, 1927 RICCARDO BACCHELLI

Now I am on the quay. It is deserted. I walk down a broad street, which looks as if it would lead to the centre. Architecture half Flemish and half modern: gables alternating with flat roofs of reinforced concrete. At the ends of narrow streets, confined between eight-storeyed buildings, are the domes of Protestant churches, which suggest that of St. Paul's in London. And above, everywhere, the vegetation of the rock and the Peak. From the ground, so soft that one's boots pass over it noiselessly, there ascends a strong odour of tar, asphalt and oil like that of Singapore. Petrol, golf clubs, all sorts of electro-plated articles in cases, copper plates round the door lintels, engraved with the names of different firms, English shops, tea-rooms, sweet stores, book shops displaying nothing but travel books and magazines; everything indicating a life of action. No trees, as at Saigon, but lawns, as at Singapore—and stones. Energy. Dominion. No dwelling-houses. But banks and offices—offices—offices—offices. Hoardings with advertisements. And over it all the peaked mountains of China hemming us in again in silence. The town might be in the clutch of some epidemic. It is an abandoned city, in which reigns a solitude as of night. And yet it hardly seems deserted, but rather the victim of some catastrophe. A great machine out of gear.

Beneath the notices indicating car and rickshaw ranks not a single vehicle. An English soldier crosses the street. Behind me, a Chinese clatters along in his wooden shoes as if to accentuate the silence. . . .

Now here is the main street. The town lies at the meeting of rock and sea, built on the one, fringing on the other. This street intersected by all the roads leading from the quay to the Peak is like a hollow palm-leaf. Here, normally, is the hub of the Island's activity. But today, here also, all is silence and solitude. Here and there, keeping close together and spying round like policemen, are couples of British volunteers, dressed like boy scouts, who are going to the market to distribute vegetables or meat. The sound of wooden shose clattering in the distance. No white women. No motor-cars.

Now I come to the Chinese shops: jewellers, jade-sellers, dealers in all sorts of luxury wares. English houses grow fewer, until, round a sharp corner, they disappear altogether. The corner is so sharp that it seems almost to bar the road; and in this kind of blind alley one is surrounded by Chinese characters of all sizes, black, red, gold, inscribed on tablets, or over doors or hanging out in squares against the sky; they seem to surround one like a swarm of insects.

The Conquerors, 1929 ANDRÉ MALRAUX

I enter Italy. A land that fits my soul, whose features I recognize one by one as I draw near. The first houses with scaly tiles, the first vines flat against a wall made blue by sulphur dressings, the first clothes hung out in the courtyards, the disorder, the men's untidy, casual dress. And the first cypress (so slight and yet so straight), the first olive-tree, the dusty fig-tree. Shadow-filled squares of small Italian towns, midday hours when pigeons seek rest, slowness and sloth, in these the soul exhausts its rebellions. Passion travels gradually into tears. And then, here is Vicenza. Here the days revolve upon themselves, from the daybreak stuffed with cockcrows to this unequalled evening, sweetish and tender, silky behind the cypress-trees, its hours punctuated by the long measure of the crickets' cry. This inner silence which accompanies me is born of the slow stride which leads from one day to another. What more can I long for than this room opening out on to the plain, with its antique furniture and its crocheted lace? I have the whole sky on my face, and feel that I could follow these slow, turning days for ever, spinning motionlessly with them. I breathe in the only happiness I can attain—an attentive and friendly awareness. I spend the whole day walking about: from the hill, I go down to Vicenza or else farther into the country. Every person I meet, every scent on this street, is a pretext for my measureless love. Young women looking after a children's holiday camp, the trumpet of the ice-cream sellers (their cart is a gondola on wheels, pushed by two handles), the displays of fruit, red melons with black pips, translucid and sticky grapes—all are props for the person who can no longer be alone. But the tender and bitter piping of the grasshoppers, the perfume of water and stars that you meet in the September nights, the scented paths among the lentisks and rose-bushes, all are signs of love for the person forced to be alone. Thus the days pass. After the dazzling glare of the sun-filled days, evening comes, in the splendid décor offered by the gold of the setting sun and the black of the cypress-trees. I then walk along the road, towards the crickets that can be heard far away. As I advance, they begin one by one to sing more softly, and then fall silent. I walk slowly forward, weighed down by so much ardent beauty.

Betwixt and Between, 1937 ALBERT CAMUS

Margarita flew on slowly through the unknown, deserted countryside, over hills strewn with occasional rocks and sparsely grown with giant fir trees. She was no longer flying over their tops, but between their trunks, silvered on one side by the moonlight. Her faint shadow flitted ahead of her, as the moon was now at her back.

Sensing that she was approaching water, Margarita guessed that her goal was near. The fir trees parted and Margarita gently floated through the air towards a chalky hillside. Below it lay a river. A mist was swirling round the bushes growing on the cliff-face, whilst the opposite bank was low and flat. There under a lone clump of trees was the flicker of a camp fire, surrounded by moving figures, and Margarita seemed to hear the insistent beat of music. Beyond, as far as the eye could see, there was not a sign of life.

Margarita bounded down the hillside to the water, which looked tempting after her chase through the air. Throwing aside the broom, she took a run and dived head-first into the water. Her body, as light as air, plunged in and threw up a column of spray almost to the moon. The water was as warm as a bath and as she glided upwards from the bottom Margarita revelled in the freedom of swimming alone in a river at night.

The Master and Margarita, 1928-40 MIKHAIL BULGAKOV

Dawn in New York bears
four pillars of slime
and a storm of black pigeons
that dabble dead water.

Dawn in New York grieves
on the towering stairs
seeking on ledges
pangs traced upon nard.

Dawn comes, there is no mouth to receive it,
for here neither morning nor promise is possible.
Only now and again a furious rabble of coins
that enter and ravage the dispossessed childhoods.

The first on the streets know the truth in their bones:
for these, neither Eden, nor passions unleafing;
they go to the slough of the ciphers and strictures,
to the games without genius and the sweat without profit.

Light is buried in chains and alarums
in the menace of science, rootless and impudent.
And staggering there in the suburbs, the insomniacs,
as though lately escaped from a bloody disaster.

'Dawn', from *Poet in New York*, 1929. FEDERICO GARCIA LORCA

She looked out the door, across the weed-choked clearing. Between the sombre spacing of the cedars the orchard lay bright in the sunlight. She donned the coat and hat and went towards the barn, the torn leaves in her hand, splotched over with small cuts of clothes-pins and patent wringers and washing-powder, and entered the hallway. She stopped, folding and folding the sheets, then she went on, with swift, cringing glances at the empty stalls. She walked right through the barn. It was open at the back, upon a mass of jimson weed in savage white-and-lavender bloom. She walked on into the sunlight again, into the weeds. Then she began to run, snatching her feet up almost before they touched the earth, the weeds slashing at her with huge, moist, malodorous blossoms. She stooped and twisted through a fence of sagging rusty wire and ran downhill among trees.

At the bottom of the hill a narrow scar of sand divided the two slopes of a small valley, winding in a series of dazzling splotches where the sun found it. Temple stood in the sand, listening to the birds among the sunshot leaves, listening, looking about. She followed the dry runlet to where a jutting shoulder formed a nook matted with briers. Among the new green last year's dead leaves from the branches overhead clung, not yet fallen to earth. She stood here for a while, folding and folding the sheets in her fingers, in a kind of despair. . . .

It was a bright, soft day, a wanton morning filled with that unbelievable soft radiance of May, rife with a promise of noon and of heat, with high fat clouds like gobs of whipped cream floating lightly as reflections in a mirror, their shadows scudding sedately across the road. It had been a lavender spring. The fruit trees, the white ones, had been in small leaf when the blooms matured; they had never attained that brilliant whiteness of last spring, and the dogwood had come into full bloom after the leaf also, in green retrograde before

crescendo. But lilac and wistaria and redbud, even the shabby heaven-trees, had never been finer, fulgent, with a burning scent blowing for a hundred yards along the vagrant air of April and May. The bougainvillaea against the veranda would be large as basketballs and lightly poised as balloons, and looking vacantly and stupidly at the rushing roadside. Temple began to scream. . . .

They reached Memphis in mid-afternoon. At the foot of the bluff below Main Street Popeye turned into a narrow street of smoke-grimed frame houses with tiers of wooden galleries, set a little back in grassless plots, with now and then a forlorn and hardy tree of some shabby species—gaunt, lopbranched magnolias, a stunted elm, or a locust in greyish, cadaverous bloom—interspersed by rear ends of garages; a scrap-heap in a vacant lot; a low-doored cavern of an equivocal appearance where an oilcloth-covered counter and a row of backless stools, a metal coffee-urn, and a fat man in a dirty apron with a toothpick in his mouth, stood for an instant out of the gloom with an effect as of a sinister and meaningless photograph poorly made. From the bluff, beyond a line of office buildings terraced sharply against the sunfilled sky, came a sound of traffic—motor horns, trolleys—passing high overhead on the river breeze; at the end of the street a trolley materialized in the narrow gap with an effect as of magic and vanished with a stupendous clatter. On a second-storey gallery a young Negress in her underclothes smoked a cigarette sullenly, her arms on the balustrade.

Popeye drew up before one of the dingy three-storey houses, the entrance of which was hidden by a dingy lattice cubicle leaning a little awry. In the grimy grassplot before it two of those small, woolly, white, worm-like dogs, one with a pink, the other a blue, ribbon about its neck, moved about with an air of sluggish and obscene paradox. In the sunlight their coats looked as though they had been cleaned with gasoline.

Sanctuary, 1931 WILLIAM FAULKNER

I remember the little, high-up town of Soria as I saw it one September evening in 1907, with a purple full moon shining over the leaden Sierra de Santana. The motto on its coat of arms is *Soria pura*, and how well the epithet suits it! Toledo, of course, is imperial, a shrine of imperial spoils; Avila, with its perfect wall of towers, is mystical and warlike, a city of 'songs and saints' as the people still more aptly call it; Burgos reminds us of the Cid's youthful grace, his gauntleted fist, his frown of defiance towards León and his smile at the lure of Valencia; Segovia, with its stone arches, perpetuates the backbone of Rome. But Soria . . . Set in its mineral, planetary, moon-like landscape, Soria with its 'all-round' wind that never ceases to blow fine snow into your face, Soria beside the infant waters of the Duero is a 'pure' city and nothing else.

Prose, 1932 ANTONIO MACHADO

From the thicket on the opposite bank four naked men strode vehemently forth, carrying on their shoulders a wooden litter. On this litter sat, Oriental fashion, a monstrously fat man. Although carried through the thicket on an untrodden path, he did not push the thorny branches apart but simply let his motionless body thrust through them. His folds of fat were so carefully spread out that although they covered the whole litter and even

hung down its side like the hem of a yellowish carpet, they did not hamper him. His hairless skull was small and gleamed yellow. His face bore the artless expression of a man who meditates and makes no effort to conceal it. From time to time he closed his eyes: on opening them again his chin became distorted.

'The landscape disturbs my thought,' he said in a low voice. 'It makes my reflections sway like suspension bridges in a furious current. It is beautiful and for this reason wants to be looked at.'

I close my eyes and say: You green mountain by the river, with your rocks rolling against the water, you are beautiful.

But it is not satisfied; it wants me to open my eyes to it.

Then I might say to it with my eyes closed: 'Mountain, I do not love you, for you remind me of the clouds, of the sunset, of the rising sky, and these are things that almost make me cry because one can never reach them while being carried on a small litter. But when showing me this, sly mountain, you block the distant view which gladdens me, for it reveals the attainable at a glance. That's why I do not love you, mountain by the water—no, I do not love you. . . .

And must we not keep it well disposed toward us in order to keep it up at all—this mountain which has such a capricious fondness for the pulp of our brains? It might cast on me its jagged shadow, it might silently thrust terrible bare walls in front of me and my bearers would stumble over the little pebbles on the road.

But it is not only the mountain that is so vain, so obtrusive and vindictive—everything else is, too. So I must go on repeating with wide-open eyes—oh, how they hurt!:

'Yes, mountain, you are beautiful and the forests on your western slope delight me.—With you, flower, I am also pleased, and your pink gladdens my soul.—You, grass of the meadows, are already high and strong and refreshing.—And you, exotic bushes, you prick so unexpectedly that our thoughts start leaping.—But with you, river, I am so delighted that I will let myself be carried through your supple water.'

Description of a Struggle, 1933 FRANZ KAFKA

Much rain and snow had fallen on Goldmund when he clambered one day to the summit of the steep side of a beechwood, full of light, yet thick already with clear, green buds, and above, through branches at the crest, peered down on another country-side, stretching away before him, rejoicing his heart, filling him with desire and expectancy. For days he had known himself near it, and had spied about for what he saw. Now, on this midday tramp, it had come when he least awaited it, delighting him and strengthening his longing. He looked down from between grey trunks and gently-stirring foliage on the brown and greenish valley spread beneath, in its midst a wide, blue, glassy river. Now he would be done with field-paths, with straying here and there across the land in the mystery of forest and heath, with only very rarely any castle or some poor village to receive him. There, through the valley, flowed the river and, stretching away along its banks, the finest, broadest, most famous highway in the Empire, with rich, fat country on either side, and rafts and galleons on its waters, while the road led on into fair villages, to castles, cloisters, and wealthy towns.

And whoever would might walk for days along it, with no fear in his heart of losing it suddenly, in the thick of woodland, or in a marsh, as he might the wretched fieldtracks of the peasants. Here was a new thing to please his heart.

Narziss and Goldmund, 1933 HERMANN HESSE

After breakfast the company couldn't help stepping out on the terrace to look for a moment at the great view of the valley of the Rivanna and the blue ridges beyond the gap above the little village of Charlottesville. Jefferson sometimes would say that the only thing he regretted was that there was not a body of water in the foreground or perhaps a volcano in the distance. Then he would take his guests around to the other end of the house to point out the little conical hill which was the only thing that broke the flatness of the leafy plain sweeping to the horizon to the south. He used to tell them this little hill was just about the size and shape of the pyramid of Cheops and describe the peculiar forms the mirage sometimes made it take on.

Landscape was one of the great pleasures of Jefferson's life. In planning his gardens and planting his hilltop he had put much thought into how best to open out and emphasize the features he liked best in the view. The type of landscape that appealed to him was the landscape of the first burst of English romanticism. Oaks were 'venerable and antient,' evergreens were 'gloomy,' vales were 'solitary and unfrequented,' walks were winding, gardens naturalistic. His garden was the parklike English garden of the romantic school where all the planting was supposed to look as if it had grown there of its own accord. It was a taste that went with grottoes, and the sudden reversal of the color of the word Gothic, and with the enthusiasm for the imaginary Celtic epics of Macpherson's Ossian, which Jefferson as a young man had shared with the fashionable reading public of the time to such a point that he wrote a friend in Scotland to get him, no matter at what cost, a copy of the original manuscript and a grammar so that he could study the poems in Gaelic.

The Ground We Stand On, 1941 JOHN DOS PASSOS

Now they were steaming up the river. At the mouth was a straggling fishermen's village standing on piles in the water; on the bank grew thickly nipah palm and the tortured mangrove; beyond stretched the dense green of the virgin forest. In the distance, darkly silhouetted against the blue sky, was the rugged outline of a mountain. Neil, his heart beating with the excitement that possessed him, devoured the scene with eager eyes. He was surprised. He knew his Conrad almost by heart and he was expecting a land of brooding mystery. He was not prepared for the blue milky sky. Little white clouds on the horizon, like sailing boats becalmed, shone in the sun. The green trees of the forest glittered in the brilliant light. Here and there, on the banks, were Malay houses with thatched roofs, and they nestled cosily among fruit trees. Natives in dug-outs rowed, standing, up the river. Neil had no feeling of being shut in, nor, in that radiant morning, of gloom, but of space and freedom. The country offered him a gracious welcome. He knew he was going to be happy in it.

Neil Macadam, 1930 W. SOMERSET MAUGHAM

The hurrying people grow fewer.
Rows
of bare trees flanking the road,
far away where the fields grow dim,
seem to close in and form a defile.
A little of the violet sky blends with them—

the sky that brings disquiet, not consolation.
A short evening,
too tranquil to human sight.

'Prospettiva', from *Poems*, 1935-43 UMBERTO SABA

The sky was pale blue: a few wisps of smoke, and from time to time, a fleeting cloud passed in front of the sun. In the distance I could see the white cement balustrade which runs along the Jetty Promenade; the sea glittered through the interstices. The family turns right on the Rue de L'Aumonier-Hilaire which climbs up the Coteau Vert. I saw them mount slowly, making three black stains against the sparkling asphalt. I turned left and joined the crowd streaming towards the sea.

There was more of a mixture than in the morning. It seemed as though all these men no longer had strength to sustain this fine social hierarchy they were so proud of before luncheon. Business men and officials walked side by side; they let themselves be elbowed, even jostled out of the way by shabby employees. Aristocrats, élite, and professional groups had melted into the warm crowd. Only scattered men were left who were not representative.

A puddle of light in the distance—the sea at low tide. Only a few reefs broke the clear surface. Fishing smacks lay on the sand not far from sticky blocks of stone which had been thrown pell-mell at the foot of the jetty to protect it from the waves, and through the interstices the sea rumbled. At the entrance to the outer harbour, against the sun-bleached sky, a dredge defined its shadow. Every evening until midnight it howls and groans and makes the devil of a noise. But on Sunday the workers are strolling over the land, there is only a watchman on board: there is silence.

The sun was clear and diaphanous like white wine. Its light barely touched the moving figures, gave them no shadow, no relief: faces and hands made spots of pale gold. All these men in topcoats seemed to float idly a few inches above the ground. From time to time the wind cast shadows against us which trembled like water; faces were blotted out for an instant, chalky white.

Nausea, 1938 JEAN-PAUL SARTRE

The spring is beautiful in California. Valleys in which the fruit blossoms are fragrant pink and white waters in a shallow sea. Then the first tendrils of the grapes, swelling from the old gnarled bines, cascade down to cover the trunks. The full green hills are round and soft as breasts. And on the level vegetable lands are the mile-long rows of pale green lettuce and the spindly little cauliflowers, the grey-green unearthly artichoke plants.

And then the leaves break out on the trees, and the petals drop from the fruit trees and carpet the earth with pink and white. The centres of the blossoms swell and grow and colour: cherries and apples, peaches and pears, figs which close the flower in the fruit. All California quickens with produce, and the fruit grows heavy, and the limbs bend gradually under the fruit so that little crutches must be placed under them to support the weight. . . .

Along the rows the cultivators move, tearing the spring grass and turning it under to make a fertile earth, breaking the ground to hold the water up near the surface, ridging the ground in little pools for the irrigation, destroying the weed roots that may drink the water away from the trees.

And all the time the fruit swells and the flowers break out in long clusters on the vines.

And in the growing year the warmth grows and the leaves turn dark green. The prunes lengthen like little green birds' eggs, and the limbs sag down against the crutches under the weight. And the hard little pears take shape, and the beginning of the fuzz comes out on the peaches. Grape-blossoms shed their tiny petals and the hard little beads become green buttons, and the buttons grow heavy.

The Grapes of Wrath, 1939 JOHN STEINBECK

Though the country was not unlike that near his home, he seemed to have travelled during the night over strange wide streams and he thought that this country was not like any he had ever seen.

As he glided along almost without sound, assisted or hindered by a soft breeze according to the windings of the road, he turned over in his mind the possible reasons why he appeared to feel so at ease in this countryside, although at first sight the landscape seemed harsh, open and forbidding. He noticed that the air was stronger, that vegetation and agriculture were less flourishing here than in his birth-place. The houses and villages which nestled in the hollows were more poverty-stricken and less attractive. Roads and paths appeared more deserted, implements simpler and more work-worn; the whole standard of life seemed more modest, as if the rule of nature was tyrannical here and more reluctant to yield to the demands of man than in other districts. He had the impression that here man must rely on his own strength and in the power within him, without that support from others which is accepted as a matter of course elsewhere, especially in towns.

Here the sky seemed endless. Clusters of clouds sailed in stately dignity across the canopy of heaven, their heavy shadows trailing on the brown earth. Isolated trees stood on hillocks in the fields, their branches often bent to one side by the prevailing wind. As the trees were silhouetted against the sky they gave even the poverty-stricken fields a look of pride, for they seemed untouched since creation, save by wind, rain or a kindly sun.

He thought that the cries of the birds were pitched higher here; nowhere had he seen so many birds hovering or circling over the fields on the look-out for prey. Gradually they seemed to him to merge with the forests which he was approaching, the home of all that moved in the skies searching for food. . . .

The outline of the forest became clearer and more defined, and it seemed to him that hidden in its twilight lay not only the real meaning of the landscape but the goal of all his searching.

Even at a distance he realised that its oppressive silence could never be broken and that combined with the fields and the village it formed a monumental landscape comparable only to the vastness of the ocean or the majesty of high mountains.

The Simple Life, 1939 ERNST WIECHERT

The garden was still empty; only a man in his shirt sleeves was doing something to a tree; but she need speak to nobody. The chow stalked after her; he too was silent. She walked on past the flower-beds to the river. There she always stopped, on the bridge, with the cannon-balls at intervals. The water always fascinated her. The quick northern river came down from the moors; it was never smooth and green, never deep and placid like southern rivers. It raced; it hurried. It splayed itself, red, yellow and clear brown, over the pebbles on the bed. Resting her elbows on the balustrade, she watched it eddy round the arches; she watched it make diamonds and sharp arrow streaks over the stones. She listened. She knew the different sounds it made in summer and winter; now it hurried, it raced.

But the chow was bored; he marched on. She followed him. She went up the green ride towards the snuffer-shaped monument on the crest of the hill. Every path through the woods had its name. There was Keepers' Path, Lovers' Walk, Ladies' Mile, and here was the Earl's Ride. But before she went into the woods, she stopped and looked back at the house. Times out of number she had stopped here; the Castle looked grey and stately; asleep this morning, with the blinds drawn, and no flag on the flagstaff. Very noble it looked, and ancient, and enduring. Then she went on into the woods.

The wind seemed to rise as she walked under the trees. It sang in their tops, but it was silent beneath. The dead leaves crackled under foot; among them sprang up the pale spring flowers, the loveliest of the year—blue flowers, and white flowers, trembling on cushions of green moss. Spring was sad always, she thought; it brought back memories. All passes, all changes, she thought, as she climbed up the little path between the trees. Nothing of this belonged to her; her son would inherit; his wife would walk here after her.

The Years, 1937 VIRGINIA WOOLF

There's a storm blowing. It's cold in the bath-house. October . . . Behind the bath-house are the walls of the local kremlin; behind St. Saviour's church, the market with its rows of stalls. The kremlin, the market square, streets, lanes, blind alleys, stone houses, wooden houses, huts, churches with their crosses screaming up there in the wind. Night, fog, darkness, nothing. Yet you can tell them in the black fog by their bluish lights. The houses have squat Dutch stoves in them, or Russian ones. Outside the town, beyond the kremlin on its cliff overlooking the river, an expanse of fields—smelling of horse-sweat till late autumn, a waste field of rye, dead and deserted. What can you do but quote Pushkin, the unquotable?—'Clouds whirl and scurry; the unseen moon lights up the flying snow; the sky is murky, so is the night.' Actually there's no moon: just murk, and fog, and nothingness.

And the town. What can I do but relate the unrelatable—the snowstorm, the howling wind, the gallop, the race and the dance. . .

. . . myself half-blinded, the snow freezing on my glasses, they frost over completely, all I can see is a greenish haze, the snow lashes my open eyes; in the haze I can suddenly see snowflakes, getting thicker and thicker, you blink and grope, the houses, the churches, the wind and snow all closing in on you . . . Higher! Higher!

. . . amid the snowstorm, the howling wind, the gallop, the race and the dance— all of a sudden comes—

absolute quiet, silence, immobility, the Unmoving—in furious pursuit. The hypothesis of Eternity. This, for me, is the Revolution, this is where I see approaching China and the 'Mordvin hordes'. In the gallop, the dance, the hissing—suddenly the stone rabble with its Mordvinian face. We shall all die—that goes without saying—what will be left is history— and the Mordvins.

The deacon's black robe flapping amid clouds of snow—the storm, hey for the storm!

That's how it was. Elegant fir-trees outside the window, then a wilderness of gardens, then the leaden river, bending sharply, and on the far side, on a hill, a white house in an old park—the city's outpost towards the river. The twilight down there goes a leaden colour like the inside of a tea-chest, the earth is black and silent; fir-trees outside my window, spruces surrounding the house on the hill; mountains of clouds in the sky, like the Pamirs on a cloudy day. Wintry clouds, advancing like the snow-king's hordes. Clouds raining lead. The outer gate crashes, there's a flurry of leaves, bits of paper and wood-shavings outside the window; it crashes again, the wind hurls itself at the house. Snow lashes suddenly against the black earth.

The storm, 1921 BORIS PILNYAK

And so April became May. There were fair days when the sun, becoming warmer and warmer, rising, drank off the dew, and flowers bloomed like girls ready for a ball, then drooped in the languorous fulsome heat like girls after the ball; when earth, like a fat woman, recklessly trying giddy hat after hat, trying a trimming of apple and pear and peach, threw it away; tried narcissi and jonquil and flag: threw it away—so early flowers bloomed and passed and later flowers bloomed to fade and fall, giving place to yet later ones. Fruit blossoms were gone, pear was forgotten: what were once tall candlesticks, silvery with white bloom, were now tall jade candlesticks of leaves beneath the blue cathedral of sky across which, in hushed processional, went clouds like choirboys slow and surpliced.

Leaves grew larger and greener until all rumour of azure and silver and pink had gone from them; birds sang and made love and married and built houses in them and in the tree at the corner of the house that yet swirled its white-bellied leaves in never-escaping skyward ecstasies; bees broke clover upon the lawn interrupted at intervals by the lawn mower and its informal languid conductor.

Their mode of life had not changed. The rector was neither happy nor unhappy, neither resigned nor protesting. Occasionally he entered some dream within himself. He conducted services in the dim oaken tunnel of the church while his flock hissed softly among themselves or slept between the responses, while pigeons held their own crooning rituals of audible slumber in the spire that, arcing across motionless young clouds, seemed slow and imminent with ruin.

Soldiers' Pay, 1926 WILLIAM FAULKNER

Being rather late, Owen and Kate bumped out to Tlacolula in a Ford taxi. It was a long way, a long way through the peculiar squalid endings of the town, then along the straight road between trees, into the valley. The sun of April was brilliant, there were piles of cloud about the sky, where the volcanoes would be. The valley stretched away to its sombre, atmospheric hills, in a flat dry bed, parched except where there was some crop being irrigated. The soil seemed strange, dry, blackish, artificially wetted, and old. The trees rose high, and hung bare boughs, or withered shade. The buildings were either new and alien, like the Country Club, or cracked and dilapidated, with all the plaster falling off. The falling of thick plaster from cracked buildings—one could almost hear it!

Yellow tram-cars rushed at express speed away down the fenced-in car-lines, rushing round towards Xochimilco or Tlalpam. The asphalt road ran outside these lines, and on the asphalt rushed incredibly dilapidated Ford omnibuses, crowded with blank dark natives in dirty cotton clothes and big straw hats. At the far edge of the road, on the dust-tracks under the trees, little donkeys under huge loads loitered towards the city, driven by men with blackened faces and bare, blackened legs. Three-fold went the traffic; the roar of the tram-trains, the clatter of the automobiles, the straggle of asses and of outside-seeming individuals.

Occasional flowers would splash out in colour from a ruin of falling plaster. Occasional women with strong, dark-brown arms would be washing rags in a drain. An occasional horseman would ride across to the herd of motionless black-and-white cattle on the field. Occasional maize-fields were already coming green. And the pillars that mark the water conduits passed one by one.

The Plumed Serpent, 1926 D. H. LAWRENCE

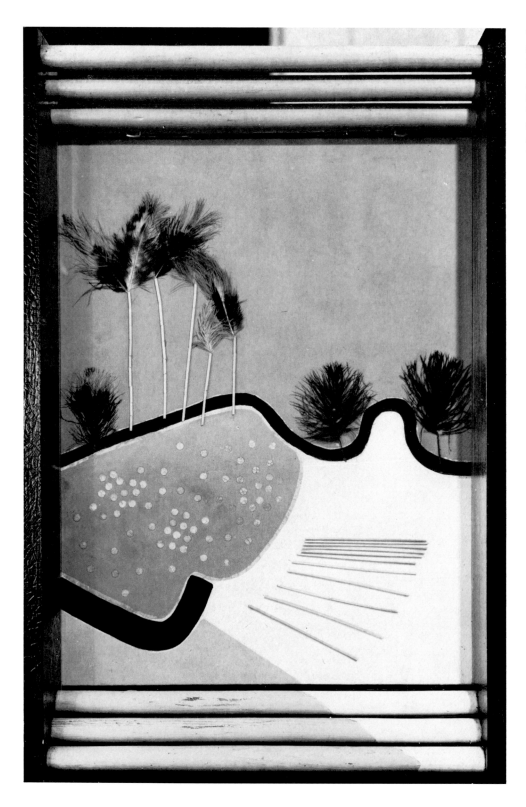

112. FRANCIS PICABIA: *Feathers* 1921. Oil and collage on canvas, 119 × 78 'cm. Milan, Schwarz Gallery.

A 'joke' in the Dadaist spirit, the landscape serving as a pretext for the whimsical use of unexpected materials. There is a certain grace and elegance in the extraordinary contour out of which the feathers spring; but clearly the whole work belongs to the realm of paradox.

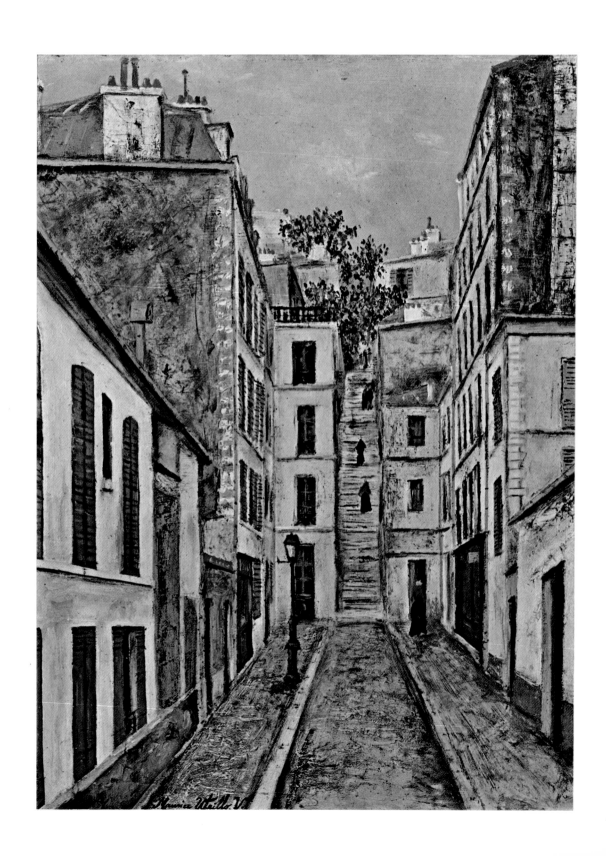

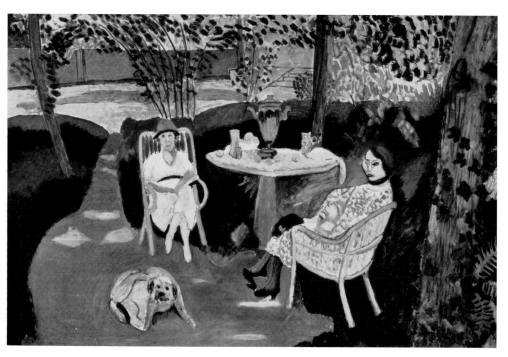

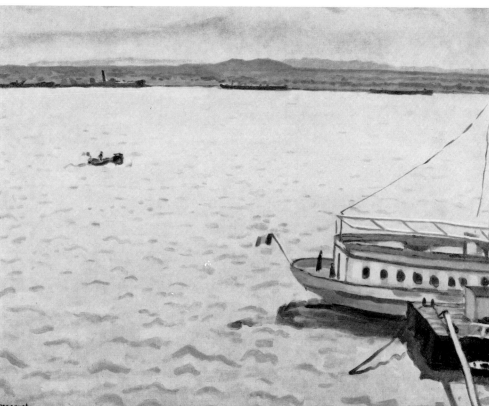

113. MAURICE UTRILLO: *The Impasse Cottin*, about 1910. Oil on cardboard, 62 × 46 cm. Paris, National Museum of Modern Art.

One of Utrillo's most celebrated views of Paris. The colouring is sober except for bright patches here and there, as at the top of the long flight of steps. The house-fronts and the surface of the street (the painter being imagined in the centre of it) are rendered with the elaborate, careful technique of veiled transparency in which he gave expression to his unique perception of the urban landscape.

114. HENRI MATISSE: *The tea*, 1919. Oil on canvas, 137 × 207 cm. Beverly Hills, California, David Loew Collection.

Matisse's characteristic wealth of colour is fully displayed in this outdoor scene, whose traditional appearance is deceptive: it is very different in spirit from eighteenth-century compositions of the same type. The artist succeeds by purely formal methods in redeeming the subject from banality.

115. ALBERT MARQUET: *The Danube at Galatz*, 1933. Oil on canvas, 46 × 55 cm. Geneva, Petit Palais (Oscar Ghez Collection).

The river, in its huge extent, may almost be regarded as a symbol of Europe. From his youth onwards Marquet excelled at rendering the fascination of great empty spaces, their power to unite as well as separate. We also find in this picture the method of recording contrasts with rapid strokes that was typical of the painter in his Fauvist period.

116. André Dunoyer de Se-
gonzac: *Farm near Saint-Tropez*,
1925. Oil on cardboard, 35 × 80 cm.
Paris, National Museum of Modern
Art.

A dramatic landscape full of immediate
impact. It bears witness to the artist's
share in the naturalistic tendency which
developed in France after the twen-
ties, in disregard or in opposition to
avant-garde movements of the past
or present.

117. Maurice de Vlaminck:
Level crossing, 14 July 1925. Oil on
canvas, 60 × 75 cm. Geneva, Petit
Palais (Oscar Ghez Collection).

Gashes of colour reminiscent of
Fauvist violence but handled in a
different style, with contrasts and
dissonances that may seem intention-
ally aggressive and unpleasing—these
are the main features of Vlaminck's
stormy landscape, which seems to
assert the right of pure instinct to
restore total creative freedom.

118. Louis Marcoussis: *The har-
bour at Kérity*, 1927. Oil on cardboard,
33 × 41 cm. Paris, National Museum
of Modern Art.

A typical example of Marcoussis's
composite style. Among his succes-
sive experiences it would seem that
Cubism, though in a hybrid decora-
tive form, remained the strongest and
liveliest. Much the same may be said
for Severini in Italy.

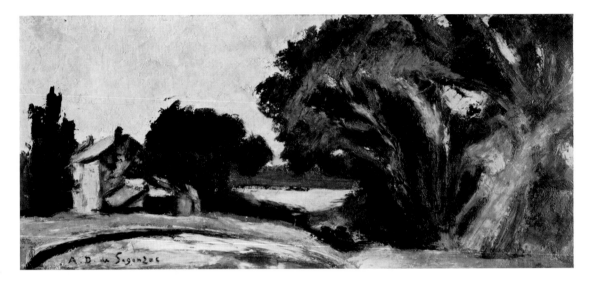

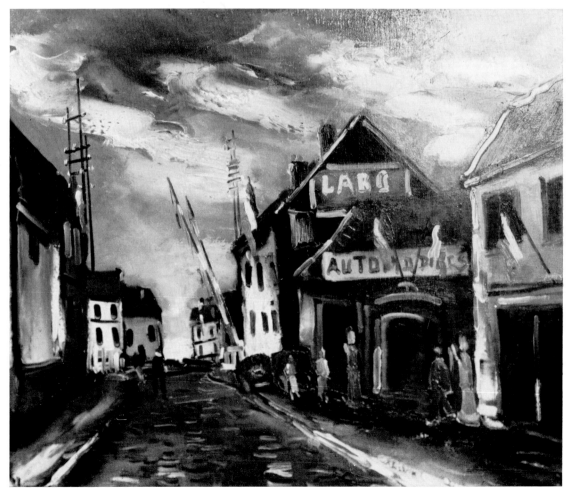

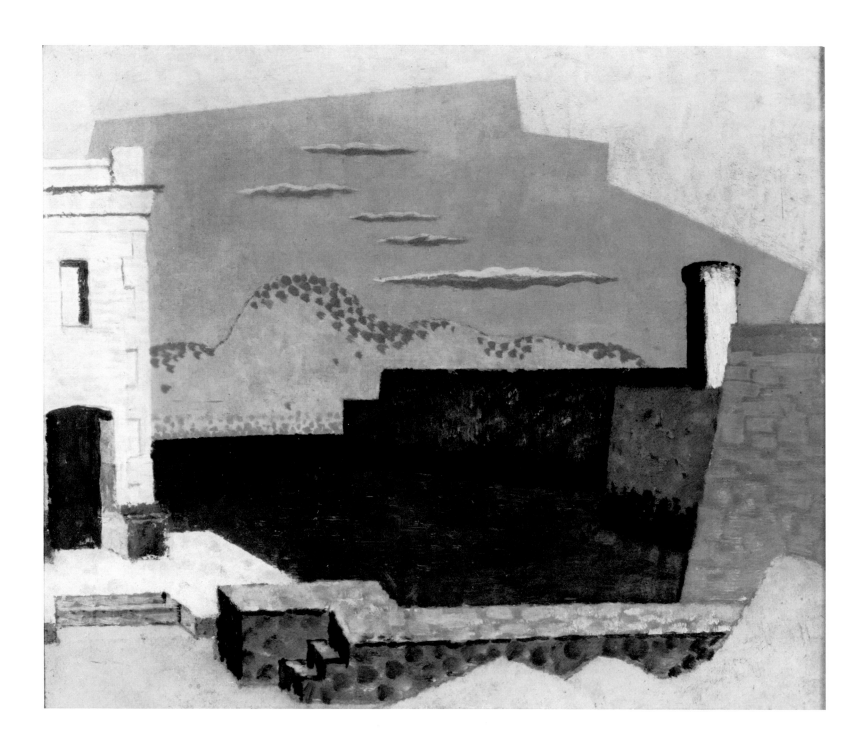

119. FERNAND LÉGER: *The city*, 1919. Oil on canvas, 230 × 297 cm. Philadelphia, Museum of Art (A.E. Gallatin Collection).

In his efforts to achieve 'a hard, rational mode of painting, geometrically defined with inexorable precision in its forms and planes—cold, insensible, mechanical', Léger produces a co-ordinated sequence of symbols which are stylistically homogeneous or, more correctly, are seen from the same angle of vision. The result is a complex structure which the outside world is constantly providing with models and stimuli.

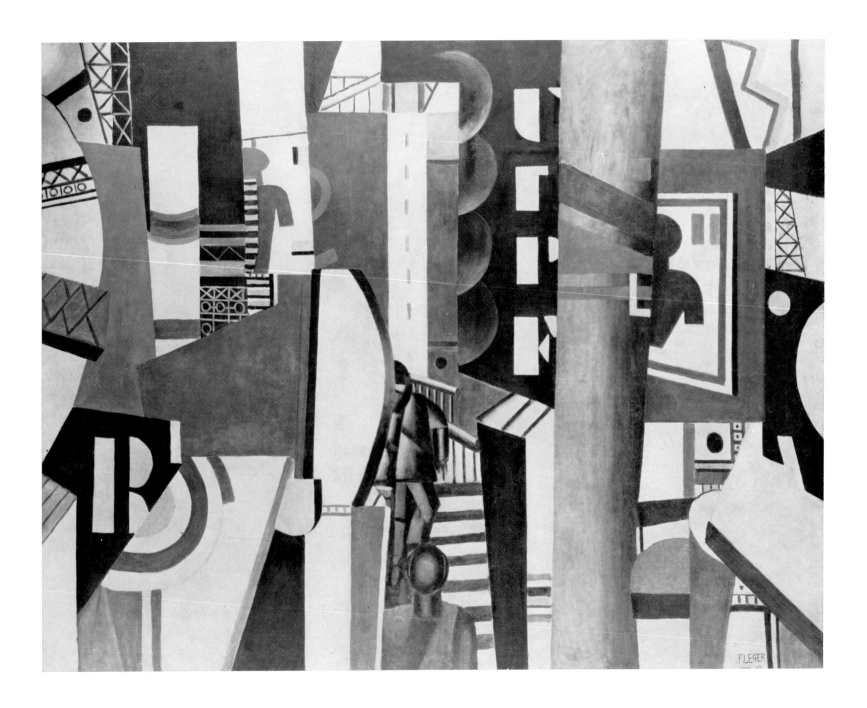

120. KEES VAN DONGEN: *Fellahin on the baks of the Nile*, about 1912. Oil on cardboard, 65 × 81 cm. Paris, National Museum of Modern Art.

A rapid glimpse of an Arab village, accurate in description despite the lack of a clearly defined structure. The picture is made up of summary indications, and in the lower part there is no clear transition from the horizontal to the vertical plane. Like some works by Marquet, it has the freshness of an improvisation or a series of notes.

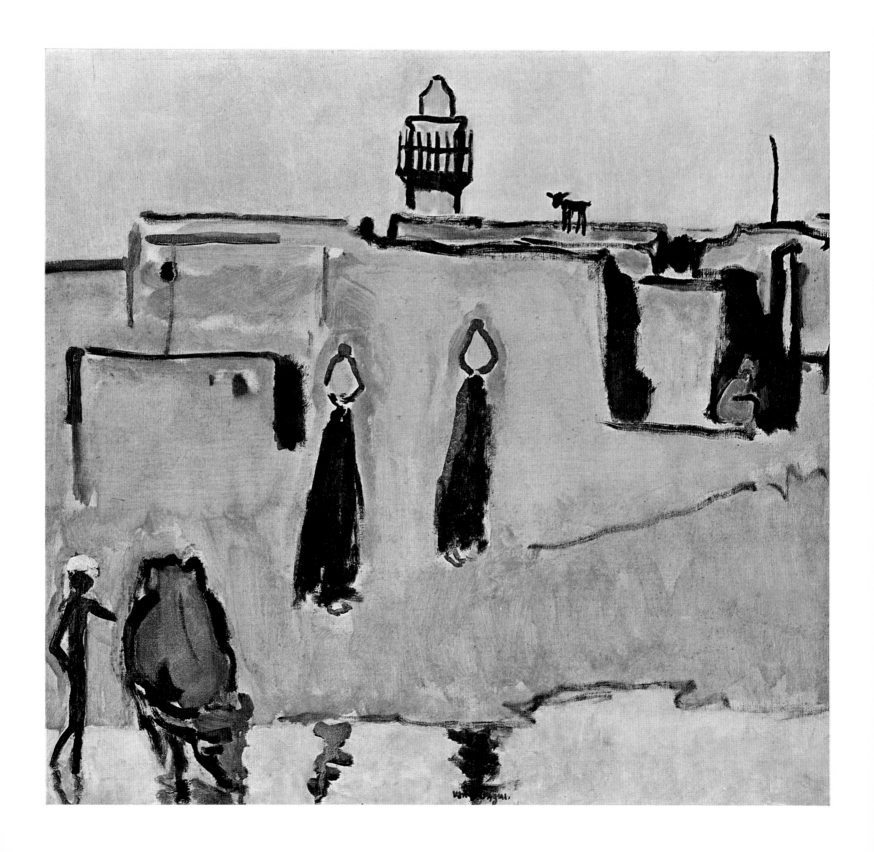

121. CHAIM SOUTINE: *Chartres Cathedral*, 1933. Oil on panel, 90 × 94 cm. New York, Museum of Modern Art (gift of Mrs Lloyd Bruce Wescott).

A tormented, grandiose representation of the cathedral. The exalted, instinctive frenzy of Soutine's style is well shown in this insistent deformation, this masterful recasting of material elements. We are at the extreme limit of tragic feeling, on the verge of the cataclysm so often reflected in the author's work.

122. MARC CHAGALL: *The dream*, 1939. Gouache and pastel, 50.8 × 66 cm. Washington, D.C., Phillips Collection.

The year 1939 was a particularly important one for Chagall, concluding one period and beginning another which was to develop in America. The present theme is one of the most frequent of the new period, intermingling in a joyful harmony the real world and that of dreams and fantasy.

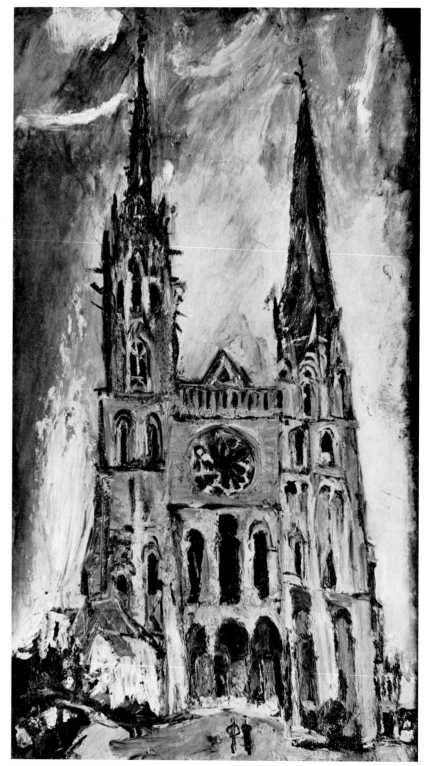

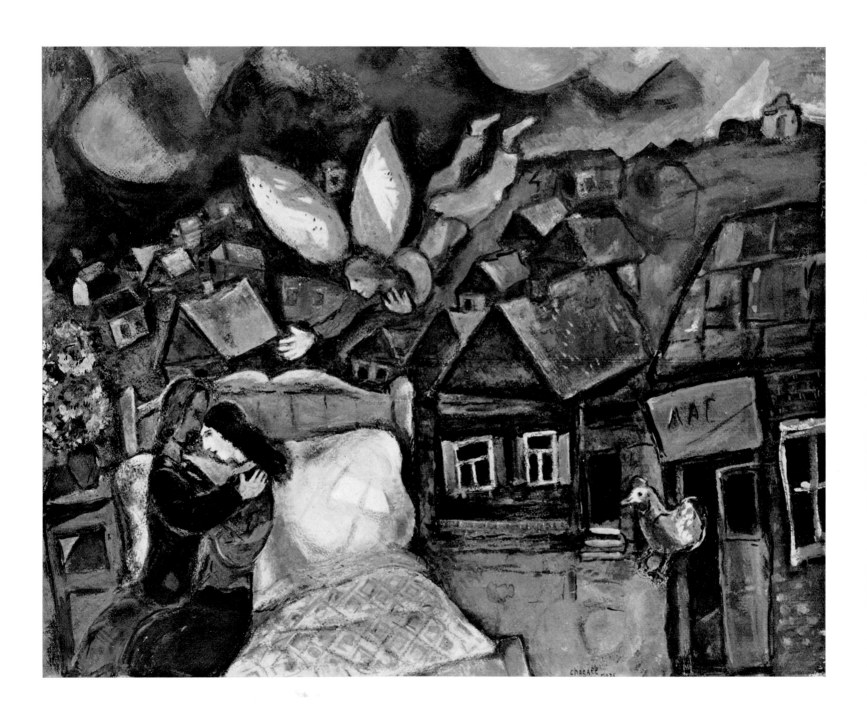

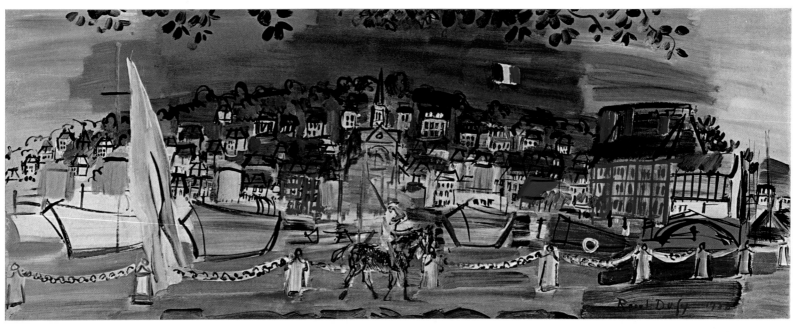

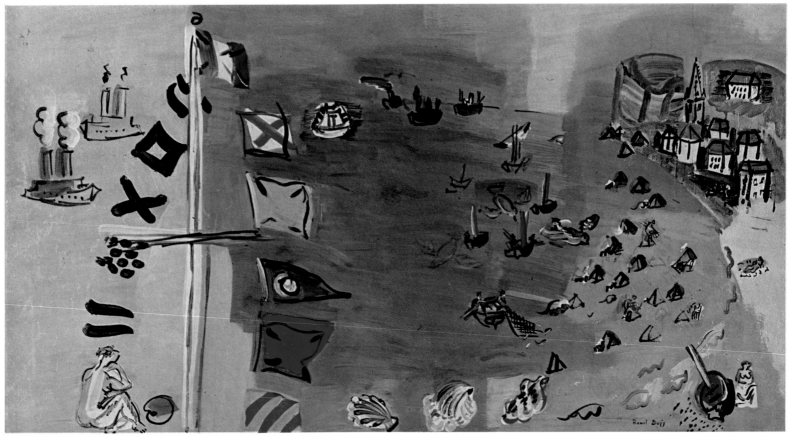

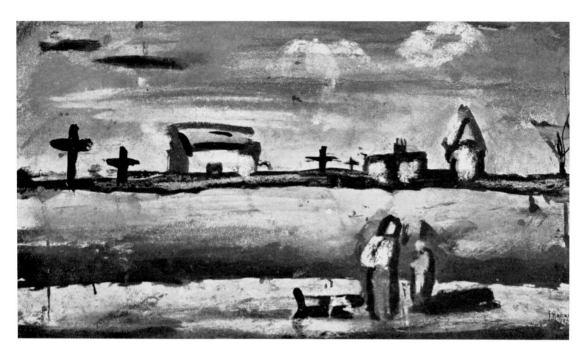

123. RAOUL DUFY: *Regatta*, 1938. Oil on canvas, 33 × 82 cm. Amsterdam, Municipal Museum.

This work typifies Dufy's sense of landscape and the inimitable style in which he depicted it for several decades. There is an extreme lightness, elegance and refinement in these joyful visions, which have the freshness of an improvisation yet are the fruit of skilled and meticulous execution.

124. RAOUL DUFY: *The beach*, about 1933. Oil on canvas, 70 × 130 cm. Private Collection.

Dufy depicts the joyfulness of a summer morning, with the sea and sky forming a single expanse of blue. The fluttering flags, the smoke of the boats' funnels, the tiny bathers, the shells and the village across the little bay—all these go to form a brilliant variegation of colour.

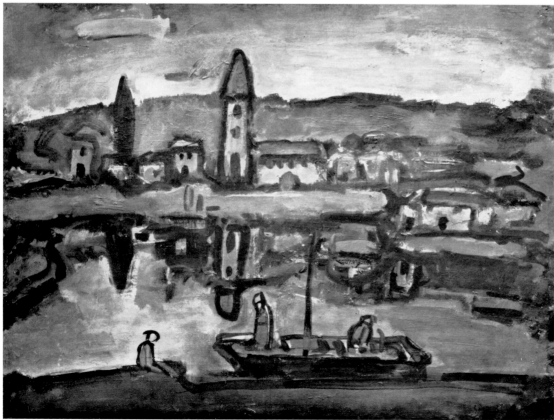

125. GEORGES ROUAULT: *Cemetery*, 1930. Pastel and indian ink, 27.5 × 47 cm. Private Collection.

A solemn, austere landscape, the direct antithesis of Dufy's *Beach*. Full of a sense of grief and death, the work shows a pattern of marked horizontals which is typical of Rouault at this time. As is usual with him, the chromatic and compositional contrasts are violent, and the symbols of this gloomy world are vividly realistic.

126. GEORGES ROUAULT: *A river bank in the Ile de France*, 1948. Oil on canvas, 75 × 105 cm. Zürich, Kunsthaus.

Here again we find a sequence of horizontal lines, varied by the reflecting surface of the water and the boat which recalls a scene from the Gospels. This was in fact the period in which Rouault's paintings were marked by a strong tinge of religion in its human aspect.

127. FÉLIX VALLOTTON: *Old bridge at Brantôme*, 1925. Oil on canvas, 55 × 73 cm. Lausanne, Collection of the Heirs of Paul Vallotton.

The year 1925, in which the painter died, was also a particularly fruitful one for his work. Despite their precision and loving attention to detail, the landscapes of his last period are as mysterious as dreams or visions in an airless space, seen through glass.

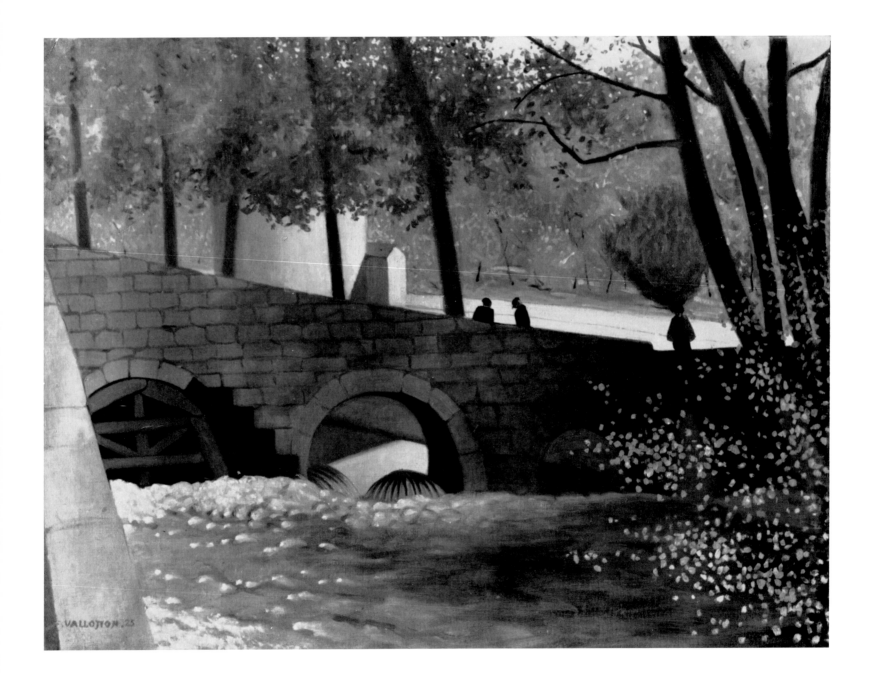

128. MOÏSE KISLING: *Saint-Tropez*, 1918. Oil on canvas, 46 × 55 cm. Geneva, Petit Palais (Oscar Ghez Collection).

One of Kisling's 'soft' landscapes, composed of a succession of planes in depth. A subtle lyrical vein of consuming melancholy pervades the shifting outlines and billowing misty shapes. The depressions of the capricious landscape are faithfully marked by the colour-scheme.

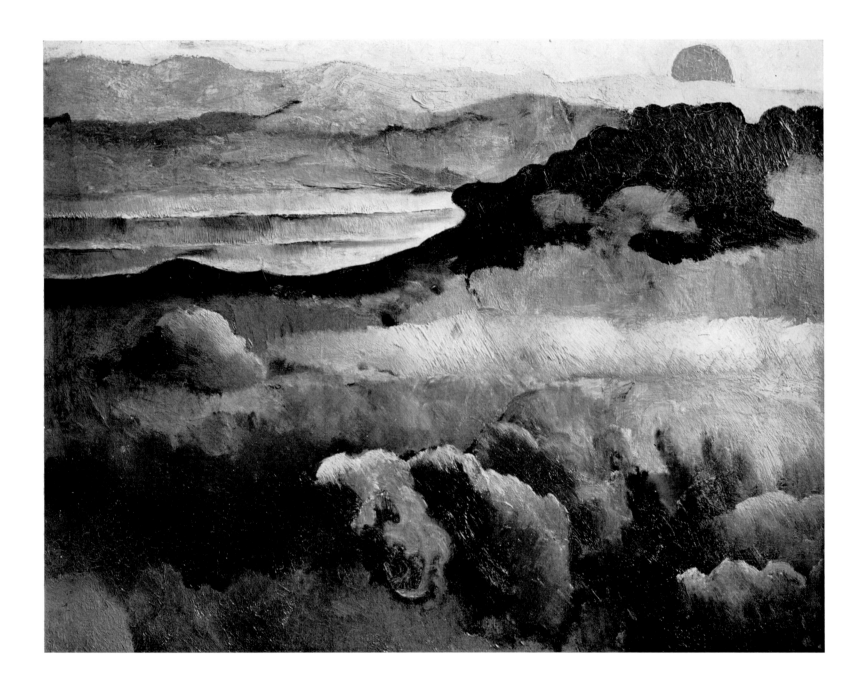

129. ANDRÉ DERAIN: *Amiens*, 1947. Oil on canvas, 90 × 109 cm. Troyes, Pierre Lévy Collection.

This work shows affinities with the exact, pure style of Corot, towards which the artist turned in the early 1920s. The view from above is fairly conventional, and there is also something rather facile in the panorama. But the picture is one of quality, and has been admired and imitated both in France and elsewhere.

130. GEORGES BRAQUE: *Beach with cabins and boats*, 1933. Oil on canvas, 27 × 41 cm. Paris, Maeght Gallery.

This seascape breaks the sequence of still-lifes which are more typical of Braque, but it is of an equally decorative character. Without exaggerating any feature of the scene, he enlivens it by using devices of a refinement almost without parallel in twentieth-century painting.

131. CAMILLE BOMBOIS: *The Bois de Vincennes*, 1928. Oil on canvas, 73 × 100 cm. Geneva, Petit Palais (Oscar Ghez Collection).

Bombois tolerates nothing imprecise: he will have nothing to do with the vibration of surfaces or the atmospheric fluidity of forms; he first defines clearly the image of a thing, and then applies it to physical reality. This is true of the present extraordinary landscape, in which the painter's image corrects nature and becomes a representational reality.

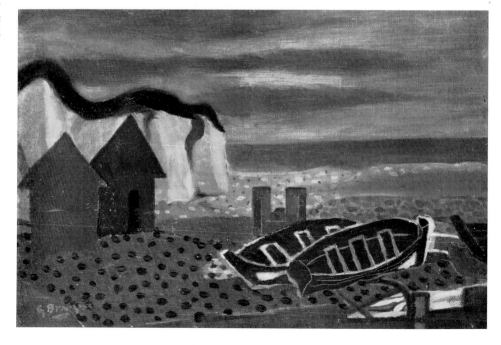

132. KRSTO HEGEDUSIC: *Popular revolt*, 1928. Tempera, 75 × 105 cm. Zagreb, Modern Gallery.

Hegedusic is the best-known Yugoslav painter of popular themes. In this work he shows once again his feeling for the realities of his own country and his determination to regain touch with the peasantry. There is an effortless skill in the narration, and the landscape too is exactly characterized.

133. KRSTO HEGEDUSIC: *Flood*, 1932. Oil on canvas, 105 × 132 cm. Zagreb, Modern Gallery.

An agitated scene, touching in its realism, this work was painted barely three years after the foundation of the *Zemlja* group at Hlebine. The pathos is not diminished by the precision of certain descriptive elements. The men and women we see here are bound ancestrally to the land on which they live and work.

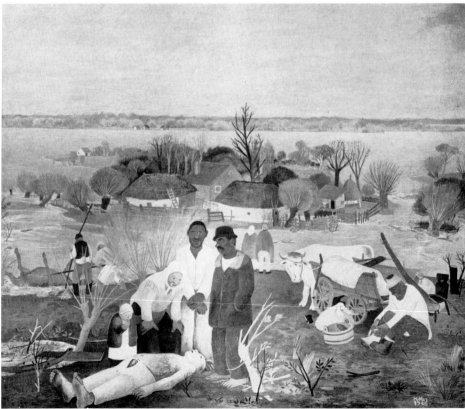

134. PIO SEMEGHINI: *Landscape*, 1927. Oil on panel, 20 × 31 cm. Milan, Giovanardi Collection.

The tree in the foreground, with its topmost branches cut off by the picture-edge, shows clearly the derivation of this work from the Post-Impressionism of the *Revue blanche*. But, unlike his companion Gino Rossi and more in Moggioli's style of 'Central European' lyricism, Semeghini allows the eye to glide freely over the landscape, which is marked by an exact balance of tonal relationships.

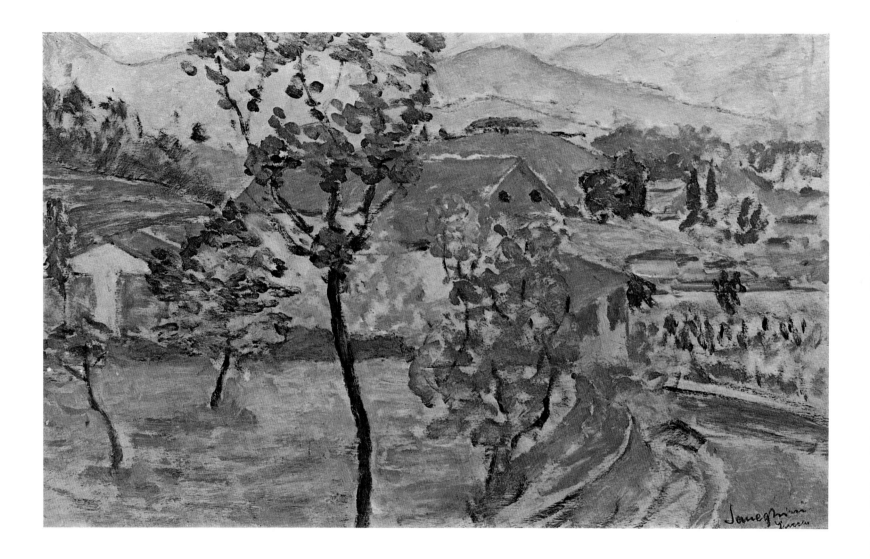

135. PIO SEMEGHINI: *Venetian landscape*, 1937. Oil on panel, 33 × 41 cm. Milan, Private Collection.

More French reminiscences, this time of Marquet. However, relating the French experience to his classical background, Semeghini expresses his hypersensitivity of vision by emphasis on formal correspondences, as well as by the almost olfactory effect of the interplay of light, water and solid objects.

136. GIORGIO MORANDI: *Rose-coloured landscape*, 1916. Oil on canvas, 40 × 55 cm. Milan, Emilio Jesi Collection.

This youthful work shows Cézanne's influence in the well-defined succession of planes in depth, separated and interlinked by houses and trees. The rosy colouring verges on the monochrome, to the exclusion of any descriptive deviation. This, like the range of objects seen in the picture, is typical of the artist's poetic approach.

137. GIORGIO MORANDI: *Village*, 1935. Oil on canvas, 60 × 71 cm. Turin, Gallery of Modern Art.

Several of Morandi's 'dramatic' masterpieces were created around 1935. In his still-lifes, the narrative element is reduced to a minimum by placing objects unexpectedly in the foreground. In landscape his technique is the opposite: the view plunges swiftly into the distance, and the elements of the composition (trees, houses and the relationship between countryside and sky) are expressed by means of large white blobs standing out against a dark background.

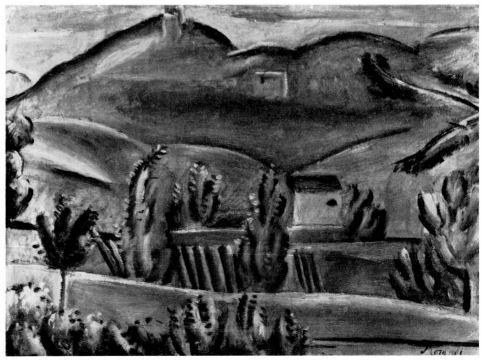

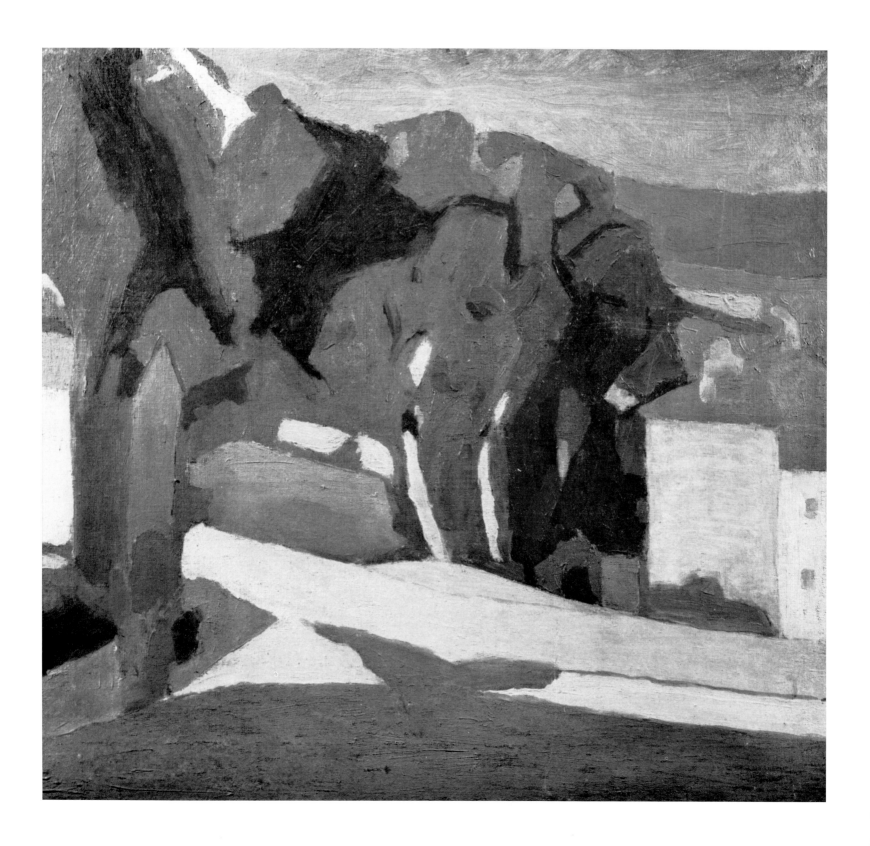

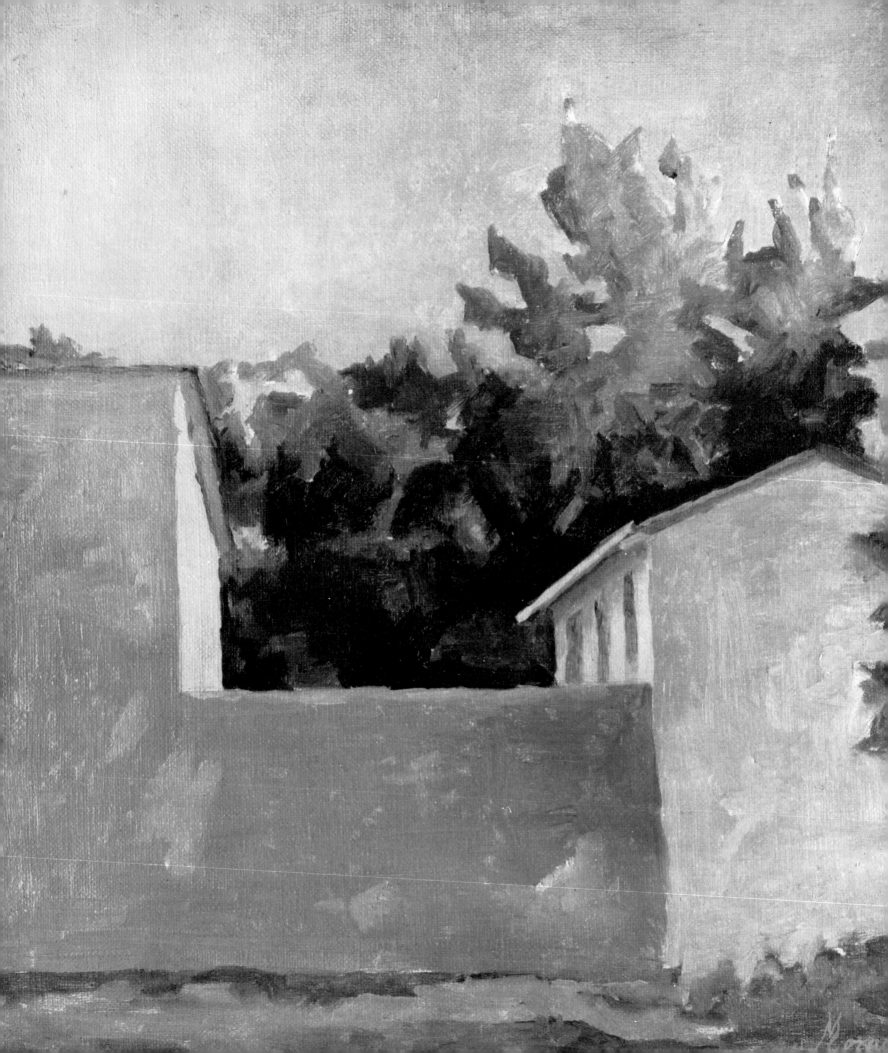

138. GIORGIO MORANDI: *Landscape*, 1925. Oil on canvas, 46 × 42 cm. Milan, Emilio Jesi Collection.

This masterpiece perhaps marks the zenith of Morandi's 'Corot' period. The latter's influence is visible in the limpidity of the surfaces, and in the almost monumental outline of the vertical features. The relationship between the pink of the walls and the dull green of the trees produces an effect of latent disquiet that is extraordinarily modern.

139. GIORGIO MORANDI: *Landscape*, about 1955. Oil on canvs, 46 × 51 cm. Milan, Raffaele Mattioli Collection.

One of Morandi's barest landscapes, extraordinary for the lack of any outwardly pleasing feature. Nearly half the canvas is filled by a vertical plane against which the artist has drawn with the utmost skill a tracery of branches stretching upwards towards the pale wintry sky of his native province. A rigorous tonality with extremely subtle gradations, and a barely perceptible vibration of light, express the interior tension that characterizes Morandi's inspiration at its highest pitch.

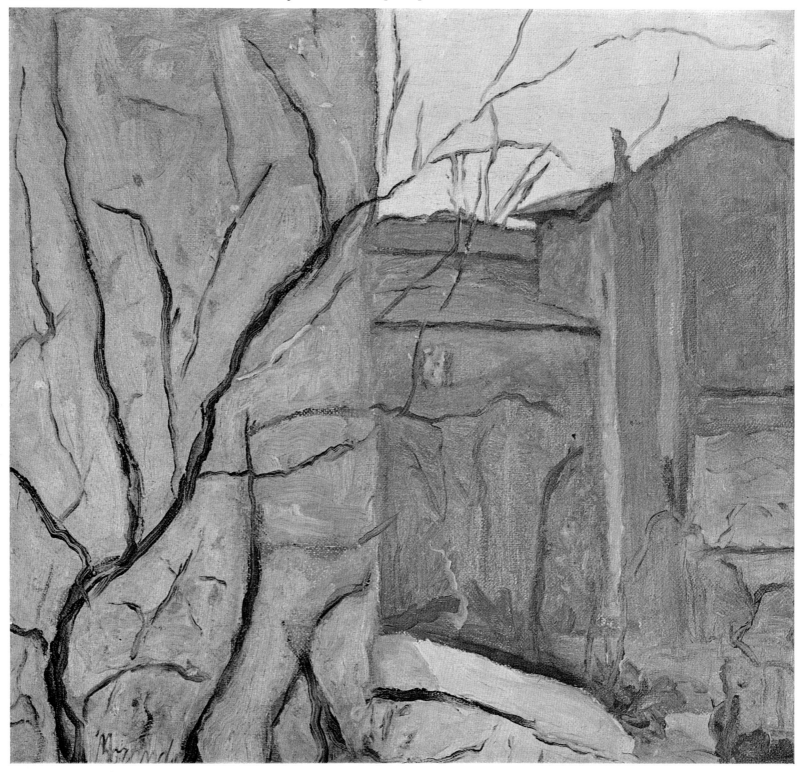

140. OSVALDO LICINI: *Landscape in the Marches*, 1926. Oil on canvas, 50 × 65 cm. Venice, Gallery of Modern Art.

Cézanne's influence is visible here in the same manner as in Plate 136. The view down to the open sea is marked off in clear stages, but this tendency towards geometrical precision is accompanied by a reckless vein of fantasy which remained typical of Licini in later years.

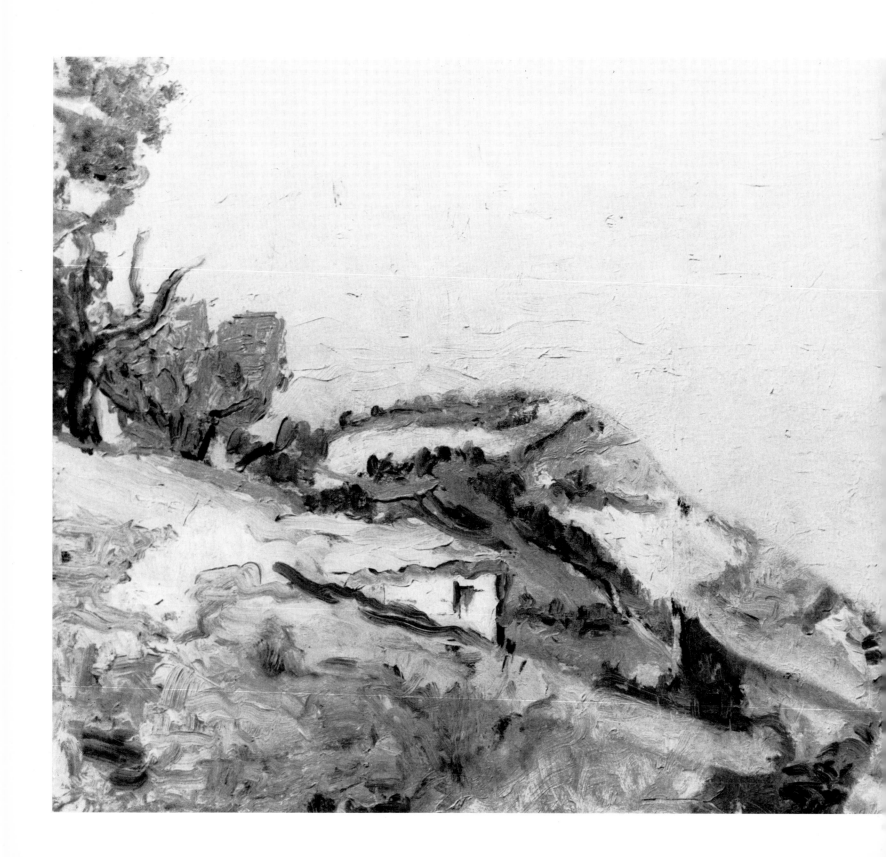

141. CARLO CARRÀ: *Pine-tree by the sea*, 1921. Oil on canvas, 68 × 52.5 cm. Rome, Yvonne Casella Collection.

The 'Gusto dei Primitivi' and 'Valori plastici' were stages, marked by successive masterpieces, in Carrà's approach towards his 'Metaphysical' crisis in the twenties. In works of this kind there is no direct citation of reality, but an anti-rhetorical setting for high contemplative poetry. Thus in the present painting we have the 'wings' with the dark sea between, the sky spread behind the round thirteenth-century type treetop, and the cave reminiscent of some early Entombment.

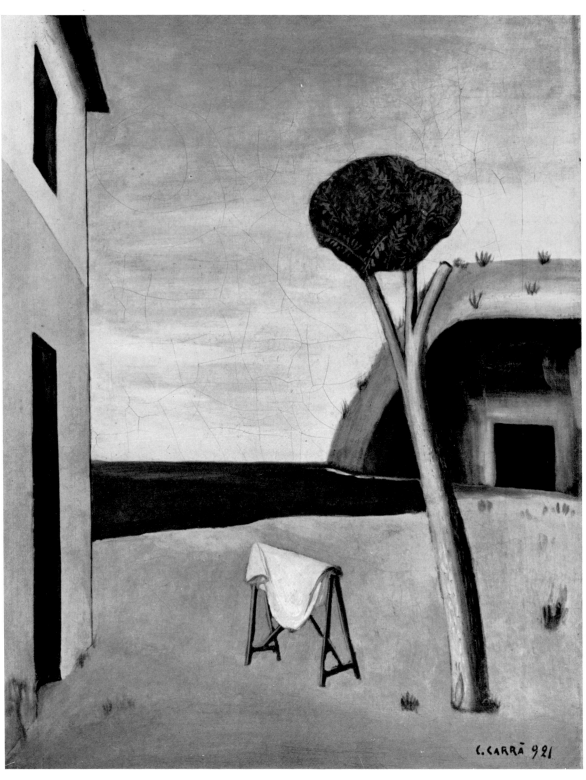

142. CARLO CARRÀ: *Seascape at Il Forte*, 1932. Oil on canvas, 37 × 54 cm. Emilio Jesi Collection.

At this period Carrà seems to rediscover some of the chief values of the *macchiaioli* whom, as a young man, he rejected with contumely. We may instance here the relationship between the lights on the house and on the beach, and also the shadowy green foreground. The connecting link consists in a common attitude towards paintings of the Quattrocento and earlier, for which Fattori's small canvases might have served as 'secular predelle'.

143. CARLO CARRÀ: *La Crevola*, 1924. Oil on canvas, 26 × 37 cm. Milan, Emilio Jesi Collection.

The economy, from a figurative point of view, of Carrà's landscapes between 1924 and 1935 is a result of his intense meditation on the Old Masters. The last traces of direct borrowing have disappeared, but essential features are depicted in richly emotive chromatic and tonal relationships.

144. CARLO CARRÀ: *Morning by the sea*, 1928. Oil on cardboard, 54 × 64 cm. Milan, Mattioli Collection.

The compositional processes are reiterated within a strongly abstractionist framework. The narrative element being eliminated, it is possible to return with fresh intensity to sentimental interpretation, by means of an almost inexhaustible range of light and colour.

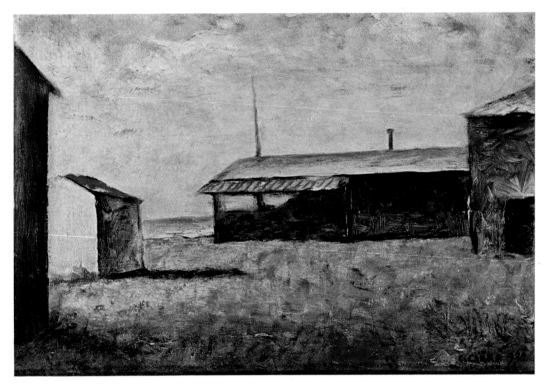

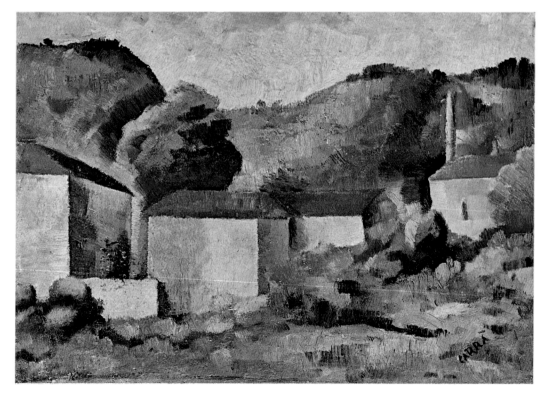

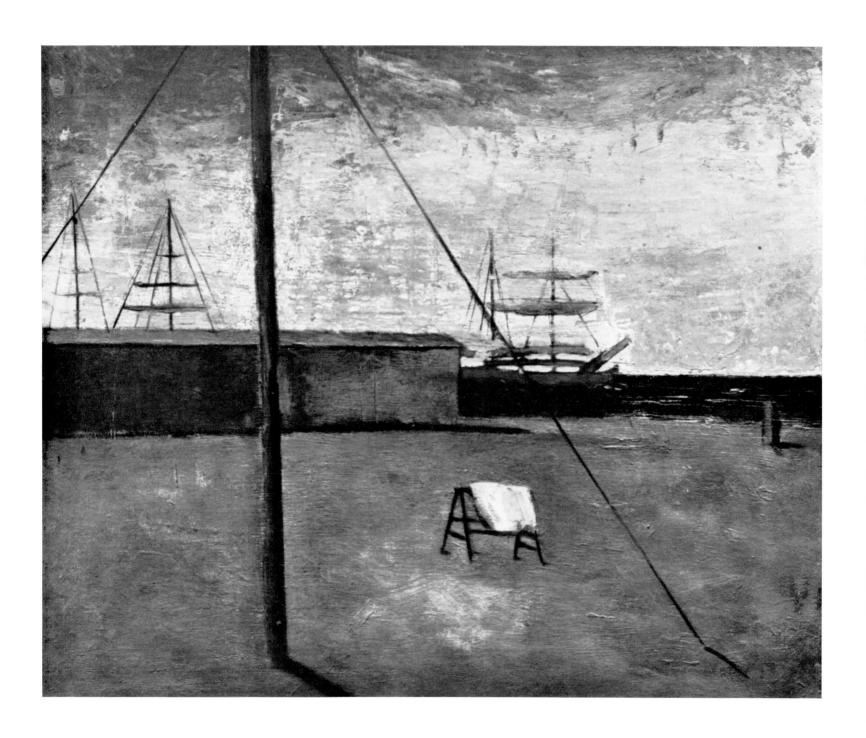

145. MARIO SIRONI: *Suburb*, 1922. Oil on canvas, 60 × 77 cm. Milan, Carlo Foà Collection.

The industrial theme and the aerial viewpoint link this picture closely with the *neue Sachlichkeit* ('new objectivity'), as does the geometrical schematization of the figures in their various perspectives. But the unification in terms of light and colour, and the tragic drabness of the figures, belong to the highest reach of Sironi's own genius.

146, 147. MARIO SIRONI: *Townscape with lorry*, 1920. Oil on canvas, 44 × 60 cm. Milan, Emilio Jesi Collection.

Sironi is the only Italian 'restorationist' of the 1900s who devoted himself not to reviving national myths but to a more fruitful meditation on the state of humanity. The structure of this work, with its geometrical modulations based on exact foci of perspective, is typical of the neo-Quattrocento; but its repeated schematism gives it an exceptional power of dramatic synthesis, expressed in large patches of sulphureous colour.

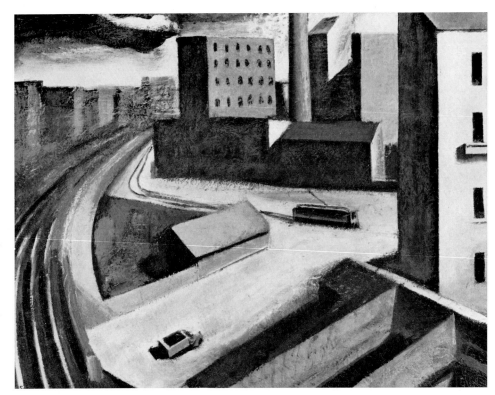

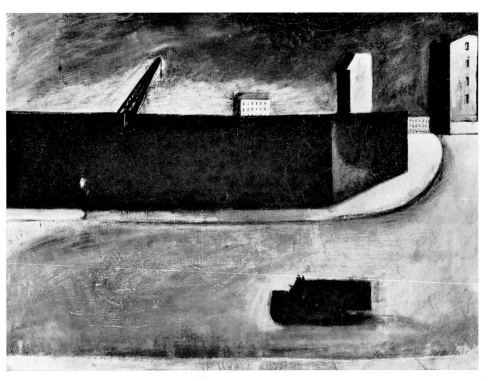

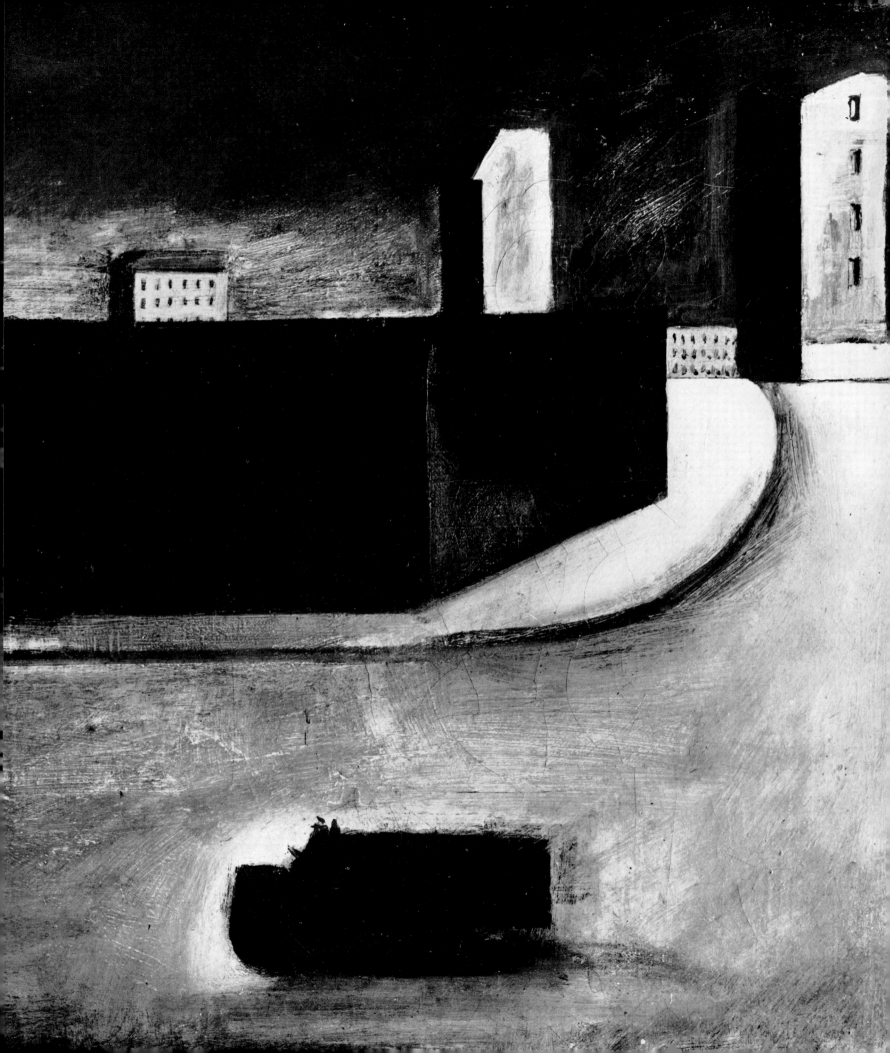

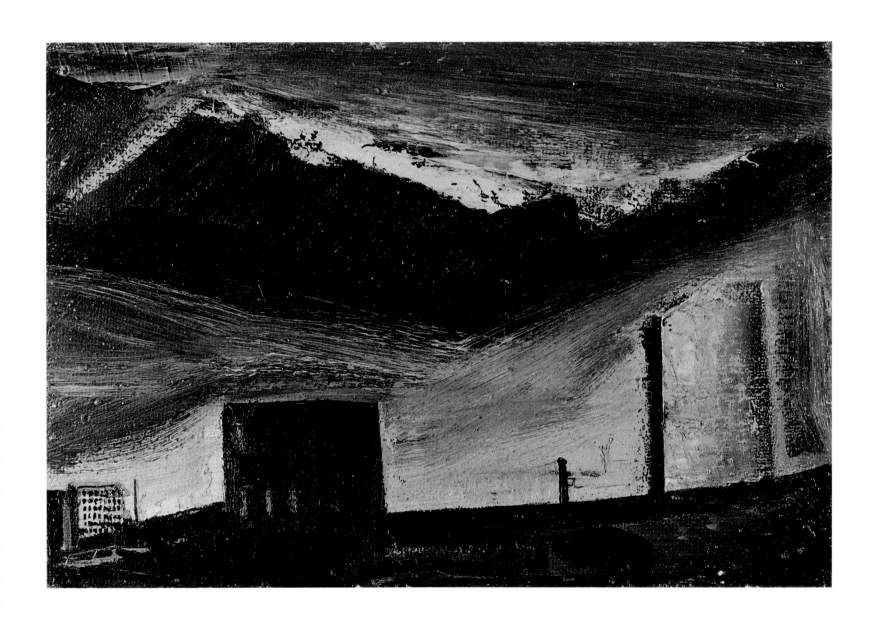

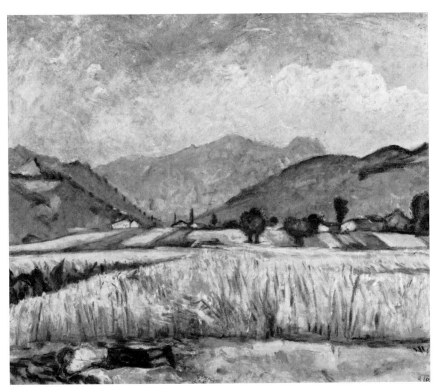

148. MARIO SIRONI: *Suburb*, 1944. Oil on cardboard, 24 × 31 cm. Milan, Mattioli Collection.

The visionary work, improperly called 'Expressionistic', exhibits the artist's talent in its full range, devoid of narrative content. The industrial scene has become an assemblage of charred ruins; the lowering sky, in its anguished unreality, suggests incandescent Dolomitic formations.

149. ARTURO TOSI: *Wheatfield*, 1928. Oil on canvas, 98 × 118 cm. Milan, Renato Picollo Collection.

Tosi's art is enriched by his interest in the emotional aspects of light and hours of the day. The extension of the field recalls Poussin, while the severity of composition is also reminiscent of the seventeenth century; but the 'luminous whole' created by the noontide scene is in Tosi's best idiom.

150. ARTURO TOSI: *Landscape at Rovetta*, 1941. Oil on canvas, 100 × 120 cm. Milan, Gian Ferrari Gallery.

Tosi, the most classical landscapist of the *Novecento* group, constructed his pictures according to the tradition which derives from seventeenth-century Holland and reached our own day via the Barbizon school. The horizon is half-way down the canvas, and the descriptive elements are disposed in a clear perspective based on a central focus.

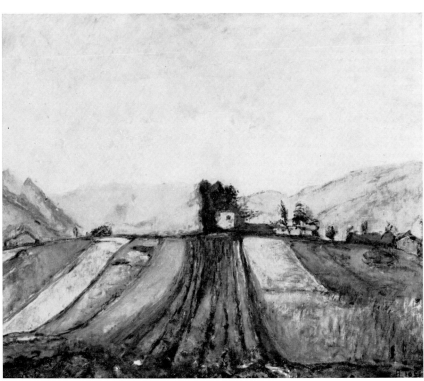

151. OTTONE ROSAI: *The windy house*, 1922. Oil on cardboard, appliqué on masonite, 61 × 47 cm. Prato, Falsetti Gallery.

It is hard to imagine more simple means for the achievement of such sure effects. One would look in vain today for an artist capable of rendering with such inspiration this Tuscan farmhouse set on a hill, like a plain, solemn fortress, with its threshing-floor, haystack and mulberries, and the green fields and soil immediately below. The impression of the hill is given without any description, with a few rapid brush-strokes on the coarse cardboard.

152. OTTONE ROSAI: *White gate*, 1933. Oil on cardboard, 100 × 72 cm. Florence, Basilio Collection.

The initial impression of ascent is confirmed and intensified as the eye travels over the picture. The wealth of colour, with its immense variety of character and inflection, underlines the importance of individual episodes as part of the total effect. While still very fluid, the colouring is typical of the artist in its resonance and the ever-changing, elemental force which seems to pervade the draughtsmanship.

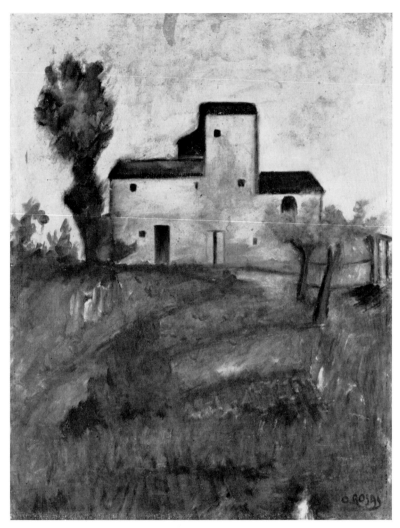

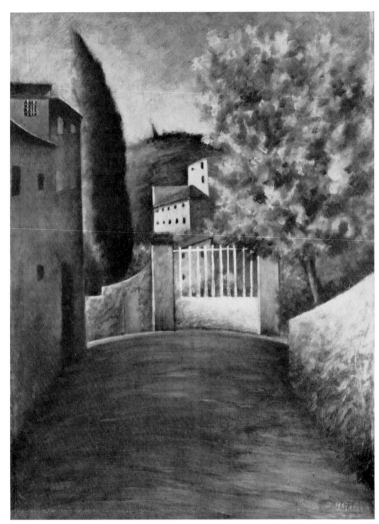

153. OTTONE ROSAI: *Tuscan house*, 1919. Oil on canvas, 45 × 58 cm. Milan, Emilio Jesi Collection.

One of the most imposing examples of Rosai's 'historical' affinity with his native province. The typical features of a Tuscan landscape are displayed in a centralized perspective on classical lines. Purged of descriptive additions, they preserve their basic meaning while at the same time a disquieting element is added by the 'human look' of the windows.

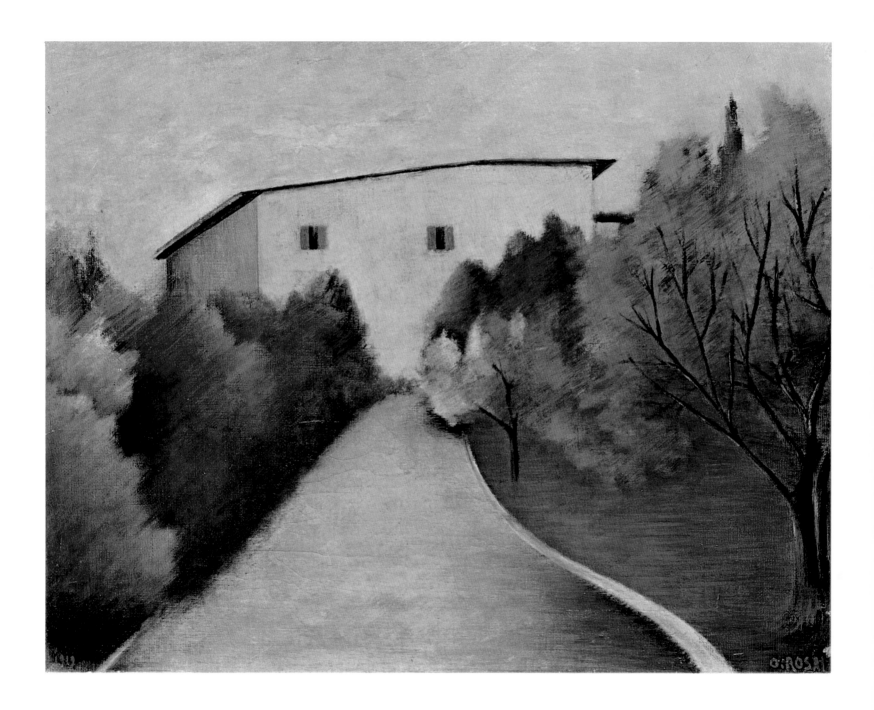

154. ANTONY DE WITT: *Village on the Skagerrak*, 1935. Oil on canvas, 55 ×97 cm. Milan, Ferdinand Ferré Collection.

The Nordic landscape takes on an unexpected look of some Thebaid of the Quattrocento. The modulation of the scene and the relationship between the houses and countryside show the influence of Gherardo Starnina. The withered boughs in the foreground, beside the pigs and brushwood, delicately suggest a 'season' after the manner of a Book of Hours.

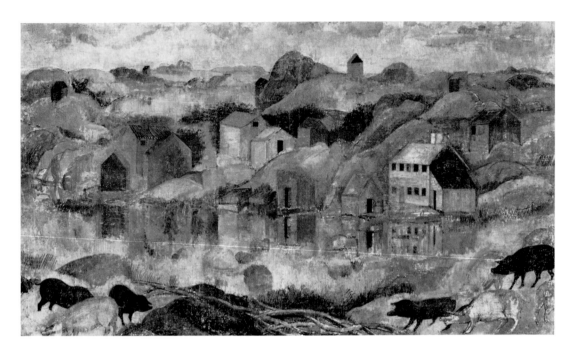

155. LORENZO VIANI: *Georgics*, 1930. Oil on canvas, 123×198. Venice, Gallery of Modern Art.

A successful assemblage of most of the narrative elements used by this artist, who combined the tradition of the *macchiaioli* with a rhetorical regionalism. The cattle and herdsmen, the sea and the boats are depicted in a monumental style, like heraldic emblems of human toil and suffering. Each event is separated and emphasized in a spacious, inexorable narrative; the ship in distress no longer carries the associations of popular symbolism, but rather a desolate enchantment with strong lyrical overtones.

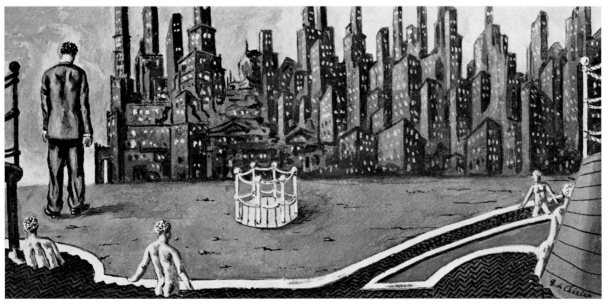

156. ARDENGO SOFFICI: *Santa Cristina*, 1908. Oil on cardboard, 64.5 × 49.5 cm. Milan, Emilio Jesi Collection.

The Tuscan tradition of Signorini and Lega, seen by a young man captivated by French ideas and particularly by Cézanne and by the school of Pont-Aven. The result is a fluid, elegant narration strung out, as it were, along the road like a sequence of everyday events.

157. GIORGIO DE CHIRICO: *A square in Rome*, 1922. Oil on canvas, 56 × 76 cm. Rome, Yvonne Casella Collection.

In the same way as the 'return to antiquity' led Carrà to study the Tuscan primitives, so it led De Chirico to Ferrara and the Quattrocento. There are frequent reminders here of Ferrarese painters from Cossa to Dosso Dossi, while the *coulisse* arrangement is reminiscent of Giotto at Santa Croce or of the fifteenth-century masters of perspective, such as Uccello or Piero della Francesca. At the peak of his creative period, De Chirico expresses his old metaphysical concept in a fairytale climate of metamorphoses recalling Ariosto.

158. GIORGIO DE CHIRICO: *Mysterious baths in New York*, 1936. Tempera on paper, 14 × 29 cm. Rome, Private Collection.

Böcklin's former pupil here recalls his master's most famous painting, the *Island of the dead*. However, instead of the Pre-Raphaelite chill of funereal cypresses he adopts the symbol of a nightmarish Manhattan. On this he imposes contrasts of perspective and proportion, in an atmosphere typical of his latest metaphysics,.

159. ALBERTO MAGRI: *Milan cathedral*, 1916. Oil on cardboard, 26 × 37 cm. Turin, Gallery of Modern Art.

Magri, the 'Primitive', here employs his culture and refinement to de-sanctify one of the most emphatic and complicated expressions of architectural rhetoric in modern Italy. He even makes use of Constructivist modular relationships, the repetition of which gives an effect of empty stupidity. The enormous crows with their great beaks are the only 'humanized' element—sardonic intermediaries between the invisible Madonna and the proto-industrial townscape.

160. MASSIMO CAMPIGLI: *Garden*, 1936. Oil on canvas, 61 × 81 cm. Milan, Emilio Jesi Collection.

One of the happiest evocations achieved by Campigli in his 'Cretan' style. Physical nature is represented by a single feature which seems to dilate in the reverberation of summer light. The sameness of the figures recalls the Cnossos frescoes; in other works, but not in this, they show an intensity of reminiscence which approaches characterization.

161. ATANASIO SOLDATI: *Landscape*, 1930. Oil on canvas, 51 × 62 cm. Rome, Zavattini Collection.

This work anticipates Soldati's 'metaphysical' phase and also echoes the 'abstractive' modulation of certain exponents of the *neue Sachlichkeit*. Unlike them, however, he expresses himself here by means of the limpid and refractive colouring which was to characterize his most famous abstract works.

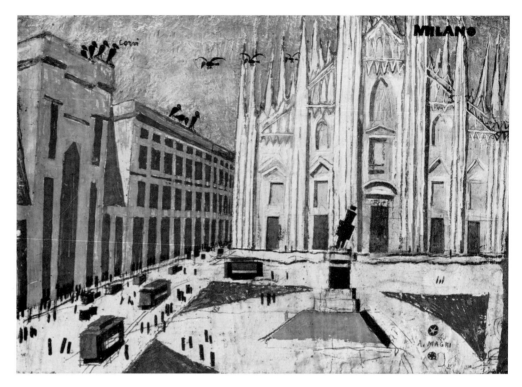

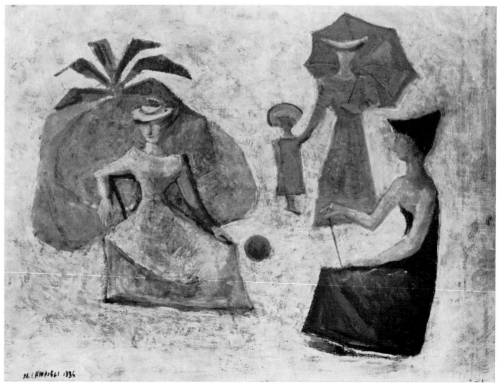

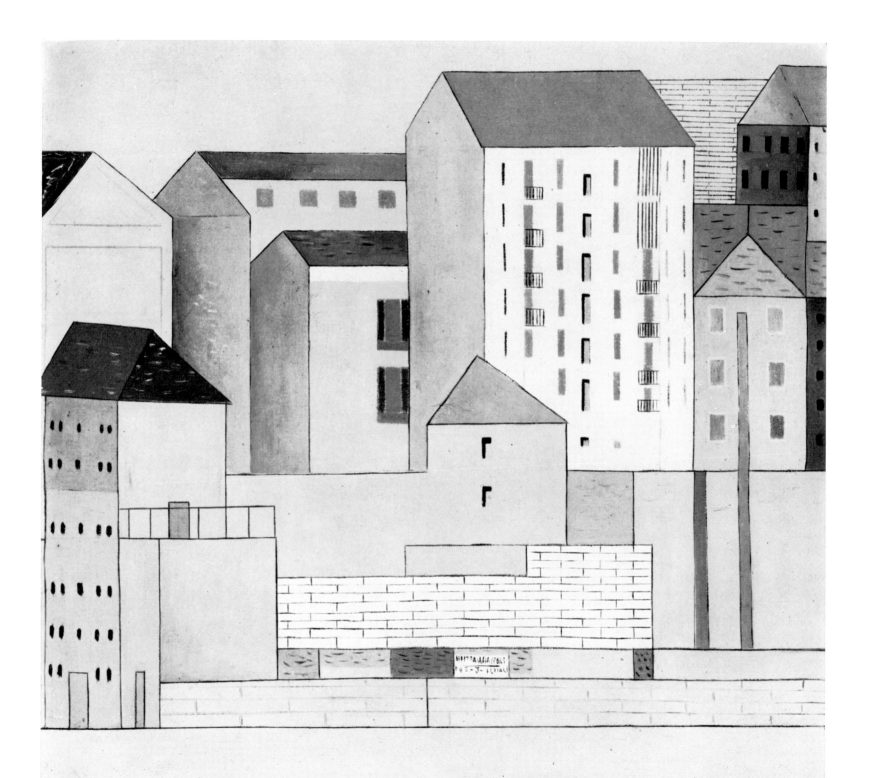

162. FILIPPO DE PISIS: *Seascape*, 1916. Oil on plywood, 50 × 66 cm. Rome, Anfuso Collection.

The rapid transition from the marine objects in the foreground to the increasingly distant ones beyond is held in a bird's-eye, mobile, cinematic view: each plane is represented by an autonomous image, and the eye travels from one to the other independently of traditional canons of arrangement.

163. FILIPPO DE PISIS: *Marine still-life with feather*, 1953. Oil on canvas, 50 × 64 cm. Milan, Emilio Jesi Collection.

The masters from whom De Pisis learnt his art, from Tiepolo to Manet, need only be named as a matter of historical reference. The most 'painterly' painter of the century has a unique power of evoking spaces and feelings with a single stroke of the brush and creating immense, reverberating distances between two patches of dark colour. If we look closely, the dominant feature is not the intense though decadent poetry of Montale's cuttlefish-bones but a triumphant sense of the all-pervading spirit of nature, linking the iridescence of an oyster-shell to the immensity of boundless horizons.

164. FILIPPO DE PISIS: *The Quai des Invalides*, 1927. Oil on cardboard, 65 × 54 cm. Milan, Emilio Jesi Collection.

One of De Pisis' most 'constructed' works: a splendid tribute to the whole French pictorial tradition of the nineteenth century, but at the same time showing great freedom of invention. The planes rise steeply towards the open sky with a mastery recalling some townscapes of seventeenth-century Holland. Although the picture is almost monochrome, the colouring appears extremely rich owing to the immense tonal range. Every detail has endless significance in itself yet remains fully relevant to the vision as a whole.

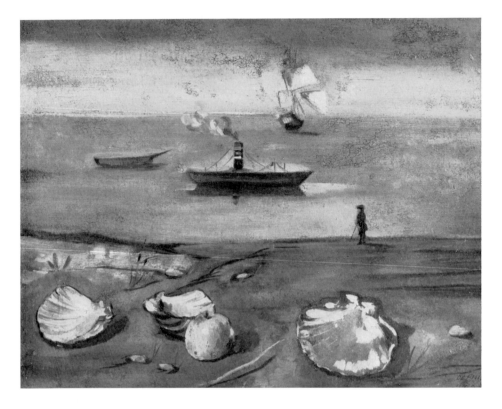

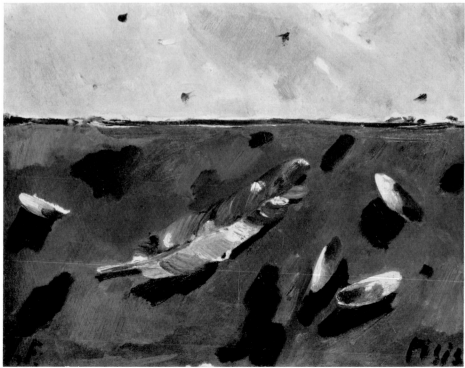

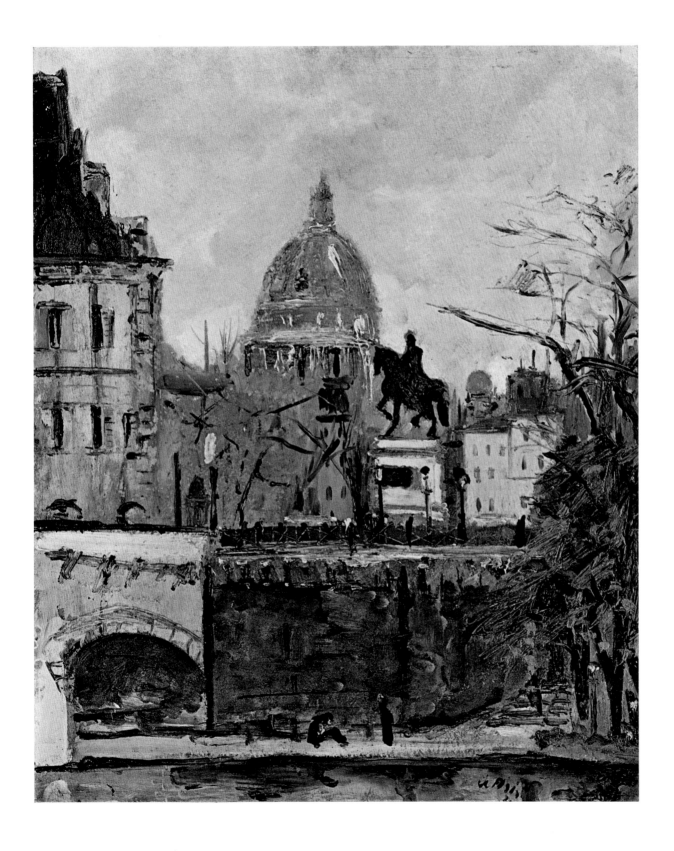

165. ANTONIETTA RAPHAEL: *Archaeological landscape*, 1928. Oil on canvas, 46.5 × 43.5 cm. Milan, Emilio Jesi Collection.

Influenced by the Orient and by Chagall, the artist expresses herself in three-dimensional visions and an intense pictorial sensibility which identifies with the object described. The curving road and the angle of the house amid dark, walled gardens give the impression of a historical landscape, rhetoricized or classicized like that of the Roman hills.

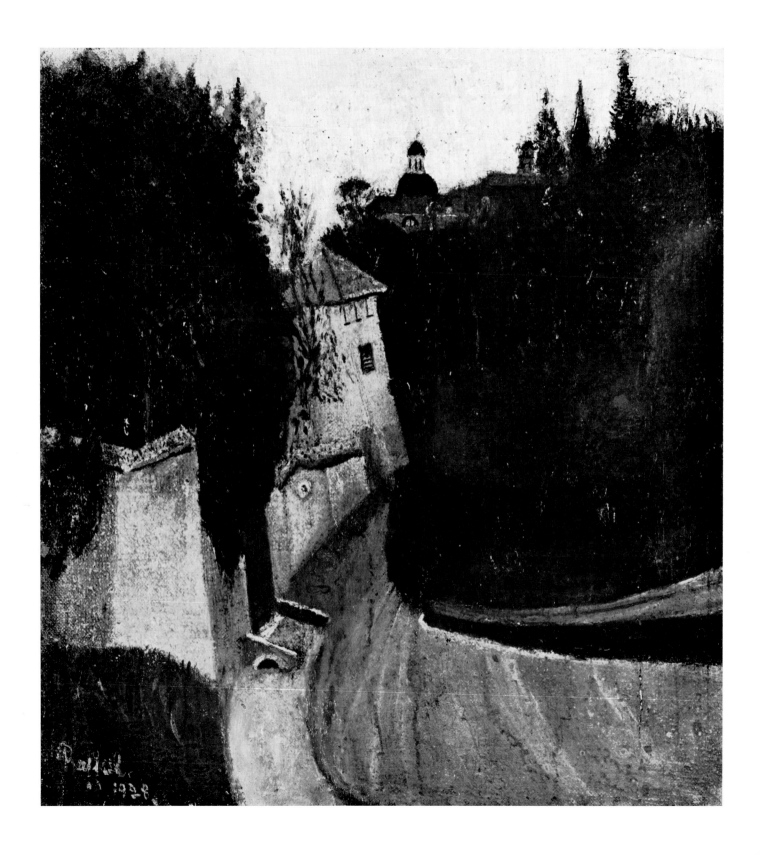

166. SCIPIONE (GINO BONICHI): *Piazza Navona*, 1930. Oil on canvas, 34 × 41 cm. Rome, National Gallery of Modern Art.

The soul of a demoniac, fiery city, with crouching Tritons sounding the last trump. Neptune himself, the sower of death, moves towards the fire. The re-invention of a historic landscape is achieved in terms of a poetic vision which is scarcely equalled except by El Greco among older painters and Kokoschka among modern ones. Monochrome is necessitated by the emotive exhaustion of all possible colours; white survives as a contrasting element in the phantasm of St. Agnes, struck by lightning between the two towers of her church.

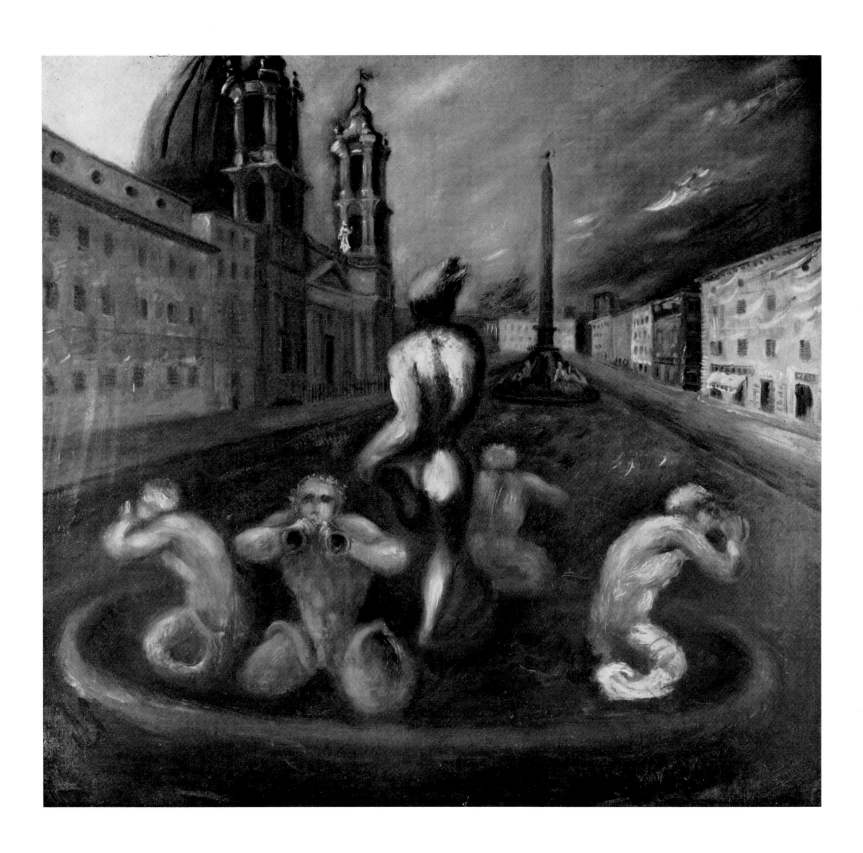

167. MARIO MAFAI: *Roman landscape*, 1939. Oil on panel, 45 × 54 cm. Milan, Giovanardi Collection.

Less apocalyptic than Scipione, Mafai depicts Rome in a 'classical' style, as Poussin or Corot might have seen it. The green foreground is no longer the pastoral hill of Goethe's day; instead we have the disquieting sense of an encroaching suburb. The main impression, however, is that of an inexhaustible variety of emotive colour, dark and smouldering or limpid and sensitive, which is an unmistakable sign of Mafai's work.

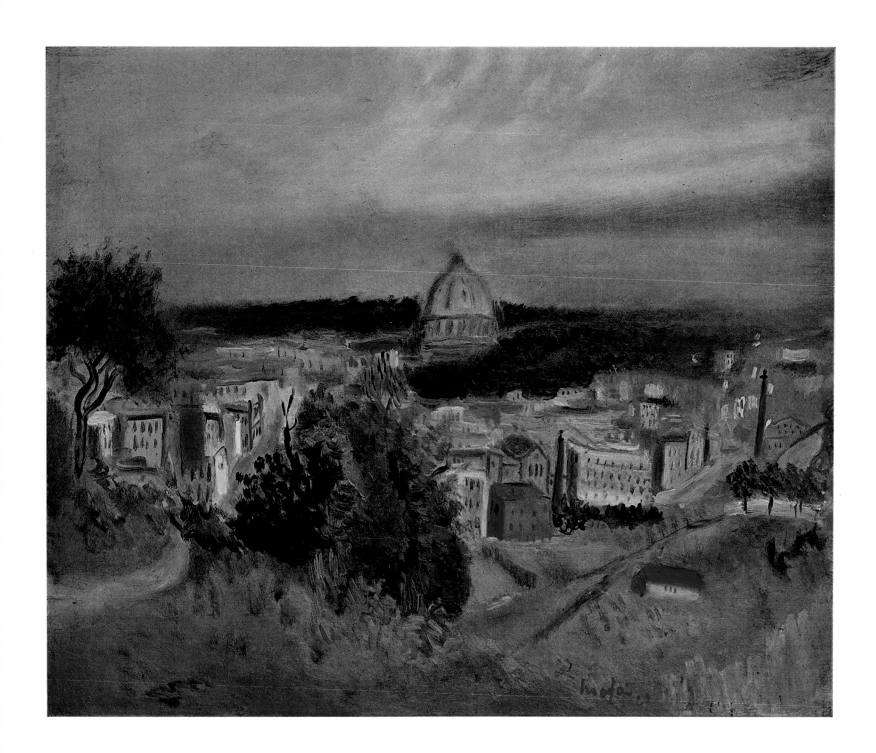

168. VIRGILIO GUIDI: *Terracina*, 1937. Oil on canvas, 40 × 50 cm. Private Collection.

The view is uplifted by a rhythmic cadence of masses, in a clear steady brightness based on the vital texture of light and colour. Space thus acquires a classic rhythm in the perfect harmony of constructive elements.

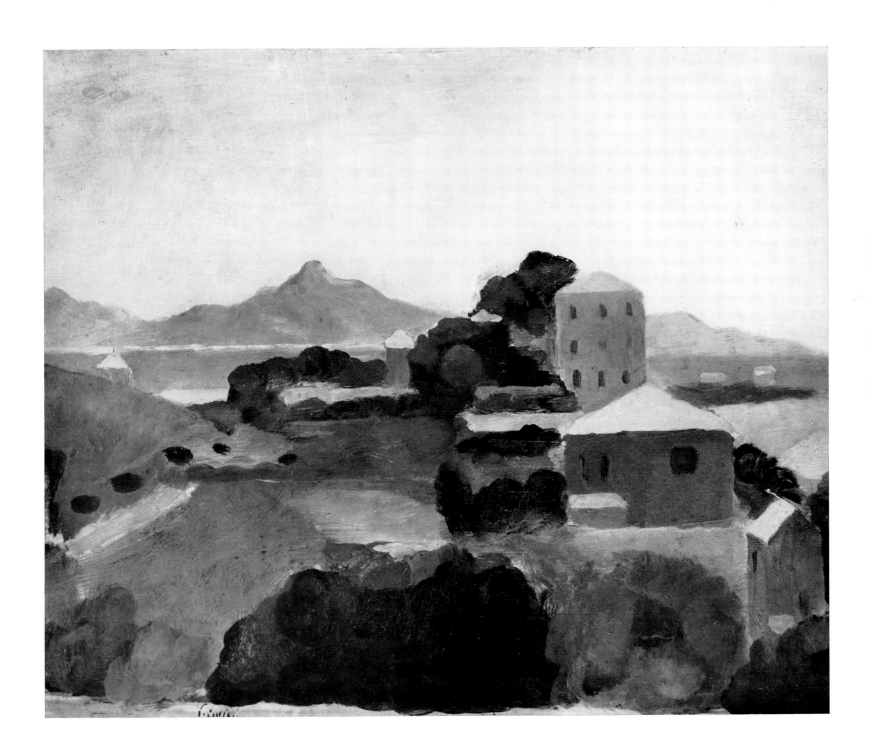

169. CONSTANT PERMEKE: *Landscape*, 1931. Oil on canvas, 98 × 118 cm. Antwerp, Royal Museum of Fine Arts.

Departing from the seventeenth-century norm, the painter places his horizon more than half-way up the picture, so as to increase the descriptive element. The visionary poetic synthesis, based on the variation of a few elements of colour and on the bare intensity of forms, reaches a point where objects are frozen and petrified.

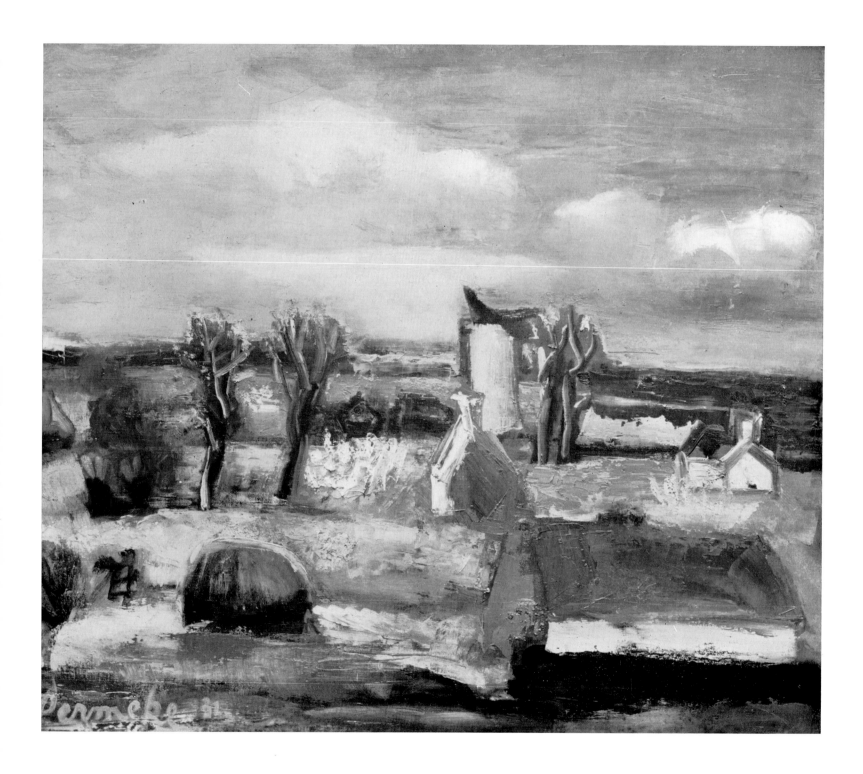

170. EMIL NOLDE: *Flowers and clouds*, 1938. Oil on canvas, 73 × 88 cm. Hanover, Bernhard Sprengel Collection

The choice of subject alone bears witness to Nolde's neo-Romanticism and his *Jugendstil* background. The composition, apparently free beyond Monet's furthest range, is in fact governed by complex rules as regards tonality and the relationship between the flowers in the foreground and the immensity of the central spaces.

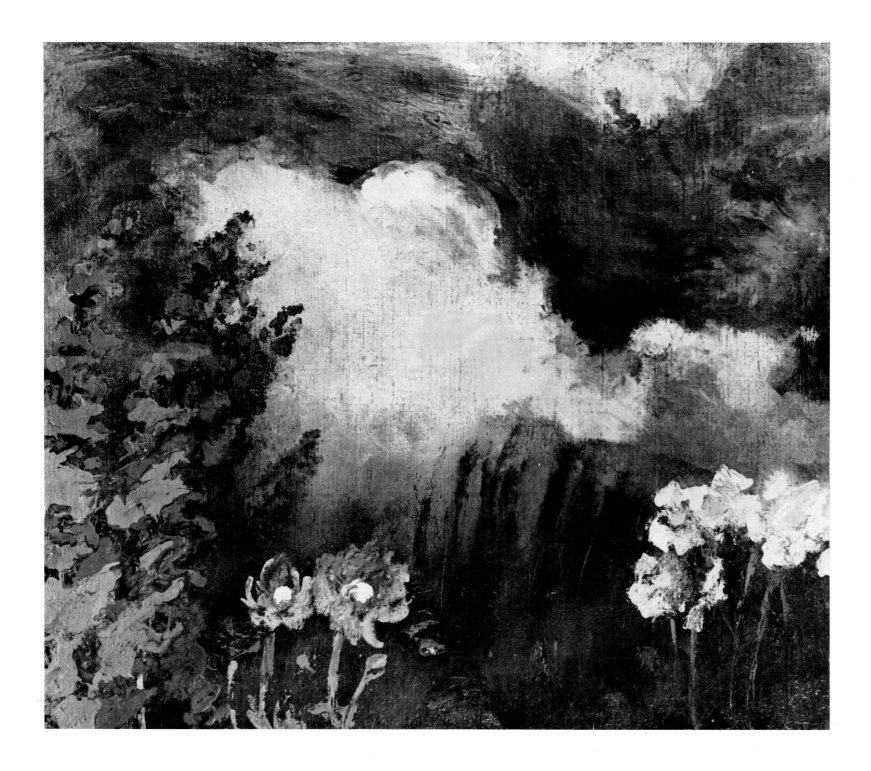

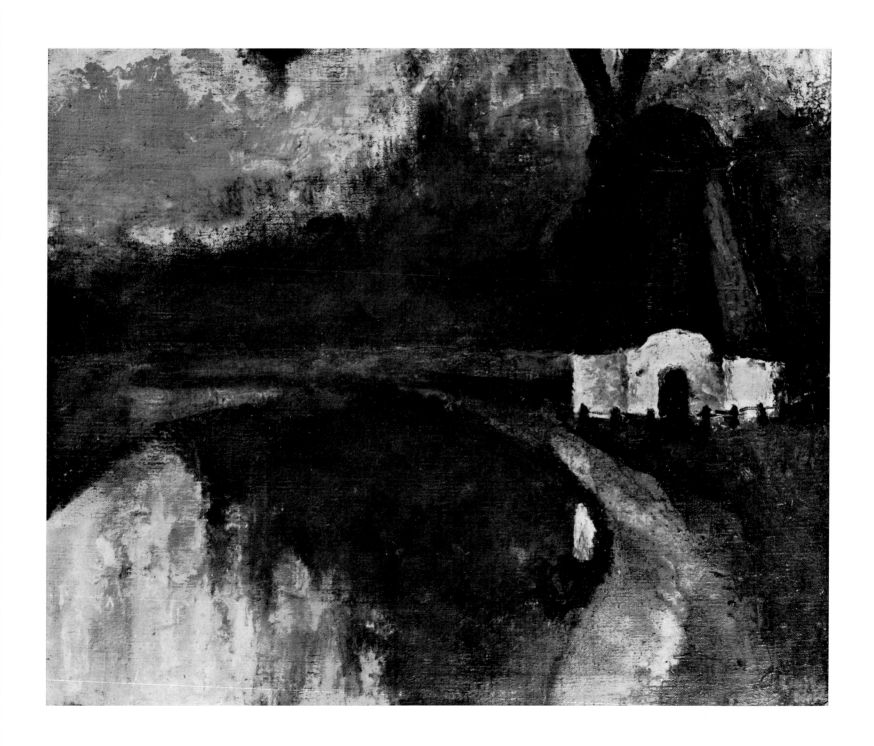

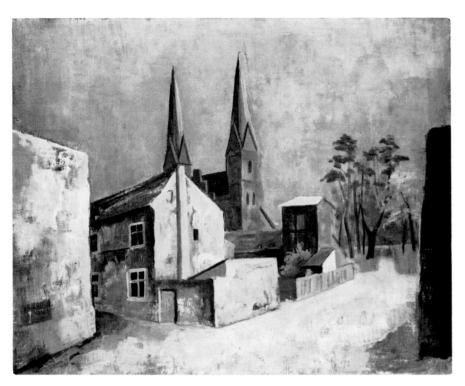

171. EMIL NOLDE: *Nordermühle*, about 1924. Oil on canvas, 75 × 88 cm. Munich, Bavarian State Art Collections.

One of Nolde's freest and most synthetic visions. An almost mirror-like construction, the line of the horizon dividing the sky from its reflection in the waters of the curving bay. The solitary windmill acts as a link between earth and heaven: the light upon it has no single source but emanates from the elements, as if in a Northern night in some great work by the later Rembrandt.

172. CARL HOFER: *The red church*. Oil on canvas, 66 × 82 cm. Dresden, Art Gallery.

A good example of the 'serene' phase of this artist, whose classical aspirations conflicted with a gloomy austerity owing to the atmosphere and culture amid which he lived. Sober in imagination, the painting is dominated by the diagonal line of the road and the volumes of the buildings, clearly defined and isolated in space.

173. LOVIS CORINTH: *Walchensee*, 1921. Oil on canvas, 70 × 85 cm. Munich, Bavarian State Art Collections.

This and the next picture belong to the artist's latest years, when his Impressionism became strongly marked by Expressionist influences. The dense impasto gives a muddy quality to the tormented scene, the lake taking on the appearance of a pool of lava.

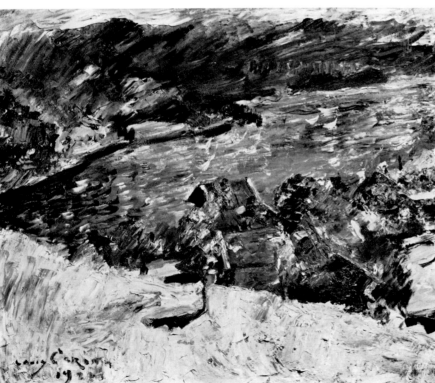

174. LOVIS CORINTH: *Lake Lucerne*, 1924.
Oil on canvas, 57 × 75 cm. Hamburg, Kunst-
halle.

The painter's Impressionist background is seen
in the light, shifting reflections of the water,
which laps the curving shore of the hilly lakeside.
The work is composed of a series of azure tones,
separated here and there by unexpected patches
of light.

175. ERNST LUDWIG KIRCHNER: *Amselfluh*,
1923. Oil on canvas, 120 × 170.5 cm. Basle,
Kunstmuseum.

Kirchner uses 'popular' themes to achieve his
regional effects. At the same time, there is a
detached intellectualism about his manner of
depicting the Alpine heights, with its typically
Expressionist search for the native roots of the
figurative, anti-classical style.

176. ERNST LUDWIG KIRCHNER: *View of
Basle and the Rhine*, 1930. Oil on canvas, 117 ×
195 cm. St. Louis, Missouri, City Art Museum.

Even more than in the previous work, 'Gothic'
devices are used here in the manner of an intel-
lectual aiming consciously at the Naïve style.
The resulting atmosphere of myth is slightly
cruel or macabre; the 'thirtyish' figures have a
disenchanted, stereotyped look.

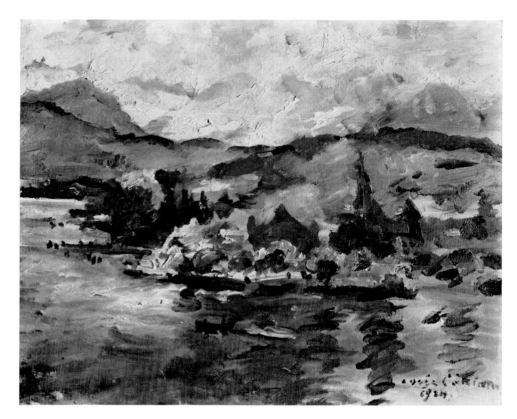

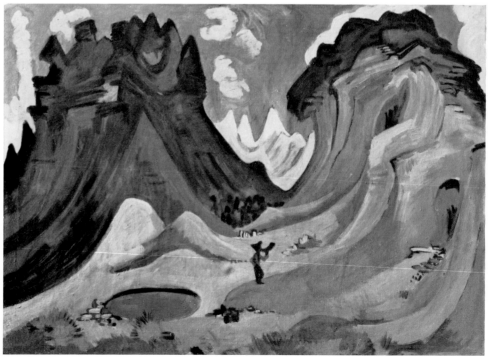

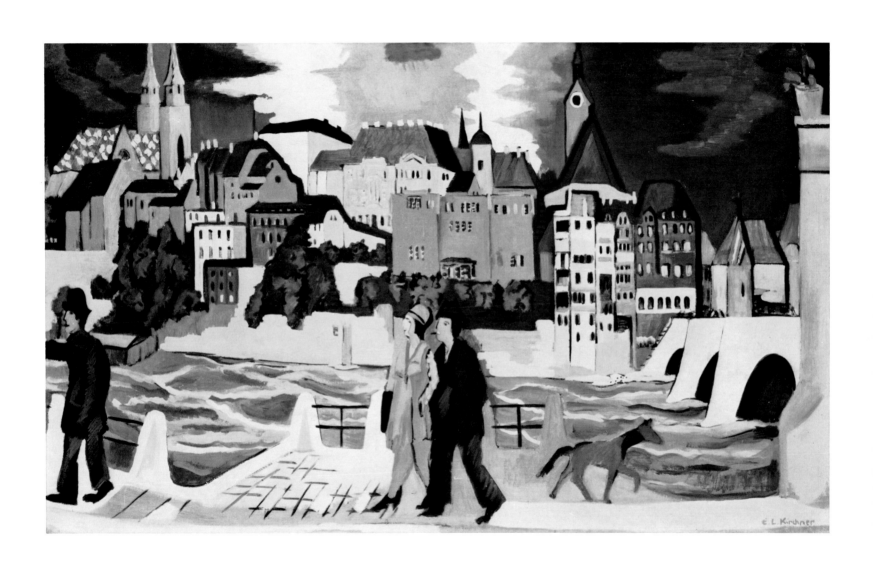

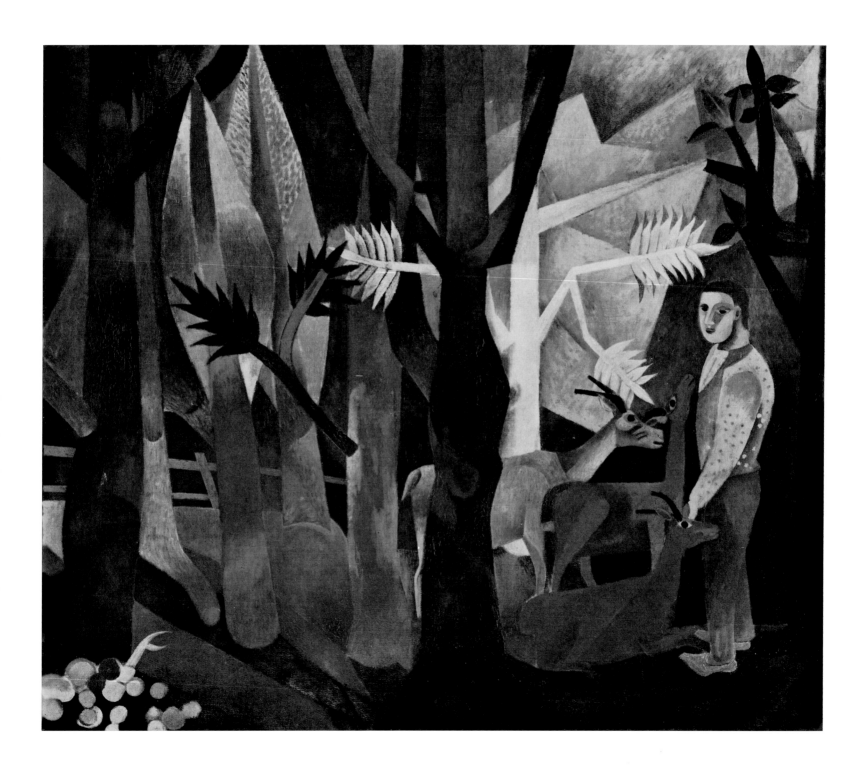

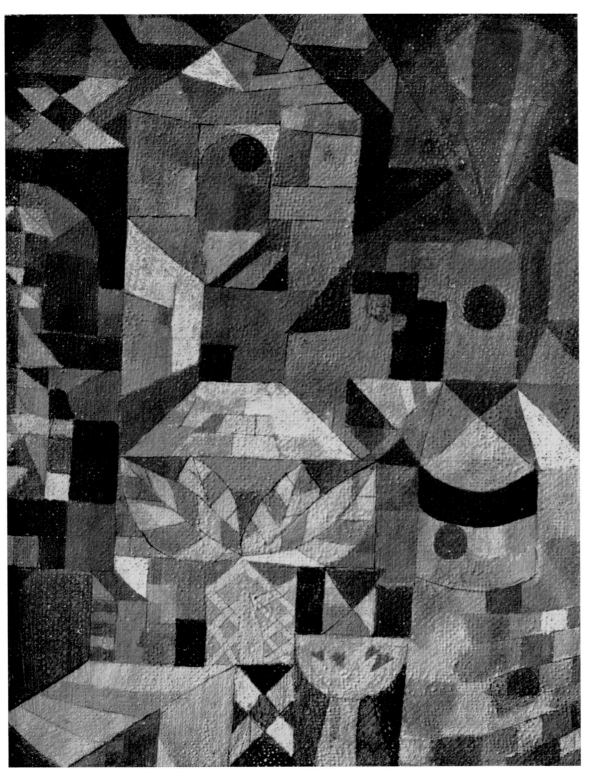

177. HEINRICH CAMPENDONK: *In the forest*, 1919. Oil on canvas, 83 ×99 cm. Detroit, Institute of Arts.

The work presents the narrative structure of a tapestry, with flat, superimposed forms. The treatment of the light areas is not the only feature which reminds us of the painter's study of the Ravenna mosaics. The stereotypes of popular illustration are deliberately used to produce a fable-like effect.

178. PAUL KLEE: *Castle garden*, 1919. Gouache, 21 ×17 cm. Basle, Kunstmuseum.

The whole picture space is occupied by a detailed analysis with the organic structure of a crystal. Innumberable perspectives with unexpected vanishing-points are contrasted, connected or superimposed on one another. Each one tells a tale enlivened by the most lyrical and refined artistic imagination of the century. Klee's 'metamorphosis' is organized and geometrical, like a kaleidoscope of crystals manipulated by a diabolic yet affectionate magician.

179. PAUL KLEE: *Landscape near Pi-lamb*, 1934. Watercolour on paper, 48.3 × 64 cm. Düsseldorf, North Rhine - Westphalian Art Collection.

A complex of outlines, disparate and extremely elegant, scorning every rule of repetition and symmetry. The web displays itself freely, no part of it being subordinate to another or merely transitional. We feel the secret pulse of a world that is coming into being, yet which by the artist's power is already set out in its quintessential harmony.

180. PAUL KLEE: *Lanscape with yellow birds*, 1923. Watercolour and gouache on paper, 35.5 ×44 cm. Félix Klee Collection.

While using a similar compositional method to those who shared his artistic principles, Klee departs from their schematic neo-Primitivism and the intellectualistic attempt to capture a lost paradise by storm. Every line of this painting shows the imaginative freedom which results from the correspondence between fancy and execution, the latter dissolving into a pure means of lyrical expression.

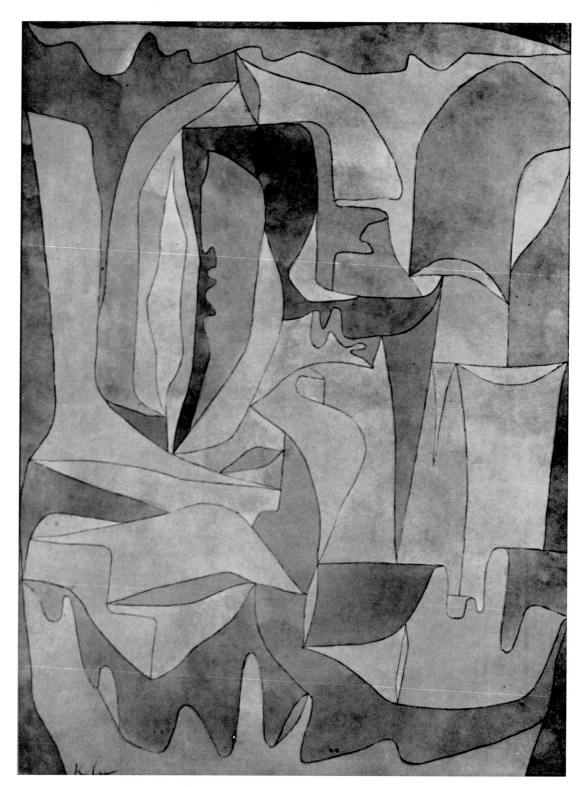

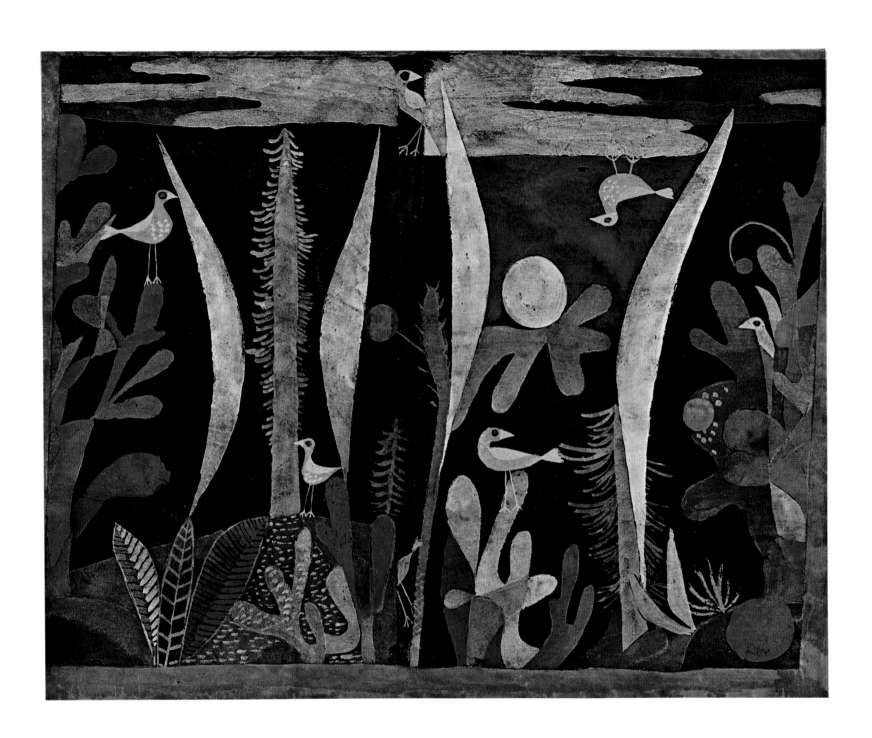

181. LYONEL FEININGER: *The Grütz tower at Treptow*, 1928. Oil on canvas, 101.3 ×81 cm. Darmstadt, Hesse State Museum.

'Neo-Gothicism' may be seen here in the colours with their tessellated limpidity. The story-book atmosphere thus subtly produced may rise to a high decorative quality or create scenic effects of extreme elegance.

182. GEORGE GROSZ: *Republican automatons*, 1920. Watercolour, 60 ×47 cm. New York, Museum of Modern Art, Advisory Commitee Fund.

A complexity of elements—Dadaism, Metaphysical painting, Constructivism—are here combined in the polemical atmosphere of the *neue Sachlichkeit* ('new objectivity'), of which Grosz was one of the chief exponents. The architecture of the 1900s, and every other feature of the townscape with its varying perspectives, have a faceless pseudo-rationality which makes them the only possible location for the two male figures who belong somewhere between the Metaphysicals and late Futurism, and whose heads are mere recipients for the mechanical symbols of convention.

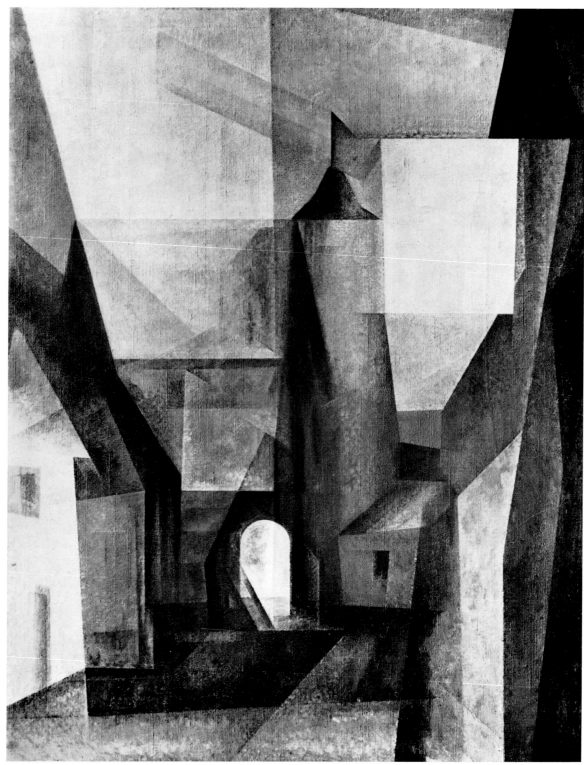

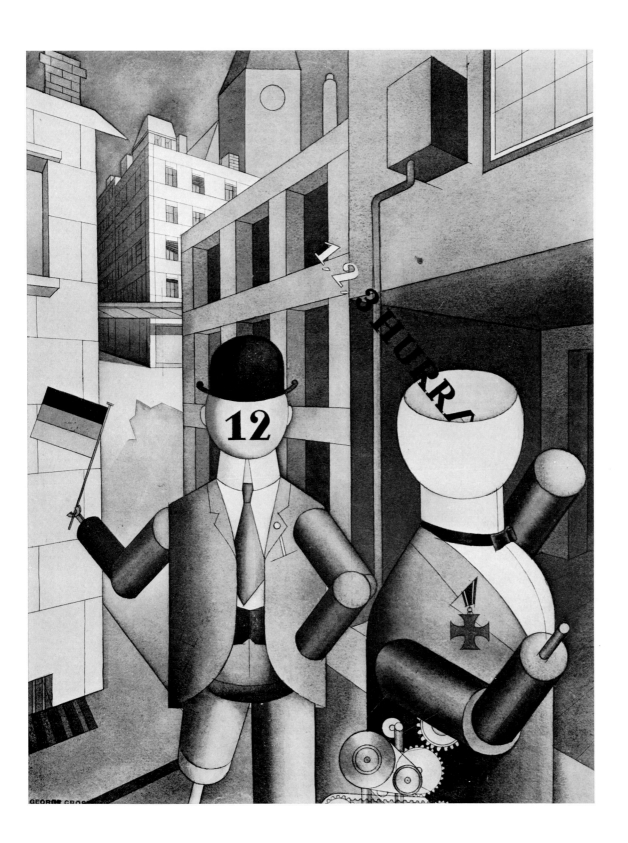

183. MAX BECKMANN: *La Promenade des Anglais, Nice*, 1947. Oil on canvas, 80.5 × 90.4 cm. Essen, City Museum.

The well-known scene is presented with a kind of reiteration of its traditional, 'touristic' aspects. There is even a female figure, seen from behind, perhaps to indicate the viewpoint.

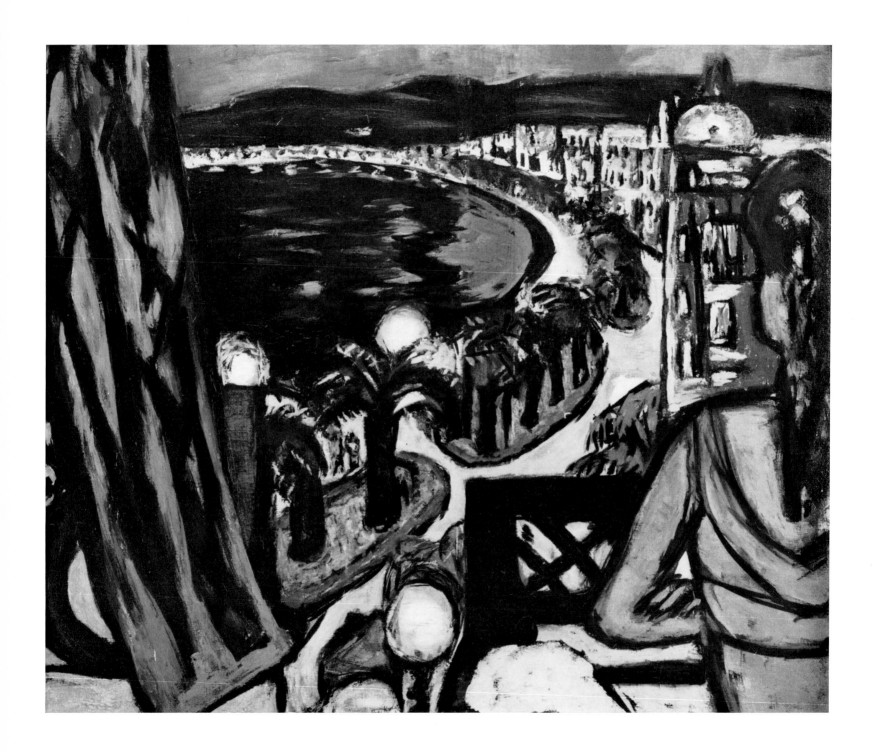

184. CHARLEY TOOROP: *Place de la Contrescarpe*, 1921. Oil on canvas, 42.5 × 73.5 cm. Otterlo, Kröller-Müller Museum.

The cluster of houses is depicted from close to, as required by so-called 'late Impressionism'; but the indistinct façades merge into *taches*, thus avoiding any descriptive ornamentation even where minor narrative elements are present.

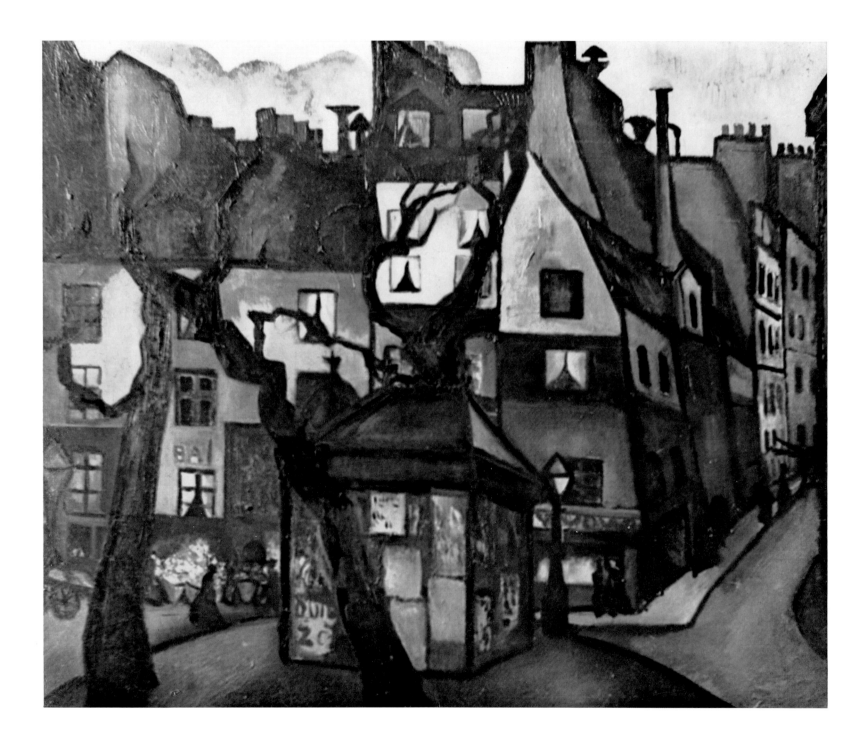

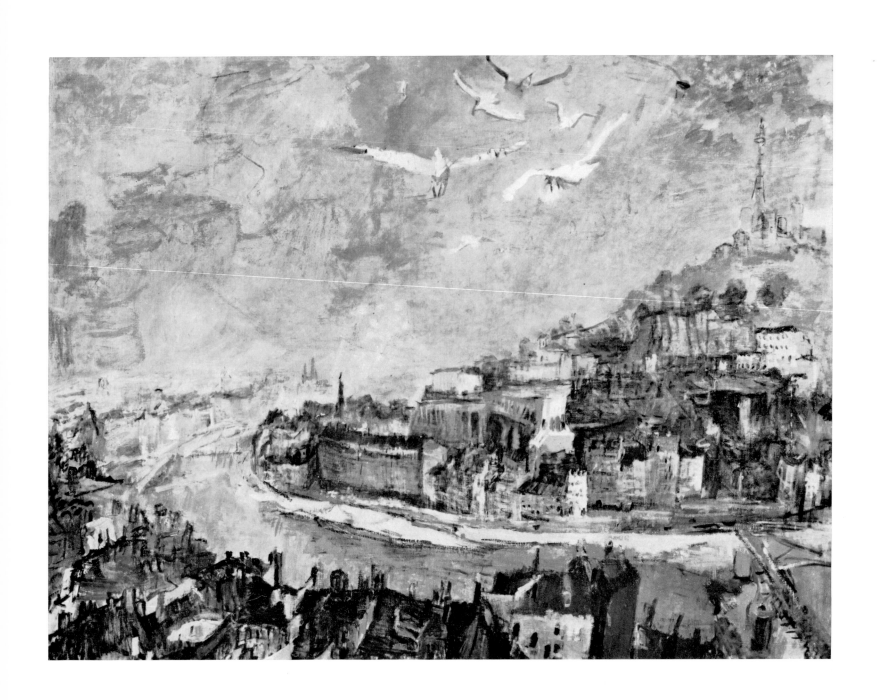

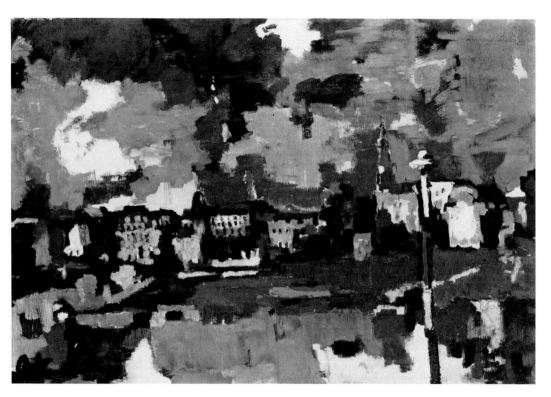

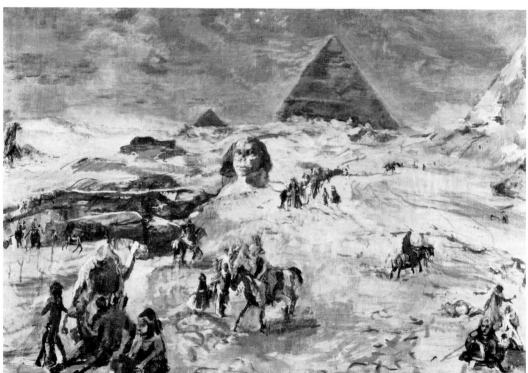

185. OSKAR KOKOSCHKA: *Lyons*, 1927. Oil on canvas, 97 × 130 cm. Washington, D.C., Phillips Collection.

The basis of Kokoschka's all-embracing visuality is the relationship between light and matter. Here the city and sky are disposed in classical fashion, each occupying exactly half of the picture; but the objects are moulded by the light which interfuses and consumes them, the vivid effect being compounded by a rich variation of colour. The gulls in the sky, with their strong forward movement, follow the immense prospect in a kind of 'tracking shot'.

186. OSKAR KOKOSCHKA: *Dresden: the 'new town'*, 1922. Oil on canvas, 80 × 120 cm. Hamburg, Kunsthalle.

Houses, open spaces and sky are merged in a geometrical pattern of shapes— juxtaposed, broken or overlapping. Only a few objects are indicated precisely, in the foreground and background, to indicate viewpoints and distances.

187. OSKAR KOKOSCHKA: *Pyramids*, 1929. Oil on canvas, 87 × 128 cm. Kansas City, Missouri, Nelson-Atkins Gallery of Art (gift of the Friends of Art).

The subject, tonality and composition are precisely such as might be found in a nineteenth-century oleograph; and this very fact reveals the transfiguring power of Kokoschka's genius. The oleograph becomes a universal vision, a dazzling reverberation in which our sense of antiquity is suspended; the eye is led upward from seething sands to endless, evocative horizons.

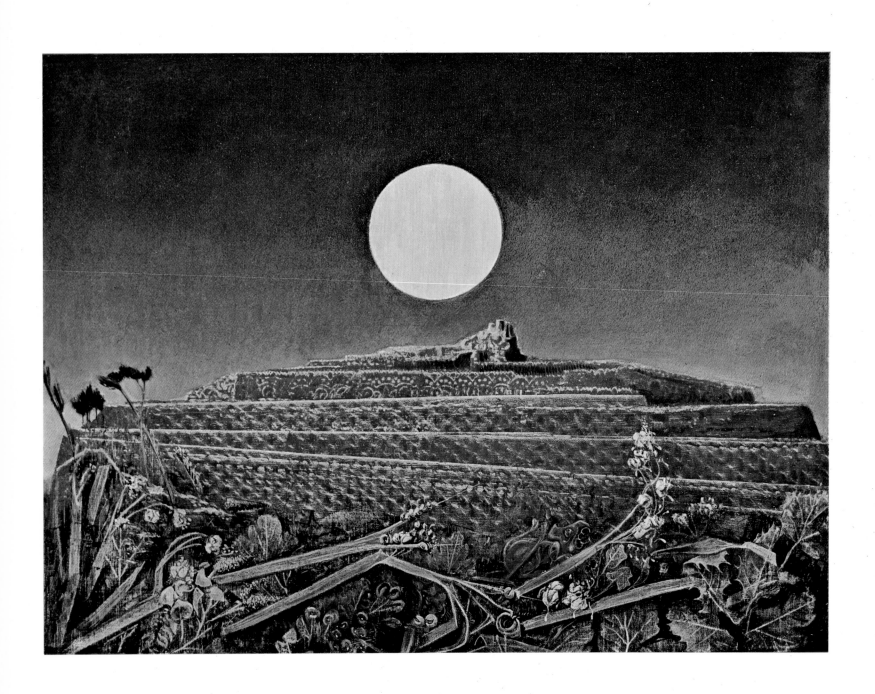

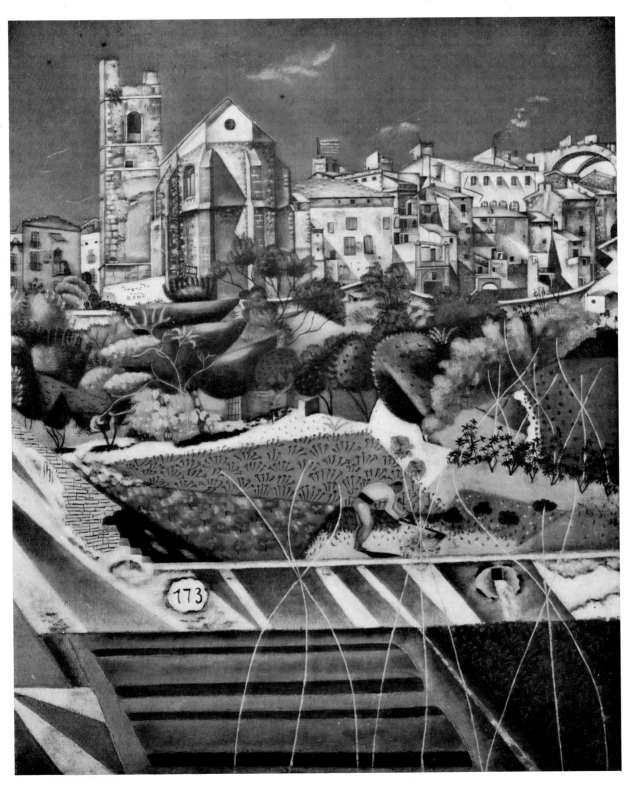

188. MAX ERNST: *The whole city*, 1935-6. Oil on canvas, 60 × 81 cm. Zürich, Kunsthaus.

A well-known painting by Le Douanier Rousseau suggested this nocturne, somewhat oleographic in character, in which a Surrealistic dream-effect is produced by the contrast between the Flemish herbarium in the foreground and the long Aztec wall with the Technicolor moon poised above it.

189. JOAN MIRÒ: *View of Montroig*, 1919. Oil on canvas, 73 × 61 cm. Paris, Maeght Gallery.

A page from a modern 'Book of Hours', as exact as a miniature, in which the artist has caught the original poetry of 'Works and Days'. The landscape is classical in design: the tessellated geometry of the space in front leads uphill to the massive apse and the houses beyond, on which the painter dwells with loving precision.

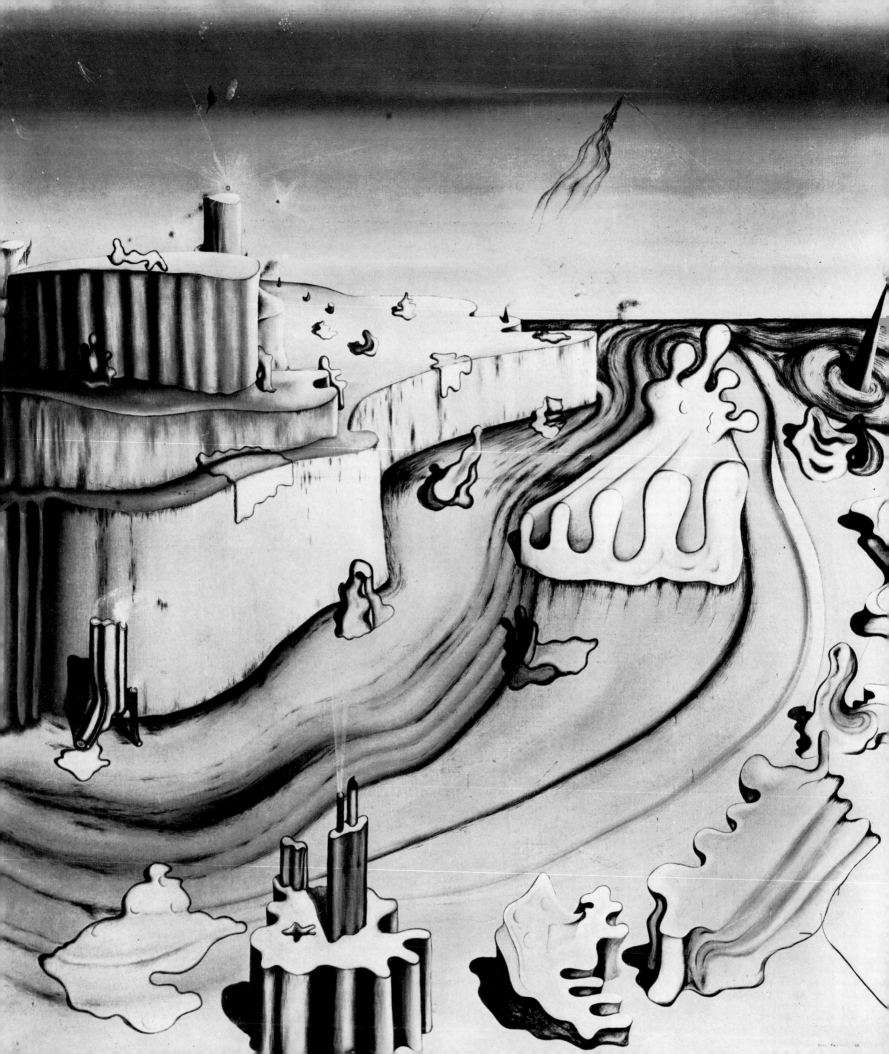

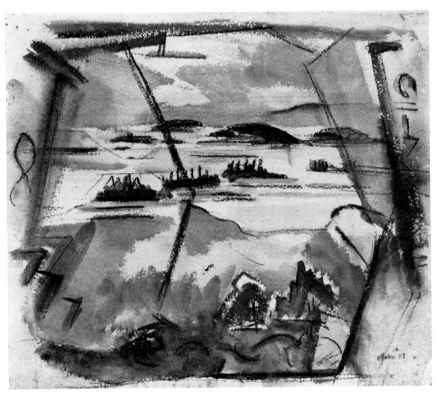

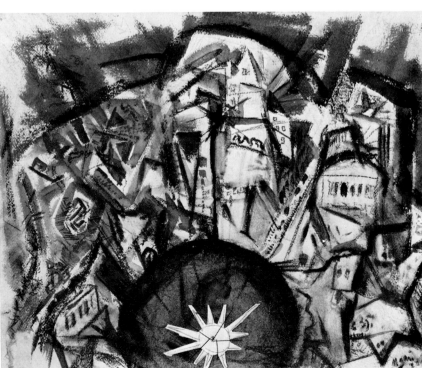

190. YVES TANGUY: *Promontory palace*, 1930. Oil on canvas, 73 ×60 cm. Venice, Peggy Guggenheim Collection.

Surrealism here assumes the guise of a science-fiction illustration, with human beings reduced to worm-like manikins. The amoeba-like object floating into the sky seems to emanate from the degradation that we feel vibrating beneath the futurist world of lighthouses and electronic factory chimneys.

191. JOHN MARIN: *Maine islands*, 1922. Watercolour, 42.5 ×50.5 cm. Washington, D.C., Phillips Collection.

The superimposition of two figurative elements (the compass or clock-face through which the islands are seen) gives a sense of instantaneousness or of a vision coming into being, which is aptly suited to the diffuseness of the subject.

192. JOHN MARIN: *Lower Manhattan*, 1922. Watercolour, 55 ×68 cm. New York, Museum of Modern Art.

The circular, or rather revolving arrangement of the figurative composition shows clear traces of Italian Futurism. The visual effect is a dramatic one, resolved here too in the fluidity of the objects depicted.

193. NILES SPENCER: *City walls*, 1921. Oil on canvas, 108.5 ×72 cm. New York, Museum of Modern Art.
Typical features of an urban landscape are turned into the formulae of geometrical Abstractism. At the same time this work recalls certain
Expressionist experiments by, for instance, Feininger.

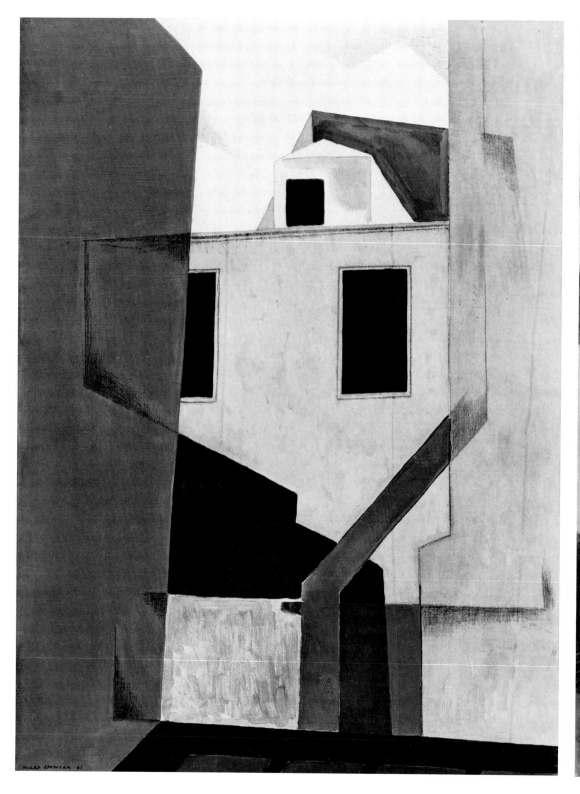
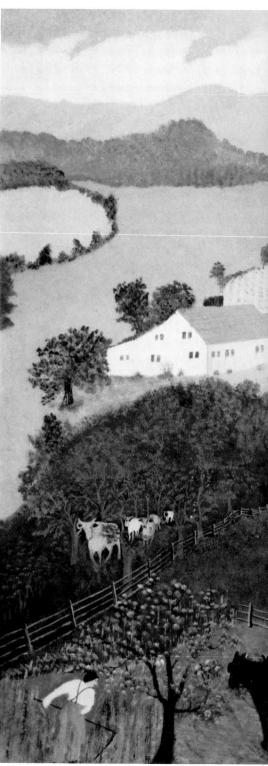

194. GRANDMA MOSES (Anna Mary Robertson Moses): *The McDonell Farm*, 1943. Tempera on masonite, 60 × 75 cm. Washington, D.C., Phillips Collection.

The 'naïve' arrangement of the scene with its rustic narrative recalls early Italian works such as Lorenzetti's *Good government* at Siena, in a similar way to Magri's experiments in Tuscany some years before. But Grandma Moses' subtly poetic approach is of Biblical, patriarchal inspiration, with a conscious leisureliness that is typically American.

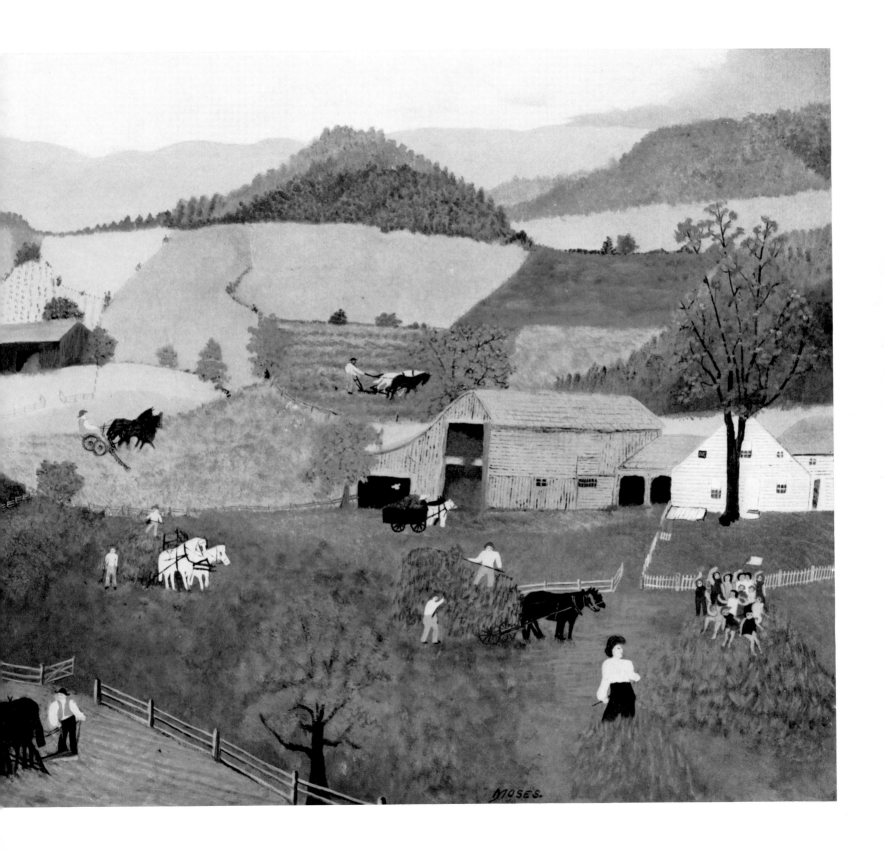

195. JOSEPH STELLA: *Brooklyn Bridge*, 1939. Oil on canvas, 175 × 55 cm. New York, Whitney Museum of American Art.

One of the syntheses by which Stella attempts to convey an immediate, aggressive image of the modern world. The famous bridge gives him ample material for depicting, in a manner inspired by the Futurists, the marvels of engineering, speed and boldness of construction. As he later expressed it, 'steel was projected to fantastic heights and embraced enormous spaces, with the skyscrapers and the bridges connecting different worlds.'

196. EDWARD HOPPER: *Nightbawks*, 1942. Oil on canvas, 82.5 × 150 cm. Chicago, Art Institute of Chicago.

Hopper has been called 'a romantic spirit operating through the crudest realism': this is true of the present evocative work, which has become justly famous. The light defines the forms and endows them with rhythm; long shadows are thrown on the house-walls and the deserted street. The expressiveness of the scene is enhanced by the unusual composition; it is a piece of relentless documentation and a work of great humanity.

197. STUART DAVIS: *New York—Paris No. I*, 1931. Oil on canvas, 96.5 × 127.5 cm. Iowa City, State University of Iowa Collection.

Abstractism and Metaphysical enchantment are to be found in this composition, with its resonant colours, assembling in an undefinable space the emblems and symbols of a too familiar world. A woman's leg stretches diagonally across the canvas, dominating the medley of items which appear as a kind of inventory of the period.

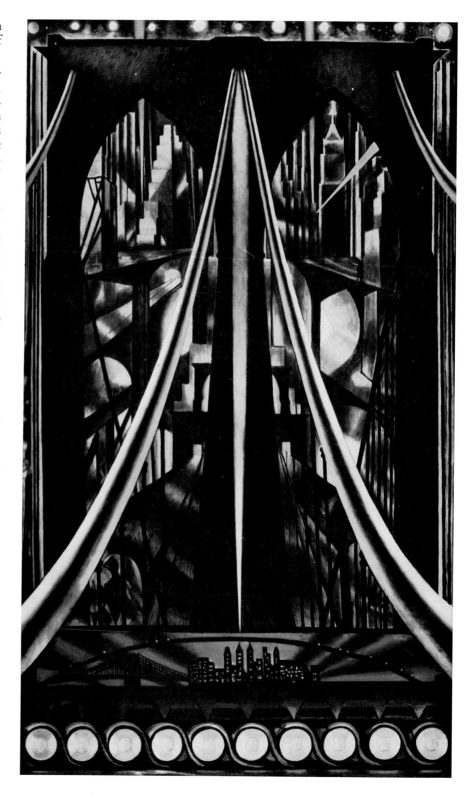

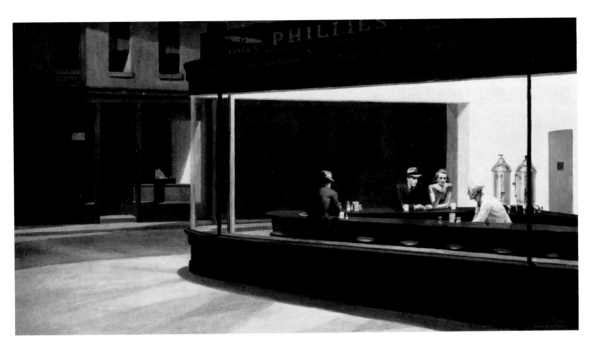

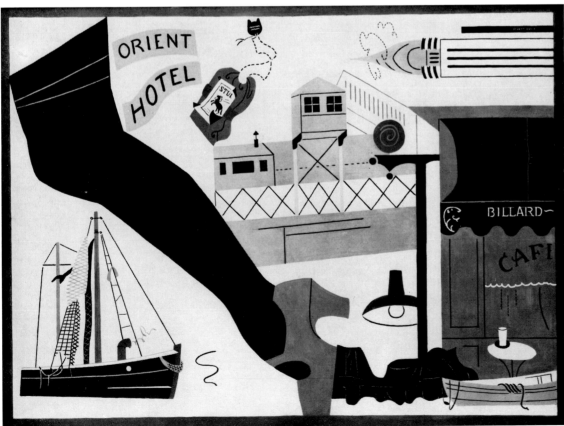

198. CHARLES SHEELER: *Factory at River Rouge*, 1932. Oil on canvas, 50 × 60.6 cm. New York, Whitney Museum of American Art.

A distinguished photographer as well as a painter, Sheeler seems to some extent to identify the two forms of experience in his quest, shared by other American painters, for absolute objectivity. This is seen here in the elaborate construction of the factory building immersed or inserted in the 'hard, glassy atmosphere'.

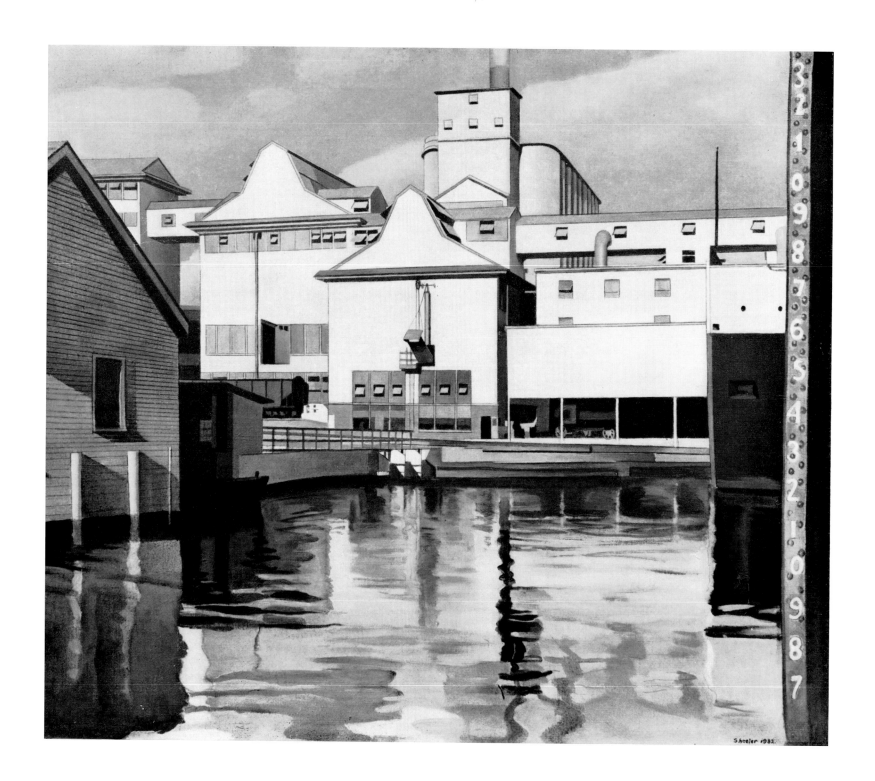

THE COLLAPSE
OF A FIGURATIVE
FORMULA
1945-1970

I had to get to the lake where the ducks were before dawn, and so I left home while it was still dark.

The soft dusty road led down ravines and up on to high ground, through occasional pine-groves with a stagnant smell of resin and strawberries, and out again into open country. No one followed me or came in my direction: I was alone in the night.

From time to time the road was bordered by fields of rye. Already ripe, it stood stiff and motionless, glowing softly in the dark. The ears bending over by the roadside brushed against my hands and riding-boots like a silent, shy caress. The air was warm and clean; the stars glittered brightly; there was a smell of hay and dust and, every now and then, the cool bitterish fragrance of fields at night. Beyond the meadows, the river and forests I could see a flicker of lightning.

Before long the soft, soundless road branched to one side, and I turned off into a rocky path which wound busily along the river-side. There was a damp, clayey smell and I could feel puffs of cold, wet air. The logs floating in the dark bumped together at intervals with a muffled sound, like someone hitting a tree gently with an axe-handle. Across the river, a long way off, I could see a bonfire like a point of light; from time to time it vanished behind the trees, but it would reappear almost at once, its reflection showing in the water as a narrow broken line.

It is pleasant at such times to indulge in thought: one remembers far-off forgotten things, faces from the past crowd about you in a gentle, dream-like melancholy, and you start to feel that at some previous time you must have lived that very same moment—as if, in the past, you had already crossed the cold, damp ravines and the arid uplands, already seen the river in the dark and heard the clods of earth plopping into the water from the bank and the dull sound of the logs knocking together, already seen the black haystacks come into view and disappear, seen the trees with their branches contorted by a silent struggle, the slimy pools covered with dark stains . . . Only you cannot for the life of you remember when and where, at what happy time of life you saw and heard these things before.

Night, 1955 YURY KAZAKOV

The hill of the Greppo was also a world. To get there we went along the Coste, along declivities and solitary slopes, beyond the region of the oaks. When we arrived under the side of the Greppo, we saw the black, luminous trees on the crest etched against the sun. From a bend half-way up the road Oreste showed us how far Poli's lands extended in the countryside through which we had driven. We had got out of the gig, which followed at our own pace, and walked along a road much wider than the previous one. This wide road—still with some patches of asphalt here and there—cut across the wild hillsides thick with briars and trees. But the astonishing thing was the tangle, the abandonment: we passed some deserted vineyards overgrown with grass and came to a thick wood where fruit trees—fig and cherry overgrown with creepers—mingled with willows and acacias, plane-trees and elders. At the beginning of the rise there was a wood of hornbeams and gloomy, almost cold, poplars; then little by little as we came out into the sun, the vegetation grew thinner and unusual trees such as oleanders, magnolias, cypresses and others I had never seen before were added to the familiar ones in a disorder which gave an air of exotic solitude to the glades. . . .

And that was how Oreste came to stay at the Greppo. Sometimes he would go away on his bicycle and then come back. The hill seemed to bake in the August sun; honeysuckle and horsemint made an invisible wall round it, and it was pleasant to walk about there and, when you reached the point of coming out in the neighbouring wood of hornbeams,

to go back into the thicket like an insect or a bird. You seemed to be entrapped in that perfume and sun. During the afternoons of the first days, we used to descend the steep slopes to the point where the vines grew smothered in grass; and once we walked all round the hill, and, penetrating a growth of briars, came upon a small, black kiosk with a half-ruined roof through the fissures of which we could see the sky. But there were no traces of hedges or paths; the hillside was all wasteland, for all that it had once been a garden and the hut a pavilion. Oreste and Poli called it the Chinese pagoda and remembered the time when it had been covered with jasmine. Now as we approached it among the thistles, we heard a rustle of rats or lizards—they had taken over the hill. The thicket appeared so virgin and wild that the contrast did not make you feel sad. Nor were our voices among the bushes enough to violate it. The idea that the great summer sun beating in the woods had an odour of death was true. Here no one broke the earth to get something out of it, no one lived on it: once they had tried and then had given up.

The Devil in the Hills, 1948 CESARE PAVESE

By midday I was walking on the open hills and I had left the Germans and the Republic somewhere behind in the valley. I had lost the main road. I called out to some women who were turning the hay in a meadow and asked how one reached a certain village not far from my own. They indicated the way back to the valley. I cried out that I couldn't follow it, that my road lay across the hills. Then they waved their pitchforks signing me to go on.

There were no villages in sight, only farmsteads on wild, chalky slopes. To reach any one of them, I should have had to climb up steep pathways beneath low, sultry clouds. I examined closely the lineaments of the hill-crests, their ruggedness, their vegetation, the stretches of ground that offered no cover. The colours, the forms, the very smell of the sultry air were known and familiar to me; although I had never been in that actual spot before, I was walking in a cloud of memories. Some of the stunted and twisted fig-trees seemed like those at home and reminded me of the one by the gate behind the well. I shall be at Belbo before nightfall, I said to myself.

A cottage by the roadside, blackened by smoke and gutted, pulled me up short and made my heart beat. It looked like a war-damaged town wall. I did not see a living soul. But the ruin was not recent; on the wall where previously there had been a vine plant was a faint blue stain of verdigris.

The House on the Hill, 1949 CESARE PAVESE

The sky, the salt sea, the rocks with their pools of water;
the anemone's heart next to the stubborn pine;
the road next to the sky, the road beside the water,
the thirsty race alongside the stubborn pine;

grasses, mosses, lichens, tiny beasts of all kinds—
our gaze is lost under the stubborn trees,
lost amid the tiny frightened beasts
that live under the stubborn trees;

the sky, the salt sea slashed by the sun;
the tops, sheared flat, of the bewildered pine-trees,
rising into the sky and descending into the water—

while a tiny beast, in the shade of a lichen,
runs its course round the forest of stubborn pine
without an idle look, without a step astray.

'Pines and fir-trees', from *Un enfant a dit*, 1943-8 RAYMOND QUENEAU

The floor of the Salinas Valley, between the ranges and below the foothills, is level because this valley used to be the bottom of a hundred-mile inlet from the sea. The river mouth at Moss Landing was centuries ago the entrance to this long inland water. . . .
Before the inland sea the valley must have been a forest. And those things had happened right under our feet. And it seemed to me sometimes at night that I could feel both the sea and the redwood forest before it.

On the wide level acres of the valley the topsoil lay deep and fertile. It required only a rich winter of rain to make it break forth in grass and fowers. The spring flowers in a wet year were unbelievable. The whole valley floor, and the foothills too, would be carpeted with lupins and poppies. Once a woman told me that coloured flowers would seem more bright if you added a few white flowers to give the colours definition. Every petal of blue lupin is edged with white, so that a field of lupins is more blue than you can imagine. And mixed with these were splashes of California poppies. These too are of a burning colour— not orange, not gold, but if pure gold were liquid and could raise a cream, that golden cream might be like the colour of the poppies. When their season was over the yellow mustard came up and grew to a great height. When my grandfather came into the valley the mustard was so tall that a man on horseback showed only his head above the yellow flowers. On the uplands the grass would be strewn with buttercups, with hen-and-chickens, with black-centred yellow violets. And a little later in the season there would be red and yellow stands of Indian paintbrush. These were the flowers of the open spaces exposed to the sun.

Under the live oaks, shaded and dusky, the maidenhair flourished and gave a good smell, and under the mossy banks of the watercourses whole clumps of five-fingered ferns and goldybacks hung down. Then there were harebells, tiny lanterns, cream white and almost sinful-looking, and these were so rare and magical that a child, finding one, felt singled out and special all day long.

When June came the grasses headed out and turned brown, and the hills turned a brown which was not brown but a gold and saffron and red—an indescribable colour. And from then on until the next rains the earth dried and the streams stopped. Cracks appeared on the level ground. The Salinas River sank under its sand. The wind blew down the valley, picking up dust and straws, and grew stronger and harsher as it went south. It stopped in the evening. It was a rasping nervous wind, and the dust particles cut into a man's skin and burned his eyes. Men working in the fields wore goggles and tied handkerchiefs around their noses to keep the dirt out.

The valley land was deep and rich, but the foothills wore only a skin of topsoil no deeper than the grass roots; and the farther up the hills you went, the thinner grew the soil, with flints sticking through, until at the brush line it was a kind of dry flinty gravel that reflected the hot sun blindingly.

She was in the alley, wondering who she was, night, a thin drizzle of mist, silence of sleeping Frisco, the B-O boats in the bay, the shroud over the bay of great clawmouth fogs, the aureola of funny eerie light being sent up in the middle by the Arcade Hood Droops of the Pillar-templed Alcatraz—her heart thumping in the stillness, the cool dark peace.— Up on a wood fence, waiting—to see if some idea from outside would be sent telling her what to do next and full of import and omen because it had to be right and just once— 'One slip in the wrong direction . . . ,' her direction kick, should she jump down on one side of fence or other, endless space reaching out in four directions, bleak-hatted men going to work in glistening streets uncaring of the naked girl hiding in the mist or if they'd been there and seen her would in a circle stand not touching her just waiting for the cop-authorities to come and cart her away and all their uninterested weary eyes flat with blank shame watching every part of her body—the naked babe.—The longer she hangs on the fence the less power she'll have finally to really get down and decide, and upstairs Ross Wallenstein doesn't even move from that junk-high bed, thinking her in the hall huddling, or he's gone to sleep anyhow in his own skin and bone.—The rainy night blooping all over, kissing everywhere men women and cities in one wash of sad poetry, with honey lines of high-shelved Angels trumpet-blowing up above the final Orient-shroud Pacific-huge songs of Paradise, an end to fear below.—She squats on the fence, the thin drizzle making beads on her brown shoulders, stars in her hair, her wild now-Indian eyes now staring into the Black with a little fog emanating from her brown mouth, the misery like ice crystals on the blankets on the ponies of her Indian ancestors, the drizzle on the village long ago and the poorsmoke crawling out of the underground and when a mournful mother pounded acorns and made mush in hopeless millenniums—the song of the Asia hunting gang clanking down the final Alaskan rib of earth to New World Howls (in their eyes and in Mardou's eyes now the eventual Kingdom of Inca Maya and vast Azteca shining of gold snake and temples as noble as Greek, Egypt, the long sleek crack jaws and flattened noses of Mongolian geniuses creating arts in temple rooms and the leap of their jaws to speak, till the Cortez Spaniards, the Pizarro weary old-world sissified pantalooned Dutch bums came smashing canebrake in savannahs to find shining cities of Indian Eyes high, landscaped, boulevarded, ritualled, heralded, beflagged in that selfsame New World Sun the beating heart held up to it)—her heart beating in the Frisco rain, on the fence, facing last facts, ready to go run down the land now and go back and fold in again where she was and where was all—consoling herself with visions of truth—coming down off the fence, on tiptoe moving ahead, finding a hall, shuddering, sneaking—.

The Subterraneans, 1958 JACK KEROUAC

'The trees! The trees!'

This shout from the leading carriage eddied back along the following four, almost invisible in clouds of white dust; and at every window perspiring faces expressed tired gratification.

The trees were only three, in truth, and eucalyptus at that, scruffiest of Mother Nature's children. But they were also the first seen by the Salina family since leaving Bisacquino at six that morning. It was now eleven, and for the last five hours all they had set eyes on were bare hillsides flaming yellow under the sun. Trots over level ground had alternated briefly with long slow trudges uphill and then careful shuffles down; both trudge and trot merging, anyway, into the constant jingle of harness bells, imperceptible now to the dazed senses except as sound equivalent of the blazing landscape. They had passed through crazed-

looking villages washed in palest blue; crossed dry beds of torrents over fantastic bridges; skirted sheer precipices which no sage and broom could temper. Never a tree, never a drop of water; just sun and dust. Inside the carriages, tight shut against that sun and dust, the temperature must have been well over 120 degrees. Those desiccated trees yearning away under bleached sky bore many a message; that they were now within a couple of hours from their journey's end; that they were entering the family estates; that they could lunch, and perhaps even wash their faces in the verminous waters of the well.

Ten minutes later they reached the farm buildings of Rampinzeri; a huge pile, only used one month in the year by labourers, mules and cattle gathered there for the harvest. Over the great solid yet staved-in door a stone Leopard pranced in spite of legs broken off by flung stones; next to the main farm building a deep well, watched over by those eucalyptuses, mutely offered various services: as swimming pool, drinking trough, prison or cemetery. It slaked thirst, spread typhus, guarded the kidnapped and hid the corpses both of animals and men till they were reduced to the smoothest of anonymous skeletons.

The Leopard, 1958 GIUSEPPE DI LAMPEDUSA

The opposite half of the weather there, above the shore of Fiumicino and Ladispoli, was a brown-colored flock, shading into certain leaden bruises: gravied sheep pressed, compact, meshed in the ass by their dog, the wind, the one that turns the sky rainy. A roll of thunder, rummm, son-of-a-gun! had the nerve to raise its voice, too: on March the 23rd!

The sergeant pressed down with his foot, accelerating towards the fountain. From the right, where the plain was dense with dwellings and went down to the river, Rome appeared, lying as if on a map or a scale model: it smoked slightly, at Porta San Paolo: a clear proximity of infinite thoughts and palaces, which the north wind had cleansed, which the tepid succession of sirocco had, after a few hours, with its habitual knavishness, resolved in easy images and had gently washed. The cupola of mother-of-pearl: other domes, towers: dark clumps of pines. Here ashen: there all pink and white, confirmation veils: sugar in a *haute pâté*, a morning painting by Scialoja. It looked like a huge clock flattened on to the ground, which the chain of the Claudian aqueduct bound . . . joined . . . to the mysterious springs of the dream.

That Awful Mess on Via Merulana, 1957 CARLO EMILIO GADDA

At one stage of the journey the road kept climbing uphill, giving an ever wider view over the country. It seemed as if there would be no end to the slow ascent or to the widening of the horizon, but when tired horses and passengers stopped for a rest they found that they had reached the summit of the hill. The road went on over a bridge and the river Kezhma swirled beneath it.

Beyond the bridge, on an even steeper rise, they could see the brick walls of the Monastery of the Exaltation of the Cross. The road wandered round the lands of the monastery and zigzagged uphill, through the outskirts of the town of Holycross.

When it reached the centre of the town it skirted the monastery grounds once again, for the green-painted iron door of the monastery gave on to the main square. The icon

over the arched gate was framed by the legend in gold letters: 'Rejoice, O life-giving Cross, O unconquerable victory of piety.'

It was Holy Week, the end of Lent; winter was almost over. As a first sign of the thaw the roads were turning black, but the roofs were still wearing their tall, white, over-hanging snow bonnets.

To the small boys who had climbed up to the belfry to watch the bell-ringers, the houses down below looked like small white boxes jumbled close together. Little black people, hardly bigger than dots, walked among the houses and stopped in front of them. They stopped to read the decree calling up three more age groups. . .

The market-place was the size of a large field. In times gone by, it had been crowded on market days with peasants' carts. At one end of it was St. Helen's Street: the other, curving in a crescent, was lined with small buildings, one or two storeys high, used for warehouses, offices and shops.

There, she remembered, in more peaceful times, Bryukhanov, a woman-hater and a cross old bear in spectacles and a long frock coat—he dealt in leather, oats and hay, cart-wheels and harness—would read the penny paper as he sat importantly on a chair outside his great, fourfold iron doorway.

And there, in a small dim window, a few pairs of beribboned wedding candles and posies in cardboard boxes gathered dust for years, while in the small room at the back, empty of either furniture or goods except for a pile of large round cakes of wax, thousand rouble deals were made by unknown agents of a millionaire candle manufacturer who lived nobody knew where.

There, in the middle of the row of shops, was the Galuzins' large grocery store with its three windows. Its bare, splintery floor was swept morning, noon and night with used tea leaves; Galuzin and his assistant drank tea all day long. And here Galuzina, as a young married woman, had often and willingly sat behind the cash desk. Her favourite colour was a violet-mauve, the colour of church vestments on certain solemn days, the colour of lilac in bud, the colour of her best velvet dress and of her set of crystal goblets. It was the colour of happiness and of her memories, and Russia, too, in her virginity before the revolution, seemed to her to have been the colour of lilac. She had enjoyed sitting behind the cash desk because the violet dusk in the shop, fragrant with starch, sugar and purple black-currant sweets in glass jars, had matched her favourite colour.

Here at the corner, beside the timber yard, stood an old, grey, weather-board house which had settled on all four sides like a dilapidated coach. It had two storeys and two front doors, one at either end. Each floor was divided in two; downstairs were Zalkind's chemist's shop on the right and a notary's office on the left. Above the chemist lived the old ladies' tailor, Schmulevich, with his large family. The flat across the landing from Schmulevich and above the notary was crammed with lodgers whose trades and professions were stated on cards and signs covering the whole of the front door. Here watches were mended and shoes cobbled; here Kaminsky, the engraver, had his workroom and two photographers, Zhuk and Strodakh, worked in partnership.

Doctor Zhivago, 1957 BORIS PASTERNAK

The village to which our family had come was a scattering of some twenty to thirty houses down the south-east slope of a valley. The valley was narrow, steep, and almost entirely cut off; it was also a funnel for winds, a channel for the floods and a jungly, bird-crammed,

insect-hopping sun-trap whenever there happened to be any sun. It was not high and open like the Windrush country, but had secret origins, having been gouged from the Escarpment by the melting ice-caps some time before we got there. The old flood-terraces still showed on the slopes, along which the cows walked sideways. Like an island, it was possessed of curious survivals—rare orchids and Roman snails; and there were chemical qualities in the limestone-springs which gave the women pre-Raphaelite goitres. The sides of the valley were rich in pasture and the crests heavily covered in beechwoods.

Living down there was like living in a bean-pod; one could see nothing but the bed one lay in. Our horizon of woods was the limit of our world. For weeks on end the trees moved in the wind with a dry roaring that seemed a natural utterance of the landscape. In winter they ringed us with frozen spikes, and in summer they oozed over the lips of the hills like layers of thick green lava. Mornings, they steamed with mist or sunshine, and almost every evening threw streamers above us, reflecting sunsets we were too hidden to see.

Water was the most active thing in the valley, arriving in the long rains from Wales. It would drip all day from clouds and trees, from roofs and eaves and noses. It broke open roads, carved its way through gardens, and filled the ditches with sucking noises. Men and horses walked about in wet sacking, birds shook rainbows from sodden branches, and streams ran from holes, and back into holes, like noisy underground trains.

I remember, too, the light on the slopes, long shadows in tufts and hollows, with cattle, brilliant as painted china, treading their echoing shapes. Bees blew like cake-crumbs through the golden air, white butterflies like sugared wafers, and when it wasn't raining a diamond dust took over which veiled and yet magnified all things.

Most of the cottages were built of Cotswold stone and were roofed by split-stone tiles. The tiles grew a kind of golden moss which sparkled like crystallized honey. Behind the cottages were long steep gardens full of cabbages, fruit-bushes, roses, rabbit-hutches, earth-closets, bicycles, and pigeon-lofts. In the very sump of the valley wallowed the Squire's Big House—once a fine, though modest sixteenth-century manor, to which a Georgian façade had been added.

Cider with Rosie, 1959 LAURIE LEE

You walked down a rutted road and came out on to stretches of fine, wet, tussocky grass dotted with little naked birches. The beech woods were beyond. Not a bough or a blade was stirring. The trees stood like ghosts in the still, misty air. Both Rosemary and Gordon exclaimed at the loveliness of everything. The dew, the stillness, the satiny stems of the birches, the softness of the turf under your feet! Nevertheless, at first they felt shrunken and out of place, as Londoners do when they get outside London. . . .
They plunged into the woods and started westward, with not much idea of where they were making for—anywhere, so long as it was away from London. All round them the beech-trees soared, curiously phallic with their smooth skin-like bark and their flutings at the base. Nothing grew at their roots, but the dried leaves were strewn so thickly that in the distance the slopes looked like folds of copper-coloured silk. Not a soul seemed to be awake.

Keep the Aspidistra Flying, 1936 GEORGE ORWELL

There are so many artists painting landscapes—they do it for the sake of repose and consolation, and many are so constituted, mentally or morally, that they find in landscape a richer life and a superabundance of colour. One can love a landscape without reflecting on it; it seems to give everything without stint. I myself rarely go back to landscape, once every two or three years perhaps, and when I do so it's in order to find in it the same things, the same kind of rationality as I do in figure-painting. I am not concerned with what is 'there' but with what it may mean; or else I try to give it a unity of time and space, exactly as if it were a figure-painting.

Some artists are fascinated by landscape because of their love for the greys and blues that they think they see there in a state of liberty. A 'light' palette suits them perfectly, and the work is absolutely painless. Others find support in the natural structure that large panoramas seem to possess, so that their picture has a built-in construction that they don't need to worry about. As we saw before, there is such a thing as a love of external reality in general. Here, in this valley, I should like to see things firstly for what they are—a vine is a vine—and secondly in a new light, because several vines together make a new kind of object. I don't mean by this that I am a good landscape painter: I could be if I followed it through, but I never do. One ought to feel the complex phenomenon of a vineyard (Cézanne) and also feel it as broken up into partial phenomena, full of poetic truth (Van Gogh), variations on the 'vine' theme. In point of fact, the secret of this landscape does not lie in its *a posteriori* character but in the pervasiveness of light, emphasizing rhythms and bringing out highlights which give it a primal significance of birth and movement. Such aspects of the scene are not accidents, they are like levers in a piece of machinery. The painter should base his tonality on them, and then we should certainly see results.

Notebooks, 1936-59 RENATO BIROLLI

It has rained every day this week, it rains harder as each day grows shorter, it was raining on Saturday when I left Matthews & Sons and went to Old Cathedral Square, where I found that the Oriental Bamboo was still closed, that it would not reopen until Saturday next, the day after tomorrow, and then went on to lunch by myself at the Oriental Rose in Town Hall Square; I watched the buses filing past under the rain, the queues forming in front of the cinemas under the rain, the minute hand of the clock on the ridiculous crenelated tower in the centre of the civic building reach the highest point in the clock-face and then move jerkily downwards, under the rain; I watched the blanket of clouds grow paler and split to reveal a glimpse of distant milky blue, and then saw the sheen of sunlight on the asphalt.

Then, as the afternoon grew ever brighter, I went to revisit Oak Park, in the 1st district to the north-east, to look once more at the great oak with its rusty bark, looking like the oaks in the fourth of the Museum tapestries; its tawny leaves were eddying in the surrounding walks and carpeting the lawns and puddles; I went to revisit Birch Park in the 2nd district, alongside the Slee, hidden by a wall above which you can glimpse the funnels of tugboats and the tops of cranes, I went to look once more at the silver birch branches, visible again through their shimmering foliage of pale moist gold; then I slowly walked upstream along the black, bubbling river, while the sky grew overcast again and the sun dropped lower, and when I reached Horace Buck's house in Iron Street it was dusk already and it was raining again, a light rain which did not prevent us from going out, eating in a snack bar in Continent Street and then travelling by a 24 bus as far as the fair in the 10th

district, where we drank pint after pint of beer to keep out the unexpected chill; then we came back on foot through the wet deserted streets, while behind the darkened windows I seemed to hear the murmur of all your sleeping inhabitants, Bleston, who long for your death as much as I do, from their very depth of their bones, under their carapace of fatigue and resigned acceptancy.

Great clouds were sailing over Dew Street when I woke up, late, on Sunday; the pale shifting sunbeams lit up transitory gleams in the windows of City Street as I made my way to the Bombay for a solitary lunch, and on the façades of Dudley Station and New Station while I was waiting for a 31 bus in the middle of Alexandra Place; they shimmered on the black swirling Slee as I crossed Brandy Bridge on my way to Ferns Park, where I carried on my farewell walk through your gardens, Bleston, in the russet underwood on which the first great glistening raindrops were falling, while women turned up their hoods.

Then I made my way under a downpour past great silent factories, under great smokeless chimneys, past great closed iron gates and grilles, as far as the muddy walks of Easter Park, where beds of withered flowers were shedding their rotting petals and their crumpled leaves.

Passing Time, 1960 MICHEL BUTOR

The entire width of the autobahn was barricaded by massive signboards; the bridge that had spanned the river at this point had been destroyed, blown clean off its ramps; rusty wire cables hung down in tatters from the pylons. Signboards three metres high announced what lay in wait behind them: *Death*. A skull and crossbones, menacing and ten times lifesize, painted in dazzling white on jet black, made the same announcement graphically to those for whom the word was not enough.

Assiduous amateurs from the driving-schools practised their gear-changing along that dead stretch, there they grew familiar with speed and crashed their gears growing familiar with turns, driving back to the left, back to the right. And neatly-clad men and women, relaxing after work, would stroll along that roadway leading past the golf-course and between allotment-gardens, and peer at the ramps and the menacing signboards, behind which, seeming to mock at death, the modest little builders' huts lay hidden, behind *Death*, and blue fumes rose up out of the stoves where the night-watchmen were warming their cans of food, toasting bread and lighting their pipe-spills. The monumental steps had survived destruction and now, on the warm summer evenings, served as seats for weary strollers who, from a height of sixty feet, could watch the progress of work. Divers in their yellow suits slid down into the waters, guiding the crane-hooks to segments of iron or blocks of concrete, and the cranes hauled up the dripping catch and loaded it on to barges. High on the scaffolding and on swaying catwalks, up in crow's nests fixed to the pylons, workmen severed the torn steel girders, their oxy-acetylene lamps giving off blue flashes, cut out twisted rivets and sheared away the remains of tattered cables. In the river, the columns with their transverse buttresses stood like giant empty gates framing acres of blue nothingness. Sirens signalled 'waterway clear', 'waterway blocked', green and red lights went on and off, the convoys bore coal and wood here and there, there and here.

The green river, the mellow banks with their willow-trees, the colourful ships, the blue flashes from the oxy-acetylene lamps: serenity. Shouldering their golf-clubs, wiry men and wiry women with serious faces went walking over the immaculate turf, behind their golf-balls, for eighteen holes. Smoke rose up from the allotments, where bean-shoots and pea-

shoots and discarded stakes were being burned and transformed into sweet-smelling clouds patterned against the sky, resembling children's elves and goblins, gathering into grotesques and then being torn asunder, against the clear, grey afternoon sky, into tormented figures, until a rush of wind mangled them again and chased them away to the horizon. Children went roller-skating on the rough-surfaced parking lots, fell down, cut their arms and knees and showed their scratches and abrasions to their startled mothers, extracting promises of lemonade and ice-cream. Hands entwined, the loving-couples went wandering down to the willow-trees, where the high-tide mark had long ago been bleached away, where the reed-stalks stood and corks and bottles and shoe-polish tins were littered. Barge-men climbed up their swaying gangways on to land, women appeared with shopping-baskets on their arms, self-confidence in their eyes; the washing flapped in the evening wind, on the spotless, shining barges; green pants, red blouses, snow-white bed-linen against the fresh, jet-black tar, gleaming like Japanese lacquer; and fragments of the bridge protruded from the surface, covered in slime and seaweed. In the background was the grey, slender silhouette of Saint Severin, and the exhausted waitress in the Café Bellevue announced, 'the cream-cake's sold out', wiped the sweat from her heavy-featured face and fumbled in her leather purse for change: 'only Madeira cake left—no, the ice-cream's sold out too.'

Billiards at Half Past Nine, 1959 HEINRICH BÖLL

Beyond the bamboos their path tunnelled under a seemingly endless ancient growth of rhododendrons and they had to duck, for though the huge congested limbs of this dark thicket had once been propped on crutches to give the path full headroom many of these were now rotten and had collapsed. At the very centre of this grove the tunnel passed by a small stone temple; but here too the brute force of vegetation was at work, for the clearing had closed in, the weather-pocked marble faun lay face down in the tangle of ivy which had fallen with him, the little shrine itself now wore its cupola awry. Thus it was not till the two men had travelled the whole length of this dark and dripping tunnel and finally reached the further border of all this abandoned woodland that they really came right out again at last under the open whitish sky.

Here, a flight of vast garden terraces had been cut in the hillside like giant stairs. Downwards, these terraces led to a vista of winding waterlily lakes and distant park with a far silver curl of river: upwards, they mounted to a house. The walking figures of the two men and the dog, ascending, and presently turning right-handed along the topmost of these terraces, looked surprisingly small against that house—almost like toys, for this ancient pile was far larger than you had taken it for at first. Nevertheless there was no hum from this huge house, no sign of life even: not one open window, nor a single curl of smoke from any of its hundred chimneys. The men's sodden boots on the stone paving made little sound, but there was none other.

This topmost terrace ended at a tall hexagonal Victorian orangery projecting rather incongruously from the older building, the clear lights in its Gothic cast-iron traceries deep-damasked here and there with dark panes of red and blue Bristol. In the angle this projection made with the main structure a modest half-glazed door was set in the house's ancient stone-work, and here at last the two men halted: the young man with the small body over his shoulder took charge of the guns as well and sent the furtive, feral-looking older man away. Then the young man with the burden and the wet dog went in by themselves, and the door closed with a hollow sound. . . .

Even at the best of times Augustine's surroundings in Germany never seemed to him quite 'real': they had a picture-book foreignness, down to the smallest detail. The very snow he was walking in differed from English snow. Those distant forests were coloured a 'Victorian' green—the colour of art-serge curtains rather than trees: the edges of the forest were all sharp-etched (outside of them no loose trees stood around on their own) and yet these plantations were formless, for their arbitrary boundaries seemed to bear no relation to Nature or the lie of the land. Thus the landscape (in his eyes) had none of the beauty almost any English landscape (in his eyes) had got.

Augustine kept passing wayside shrines, and even the farms had each its own little doll's-chapel outside with a miniature belfry and an apse as big as a cupboard. Taken all together and on top of the churches they added up to a pretty frightening picture Often these chapels were almost the only outbuildings the farms had got, apart from a crow's-nest up an apple tree for potting at foxes.

Indeed these hardly looked like 'farms' (which are, surely, essentially a huddle of big byres and barns with a tiny house tucked away in the middle?). These (because the animals lived indoors on the ground floor) looked all 'house'.

Since landscape changes like this from country to country it must owe very little to Nature: Nature is no more than the canvas, and landscape the self-portrait the people who live there paint on it. But no, hold hard! Surely, rather the people who *have* lived there; for landscape is always at least one generation behind in its portrayal (like those other portraits that hung on the parlour wall). This was Augustine's 'new' Germany, but the landscape here was unchanged since Kaiserdom or even before: whereas the people. . . .

The Fox in the Attic, 1961 RICHARD HUGHES

From that balcony in the Madonie mountains, in the bluish breeze of that evening, lights could be seen which indicated, from north-west to south-west, the position of a hundred towns and localities, right over to the gulf of light which was Palermo and the smaller and dimmer clusters of Caltanissetta and Agrigento. The lights were like bunches of grapes, single ones for the most part but sometimes five or six together, among the dark tendrils of the still darker vineyard which was the earth. The Signora could have named them one by one through the window-pane, making an imaginary journey from place to place. Some looked like a handful of light, others an armful: Caltavuturo, Sclafani, Aliminusa, Valledolmo, Villalba, Marianopoli, Campofranco, Sutera, Bompensiere (upper and lower), Caccamo, Corleone, Prizzi (also upper and lower), Cammarata, Mussomeli . . . But she could see nothing of the world buried in the mountains to the east and south-east: Gangi, Sperlinga, Nicosia, Capizzi, Cerami, Agira; nor even, slightly eastward of Caltanissetta, the rich hillside of Enna with Calascibetta at its foot.

Enna stands on a hill some twenty miles from Leonforte: the summit is flat, like a terrace, and the sides are as steep as battlements. Similar hills—some of them green with pastureland but mostly rugged and reddish or blackish, and all of them crowned with a limestone top which, according to the distance, may be taken for a snow-line or a series of white cottages—extend beyond Enna towards the northern Madonie or Caltanissetta, and also to

the south of the wide basin that faces Enna. The main road from Leonforte skirts the most imposing of these hills near Enna, and then divides into a westerly and a southern route, the former towards Agrigento and the latter reaching the wooded heart of 'Hyblaean Sicily'. Both these roads follow the line of the hills, some of which rise singly and others in groups. But at a speed of three or four miles an hour—that of an average beast of burden pulling a cart with an average load—Odeida would have to spend four or five hours travelling through flat cornfields before reaching the bare, flat, higher ground where the road crosses the railway at the lonely station of Enna, and divides into two after encircling the rock on which the town stands.

How long had she actually been travelling, in a doze with Rhea Silvia and the puppy sleeping at her feet? Was it hours or minutes? Every time she awoke for a few moments there were still fields to right and left, the ripe corn interspersed with patches of green and early poppies that seemed to flit in and out like red butterflies. From time to time she met other vehicles: cars, small vans, carts and light carriages; from time to time she stopped and half-heard someone talking to her, or took notice of some object and fell to dreaming about it. But when she finally awoke, she could not have told whether she had gone a long or a short distance. The skyline had wrinkled up in such a way that the sun could not be seen. Mount Enna had shifted by a few degrees on the horizon, but she did not feel closer to it, perhaps because the air was no more limpid than before.

Le Città del Mondo, 1952-9 ELIO VITTORINI

The window of the waiting-room was clear for an instant as the train started to move. Komako's face glowed forth, and as quickly disappeared. It was the bright red it had been in the mirror that snowy morning, and for Shimamura that colour again seemed to be the point at which he parted with reality.

The train climbed the north slope of the Border Range into the long tunnel. On the far side it moved down a mountain valley. The colour of evening was descending from chasms between the peaks. The dim brightness of the winter afternoon seemed to have been sucked into the earth, and the battered old train had shed its bright shell in the tunnel. There was no snow on the south slope.

Following a stream, the train came out on the plain. A mountain, cut at the top in curious notches and spires, fell off in a graceful sweep to the far skirts. Over it the moon was rising. The solid, integral shape of the mountain, taking up the whole of the evening landscape there at the end of the plain, was set off in a deep purple against the pale light of the sky, The moon was no longer an afternoon white, but, faintly coloured, it had not yet taken on the clear coldness of the winter night. There was not a bird in the sky. Nothing broke the lines of the wide skirts to the right and the left. Where the mountain swept down to meet the river, a stark white building, a hydro-electric plant perhaps, stood out sharply from the withered scene the train window framed, one last spot saved from the night.

Snow Country, 1956 YASUNARI KAWABATA 250

199. BEN NICHOLSON: *Chytton, Cornwall,* 1949. Chalks on paper. Brissago (Ticino), Ben Nicholson Collection.

Nicholson reduces the irregular, unrhythmical structure of the landscape to an incisive graphic formula. The little village on the right and the scattered houses on undulating ground serve to punctuate the scene. The level of abstraction is such that a thicker chalk-mark here and there, a tangle or repetition of lines is sufficient to denote and recall the everyday life of man and nature.

200. BEN NICHOLSON: *Yorkshire,* October 1954. Chalks on paper. Brissago (Ticino), Ben Nicholson Collection.

More than perhaps any other artist, Nicholson has sought to find in nature themes and co-ordinates that can be reduced to a formal order; or, to put it differently, he projects into nature certain chosen features of his own artistic language. Thus, in the present landscape the outline of the hills, the roads, trees, houses and sky combine into a harmonious whole, the irregularity of nature being transformed into a system of lucid and effective signs.

201. LYONEL FEININGER: *Dunes with ray of light II*, 1944. Oil on canvas, 50.5 ×89 cm. Buffalo, Albright-Knox Art Gallery.
A grandiose scene, one of the most representative of Feininger's work. The picture is permeated by a kind of august spaciousness, the oblique planes looming up only to re-dissolve in air. The two minute figures are no more than a scale-reference which underlines the overwhelming domination of the atmosphere.

202. WILLEM DE KOONING: *Suburb of Havana*, 1958. Oil on canvas, 203 × 178 cm. Uccle (Brussels), Philippe Dotremont Collection.

We can only take note of the title which the artist has chosen for this work. What he has done is to fill the large canvas with signs of the utmost vehemence which are not figurative in intention but are a direct projection, an extension in physical terms of the painter's energy and inner tension. His rejection of nature is not pre-ordained or even deliberate: but his images seem all the more expressive because they bear no relation to specific reality.

203. BEN SHAHN: *The red staircase*, 1944. Tempera on masonite, 24.5 × 34.6 cm. St. Louis, Missouri, City Art Museum.

Another dramatic vision by Shahn, almost aggressive in its extraordinary bareness. The destruction of war is expressed by the heap of rubble and the battered structure in the left foreground. Then comes the long, masterly foreshortening of the building with its tall windows and, alongside it, the great flight of steps, miraculously intact.

204. BEN SHAHN: *Fourth of July orator*, 1943. Oil on canvas, 56 × 70.3 cm. New Canaan, Connecticut, Samuel W. Childs Collection.

One of the most disturbing and compassionate works by this great painter. A vast empty space covers nearly three quarters of the canvas; at the far end is a grassy bank surmounted by illegible hoardings. On a low platform in the middle of the space are three lonely, enigmatic figures without an audience. Their relationship to the landscape could not be closer or more significant.

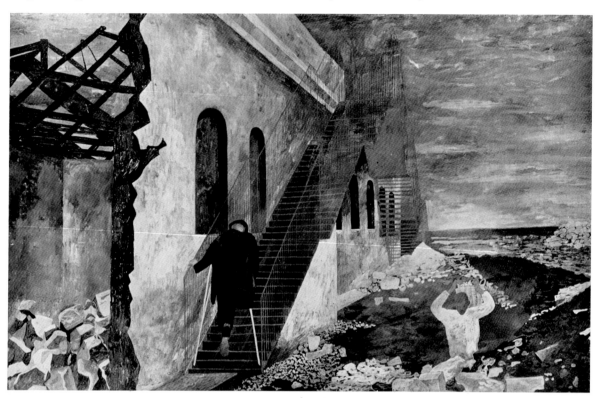

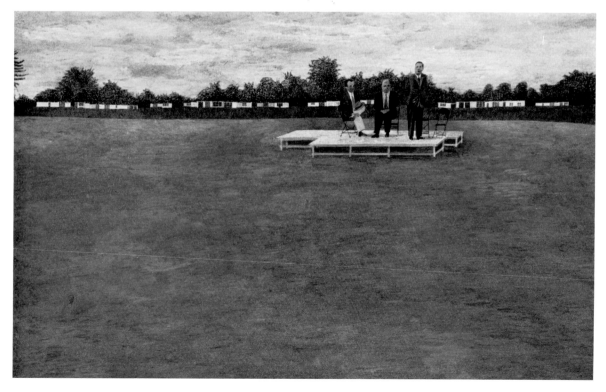

205. BEN SHAHN: *Pacific landscape*, 1945. Tempera on pressed panel, 64.3 × 99.6 cm. New York, Museum of Modern Art (gift of Philip L. Goodwin).

A picture of similar inspiration to that of the patriotic meeting. The painter's capacity to evoke desperate pity for the human figure, cast away like a useless object into the *mare magnum* of the sterile, unfriendly beach, here rises to an intensity that perhaps surpasses any other artist of our time.

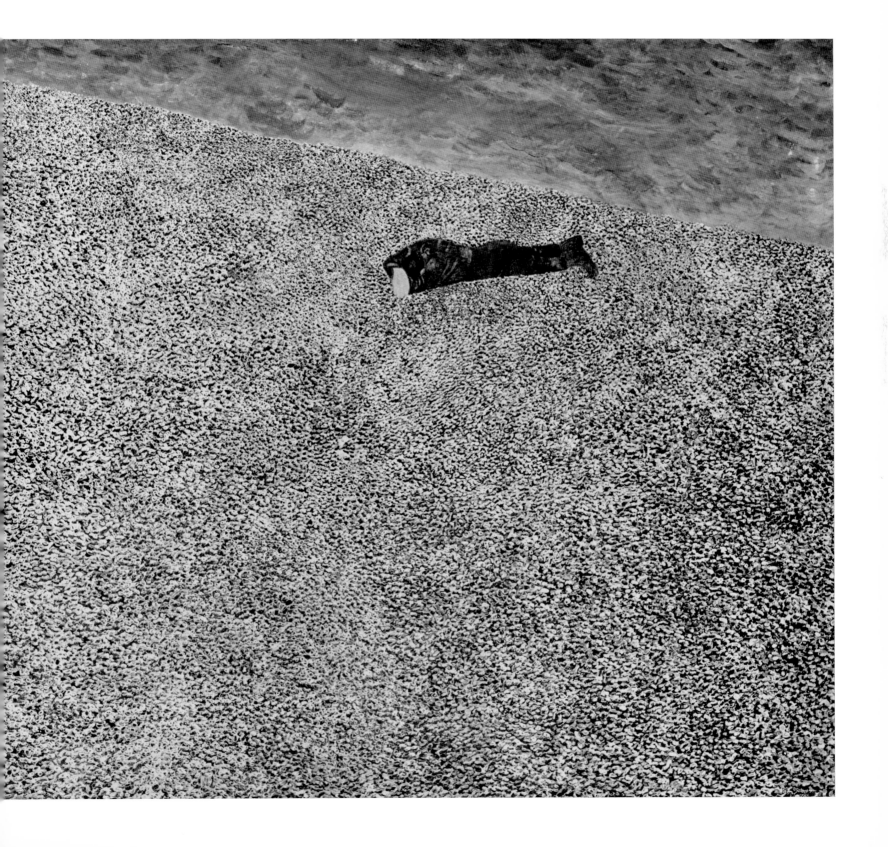

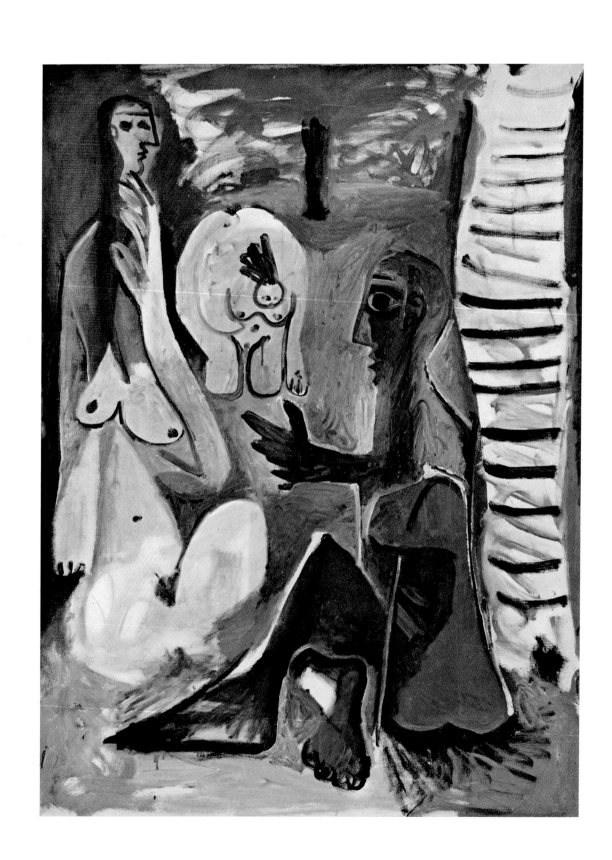

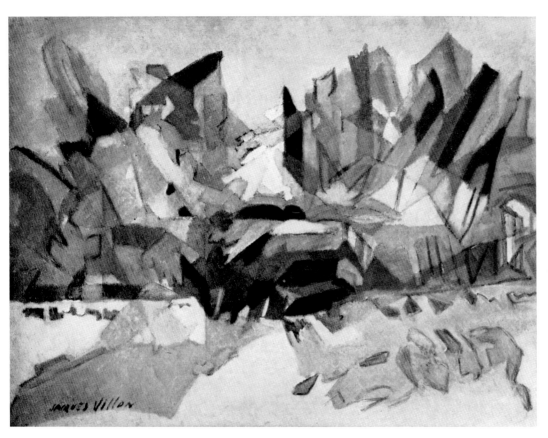

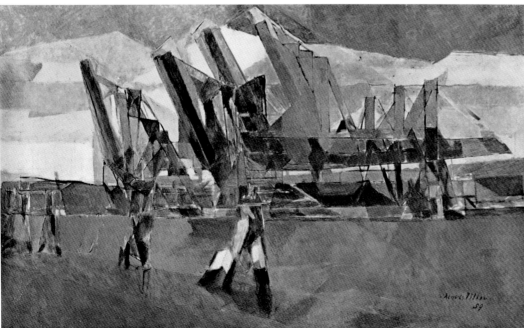

206. PABLO PICASSO: *Déjeuner sur l'herbe*, 1961. Oil on canvas, 130 × 97 cm. Paris, Louise Leiris Collection.

One of Picasso's celebrated recompositions, to be compared, for example, with those after Velazquez' *Las Meninas*. In this case Manet's painting provides only a rough basis for an independent statement of the theme, with new spatial dimensions and a morphology showing the most typical Picassian deformations.

207. JACQUES VILLON: *Entrance to a park*, 1948. Oil on canvas, 54 × 73 cm. Paris, Photo Editions Louis Carré.

Throughout his career Villon showed much fidelity to Cubism, which had been the strongest influence on him as a youth. This landscape shows his exquisite gifts as a colourist of wide range and delicate gradations; the facets that typify his manner unite in a varied and inconstant rhythm.

208. JACQUES VILLON: *The Seine at Val de la Haye*, 1959. Oil on canvas, 97 × 162 cm. Paris. Photo Editions Louis Carré.

Painted when Villon was 84 years old, this work displays a crystallographic structure which is especially clear in the central part but is also seen in the waters below and in the sky. The whole is combined with harmony, discipline and clarity of vision.

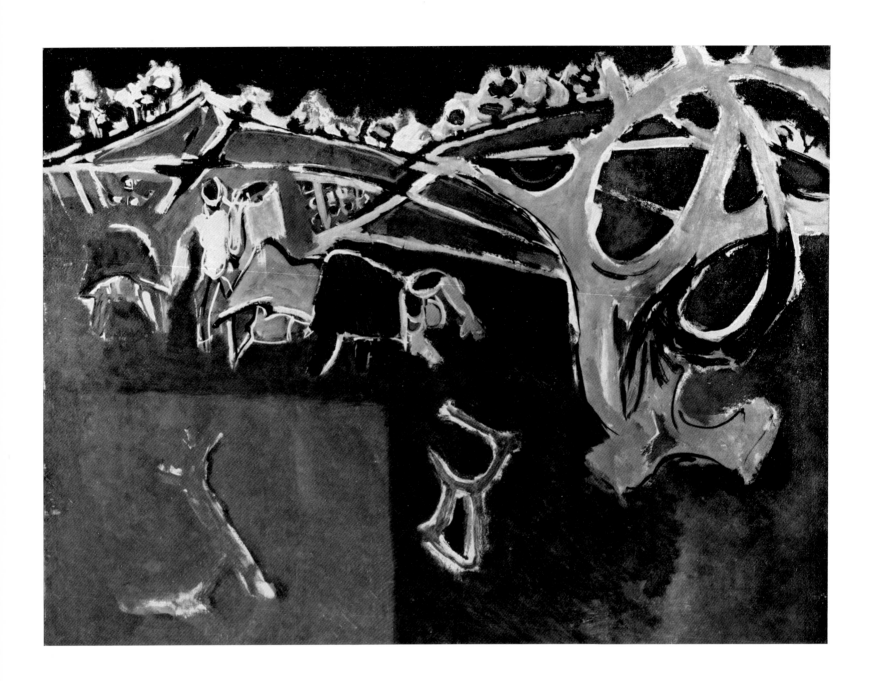

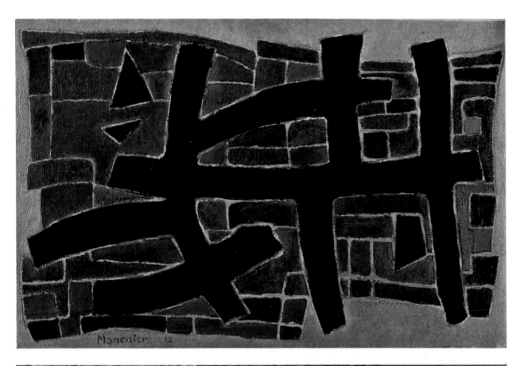

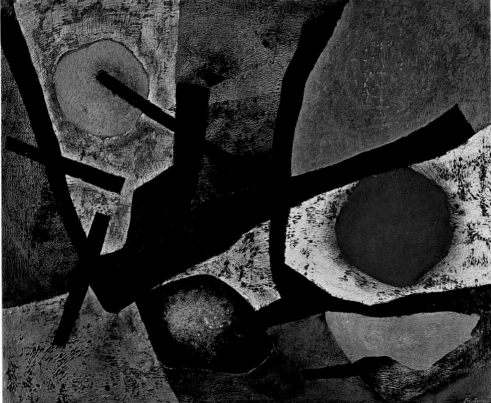

209. EDOUARD PIGNON: *Prairie*, 1954. Oil on canvas, 73 × 93 cm. Weert (Holland), Smeets Collection.

Although Pignon is one of the most socially conscious of the *peintres de tradition française*, his self-expression as a painter is unaffected by external conditions. This is shown by the present work, which is devoid of any illustrative or didactic intention and is constructed freely around the involved and tangled shapes that spread across the canvas.

210. ALFRED MANESSIER: *That which was lost*, 1952. Oil on canvas, 65 × 100 cm. Brescia, Pinacoteca Tosio Martinengo (Cavellini Collection).

Here again the non-figurative approach prevents a literal interpretation. The painter's characteristic symbols and devices, which have a ritual dignity of their own, are interwoven into a grandiose, sonorous and musical pattern.

211. FRITZ WINTER: *March*, 1951. Oil on canvas, 120 × 150 cm. Brescia, Pinacoteca Tosio Martinengo (Cavellini Collection).

Winter brings before our eyes that which cannot be shown by purely figurative painting: the growth of living things, the vital forces of the earth, vegetable life, the breath of wind and the flow of water. His attitude towards the outside world is similar to that of Franz Marc or Paul Klee many years earlier. But the pictorial problem is different and the invocation of nature is remote, since the artist's object is to reconstruct or re-create its forms.

212. NICOLAS DE STAËL: *The roofs of Paris*, 1952. Oil on hardboard, 200 × 150 cm. Paris, National Museum of Modern Art.

The city roofs, seen by de Staël as a changeable and inconstant composition, form a brilliant and brittle pattern, which occupies rather more than a third of the canvas and contrasts with the calm of the sky surmounting it. This is one of the most deeply 'felt' works by the artist, who was never hampered by any one figurative formula.

213. NICOLAS DE STAËL: *The fort at Antibes*, 1955. Oil on canvas, 130 × 89 cm. Paris, Jacques Dubourg Collection.

De Staël is one of the artists who have done most to give a new and genuinely modern interpretation to landscape. In quite a different direction, and with other intentions and means, his development of the art has something in common with that of Ben Nicholson. As this clear landscape shows, de Staël too is concerned to 'regain touch with visible reality through the evocative force of abstract means'.

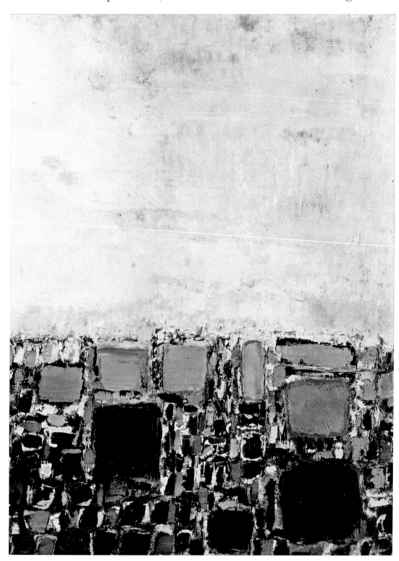
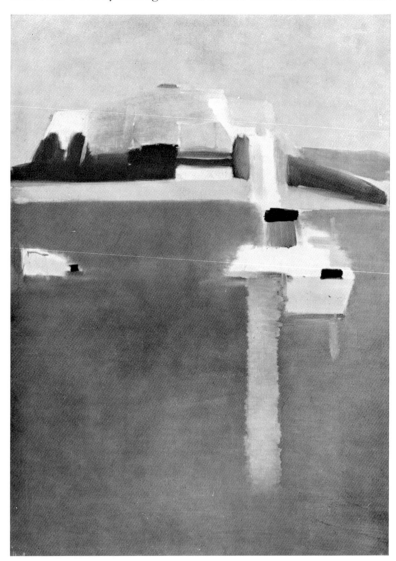

214. NICOLAS DE STAËL: *Agrigento*, 1954. Oil on canvas, 73 × 100 cm. Zürich, Kunsthaus.

A high degree of abstractness is again seen in this firmly outlined composition of a few forms whose light colour contrasts with the bright red of the roofs and the deep blue of the sky. The 'elementary figures', as they used to be called, are juxtaposed in a strong rhythm which takes account of the differing weight of colour. The painter's exceptional vision is a safeguard against the sentimentalism which sometimes prevents a correct reading of the figurative values of a landscape.

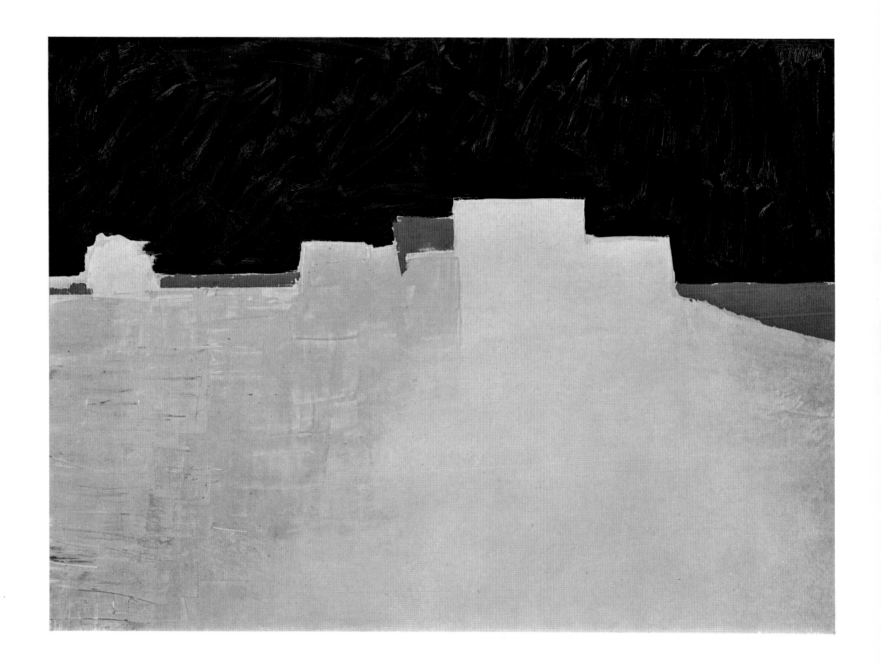

215. JEAN BAZAINE: *Noon, trees and rocks*, 1952. Oil on canvas, 100 × 81 cm. Zürich, Gustave Zumsteg Collection.

This astonishing landscape symbolizes in an unusually effective way the atmosphere of French painting between 1940 and 1955. The Cubist starting-point belongs by now to the remote past: everything is transfigured by the renewed endeavour to comprehend nature as an inexhaustible fount of life and the mainspring of human existence. The painting shows a movement and grasp which cannot be reduced to any premeditated scheme.

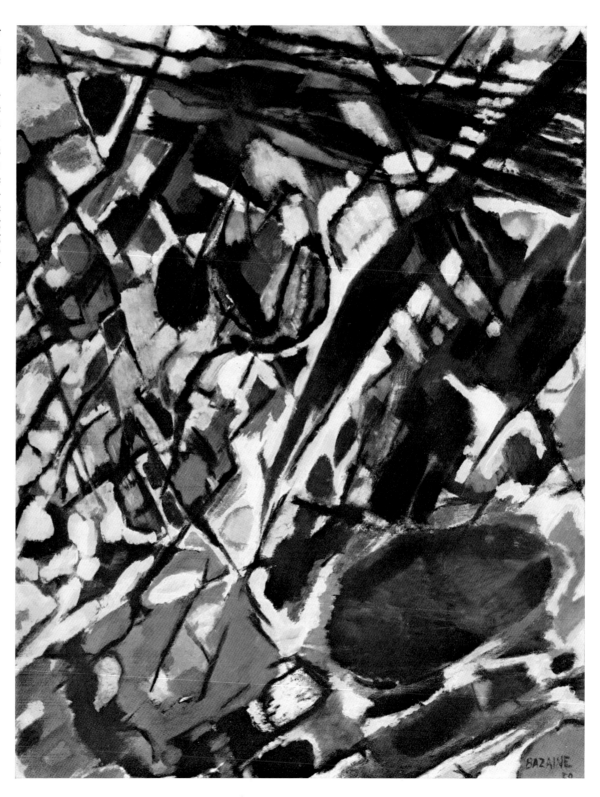

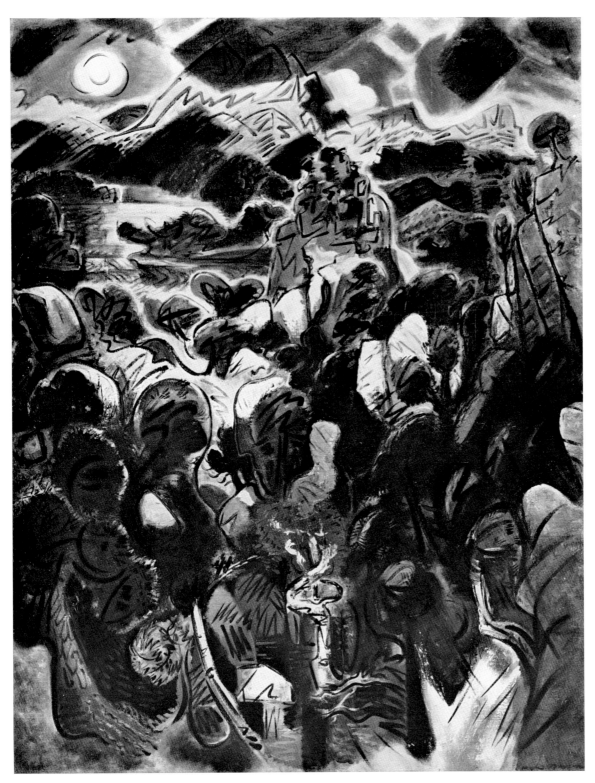

216. ANDRÉ MASSON: *Large landscape*, 1948. Oil on canvas, 146 × 114 cm. Paris, Louise Leiris Collection.

Masson's work is characterized by acute sensibility, an irresistible impetus, wealth of fantasy and manifold resources of style. All these are exemplified in this impressive painting, which also reflects clearly the various influences undergone by the artist during his long career. The draughtsmanship and colouring are so completely integrated as to suggest a free outburst of creativity.

217. CAMILLE BRYEN: *Landscape*, 1958. Oil on canvas, 115 × 81 cm. Brescia, Pinacoteca Tosio Martinengo (Cavellini Collection).

A landscape bearing witness to the painter's anxieties, which are clearly enough discernible even in his 'poetic' vein. One feels that his work is capable of being imbued to an infinite degree with lyric vitality and extreme liveliness of mind. We should not forget that he was a friend of Wols.

218. GUSTAVE SINGIER: *Provence: estuary, sun and sand*, 1959. Oil on canvas, 130 × 162 cm. Paris, Galerie de France.

'Any sight, be it a landscape, a still-life or an interior, suggests to me of its own accord a shape or a colour peculiar to itself and affectively at one with it.' Once again, the object is to re-establish a warm *rapport* with nature, pursuing the line of development opened up by Klee with his unfettered imagination. It is Klee, too, who provides the model for these subtle, sensitive lines traversing the picture-space.

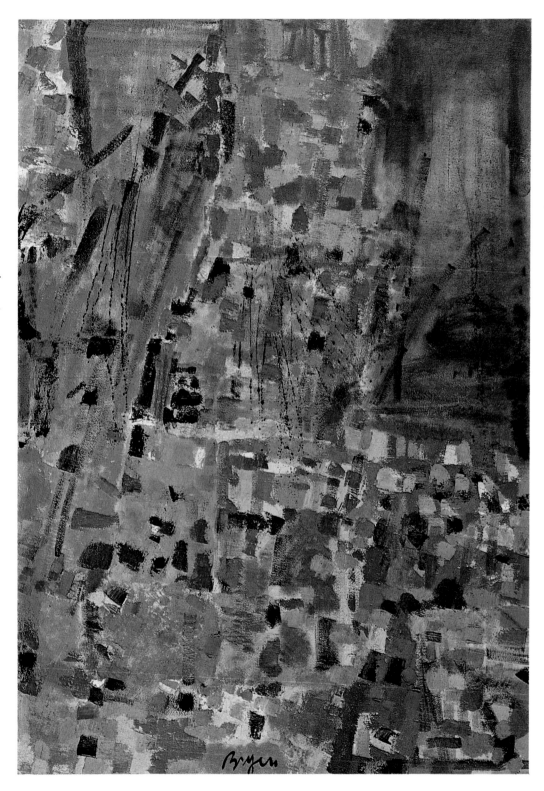

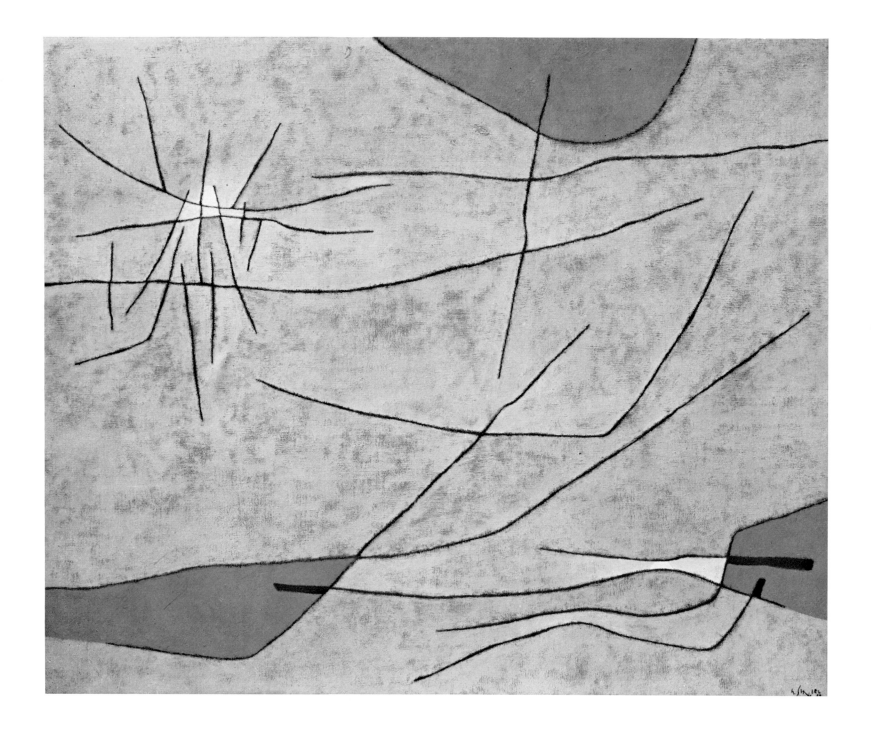

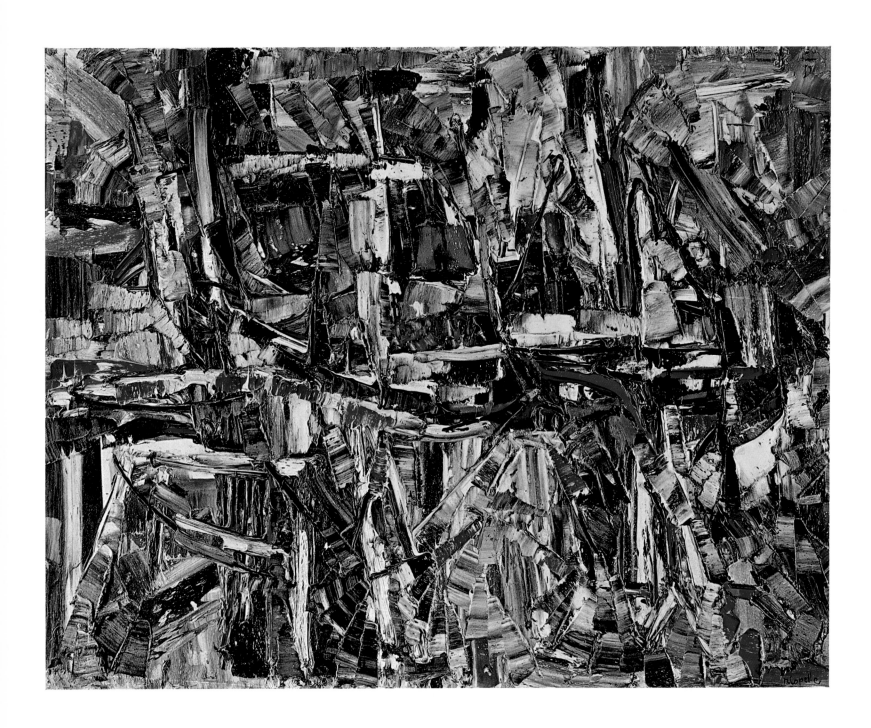

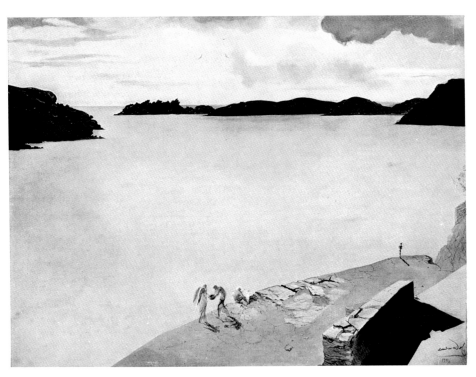

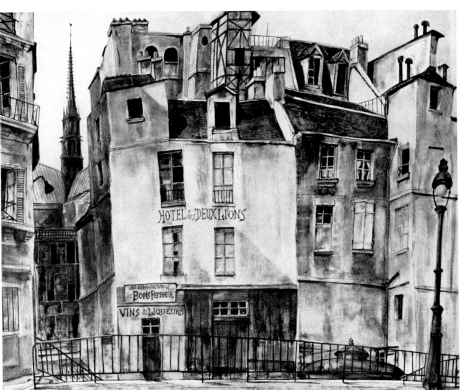

219. JEAN-PAUL RIOPELLE: *Landscape*, 1958. Oil on canvas, 146 × 114 cm. Brescia, Pinacoteca Tosio Martinengo (Cavellini Collection).

From the apparently uncontrolled effervescence of the tormented surface, full of internal movement and tension, there emerges a flawless order, even a regularity of structures and motifs. There is a central dividing line, above and below which the composition is articulated almost in mirror-fashion.

220. SALVADOR DALI: *Landscape of Port Lligat*, 1950. Oil on canvas, 58.5 × 79 cm. Cleveland, Reynolds Morse Foundation (The Salvador Dali Museum Collection).

One of Dali's hallucinatory visions, with exaggerated distances and a distorted frame of reference. An unreal light pervades the infinite expanse of water, while the tiny figures on the shore appear to symbolize an impossible coexistence between man and his surroundings. As always, Dali pays minute attention to detail.

221. TSUGUJI FUJITA: *Notre-Dame and the Quai aux Fleurs*, 1950. Oil on canvas, 38 × 45 cm. Paris, National Museum of Modern Art.

This Paris scene is characterized by a wealth of realistic observation, an almost inquisitive attention to the smallest details of architecture and other urban features. The recondite aspects of the city are strongly felt and well caught, though the painting is not free from a diffuse anecdotic quality.

222. RENATO BIROLLI: *Eldorado*, 1935. Oil on canvas, 90 × 100 cm. Milan, Boschi Collection.

This amazing landscape, almost frenzied in its use of colour and suggestive of Van Gogh in its rapid movement, serves to define clearly Birolli's position as a pre-war exponent of Italian figurative art. A lively sensibility and freedom of manner are shown in this unconventional scene, independent of the tenets of the *Novecento* movement and to some extent opposed to them.

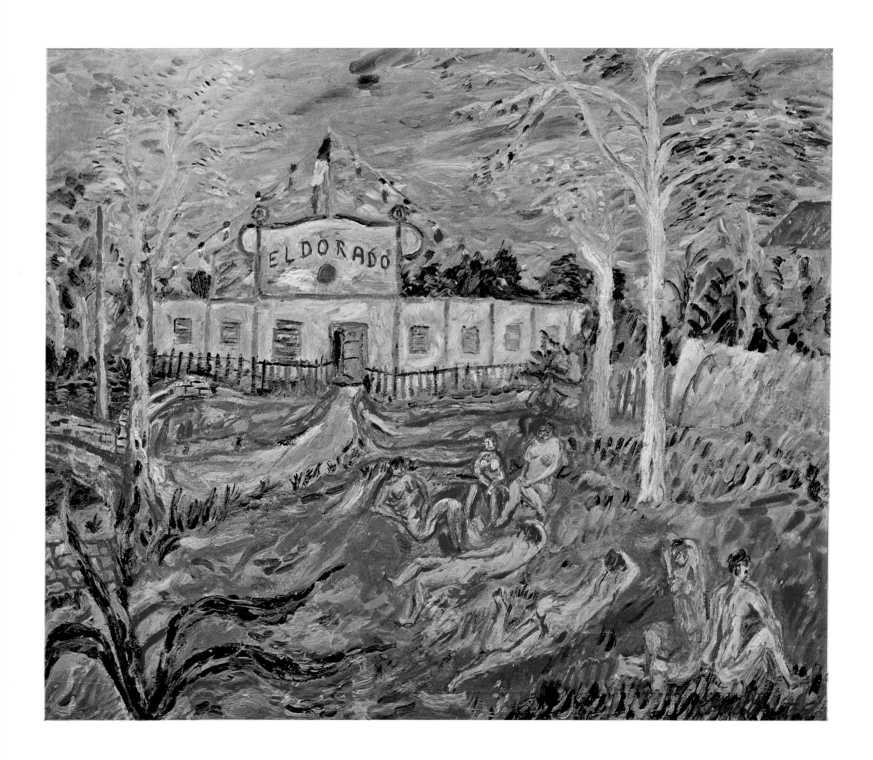

223. RENATO BIROLLI: *Notre-Dame*, 1948. Oil on canvas, 73 × 60 cm. Brescia, Cavellini Collection.

An example of Birolli's Cubist phase immediately after the Second World War, when the *Fronte Nuovo delle Arti* expressed the aspirations and uncertainties of a number of Italian artists. The constructional aspect dominates over the colour-scheme, the tones being for the most part light and subdued.

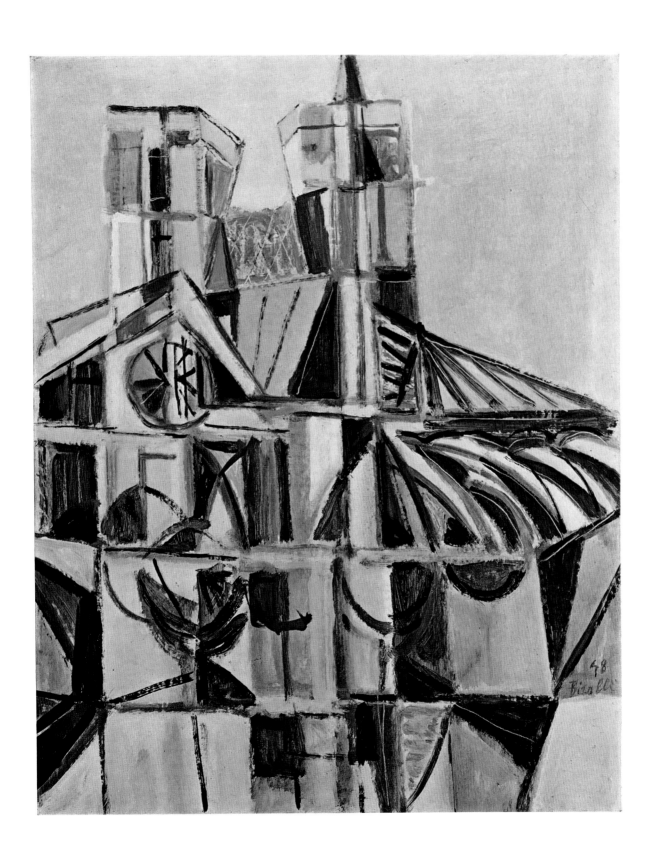

224. RENATO BIROLLI: *Liguria is vertical*, 1955-6. Oil on canvas, 73 × 116 cm. Turin, Pinottini Collection.

In his later years Birolli's work resolves itself into zones of intense, contrasting colour: greens, reds and yellows jostle or enclose one another, forming a changeable and varied rhythm. The Ligurian landscape is here interpreted in terms of the artist's new vision, based on sharp recollection but fully autonomous in itself.

225. RENATO GUTTUSO: *Landscape*, 1956. Oil on canvas, 50 × 70 cm. Varese, Vittorio Tavernari Collection.

A splendid landscape, painted rapidly and with the freshness typical of Guttuso's frank naturalism during the past two decades. The view is seen from close up, the objects are vibrant and there is no mental or intellectual screen between the artist and the spontaneous happiness of his work.

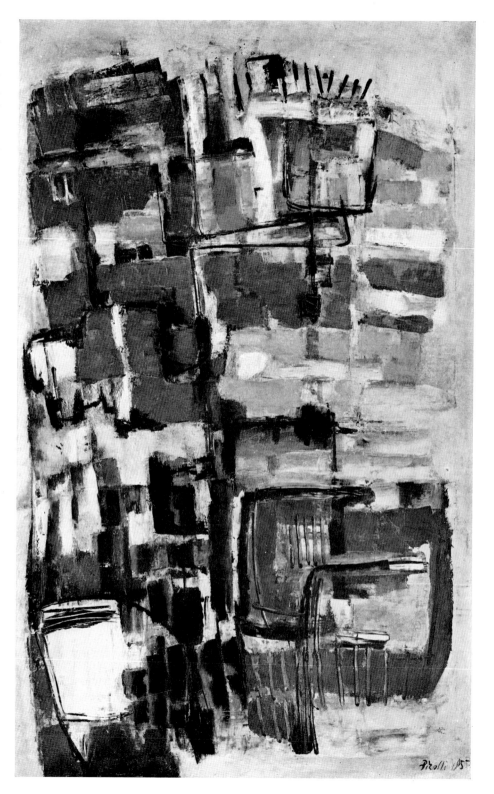

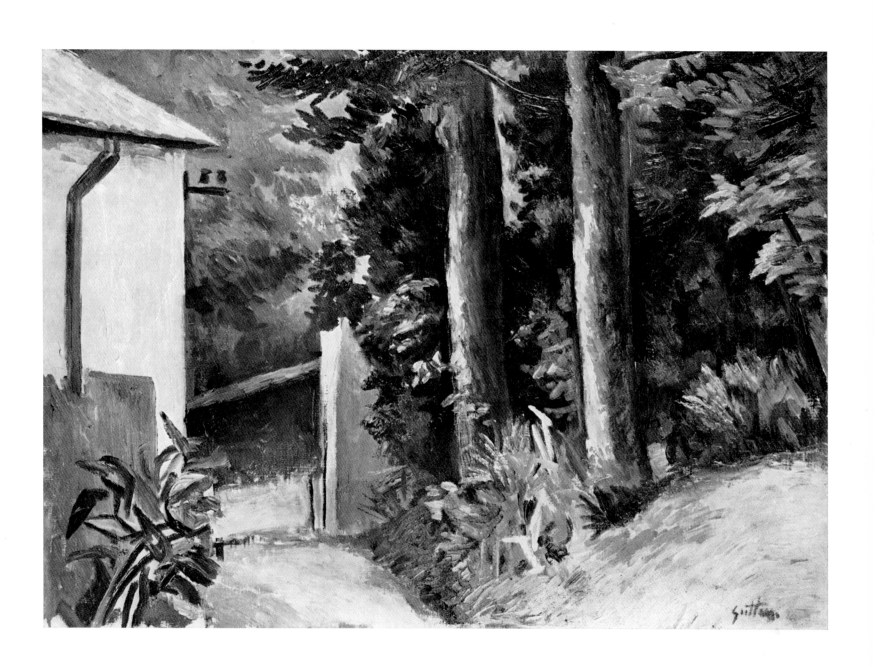

226. BRUNO CASSINARI: *Gropparello* 1959. Oil on canvas, 114 × 146 cm. Milan, Brambilla Collection.

Dilatations and sudden contractions, calculated convergence and brusque separation, slightly flawed tones that catch fire and burst into luminous red—such are the most evident characteristics of this grand, polyphonic construction. It also shows great variety and wealth of rhythm and a delight in the insertion of disparate features: centres and points of expansion, disjoined and linked in a variety of ways.

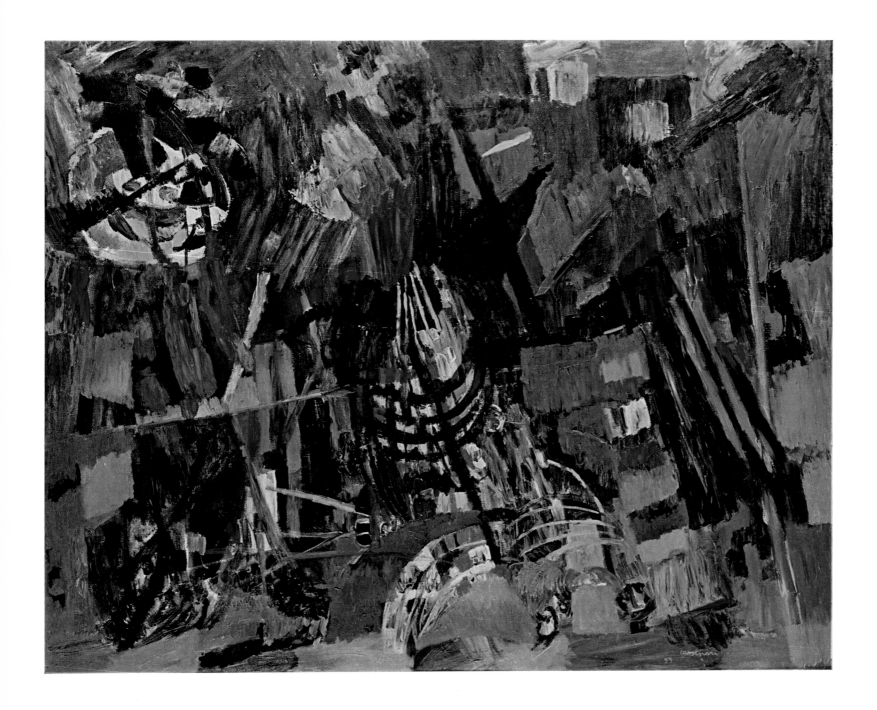

227. BRUNO CASSINARI: *Sunset at Brianza*, 1967. Oil on canvas, 80 × 100 cm. Milan, Private Collection.
Red again dominates in this fiery *Sunset*, the essence of which consists in the grand sweep of its main structure. None of the component forms are directly related to nature, nor is it necessary to embark on improbable conjectures in order to read the painting correctly.

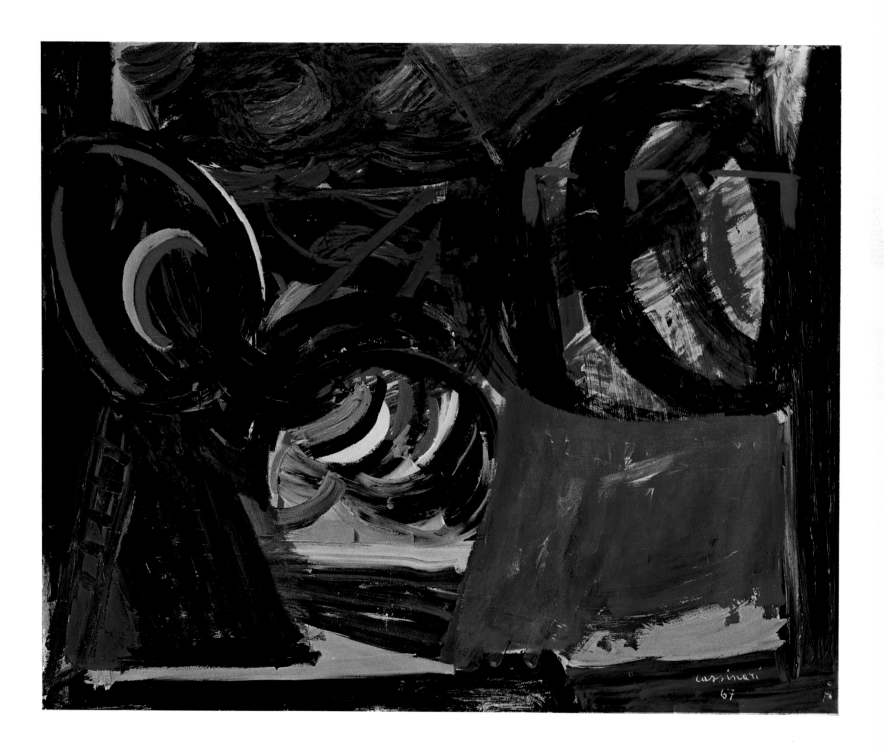

228. ENNIO MORLOTTI: *Field of maize*, 1961. Oil on canvas, 85 × 60 cm. Milan, Private Collection.

Morlotti sees the world of nature as composed of vital saps and fluids, pulsating amid the foliage and vegetation in the woods and rich fields of Lombardy. The impasted canvas gives us a sense of the artist's warm feeling for the fruits of the earth and the revolving seasons that bring fecundity.

229. ENNIO MORLOTTI: *The Adda at Imbersago*, 1955. Oil on canvas, 70 × 90 cm. Milan, Private Collection.

The great wall of vegetation is so strongly reflected in the waters of the river that the latter almost disappear. The whole scene is a turmoil and effervescence of colours, mingling and overlying one another, their warm tonality suggesting the luxuriance of the season. The painting gives a good idea of the poetic scope of the great Lombard artist.

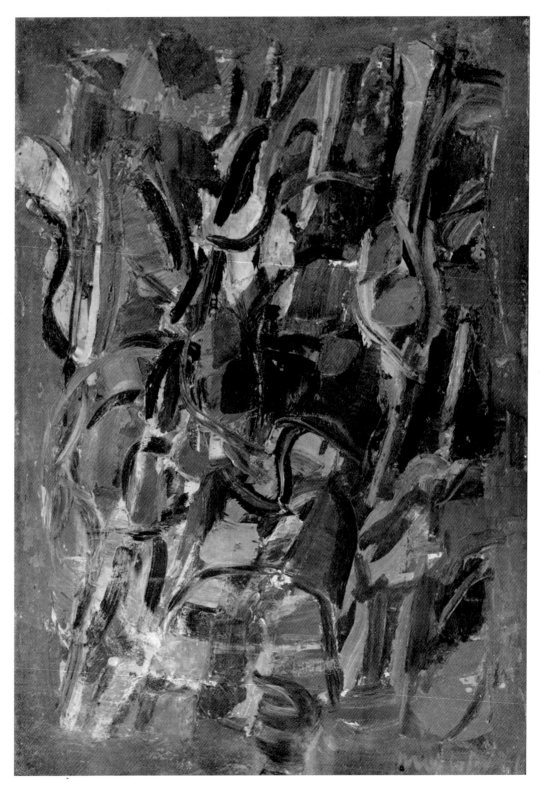

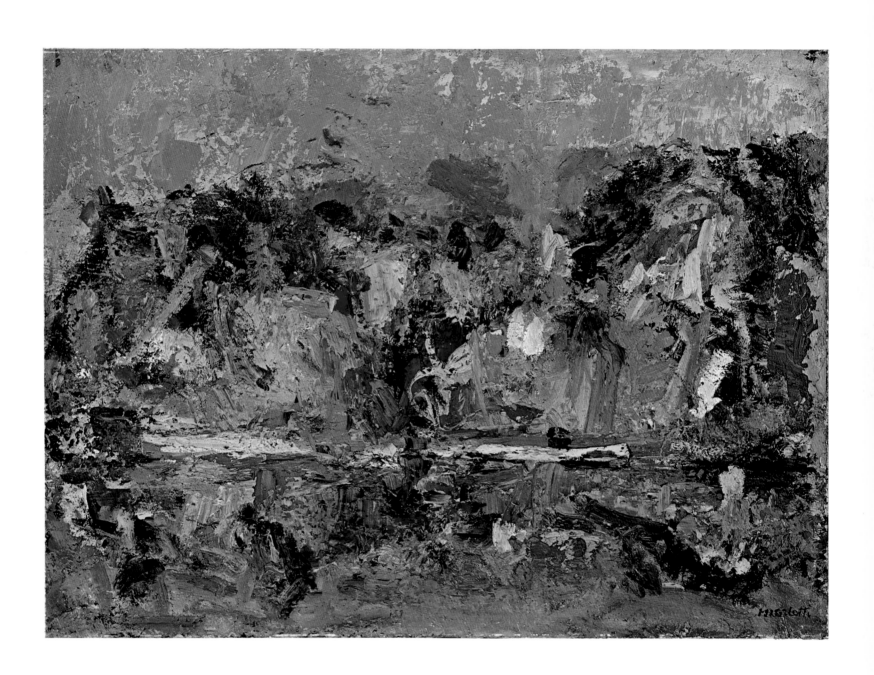

230. LEONARDO CREMONINI: *Les écrans du soleil*, 1967–8. Oil and tempera on canvas, 195 × 273 cm. Private Collection.

One of Cremonini's most significant works, constructed with relentless precision in every detail. The perspective on the left, with its clearly scenic effect, is exactly balanced by the right-hand portion in which distance and space are measured by variously angled planes and axes. The clarity of the whole is reinforced by a clear, rhythmic use of colour, the firmness of which does not exclude gentle transitions and delicate transparences.

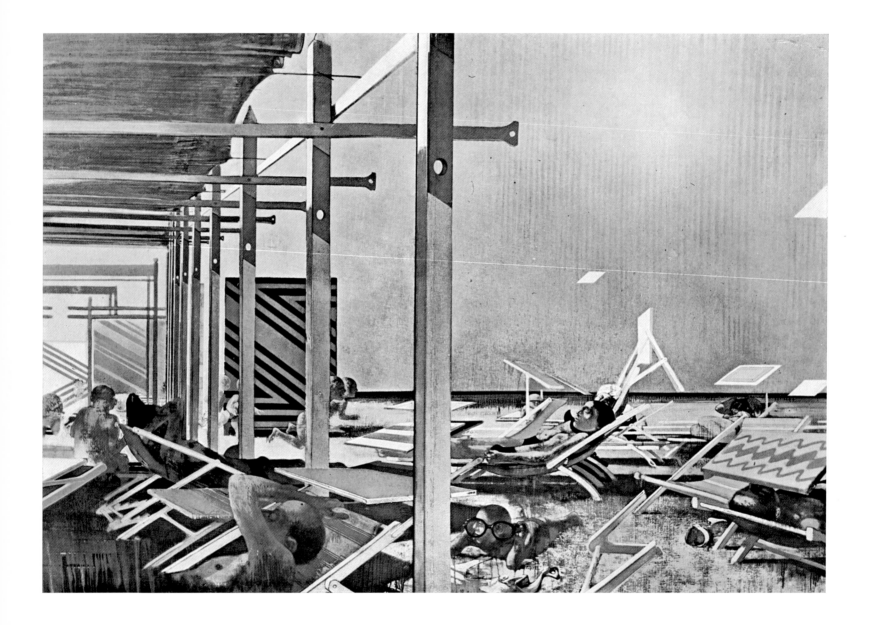

231. WERNER GILLES: *Stone quarry*, 1947. Tempera, 45 × 62.5 cm. Munich, Bavarian State Art Collections.

As Haftmann wrote of Gilles: 'In the love of a landscape or in a moment of lyric inspiration, he encounters dreams transformed into scenery, figures and objects. He turns the dream into a picture wherein the scenery keeps its symbolic significance and the lyricism is embodied in form and colour.' In the present work we see not only the variety of forms but the fact that they derive from the most venerable sources of European art.

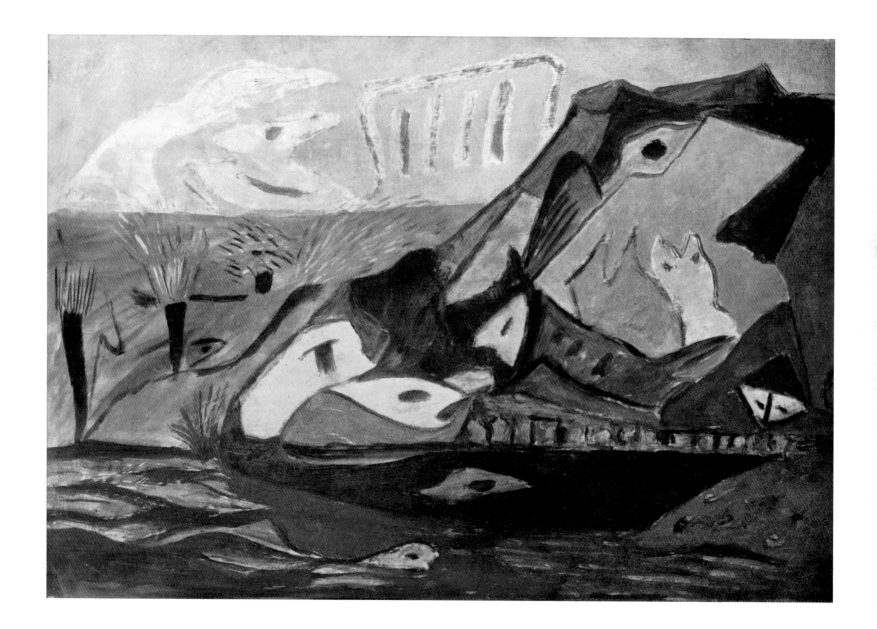

232. ERNST WILHELM NAY: *Oasis*, 1952. Oil on canvas, 100 × 120 cm. Mannheim, Kunsthalle.

This work belongs to what was perhaps the most fruitful period in Nay's career, rich as he was in inspiration and experience. The colouring, which he regarded as the key element in painting, is exquisitely personal, while the numerous features and symbols show his debt to the early Kandinsky.

233. OSKAR KOKOSCHKA: *Salzburg*, 1950. Oil on canvas, 85 × 120 cm. Munich, Bavarian State Art Collections.

The city, with its spires, domes and churches, is crowded between the river and the steep hills, under a sky rent by shifting patches of light. The layout is defined by innumerable details, while the colour imparts a resonance of the utmost variety.

234. OSKAR KOKOSCHKA: *The port of Hamburg*, 1951. Oil on canvas, 87 × 128 cm. New York, Museum of Modern Art (Rose Gershwin Fund).

One of Kokoschka's most masterly paintings. The viewpoint is high, as usual, and the eye covers a vast area as far as the distant horizon. The rendering of space is intensely personal, as in the artist's other works. It would be hard to imagine a truer, more evocative portrayal of the great maritime city.

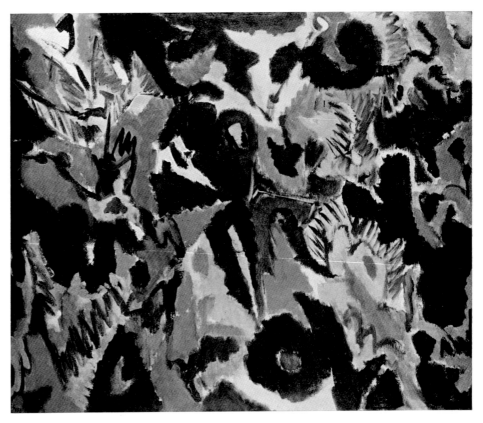

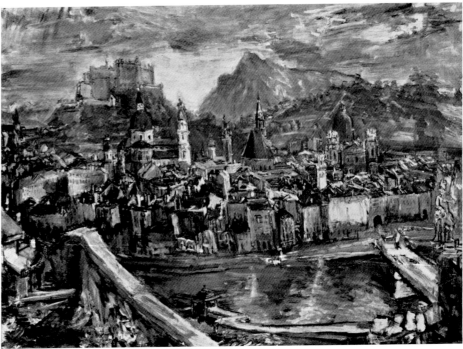

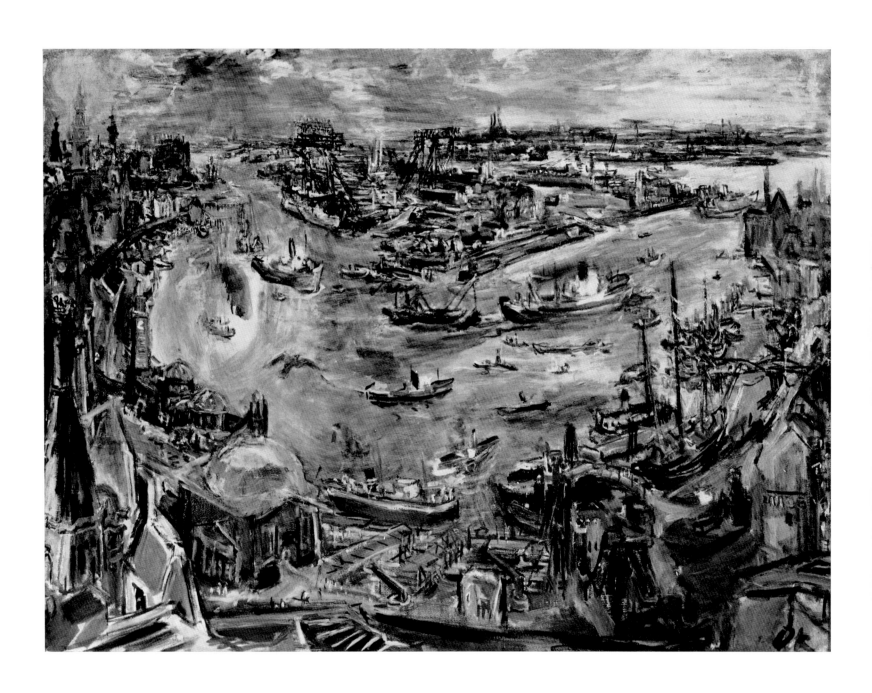

235. FRANCIS BACON: *Study of a dog*, 1952. Oil on canvas, 198 × 137 cm. London, Tate Gallery.

Bacon has painted few landscapes, being mainly concerned with the intricacies of human psychology. Here too the landscape and the huge flat area are only an artificial setting for the snarling beast, helpless in its frustrated rage.

236. GRAHAM SUTHERLAND: *Red landscape*, 1942. Oil on canvas, 66 × 96.8 cm. Southampton, Art Gallery.

In this amazing landscape Sutherland gives surrealistic importance to what may seem minor or insignificant aspects of nature. The work is remarkable for the originality of its language and the sensitive emanations of a free, expansive imagination.

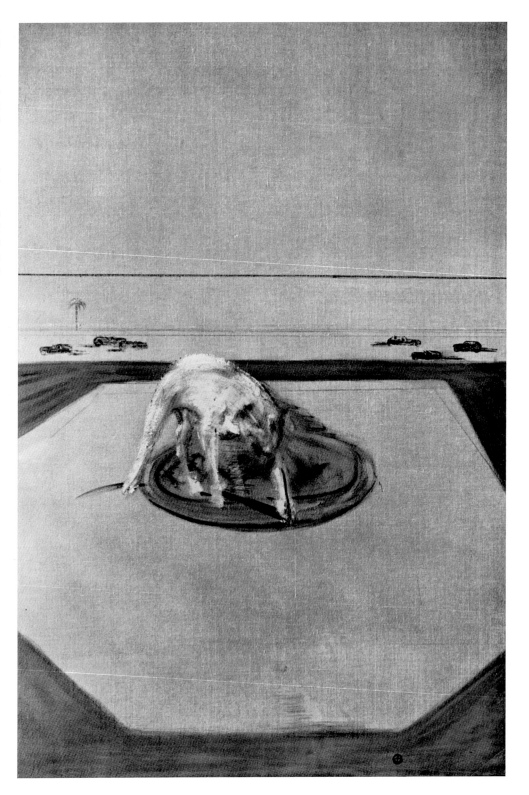

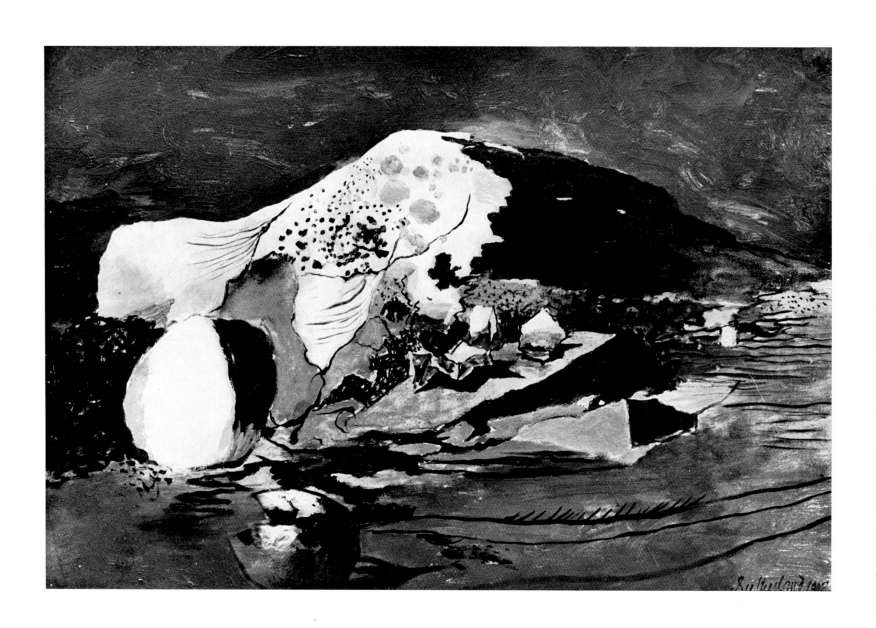

237. JEAN FAUTRIER: *Landscape*, 1957. Mixed technique on canvas, 50 × 65 cm. Brescia, Pinacoteca Tosio Martinengo (Cavellini Collection).

Landscape or fragment of matter, depending on how one chooses to regard it, this is a good example of the moods with which the artist was preoccupied for many years. His work has provoked discordant and hostile judgements, but can now be seen in a proper focus.

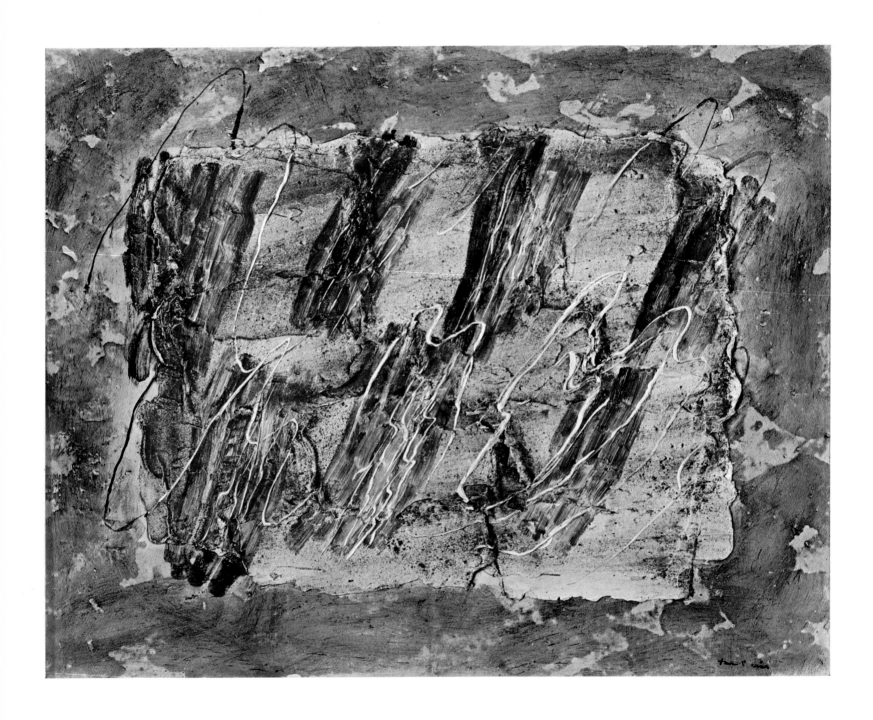

238. MARIA-ELENA VIEIRA DA SILVA: *Stone city*, 1954. Oil on canvas, 60 × 73 cm. Amsterdam, Municipal Museum.

Urban reality seen in an unreal perspective—an assemblage of structures and infrastructures, some enormous and others minute—is the usual basis of this artist's work. Her keen intelligence and natural compositional skill are matched by her delicate and appropriate use of colour.

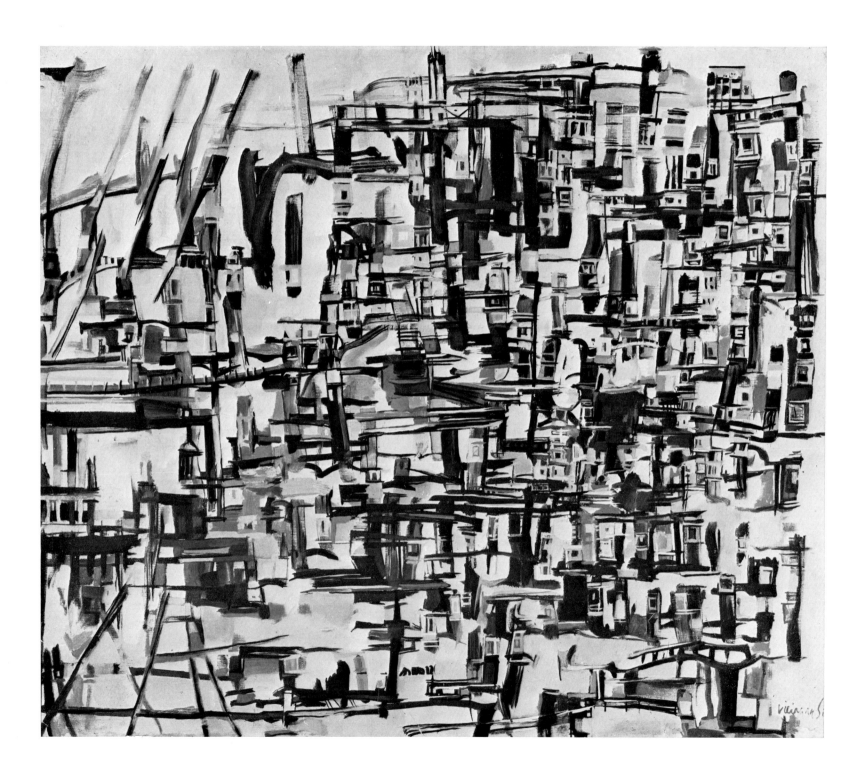

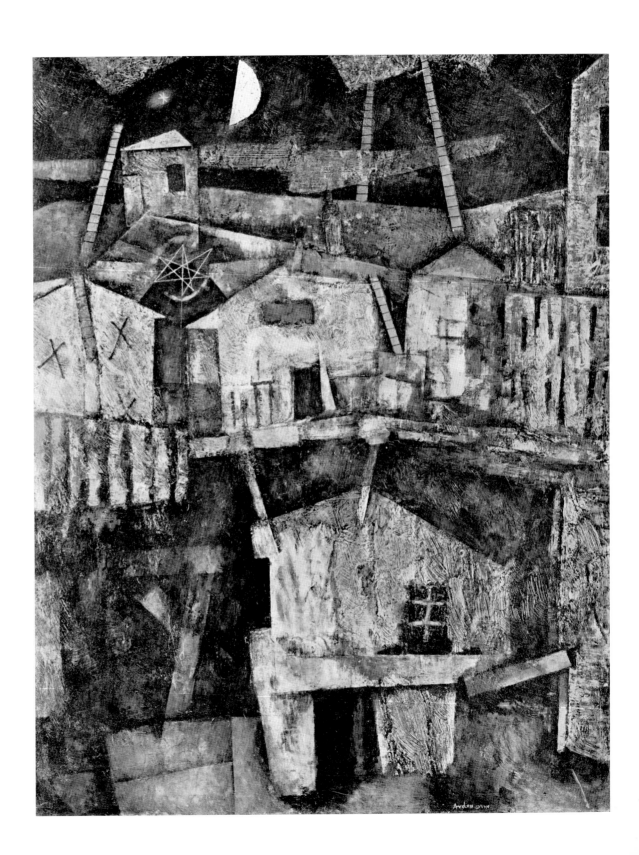

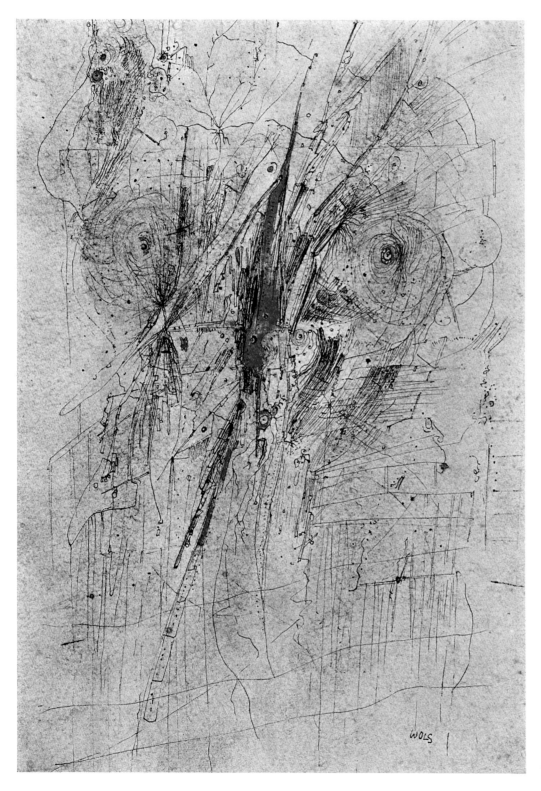

239. MORDECHAI ARDON: *The Maggid's house*, 1954. Oil on canvas, 147 × 114 cm. Brussels, Museum of Fine Arts.

A world half-way between reality and fable, depicted by an artist who is somewhat hard to place although of especial importance in regard to landscape. Complex in its artistic background, his work is marked by sentimental rhetoric and pathos to which there is little parallel among the painters of our century.

240. ALFRED OTTO WOLFGANG WOLS: *Composition*. Drawing and watercolour, 20 × 14 cm. Brescia, Pinacoteca Tosio Martinengo (Cavellini Collection).

Wols's thread-like compositions are none the less important for their small size. The mobility and expansive force, the acceleration and intensification of the design would be as significant in a microcosm as in a huge territory.

241. CORNEILLE (Cornelis van Beverloo): *Off the beaten track*, 1960. Oil on canvas, 195 × 130 cm. The Hague, Municipal Museum.

This imaginative work is exceptional for its wealth of colour and the liveliness of the motifs and episodes. Compared to other pictures by Corneille it shows control, balance and close attention to detail.

242. CORNEILLE (Cornelis van Beverloo): *The hostile city*, 1954. Oil on canvas, 91 × 128.5 cm. Eindhoven, Van Abbe Museum.

Here again the draughtsmanship is elaborate and subtle. This time it is not the country-side but an irregular arrangement of city blocks which has inspired the artist's labyrinthine tracery, extending slantwise across an undefined space.

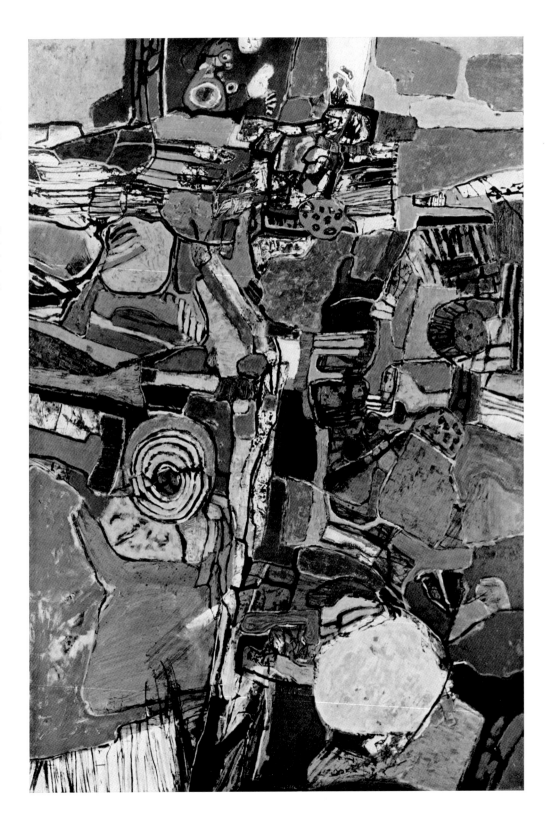

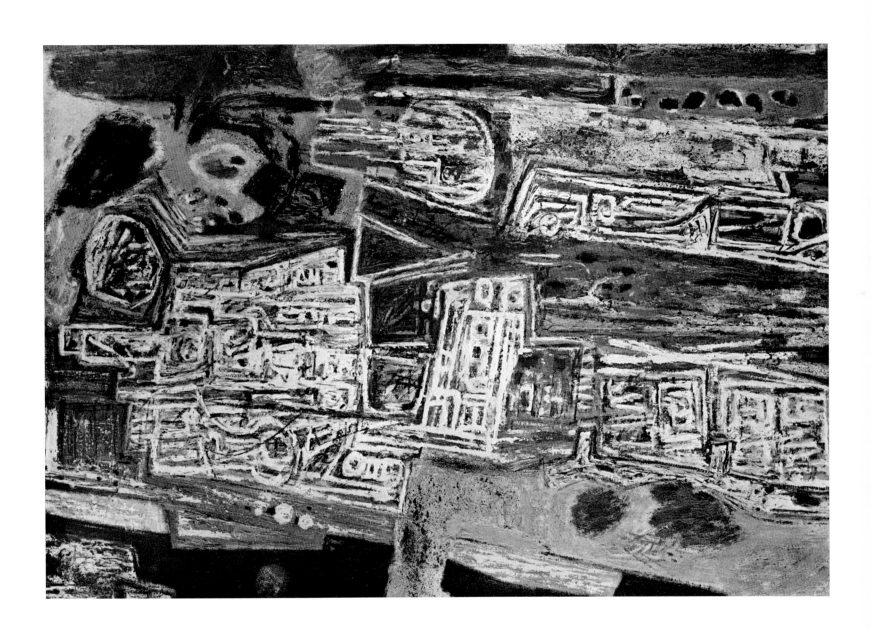

243. SAM FRANCIS: *Composition*, 1958. Coloured inks on paper mounted on canvas, 203 × 150 cm. Brescia, Pinacoteca Tosio Martinengo (Cavellini Collection).

This work belongs to the artist's most joyfully and successfully creative period, when after long and manifold experiments in Europe and Japan he discovered the function of colour 'as a concrete material'. According to his theory, a picture is the momentary materialization of the endless, irresistible process of the development of reality.

244. JEAN DUBUFFET: *Landscape with three trees*, 1959. Collage of leaves, 57 × 59 cm. Paris, Daniel Cordier Collection.

The artist's passion for different combinations of material substances, and his belief that when thus displayed they possess an extraordinary evocative power, is evinced in this landscape which might be a page from a herbarium. Dubuffet has a rare ability to discern the infinite animation of physical nature, its eternal cycle of dissolution and renewal, and the numberless organisms by which it is mysteriously populated.

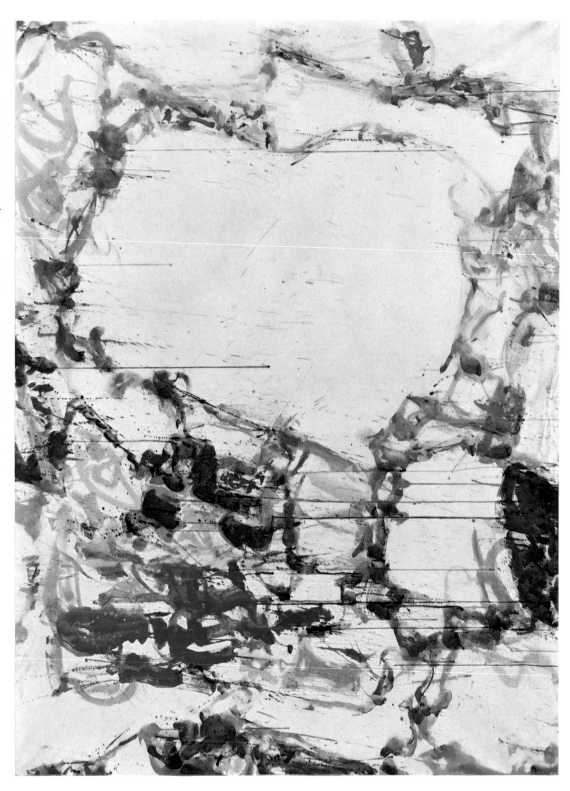

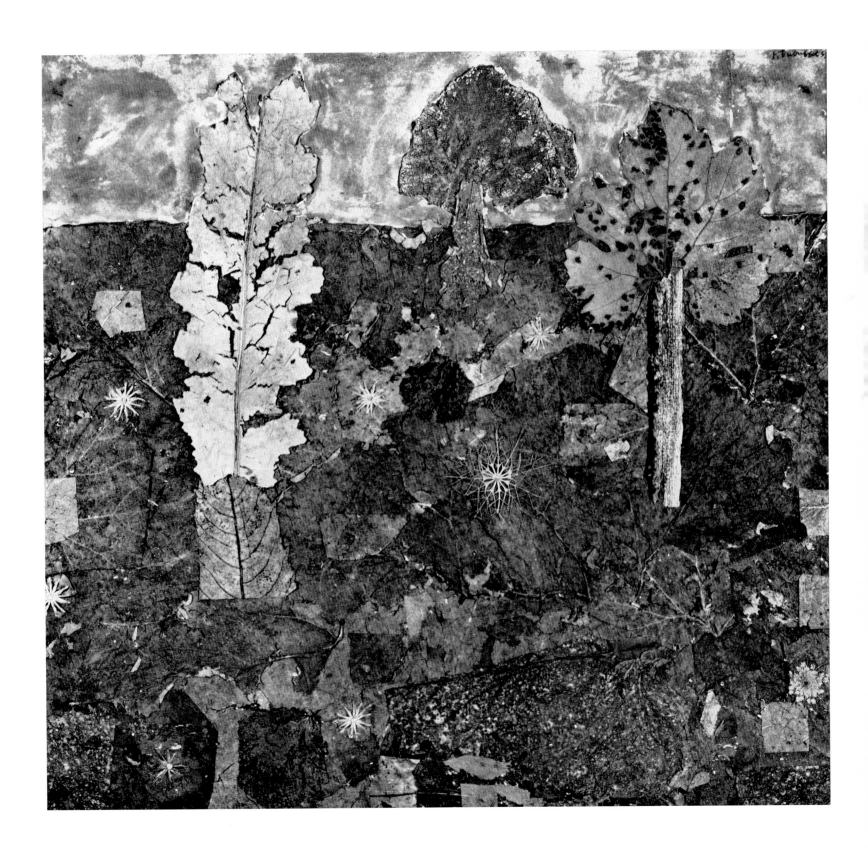

245. JEAN DUBUFFET: *Rue Brise-Elan*, 1963. Oil on canvas, 97 × 130 cm. Paris, Dubuffet Collection.

Other painters of the early 1900s, of diverse origin and culture, had been interested in anonymous graffiti such as we see here in the work of Dubuffet — a free, irregular, unprejudiced artist *par excellence*. It is not hard, despite the apparent infantilism of these forms, to discern the artist's ability and sureness of purpose.

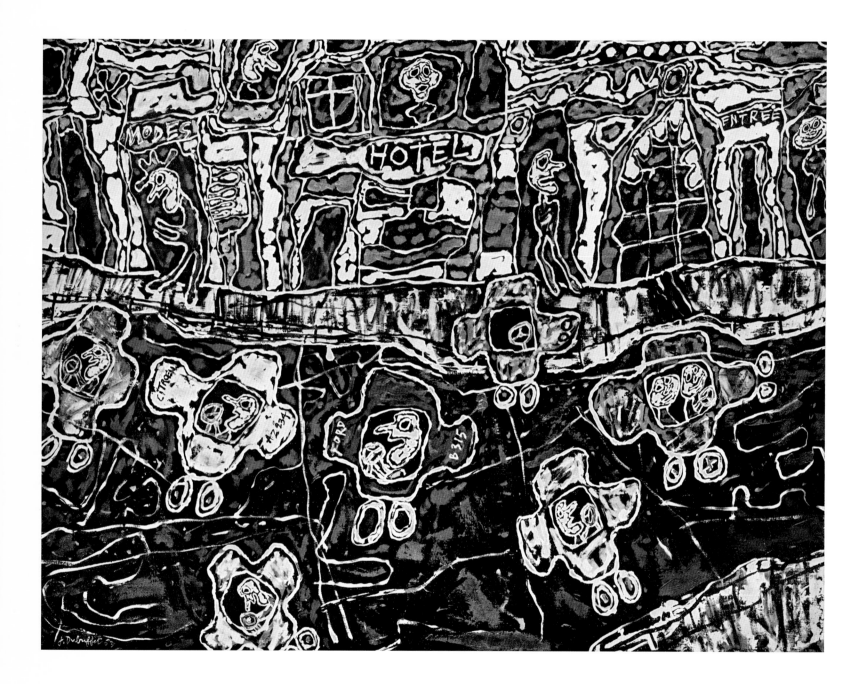

The biographical notes have been compiled by Franca Geri and translated by Barbara Thompson.

ARDON, MORDECHAI (Tuchow, Poland 1896)

Ardon studied in his country of origin and then went to the *Bauhaus* in Weimar, where he came under the influence of Paul Klee. In 1933 he emigrated to Palestine and shared in the struggle of the Jewish communities for the creation of the State of Israel. Ardon directed the Bezalel school of art in Jerusalem for many years and also became artistic adviser to the Ministry of Education. He lives in Paris and Jerusalem.

BACON, FRANCIS (Dublin 1910)

Francis Bacon is a self-taught artist whose work is free of all academicism. He took his lessons directly from the masters, especially from Velazquez, Van Gogh, and Picasso. Bacon began to draw and to paint watercolours at the age of seventeen, but it was not until several years later that he took up oil-painting. In 1930 he organized a small show in his London studio and in 1933 took part in an exhibition held in the Mayor Gallery. The following year he showed his work in the basement of Sunderland House in Curzon Street. Disappointed at his repeated lack of success, Bacon then gave up painting for almost ten years. In 1945 however, he won immediate recognition with three pictures shown in the Lefèvre Gallery: *Three studies for figures at the base of a crucifixion*, *Figure in a Landscape*, and *Figure study*, also known as the *Magdalene*. From then on Bacon's work began to be appreciated not only by the critics but by a growing section of the public. In 1951 he produced the portraits of *Pope Innocent X* after Velazquez and in 1952 the *Studies for a dog*. He had his first one-man exhibition in New York in 1953.
Unfortunately, Bacon's acute self-criticism, often provoking iconoclastic outbursts, has made it impossible to give an exhaustive account of his achievement, particularly during the early period. A retrospective exhibition held at the Tate Gallery in 1962 acclaimed him as one of the most significant painters of our time.

BALLA, GIACOMO (Turin 1871 – Rome 1957)

Balla studied at the Albertina Academy in Turin and worked in the painter Bernardi's studio.
In 1893 he moved to Rome and at the turn of the century went to Paris.
Most of the pictures he painted during his stay in Paris have been destroyed.
On his return to Rome in 1901 Balla moved into an old eighteenth-century monastery with his mother. He painted a portrait of his mother that year and in 1902 showed a picture called *In the mirror* at the Mostra degli Amatori e dei Cultori (Art Lovers Exhibition). *The Proprietor*, which he showed in the same exhibition the following year, aroused violent reactions.
The support of Marcucci and Gambellotti and the friendship of Boccioni and Severini drew Balla from his isolation and he daily became more popular and more in demand with Roman society.
The large polyptych *The living*, shown in the LXXIX (79th) Roman Fine Arts Exhibition, was painted in 1909 and the triptych *Affections* in 1910. Also in 1910, Balla signed the Futurist Manifesto with Boccioni, Carrà, Severini, and Russolo.
Balla's patriotic and interventionist pictures painted at the outbreak of the First World War, including *Interventionist demonstration*, *Forms shout*, and *Long Live Italy*, were in harsh

brilliant colours. In 1920, however, he underwent a new metamorphosis with such psychological works as *Sincere and false* and *Pessimism and optimism*.
In 1930 he broke away from Futurism altogether to return to figurative art.

BAZAINE, JEAN (Paris 1904)

After studying sculpture with Landowski, Bazaine turned to painting in 1924. In 1930 he had his first exhibition at the Galerie Jeanne Castel in Paris and continued to show there regularly until the end of the Second World War. He also showed at the Galerie Van Leer and, at Gromaire's invitation, took part in the Art Indépendant Maîtres d'Aujourd'hui exhibition held in the Petit Palais. During this period he became acquainted with Villon.
In 1938 Bazaine won the Blumenthal prize. He exhibited again in 1941 at the Galerie Jeanne Bucher and from 1942–8 showed regularly at the Galerie Louis Carré. In 1948 he published his *Notes sur la peinture d'aujourd'hui* (*Notes on painting today*) and in the same year completed the designs he had been working on since 1943 for the stained-glass windows of the church in Assy. In 1949 he showed twenty-three pictures, painted in 1944, at the Galerie Maeght.
In 1951 Bazaine designed a mosaic for the church in Audincourt and the settings and costumes for the Jean Dasté theatre in Saint-Etienne. From 1952–8 he travelled widely in Spain, America, and New Zealand. In 1960 he designed a mosaic for the UNESCO building in Paris.
In the course of 1963 retrospective exhibitions of Bazaine's work were held at the Kestner Gesellschaft in Hanover, the Kunsthaus in Zürich, and the Kunstnernes in Oslo.
In 1964 he completed the illustrations for *Entre savoir et croire* (*Between Knowing and Believing*) by Pierre Lecomte de Nouy.

BECKMANN, MAX (Leipzig 1884 – Brooklyn 1950)

From 1899–1903 Beckmann studied under Frithjof Smith at the Weimar Academy.
In 1904 he moved to Berlin and joined the Berlin *Sezession*, remaining with the group until 1911.
In 1906 he was awarded the Rome Prize. He also visited Florence and Paris during this period.
Beckmann enlisted in the Medical Corps at the outbreak of the war. He was deeply affected by the horror of his war experiences and painted a series of pictures of sick people crouching in fear and of women in anguish. In 1915 he became a teacher at the school of art in Frankfurt am Main. With the advent of Nazism in 1933, however, he lost his post and was obliged to move first to Berlin and then to Amsterdam, where he remained until 1947.
In the years immediately following the war, Beckmann was appointed to the School of Fine Arts in Washington and in 1949 to the art school attached to the Brooklyn Museum.
In his later years he painted deeply symbolic pictures such as *The caravan* and *The departure* (1932–5), *Blind fly*, and *The Argonauts* (1949–50).
In 1950 Beckmann won the Carnegie Prize and the prize for painting at the Venice Biennale.

BIROLLI, RENATO (Verona 1905 – Milan 1959)

Birolli first studied at the Cignaroli Academy in Verona.
In 1926 he moved to Milan and within a very short time became one of the leading figures in the new artistic revival. It was during this period that he painted his first important pictures: *Red taxi*, *The knight's dream*, *Polo players*, and the various *Gynaecei* (1932–3).
In 1936 Birolli visited Paris for the first time and came into contact with the different *avant-garde* movements. He took part in the activities of the *Corrente* group in 1938, and in 1944 began work on the Eighty-six Drawings of the Resistance, documenting the horrors of the war.
In 1946 Birolli and a group of leading artists founded the New Italian Art Secession which later became known as the *Fronte Nuovo delle Arti* (New Art Front).
He spent 1946–7 in Paris and in Brittany, where he painted landscapes. In 1950 he joined

the *Gruppo degli Otto* (The Eight). Between 1950 and 1958 Birolli spent long periods in Fossa Sepore, Porto Bruso, Bocca di Magra, and Cinque Terre. In 1957–8 he went to Antwerp for a few months and then to New York for his one-man exhibition at the Catherine Viviano Gallery, presented by his great friend and admirer, Lionello Venturi.

BOCCIONI, UMBERTO (Reggio Calabria 1882 – Verona 1916)

Boccioni frequented Giacomo Balla's studio from 1898–1902 at the same time as Severini. In August 1906, after a brief visit to Paris, he went to Russia and thence to Milan as the city which best fulfilled his yearnings for dynamism. He established contact with Marinetti and in 1910 signed the Futurist Manifesto along with Balla, Russolo, Severini, and Carrà. It was at about this time that Boccioni produced his most disconcerting series of Futurist paintings: *The rising city*, *Moods*, and *Brawl in the Gallery*.
For Boccioni 1912 was a year of intense activity. He went to all the Futurist meetings, organized exhibitions in the different European capitals, and in October showed his first sculptures at the Salon d'Automne in Paris. They were entitled *Dynamism of a human body*, *Dynamism of a cyclist*, and *Figure in motion*. Boccioni's express aims were to render every possible kind of movement in painting or sculpture.
His later period, after the interventionist campaign, was characterized by a return to Cézanne with paintings such as the *Portrait of Busoni* in 1916.
Boccioni enlisted as a volunteer in the First World War and died after being thrown from a horse near Verona in 1916.

BOMBOIS, CAMILLE (Vuarey-les-Laumes 1883–1966)

Camille Bombois was the son of a river boatman and spent most of his childhood on his father's boat. At the age of twelve, after a brief period of schooling, Bombois was taken on as an apprentice farm-hand in Migennes.
At sixteen he began to draw pictures of his life as a cowherd and labourer in the fields. He was a sturdy and pugnacious boy and would often fight with his friends in the village square. When he was elected regional wrestling champion he indulged in trials of strength with circus athletes and eventually joined Lucien Gay's circus. He remained with the troupe for several years before transferring to the Minard Caron Circus.
His favourite subjects were studies of prize-fighters and riding-masters, and scenes of country life. Bombois had always longed to see Paris so one day he set out for the capital on foot. In Paris he worked as a road-mender for a time and then as a navvy on the city building-sites. Finally he found night work at a printer's and stayed for seven years, painting during the daytime. In 1922 Bombois's work came to the notice of the public and began to be appreciated in France and abroad.

BONICHI, GINO (SCIPIONE) (Macerata 1904 – Arco 1933)

Bonichi moved to Rome with his family in 1909. At first he devoted a great deal of his time to sport but he was obliged to give it up completely after an attack of pleurisy permanently injured his health. He spent some time in a sanatorium and gradually developed an interest in art. He attended the Free Nude School at the Academy in Rome, visited museums and monuments, and struck up an acquaintance with various writers and artists, but above all with Mafai.
Bonichi had an intensely creative period between 1929 and 1930 and produced some of his best work: *The octopus*, *The half-caste woman*, *The Catholic Prince*, *Portrait of the Cardinal-Deacon*, *Man turning*, *The Roman courtesan*, and a large number of drawings.
In 1920 he began to publish drawings in *Italia letteraria*. By the spring of 1931, however, Bonichi's health had grown much worse and he was forced to go into the St Pancras Sanatorium in Arco in the province of Trento for treatment. From then on increasingly frequent periods in nursing-homes made it almost impossible for him to continue his painting. After returning to Rome in the autumn of 1932, he tried a new treatment in the Valtellina. He died in Arco in 1933.

BONNARD, PIERRE (Fontenay-aux-Roses 1867 – Le Cannet 1947)

Bonnard spent his childhood in Fontenay and in the Dauphiné province. He became a law-student in Paris in 1887 but took up painting at the same time.
At first he attended courses at the Ecole des Beaux-Arts, then he went to the Julian Academy, where he met Sérusier, Denis, Ibel, Ranson, Vallotton, Vuillard, and Roussel. It was with these artists that he helped to form the group called the *Nabis*. Bonnard's painting after the discovery of Gauguin and Japanese art shows that he had evolved a stylistic solution of his own from the confrontation between neo-traditionalist theories and the 'modernism' of Art Nouveau. The Bonnard of the posters (which profoundly influenced Toulouse-Lautrec), the gardens, the interiors, and the street scenes is the human comedy of Degas, Monet, and Renoir filtered through a symbolist vision of form.
When Thadée Natanson, Bonnard's friend, asked for a poster for the *Revue Blanche*, the painter was able to establish important contacts with the contributors, Octave Mirbeau, Henri de Régnier, Jules Renard, Tristan Bernard, and Félix Fénéon.
In 1896 Bonnard had his first one-man exhibition, collaborated with the Théâtre des Pantins (Puppet Theatre), and designed the settings for Alfred Jarry's *Ubu-Roi*.
In 1900 the publisher Vollard commissioned him to illustrate his editions of *Daphnis et Chloë*, Verlaine's *Parallèlement*, the *Histoires Naturelles* by Jules Renard, and *628-E8* by Mirbeau.
Bonnard took part in the Vienna *Sezession* in 1903 and in the Munich *Sezession* in 1908. On his return to France he began work on the three large decorative panels for the Salon d'Automne and finished them the following year. After a period of inactivity due to the war, he produced a large number of drawings, lithographs and paintings.
Numerous exhibitions of his work have been held in Europe and America.

BRAQUE, GEORGES (Argenteuil 1882 – Paris 1963)

Braque was born in Argenteuil but his family soon moved to Le Havre, which was where he spent his childhood and adolescence. He began to study painting at night school at the Ecole Régionale des Beaux-Arts and also worked as a decorator's apprentice. In 1900 he went to Paris to take courses in mural decoration, but gave this up in 1902 when he enrolled in the Humbert Academy. Here he met Francis Picabia and Marie Laurencin. He went on to the Ecole des Beaux-Arts and decided to devote himself exclusively to painting. The Fauve pictures in the Salon des Indépendants in 1905 were a revelation for Braque. The following year he showed some of his own work in the Salon des Indépendants and began to adopt Fauve techniques. After a second showing with the Indépendants in 1907, he met Matisse, Derain, and Vlaminck. In the summer of that year he went to La Ciotat with Friesz.
On his return to Paris he met Apollinaire who introduced him to Picasso, engaged at the time on the *Demoiselles d'Avignon*. At this point Braque broke away from Fauvism altogether and embarked upon the 'Cubist adventure'.
His first Cubist paintings were rejected by the Salon d'Automne, but he was able to show them at a one-man exhibition organized for him by Kahnweiler.
He spent the summer of 1909 in La Roche-Guyon with Derain and continued to keep in touch with Picasso during the following years while they worked their way towards 'analytical Cubism'. Braque was closest to Picasso in 1911 when he began to introduce alphabetical characters, sand, and imitations of marble and wood into his paintings.
From 1912–13 Braque painted in Sorgues, later returning there on several occasions with Picasso. He was called up at the outbreak of the First World War but a severe wound in Artois in 1915 obliged him to undergo an operation for a trepanning of the skull. After a long period of convalescence Braque took up painting again at Sorgues in 1917, bearing in mind the recent experiments of Juan Gris.
In 1920 Braque made his first sculpture and in 1922 designed the costumes and the settings for the ballets of Diaghilev and the Comte de Beaumont. In 1931 he did a series of engravings to illustrate Vollard's edition of the *Theogony* by Hesiod.
In 1932 several important retrospective exhibitions of his work were held all over Europe (Basle, London, and Paris) and in the United States.
Braque remained in Paris for most of the Second World War but in 1945 a serious illness forced him to stop painting for a while. In 1947 he began to exhibit his work regularly in the Galerie Maeght. In 1948 he was awarded the First Prize at the Venice Biennale. His decoration of the ceiling of the Henri II Cabinet in the Louvre dates from 1952–3.

BRYEN, CAMILLE (Nantes 1907)

Bryen moved to Paris in 1926 and participated in various *avant-garde* art movements. In 1932 he published *Expériences* to show his experimental drawings and *collages*. In 1934 he exhibited his spontaneous drawings and mechanical objects, and in 1936 brought out *L'aventure des objets* in book form. This was the lecture he had given at the Sorbonne on his recent research in the plastic arts. Bryen left Paris for Marseilles and Lyons during the war.
In the years immediately following the war he came to be regarded as one of the principal founders of lyrical abstract art and as the father of *tachisme*.
He has taken part in several exhibitions in Europe.

CAMOIN, CHARLES (Marseilles 1879-1965)

Camoin's father sent him to study in Paris in 1896. He enrolled in the Ecole des Beaux-Arts and also attended courses in Gustave Moreau's studio along with Albert Marquet. He and Marquet went to the Louvre and drew from life in the streets or at the music-hall. From 1899–1902 Camoin did his military service in Arles, Avignon, and Aix-en-Provence, where he became closely acquainted with Cézanne.
He exhibited in the Salon des Indépendants in 1903 and showed regularly in the Salon d'Automne until 1908. He also took part in the famous Salon d'Automne of 1905 which officially recognized the Fauves although he only partly adhered to their ideals. From 1912–13 he visited Morocco with Matisse. In 1914 when war broke out he was sent to the camouflage sector, where he met Renoir.
Renoir exerted a great influence on Camoin and the paintings of the post-war period in particular recall both Renoir and Bonnard.
Camoin also lived in Paris and Saint-Tropez painting mainly landscapes and still-lifes.

CAMPENDONK, HEINRICH (Krefeld 1889 – Amsterdam 1957)

Campendonk began to paint from life at an early age while he was studying with Jan Thorn Prikker. His master also helped him to appreciate the work of Giotto, Fra Angelico, and Van Gogh.
When he left the studio, he began to paint on his own in the countryside near Krefeld. Soon, however, economic reasons made it necessary for him to move to Osnabruck where he became the assistant of a historical painter who was decorating the cathedral.
The following year he returned to Krefeld and resumed his painting, once more in complete solitude.
In 1912 Kandinsky and Marc noticed the quality of Campendonk's work and persuaded him to move to Sindelsdorf in Upper Bavaria and to take part in the exhibitions organized by the *Blaue Reiter* group in Munich.
In 1926 Campendonk was appointed to the Düsseldorf Academy. With the rise of Nazism in 1933, however, he lost his post and his work was banned.
Eighty-seven of his pictures were removed from German museums. It was during this period that he was awarded the Grand Prix at the Universal Exhibition in Paris.
In 1937 Campendonk began to design stained-glass and he also painted a very large picture for the liner, the *Nieuw Amsterdam*.
During the Second World War Campendonk took refuge in Belgium and later in Amsterdam, where he was offered the chair of painting at the Academy of Figurative Arts.

CAMPIGLI, MASSIMO (Florence 1895)

Campigli moved to Milan with his family in 1909 and began to study literature.
He enlisted at the outbreak of the First World War but was soon taken prisoner in Hungary. Eventually he succeeded in escaping to Russia.

He went to Paris in 1919 as special correspondent for the *Corriere della Sera*, and by night worked as a journalist leaving the day free for painting.

On his return to Rome in 1928 Campigli was deeply affected by a visit to the Etruscan museum in the Villa Giulia. In 1929 he exhibited for the first time in Paris with immediate success. In 1933 he collaborated with Sironi, Funi, and De Chirico on a large mural painting for the Palazzo dell'Arte in Milan, but this was destroyed later. The following year Campigli painted the *Fishermen's wives* in Milan and a series of *Bathers*, which were greatly admired when he showed them at the Quadriennale in Rome. In 1935 he went to New York and painted a large number of portraits. From 1937–8 he designed two large frescoes: *The builders*, for the League of Nations building in Geneva, and *Thou shalt not kill*, for the Palazzo di Giustizia (Law-Courts) in Milan.

From 1939–40 he painted a fresco for the Palazzo del Liviano in Padua, and then spent the rest of the war period in Milan.

In recent years Campigli has worked on the theme of the doll-like woman, inspired by Etruscan art, both in his pictures and in a large number of lithographs.

CARRÀ, CARLO (Quargnento-Alessandria 1881 – Milan 1966)

After losing his mother at an early age, Carrà began work at a decorator's in Valenza. In 1895 he became an apprentice bricklayer in Milan but was also able to attend the Brera school of art. In 1900 he paid his first visit to Paris, staying there several months admiring the painting of Courbet, Delacroix, Géricault, Monet, Manet, Cézanne, and Gauguin. In the spring of that year he went to London where he developed a passion for politics and associated with several anarchist and libertarian groups. On his return to Milan he resumed his work as a decorator. He also made several visits to Switzerland.

In 1904 Carrà was deeply affected by the funeral of the anarchist, Galli, and the experience was to have an influence upon his development. In 1905 he won two prizes from the High School of Applied Arts and the following year enrolled in the Brera Academy to study under Cesare Tallone.

In February 1910 he signed the Futurist Manifesto with Boccioni, Russolo, Balla, and Severini. Carrà's Futurist period was to be short-lived, however. A visit to Paris in 1911 which brought him into contact with Cubist painting soon spurred him on towards a more international conception of art. The meetings with Picasso, Apollinaire, and Braque, his study of Courbet and Cézanne, and his friendship with Soffici and the *La Voce* group all combined to disenchant him with Futurism. He set out his reasons in the essays entitled *On Giotto* and *Giotto the Builder*. In 1916 Carrà met Giorgio De Chirico in Ferrara and in the same year painted his *Antigrazioso*. His best metaphysical pictures were painted in the course of 1917 .

On his return to Milan in 1919 Carrà came into contact with such men as Cardarelli, Bontempelli, Ungaretti, and Medardo Rosso. In 1922 he became the art critic for the daily newspaper, the *Ambrosiano*. Carrà's art took a new turning in 1923 with his landscape painting and his wholehearted adherence to the *Novecento* (Twentieth-Century) group. In 1944 he was appointed to the chair of painting at the Brera Academy.

CASSINARI, BRUNO (Piacenza 1912)

Cassinari began to study painting in 1926 at the Art School in Piacenza. In 1929 he moved to Milan and enrolled in the *Umanitaria*, also attending evening classes at the Brera School of Art and the Castello school. In 1934 he was admitted to the Brera Academy where in 1938 he took his diploma. He frequented art circles in Milan and made many friends among the young *avant-garde* artists. From 1938–43 he belonged to the anti-*novecento* group called *Corrente* with whom he exhibited his pictures for the first time in 1940, presented by Elio Vittorini.

In 1942 he painted the *Pietà*.

After the war Cassinari painted in the countryside near Gropparello, working with his friend Morlotti of whom he did a fine portrait. Not long afterwards Cassinari joined the *Nuova Secessione* (New Secession) which Birolli, Santomaso, Vedova, and several others had founded in Venice.

He next visited Paris and Antibes, and met Eluard, Chagall, and Picasso who invited him to show his pictures in one of the rooms in the Grimaldi Museum.

Cassinari has taken part in a number of collective shows and has had several one-man exhibitions. In 1945 he won the Fra' Galgario Prize and the Pro Fondo Matteotti Prize, and in 1952 was awarded the Grand Prize at the Venice Biennale. In 1954 he began to exhibit in the Salon de Mai in Paris. In 1964 Cassinari illustrated Cappelli's edition of *Per via di cavalli* (By Way of Horses) by Vittorio Alfieri and Horace's *Odes* in 1966. In 1969 he illustrated Petronius's *Satyricon*.

In 1970 he was awarded the international prize for graphic arts in Florence.

CHAGALL, MARC (Vitebsk 1887)

After studying for several years at Léon Bakst's school in St Petersburg and beginning a few early experiments in painting, Chagall married Bella Rosenfeld and moved to Paris in 1910. He soon became friendly with Modigliani, Soutine, and Léger and came into contact with the *avant-garde* poets, Guillaume Apollinaire, Cendrars, and Max Jacob. The large compositions: *I and my village, Self-portrait with seven fingers* and *Homage to Apollinaire* belong to this period in Paris as do the pictures exhibited in the Salon des Indépendants and the Salon d'Automne. After another exhibition in the Sturm Gallery in Berlin in 1914 Chagall returned to Russia to take up a post at the Academy. He also began to design costumes and settings for the Jewish Theatre in Moscow. He returned to Berlin in 1922 and learned copper-engraving from Hermann Struck. The following year in Paris the art dealer, Vollard, commissioned him to design the lithographs for Gogol's *Dead Souls* (1924–5), the *Fables* of La Fontaine (1926–7), and the Bible. During this period Chagall visited Palestine (1931), Holland (1932), Spain (1934), Poland (1935), and Italy (1937). In 1939 he won the Carnegie Prize.

During the Second World War, Chagall was obliged to go to America. He worked mainly at lithographs, but after his wife's death in 1944 he painted a series of portraits in her memory. Chagall returned to France in 1948. He stayed in Paris at first and then moved to Vence on the Côte d'Azur. His later works include a series of paintings of Paris, the designs for the stained-glass windows in Metz cathedral, the ceiling of the Paris Opera House and the stained-glass windows for the hospital in Jerusalem.

CORINTH, LOVIS (Tapiau, Prussia 1859 – Zandvoort, Holland 1925)

Corinth studied at the Königsberg Academy (1876–80) and in Munich (1880–84), and in 1884 went to Paris to follow courses with Bourguereau. On his return, he stayed in Königsberg until 1891 and then moved to Munich. In 1902 he went to Berlin to work with Liebermann and Slevogt. Apart from the obvious influence of Rubens and Hals, Corinth's pictures from 1880–90 show the impact of Impressionism in their sustained psychological tension, and at the same time herald the Expressionists.

In 1911 a profound spiritual crisis caused Corinth to change his style. His later work consists mainly of still-lifes, landscapes, and compelling portraits reminiscent of Kokoschka and the *Blaue Reiter* group.

CORNEILLE (CORNELIS VAN BEVERLOO) (Liège 1922)

Corneille, who was of Dutch origin, studied fitfully at the Fine Arts Academy in Amsterdam and held his first one-man exhibition in 1946. The following year he became a co-founder of the Dutch experimental group called *Reflex* and in 1948 was a member and founder of *Cobra*, an international group in Paris.

From 1947 onwards he showed in several exhibitions: the 'Europa Isbola' in Budapest (1947), the Martinet Gallery in Amsterdam (1941 and 1954), the Venice Biennale and the São Paulo Biennale (1954), the Museum of Modern Art in Amsterdam, and the Palais des Beaux-Arts in Brussels (1956). He was awarded the Guggenheim prize in 1956.

From 1957–8 Corneille visited Africa, South America, the West Indies, and lastly New York.

In 1959 he took part in the São Paulo Biennale. He lives in Paris.

CREMONINI, LEONARDO (Bologna 1925)

Cremonini first studied at the Fine Arts Academy in Bologna and afterwards at the Brera Academy in Milan. He was granted the Angelo Venturoli scholarship in 1942 which lasted until he finished his course in 1949.
Cremonini went to Paris in 1951 on another scholarship and decided to settle there. He also spent a few brief periods at Forio d'Ischia, and in Provence, Brittany, and Panarea. In 1951 he had his first one-man exhibition at the Italian Art Centre.
The following year marked the beginning of critical appreciation of his painting in America after an exhibition held at the Catherine Viviano Gallery in New York.
The city of Bologna recently organized a large retrospective exhibition documenting Cremonini's entire production to date.

DALI, SALVADOR (Figueras 1904)

Salvador Dali went to the Fine Arts Academy in Madrid after first studying in Figueras and began work under the elderly master, Moreno Carbonero.
He struck up a close friendship with Garcia Lorca and developed a passion for philosophy, psychology, and *avant-garde* art, including Cubism, Futurism, and metaphysical painting.
He had his first exhibition at the Dalman gallery in 1925 and the following year showed a number of pictures with Ferrant, Palencia, and Borès in Madrid.
After a brief attempt to reconcile the experiments of De Chirico, Gris, and Carrà with the techniques of the past, Dali eventually found his own style in metaphysical painting.
He went to Paris by taxi to visit Versailles and the Musée Grévin, and to meet Picasso personally. The impact of Surrealism inspired him to paint *Blood is sweeter than honey* and in 1928 he published the Groc manifesto. He encouraged many of the Paris Surrealists to go to Cadaqués and organized a triumphal exhibition at the Goemans gallery. The new creative method he elaborated was based on the power to interpret visionary experiences and memories and their deliberate psychological deformations in an original fashion. In 1929 he made the film, *Un chien andalou* (*The Andalusian Dog*), with Luis Buñuel and in 1931 collaborated on *L'Age d'Or* (*The Golden Age*). In 1934 he illustrated Lautréamont's *Chants de Maldoror*. From 1937–8 Dali came more and more under the influence of the Italian Renaissance as a prelude to the return to classicism, which was violently criticized by his friends and by Breton. By 1940 his fame was enormous, particularly in America where his art also influenced fashion and the world of advertising. During this period he painted several sacred pictures.
On his return to Spain he moved closer to the Baroque traditions which were more in harmony with his personality.

DAVIS, STUART (Philadelphia 1894 – New York 1964)

Davis studied under Robert Henri in New York from 1910–13. He took part in the Armory Show in 1913 and from 1913–16 designed illustrations and covers for *The Masses*. In 1918 he joined the army as a cartographer and in the same year visited Havana. In 1919 he began to turn to non-objective art.
Davis spent the summer of 1923 in New Mexico and from 1928–9 lived in Paris.
On his return to the United States he taught at the Art Students League. In 1933 he collaborated in the WPA. He was director of the Artists Congress from 1934–9 and published *Art Front*. In 1940 he began to teach at the New School of Social Research.
A large retrospective exhibition of his work was held in the Museum of Modern Art in New York in 1945.

DE CHIRICO, GIORGIO (Volo-Tessaglia 1888)

De Chirico spent his childhood in Athens, revealing a talent for painting at a very early age. He began to study drawing under Mavrudis and enrolled in the Fine Arts Academy. When

his father died, however, De Chirico left Greece to settle in Germany with his mother and brother.

During the period in Bavaria he attended the Fine Arts Academy and became a great admirer of Böcklin. He also became extremely interested in Schopenhauer, Weininger, and Nietszche. After he had returned to Italy, his delicate health often kept him in bed for long periods and he divided his time between painting pictures in a Böcklinian vein and reading his favourite philosophers.

De Chirico's artistic career did not begin in earnest until he moved to Paris with his family in 1914. During these years he frequented the same circles as Brancusi, Max Jacob, Marie Laurencin, Derain, and many others who gathered round the prestigious figure of Apollinaire. Apollinaire encouraged De Chirico to take an interest in the Salon d'Automne and the revolutionary painting of Picasso and the Cubists. It was also on Apollinaire's advice that he decided to exhibit his own work for the first time in the Salon d'Automne. Soon De Chirico's metaphysical painting, which had seemed incomprehensible in Italy, began to be understood and appreciated in France. He also showed in the Salon des Indépendants. During the war he returned to Italy and continued his metaphysical experiments in Ferrara from 1915–18.

De Chirico spent the years immediately following the war in Rome visiting the museums, especially the Villa Borghese, and copying the old masters. In 1925 he paid another visit to Paris and showed his new more classical canvases at a one-man exhibition organized by Léonce Rosenberg. He also designed the settings for the ballet *Le Bal* (*The Ball*) performed in Monte Carlo and afterwards in Paris, and scenery for the Paris Opera House, the Berlin Opera House, and Covent Garden. In 1933 he returned to Italy and had various exhibitions in Milan and other cities. He designed the setting for *I Puritani* (*The Puritans*) by Bellini and a mural for the Triennale building which was later destroyed. In 1936 he went to New York for a large exhibition of his work. After that he went back to Paris and did not return to Italy until the end of the Second World War.

He has lived and worked in Rome ever since.

DE LA FRESNAYE, ROGER (Le Mans 1885 – Grasse 1925)

After a sound classical education, de la Fresnaye enrolled in the Julian Academy in 1903 and then went on to the Ecole des Beaux-Arts. In 1908 he studied at the Ranson Academy under Denis and Sérusier and was greatly influenced by their aesthetic theories. His first paintings are very reminiscent of the *Nabis*. The revelation of Cézanne, however, enabled him to overcome this tendency and to paint the series of *Landscapes* dating from 1910. In 1913 de la Fresnaye began to take an active part in Cubism.

He was the first to introduce the synthetic style aimed at eliminating all detail and superstructures, which had been foreshadowed in Gauguin.

The pictures painted during this period include: *Man seated* (1913), *The conquest of the air* (1913), *Married life* (1914), and the fine series of *Still-lifes*.

The outbreak of the war was to interrupt de la Fresnaye's experiments. He joined up as a volunteer but soon fell ill and had to be taken into hospital in Tours. In a state of total collapse with tuberculosis he was obliged to rest and retired to Grasse. During his last years he painted a few portraits of his friend, Campert, some watercolours, drawings, and gouaches.

DELAUNAY, ROBERT (Paris 1885 – Montpellier 1941)

Delaunay painted his first picture in 1904 under the influence of the Fauves.

In 1906 he did his military service as a librarian in Laon and began a series of studies of the cathedral, paying particular attention to the work of Cézanne, Braque, Picasso, and to Negro sculpture and Egyptian and Mesopotamian art.

He struck up a close friendship with Henri Rousseau.

In 1908 Delaunay painted his large studies of plants drawn from nature and his first *Eiffel Tower* which marked his definite departure from Fauvism.

The following year he painted the *Tower of Notre-Dame*, the series of *Saint Séverin*, and the *City*, all clearly illustrating his evolution towards Cubist art. At this time he married Sonia Uhde Terk who was also a painter and together they pursued their respective experiments.

Delaunay also made some important contacts among the painters belonging to the *Blaue Reiter* group and, at Kandinsky's invitation, took part in their first exhibition. His influence on all the representatives of this movement, particularly Macke, Marc, and Klee, was to be decisive. Delaunay also grew friendly with Apollinaire, Le Fauconnier, and Gleizes. When he returned to Laon in 1912 he did another series of the cathedral and painted the gigantic *City of Paris* for the Salon des Indépendants as a grand conclusion to his 'destructive period'. With the *Windows* his 'constructive period' began.

The new style Delaunay had created was called Orphism, a name invented by Apollinaire. He spent quite a long time in Spain and Portugal during the war and on his return to Paris resumed his favourite themes with a new series of the *Eiffel Tower* and the *Runners*. He also painted a large number of portraits at this time.

In 1925 Delaunay worked with Fernand Léger on the decoration of the French Embassy building for the National Exhibition of Decorative Arts. From 1930–35 he returned to the subject of *Disks*, which he had already toyed with in 1914, this time expanding it with *Coloured rhythms* and *Endless rhythms*.

His last work, carried out in collaboration with Gleizes, Lhote, and Villon was the triptych in the sculpture room in the Tuileries.

DE PISIS, FILIPPO (Ferrara 1896 – Milan 1956)

De Pisis' family name was Tibertelli, but he chose the pseudonym De Pisis when he embarked on his artistic career. When he took up drawing he had already begun to study literature and in 1916 published his *Canti della Croara* with a preface by Corrado Govoni. In the same year he enrolled as a student in the arts faculty of the University of Bologna. A meeting with Carrà, De Chirico, and Savinio in the hospital in Ferrara was to have a profound influence on his artistic development. After discovering metaphysical painting, De Pisis left Ferrara in 1920 for Rome and devoted himself to writing and painting. During this period he came into contact with the *Rondisti* (Cardarelli, Baldini, Barilli) and met Spadini. He also contributed to the review *Valori Plastici* (Plastic Values). In 1924 he painted a few more pictures in a metaphysical vein and in 1925 moved to Assisi to teach Latin in a grammar school. Two years later, however, he left for Paris where he remained for fifteen years apart from occasional visits to Italy during the summer.

In Paris De Pisis made the acquaintance of Soutine, Braque, Matisse, and Picasso. In 1926 he had his first one-man exhibition in Milan, presented by Carrà, and in the same year another one-man exhibition in Paris at the Sacre du Printemps, under the auspices of De Chirico. During the years 1930 to 1940 his work was particularly rich and interesting. He exhibited at the Zwemmer Gallery in London in 1935 and again in 1938. In 1939 he published his *Poems*. It was in 1943 that he finally moved to Venice and purchased the extravagant palace at San Barnabà. The next years produced still-lifes, interiors, figure-drawings, and a series of *vedute*.

He also wrote several books including *Prose and articles*, *The city of the hundred marvels*, and studies on French and Italian painters, both early and modern.

In 1948 De Pisis returned to Paris. The following year he went back to Italy, first to the Val d'Aosta and then to Bologna. By this time he had begun to show the first signs of the mental illness which was to destroy him seven years later.

In 1950 he stayed at the Villa Fiorita di Brugherio, where he painted the *Spider's webs*.

DERAIN, ANDRÉ (Chatou 1880 – Chambourcy 1954)

Derain attended the Ecole Sainte-Croix in Le Vésinet and the Lycée Chaptal in Paris. He took up painting in 1895 under Jacomin, a pupil of Cézanne.

In 1897 Derain met Vlaminck and invited him to share his studio in Chatou in 1899. He also became friendly with Matisse. During this period he painted a series of landscapes of Chatou, Saint Germain-en-Laye, and Carrières, and began to draw for the reviews *Le Rire* and *Le Sourire* under the pseudonym of Bouzi. It was due to Vlaminck that he began to appreciate Negro art. After his military service, Derain enrolled in the Julian Academy in 1904 and made friends with Apollinaire. Matisse encouraged him to exhibit for the first time in the Salon des Indépendants in 1905. That year he spent the summer with Matisse at Collioure, l'Estaque, and Marseilles.

On his return to Paris he took part in the famous Fauves exhibition in the Salon d'Automne and after that showed regularly in the Salon des Indépendants, the Salon d'Automne, and the Galerie Berthe Weill. Both Vollard and Metthey commissioned him to design ceramics. On a visit to London Derain painted the famous *Views* of the Thames. In 1907 he signed a contract with Kahnweiler and took up sculpture in stone; he also painted the *Bathers*. At this point he destroyed a large part of his earlier work and drew closer to Cubism, becoming friendly with Picasso, Braque, and Van Dongen. From 1909-10 he painted in Montreuil and in Ville on the Somme. He also did the wood-cuts for Apollinaire's *Chanteur pourrissant*. In 1910 he spent the summer with Picasso at Cadaqués. On his return to Paris he exhibited in the Salon des Indépendants and in the Grafton Gallery in London. He designed illustrations for Reverdy, Max Jacob, and Apollinaire.

Immediately after the war Derain designed costumes and settings for the ballets of Diaghilev and illustrated some of the writings of Dalize and Vlaminck. During the summer of 1920 at Cahors he painted a series of portraits and nudes. When he returned to Paris he insisted on selling his production up to 1922 to Kahnweiler. In 1921 Derain visited Italy, staying in Rome and painting in Castelgandolfo. He also took the opportunity to study the Pompeii wall paintings. Back in France once more he devoted himself to portraiture for a time and then in 1924 painted *Pierrot and Harlequin*, a series of nudes, and some still-lifes.

Derain eventually retired to Chambourcy, and in his later works adopted a markedly realistic manner.

DE STAËL, NICOLAS (St Petersburg 1914 – Antibes 1955)

De Staël, the son of a cavalry general, was born in St Petersburg. In 1920 he moved to Brussels and began to study painting under Van Haelen at the Fine Arts Academy.

From 1930–34 he travelled all over Holland admiring the painting of Vermeer, Rembrandt, and Hals. On his return to Brussels in 1935 he began work as a painter and decorator. He visited Paris and Spain and between 1935 and 1937 went to Morocco, Algeria, and Italy. At the outbreak of the Second World War he joined the Foreign Legion in Tunisia, but was demobilized in 1940. De Staël then settled in Nice, painting his first abstract picture in 1942. In 1943 he returned to Paris and became friendly with Georges Braque and Lanskoy. He took part in the Exhibition of Abstract Painting at the Galerie l'Esquisse with Kandinsky, Magnelli, and Domela. In 1948 he was granted French citizenship. The following year he visited Amsterdam, The Hague, and Brussels. In 1950 he had an exhibition in New York and in 1951 he went to London. De Staël showed pictures at the São Paulo Biennale in 1953 and the Venice Biennale in 1954. His favourite spots for painting were Paris, the Channel coasts, and Antibes. He committed suicide in 1955.

DE WITT, ANTONIO (ANTONY) (Leghorn 1876 – Florence 1966)

De Witt was a friend of Fattori and the secretary of Giovanni Pascoli. He was an extremely cultured man with an insatiable passion for travelling. He went all over the world in the course of his life but one of his most important experiences was undoubtedly his stay in the Argentine. In 1907 he took up painting and engraving with tremendous enthusiasm. De Witt illustrated many of the classical writers (Dante, Tasso, and Ariosto) and published critical essays on the master-engravers.

DIX, OTTO (Unterhausen 1891)

Dix studied painting as an apprentice in Gera from 1905-9. In 1910 he enrolled in the School of Arts and Crafts in Dresden and began to paint landscapes and portraits. At the beginning of the First World War he was called up to serve on the Western front. The war experiences inspired his cycle of fifty etchings which made him famous. After the war Dix entered the Dresden Academy for four years, becoming very interested in Dadaism for a time and

especially in the art of Grosz. From 1922–5 he lived in Düsseldorf.

In 1926 Dix became a teacher at the Dresden Academy but lost his post with the rise of Nazism in 1933. In 1936 he moved to Hammehofen on Lake Constance and began some religious painting. In 1939 he was taken prisoner by the Gestapo.

In 1945 he was imprisoned in France for a brief period as a soldier in the territorial army.

In 1950 he became professor of painting in the Düsseldorf Academy.

DUBUFFET, JEAN (Le Havre 1901)

At seventeen Jean Dubuffet went to Paris to study at the Julian Academy. He was very influenced by Suzanne Valadon, Raoul Dufy, Max Jacob, Charles Albert Cingria, and Fernand Léger. Wishing to make a complete break with intellectualism, however, he left for the Argentine with the intention of going into business. In 1930 he returned to France and opened a small wholesale wine-store. In 1933 he resumed his artistic activites, painting some portraits and making puppets and masks out of coloured cardboard. At about this time Dubuffet experienced a new crisis and began to hesitate between painting and literature. In 1943 he went back to painting: more portraits and still-lifes, nudes, pictures of musicians, and views of Paris. In 1944 he had his first one-man exhibition. In 1947 the exhibition of some of Dubuffet's *Portraits* at the Galerie Drouin aroused a violent controversy. Between 1947 and 1951 he organized the exhibition of *Art Brut* (Raw Art) showing paintings and drawings by illiterate persons and people belonging to primitive civilizations. In 1954, without interrupting his painting, Dubuffet made forty small statues in a variety of materials. He showed them the same year at the Galerie Rive Gauche as *Small statues of precarious life*. In April 1955 an exhibition which grouped Dubuffet's paintings, drawings, and tempera was held at the Institute of Contemporary Art in London. The following year the Galerie Rive Gauche organized an exhibition of his China ink drawings done according to a special technique known as *Assemblage d'empreintes* (Assembling impressions).

Collections of Dubuffet's painting and sculptures from the *Hourloupe* cycle were shown at the Tate Gallery in London, the Amsterdam Museum, and the Guggenheim Museum in New York in 1966.

DUFY, RAOUL (Le Havre 1877 – Forcalquier 1953)

When Dufy left secondary school he started work as a clerk and attended evening classes in Fine Arts at the municipal school in Le Havre. In 1889 he won a scholarship to study at the Ecole des Beaux-Arts in Paris and entered Bonnat's studio with Othon Friesz.

In 1901 he exhibited his work in the Salon des Artistes Français and in 1905 took part in the Salon d'Automne. The following year his meeting with Matisse proved to be decisive. In 1911 Dufy worked at a series of wood-cuts for Apollinaire's *Bestiaire* and also designed some textiles for the Bianchini-Férier factory in Lyons. During the First World War he was called up and employed in the Library of the War Museum from 1917–18. After a brief stay in Vence in 1920 he began to travel extensively and spent a long time in Sicily and Morocco. During this period he began to work at ceramics and also designed the settings for the ballet *Palm Beach* which was performed at the Châtelet theatre. During these years Dufy did his best oil paintings with the landscapes of Paris, Marseilles, Hyères, Nice, Cannes, and Deauville.

In 1937 Dufy produced the grandiose panel, *Electrictiy*, for the Universal Exhibition in Paris. After this he moved to Perpignan for health reasons and began work on two large tapestries for Louis Carré: *The beautiful summer* and *The birth of Venus*. Dufy's first one-man exhibition was held at the Galerie Louis Carré in Paris in 1947. Two other important exhibitions of his work were held in New York in 1951 and 1952.

In 1952 three hundred paintings by Dufy were shown in the Museum in Geneva.

DUNOYER DE SEGONZAC, ANDRÉ (Boussy-Saint-Antoine 1884)

In 1901 Dunoyer de Segonzac began to study engraving with Olivier Merson and Jean Paul Laurens but in 1909 gave it up in order to demonstrate his hostility to Impressionism and the art of the Fauves along with Albert Moreau, Boussinqualt, and André Marc.

The 1909 drawings and landscapes are definitely more austere than his previous work, with predominating ochres, tawny shades, cadmium, and ultramarine.

In 1908 Dunoyer de Segonzac exhibited in the Salon d'Automne and the Salon des Indépendants. From 1910–13 he painted *The drinkers* and *The fantastic loaves*. In 1914 he also began to study copper-engraving with his friend, Laboureur. He made two thousand plates in all, including the series of *Morin* (1923), *Beaches* (1935), *From Joinville to Bougival* (1936). From 1925 onwards Dunoyer often stayed in Provence and in Saint-Tropez, painting still-lifes, watercolours, and landscapes in the manner of Corot and Courbet. In 1947 he illustrated *The Georgics* with a series of etchings.

An important exhibition of his work was held at the Art and History Museum in Geneva in 1951.

ENSOR, JAMES (Ostend 1860–1949)

Ensor's father was English and his mother Flemish. All his life he remained deeply attached to his native city and his parents' house with its homely interior and the curiosity shop where they sold souvenirs of Ostend.

Ensor returned to Ostend in 1880 after a brief schooling in Brussels and painted the first pictures belonging to the 'dark period' (1880-85) already showing signs of the new Impressionist manner despite the conventional subject matter. Ensor's style was still developing rapidly, however, and did not become clearly defined until the 'light period', with pictures like *Beach carnival* (1887), *Christ's entry into Brussels* (1888) and *Carnival in Brussels*. In 1894 he had his first one-man exhibition in Brussels and this was followed by a small exhibition in Paris in 1898 on the premises of the review *La Plume*. It was not until 1905 however, when François Franck noticed his work, and 1908, when Verhaeren dedicated one of his books to him, that Ensor at last became known and recognized.

He has been generally acknowledged as the fountain-head of all the Expressionist movements in Northern Europe.

ERNST, MAX (Brühl 1894)

From 1898–1914 Max Ernst studied in Brühl and afterwards took up art history in Bonn. In 1913 he participated in the first German Salon d'Automne in Berlin and visited Paris for the first time.

After a period of inactivity due to the war, Ernst went to Munich in 1919 and came into contact with Dada art and De Chirico's metaphysical painting, finding both a kind of revelation. In 1920 he exhibited a few Dada objects with Arp and began to work on some *collages*, which eventually won him a name in *avant-garde* circles. He published the *Parley* and showed his work for the first time in the Galerie Sans Pareil in Paris. He became acquainted with Kurt Schwitters, Tzara, and Breton. In 1922 Paul Eluard went to visit him in Cologne and persuaded him to move to Paris. He found the contacts with Eluard, Desnos, and Picabia very stimulating but soon fell into financial difficulties and was obliged to take a job in a souvenir factory in order to earn a living. In 1923 he went to Tahiti but returned to Paris the following year. At this period he began to contribute to *Littérature* and took part in the founding of the Surrealist movement. In 1925 he showed at the first Surrealist exhibition in Paris. The same year he did the series of drawings entitled *Natural History* which were published by Jeanne Bucher in 1926.

In 1936 he began his *frottages* or transfer technique. From 1939-40 he was interned in the south of France and then emigrated to America, remaining in New York until the end of the war.

In 1946 he settled in Sedona in Arizona and in 1949 produced his *Paramyths*.

From 1950–53 he paid frequent visits to Paris and in 1954 he won the First Prize at the Venice Biennale. In 1966 a large exhibition of his work entitled *Beyond Painting* was held in the Grassi Palace in Venice.

FAUTRIER, JEAN (Paris 1898–1964)

At the age of eleven Fautrier went to England and in 1912 enrolled as a student in the Royal Academy of Arts and in the Slade School in London. He returned to France when he was mobilized in 1917. At the end of the war he settled in Paris, only leaving it in 1935

when he went to live in the mountains where for four years he ran a hotel and acted as a ski instructor.

Fautrier signed an exclusive contract with the art dealer, Paul Guillaume, in 1925 and in 1928 began to paint his first abstract pictures. He gave up canvas painting from 1930–32 in order to work entirely on paper. He had a showing in the Galerie Jeanne Castel and the Galerie Bernheim in 1935 and another exhibition with Gallimard in 1939. In 1945 he showed his *Hostages* in the Galerie Drouin at Place Vendôme, and in 1950 the *Multiple originals* at the Caputo and the Iolas galleries in New York.

In 1956 Fautrier had an exhibition of his *Nudes* at the Galerie Rive Droite in Paris and the following year showed his *Partisans*, inspired by the recent uprising in Hungary.

Many collective shows and several one-man exhibitions of Fautrier's work were organized in France and other countries during the last years of his life.

FEININGER, LYONEL (New York 1871–1956)

Feininger was born in New York of German parentage and until the age of sixteen lived immersed in the musical atmosphere cultivated by his family.

In 1887 his father suggested that he should go to Germany to study music, but Feininger suddenly abandoned this idea altogether in order to take up painting. He first went to the art school in Hamburg and then to the Berlin Academy, studying under Hancke and Woldemar Friedrich. When he visited Paris in 1892 he was so attracted by the *avant-garde* movements that he stayed there for a year. On his return to Berlin he worked as a caricaturist for two reviews, *Ulk* and *Lustige Blätter*, and also for the American newspapers the *Chicago Sunday Tribune* and *Wee Willie Winkie's World*, until 1906. He spent 1906–7 in Paris and began to collaborate on the review, *Le Témoin*. His first exhibition at the Salon d'Automne in 1911 won him immediate recognition. During these years he moved steadily towards Cubism, and the art of Delaunay and the Futurists.

In 1913 Feininger took part in the first Salon d'Automne in Berlin with Marc and the *Blaue Reiter* group, and later, in 1919, when Gropius asked him to the *Bauhaus* he was able to establish important contacts with Schlemmer, Klee, and Kandinsky. The subjects of his paintings were mainly the cities of Thuringia: Oberweimar, Gembrode, Erfurt, and Goberndorf. He always spent the summer at Deep in Pomerania on the shores of the Baltic. After the war Feininger took up musical composition once more and from 1919–26 wrote a series of fugues for the organ. In 1924 he became one of the founders of the art group known as *Die blauen Vier* (The Blue Four) and in 1926 moved to Dessau and then to Halle with the *Bauhaus*. He did a great many drawings at this time and also twelve paintings of the churches and the streets of Halle, all of which are now housed in the Moritzburg museum. They include: *Scharenkreuzer* (1931), *Fishing for sardines* (1932), and *Islands II* (1933). During this period Feininger also received his first and only official commission when he was asked to paint a picture of the city of Halle to be presented to the first president of the province of Saxony in Magdeburg.

Feininger was persecuted by the Nazi regime and was obliged to leave Europe for America. From 1938–9 he designed two frescoes: one for the Marine Transportation Building and another for the Art Building in the Universal Exhibition. He also painted two *Seascapes* and two scenes of New York entitled *The tower* and *Towards the centre of the city* (1952), which belong to his later period.

FRANCIS, SAM (San Mateo 1923)

From 1941–3 Francis attended the University of California at Berkeley. He joined the airforce in 1943 but after an accident he was sent to hospital and it was then that he started to paint. He took lessons under David Parks at the art school in California.

In 1946 Francis had his first exhibition in the Museum of San Francisco.

In 1950 he left for Paris to join the group of American painters working with Jean-Paul Riopelle. In January 1957 he went on a trip round the world for a year. Ancient Japanese art made a profound impression on him and while he was in Tokyo he had the opportunity of designing a fresco for the school of floral decoration in Sofu. During this period he introduced the use of white into his pictorial compositions: *Blue and white, Violet, yellow and white*. He also began work on the large triptych for the *Treppenhaus* (staircase) in the Basle Kunsthalle. In 1958 his painting was brought to the notice of the public for the first time by Nina Dausset and Michel Tapié.

Francis took part in the exhibition entitled 'Present Trends III' at the Berne Kunsthalle, which included work by Pollock, Tobey, Riopelle, Mathieu, Wols, Tancredi, and several others. In 1956 he participated in the important exhibitions held in Martha Jackson's gallery in New York and in the Galerie Rive Droite in Paris, and in 1957 showed at the Gimpel Gallery in London and at the Klipstein and Kornefeld gallery in Berne.
Francis also showed in the exhibition 'Fifty Years of Modern Art' held in Brussels in 1958 and in 'New American Painting' in Milan, Basle and Amsterdam.
An exhibition of his work was also organized at the American Cultural Centre in Paris.

FRIESZ, OTHON (Le Havre 1879 – Paris 1949)

Friesz attended evening classes at the Ecole des Beaux-Arts in Le Havre under Charles Marie Lhuillier, and it was here that he met Raoul Dufy. In 1897 he moved to Paris and continued his studies at the Ecole Nationale des Beaux-Arts with Bonnat and later with Gustave Moreau. He met Matisse in Moreau's studio and in 1904 exhibited with his group in the Salon d'Automne.
In 1905 he also took part in the Fauves exhibition. Friesz stayed at La Ciotat with Braque in 1906. In 1909 he made several journeys to Munich and to Italy. During a long stay in Portugal in 1911 he began to draw closer to Cubism. In 1913 he exhibited at the Cassirer gallery in Berlin.
In 1935 Friesz designed several cartoons for tapestries and in 1937 worked on the decorations for the Palais de Chaillot with Dufy. In 1938 he visited the United States for the first time. His landscapes of Normandy and Provence are particularly fine.

FUJITA, TSUGUJI (Tokyo 1886 – Paris 1968)

Foujita studied at the School of Fine Arts in Tokyo from 1907–12.
In 1913 he settled permanently in Paris and in 1915 visited London, sharing a Chelsea studio with French friends and artists for a time.
In 1938 he returned to Japan where he remained until 1949.
Once back in Europe Foujita painted a long series of pictures, consisting mainly of nudes and portraits of ladies in Spanish dress. He has also illustrated several books.

GESTEL, LEO (Woerden 1881 – Blaricum 1941)

Gestel was taught by his father and also took some courses at the Academy in Amsterdam. In 1904 he went to Paris with Sluyters and came under the influence of Impressionism. Towards 1908 he was attracted by Divisionism and finally in 1911 by Cubist art. After a long stay in Majorca Gestel eventually returned to Holland and took up realism once more, following the example of the Bergen painters.

GILLES, WERNER (Rheydt 1894 – Essen 1961)

In 1914 Gilles began to study at the Academy in Kassel. After serving in the army, he went to the School of Arts and Crafts in Weimar and also attended the *Bauhaus*, under Klemm and Feininger. He spent some time studying in France and then moved to Italy for ten years.
In 1930 he won the Rome Prize. From 1933–6 he was in Berlin but continued to paint in southern Italy until 1941. After that he lived in Berlin until he was called up. At the end of the war Gilles moved to Schwarzenbach (Saale). He also lived in Munich and Ischia.

GLEIZES, ALBERT (Paris 1881 – Avignon 1953)

Gleizes studied at Courbevoie and Chaptal and in 1900 began work in his father's studio as a textile designer.

In 1901 he painted some Impressionist pictures and showed his work at the Société Nationale des Beaux-Arts and in the Salon d'Automne. In 1906 he helped Charles Vildrac and Duhamel to found the abbey of Créteil.

In 1910 Gleizes again showed in the Salon d'Automne and also in the Salon des Indépendants. The following year he took part in the famous Cubist exhibition at the Salon des Indépendants.

Gleizes attended the meetings of the Puteaux group in Jacques Villon's studio with de la Fresnaye, Léger, Metzinger, Picabia, and Kupka, while he concentrated all his own experiments on the problems of the plastic rendering of motion.

The book, *Du Cubisme (On Cubism)*, which he published in 1912 together with Metzinger, in fact proved to be the most important theoretical work on the subject.

He had exhibitions in Moscow, Barcelona (1913), at the Armory Show in New York, and in the first German Salon d'Automne in Berlin. When he was called up at the outbreak of the First World War he began a series of paintings on military subjects. After being invalided out he left for America and painted several landscapes including the series of *Brooklyn Bridge*. In 1918 he returned to France where he experienced a profound religious crisis which induced him to write two books forecasting a new Christian art. He also made several studies of Roman art during the same period. In 1927 he founded the arts and crafts community at Moly-Sabata in Val d'Isère.

In 1932 Gleizes published *Homocentricism or the Return to Christian Man* and *Form and History* in which he claimed the superiority of art inspired by religious themes. In 1953 he painted the *Eucharist* fresco for the chapel of Les Fontaines in Chaptal.

GRIS, JUAN (Madrid 1887 – Boulogne-sur-Seine 1927)

Juan Gris began to study at the School of Arts and Crafts in Madrid at a very early age. He also contributed illustrations to the reviews *Blanco y Negro* and *Madrid Cómico*.

In 1904 he enrolled for a course of painting with José Maria Carbonero while he continued his work as a designer.

In 1906 Gris went to Paris and joined the intellectual circle gravitating round Apollinaire. He struck up a close friendship with Picasso and for a time the two pursued their experiments together. The result was Gris's first Cubist picture in 1911. He exhibited in the Salon des Indépendants in 1912 and also with the *Section d'Or* (Golden Section) group.

In 1913 Gris and Picasso went to Céret in the Eastern Pyrenees and embarked on a period of ardent research and polemics.

In 1914 Gris produced several *papiers collés* with Picasso and Braque.

At the outbreak of the war, however, he found himself in difficulties, being no longer able to rely on the support of Kahnweiler who had gone to Switzerland.

He finally sold all his pictures to Rosenberg and retired to Turenne until the war was over. On his return to Paris in 1919 he had his first one-man exhibition under the auspices of Rosenberg at the Effort Moderne. The following year he was taken into hospital with pleurisy and then spent a period of convalescence in Turenne and Bandol. Diaghilev invited him to Monte Carlo to draw portraits of his ballet dancers. In 1922 Gris took up permanent residence in Boulogne-sur-Seine and continued to design settings and costumes for Diaghilev. From 1923–7 he showed his work regularly in collective exhibitions and had several extremely successful one-man exhibitions which confirmed his international fame.

He spent the last years of his life in Paris.

GROSZ, GEORGE (Berlin 1893–1959)

Grosz spent his youth in the small town of Stop, the headquarters of a garrison, where his mother ran the Officers' Club. At sixteen he enrolled as a student in the Dresden Academy and three years later went to the school of applied arts in Berlin where he soon became the favourite pupil of Orlik.

Grosz was mobilized at the outbreak of the war but was so insolent and disobedient that he was finally interned and placed under psychiatric observation. In 1918 he became one of the founders of the Dada movement along with Hulsenbeck and the publisher Wieland Herzefeld. Five years later Herzefeld opened the publishing house, Halik, in order to aid the hazardous undertaking of printing books illustrated by Grosz, such as *The Face of the*

Ruling Classes, Ecce Homo, and *Spiesserspiegel*. Grosz's work was enthusiastically acclaimed by the progressive critics but was hated and feared by the generals, industrial magnates, and speculators at whom his satire was aimed.

In 1932 Grosz visited America to give a series of lessons at the Art Students League in New York. When he returned to Germany the following year his painting was banned by the Nazi regime. On May 10 his books were burned in the public squares along with those of Mendelsohn, Heine, Einstein, Freud, Rolland, Gorki, Mann, and Hemingway.

Grosz left for America once again and pursued his successful career selling paintings to the Metropolitan Museum, the Museum of Modern Art, and the Whitney Museum. He also won the Blair prize and the Beck prize and was awarded a grant by the Guggenheim Foundation. In 1947 a New York gallery organized an exhibition of Grosz's work entitled *The Stickmen*. In 1951, six years after the war, Grosz returned to Germany and three years later settled in Berlin.

GUIDI, VIRGILIO (Rome 1892)

While Guidi was still at technical College he began to attend a free school of painting. In 1908 he started work in the studio of a well-known picture-restorer and spent another two years at the Fine Arts Academy in Rome under Sartorio. He felt attracted by the various *avant-garde* movements although he never fully adhered to any. He made several friends among the Roman painters and writers and particularly with Vincenzo Cardarelli.

In 1913 one of Guidi's pictures was accepted for exhibition. In 1916 he entered the Ministry of Public Works as a designer and worked there for two years. He frequented the Caffé Aragno along with Cecchi, Cardarelli, De Chirico, Baldini, Ungaretti, Spadini, Broglio, and Bachelli.

During these years he painted the *Portrait of my mother* and the first version of *Visit*. In 1922 he showed the second version of *Mother getting up* and *Visit*, both of which provoked very mixed reactions. The following year, however, *The tram* was acclaimed with enthusiasm when it was shown in Venice.

In 1924 Guidi took part in the first exhibition organized by the *Valori Plastici* group and in 1927 collaborated with Sarfatti in the Roman *Novecento* Exhibition. The same year he was appointed to the chair of painting at the Fine Arts Academy in Venice. In 1930 he took up residence in the Strà villa with his students in what proved to be an unsuccessful attempt to found a free school of painting. Eventually, feeling that the cultural atmosphere in Venice was hostile to him in every way, Guidi accepted a similar post at the Academy in Bologna. He published art bulletins and painted *Seascapes* and *Portraits* during this period. Guidi continued his teaching in Bologna during the Second World War but many of his paintings were destroyed by the bombing. When the war was over he did some very fine lithographs. In 1948 he took part in the Roman Quadriennale and the Venice Biennale and had several other collective and one-man exhibitions in Italy and abroad.

In 1949 he began work on the *Old Sky* and *New Sky* cycles and painted a series of pictures in a technique close to *tachisme*. He also worked on his *Human architectures* and *Cosmic architectures*.

GUTTUSO, RENATO (Begheria 1912)

Guttuso spent his boyhood in the province of Palermo among the peasants.

The tragic living conditions of these people had a profound effect on his character and on his development as an artist. After spending some time in a cart-painter's workshop, Guttuso left Sicily in 1931. The following year he exhibited with other young Sicilian artists in the Milione gallery in Milan.

In 1934 Guttuso was able to come into contact with the anti-conformist painters in Rome: Cagli, Mafai, Melli, Fazzini, Ziveri, and others. The following year in Milan he became friendly with Birolli, Manzù, and Sassu.

In 1937 he settled permanently in Rome. It was during this period that he painted two of his most important pictures: the large realistic composition entitled *Flight from Etna*, and *Execution in the country*, inspired by the death of Garcia Lorca. The following year he had his first one-man exhibition at the Cometa gallery in Rome. His *Crucifixion*, shown in Bergamo in 1942, aroused violent criticism from the Church and the Fascist regime.

Guttuso also began to participate in the movement formed by some young intellectuals in Rome who wished to set up a youth organization of the Italian Communist Party. He painted the *Massacres* and designed a series of covers for the review *Documento*, which was immediately banned.

After September 8, Guttuso took part in the struggle of the Partisans.

The drawings *Gott mit uns* were inspired by his war experiences and in particular by the massacre in the Fosse Ardeatine in Rome in 1944. From 1944–5 he led the controversy over realism in the newspapers *L'Unità*, *Rinascita*, and *Cosmopolita*.

Next he joined Birolli, Turcato, Morlotti, Vedova, Santomaso, Pizzinato, Corpora, Fazzini, Franchina, Leoncillo, and Viani and helped to found the *Fronte nuovo delle arti* (New Arts Front).

In 1949 Guttuso had a one-man exhibition at the Secolo in Rome to show the pictures and drawings he had brought back from his long stays in Acciaierie di Terni and Sicilia.

The following year he showed his *Occupation of uncultivated lands in Sicily* at the Venice Biennale which again aroused strong reactions.

Since then Guttuso has participated regularly in the Venice Biennale.

At present he is engaged in his campaign for a socially committed art under the auspices of the Italian Communist Party, with which however he is often in disagreement.

HECKEL, ERICH (Döbeln 1883 – Radolfzell 1970)

Heckel first studied in Freiberg and later in Chemnitz where he became friendly with Karl Schmidt-Rottluff.

In 1905 he enrolled in the faculty of architecture in Dresden and worked in the studio of Wilhelm Kreis. This was where he met Ernst Ludwig Kirchner and Fritz Bleyl. In 1906 he joined them in founding the *Brücke* movement. The following year Nolde and Pechstein also became members. Heckel spent the summers of 1909 and 1910 by the Moritzburg lakes with his friends, studying the nude in the freedom of natural surroundings.

In 1911 he moved to Berlin, attracted like Kirchner by the dynamism of the city. After the *Brücke* split up, Heckel had his first one-man exhibition in the Gurlitt gallery in Berlin. During this period he painted a series of pictures portraying invalids, with great plastic intensity. They include *Two men at table* (1912), and *Jour de Verre*. At the outbreak of the war Heckel enlisted as a volunteer in the Red Cross in Flanders. He struck up a friendship with James Ensor and painted a very fine portrait of him in 1924. He also became friendly with Max Kaus. The *Madonna of Ostend*, which was later destroyed, was painted at this time.

At the end of the war Heckel returned to Berlin and began to travel widely.

He went to Italy, France, Germany, and Switzerland and continued to paint landscapes. With the advent of Nazism his work was banned like that of the rest of the *Brücke* artists and his pictures were removed from German museums. In 1944 his studio in Berlin was destroyed along with a great part of his production, especially his drawings.

From 1949–55 he held the chair of painting at the Academy of Figurative Art in Karlsruhe.

HERBIN, AUGUSTE (Quiévy 1882 – Paris 1960)

Herbin studied at the art school in Lille from 1900–1. In 1903 he moved to Paris and began to adopt Impressionist techniques. By 1910, however, he had grown extremely interested in Cubism.

Herbin's painting remained objective from 1922–5 but in 1926 he took up abstract art and became a member of the *Abstraction-Création* group.

He died in Paris.

HODLER, FERDINAND (Berne 1853 – Geneva 1918)

At the age of nineteen, Hodler enrolled in the Fine Arts Academy in Geneva to study with Barthélémy Menn, who had been a pupil of Ingres and a friend of Corot. During his holidays in Langenthal in 1875 Hodler painted his first picture, *The scholar*, revealing his interest

in Holbein. At the same time he painted portraits of labourers and craftsmen at their work and a series of landscapes.

In 1891 he exhibited *Night* at the National Society of the Champ du Mars and the following year participated in the Salon organized by the Rose Croix (the Rosicrucians). Such pictures as *Disappointed souls*, *The chosen one* (1894), and *The hermit* (1895) showed his new interest in Symbolism.

Towards the turn of the century Hodler devoted himself principally to historical subjects with the *Retreat from Marignan* (1899) and *Truth* (1903).

In 1904 he showed at the Vienna *Sezession*.

The most important pictures belonging to Hodler's later period include *Humanity*, and a few *Landscapes*, and also the *Oath of the Reformation* painted for the city of Hanover in 1910.

HOFER, CARL (Karlsruhe 1878 – Berlin 1955)

After much privation and hardship during his boyhood, Hofer entered the Karlsruhe Academy at the age of eighteen and studied with Hans Thoma and L. von Kalckreuth. In 1900 he visited Paris for the first time and did not return to Germany until the following year. In 1902 he followed Thoma and Kalckreuth to Stuttgart.

On his return to Germany Hofer worked in Thoma's studio. In 1903 he moved to Rome for five years under the patronage of the Swiss collector, Dr. Theodore Reinhart. In 1908 he went to live in Paris, absenting himself on two occasions to visit India.

At the outbreak of the First World War, Hofer was called up but was soon taken prisoner in France. He was freed three years later.

From 1919–33 he taught at the Berlin Academy.

Hofer painted his first landscapes in Ticino in Switzerland in 1925. In 1930, however, he began to abandon his earlier classical manner for abstract painting. In 1943 a great part of his work was destroyed in a bombing raid.

Hofer resumed his teaching in 1945; he was made president of the Berlin Academy in 1947. He has left some theoretical writings: *Wege der Kunst* (The Paths of Art) (1947), *Das Selbstverständliche und das Artistische in der Kunst* (The natural and the artistic in Art) (1949), and an autobiography, *Aus Leben und Kunst* (From Life and Art) (1952).

HOPPER, EDWARD (Nyack 1882 – New York 1967)

Hopper studied at the School of Art in New York from 1900–6 and was a contemporary of Bellows, Rockwell Kent, and Guy Pène de Bois.

Between 1906 and 1910 Hopper went frequently to Europe, spending most of his time in Paris where he greatly admired the Impressionists, particularly Pissarro and Degas.

On his return to America he resumed landscape painting but also began to show a definitely non-Impressionist interest in architecture. Disappointed and embittered at his repeated lack of success, Hopper gave up painting in 1915 in order to devote all his time to illustration. In 1919 he took up drawing once more and within a very short period produced twenty-five compositions depicting various aspects of American life.

In 1920 he exhibited some oil paintings and watercolours of Parisian life at the Whitney Club in New York.

The exhibition organized at the Rehn Gallery in 1927 and the retrospective exhibition held in the Museum of Modern Art in 1933 confirmed Hopper as one of the most important modern American painters. In his later years he painted increasingly naturalistic pictures of American life.

JAWLENSKY, ALEXEJ VON (Kuzlovo 1864 – Wiesbaden 1941)

Jawlensky was an officer in the Imperial Guard. In 1889 he decided to give up his career in order to take up painting. He began to follow courses at the Academy in Moscow and then went on to Anton Azbe's school in Munich, where he met Kandinsky. In 1909 he founded the *Neue Künstlervereinigung* with Kandinsky, Kubin, and Gabriele Münter. He also associated with the *Blaue Reiter* group although he did not participate in their exhibitions.

During his stay in Bavaria in 1909 Jawlensky became deeply impressed by the art of Cézanne and Van Gogh. A later stay in Brittany and Provence brought out his gifts as a colourist. A meeting with Matisse, however, was to prove decisive. During the First World War, Jawlensky went to Switzerland (Saint-Preux, Zürich) and in 1921 settled in Wiesbaden in Germany.

In 1924 he joined the *Blauen Vier* with Kandinsky, Klee and Feininger, showing in their exhibitions in America and Germany. At the outbreak of the Second World War, Jawlensky's painting took on a greater spirituality with the *Variations* on a landscape near Saint-Preux, the *Mystic heads* and the *Visions of the Saviour*.

KANDINSKY, WASSILY (Moscow 1866 – Paris 1944)

Kandinsky went to grammar school in Odessa and then enrolled in the university of Moscow in 1886. After graduating in jurisprudence he became an assistant in the law faculty. During this period he paid one important visit to St Petersburg and remained deeply impressed by the Rembrandts he saw at the Hermitage Museum. In 1896 he refused a post at the university of Dorpat and moved to Munich in order to study painting. He attended Azbe's school and then went on to the Academy, meeting Jawlensky, Franz von Stuck, and Paul Klee. Under the influence of the *Jugendstil* (Art Nouveau) and of Impressionist painting he did some wood-engravings and painted landscapes and romantic pictures. In 1905 he began some Russian scenes in a style close to *pointillisme* and during the same period began to travel widely with the painter Gabriele Münter. They visited France, Tunisia, and Italy and settled in Murnau on the Staffelsee in 1908.

From 1908–9 Kandinsky painted the Murnau landscapes, his first really original pictures, then the first *Improvisations* (1910), the *Compositions*, and the *Impressions*. He painted his first abstract watercolour in 1910.

In 1909 Kandinsky founded the *Neue Künstlervereinigung* which gave birth to the *Blaue Reiter* group in 1911. He was joined by Paul Klee, Franz Marc, Hans Arp, August Macke, and Gabriele Münter among others. This was also the period of the writings on art: *Über das Geistige in der Kunst* (Concerning the Spiritual in Art), and *Über die Formfrage* (The Question of Form), and the poetic drama, *Der gelbe Klang*.

At the outbreak of the war Kandinsky returned to Moscow and married Nina von Andreewsky. He travelled a great deal with her throughout the years 1924–44. In 1919, after he was made a member of the Russian Commissariat for Popular Education and a teacher in the state schools, he founded the Pictorial Culture Museum.

In 1920 Kandinsky left Russia for Berlin and then moved to Weimar. He taught at the *Bauhaus* until 1933. In 1924 he founded the *Blauen Vier* with Feininger, Klee, and Jawlensky. In 1925 he moved to Dessau with the *Bauhaus* and in the same year published his *Punkt und Linie zur Fläche* (Dot and Line to a Surface).

In 1929–30 Kandinsky had his first exhibitions in Paris. When the *Bauhaus* had to close in 1933, Kandinsky decided to settle in Paris and remained there for the rest of his life.

KIRCHNER, ERNST LUDWIG (Aschaffenburg 1880 – Davos 1938)

Kirchner studied architecture at the High School in Dresden from 1901–5 with one year's interruption (1903–4) to study painting in Munich under Debschitz and Obrist.

In 1904 he met Heckel and Bleyl and together with them and Karl Schmidt-Rottluff founded the *Brücke* in 1905. Nolde and Pechstein joined the group in 1906. That same year they organized their first exhibition in the Seifert lamp factory. The *Brücke* painters spent the summers of 1909 and 1910 together beside the Moritzburg lakes. In 1910 they had an exhibition in the Arnold gallery in Dresden.

In 1911 Kirchner moved to Berlin and painted a series of pictures inspired by street scenes, variety shows, and the circus. He spent the summer with Heckel on the island of Fehrman on the Baltic, returning to Berlin the following year. In 1912 he designed the wall paintings for the chapel in the *Sonderbund* exhibition in Cologne. In 1913 the *Brücke* was disbanded. Kirchner was called up in 1914 but was classed as unfit for active service and sent to the sanatorium of Königstein in the Taunus. He was profoundly affected by his experience of the war and began a period of peregrination, moving back to Berlin, then to Jena, Frieburg, and finally to Davos where he took up permanent residence in 1918. He had frequent

exhibitions: at the Kunsthaus in Zürich (1922), at the Kunsthalle in Basle (1924), and at the Kunstmuseum in Winterthur (1924). In 1926 he began his 'abstract period'. Between 1927 and 1933 he worked on the decoration for the Folkwang Museum in Essen, but this was eventually prohibited by the Nazi regime. Kirchner also worked with the weaver, Lise Gujer, from 1922–38.

Persecuted by the Nazis and a sick man, Kirchner committed suicide in Davos in 1938.

KISLING, MOISE (Cracow 1891 – Sanary 1953)

At the age of fifteen Kisling enrolled in the Cracow Academy and began to study under Pankiewicz. His teacher introduced him to the art of the Impressionists, many of whom he knew personally, and advised him to go to Paris. In 1910 Kisling went to live in Montparnasse and soon became one of its most picturesque and friendly inhabitants. He studied the painting of Cézanne and became friendly with Picasso, Juan Gris, Max Jacob, Manolo, Modigliani, and Soutine. He enlisted in the Foreign Legion at the outbreak of the war, but was wounded in 1914 and invalided out. On his return to Paris, his pictures began to be appreciated and sold by the art dealers, Zborowski and Coquiot. In 1919 he exhibited a series of still-lifes and portraits in the Salon d'Automne and in the Galerie Druet. He often went to the south of France, usually staying in Saint-Tropez, Sanary, or Marseilles; he also painted several landscapes.

Kisling soon drew very close to Modigliani and helped him to the last. Both of them painted the portraits of their friends, Max Jacob, Picasso, and Cocteau.

In 1919 Kisling was commissioned to illustrate *War in Luxemburg* by Blaise Cendrars for the publisher, Niestée. He also painted the portraits of Denise le Bec, Falconetti, Colette Audry, Arletty, and Michèle Morgan.

During the Second World War Kisling took refuge in Lisbon and then went to the United States. In 1942 he painted the portrait of Arthur Rubenstein and his family in Hollywood and had a one-man exhibition there the same year.

After spending some time in Washington, Kisling moved to New York in 1943, still painting portraits, landscapes, nudes, and still-lifes.

In 1946 he returned to Paris.

KLEE, PAUL (Münchenbuchsee 1878 – Locarno 1940)

Klee was the son of a music teacher. He first studied in Berne and then moved to Munich to attend the painting schools of Kirr and Franz von Stuck.

From 1901–2 he visited Italy with the composer Haller and stayed in Milan, Genoa, and Naples. When he returned to Berne in 1902 financial reasons obliged him to live with his parents until 1906. It was during these years that he painted the ten *Inventions* he showed in the Munich *Sezession*. From 1911–12 he illustrated Voltaire's *Candide*. He also began to associate with the *Blaue Reiter* group and the *Sonderbund* in Cologne.

Klee grew friendly with Kandinsky, Marc, Macke, and Jawlensky. In the spring of 1912 he went to Paris and met Delaunay, Picasso, Rousseau, and Braque. He established relations with the Expressionist painters connected with the review *Der Sturm* and in 1914 visited Tunisia with Macke and Moillet.

At the outbreak of the First World War Klee's group of friends scattered.

Marc and Macke died within a short while of each other, and Klee himself had to serve from 1912–16.

From 1921–30 he taught at the *Bauhaus* in Weimar and Dessau in the departments of stained-glass design and weaving, and gave lectures on the theory of form with Kandinsky. These were published as essays in 1956.

The close acquaintance with Kandinsky, Feininger, and Schlemmer and the journeys to Sicily (1924–31), Italy (1927), and Egypt (1928–9) were all extremely important for Klee's development. The visit to Egypt in particular inspired his *Main roads and side roads*. In 1925 Klee took part in the first Surrealist Exhibition in Paris and also had a one-man exhibition in the Galerie Vavin-Raspail. In 1933 he moved to Düsseldorf after the closure of the *Bauhaus* but he was accused of 'cultural Bolshevism' and lost his post.

When he returned to Berne in 1935 a large retrospective exhibition of his work was organized there.

KLIMT, GUSTAV (Baumgarten 1862 – Vienna 1918)

After learning the rudiments of art from his father, a jeweller and engraver from Bohemia, Klimt took courses in the applied arts in Vienna with Berger and Hans Makart. He opened a studio there in 1883 with Franz Matsch and his younger brother, Ernst. In 1892 the group scattered because of Ernst's death. After a period of deep discouragement, Klimt finally accepted a commission to decorate the ceiling of the Aula Magna in the university. The subject was to be a series of allegorical figures representing Philosophy, Medicine, and Jurisprudence. It was during this period that Klimt broke with the Society of Viennese Artists.
In 1900 he showed *Philosophy*, the first of the three figures (which were destroyed during the last war), in the Exhibition building. It created such a sensation that the commission finally had to be withdrawn. The open polemic aimed at Klimt incited a number of other painters to found the Vienna *Sezession*.
Klimt himself, however, broke away in 1904 to visit Berlin, Brussels, and London.
His art, consisting of allusions to literature and music, gradually acquired a more eccentric sinuosity of line and the brilliant colours of enamel. He also began to introduce the use of decorative materials. While Klimt was in Belgium he designed his most important decorative work: the mosaic frieze for the dining-room in the Maison Stoclet by Josef Hoffmann, which occupied him until 1909. He also paid frequent visits to Italy and made a careful study of the Ravenna mosaics in 1903. In 1908 Klimt won a prize for his picture *The three ages of life* in Rome and in 1911 was awarded the gold medal at the Venice Biennale. In 1917 he was made an honorary member of the Munich and Vienna Academies.

KOKOSCHKA, OSKAR (Pöchlarn 1886)

Kokoschka studied at the School of Arts and Crafts in Vienna from 1905–9.
He also collaborated in the *Wiener Werkstätte* (Workshop) and took up painting.
Kokoschka published two plays in 1908 and two years later illustrated his poem *The Dreaming Boys* with nine lithographs. His first exhibition in Berlin was an immediate success. It was during this period that he painted some powerful almost obsessive portraits.
At the outbreak of the First World War Kokoschka fought on the Russian front.
In 1915 he was severely wounded.
After the war he painted his masterpieces: *The woman in blue* and *The lovers*, drawing inspiration from the Expressionist painters who had belonged to the *Brücke*. In 1921 he designed ten lithographs which he called *Variations on a Theme*.
In 1924 Kokoschka left Dresden in order to travel. From 1930 until today he has devoted most of his time to portraits and landscape painting.
Kokoschka also directed a free school of painting in Salzburg for many years.

KOONING, WILLEM DE (Rotterdam 1904)

At the age of twelve de Kooning became apprenticed to a firm of painters and decorators and shortly afterwards to the painter, Bernard Romein. At the same time he attended evening classes at the Fine Arts Academy in Rotterdam and finally obtained his diploma in 1924. He then enrolled in the art schools in Brussels and Antwerp but in 1926 decided to go to America. He first found work as a house painter and a decorator but was soon commissioned to design stage-sets and posters for advertisements. He became friendly with Gorky and shared a studio with him for several years. From 1935–6 de Kooning worked in the department of mural and easel painting in the WPA Federal Art Project in New York.
In 1939 he painted a fresco for the World Fair.
Since 1948 he has had several one-man exhibitions and has taken part in numerous collective shows, including the exhibition held at the Egan Gallery in New York (1948), the shows at the Sidney Janis Gallery also in New York (1953 and 1957), and the exhibition at the Workshop Art Center in Washington (1953).
From 1950–51 de Kooning taught at the Yale Art School in New Haven.
He has also exhibited at the Venice Biennale and at the São Paulo Biennale.
He resides in New York.

KUPKA, FRANK (Opocao 1871 – Montpellier 1957)

Kupka first studied at the Fine Arts School in Prague and then moved to Vienna in 1891 to study under Eisenmenger at the Academy.

In 1895 he went to live in Paris. He painted pictures from life and developed a passion for the work of Rodin and Toulouse-Lautrec. He also did some illustrating. In 1906 he gave up figurative art to embrace Cubism.

The Cubist exhibitions which caused such a stir at the Salon d'Automne and the Salon des Indépendants were held in 1911 and 1912. Kupka, who went to the meetings organized by the *Section d'Or* in Villon's studio, is mentioned by Apollinaire as figuring among the Orphic painters and being an inventor of a new form of art. During the war Kupka became an officer in a Czech regiment stationed in France. Later, he was offered a post at the Ecole Nationale des Beaux-Arts. In 1924 he showed his work at the Galerie La Boétie. When he exhibited at the Jeu de Paume in 1936, he divided his pictures into five very broad categories: round, vertical, vertical and diagonal, triangular, and diagonal.

In the Second World War Kupka had to take refuge in Beaugency. He settled in Puteaux once the war was over.

LARIONOV, MIKHAIL FEDEROVIC (Tiraspol 1881 – Paris 1964)

Larionov attended the School of Fine Arts in Moscow from 1897–1908 and then became a pupil of Archipov, Pasternak, Serov, and Koroni.

He exhibited for the first time in 1902 in Moscow. In 1909 he showed *Le verre* (The glass), painted in an abstract style influenced by Cubism, at the Free Aesthetics Society.

The following year Larionov attended the lectures which Marinetti gave in Russia and developed a keen interest in Futurism.

It was during this period that he elaborated the new style of painting which he called Rayonism. He exhibited a few canvases in Kraft's studio consisting essentially of brushwork set off by luminous streaks, and in 1913 proclaimed his manifesto. In 1914 he moved to Paris and showed at the Salon d'Automne, the Salon des Indépendants, and the Tuileries. Between 1914 and 1918 Larionov had several one-man exhibitions in Paris and in Berlin. His friendship with Malevich and Tatlin also had a very important effect on his development. He has left a very famous portrait of Tatlin.

In 1915 he began to work almost exlusively for the theatre, designing settings and costumes for Diaghilev's Russian ballets in a deliberately traditional style which nevertheless tended to become more and more geometrical.

His most famous settings are: *Midnight Sun* and *Russian Tales*.

In addition to his Rayonist pictures, Larionov also painted a number of primitive studies of soldiers and peasants.

LÉGER, FERNAND (Argentan 1881 – Gif-sur-Yvette 1955)

Léger studied architecture in Caen from 1897–9. In 1900 he went to Paris and in 1903 began to study at the School of Decorative Arts, working as an architect's designer and as a retoucher in a photographic laboratory. He opened his first studio with André Mare in the Avenue du Maine before moving to La Ruche.

From 1905–6 Léger spent a period of convalescence in Corsica and painted a few landscapes influenced by Cézanne.

On his return to Paris he began to react against Impressionism and grew interested in Cubism and in the work of Henri Rousseau. In 1910 he attended the meetings in Jacques Villon's studio which led to the founding of the *Section d'Or* with Delaunay, Le Fauconnier, Gleizes, Mare, Picabia, and Kupka.

He also became friendly with the dealer, Kahnweiler, and signed an exclusive contract with him in 1913. From 1909–10 he painted *Woman sewing*, the series of *Roofs*, and *Weddings*, followed by *Nudes in the forest*, which he showed in the Salon des Indépendants in 1911. Léger also took part in the eighth exhibition held by the Indépendants in Brussels with Delaunay, Le Fauconnier, Metzinger, and Marie Laurencin, and in the first Salon organized by the *Section d'Or* with Villon, de la Fresnaye, Metzinger, and Picabia. In 1912 he showed in the Salon d'Automne and in the same year had his first one-man exhibition at Kahn-

weiler's with the series of *Contrasts of forms*. At the beginning of the war Léger was called up but had to be taken into hospital in Villepinte after gas poisoning at Verdun.

During his convalescence he painted *The game of cards*, which marked an important turning-point in his artistic sensibility and plastic conceptions.

In 1920 Léger became the friend and collaborator of Le Corbusier. He also designed the settings and costumes for the Swedish ballet, *Skating Rink*, and did some important research in the field of the cinema. The outcome was his first film without a subject—*Le Ballet Mécanique* (The Mechanical Ballet)—in 1924.

In 1925 Léger decorated the entrance to a French Embassy building with Delaunay and painted his first murals for Le Corbusier for the *Esprit Nouveau* building. His *Mechanical elements* and *Compositions* belong to this period.

From 1926 onwards Léger had many one-man exhibitions all over the world.

In 1936 he went to the United States with Le Corbusier and showed at the Museum of Modern Art in New York. In 1937 he helped to decorate the Winter cycle-track for the Syndicates Festival and also designed several murals for the Palace of Discovery. During the war Léger went to America again and taught at Yale University and in various other American schools. He came into contact with other artists living in exile like André Masson, Tanguy, Breton, and Chagall. Back in France again after the war, he began to take an active part in politics.

Léger designed the mosaics for the façade of the church in Assy and in 1949 took up ceramics. In the same year an important retrospective exhibition of his work was organized at the Museum of Modern Art in Paris and in 1950 went to the Tate Gallery in London. In 1951 Léger painted a decorative composition for the French pavilion in the Milan Triennale. His last years were devoted to the stained-glass windows for the churches in Audincourt and Courfaivre and for the University of Caracas.

LHOTE, ANDRÉ (Bordeaux 1885 – Paris 1962)

Lhote was a self-taught artist and showed his work for the first time in 1910 in the Salon d'Automne. The following year he showed in the Salon des Indépendants. In 1910 he also had his first one-man exhibition in the Galerie Druet showing a very large number of pictures, including *The widow*. This painting aroused the interest of the critics and particularly excited Apollinaire and Vauxcelles.

André Lhote became an enthusiastic Cubist in 1911. But although he became the impassioned theorist and spokesman of the movement, he could never be fully identified with it. From 1918–20 he taught at the Academy of Notre Dame des Champs and at the Raspail Academy and in 1921 founded his Academy in the rue d'Odessa. In 1937 he designed a large decorative work for the Palace of Discovery which he entitled *Gas*. At the end of the Second World War Lhote resumed his activity as a painter but also began to devote considerable time to archaeology, visiting Thebes in 1951 to study the frescoes in the tombs.

He also had several exhibitions in France and abroad.

In 1955 Lhote composed three panels for the Faculty of Medicine in Bordeaux and the same year won the National Grand Prize for Painting. The UNESCO Plastic Arts Commission also nominated him president of the international association of artists and painters.

LICINI, OSVALDO (Monte Vidon Corrado 1894–1958)

Licini studied at the Fine Arts Academy in Bologna at the same time as Giorgio Morandi, Mario Bacchelli, Giacomo Vespignani, and Severo Pozzati (Sepo).

He visited Paris several times before he finally moved there with his family in 1902. In 1913 he attended the Futurist evenings in Modena and the following year took part in an exhibition organized in the Baglioni Hotel in Bologna with Modigliani, Pozzati, and Vespignani. At the outbreak of the war Licini enlisted as a volunteer and was severely wounded in 1916. After a long convalescence in the military hospital in Florence he returned to Paris. The famous première of *Parade* at the Châtelet Theatre on 18 May 1917 aroused his youthful enthusiasm for the achievements of Picasso and Cocteau, whom he had already met at the Rotonde café with Kisling, Soutine, Zborowski, and Modigliani. During this period he painted a few fantastic pictures in a primitive style inspired by the settings and costumes for the Russian ballets: *Ballerina, Two skaters, Hunter, Italian soldiers*.

314

Licini remained in Paris until 1925. From 1920–23 he lived in Saint-Tropez painting landscapes and portraits in the manner of Cézanne and Matisse. He exibited often in the Salon d'Automne, the Salon des Indépendants, the Galerie Devambez, and the Salon de l'Escalier. On his return to Italy in 1925 Licini retired to Monte Vidon Corrado. By 1930 he had outgrown realism and turned to abstract painting which he pursued until 1940. In March 1936 he took part in the first collective exhibition of Italian Abstract Art with the group formed by Fontana, Reggiani, Soldati, Veronesi, Melotti, and Ghiringhelli. It was held in the studio of Casorati and Paolucci in the Via Barolo in Turin.
The same year Licini showed some pictures in the second Roman Quadriennale.
In April 1937 he had another exhibition in the Milione gallery in Milan. In 1938 he assisted at Marinetti's lecture on 'The *Italianità* of Modern Art' in Rome.
After a break due to the Second World War, Licini made his reappearance at the XXVI (26th) Biennale in Venice in 1948. Two years later he showed his nine best *Amalassunte*. He devoted the years from 1950–57 to completing his numerous sketches on paper. His last important exhibitions were at the Olivetti Cultural Centre in Ivrea, the Italia-Francia show in Turin and the exhibition presented by Apollonio at the XXIX (29th) Venice Biennale.
On this occasion Licini won the International Grand Prize for Painting.

MACKE, AUGUST (Meschede 1887 – Perthes 1914)

After spending his childhood in Cologne and Bonn, Macke moved to Düsseldorf and enrolled as a student in the Academy.
His first visit to Paris in 1907 brought him into contact with French painting.
He was interested in the Impressionists, the Fauves, and the Cubists, but it was the work of Delaunay which had a really decisive influence on his development. On his return to Germany he met Marc and Kandinsky in Munich in 1909–10 and collaborated with them on the *Blaue Reiter* almanach the following year.
During the period 1910–14 Macke produced the most important pictures of his brief career. A visit to Tunisia in the spring of 1914 with Klee and the Swiss painter, Moillet, inspired him to paint a series of watercolours.
On his return to Bonn he also painted several landscapes.
Macke was called up at the outbreak of the war and died the same year in Perthes.

MAFAI, MARIO (Rome 1902–65)

Mafai began to study at a technical school but gave it up in 1921 to go to the School of Industrial Arts. He also attended evening classes at the English Nude Academy in the Via Margutta and the following year enrolled in the Free Nude School in the Academy of Fine Arts at Rome. In 1924 after his military service he grew very friendly with Gino Bonichi (Scipione).
Mafai resumed his work at the Academy with Bonichi and several other artists, painting in the open air, from nature, in the city and 'outside the walls' (extra muros). By this time he had met Antonietta Raphael and he married her the following year. In 1925 Mafai was expelled from the Academy because of a disagreement with the director. With Gino Bonichi he attempted to sell commercial paintings, figurines, posters, and miscellaneous articles. In the autumn he met Renato Mazzacurati. Three years Later, in 1928, he showed his paintings in the Mostra degli Amatori e Cultori di Belle Arti (Art Lovers Exhibition) and from 1928–33 took part in the exhibitions organized by the Latium Fascist Syndicate of Fine Arts. During this period he also showed in the Biennales in Venice and in the Roman Quadriennales. Mafai spent the war period in Genoa, resuming his creative activity with enthusiasm as soon as it was over. In 1941 he won the II Bergamo Prize for *Models in the studio*.
In 1948 his name figured among the artists who signed the letter to *Rinascita* reasserting the struggle against formalism and art 'without content' at the service of the ruling classes. In 1956 Mafai was appointed to the chair of painting in the Fine Arts Academy in Florence. In 1961 he moved back to Rome to occupy the chair of decoration at the Fine Arts Academy. That same year he showed his non-figurative pictures at the VI Biennale in São Paulo.

MAGRI, ALBERTO (Fauglia 1880 – Barga 1939)

Magri was a self-taught painter who learned largely from his observation of the Giottists and the pre-Giottists.
From 1902–3 he went to Paris and worked for several comic papers for a time. On his return he settled in Pisa and continued his university education. A little later he moved to Florence and worked there as a chemist until he retired to Barga in 1910. During the period in Barga he painted the polyptych now in Mestre. In 1914 Magri went back to Florence and painted *House in order and house in disorder*. He also had a one-man exhibition in the Lyceum. At the outbreak of the First World War he enlisted as an officer in the pharmacy sector. After the war he taught for two years at the commercial school in Intra and worked as a chemist in Barga. In the last years of his life he became a bank representative.

MALEVICH, KASIMIR (Kiev 1878 – Leningrad 1935)

Malevich moved to Moscow when he was just over twenty-one and enrolled as a student in the Rerberg private academy. This brought him into contact with Western painting for the first time. He became friendly with many *avant-garde* artists, especially Larionov. From 1910–11 he and Larionov participated in the *Bubnovij Valet* (Knave of Pictures) exhibition. In the same year Kandinsky invited him to show in the second graphic arts exhibition being organized by the *Blaue Reiter* group in Munich. He also paid a visit to Paris where he was immediately struck by the work of the Cubists and Fernand Léger. In the spring of 1913 Malevich showed seven Cubist pictures with the Target group in Moscow. With Vladimir Tatlin in 1915 he sent eighteen paintings to the 'Tramway' exhibition organized by Ivan Puni in St Petersburg. In the same year he published his Suprematist Manifesto, thus founding a movement in which Cubist and Futurist experiments seemed to converge. After the October Revolution Malevich was appointed to the Fine Arts Academy in Moscow and in 1918 to the Vitebsk Academy. In 1919 he showed *Black square on a white background*, painted in 1913 (?), and *White square on a white background* (1918) in the same exhibition as Kandinsky and Pevsner in Moscow.
From 1919–20 Malevich also did some theoretical writing, including *Statics and dynamics in the new system of art* and his fundamental essay entitled *The world of non-representation*.
In 1921 he designed a ceramic for the Leningrad State Manufactory and in 1922 took part in an exhibition of modern Russian art in Berlin. From 1923 onwards Malevich devoted himself almost exclusively to applied arts, producing his three-dimensional constructions and architectonic projects. During this period his *Betrachtungen* (Considerations) appeared in the magazine *Künstlerbekenntnisse* (Artists' Confessions) published by Paul Westheim in Berlin. In 1924 Malevich took part in the XIV Biennale in Venice with three Suprematist paintings and six drawings.
In 1927 he visited Kandinsky at the *Bauhaus* in Dessau in order to negotiate the publication of his collected writings in a volume entitled *The world without objects*.
Finally Malevich was arrested by the Soviet regime and put into prison. He was released only when he had contracted the disease which, after years of extreme poverty, eventually caused his death.

MANESSIER, ALFRED (Saint–Ouen 1911)

Manessier first studied in Amiens. In 1931 he went to Paris and in 1935 enrolled in the Ranson Academy, vhere he met Bissière. He also became friendly with Le Moal and Bertholle B. Manessier did his military service from 1936–9 and resumed his studies with Bissière in 1940–41. In 1949 he did a series of lithographs on the theme of Easter, and designed the stained-glass windows for the church in Bréseux (Doubs). After the war he became one of the chief exponents of lyrical abstract painting.
He lives in Paris.

MANGUIN, HENRI (Paris 1874 – Saint-Tropez 1943)

Manguin began to study painting in Gustave Moreau's studio in 1894. He showed in the Galerie Berthe Weill in 1902 and 1904, and in the Salon des Indépendants in 1903.

Manguin also joined the Fauves, although his pictures lack their characteristic vehemence. His harmonious landscapes impart a feeling of great serenity and calm.

MARC, FRANZ (Ried 1880 – Verdun 1916)

Franz Marc was the son of a Munich painter. In 1900 he enrolled in the Academy in order to take up his father's profession.
In 1903 he visited Paris and came into contact with Impressionism. After his return to Munich a period of deep depression led him to paint *The dead sparrow*, already a sign that animals were to be his favourite subject. Marc began to teach animal anatomy at about this time, while still continuing his own research. He became interested in the *Jugendstil* (Art Nouveau) and found that it helped him to gain a clearer understanding of the problem of form. Another visit to Paris in 1907 brought him under the influence of Van Gogh. In 1910 he designed the frieze *Horses at Leggries* which marked his progress from single studies of animals to full composition. It was then that Marc met Kandinsky and Macke and joined them in publishing the *Blaue Reiter* almanach.
Marc's next visit to Paris exposed him to the impact of Delaunay and Henri Rousseau. From 1912-14 he painted several important pictures in Munich. His last paintings all show a definite tendency to adopt more abstract forms. Marc was called up at the outbreak of the war in 1914. His last work consists of the drawings in his war diary.

MARCOUSSIS, LOUIS (Warsaw 1883 – Cusset 1941)

Marcoussis first studied law but gave it up in 1901 to go to the Cracow Acacemy. In 1903 he went to Paris and started work in Jules Lefèvre's studio at the same time as de la Fresnaye. From 1906–7 he showed his first Impressionist and Fauve landscapes in the Salon des Indépendants and in the Salon d'Automne.
In order to earn a living he began to contribute to the magazines *Journal*, *Vie Parisienne*, *Le Rire*, and *Le Sourire*. He became friendly with Braque, Picasso, and Apollinaire. It was Apollinaire who changed his name to Marcoussis after a small village near Monthléry. He took part in the early Cubist experiments and became an important member of the *Section d'Or* group in 1912. In 1914 he showed *Man with a cello* and a few *papiers collés* in the Salon des Indépendants.
Marcoussis fought as a volunteer during the war. When he returned to Paris he began his first designs for stained glass, showing them in 1920 in the Salon des Indépendants and in the International Exibhition of Modern Art in Geneva. From 1921–2 he exhibited in the Der Sturm gallery in Berlin. In the same year he painted his series of *Still-lifes with fish*, the *Windows on the Eiffel Tower* and the *Sacré Coeur*.
In 1930 he did ten etchings for *Planche de Salut* and *Aurélia* by Gérard de Nerval. In 1934 he illustrated *Alcools* by Apollinaire.
During the last years of his life he participated in several exhibitions in France and abroad. In 1941 Marcoussis completed his last collection of dry-point etchings on the theme of *Fortune-Tellers*.

MARIN, JOHN (Rutherford 1870 – Cliffside 1953)

After studying at the Hoboken Academy, the Stevens Preparatory, and the Stevens Institute Marin began work as an architect in 1893.
In 1889 he gave up his career to enrol in the Fine Arts Academy in Philadelphia which was directed at the time by P. Anschutz and H. Breckenridge.
Marin went on to study under Franck Vincent Dumond at the Art Students League in New York from 1901–3. In 1905 he left America to study at the Ecole des Beaux-Arts in Paris. He became a great admirer of Whistler and Rembrandt and took up engraving. During this period he travelled widely in France, England, and Belgium.
In 1906 Marin painted the *Mills at Meaux*. From 1908–9 he exhibited in the Salon des Indépendants and the Salon d'Automne and in the same year received an invitation from Edward Steichen to show his paintings in the 291 Gallery in New York, founded by Alfred

Stieglitz. While he was in the United States Marin painted several landscapes. On his return to Paris he showed ten watercolours in the Salon d'Automne.

Five years later Marin returned to America and took part in the Armory Show with Hartley, Weber, and others.

In 1936 the Museum of Modern Art in New York organized an important exhibition of his work. In 1950 he was given a retrospective exhibition at the Venice Biennale.

MARQUET, ALBERT (Bordeaux 1875 – Paris 1947)

Marquet studied in Paris at the School of Arts and Crafts. In 1897 he went on to the Ecole des Beaux-Arts and then worked in Gustave Moreau's studio, where he met Matisse. He and Matisse were commissioned to design the stucco relief for the Grand Palais at the Universal Exhibition in 1900. The same year Marquet exhibited in the Salon des Indépendants and at the Galerie Weill. In 1905 he took part in the Salon d'Automne with Matisse, Derain, and Vlaminck. He spent the summer of 1906 in Saint-Tropez and in Normandy and at about the same time established contact with André Rouveyre and Charles Louis Philippe, two writers associated with the group of the *Revue Blanche*. From 1909–14 Marquet painted many landscapes on the Channel coasts. He spent the years 1916–19 in Marseilles and Nice near Matisse. From 1923–5 he went to North Africa several times and in 1928 visited Egypt, Rumania, the Soviet Union, and Scandinavia.

During the Second World War he went to live in Algeria.

In 1945 Marquet returned to Paris and spent his last years painting *Views* of Paris.

MASSON, ANDRÉ (Balagny 1896)

Masson studied at the Fine Arts Academy in Brussels. In 1912 he took the advice of Emile Verhaeren and moved to Paris.

Masson fought in the First World War as a volunteer. In 1922 he met Kahnweiler who was immediately interested in his painting. During this period he also came under the influence of the Cubists, especially Juan Gris and Derain. It was Derain who turned out to be his real master.

That same year (1922) Masson painted *The forests* and *The players*. In the winter of 1923 he produced his first deliberately symbolical painting, *The four elements*, showing it in the Galerie Simon in the spring of 1924. This picture attracted the attention of André Breton. Masson also became friendly with Antonin Artaud, Mirò, and Max Ernst. From 1924–5 he painted several Surrealist pictures including: *The birth of the birds, The lovers, and The dead man*.

At the end of 1928 he took part in the exhibitions organized by the Surrealist group. From 1930–36, however, Masson gradually broke away from Surrealism in order to treat a greater variety of subjects. This was the period of the massacres, bull-fights, landscapes, and studies of insects. He went to Spain and did a number of satirical drawings of the Civil War. On his return to France he resumed contact with Breton and Surrealism, painting *Anthropomorphic furniture* and the imaginary portraits of Goethe, Kleist, and Heraclitus. After spending some time in Martinique, he eventually settled in Provence in 1947 and painted landscapes in a somewhat Impressionist vein. In 1949 he wrote his *Monet, the founder* as a tribute to the tradition he was following at the time. He also took an interest in oriental art and Zen philosophy.

In 1953–4 Masson paid several visits to Rome and Venice. In 1955 he painted the series of *Migrations* and a few pictures inspired from life in the city. In 1958 a retrospective exhibition of his work was held in the Albertina in Vienna.

He illustrated *Une Saison en Enfer* (A Season in Hell) by Rimbaud and Sade's *Philosophie dans le boudoir*.

In 1962 Masson became a member of the National Museums Council.

In 1964 retrospective exhibitions were held at the Berlin Art Academy and at the Stedelijk Museum in Amsterdam.

MATISSE, HENRI (Cateau-Cambrésis 1869 – Cimiez 1954)

Matisse took up painting in 1890 after studying law for a time.

In the winter of 1891–2 he went to Paris and attended lessons at the Julian Academy and the School of Decorative Arts, where one of his fellow students was Albert Marquet. Gus-

tave Moreau noticed his work and asked him to join his studio with Rouault, Manguin, Camoin, and Linaret. From 1896–9 Matisse showed some pictures at the Société des Beaux-Arts and was able to meet Rodin and Pissarro. He spent 1898–9 in Corsica and Toulouse and returned to Paris in 1899 to enrol in the Academy in the rue de Rennes. He had come under the influence of Cézanne by this time and begun work on his first sculpture. Matisse worked with Marquet on a decorative frieze for the Grand Palais at the Universal Exhibition of 1900. In 1901 he took part in the Salon des Indépendants. In 1903 he showed in the Salon d'Automne and in 1904 he had his first one-man exhibition at Vollard's gallery. He spent the summer of that year in Saint-Tropez with Signac and Cross.

In 1905 Matisse became the chief protagonist in the historic Salon d'Automne where the central room (called the *cage des fauves*) caused such a scandal. In 1907 he painted his famous *Joy of life* and the same year visited Italy, much admiring the work of Piero della Francesca and Giotto. At the request of Sarah Stein and Hans Purmann, Matisse agreed to form a group of students and teach painting. During this period he began to adopt Cubist techniques but always solved the problems in a highly personal manner. In 1921 he retired to the Mediterranean where some of his finest pictures were inspired by the beauty of its landscapes. He continued to travel widely in Italy, England, America, and Polynesia.

From 1920–39 Matisse devoted himself to designing costumes and settings for ballet. His work on the Dominican chapel in Vence constitutes a synthesis of his entire production and can be regarded as his artistic legacy.

MIRÒ, JOAN (Barcelona 1893)

Mirò studied at a commercial school and followed courses at La Lorya Fine Arts Academy. A period of convalescence in Montroig from 1910–11 made him keenly aware of the beauty of nature.

On his return to Barcelona the following year Mirò enrolled in the school of Francisco Gall. Gall's rebellious anti-conformist temperament had a powerful influence on Mirò's growing talent.

In 1916 Mirò was very impressed by an exhibition of French painting organized in Barcelona. He met Picabia in 1917 and showed his own pictures for the first time in the Dalman gallery. In 1919 he left for Paris. He became friendly with Picasso, Maurice Raynal, and the Dadaists, but continued to paint several pictures in the Fauve manner. In 1921 Mirò had his first exhibition in Paris and the following year joined the group of the rue Blomet (André Masson, Michel Leiris, Georges Limbour, Antonin Artaud). He also became friendly with Prévert, Hemingway, and Miller.

Some of Mirò's best work was done during the Surrealist period which began after the encounter with Aragon, Breton, and Eluard in 1924. In 1925 he had an extremely successful exhibition in the Galerie Pierre. Two years later he moved to Montmartre and became the neighbour of Ernst, Arp, and Eluard.

In 1928 Mirò painted his very beautiful *Dutch interior*. From 1932–7 he worked on the lithographs for *Arbre des voyageurs* by Tristan Tzara, the settings for the ballet *Jeux d'enfants*, the *Primitive pictures* and the *Nudes* for the Grande Chaumière. In 1939–40 he began the series of *Constellations* concluding it in 1941. This was also the year of a large retrospective exhibition at the Museum of Modern Art in New York and the publication of the first monograph on his work by J.J. Sweeney.

In 1944 Mirò collaborated on a series of ceramics with Artigas. From 1954–6 he again worked with Artigas on some earthenware. In 1957–8 he designed the large ceramic panel for the UNESCO building in Paris.

MODIGLIANI, AMEDEO (Leghorn 1884 – Paris 1920)

Modigliani studied at the grammar school in Leghorn and then took painting lessons with a pupil of Fattori. In 1901 he spent a period of convalescence in Capri and from there went to Rome, Florence, Naples, and Venice. He attended evening classes at the Academy in Venice rather intermittently and in 1906 decided to go to Paris, unable to bear the provincialism of Italian artistic circles any longer. In Paris he enrolled in the Colarossi Academy and established contact with artists in Montparnasse and Montmartre, becoming especially friendly with Utrillo, Salmon, and Soutine. In 1907 he joined the Société des Artistes In-

dépendants and showed five pictures in their Salon the following year. Brancusi soon became one of his closest friends.

Modigliani studied sculpture, Negro art, and the work of Brancusi and Lipschitz with passionate enthusiasm, adding an Expressionist note to his experiments. He began to take up sculpture himself, first in Paris and then in Leghorn, after discouragement and prolonged poverty had driven him back there in 1909. A few months later, however, he returned to Paris and showed seven sculptures in the Salon des Indépendants and the Salon d'Automne. Human contacts were extremely important for Modigliani during these years.

He could count on the esteem of intelligent and sensitive dealers like Paul Guillaume and Zborowski and was sentimentally linked with Beatrice Hastings and afterwards with Jeanne Hébuterne. His finest pictures were also painted during this period (1915–18).

In 1917 Modigliani had his first one-man exhibition in the Galerie Weill. It was an utter failure and heralded the tragic years of 1917–20.

Modigliani's poor health was soon aggravated by his extreme poverty. In 1918 when he became very ill he agreed to follow Zborowski to Nice but returned to Paris the following year, painting again with feverish anxiety.

His death a few months later was immediately followed by the suicide of Jeanne Hébuterne.

MONDRIAN, PIET (Armsfoort-Utrecht 1872 – New York 1944)

Mondrian studied at the Fine Arts Academy in Amsterdam and made copies of paintings in the museums in order to suplement his very limited income. He also began to study theosophy with his brothers, Carel and Lewis.

In 1901 he visited Spain with Simon Maris and then went to Brazil, setting up residence with Van den Briel. The following year he returned to Holland and did not leave Amsterdam again until 1911. In 1909 an exhibition of his paintings in Amsterdam met with little success. He also painted a number of landscapes during this period. After a spell in Paris Mondrian returned to Amsterdam in 1914 and began his experiments in the field of abstract art which lasted until 1919. Together with Bart van der Loeck and Theo van Doesburg he founded the review *De Stijl*. He was in Paris again from 1919–38 and in 1920 he published *Neo-Plasticism*. He also painted the series of *Compositions*, working steadily towards a radical simplicity. In 1938 Mondrian moved from Paris to join his friends Ben Nicholson and Barbara Hepworth in london. He also belonged to the group called Circle. In October 1940 he moved to New York and painted his series of *Boogie-Woogie*.

MORANDI, GIORGIO (Bologna 1890 – Bologna 1964)

Morandi studied at the Fine Arts Academy in Bologna. He had a great passion for Impressionism and in 1909 went to the Venice Biennale to see the Renoir room. In Florence a little later he also conceived an admiration for Giotto, Masaccio, and Paolo Uccello. Morandi's real master, however, was Cézanne. This influence is particularly marked in the early paintings of 1911–14. Morandi also took up etching in 1912 and this was to become his favourite medium. From 1912–13 he did two etchings of *Villages* and in 1915 a *Still-Life*. His discovery of Cubism became more noticeable in the pictures of 1914–15. In 1914 he also attended the Futurist Exhibition in Florence where he met Boccioni and Carrà. He showed his own paintings for the first time at the Baglioni Hotel. In the same year he began to teach drawing at a primary school. Morandi continued to fill this post until he was offered the chair of engraving at the Fine Arts Academy in 1930. In 1916 he began an intensely creative period which was to last until 1920 and was called his 'metaphysical' phase. He painted a number of still-lifes, landscapes, and flowers.

With Bacchelli and Raimondi, Morandi contributed to the local review *La Raccolta*, and met several of the writers connected with *La Ronda*. He also came into contact with Mario Broglio, the director of *Valori Plastici*. From 1921–2 Morandi exhibited with De Chirico and Carrà in Berlin and Florence.

From 1928 onwards he took part in the Venice Biennales and the Quadriennales in Rome. During the Second World War he divided his time between Bologna and Grizzina and devoted himself mainly to landscape painting.

In 1948 he won the First Prize at the Venice Biennale.

MORLOTTI, ENNIO (Lecco 1910)

After working as an accountant's clerk, Morlotti decided to take up painting and began to study at a private school. In 1936 he obtained his diploma and enrolled in the Academy in Florence. A year later he went to Paris for two months. He began a series of landscapes in Lombardy and in the Brianza region by the Adda. In 1939 he won a scholarship to the Brera Academy. The following year Morlotti joined the group of artists at the head of the review *Corrente*. He continued to paint landscapes in Brianza until 1945.

Immediately after the war Morlotti contributed a large number of articles to various leading magazines dealing with the controversy over a revival of Italian painting in a European sense. Towards the end of 1946 he returned to Paris with Birolli and grew more proficient in Picassian techniques. In 1947 he began to take part in the *Fronte Nuovo delle Arti* (New Arts Front) and a little later joined the *Gruppo degli Otto*. After several important exhibitions Morlotti retired permanently to Imbersago in Brianza in about 1953–4. This was when he painted his most personal pictures. In 1960 he either stayed beside the Adda or spent intensive working sessions in the hills near Bordighera.

In 1962 Morlotti won the Grand Prize at the Venice Biennale. He has exhibited his work in London, New York, Winterthur, and the major Italian cities.

MOSES, GRANDMA (ANNA MARY ROBERTSON MOSES) (Greenwich 1860 – Hoosick Falls, New York 1961)

Anna Maria Robertson married on a ranch near Staunton in Virginia in 1876. She took up painting at the age of seventy-seven. In 1939 her work was discovered and popularized through the auspices of the Unknown American Painters Exhibition.

In 1949 she was awarded the Women's National Club Prize.

MÜLLER, OTTO (Liebau 1874 – Breslau 1930)

Müller's father was an army officer and his mother probably an abandoned gipsy who was brought up by the Gerhard Hauptmann family. Müller became an apprentice in a printing-works as soon as he left primary school. From 1895–8 he attended Dresden Academy. In 1907 he spent some time in the Riesengebirge and the following year went to Berlin. He met Erich Heckel in Berlin and in 1910 became a member of the *Brücke*. During the war he served with the army. In 1919 he was offered the chair of painting at Breslau Academy.

MUNCH, EDVARD (Loten 1863 – Ekely, Oslo 1944)

Munch studied at the Arts and Crafts school in Oslo and also took lessons from the sculptor Julius Middelthun and from Christian Krogh. In 1885 he visited Paris and came into contact with Impressionism and Post-Impressionism. On his return to Oslo in 1889 he had his first one-man exhibition at the Norwegian Students Centre. In the autumn of the same year he spent another four months in Paris.

In 1892 a showing of Munch's paintings at Berlin, entitled *Arabesque of Life*, created such an outcry that the authorities were obliged to close the exhibition. A large number of artists in favour of his work seized this opportunity to found the Berlin *Sezession*. Munch met many artists, art critics and collectors in Berlin. He began a series of etchings at about this time which were soon followed by his first lithographs, designs for Ibsen's *Peer Gynt* (1896), and the illustrations for *Les Fleurs du Mal* by Baudelaire.

He spent 1896–7 in Paris improving his technical knowledge with the printer, August Clot. Although Munch's work continued to be ignored in other countries, it was highly successful in Germany. One of his friends and admirers was Mrs. Förster-Nietzsche, for whom he painted the *Ideal portrait of Nietzsche*. Munch had several one-man exhibitions in the different European capitals: in Berlin in 1902, in Cologne in 1912, and in Zürich in 1922. He also showed at the Paris Exhibition in 1934.

From 1906–7 he designed the sets for *Ghosts* and *Hedda Gabler* for the Reinhard Theatre in Berlin.

His later works include the mural decorations for the Aula Magna in the University of Oslo (1906–16) and the decoration for the Freia chocolate factory in Oslo (1921–2). The hostility of the Nazi regime obliged Munch to spend his last years in total solitude on the Ekely estate.

NAY, ERNST WILHELM (Berlin 1902)

Nay was born in Berlin, where he studied under Hofer from 1925–8.
In 1928 he went to Paris and met Picasso. In 1930 he won the Rome Prize.
He spent 1935–7 in Norway at Munch's invitation and painted several landscapes of the Lofoti islands.
From 1939–44 he fought in the Second World War. He then did some more painting in Brittany and in 1945 moved to Hofheim. He eventually settled in Cologne.

NEVINSON, C.R.W. (London 1889 – London 1946)

Nevinson studied at the Slade School of Art from 1908–12 with a year in Paris from 1911–12. He was very much influenced by Cézanne and the Cubists. In 1912 he attended the Futurist Exhibition in London and in 1913 became friendly with Marinetti and Severini. In 1914 he drew up the Futurist Manifesto entitled *Vital English Art* together with Marinetti. He also joined the London Group. From 1914–16 Nevinson served with the army in Flanders.
He took part in the Vorticist Exhibition in 1915 and the following year showed some Futurist war pictures in the Leicester Gallery. He was made Official War Artist in 1917. In 1918 he began his first Aeropaintings. After 1920 however, his work drew closer to the *Neue Sachlichkeit*.
In 1922 Nevinson went to New York for an exhibition of his paintings. He became a member of the Royal Academy in 1939.

NICHOLSON, BEN (Denham 1894)

Nicholson's father, Sir William Nicholson, and mother, Mabel Pryde, were both painters. He studied at the Slade School in London and also in Tours, Milan, and Pasadena. From 1920–31 he lived in Castagnola (Switzerland), in Cumberland, and in London, painting several landscapes and still-lifes.
From 1922–3 Nicholson exhibited at the Paterson Gallery and at the Adelphi Gallery. In 1930 he showed his work with Christopher Wood at the Galerie Bernheim in Paris and at the Lefèvre Gallery in London. He continued to show regularly at the Lefèvre Gallery until 1954. From 1933–4 Nicholson participated in the exhibition organized by the *Abstraction-Création* group in Paris and in the 'Cubism and Abstract Art' exhibitions held in New York and Amsterdam. During this period he painted his *White reliefs*. In 1936 he had his first exhibition at the Museum of Modern Art in New York.
In 1937 Nicholson began to contribute to *Circle*, a magazine published by Faber and Faber, at the same time as J.L. Martin and Naum Gabo.
In 1941 he published his *Notes on Abstract Art* in *Horizon*. Nicholson's work was included in a British Council exhibition of contemporary art held in Athens, Paris, and Prague from 1947–8. He was commissioned by the Easton and Robertson Navigation Company to paint two concave panels for the steamer *Rangitone*. The Festival of Britain authorities asked him for a fresco and he also painted a mural for the Time-Life Building in New Bond Street. From 1952–5 important retrospective exhibitions of his work were held in the Detroit Institute of Arts and the Walker Center in Minneapolis.
In 1954 more exhibitions were organized in the English Pavilion at the XXVII (27th) Biennale in Venice and in 1955 at the Stedelijk Museum in Amsterdam, the Museum of Modern Art in Paris, the Palais des Beaux-Arts in Brussels, and the Kunsthalle in Zürich.

NOLDE, EMIL (EMIL HANSEN) (Nolde 1867 – Seebüll 1956)

Nolde's family was of Danish and Friesian origin. He began painting in 1898, studying at the Academies in Munich, Paris, and Copenhagen. In 1901 he assumed the pseudonym,

Nolde, after his native village. During these early years he mainly used Impressionist techniques.

In 1904 Nolde's painting began to take on a more compelling and original note.

He created fantastic grotesque figures, painted pictures of flowers, and began the engravings of Soest-Alsen Schoelst, although he continued to paint landscapes of Nolde (the sea, the marshes, and the gardens).

In 1906–7 he joined the *Brücke* but his rebellious, cantankerous nature always kept him somewhat aloof. The following year he did a series of engravings of Flensburg harbour and produced his first collection of lithographs.

He took part in the Berlin *Sezession* and in the *Brücke* exhibitions in Flensburg and Hamburg. In 1909 Nolde began to paint his large religious compositions.

From 1913–14 he went on an ethnological expedition to Polynesia which inspired a large number of his pictures. On his return to Germany, he moved to Berlin and resumed religious painting and lithographs. In 1935 he wrote the *Account of the journey to New Guinea* during a serious illness. Like the other members of the *Brücke*, Nolde was condemned by the Nazi regime and his work banned.

In 1946 he became a teacher of painting.

During the last years of his life he participated in many collective shows and had several one-man exhibitions.

PECHSTEIN, MAX (Zwickau 1881 – Berlin 1955)

Pechstein first studied under a painter and then in 1900 enrolled in the School of Arts and Crafts and the Academy of Fine Arts in Dresden.

After an apprenticeship with the architect, Wilhelm Kreis, Pechstein helped Heckel and Kirchner to found the *Brücke* in 1906. The following year he visited Italy. He also spent several summers at Nidde. In 1910 he was one of the founders of the New Berlin *Sezession*.

After the First World War Pechstein settled in Berlin. In 1922 he was made a member of the Art Academy.

He lost his post with the rise of the Nazi regime and retired to the coast of Pomerania. Finally, at the end of the war, he was offered the chair of painting at the Academy of Figurative Arts in Berlin.

PERMEKE, CONSTANT (Antwerp 1886 – Jabbeke 1951)

Permeke studied at the Academies of Bruges and Ghent. Eventually, however, he went to live in Laethem Saint-Martin, the home of Flemish Expressionism.

He joined the second Laethem group with Servaes, Van den Berghe, and the Smet brothers. After an early Post-Impressionist phase, Permeke's painting took a new turning in 1913 with *Motherhood*.

At the outbreak of the war, he was called up but was severely wounded before Antwerp. He spent a long period of convalescence in England and in 1916 began to paint again in Devonshire, concentrating mainly on landscapes. On his return to Belgium he settled in Antwerp for a time and then moved to Ostend, where the harbour and the fishermen's activities provided him with a constant source of inspiration.

Permeke showed in a number of exhibitions: in the Sélection in Brussels from 1920–21, in the Licorne in Paris in 1921, and in the Giroux gallery in Brussels in 1924. In 1925 he settled permanently in Jabbeke.

In 1936 Permeke took up sculpture with equal success. From 1930–47 important retrospective exhibitions of his work were held in Brussels, Amsterdam, Prague, Paris, and London.

PICABIA, FRANCIS (Paris 1879–1953)

Picabia's parents were Spanish but he was born in Paris. He took up painting at a very early age and when he was only seventeen exhibited his first pictures in the Salon des Artistes. He enrolled in the Ecole des Beaux-Arts and painted a series of Impressionist landscapes. In 1908 he grew interested in Cubism and in 1911 joined the Section d'Or, although he broke away the following year to take up Orphism.

During a visit to America from 1914–15 to attend his one-man exhibition at the Stieglitz gallery in New York, Picabia met Marcel Duchamp and helped him to lay the foundations of Dada.

From Barcelona in 1916 he founded *391*, a review which continued to appear somewhat erratically in Barcelona, New York, Zürich, and Paris until 1924.

In 1918 an exhibition of Picabia's drawings in Geneva caused a great outcry on account of the bizarre compositions.

On his return to Paris Picabia acted as the link between the Dadaists in Zürich and their counterparts in Paris. He took part in the various demonstrations which scandalized the Parisian public and composed his *ironical machines* as a form of challenge. Picabia broke with Dadaism in 1921 to join André Breton and the Surrealists.

He designed the costumes and settings for the ballet *Relâche*, and exhibited with Miró, André Masson, Max Ernst, and Salvador Dali.

Growing tired of Surrealism in turn, Picabia eventually went back to figurative art, although in 1945 he gave that up too to return to abstract painting.

PICASSO, PABLO (Malaga 1881)

Picasso studied at the School of Fine Arts in Barcelona and at the Academy in Madrid. He soon began to contribute to various reviews like *Pel y Ploma*, *Joventud*, and *Catalunya Artistica*, and came into contact with *avant-garde* poets, writers, and artists including Baroja, Manolo, Sabartès, Nonell, Casas, Sunyer, Soler, and Casagemas.

In October 1900 Picasso went to Paris for three months with Casagemas and Pallarès. On his return to Spain he founded the review *Arte Joven* in Madrid.

He went back to Paris in 1901 and established contact with Max Jacob, Jarry, Raynal, Salmon, Reverdy, Apollinaire, and Duhamel. This was the beginning of the 'blue period'.

Picasso decided to settle permanently in Paris in 1904 and moved into the Maison du Trappeur (The Trapper's House), later to become famous as the *Bateau-Lavoir*. In 1905 he paid a visit to Holland and did a great deal of painting. He also went to Barcelona, Gosol, and Lerida.

Once back in Paris he discovered the painting of Cézanne and became friendly with Braque, Kahnweiler, and Matisse. It was Matisse who introduced him to Negro sculpture. At this point he began the 'rose period'.

In the winter of 1907 Picasso embarked upon the *Demoiselles d'Avignon*. In 1909 he spent the summer in Horta de San Juan and painted a series of Cubist landscapes which paved the way to 'analytical Cubism'. In 1910 he worked with Derain in Cadaqués and in 1911 went to Céret with Braque. In 1912 he did his first *papiers collés*, and began synthetic Cubism, returning to Céret with Juan Gris. The following year he went to Avignon with Derain and Braque.

At the outbreak of the war Picasso retired to Montrouge. It was during the war years that he painted the realistic portraits of Max Jacob, Vollard, and Cocteau, and began to design settings and costumes for Diaghilev's ballets.

Picasso painted some of his most important neo-classical pictures from 1919–21 but in 1925–7 he turned to Surrealism. From 1931–6 he illustrated the *Metamorphoses* of Ovid, *The Unknown Masterpiece* by Balzac, *Lysistrata* by Aristophanes and Buffon's *Histoire Naturelle*. When the Civil War broke out in Spain in 1936 Picasso sided with the Republicans, who had recently offered him the post of Director of the Prado Museum.

In 1937 he painted *Guernica* for the Spanish Pavilion in the Universal Exhibition in Paris.

In 1944 Picasso's paintings, which had been decried by the Nazi and Fascist regimes, were welcomed like a standard of liberty when they were shown in the Salon d'Automne, renamed Salon de la Liberté for the occasion.

In the years immediately following the war Picasso moved to Vallauris and devoted himself to lithographs, ceramics, and sculptures. Aragon commissioned him to paint the *affiche* (poster) of the dove for the Peace Congress held in Paris in 1949.

During 1951–2 he painted *Massacre in Korea* and the two large panels entitled *War and Peace*. In 1955 he produced a series of fourteen variations on the *Women of Algiers* by Delacroix. In 1954 he moved to La Californie near Cannes and in 1957 painted the twenty versions of *Las Meninas* after Velazquez, and the large panel called *The Fall of Icarus* for the UNESCO building.

In 1960 a large exhibition of his work was held in Paris and at the Tate Gallery in London.

PICKETT, JOSEPH (New Hope, Pennsylvania 1848–1918)

Pickett was the proprietor of a haberdashery store and shooting-range in New Hope. He took up painting at the age of sixty-five.
In 1918 he submitted his picture *Manchester Valley* for exhibition in Philadelphia but it was rejected by the jury despite the favourable votes of Lathrop, Robert Henri, and Robert Spencer.
Pickett's work did not become known until some time after his death. He began to be appreciated when Holger Cahill decided to show his paintings at the American Primitives Exhibition in the Museum in Newark in 1930.

PIGNON, EDOUARD (Bully 1905)

Pignon first worked as a collier and a bricklayer in his native town. In 1927 he moved to Paris and found jobs with Citroen, Farman, and Renault. He went to evening classes at the Montparnasse School and followed courses in philosophy and political economy at the workers' university. Finally he entered the studio of the sculptors Wlérick and Arnold, and made friends with the painter, Georges Dayez.
In 1932 Pignon exhibited in the Salon des Indépendants and in 1933 in the Galerie Billiet. In February 1934 he took part in the Association of Revolutionary Artists and Writers with Léger, Lhote, Senecz, and Vieira da Silva. At the same time he appeared in Raymond Rouleau's production of *Races* by Brückner and *Frénétiques* by Salacrou with Charles Dullin. In order to solve his financial problems, Pignon eventually began to work as a lithographer in the studio belonging to Dayez's father. In 1937 he exhibited in the Salon du Temps Présent in the Galerie Durand Ruel. He also took part in the show held in the foyer of the Alhambra theatre for the first night of Romain Rolland's *Fourteenth of July* with Braque, Picasso, Matisse, Léger, Lipschitz, Gruber, and many others.
Pignon also worked as a clicker for *Regards*. In 1939 he exhibited in the Galerie d'Anjou. During the Second World War he became an active member of the French Resistance. In 1944 he moved back to Paris and after the Liberation showed *Motherhood* in the Salon d'Automne. He spent the summer of 1945 in Collioure and painted the *Catalan women*, exhibiting it the following year in the Galerie de France.
In 1948 Pignon stayed briefly in Marles-les-Mines and painted a series of pictures of the collieries. In the same year he designed the costumes and settings for Supervielle's *Scheherazade*, produced by Jean Vilar. In 1950 he settled in Sanary and began the *Wine-harvests* and the *Olive-trees*, themes to which he always returned. He stayed in Vallauris with Picasso, resumed the *Motherhood* theme and also did some ceramics.
On his return to Marles-les-Mines in 1960 Pignon painted his series of *Cock-fights*.
Since 1961 he has had several exhibitions in France and abroad.
In 1966 he published *La quête de la réalité* (In Quest of Reality).

RAPHAEL, ANTONIETTA MAFAI (Wilno 1900)

Antonietta Raphael first obtained a diploma in piano-studies from the Royal Academy of Music in London and then became a teacher of English.
She grew friendly with the sculptor, Jacob Epstein, and in 1924 went to Paris and frequented the *avant-garde* art circles. A year later she went to Italy with Mafai and Scipione, becoming a fanatic explorer of Rome and an occasional painter. She was entirely self-taught and variously adopted primitive, Surrealist and Expressionist techniques. During these years she also painted a few Roman *Vedute* of the Forum, the Colosseum, the Arch of Constantine under the snow, and the Palatine Hill. Her colours were the reds and blacks of the Roman atmosphere and she chose a style influenced by Chagall and Rousseau, and also by oriental folklore.
She suffered from racial persecution during the war.
Some of her paintings were lost when she sent them to London for exhibition in the Redfern Gallery; the rest were burned when Epstein's studio was bombed in 1942.
After the war, Antonietta Raphael gave up painting to concentrate exclusively on sculpture, which she had also practised during the early years in Rome.

RICHTER, HANS (Berlin 1888)

Richter first studied at the Fine Arts Academy in Berlin under George Koch.
In 1909 he moved to the Weimar Academy and continued under Gary Melchers. In 1913 he attended the Futurist lecture given by Marinetti in Berlin and the following year began to contribute to the newspaper *Aktion*, eventually becoming its official portraitist. He adopted Cubism for a time and in 1917 followed the Zürich Dada movement. During this period he painted his *Visionary portraits* and *Dada heads*; he also began his first abstract experiments together with the Swedish painter, Wiking Eggeling, who was one of his closest friends. In 1919–20 Richter painted *Prelude* and *Horizontal and vertical fair*. The following year he took up the cinema. His first abstract film, *Rhythm 21*, was shown in 1924 in the Ufa theatre in Berlin with *Entr'acte* (Interval) by René Clair and Léger's *Ballet mécanique* (Mechanical Ballet).
In 1929 Richter published *Enemies of the cinema to-day, friends of the cinema tomorrow*, a book which provided the first document on *avant-garde* cinema techniques. In 1942 he was made Director of the Film Institute at City College in New York and remained there for fifteen years. He joined the American Abstract Artists group and pursued an intensely active career as a painter. From 1944–7 he made the sound film in colour entitled *Dreams that money can buy* with Léger, Duchamp, Man Ray, Max Ernst, and Calder and was awarded the International Prize at the Biennale in Venice.
From 1944–54 he created his great 'scrolls': *Symphony*, *Rhapsody*, and *Triptych*. In 1948 he also began to teach at City College.
From 1954–7 Richter worked on the film *8 x 8*, and *Anthology of my films from 1921–51*, and *Dadascope* with poems by Arp, Duchamp, Haussmann, Hulsenbeck, Schwitters, and Chess Cetera.
In 1957 Richter returned to Berlin after an absence of almost thirty years.

RIOPELLE, JEAN–PAUL (Montreal 1924)

From 1940–42 Riopelle studied mathematics at the Polytechnic school in Montreal, taking up painting at the same time. Under the influence of Breton's *Surrealism and Painting* he produced his first non-objective pictures in 1945. In 1946 he paid several visits to France, Germany, and New York.
In 1947 he moved to Paris and took part in the Salon de Mai as well as several other exhibitions.
In 1951 Riopelle showed in the São Paulo Biennale. In 1960 a large room was devoted to his work in the Biennale in Venice.
He lives in Paris.

ROSAI, OTTONE (Florence 1895 – Ivrea 1957)

Rosai enrolled in the Institute of Decorative Arts in Florence at the age of eleven and began to work in his father's workshop.
He went on to the Fine Arts Academy afterwards but left fairly soon, finding himself in constant disagreement with his teachers and fellow-students.
In 1911, when he was only sixteen, Rosai had an important exhibition of engravings in Pistoia. In 1913 he exhibited his first pictures in Florence and made the acquaintance of Marinetti, Palazzeschi, Boccioni, and Carrà.
He embarked on his Futurist period but this was interrupted by the war.
Rosai enlisted as an ardent interventionist and was sent to the Austrian border. At the end of the war he began to paint again tirelessly. Some of his finest pictures, mainly portraits and landscapes, date from the period between 1920 and 1922.
At this point Rosai began to change his style radically, moving from the domestic intimity of the previous years and the crystalline rigour of 1922–4 to greater receptivity towards outside cultural events. He became more and more inclined to vary his subjects, painting *The Latch*, *Musicians*, and *Man on a bench*.
In 1922 he painted a series of landscapes on large pieces of cardboard, and panels for the railway-station in Florence. He also executed large figures and compositions such as *Large nude in a landscape* and series like *The family*, *The friends*, and *The serenade*, and other pictures

which he showed in the 1938 Biennale in Venice. Rosai's most important shows were the one-man exhibitions in Genoa in 1937 and 1940, and at the Venice Biennale in 1942. Monographic exhibitions of his paintings (1953) and his drawings (1956) were held in the Strozzina in Florence.

ROSSI, GINO (Venice 1884 – Treviso 1947)

Rossi studied under the Scolopian Fathers at the Badia Fiesolana in Florence.
In 1907 he went to Paris with Arturo Martini and also visited Brittany. The Fauves exhibition he saw in Paris was to have a profound influence on his artistic development together with the Vienna *Sezession* paintings exhibited in the Venice Biennale. In 1910 Rossi showed his first pictures in the exhibitions organized by Barbantini in Ca' Pesaro. At the time he lived in Venice and Ca' Pesaro. In 1912 he returned to Paris and showed in the Salon d'Automne. He also went back to Brittany to paint landscapes and draw portraits.
At the outbreak of the war Rossi was called up and served in the eighth infantry regiment. He was taken prisoner at the rout of Caporetto and sent to a concentration camp until the end of the war. In 1918 he went to Paris once more and took a great interest in Cubism. He also travelled in Holland and Belgium.
On his return to Italy he went to live in the country in the province of Treviso and in 1919 again showed some pictures in Ca' Pesaro. In the meantime, however, poverty, hardship, and his experience during the war had completely shattered his nerves. His painting was not understood and he began to feel persecuted. He wrote aguished letters to his friends, thoroughly convinced that art in Italy was in a critical state. Degraded by poverty, Rossi was finally reduced to selling notepaper as a pedlar in the country villages.
He painted his last known work in 1923: *Poem of evening*.
Rossi began to grow violent and dangerous and had to be sent to a mental institution in 1925. Although he was discharged almost immediately he had frequent relapses. In 1929 he went into hospital permanently and spent the rest of his life going from one asylum to another.

ROUAULT, GEORGES (Paris 1871–1958)

Rouault was born in Paris during the shelling in 1871, the year of the *Commune*.
He was later to regard this as a premonition of the dramatic tension that characterized his life. After an initial training with his maternal grandfather, Rouault went to evening classes at the School of Decorative Arts and became apprenticed to a stained-glass designer. He then went on to the Ecole des Beaux-Arts to study under Elie Delaunay and later under Gustave Moreau. He soon became Moreau's favourite pupil and it was in his studio that he came into contact with the Fauves: Matisse, Marquet, Manguin, and Camoin. On his teacher's advice Rouault left the Beaux-Arts in 1894 and showed a few religious pictures in the Salon des Artistes Français.
When Moreau died in 1898, however, and his own family had moved to Algeria, Rouault began to find himself in serious financial difficulties. This was aggravated by his delicate health. At about the turn of the century he went through a profound spiritual crisis. His concern centred on the poor and on the social outcasts, and he symbolized them in his figures of prostitutes and clowns, portraying them with a popular violence reminiscent of Daumier and Goya. His series of prostitutes dates from about 1906.
In 1902 Rouault began to exhibit regularly in the Salon des Indépendants.
In 1903 he helped to found the Salon d'Automne. During these years he was greatly influenced by his reading of Bloy and Maritain. In 1908 he began to take an interest in the world of the law-courts, conveying the inadequacy and the limitations of human justice in his figures of judges and magistrates.
In 1917 Rouault met the publisher, Vollard, and did a number of illustrations for his editions. From 1917–27 he worked on the important series of engravings published in 1948 as *Miserere*. About 1930 he resumed the religious subjects of his early years. In 1929 he designed the settings of Prokofiev's *Prodigal Son* for Diaghilev and in 1933 drew several cartoons for tapestries. In 1945 he designed a further series of cartoons for the stained-glass windows in the church of Plateau d'Assy.
In 1945 a large retrospective exhibition of Rouault's work was held in the Museum of Modern Art in New York.

ROUSSEAU, HENRI (Laval 1844 – Paris 1910)

Rousseau worked as a lawyer's clerk until he enlisted in the army in order to escape arrest for embezzlement. A myth grew up about his character and his military exploits and there were rumours that he took part in the Mexican campaign with the Emperor Maximilian. In 1867 Rousseau went to live in Paris and found employment as an excise-man.
He took up painting at about the same time and showed his first pictures *An Italian ball* and *Sunset* in the Salon des Refusés in 1875. Signac invited him to show in the Salon des Indépendants in 1885 and after that he exhibited there regularly. In 1890 he met Gauguin, Redon, Seurat, and Pissarro. In 1891 he painted several exotic pictures. Rousseau retired in 1893 and was thus able to devote all his time to painting and to music.
He gave drawing, violin, and sol-fa lessons. He also became a friend of Alfred Jarry and painted a very fine portrait of him. A little later he met Natanson, who was the first to call his style of painting 'primitive'.
In 1899 Rousseau wrote a melodrama *The vendetta of a Russian orphan* which was never performed. After the death of his second wife he led a life of complete solitude. From 1908 onwards his painting began to be appreciated in France and abroad.

SCHIELE, EGON (Tulln 1890 – Vienna 1918)

In 1906 Schiele became a student at the Fine Arts Academy in Vienna.
The following year he met Gustave Klimt and at his invitation showed four pictures in an exhibition of international painting organized in Vienna in 1908.
He also showed with some painters from Klosterneuberg and began to work for the *Wiener Werkstätte*, a centre of *avant-garde* painting. In April 1908 he formed the *Neukunstgruppe*, an association of independent artists, and took part in its first exhibition in the Kunstsalon Prisco. Although his art was becoming known and appreciated Schiele still continued to live in extreme poverty. He painted many almost obsessive portraits and self-portraits. Shortly after moving to Kruman in 1911 he was accused of pornography and obliged to leave. In the same year he showed his work in exhibitions held in Vienna and Munich and again with the *Neukunstgruppe* in Budapest. In April 1912 Schiele was arrested on the charge of immorality in Neulingbach and his paintings were confiscated by the police. During the twenty-four days he spent in prison he wrote a diary and painted some twenty watercolours. Deeply humiliated and disturbed by this experience he next began work on a series of pictures portraying hermits and other ascetic figures.
Schiele produced his best landscapes in 1913 along with a few portraits. He exhibited in the Vienna *Sezession* and the Munich *Sezession* and also took part in a number of collective shows. He contributed to the review *Aktion* in Berlin, but was called up at the outbreak of the First World War. After being discharged almost immediately he became a guard in the village of Mühling. He did several drawings of Russian prisoners-of-war while he was in Mühling and continued to show in exhibitions in Germany and Vienna. The *Portrait of an old man* and the *Saw-mill* belong to this period. In 1917 Schiele was transferred to Vienna and given a post in the Army Museum. That same year his work was extremely successful in the March exhibition of the Vienna *Sezession* and in an exhibition of Viennese painting held in Zürich. During his last years Schiele painted a series of monumental portraits.

SCHLEMMER, OSKAR (Stuttgart 1888 – Baden-Baden 1943)

Oskar Schlemmer studied under Adolf Hölzel at the Stuttgart Academy and became friendly with Willy Baumeister and Otto Meyer Amden.
In Berlin in 1910 he was able to make contact with the *avant-garde* group, *Sturm*, and came under the influence of French painting, particularly the work of the Impressionists and the Neo-Impressionists.
Schlemmer returned to Stuttgart the following year and resumed work with Hölzel. He also painted some murals for the *Werkbund* exhibition in Cologne. At the beginning of the war he was mobilized and sent to the front. He was wounded shortly afterwards.
At the end of the war he turned to sculpture and the theatre, studying the possibilities for a *Triadisches Ballett*. In 1920 Schlemmer was invited to teach mural painting at the *Bauhaus* in Weimar and also to direct the theatre.

That same year he designed the costumes and settings for *Mörder* (Murderer), and *Hoffnung der Frauen* (Women's Hope) by Hindemith to a text by Kokoschka, and *Nusch Nuschi*, again by Hindemith, but to a text by Franz Blei.

Schlemmer also designed the settings and costumes for *König Hunger* by Leonida Andrejew, and for *Don Juan and Faust* by Grabbe. In 1924 he moved to Dessau with the *Bauhaus*, where he continued to direct the theatre and to teach sculpture until he accepted a post at the Academy in Breslau.

A number of Schlemmer's important paintings date from 1930–32: *Entrance to the stadium* (1930), *Vision in blue* (1931), and *Staircase in the Bauhaus*, representing the synthesis of his research.

In 1933 Schlemmer's painting was banned by the National Socialists and he decided to retire to Eichberg near Baden. He began to take up abstract painting with *Symboliques* (1936), and the series of *Windows* (1942) showing his acute mystic sense. Schlemmer continued to work for the theatre during this period and in his last years designed the sets for the *Komisches Ballett* and *Mister Ey*.

SCHMIDT-ROTTLUFF, KARL (Rottluff, Chemnitz 1884)

Schmidt-Rottluff went to grammar school in Chemnitz. In 1905 he moved to Dresden to study architecture. He soon met Heckel and Kirchner and together with them founded the *Brücke* in 1906. He also showed a few Impressionist paintings in their exhibitions in 1906, 1907, and 1911. The group split up when war broke out in 1914.

In 1915 Schmidt-Rottluff grew interested in the problems of volume and form and began to associate with the Berlin group and with the *Bauhaus*. He also did some religious woodcuts, several large watercolours and some romantic landscapes.

In 1925 he went to Italy and France on several occasions and exhibited his work in Germany and in other countries.

Schmidt-Rottluff's work was banned by the Nazi regime in 1933. In 1937, twenty-five of his paintings were included in the Exhibition of Degenerate Art held in Munich. Many of his pictures were removed from German museums.

During the bombing in 1943 much of his work was destroyed.

In the years immediately following the war he taught in the Art School in Berlin. In 1952 he was awarded the City of Berlin prize for art.

SEMEGHINI, PIO (Quistello 1878–1964)

Semeghini was born on the border of Lombardy and Emilia, but was a Venetian by adoption. He had a very turbulent youth and when little more than an adolescent went to Switzerland, attracted by the new libertarian ideas of Bakunin and Malatesta.

On his return to Italy he took up sculpture entirely without training. From 1897–8, however, he began to attend, albeit irregularly, the painting academies in Florence and Modena. He visited Paris for the first time in 1899 and continued to return frequently until 1914. He also became friendly with Ardengo Soffici and exhibited in the Galerie Chapot with Picasso.

Semeghini's *Nocturne in Paris* (1904) and his tempera portraits of Sarah Bernhardt, Coquelin, and Lucien Guitry date from this period.

He then gave up sculpture and helped Gino Rossi to found the Burano group in Italy in 1912. During these years he painted some of his finest landscapes of Venice and Burano. In 1919 and 1923 he took part in the major exhibitions held in Ca' Pesaro and in 1920 also showed in the dissidents' exhibition in the Geri-Boralevi gallery.

Semeghini stayed in Venice until 1927. After teaching painting for a few years in Lucca he moved to Monza. He spent 1930–40 in Lombardy almost without interruption, painting a long series of landscapes of the Brianza region and the lakes, as well as a number of portraits revealing great psychological depth. Semeghini continued to take part in collective shows and had several very successful one-man exhibitions. He also won a large number of prizes.

SEVERINI, GINO (Cortona 1883–1966)

Severini went to Rome in 1901 and met Boccioni and Balla. In 1906 he moved to Paris and grew friendly with Max Jacob, Modigliani, and Braque.

In 1910 he signed the Futurist Manifesto with Boccioni, Carrà, and Russolo.

During the period 1910–12 Severini painted a series of important pictures showing his very free interpretation of Futurist techniques.

In 1913 he exhibited at the Marlborough Gallery in London and with Marinetti's encouragement wrote his own manifesto. This was published in French in 1957 under the title: *Dictionnaire de la Peinture Abstraite*. From 1915–21 Severini moved from Cubism towards neo-Classicism in the wake of Picasso, and also drew nearer the *Valori Plastici*. In 1924 he became a Catholic under the influence of Jacques Maritain. Severini was commissioned to decorate several churches and he also designed a number of frescoes and mosaics in a classical style for public buildings. He illustrated books and in 1938 designed the costumes and settings for Stravinsky's *Pulcinella*, *Casa Nova* by Goldoni, and *Scarlattiana* by Casella. After spending the difficult war years in Italy, Severini returned to France in 1946, sharing Maritain's house in Meudon for six years. In 1948 he turned to abstract painting. He was commissioned to design a composition for the Agricultural Exhibition in Rome, and several murals for the KLM offices in Rome and the Alitalia buildings in Paris.

In 1959 Severini returned to Italy, first to Rome and then to Cortona.

In 1963 he worked on a series of still-lifes entitled *Les objets deviennent peinture* (Objects become painting).

SHAHN, BEN (Kaunas 1898 – New York 1970)

Shahn was a Lithuanian Jew whose family moved to America in 1906. He studied at New York University and New York City College and in 1922 enrolled in the New York National Academy of Design. In 1925 he travelled in North Africa, Spain, and Italy and was deeply impressed with Tuscan painting of the early Renaissance. On his return to America in 1926 he began work as an assistant in a small Brodway theatre and became friendly with the Negro actor, Charles Gilpin, who introduced him to Harlem. In 1927 he went to Paris and grew interested in Dufy, Rouault, and Picasso.

He settled permanently in America in 1929 and shared his studio in New York with a young photographer, Walker Evans.

The following year Shahn had an exhibition at the Downtown Gallery in New York to show his oil-paintings and watercolours of African subjects, still very much in the style of Rouault and Matisse. The same year his series of watercolours inspired by the Dreyfus case marked his first attempt to treat political and social themes. In 1932 he showed some gouaches about the trial of the two Italo-American anarchists, Sacco and Vanzetti, at the Downtown Gallery and exhibited the panel entitled *The Lovell Committee* in the Museum of Modern Art.

In 1933 Shahn collaborated with Diego Rivera on the panel *Man at the crossroads* (later destroyed) for the Rockefeller Centre. The following year the Federal Emergency Relief Administration commissioned him to paint a series of frescoes for the prison on Riker's Island, but these were ultimately rejected by the Municipal Art Commission as unsuitable.

In 1935 Shahn entered the Farm Security Administration as a photographer and poster-designer and was sent to the South and the Middle West to document the effects of the economic crisis.

In 1937 he withdrew from the Art Front group when it attacked Rivera, who was a Trotskyist. He began work on the *Sunday pictures* and on thirteen decorative murals for the post-office in the Bronx.

Shahn took an active part in the fight against Fascism in the Second World War as a poster-designer for the Office of War Administration. He became friendly with Einstein and drew several portraits of him. He also painted a great many pictures inspired by the war. He showed three pictures in an exhibition of American painting held at the Tate Gallery in London and addressed a letter to the Chrysler Corporation which stands as a testimony to the autonomy of art.

Shahn participated in many exhibitions in America and abroad. In 1951 he was appointed to the art school attached to the Brooklyn Museum in New York.

In October he exhibited at the Chicago Arts Club with Willem de Kooning and Jackson Pollock. He also illustrated an anthology of Jewish tales entitled *The Old Country* by Sholom Aleichem and did a series of drawings on jazz for Louis Armstrong.

He was also offered the chair of art at Harvard University. He next illustrated *The Sorrows of Priapus* by Dahlberg, *The Road to Miltown* by Perehman and a children's book entitled *Ounece dece Trice* by A. Ried.

In 1959 Shahn designed the cartoons for two murals, one of which was used for a mosaic panel in the Nashville synagogue. In 1960 he visited Japan, painting a series of pictures inspired by the plight of the Japanese fishermen after the fall-out. He also designed the settings for the ballet *Events* by Jerome Robbinson, performed at the Festival of the Two Worlds in Spoleto in 1961.

From 1961–2 exhibitions of Shahn's work were held in Amsterdam, Brussels, Rome, and Vienna.

SHEELER, CHARLES (Philadelphia 1883)

From 1900–3 Sheeler studied at the School of Industry and Design in Philadelphia. In 1903 he went to the Academy of Fine Arts to take lessons under William Chase with whom in the following years he visited Italy, France, and Spain.

In 1913 Sheeler exhibited some paintings in the Armory Show in New York and in 1915 showed in the Montrose Gallery. He also began to be recognized as a photographer. In 1918 he had his first one-man exhibition of photographs in the Modern Gallery in New York. In 1919 he moved to New York and collaborated on *Motion picture* with Paul. In 1920 Sheeler took part in several collective shows, and had a number of one-man exhibitions in the Zayas Gallery, the Daniel Gallery, and the Whitney Studio. Two more one-man exhibitions were organized for him in 1926: one by Louis Lozowick in the Neumann Print Room and the other in the Art Center in New York. The following year he took a series of photographs for the Ford Plant at River Rouge.

In 1929 Sheeler visited Europe again and took a series of photographs of Chartres cathedral. He also began a new style of painting with *Upper deck*.

In 1931 he had a one-man exhibition at the Downtown Gallery and in 1935 took part in the shows at the Charles Burchfield Gallery and at the Society of Acts and Crafts in Detroit. In 1934 he took up industrial design.

SINGIER, GUSTAVE (Warneton 1909)

Singier moved to Paris in 1919 and took up painting in 1923.

He attended a course at the Ecole Boulle for three years, painting from life and doing a number of copies of old masters. He worked as a designer until 1936 and then began to show his own pictures regularly in the Salons and the private galleries. He exhibited with the Indépendants until 1939 and in the Salon d'Automne from 1934–9, becoming secretary in 1942.

From 1939–42 he exhibited in the Salon des Tuileries and became a founder and member of the management committee of the Salon de Mai.

Singier painted his *Olive-trees and the sea*, *Tauromachy*, *Black and pink nocturne*, *Sun and sand*, and *Landscapes* between 1948–51. In 1946 he painted *The miracle of the loaves* for the refectory of a Dominican convent and designed tapestries for various public bodies. In 1952 he designed the stained-glass windows for the Dominican chapel in Monteils.

He also did some lithographs, including the illustrations for André Frédérique's *Le traité des Appareils* (Treatise on Machines) and designed the costumes for the performance of Monteverdi's *Orfeo* at the Festival of Aix-les-Bains.

SIRONI, MARIO (Sassari 1885 – Milan 1961)

Sironi studied in Rome and soon became friendly with Balla, Boccioni, and Severini. In 1914 he moved to Milan where he came into contact with Futurism. At the outbreak of the First World War he enlisted as a volunteer cyclist and collaborated as a designer on Umberto Notari's review, *Gli avvenimenti* (The Events). After a period of 'metaphysical' painting, Sironi settled in Milan in 1919, working as a designer and as a clicker. He was also art critic on the daily newspaper *Popolo d'Italia*, and worked for an illustrated magazine issued by *Popolo d'Italia*. In December 1922 Sironi joined the group known as *Sette pittori moderni* (Seven Modern Painters) with Anselmo Bucci, Leonardo Dudreville, Achille Funi, Gian Emilio Malerba, Piero Marussig, and Ubaldo Tosi. They were joined later by Arturo

Tosi. This group showed in the Pesaro gallery and later became known as the *Gruppo del Novecento*. During these years Sironi became very interested in the relationship between painting and architecture and collaborated with the architect, Muzio, on the Italian pavilion in Cologne (1928), and the one in Barcelona (1929). He also took part in the organization of the IV Triennale (1930) in Milan with the architects Alberto Alpago Novello and Gio Ponti, and in the V Triennale (1933) with Carlo A. Felice and Gio Ponti again. Sironi also did some important decorative designs. From 1935–7 he formed part of the management committee for the VI Triennale with Carlo A. Felice and Giuseppe Pagano and also contributed to the Italian pavilion in the Universal Exhibition in Paris.

In 1941 Sironi again worked with Muzio, this time on the new Popolo d'Italia building in Milan, contributing decorative designs and mosaics. From 1942–3 he showed a tendency to return to a form of metaphysical painting.

He took part in many collective shows and had several one-man exhibitions during the last years of his life.

SLUYTERS, JAN (Herzogenbusch 1881 – Amsterdam 1957)

Sluyters studied at the Academy of Fine Arts in Amsterdam. His early pictures show the influence of G.H. Breitner and the Impressionists and Neo-Impressionists.

Sluyters also adopted Futurist techniques for a time but a visit to Paris aroused his interest in the methods used by Gauguin. He was thus able to reach a more personal synthesis of colour and form. He painted nudes, still-lifes, landscapes, and interiors.

SOFFICI, ARDENGO (Rignano sull'Arno 1879 – Vittoria Apuana 1964)

Soffici began to study in his native town, but his father presently sent him to the Scolopian Fathers in Florence. Later he attended the Academy at the same time as Spadini. In 1900, when he was just over twenty, he left for Paris, having assimilated his first artistic experiences. Soffici remained in Paris until 1907. He became a great admirer of the Impressionists and also took an interest in the *avant-garde* movements.

He struck up a friendship with Braque, Picasso, and Derain and exhibited with them in the Salon d'Automne and the Salon des Indépendants.

On his return to Italy, Soffici founded *La Voce* and *Lacerba* with Giovanni Papini and Giuseppe Prezzolini. He also published a series of essays from 1909–14.

In 1912 he painted several Futurist pictures, mainly decompositions of landscapes and still-lifes. In 1914 he went back to Paris and met Matisse, Marie Laurencin, and Vlaminck and renewed his friendship with Apollinaire and Picasso, although his artistic activities were soon interrupted by the outbreak of the war. Soffici was called up and posted first to Pistoia and then to Naples. He settled in Poggio a Caiano when the war was over.

In 1920 he founded and directed a new review called *Rete mediterranea*, in which he advocated a return to classicism and to the reality of nature, now that the excitement of Futurism was over. He made friends with Rossi and together they painted pictures in the open air in the manner of the Impressionists.

He also founded the *Galleria* to which he contributed both socially and through his writings. In 1926 he took part in the first exhibition of the Italian *Novecento* group and the following year contributed to *Il Selvaggio*, directed by Maccari as part of Strapaese's naturalistic campaign.

Accused of collaborating with the Fascists because of his writings exalting the dictatorship, Soffici was taken to the Murate prison in 1945 and later placed in a concentration camp near Terni. In 1946 he was released and he resumed his activities as a painter and writer. From 1951–5 he wrote his *Self-portrait of an Italian artist in his own time*, for which he was awarded the Marzotto prize. In 1959 Vallecchi published his complete works.

SOHLBERG, HAROLD OSCAR (Kristiania 1869 – Oslo 1935)

Sohlberg studied at the School of Arts and Crafts under Sven Jorgenson, Erik Werenskiod, and Harriet Backer. He spent 1891–2 in Copenhagen working under Zartmann.

In 1895–6 he was in Paris, returning there again in 1906.

In 1906 he visited Venice.

He has painted a large number of landscapes and pictures of architectural subjects.

SOLDATI, ATANASIO (Parma 1896–1953)

Soldati studied at the School of Architecture in Parma. He then interrupted his course in order to serve as a volunteer in the war, but finally took his diploma in 1920.

In 1922 Soldati had his first one-man exhibition in Parma and designed a project for the restoration of the church of Sant'Alessandro together with the architect, Mora. After teaching in Langhirano, he moved to Milan to teach decoration at the Book School attached to the *Umanitaria*. In 1931 he had his first one-man exhibition in the Milione Gallery.

During these years Soldati quietly pursued his work as a painter. He was also commissioned to design several architectural projects.

In 1932 he began to take part in collective exhibitions like those held by the Milione group in Rome. He remained closely associated with this group for several years. It was not until 1933 that Soldati began to give real proof of his artistic qualities and his personal resources in his second one-man exhibition in the Milione Gallery, this time presented by Carlo Belli. From 1934–8 he adhered to abstract art but never in a purely orthodox or uncritical fashion. In 1943 he began to return to metaphysical subjects. Much of Soldati's work was destroyed during the war or became scattered in the course of his frequent moves from Milan to Solbiate, Olona, and Losanna (Pavia). After taking part in the liberation struggles at the end of the war, he moved to Voghere and commuted regularly to Milan.

When he was awarded the chair of decoration at the Brera Academy in 1947 he settled permanently in Milan. From 1946–50 he had one-man exhibitions in the Bergamini and Borromini galleries. He also helped to found the Concrete Art Movement with Dorfles, Monnet, and Munari.

In 1950 Soldati fell very ill but the following year worked on the pictures for the XXVI Biennale in Venice, where a room was devoted to his work. In the spring of 1953 he was taken to hospital, but still managed to paint a few splendid tempera before his death.

SOUTINE, CHAIM (Smilovitchi, Lithuania 1893 – Paris 1943)

After a childhood spent in hardship and privation in the Jewish ghetto in Smilovitchi, Soutine moved to Minsk in 1907.

In 1910 he enrolled in the Fine Arts Academy in Vilna with his friend Kremegne, but studied under very difficult conditions because of psychological problems and lack of money.

In 1913 he went to Paris with Kremegne and met Chagall, Laurens, Léger, Cendrars, and Modigliani.

It was through Modigliani, who was a great admirer of Soutine's painting, that he met Zborowski, the poet and art collector, who sent him to Céret at his expense and then to Cagnes in the Maritime Alps.

During these intensely creative years (1919–22), Soutine painted more than two hundred pictures.

On his return to Paris he sold a lot of one hundred canvases to the collector, Barne. Despite this material relief, Soutine still found no peace of spirit.

Periods of intense creative activity frequently alternated with fits of deep discouragement. At the approach of the Second World War the growing racial persecution in Europe made his position increasingly difficult. Although he was urged to leave France, particularly when his friend, Gerda Groth, was sent to a concentration camp, he refused and took refuge in Champigny-sur-Beuldre where he remained till his death in 1943.

SPENCER, NILES (Pawtucket 1893 – New York 1952)

Spencer studied from 1913–15 at the Design School in Providence, Rhode Island.

In 1915 he went to New York and studied under Henri and Bellows at the Arts Students League. In 1916 he settled permanently in New York, travelling regularly to Italy and France during the years 1922–9. In 1923 Spencer began to exhibit his pictures at the Whitney Studio Club. In 1925 he had his first one-man exhibition in Daniel Gall's gallery in New York. From 1933–40 Spencer spent various periods in Princeton, Massachusetts, and New York. In 1943 he began to adopt a new style of painting approaching abstract Purism.

SUTHERLAND, GRAHAM (London 1903)

Sutherland spent his early childhood in Merton Park in Surrey. He later went to Rustington in Sussex and then moved to Sutton in Surrey.

He studied at Epsom College from 1914–18 and in 1921 enrolled in Goldsmiths College in London, working as an apprentice in the Midland Railway Company at the same time. He also studied engraving under Stanley Anderson and Malcolm Osborne and in 1923 produced his first etchings. In 1925 he was made a member of the Royal Society of Etchers and Engravers, but was expelled in 1933.

Sutherland began to teach drawing in an art school in Kingston and then went on to teach engraving, composition, and book-illustration at the Chelsea School of Art. He also designed posters and decorative motifs for ceramics and textiles.

In 1931 Sutherland decided to give up engraving for painting. He had his first exhibition of pictures at the Rosenberg and Heft Gallery in London in 1938. During this period he painted: *Streets and hills at sunset*, *Forms of a green tree*, and *Forest interior*.

At the outbreak of the Second World War Sutherland and several other artists like Paul Nash, Stanley Spencer, and Henry Moore had the task of documenting the activities of the English people in wartime. From 1940–45 he thus did a great deal of sketching and painting in watercolours in and around London and the counties and even in France. During the last years of the war he executed his first compositions of thorny brambles which prefigure his *Christ on the Cross* of 1945, and his *Men walking* and *Christ carrying the Cross* of 1953.

In 1947 Sutherland visited the south of France for the first time. He returned several times in the following years, visiting the Picasso museum in Antibes and becoming acquainted with Picasso and Matisse.

In 1949 his portrait of Somerset Maugham initiated a long cycle of portrait-painting. In 1952 he had a one-man exhibition in the Biennale in Venice and in the same year began work on his *Christ in Glory* for Coventry Cathedral. He completed it in 1961. Sutherland's later works include portraits and studies of animals. In 1960 he was awarded the Order of Merit and in 1962 was made Doctor Honoris Causa at Oxford University. In 1965 a large retrospective exhibition of his work was organized in the Museum of Modern Art in Turin.

TANGUY, YVES (Paris 1900 – Woodbury 1955)

From 1908–18 Tanguy studied at the Lycée Montaigne and the Lycée St Louis. He did his military service from 1918–20 in Lunéville and then in Tunisia, where he met Jacques Prévert. On his return to Paris in 1922 he found a job on the trams in order to earn a living. In 1924 a work by De Chirico inspired him to take up painting. The following year he joined the Surrealists and in 1927 began to participate in their exhibitions. In 1930 he visited Africa. In 1939 he spent the summer at Château de Chemillieu with Breton, Matta, and Esteban Francés.

At the outbreak of the Second World War, Tanguy moved to the United States. He married the Amercian painter, Kay Sage, and in 1946 retired to a ranch in Woodbury, Connecticut. He became an American citizen in 1953.

In 1954 he took part in Hans Richter's film *8x8* with the other Surrealists.

TOSI, ARTURO (Busto Arsizio 1871 – Milan 1956)

Tosi first studied in Gola and then went on to the Technical School in Milan. At the age of eighteen he started work as a commercial correspondent with the Gaspare Gussoni firm. However he soon gave this up to devote himself exclusively to art, beginning to paint and draw although he had no training.

In 1889 Tosi took courses at the Nude School in the Brera Academy and afterwards spent two years in the studio of the painter, Ferraguti Visconti. In 1891 he met Vittore Grubicy, who proved to be his true master. Tosi was originally interested in figure drawing, as his early work demonstrates: *Head of a sick girl* and *Portrait of my father*, but at about the turn of the century he began to paint more landscapes and still-lifes.

From 1909 onwards he participated in a number of exhibitions in Italy and in other coun-

334

tries, especially in the Venice Biennales. In 1926 he joined the *Novecento* group with Funi, Marussig, Sironi, and others.

In 1936 Tosi was awarded an honorary diploma in Budapest and another in Paris in 1937. In 1943 he became a member of the Academy of San Luca.

His landscapes of Rovetta (Bergamo) and the views *(vedute)* of Liguria are among his most characteristic paintings.

UTRILLO, MAURICE (Paris 1883 – 1955)

Utrillo's mother, Suzanne Valadon, was an ex-circus acrobat, a painter's model, and also an occasional painter herself. Utrillo had an unhappy childhood spent in hardship and privation which permanently affected his health and character. In 1891 the Spanish critic and painter, Miguel Utrillo y Molins, legally recognized him as his son. A short time later his mother married Paul Mousis.

Utrillo led such a disordered existence from his early adolescence that he had to be taken into the psychiatric clinic of St Anne when he was only fifteen. As soon as he was discharged in 1901 he was pushed into painting by his mother. However, Utrillo soon found that creative work brought him comfort in his distress and helped to overcome his alienation from society. His early period, called the 'Montmagny period' after the Parisian suburb where he spent most of his time, lasted until 1907. This was followed by the 'white period', from 1908–14, the happiest and most productive time in his whole life. The gloominess of the first paintings gave way to greater serenity. Utrillo began to use a lighter palette with predominating whites and blacks with blue reflections. At the outbreak of the First World War he was called up. On his return home he suffered from new fits of depression and had to have treatment in Villejuif in 1916 and then in Picpus. In 1918 he managed to escape from yet another clinic and hid in a tavern belonging to his friend Gay. At the end of the war Utrillo's painting became recognized officially and was consistently praised in the collective shows and one-man exhibitions which followed. Fame and financial security could not keep him out of hospital, however, and he made several attempts at suicide. In 1934 he was made Chevalier de la Légion d'Honneur.

During the last years of his life, Utrillo succumbed to alcohol and retired with his wife to a quiet villa in Le Vésinet. He had increasingly frequent mystic crises but was unable to add anything new to his painting. His last work was merely sterile repetition in imitation of his earlier manner.

VALLOTTON, FÉLIX EDMOND (Lausanne 1865 – Paris 1925)

Vallotton studied first in Lausanne and then in Paris at the Julian Academy in 1882. He took part in the 1885 Salon with little success. In order to earn a living he worked as a picture restorer and contributed drawings and articles on aesthetics to the *Revue Blanche*. From 1891–7 he did some dry-point etching, a few lithographs, and a large number of woodcuts.

In 1893–4 he showed his work with the *Nabis* at Le Barc de Boutteville gallery, although he always preserved a slightly more realistic manner.

In 1906 he had another exhibition at the Galerie Bernheim Jeune with Bonnard, Roussel, Vuillard, and Sérusier.

Vallotton produced a number of etchings, caricatures, and portraits and also wrote novels and plays.

VALTAT, LOUIS (Dieppe 1869 – Paris 1952)

Louis Valtat went to grammar school in Versailles and moved to Paris in 1888 to study at the Julian Academy and in Gustave Moreau's studio. In 1889 he showed for the first time in the Salon des Indépendants. He stayed in the south of France on a number of occasions, especially in Banyuls and Collioure.

He also visited Spain in 1895, Italy in 1902, and Algeria in 1903. In 1905 Valtat took part in the famous Fauves exhibition in the Salon d'Automne. He travelled widely in Normandy and Brittany. During the last years of his life he became blind and had to give up painting.

A retrospective exhibition of his work was held at the Musée Galliera in Paris in 1956.

VAN DONGEN, KEES (Delfshaven 1877 – Monte Carlo 1967)

Van Dongen began to paint at a very early age. His first pictures were in a realistic style influenced by the French Impressionists.

In 1897 he moved to Paris and in order to earn a living took all sorts of jobs, such as house painter, porter in the central markets, and pavement artist in front of the cafés. He also contributed to satirical journals, took part in the life of Montmartre and learnt from the schools of Toulouse-Lautrec and Forain. He rapidly acquired a simpler, more concise and nervous touch. In 1906 Van Dongen joined the Fauves with enthusiasm. He remained faithful to their creed for quite some time and it was not until the end of the war that he became a society portrait-painter in constant demand with the French aristocracy. In his portraits of Anatole France, the politician Rappoport, and Boni de Castellane, Van Dongen not only revealed his talents as a colourist, he also painted a pitiless indictment of an entire epoch and social class.

His landscapes count among his most beautiful paintings. He also did a number of important book illustrations including *The Thousand and One Nights*, Kipling's *Tales*, *A la Rercherche du Temps Perdu* by Marcel Proust, *The Lepers* by Montherlant, and *The Princess of Babylon* by Voltaire.

Van Dongen spent the last years of his life in Paris and Monte Carlo.

VIANI, LORENZO (Viareggio 1882 – Lido di Roma 1936)

After attending school in Viareggio up to the third form, Viani started work as an apprentice in a barber's shop.

His poverty led him to adopt anarchism and he soon became the leader of the local association known as *Delenda Carthago*. In 1900 he enrolled in the Fine Arts Academy in Lucca and from 1904–5 studied at the Academy in Florence, where he grew interested in Giovanni Fattori's school.

During the years in Florence Viani came into contact with the artists belonging to the *Giubbe Rosse* (Red Jackets) group such as Spadini, Andreotti, Giuliotti, and Papini. He also became a friend of Anthony De Witt and Moses Levy. In 1906 he went to live in Torre del Lago.

In 1907 Viani took part in the VII Biennale in Venice, showing two series of drawings: *The scattered* and *The obsessed*. In the same year he visited Paris for the first time. In 1910, however, he returned to Viareggio weary of hardship and privation, with just a handful of drawings and paintings.

At the outbreak of the war, Viani, who was an ardent interventionist, enlisted as a volunteer. He fought on the Carso and on the Asiago plateau, continuing to draw and paint with makeshift materials for almost three years. His subjects were almost invariably inspired by the war.

In 1919 he moved to Montecatini with his wife and began a career as an advertising agent and a writer, contributing to *Popolo d'Italia* in 1921.

In 1930 his health already weakened by the asthma he had contracted during the war, suddenly grew very much worse. Alcoholism and a continued state of nervous strain obliged him to have treatment in the Maggiano mental hospital, but he still continued painting, portraying mad people and invalids.

In July 1934 he returned to Fossa dell'Abbate and began the series of *Harbours* and *Red carriages*. The *Pietà* and *Mazzini* were among his last works.

VIEIRA DA SILVA, MARIA-ELENA (Lisbon 1908)

Vieira da Silva took up drawing and painting in 1919. In 1924 she turned to sculpture. On her arrival in Paris in 1928 she enrolled in the Grande Chaumière Academy and studied under Bourdelle and Despian. In the same year she visited Italy and was very impressed by the Sienese school. In 1929 she gave up sculpture in order to devote herself exclusively to painting under Dufresne, Friesz, Léger, and Bissière. She also followed courses in engraving at the Atelier 17 with Hayter.

In 1932 Vieira da Silva met Jeanne Bucher and had a one-man exhibition at her gallery the following year. From 1939–40 she went to Portugal and Brazil.

In 1947 she returned to Paris and became a French citizen in 1956.

VILLON, JACQUES (GASTON DUCHAMP) (Damville 1875–1963)

After studying at the Ecole des Beaux-Arts in Rouen, Duchamp moved to Paris in 1894 to study painting. He soon adopted the name of his favourite poet, Villon, as a pseudonym. Following the examples of Forain, Steinlein, and above all Toulouse-Lautrec he began to publish satirical and humorous drawings in newspapers and magazines. He also designed *affiches* (posters) for Parisian cabarets and began to study engraving. In 1903 he showed in the Salon d'Automne. Villon's first pictures show the influence of Degas and Toulouse-Lautrec. Later, however, he turned to Fauvism and in 1911 adopted 'analytical Cubism'.

It was Villon who was largely responsible for the creation of the *Section d'Or*, a group of painters including Gleizes, Léger, Metzinger, Kupka, de la Fresnaye, Delaunay, Suzanne Duchamp, Raymond Duchamp Villon, and Marcel Duchamp. They met regularly at his studio in Puteaux.

After a period of inactivity due to the war, Villon resumed painting in 1919. From 1922–30 he painted his first abstract picture in greys and browns. Soon, however, he found that he was obliged to restrict his activities to engraving in order to earn a living. He also did some coloured reproductions of the works of modern painters such as Manet, Picasso, and Matisse. During these years he had successful exhibitions of his work in New York and Chicago.

After a second abstract period (1932–3), Villon went back to figurative art and the use of pure colours, which enabled him to acquire a clearer conception of space and rhythm.

At the outbreak of the Second World War he retired to the Tarn and devoted himself to landscape painting.

VLAMINCK, MAURICE DE (Paris 1876 – Rueil-la-Gadelière 1958)

Vlaminck's parents were modest music-teachers in the country and this was where he took his first painting lessons.

When he was just over eighteen he went to Paris and led a precarious existence, supporting himself by taking part in cycle races and playing the violin in small orchestras. In 1900 he became friendly with Derain and Matisse.

In 1905 he exhibited eight pictures in the Salon d'Automne which also included work by the Fauvists. The following year he devoted himself exclusively to painting.

In 1911 Vollard invited him to go to England. He also became acquainted with Modigliani, Boccioni, Carrà, Soffici, and Marinetti.

Vlaminck was called up at the beginning of the First World War. His experience in the war and his private reflections later brought about a severe moral and aesthetic crisis. He solved this stylistically by correcting his means of expression and gradually becoming more independent.

In 1919 he moved to Valmondois with his second wife after having had a particularly successful exhibition in the Galerie Druet. He retired to the country and spent his time writing and painting.

A large exhibition of his work was organized in 1956 at the Galerie Charpentier to celebrate his eightieth birthday.

VUILLARD, EDOUARD (Cuiseaux 1868 – La Baule 1940)

Vuillard was the son of a retired army officer. When his family moved to Paris in 1887 he took the advice of his friend, Roussel, and enrolled in the Ecole des Beaux-Arts. He later attended the Julian Academy where he met Bonnard, Vallotton, Ibels, Ranson, and Sérusier. Together with these painters, the poet Cazalis and the sculptors Lacombe, Seguin, Percheron, Verkadde, and Maillol, he formed the group known as the *Nabis*.

Vuillard then embarked upon several years of polemics and entered a period of intense creative activity. In about 1890–91 he produced his first autonomous pictures. In 1891 he exhibited in Le Barc de Boutteville gallery and the following year painted the decorative panels for Mme Desmarais. He met the art dealer, Joseph Hessel, and established relations with the Bernheim Jeune gallery. He also met Toulouse-Lautrec, Gustave Geffroy, Romain Coolus, Mirbeau, and Fénéon. During this period Vuillard also discovered Gauguin and Japanese art.

He designed settings and lithographs for the repertoire of the Théatre de l'Oeuvre which Lugné-Poe founded in 1893 and did some important decorative work.

From 1903–4 he had several one-man exhibitions, showed in the Salon des Indépendants, and helped to found the Salon d'Automne. He made numerous trips abroad and in 1903 began teaching at the Ranson Academy. He became a member of the Institute in 1938. In 1913 he decorated the foyer of the Comédie des Champs Elysées. In 1937 he collaborated on the decoration of the Palais de Chaillot. A vast retrospective exhibition of his work was organized in the Musée des Arts Décoratifs in 1938.

Two years later the German advance forced him to leave Paris and he died on his way to La Baule.

WILLUMSEN, JENS FERDINAND (Copenhagen 1863 – Cannes 1958)

Willumsen studied architecture and painting in the Academy in Copenhagen from 1881–5 and took painting lessons with P.S. Kroyer.

From 1888–94 he travelled widely and visited Paris, Spain, and Brittany.

In 1890 Willumsen became friendly with Paul Gauguin. The following year he helped to found the *Frie Udistilling*. In 1893 he went to the United States to see the Universal Exhibition in Chicago. In the spring of 1900 he visited New York and in 1901 he spent a summer in Switzerland. Later, from 1910-11, he went to Italy and Spain and studied the art of El Greco. In 1913–14 he went to Tunis and Athens.

In 1920 Willumsen settled in Nice. He has participated in a large number of exhibitions and collective shows. He has also done many lithographs and wood-cuts.

WINTER, FRITZ (Altenbogge 1905)

Winter first worked as an electrician and then as a collier. From 1927–30, however, he studied at the *Bauhaus* in Dresden under Klee, Kandinsky, and Schlemmer. From 1930–33 he lived in Berlin and struck up a friendship with Naum Gabo. In 1933 he also began to move in the artistic circles of Munich. From 1939–49 he served with the army and was taken prisoner in Russia. In 1955 he began to teach at the Werkakademie in Kassel.

WOLS, ALFRED (WOLFGANG SCHULZE) (Berlin 1913 – Paris 1951)

When Wols finished his studies in Dresden he took up photography. In 1933 he went to Paris where he was greatly attracted by the intellectual and artistic life of the city and decided to settle there. In 1937 he had his first exhibition of photography in the Pléiades gallery and officially assumed the name of Wols. In 1939 he painted his first pictures: *The trumpet sounds* and *Insectoïdes*. These were followed in 1942 by the more pessimistic gouaches swarming with microscopic creatures and strange protuberances like tumours, which he painted in Cassis and Dieulefit.

Wols spent the Second World War in a concentration camp, returning to Paris in 1946.

His painting now took a new turning and he seemed to be creating from a state of trance. All his paintings of these years (1946–51) appear as direct transmissions, on canvas or paper, of his existential consciousness.

Alain-Fournier, *The Lost Domain* (Le Grand Meaulnes), 1913; translated from the French by Frank Davison; published by Oxford University Press.

Bacchelli, Riccardo, *Il Diavolo al Pontelungo*, 1927; published by Arnoldo Mondadori, Milan, 1965; extract translated from the Italian by P. S. Falla.

Birolli, Renato, *Taccuini*, 1936–59; published by Einaudi, Turin, 1960; extract translated from the Italian by P. S. Falla.

Böll, Heinrich, *Billiards at Half Past Nine*, 1959; translated from the German by Patrick Bowles; English translation © 1961 by George Weidenfeld and Nicolson Ltd.; published by Weidenfeld and Nicolson Ltd. and McGraw-Hill Book Company.

Bulgakov, Mikhail, *The Master and Margarita*, 1928–40; translated from the Russian by Michael Glenny; copyright © 1967 by The Harvill Press and Harper & Row.

Butor, Michel, *Passing Time*, 1960; translated from the French by Jean Stewart; reprinted by permission of Faber and Faber Ltd. and Simon and Schuster, Inc.

Camus, Albert, *Betwixt and Between*, 1937; from 'Lyrical and Critical'; translated from the French by Philip Thody; copyright © 1967 by Hamish Hamilton Ltd. and Alfred A. Knopf, Inc.

Dos Passos, John, *The Ground We Stand On*; copyright by H. Marston Smith and Elizabeth H. Dos Passos, co-executors of the estate of John R. Dos Passos.

Eliot, T. S., *Collected Poems 1909–1962*; copyright, 1936, by Harcourt Brace Jovanovich, Inc.; copyright © 1963, 1964, by T. S. Eliot; reprinted by permission of Faber and Faber Ltd. and Harcourt Brace Jovanovich, Inc.

Faulkner, William, *Sanctuary*, 1931; copyright 1931, and renewed, 1958, by William Faulkner; reprinted by permission of Curtis Brown Ltd. and Random House, Inc.

Faulkner, William, *Soldiers' Pay*, 1926; copyright, 1926, by Boni & Livereight, Inc., copyright renewed, 1953, by William Faulkner; reprinted by permission of Curtis Brown Ltd. and Random House, Inc.

Forster, E.M., *A Passage to India*, 1924; reprinted by permission of Edward Arnold Ltd. and Harcourt Brace Jovanovich, Inc.

Gadda, Carlo Emilio, *That Awful Mess on Via Merulana*, 1957; translated from the Italian by William Weaver; English translation © 1965 by George Braziller, Inc.; published by Martin Secker & Warburg Ltd. and George Braziller, Inc.

Gide, André, *Strait is the Gate*, 1909; translated from the French by Dorothy Bussy; copyright 1924, 1952 by Alfred A. Knopf, Inc.; published by Secker & Warburg Ltd. and Alfred A. Knopf, Inc.

Gorky, Maxim, *Byvsie Liudi*, 1905; published by Mezhdunarodnaya Kuiga, Moscow; extract translated from the Russian by Teresa Wilde.

Hesse, Hermann, *Narziss and Goldmund*, 1933; translated from the German by Geoffrey Dunlop; copyright © Hermann Hesse 1959 and 1968 by Farrer, Straus & Giroux, Inc.; published by Peter Owen Ltd. and Vision Press and Farrar, Straus & Giroux, Inc.

Hughes, Richard, *The Fox in the Attic*, 1961; copyright © Richard Hughes 1964; published by Chatto and Windus Ltd. and Harper & Row.

Joyce, James, *Ulysses*, 1914; copyright, 1914, 1918, by Margaret Caroline Anderson, copyright, 1934, by Modern Library Inc., copyright renewed, 1961, by Lucia and George Joyce; published by The Bodley Head Ltd. and Random House, Inc.

Kafka, Franz, *Description of a Struggle*, 1933; translated from the German by Tania and James Stern; English translation © 1958 by Schocken Books Inc.; published by Martin Secker & Warburg Ltd. and Schocken Books Inc.

Kazakov, Yury, *Night*, 1955; from 'Racconti dell'U.R.S.S.', published by Schwarz, Milan, 1961; extract translated from the Italian by P. S. Falla.

Kawabata, Yasunari, *Snow Country*, 1956; translated from the Japanese by Edward G. Seidensticker; copyright 1956, 1958 by Alfred A. Knopf, Inc.; originally published in Japan as 'Yukiguni'; first published in English by Alfred A. Knopf, Inc., January 7, 1957; published by Martin Secker & Warburg Ltd. and Alfred A. Knopf, Inc.

Kerouac, Jack, *The Subterraneans*, 1958; copyright © 1958 by Jack Kerouac; published by Grove Press, Inc.

Lampedusa, Giuseppe di, *The Leopard*, 1958; translated from the Italian by Archibald Colquhoun; copyright © in the English translation William Collins Sons & Co., Ltd., London; published by William Collins Sons & Co., Ltd. and Pantheon Books, a division of Random House, Inc.

Lawrence, D.H., *The Plumed Serpent*, 1926; copyright, 1926, by Alfred A. Knopf, Inc.; reprinted by permission of Laurence Pollinger Ltd. and the Estate of the late Mrs. Frieda Lawrence; published by William Heinemann Ltd. and Alfred A. Knopf, Inc.

Lee, Laurie, *Cider with Rosie*, 1959; copyright © Laurie Lee, 1959; published by The Hogarth Press Ltd. and William Morrow & Company Inc. (under the title of *The Edge of Day*).

Lorca, Federico Garcia, *Selected Poems*, 1929; translated from the Spanish by Stephen Spender and J. L. Gili; copyright 1955 by New Directions Publishing Corporation; reprinted by permission of New Directions Publishing Corporation.

Machado, Antonio, *Prose*, 1932; extract translated from the Spanish by P. S. Falla.

Malraux, André, *The Conquerors*, 1929; translated from the French by Winifred Stephens Whale; English translation © 1929 Jonathan Cape Ltd.; published by Jonathan Cape Ltd. and Random House, Inc.

Mann, Thomas, *Death in Venice*, 1912; translated from the German by H. T. Lowe-Porter; English translation copyright © H. T. Lowe-Porter, 1928, copyright 1930 by Alfred A. Knopf, Inc.; published by Martin Secker & Warburg Ltd. and Alfred A. Knopf, Inc.

Masters, Edgar Lee, *Spoon River Anthology*, 1914; permission granted by Ellen C. Masters; copyright © 1915, 1916, 1942 and 1949 by Edgar Lee Masters; published by The Macmillan Company.

Maugham, Somerset W., *Neil Macadam*, 1930; reprinted by permission of the Literary Executor of W. Somerset Maugham from 'The Complete Short Stories of W. Somerset Maugham'; 'Neil Macadam' copyright 1930 by W. Somerset Maugham, from 'Ah King' by W. Somerset Maugham; reprinted by permission of Doubleday & Company, Inc.; published by William Heinemann Ltd. and Doubleday & Company, Inc.

Montale, Eugenio, *Selected Poems*, 1921–26; translated from the Italian by George Kay; copyright © Eugenio Montale and George Kay, 1964, copyright © 1965 by New Directions Publishing Corporation; published by Edinburgh University Press and New Directions Publishing Corporation.

Orwell, George, *Keep the Aspidistra Flying*, 1936; copyright © the Estate of Eric Blair; published by Martin Secker & Warburg Ltd. and Harcourt Brace Jovanovich Inc.

Pasternak, Boris, *Doctor Zhivago*, 1957; translated from the Russian by Max Hayward and Manya Harari; English translation © William Collins & Co. Ltd., London, 1958; published by William Collins & Co., Ltd. and Pantheon Books, a division of Random House, Inc.

Pavese, Cesare, *The Devil in the Hills*, 1948; translated from the Italian by D. D. Paige; from 'The Selected Works of Cesare Pavese'; copyright © 1968 by Farrar, Straus & Giroux, Inc.; published by Peter Owen Ltd. and Farrar, Straus & Giroux, Inc.

Pavese, Cesare, *The House on the Hill*, 1949; translated from the Italian by W. J. Strachan; reprinted by permission of Peter Owen Ltd. and Walker & Company.

Pilnyak, Boris, *La tormenta*, 1921; from 'Racconti dell'U.R.S.S.'; published by Schwarz, Milan, 1961; extract translated from the Italian by P. S. Falla.

Pirandello, Luigi, *La giara e altre novelle*, 1912; published by Arnoldo Mondadori, Milan, 1965; extract translated from the Italian by P. S. Falla.

Proust, Marcel, *Swann's Way*, 1913; from 'Remembrance of Things Past'; translated from the French by C. K. Scott Moncrieff; copyright © Chatto & Windus Ltd. 1922, copyright, 1928, by The Modern Library Inc., copyright renewed, 1956, by The Modern Library Inc.; published by Chatto & Windus Ltd. and Random House, Inc.

Queneau, Raymond, *Pins, pins et sapins*, 1943–48; from 'Un enfant a dit'; translated from the French by P. S. Falla.

Saba, Umberto, *Poesie*, 1935–43; published by Arnoldo Mondadori, Milan, 1966; translated from the Italian by P. S. Falla.

Sartre, Jean-Paul, *Nausea*, 1938; translated from the French by Lloyd Alexander; copyright © 1962 by Hamish Hamilton Ltd., copyright © 1964 by New Directions Publishing Corporation; published by Hamish Hamilton Ltd. and New Directions Publishing Corporation.

Steinbeck, John, *The Grapes of Wrath*, 1939; copyright © John Steinbeck, 1939; published by William Heinemann Ltd. and The Viking Press Inc.

Steinbeck, John, *East of Eden*, 1952; copyright © John Steinbeck 1952; published by William Heinemann Ltd. and The Viking Press Inc.

Ungaretti, Giuseppe, *Sentimento del tempo*, 1920; from 'Poesie'; published by Arnoldo Mondadori, Milan, 1966; translated from the Italian by P. S. Falla; reprinted by permission of Cornell University Press.

Vittorini, Elio, *Le Città del Mondo*, 1952–59; published by Einaudi, Turin, 1969; translated from the Italian by P. S. Falla.

Wiechert, Ernst, *The Simple Life*, 1939; translated from the German by Marie Heynemann; reprinted by kind permission of Verlag Kurt Desch GmbH.

Woolf, Virginia, *The Years*, 1937; copyright © Literary Estate of Virginia Woolf, copyright © 1937 by Harcourt Brace Jovanovich, Inc., renewed, 1965, by Leonard Woolf; published by The Hogarth Press Ltd. and Harcourt Brace Jovanovich, Inc.

Woolf, Virginia, *To the Lighthouse*, 1927; copyright © Literary Estate of Virginia Woolf, copyright © 1927 by Harcourt Brace Jovanovich, Inc., renewed, 1955 by Leonard Woolf; published by The Hogarth Press Ltd. and Harcourt Brace Jovanovich, Inc.

ACKNOWLEDGEMENTS

344

LIST OF COLLECTIONS